34.50/
2 /27.60

APPLIED PHOTOGRAPHY

THE FOCAL LIBRARY: EDITORIAL BOARD

Publishers
FOCAL PRESS LIMITED
31 Fitzroy Square, London, W.1, England

APPLIED PHOTOGRAPHY

C. R. Arnold P. J. Rolls J. C. J. Stewart

Edited by
D. A. Spencer

THE FOCAL PRESS
LONDON and NEW YORK

First Edition 1971

ISBN 0 240 50723 1

Printed in Great Britain at The Curwen Press, Plaistow, London E.13.

CONTENTS

2. INFORMATION CAPACITY AND RESOLUTION

6

3. LIGHT SOURCES

4. MACROPHOTOGRAPHY

8

5. PHOTOMICROGRAPHY

6. MICROPHOTOGRAPHY

7. INFRARED PHOTOGRAPHY

11

8. ULTRAVIOLET PHOTOGRAPHY

12

9. RADIOGRAPHY

10. CINEMATOGRAPHY

11. HIGH SPEED PHOTOGRAPHY

14

12. INSTRUMENTATION AND RECORDING

13. STEREOSCOPIC PHOTOGRAPHY

14. PHOTOGRAMMETRY

15. PHOTOGRAPHIC VISUALISATION

16. APPLICATIONS OF PHOTOGRAPHY IN ENGINEERING

17. SPECIAL PURPOSE CAMERAS

18. PHOTOGRAPHY OF INACCESSIBLE OBJECTS

Appendices

INTRODUCTION

The term 'applied photography' covers the uses of photography for the production of records of value in the study, understanding and control of basic processes in all branches of science, industry and education.

Most of us are now surely aware that photography has other applications than entertainment or comment on the times we live in—that amateur, professional, news and motion picture photography is not the whole story. We are, however, typically startled to learn that the majority of the world's output of photographic material is used in these other applications.

The basic contribution of photography to science is the provision of records that cannot be made in any other way. Although our knowledge of the external world and our mastery over it depends entirely on our five senses, the development of science and technology ultimately depends on making observations by eye and scientific effort is almost entirely concentrated on transforming phenomena into a form that can be seen and studied at leisure.

The camera provides us with a sort of synthetic eye—a detached retina with an infallible memory—capable of turning into visible records phenomena whose existence we should otherwise neither suspect nor understand.

The methods of using photography as a tool can be broadly divided into two groups
1 Making illustrations for record, demonstration or investigation purposes of things which the eye can see.
2 Recording phenomena under conditions where the human eye is helpless, either because the light is too bright, too dim or too transient to see by or because the radiation of interest does not give rise to vision. This second group has led to the development of cameras ranging in size from instruments small enough to be swallowed to others weighing several tons as well as hundreds of specialized photographic materials.

In the circumstances, it is perhaps surprising, if understandable, that the majority of textbooks on photography are written to inform and help the users of conventional cameras making pictures in the conventional sense of the word.

Much of the information such texts contain is irrelevant to the newcomer to applied photography. He has, typically, only a limited number of specialised textbooks or papers scattered through journals to turn to and, in consequence, only too often his attempts to apply photographic techniques to new problems is hindered by misunderstanding of the relevant characteristics of the sensitive materials or ignorance of the facilities and techniques already available. The devising of new applications is then hindered or made unnecessarily costly.

As no one possesses personal experience in all branches of applied photography, the present book is the product of collaboration between three experts who, between them, have covered the field in a most comprehensive manner.

Besides covering the basic fundamentals which the applied photographer needs to understand, the resulting text is an authoritative survey of the amazing diversity of the uses to which photography has been turned by human ingenuity.

D. A. SPENCER

ACKNOWLEDGMENTS

The authors wish to thank the following for their constructive comments on sections of this book: G. R. Cooper, L. E. Elliott, J. C. Rockley, P. B. Nuttall-Smith, W. J. Sexton, Dr. D. E. W. Stone, W. McL. Thompson and W. Turner. The co-operation of many other friends and colleagues is also gratefully acknowledged.

The following organisations have supplied technical information and their assistance and permission to publish details of their products or techniques, and in some cases, illustrations are gratefully acknowledged. Acmade Ltd., A.E.I. Lamp & Lighting Co. Ltd., Aga Standard Ltd., Aga (U.K.) Ltd., Agfa-Gevaert Ltd., P. W. Allen & Co., The Amateur Photographer, American National Standards Institute, Aveley Electrics Ltd., Balzers High Vacuum Ltd., Barr & Stroud Ltd., Bausch & Lomb Optical Co. Ltd., R. & J. Beck Ltd., Bell & Howell Ltd., Bellingham & Stanley Ltd., British Lighting Industries Ltd., Cambridge Scientific Instruments Ltd., Central Electricity Generating Board, Chance Brothers Ltd., Contraves AG, Cossor Electronics Ltd., C.Z. Scientific Instruments Ltd., Dale Electronics Ltd., Dawe Instruments Ltd., Degenhardt & Co. Ltd., Deutsche Kamera- und Orwo-Film-Export GmbH, Direct Photographic Supplies Ltd., Dumont Oscilloscope Laboratories Inc., Duval Ltd., Ealing Beck Ltd., Eclair Debrie (U.K.) Ltd., E.M.I. Electronics Ltd., Engelhard Hanovia Lamps, Envoy (Photographic Instruments) Ltd., Evans Electroselenium Ltd., Evershed Power-Optics Ltd., Field Emission U.K. Ltd., Foster Instrument Co. Ltd., Gillett & Sibert Ltd., John Godrich, Gordon Cameras Ltd., Guest Electronics Ltd., John Hadland (Photographic Instrumentation) Ltd., Hilger & Watts Ltd., Ilford Ltd., Instruments Division (D. R. Grey) Ltd., Johnsons of Hendon Ltd., Joyce, Loebl & Co. Ltd., Kodak Ltd., Lee Smith Photomechanics Ltd., E. Leitz (Instruments) Ltd., Leland Instruments Ltd., Lunartron Electronics Ltd., 3M Company Ltd., Metallographic Services Laboratories Ltd., Micro Cine Ltd., Micro-Instruments (Oxford) Ltd., D. B. Milliken Co., Department of Trade and Industry (renamed, ex-Ministry of Technology)—Hydraulics Research Station—National Physical Laboratory, Ministry of Aviation Supply (renamed, ex-Ministry of Technology)—Royal Aircraft Establishment, Morgan & Morgan Inc., National Cash Register Co. Ltd., Newman & Guardia Ltd., Nuclear Enterprises (G.B.) Ltd., Optec Reactors Ltd., Optical Works Ltd., Osram-G.E.C. Ltd., Pantak Ltd., Philips Electrical Ltd., Pilkington Brothers Ltd., P.M.D. Chemicals, Polaroid (U.K.) Ltd., The Projectina Co. Ltd., Racecourse Technical Services Ltd., Rank Audio Visual Ltd., Rank Precision Industries Ltd., Research Engineers Ltd., Science Research Council, David Shackman & Sons Ltd., Shandon Scientific Ltd., H. V. Skan Ltd., Society of Photographic Scientists & Engineers, Telford Products Ltd., Thorn Electric Ltd., Ernest Turner Electrical Instruments Ltd., United Kingdom Atomic Energy Authority, Vickers Ltd., W. Vinten Ltd., Vinten Mitchell Ltd., Vision Engineering Ltd., W. Watson & Sons Ltd., Wild Heerbrugg (U.K.) Ltd., Williamson Manufacturing Co. Ltd., Carl Zeiss, Oberkochen.

1. SENSITOMETRY

1.1 *Introduction*

An understanding of sensitometric principles must be one of the primary aims of the applied photographer. The term sensitometry is not used here in the narrow sense of film speed determination, but covers practical comparison of materials, process control and the various forms of photographic photometry. In all these fields a methodical approach is essential if meaningful results are to be obtained.

The general principles and terminology are well enough known. The intention here is to re-state briefly the basic language of the subject, to mention some of the equipment used and to discuss some of the problems that can arise in the application of sensitometric methods.

Sensitometric tests do not allow evaluation of *all* aspects of photographic performance and picture tests may be necessary to check that the normal sensitometric criteria are valid for a particular application.

Absolute sensitometry implies that the total exposure (image illuminance × exposure duration) given to the film is known quantitatively (in lux-seconds). This is normally required only for absolute film speed determination (see p. 51) and in most cases *comparative* sensitometry is adequate, in which it is sufficient to know that the exposure is constant from test to test. The image illuminance is not, therefore, normally measured, although the duration of exposure must be specified to avoid discrepancies due to reciprocity failure.

There are four basic stages in any sensitometric experiment:
Exposure and storage of the film
Processing
Measurement (densitometry)
Interpretation.

1.2 *Exposure*

1.2.1 STORAGE BEFORE EXPOSURE. No photographic emulsion has a constant film speed throughout its life and comparisons should only be made on materials of the same batch that have had the same storage history prior to exposure. In addition, there are always small variations within a large batch of material and for critical work a series of tests must be made to establish the mean characteristics (see p. 54). In such work great care is necessary to ensure that any observed variations are not due to inconsistent processing or other errors in handling by the photographer.

Considerable changes in emulsion speed, contrast and colour balance occur immediately after manufacture, but the rate of change has greatly reduced by the time the material is released to the public. However, the speed and contrast continue to drop slowly and the fog level rises throughout the life of the film. A reduction of one-third of a stop in film speed during the first year of life is quite common and this is accelerated by increased temperature and relative humidity; careless storage under high temperature for as little as a week can reduce the speed by 50 per cent. In some cases the increased size of fog centres may give a temporary slight increase in effective sensitivity.

All these problems can be reduced by refrigeration, which is the only way in which strips can be stored for comparative processing over a period of time.

In extreme cases the effects of chemical vapours or storage in wooden boxes (Russell effects) may affect the film sensitivity and fog level.

1.2.2 LATENT IMAGE REGRESSION. The latent image may show a slight increase for a short period after exposure but the general tendency is for a steady decline in effectiveness; this drop is fairly rapid for a few minutes and it is advisable to wait for at least 30 minutes after exposing the last of a batch of strips in order to allow the separate latent images to reach equilibrium. Bromide paper is usually developed immediately,[10] but for monochrome negatives processing should commence between 1 and 2 hours after exposure.[11] For colour negatives the film speed standard calls for 5–10 days storage,[12] although this delay is not applicable to most professional practice.

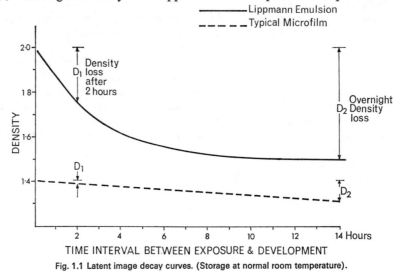

Fig. 1.1 Latent image decay curves. (Storage at normal room temperature).

Emulsions vary considerably in their regression characteristics; fine grain materials are the most susceptible and some micro-recording films require 1–3 days to achieve equilibrium. The latent image decay curves in Fig. 1.1 indicate the possible need for standardisation of short-term storage. Other emulsions may be less critical in this respect, but it remains a factor for consideration in any sensitometric work. As a rule of thumb, if there is an interval T between the first and last exposure, a further delay of $10\,T$ may be allowed before processing.

Pre-exposed control strips are supplied by film manufacturers for many processes and refrigerated storage of these strips is essential to arrest latent image regression. For short-term storage (4–6 weeks) Kodak recommend a temperature below $-1°C$ (30°F) but for longer periods a temperature below $-18°C$ (0°F) is necessary.

In long-term comparative studies there are two possible approaches to the storage of control strips:

(1) To expose sufficient strips at the start of the experiment and to store them for subsequent development as required.

24

(2) To store the batch of strips in an unexposed form and to expose them shortly before they are needed for processing.

The choice is really between the risks, respectively, of latent image regression and pre-exposure deterioration of the film characteristics. Refrigerated storage makes both methods practicable, but the latter course is probably preferable if a good sensitometer is available. Experimental work on latent image regression and intensification has been reported by Gutoff and Timson.[13]

It must further be ensured that the material is not exposed to light or stored near any radioactive materials. Any possibility of post-exposure latent image destruction (due to the Herschel effect, the Clayden effect etc.) must also be prevented. In the specialised case of autoradiography (see p. 300) the emulsion is in contact with the specimen, which may cause chemical effects on the latent image (negative or positive chemography). This may combine with normal latent image fading, background fogging and the primary exposure, causing problems in quantitative work.

Colour films vary considerably in their susceptibility to image regression and the manufacturer should be consulted on the precautions necessary for critical long-term studies.

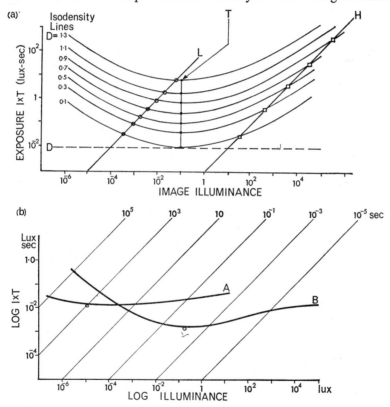

Fig. 1.2 Reciprocity failure (a) Basic features of Log $IT \times$ Log I curves (simplified isodensity lines of exaggerated curvature) : T, Time scale exposure of fixed intensity (0.1 lux). H, Intensity scale exposure of 10^{-3} sec duration. L, Intensity scale exposure of 10^2 sec duration. D, Ideal iso-density line for D=0.1. (b) Comparison of iso-density curves : A, Astronomical plate (maximum efficiency 10^3 sec). B, High speed film (maximum efficiency 10^{-2} sec). Film B has inherently higher speed ($10\times$) than film A but the latter is faster for exposure levels less than about 10^{-4} lux.

1.2.3 RECIPROCITY FAILURE. Photographic exposure is expressed as the product of intensity (I)* and time (T)—in lux-seconds. Ideally, there should be a reciprocal relationship between the two factors, as stated by the Bunsen-Roscoe law of reciprocity in photo-chemical reactions. The condition is indicated by line A in Fig. 1.2 which shows the total exposure (I × T) necessary to give a constant density level, irrespective of the intensity.

In photography, the reciprocity law never holds absolutely true and the efficiency of latent image formation varies with the image intensity level, as shown by the set of iso-density curves in Fig. 1.2; at both high and low intensities an increased total exposure is necessary to give the required density. This reciprocity failure is sometimes termed the Schwarzschild effect.

In this type of graph (due to Kron, 1913), the density increments given by a range of exposure times at constant intensity are shown along the vertical line (T). The density increments given by an exposure of constant time and varying intensity are shown along the diagonal line (L). Because of the curved shape of the isodensity lines, the density increments along L and T are not identical; this is shown in a more familiar form by plotting the figures as D/Log E characteristic curves (Fig. 1.3b).

Fig. 1.3a shows another way of expressing the interaction of intensity and time by plotting the densities resulting from different combination of Log I and Log T. The separation of the iso-density lines is a measure of the contrast and the differences between high-intensity and low-intensity exposures can be seen from the different density increments plotted along the lines H and L.

The same approach can be used to produce three-dimensional models, plotting Log I against Log T with density as the model height or Z-axis. The 'characteristic surfaces' so produced show the complete intensity-time relationship of emulsion performance.

The practical implication of all these curves is that the contrast and speed of photographic materials is not constant, but varies according to the exposure time. High-intensity short-duration exposures tend to give low contrast, while long exposures under low illumination tend to produce higher contrast because the reciprocity failure has greater effect in the shadows.

In both cases, the simple remedy is to give more exposure (although that does not correct the contrast swing) and tables of generalised exposure correction factors are available. However, emulsions differ so much in their behaviour that it is best to seek specific information or to make exposure and development tests on each material that is to be used for critical work.

The loss of speed and contrast with high-intensity exposures can be minimised by extra development (25–50 per cent), at the probable cost of increased granularity and fog. The reduced efficiency produced by low-intensity exposures may sometimes be restored by latensification but the normal procedure is to reduce development and increase exposure.

Under certain exposure conditions, reciprocity failure causes a change of colour balance in colour tri-pack films, because the three emulsions do not have exactly matching intensity-time characteristics; colour correction filters may then be necessary in addition to the exposure correction factor for the speed loss. In general, very short exposures tend to give a magenta cast and long exposures a green-yellow cast.

*The term image illuminance (E) would be more in keeping with photometric terminology (see Chapter 3), but intensity (I) is so firmly established in this context that it is retained in this chapter.

26

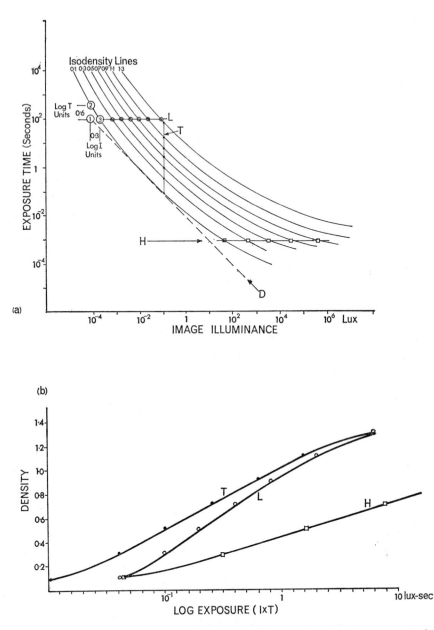

Fig. 1.3. Reciprocity failure. T, Time scale exposure of fixed intensity (0.1 lux). L. Intensity scale exposure of 10^2 sec duration. H, Intensity scale exposure of 10^{-3} sec duration. D, Ideal isodensity line for D=0.1. (a) Log T × Log I curves. The difference between intensity and time correction factors is illustrated as follows: 1, In the absence of reciprocity failure, an exposure of 100 sec × 1/10,000 lux would give a density of D=0.1. 2, Because of reciprocity failure the exposure duration must be increased by 4× to give D=0.1.3, However, if the *intensity* can be increased, the correction factor is only 2×. (b) D/Log E curves for time-scale and intensity-scale exposures. These curves are plotted from the simplified curves of Fig. 1. 2a. In practice the D/Log E curves may not show such marked variation but this figure illustrates the fact that speed and contrast are affected by the individual values of I and T.

The changes in response with varying temperature are complex, owing to variations in the silver halide absorption and in the effectiveness of the panchromatic dye sensitiser. Sensitometric comparisons can be made only when the exposure temperature is standardised (see p. 54), although this is unimportant within the normal range of ambient temperatures (10–20°C). The complication caused by reciprocity failure can be minimised by operating at low temperature; this technique and other methods (e.g. hypersensitisation) for optimising performance in astronomical photography have been discussed by Hoag and Miller.[14]

The effect of high-intensity reciprocity failure on the contrast and colour balance of colour films used for high-speed photography has been discussed by Von Wartburg;[15] in general reversal films show less change of performance than negative colour films.

The effects of low-intensity failure sometimes arise when applying filter factors and other exposure correction factors; in such cases it is important to stipulate whether it is the exposure time or the exposure intensity that is to be increased (see p. 58).

The theoretical background to the subject of reciprocity failure and further discussion of its practical implication has been given by Hamilton.[16] The practical interpretation of Log E/Log I curves has been discussed by Todd and Zakia.[9]

1.2.4 INTERMITTENCY EFFECT.[10] As a consequence of reciprocity failure, a series of short exposures on the same emulsion does not normally give a density equal to a single (continuous) exposure of equivalent total intensity and time. This effect varies with the interruption frequency and for some materials disappears above a frequency of 50 or 100 'flashes' per exposure. The intermittency effect is more noticeable with slow emulsions, low exposure intensities and longer intervals between the exposures.

1.2.5 WAVELENGTH. The variation of emulsion speed over the electromagnetic spectrum is shown by the normal spectral sensitivity curves (Fig. 8.7). The different wavelengths also produce different photographic contrast. The lower contrast commonly encountered with shorter wavelengths is referred to as the gamma-lambda effect or gradient-wavelength effect; its importance in ultraviolet photography is discussed on page 273. The relationship between wavelength and gamma is a complex one, particularly with dye-sensitised emulsions and Farnell[17] has shown that variations are found throughout the visible spectrum.

Clearly, in any sensitometric work the exposing waveband must be carefully chosen and, if necessary, adjusted by filter to suit the purpose of the experiment. It is particularly important to match the UV content to that normally falling on the film plane in the camera.

Cree[18] has described the use of filtered tungsten or xenon flash lamps for sensitometric simulation of the emission of the phosphors used in cathode ray oscilloscopes.

1.2.6 SENSITOMETERS

1.2.6.1 *Basic classification.* A sensitometer is a device for giving a series of reproducible exposures to photographic materials. Sensitometers vary in their designed purpose, but the essential features are common to all:

(1) A lamp of suitable intensity and appropriate spectral distribution
(2) A method of controlling the source supply to give a constant output over the life of the lamp
(3) Careful design to ensure even illumination of the test area
(4) A light modulator giving the required increments of exposure.

Sensitometers are classified according to their method of modulating the exposure.

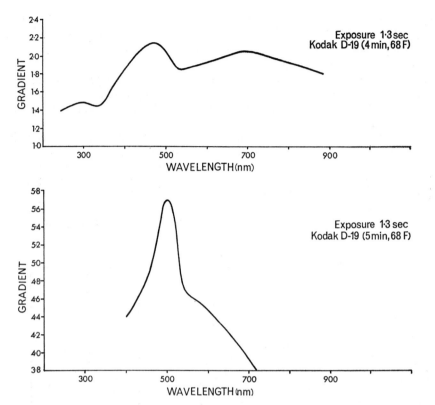

Fig. 1.4. Gamma/wavelength curves (By courtesy of Eastman Kodak Ltd.) (a) Kodak LN plate. (b) Kodak 649 plate.

If the illumination level is varied, as with a step-wedge, the system is termed 'intensity-scale'* (also called a Type I instrument). If the exposure time is varied for each step, the system is termed 'time-scale' (also called a Type II instrument).**

1.2.6.2 *Time-scale sensitometers*. Time-scale instruments use a rotating or dropping shutter, with slots of different length to give the exposure increments. The system has the advantage that the relationship between the steps is accurately known and the quality of the light is not altered by selective spectral absorption. The time-scale exposure does not give results strictly comparable with normal practice (see below) but the system is nevertheless suitable for process control purposes, where consistency is more important than correlation with normal photographic conditions.

1.2.6.3 *Intensity-scale sensitometers*. In almost every practical situation the camera image is intensity modulated and the overall exposure time, governed by the shutter speed, is constant. As it is often important that the sensitometric exposure should match these practical conditions, most modern sensitometers are intensity-scale instruments.

*This term is firmly established, although 'illuminance scale' would be more correct terminology.

** In Jones' original classification, sensitometers are further divided into Class A and Class B, according to whether the exposure is intermittent or non-intermittent; further sub-division into type 1 or 2 shows whether the exposure is modulated by a continuous wedge or a stepped wedge. This classification is not universally used by manufacturers, but it remains a convenient way of summarising the important features of the apparatus. Most modern instruments are Type IB 1 or Type IB 2.

29

The main problem in intensity-scale machines is to produce a neutral wedge of accurately-known density increments. Various methods have been proposed[19] for giving a truly neutral intensity scale exposure with stepped diaphragms, but none of these has found widespread application.

1.2.6.4 *Commercial sensitometers.* Most early sensitometers (e.g. Hurter and Driffield, Scheiner) were of the time-scale type, using rotating discs. Unfortunately, the exposures were built up over a number of revolutions of the disc and this produces an intermittency effect (p. 28).

For many years the best-known sensitometer was the Eastman Model IIB, a time-scale machine, using a sector drum as the modulating device.

The Eastman X6 High Intensity sensitometer is an intensity-scale machine, normally using a cast carbon wedge. The tungsten lamp housing is driven along the length of the wedge and an adjustable slit allows the exposure duration to be set at 1/10, 1/20 or 1/50 second; the whole film is exposed in about 1 second. The design gives a high order of evenness and Corbett has described its use for absolute sensitometry.[20]

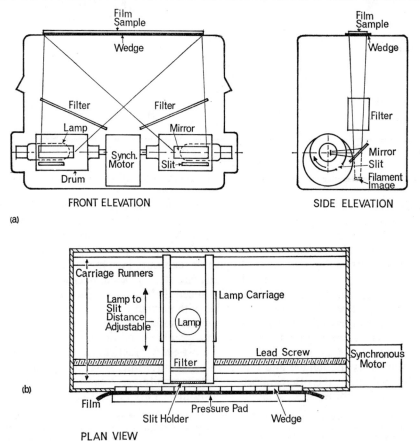

Fig. 1.5. Sensitometers. (a) Joyce Loebl Type 2L Sensitometer. (b) Eastman High Intensity Sensitometer. (Shouet). The lamp carriage (with filter and slit) is driven along the length of the wedge.

The Joyce-Loebl* Type 2L intensity-scale sensitometer (Fig. 1.5a) is unusual in that two lamps are used, giving even illumination with reasonably high intensity in a compact unit. The illuminance is claimed to be 5,000 lux with a variation of less than 1 per cent over the 21cm exposure area. The exposure duration is controlled by rotating drums and is fixed at 1/10, 1/20 or 1/50 second. The lamps are only switched on for a short time before each exposure, which increases the lamp life; the intensity is claimed to drop by 50 per cent over a life of a million exposures.

The E.G. & G.** xenon sensitometers use flash discharge tubes to give the short exposures necessary for testing materials for high-speed work. Exposures are available in the range 10 msec to 1 μsec, with a claimed repeatability of ± 3 per cent from flash to flash. Modulation is by means of a step wedge and the output is sufficient for testing films with speeds down to 1 ASA.

Other commercial designs are described in the literature [21, 22] and special-purpose sensitometers have been designed by individual research workers for the study of UV-sensitive materials,[23] X-ray films,[24, 25] half-tone (lith) films,[26, 27] photo-plastic films[28] and print-out recording papers.[29, 30]

1.2.6.5 *Design features of sensitometers.* A sensitometer is not necessarily very expensive; the Joyce-Loebl Type 2L, which is suitable for many purposes, costs about £250 in Britain. However, it may be necessary to build a sensitometer for a specific purpose and it is worth briefly considering the requirements for each component of an intensity-scale system:

(1) Because of the variation of contrast with wavelength (see p. 28) the sensitometer lamp must give the same spectral quality as the light source for which the emulsion is normally used. Tungsten lamps give the best long-term stability, but to achieve a long life the lamp is under-run and the colour temperature of the source is usually standardised at 2850K. This is then adjusted to the normal working requirement of 3000K 3200K or 6500K by photometric filters.

(2) The lamp must be operated on a voltage-controlled supply, although Corbett[31] has illustrated the fact that a constant-current supply gives better maintenance of light output over the life of the lamp.

(3) Lamp performance shows its greatest variation during the first few hours of life and it is usual to pre-age the lamp by running for a few hours before sensitometric use. It may then be decided to restrict the use of the lamp to, say, 50 or 100 hours.

(4) It is preferable to obtain three identical lamps and to pre-age them together. One lamp is then kept to give an occasional photometric check to the working lamp and the other is kept as a spare. If absolute sensitometric measurement is required the lamp performance must be checked by a standards laboratory.

(5) Even illumination of the wedge is essential; a variation of less than 1 per cent should be achieved over the length of the wedge. Unevenness due to the cosine law (p. 119) can be reduced to a reasonable level by setting the lamp at a distance from the wedge plane of six times the wedge length. A high standard of uniformity with a much more compact layout can be achieved with a *pair* of lamps.[32]

*Joyce, Loebl Co. Ltd., Team Valley, Gateshead-on-Tyne 11.
**Edgerton, Germeshausen and Grier Inc.

Many of these problems can be eased if the wedge steps are arranged in a rectangular block rather than along the conventional strip.

(6) If high-power lamps are used to give short exposure times, forced ventilation may be required because heating of the film can affect its speed.

(7) The sensitometric exposure should match the duration of normal exposures. The exposure time is usually governed by a rotating disc, although Hornsby has suggested the use of a fixed-speed Compur shutter in 'home-made' sensitometers.[33]

(8) The wedges in common use have steps giving $2\times$ increments of exposure (0·3 density units). For materials of restricted exposure scale, $1\cdot4\times$ increments (0·15 density units) are more suitable. The total density range of the wedge is normally 3·0 (1000:1).

(9) A continuous wedge with a constant density gradient (e.g. 0·3 density units per cm) is convenient when automatic plotting apparatus is available, because characteristic curves can then be drawn directly.

(10) Wedges made from photographic emulsions are never entirely neutral.[34] The peak density is in the range 380–480 nm, although developers vary in this respect. The silver wedges that are available commercially show reasonably good neutrality, but for critical work cast wedges of colloidal carbon are available.

According to BS 1380:1962[35] the transmission density of the light modulator for film speed measurement should not vary by more than 0·08 density units over the range 350–700 nm. Even closer tolerances for neutrality are specified in other standards.[10,62]

(11) Wedges produced photographically are seldom constant in density because of development adjacency effects at the margins. A step width of 8–10 mm is desirable so that several readings can be made and a mean figure determined if necessary.

Whatever sensitometric equipment is used, regular maintenance and provision for periodical calibration is necessary.[36]

1.3 *Processing*

1.3.1 DEVELOPMENT. In any sensitometric application the processing conditions are selected to suit the purpose of the experiment and are then rigorously maintained. Similar principles apply whether dish or machine processing is to be used, but some of the points made below apply to the manual methods rather than to the sophisticated systems in which the agitation and other factors are less easily adjusted by the operator. Standardised procedures for manual processing (dish, tank, spiral) have been suggested for films[37] and paper.[38]

(1) Special sensitometric developers were originally favoured, but it is now more usual to use formulae similar to those used in practice. Speed determination systems normally specify an appropriate developer formula.

(2) If tests are processed separately, fresh developer from the same stock solution is required for each batch. Precautions must be taken to minimise aerial oxidation of liquid developers during storage.

(3) The quantity of developer should be adequate: 2 litres for every 1000 cm² of

emulsion area is suggested (250 cc per 5×4 sheet); more solution may be necessary for dish development.

(4) The developer temperature must be controlled to ±0·5°C; the other solutions should be within about 5°C of this temperature. The developing vessel and any spiral or film hanger should be at approximately the required temperature.

(5) Latent image regression is often quite rapid for several minutes after exposure and the time interval between exposure and development must be standardised.

Regression is worse under warm and humid conditions, but can be arrested by refrigerated storage. Emulsions with small grains are more susceptible to regression and this is of practical importance in microphotography (see p. 24) and quantitative autoradiography (p. 300).

(6) The greatest attention should be paid to adequate and consistently randomised agitation, particularly with high-activity developers, to avoid variation between different operators.

With colour materials the *type* of agitation (rotary, lift and drain) is specified for optimum results.

(7) Short development times should be avoided if possible, because of variations in wetting and the initiation of development; a minimum of five minutes is suggested.

(8) At the end of the development stage the draining time should be standardised at about 10 seconds and a fresh acid stop bath used.

Apart from the sensitometric characteristics (speed and contrast), the degree of development can affect the width of fine line images.[39]

1.3.1.1 *Dish processing.* Dish development is not generally recommended for sensitometry because it is difficult to control the temperature accurately or to achieve repeatable agitation; for quantitative work a developing machine is preferable. However, these machines are not readily available and, in any case, dish processing is so widely used that an attempt should be made to establish a standard routine for normal work. Comparative tests can then be made and reliable gamma-time curves can be plotted.

(1) Uneven development is usually produced at the edge of a dish. Dishes should therefore be of generous size (e.g. a whole-plate dish for a 5×4 in. film).

(2) The emulsion must remain immersed and films should be taped to the bottom of the dish to prevent them from floating about. A minimum solution depth of 1cm is suggested.

(3) Developer oxidation is unavoidable in an open dish; stock solutions should be diluted shortly before use and should not be used twice.

(4) Control of room temperature is the best way of ensuring consistency of solution temperature, but where this is not possible, a dish is preferably set in a thermostatically-controlled water bath or air jacket.
Electrically heated pads or dish warmers can be used provided that they do not cause local temperature variations (careful sensitometric tests would be necessary to establish this point). It is inadvisable to use heaters directly in the developing vessel, because of the risk of uneven warming.

(5) A continual and vigorous agitation by rocking is necessary and it should be random in direction and frequency to prevent any regular pattern being set up. The ASA recommendations suggest a *continuous* 4-way dish rocking cycle taking 8–12 seconds per cycle.[37] Some loss of solution by splashing may be unavoidable

if agitation is to be efficient; this is yet another reason for using plenty of developer.

It may be possible to achieve improved consistency by developing for a long time, thus approaching the condition of gamma infinity. Monobath solutions are relatively insensitive to variations in processing and may be useful where conditions are not readily controlled.

(6) A good method of achieving even development is to brush the immersed emulsion with a soft flat brush or velvet-covered roller, which should be wider than the emulsion surface. A rubber blade can also be used to sweep close to the surface and act as a 'hydraulic brush'.[40]

The efficiency of brush development is very high and the results may not correlate with other methods. Unless a high rate can be achieved (3 to 4 strokes per second) the frequency of brushing has a marked effect on the density and gamma. This makes it difficult for different operators to achieve repeatable results with brush development, but it remains a good way of producing a uniform density and also tends to minimise the development adjacency effects that are undesirable in some work.

(7) Similar care must be taken in sensitometric studies of bromide papers,[10, 41] which may be taped on glass plates for processing.

It is normally impossible to over-agitate provided that the effect is even, but there are special cases (for example, still bath techniques and acutance development) where a small but precisely controlled degree of agitation is important.

Many of the factors mentioned also affect the consistency of pre-baths (e.g. latensification) and after treatment (reduction or intensification).

1.3.1.2 *Tank development.* Roll film spiral tanks often give uneven development, particularly with rotational agitation. Before any sensitometric work with these tanks, tests should be made using inversion agitation to check that the rate of development is the same in the centre of the spool as at the outer edge. For critical work involving a number of spirals it may be preferable to develop by immersion and agitation in a 3-gallon tank.

The BS method for film speed determination specifies that single strips of film should be developed in a suitable vacuum flask to minimise temperature changes during processing. The developer formula is also specified and a standard procedure for continuous agitation is laid down.

Deep tanks of still developer (including the common 3-gallon tanks) frequently contain temperature gradients and also show significant variations in activity. Thorough stirring and adjustment of temperature is necessary before processing; fortunately, the large bulk of liquid normally gives good thermal stability during the processing cycle. If nitrogen burst is not available, the most common method is to 'lift and turn', draining the film from alternate corners at regular intervals.

In deep tanks it is necessary to insert sensitometric test films in a consistent manner; the low-density end of the strip is usually placed above the high-density end.*

*Development by-products released into the solution have a greater density and tend to sink. Their effect is to restrain development and if the high-density end of the wedge is placed at the top the 'bromide streamers' may seriously affect the low-density strips, causing an apparent loss of film speed. Such effects normally occur randomly within the picture area, but they must be eliminated from any system purporting to monitor the development process. The use of two strips with different orientation will show if the agitation needs to be improved.

The strips should also be arranged so that the emulsion side always faces the same way and is not too close to the tank wall. In a perfect system this precaution would not be necessary, but, as can be shown by sensitometric tests, zones of different activity are present in most tanks and standardisation of the control strip treatment is required.

Baker and Kage have described a method for developing film strips in a glass measuring cylinder which allowed rapid assessment of exposure in studio cinematography.[42] A 'push-pull' agitator was used and the aimed gamma of 0·7 was reproduced to within ±0·03 on monochrome films, with a speed variation of less than 0·1 LogE units. Colour materials were also assessed for correct exposure on the basis of black-and-white development by this method.

1.3.1.3 *Continuous processing machines*. The system of temperature control and agitation in continuous processing machines is decided by the manufacturer; all that the operator can do is to carry out regular chemical analysis and sensitometric tests (see p. 54). There is a risk that opposing factors (e.g. a drop in developer activity and a rise in temperature) will temporarily cancel each other and not be fully apparent from the developed control strips. This situation can be avoided only by proper instrumentation of the machine performance (e.g. monitoring machine speed and solution temperature).

The potential user of the simpler machines may find it advisable to check that the agitation is sufficient to prevent bromide streamers from high density areas. A test film with heavily exposed areas on a lightly exposed background will show any directional effects.

Even with efficient agitation, it is normal practice to situate sensitometric wedges consistently in the machine (with the low-density end leading).

1.3.1.4 *Special sensitometric processing machines*. The most consistent development of sensitometric strips is given by machine processing. The construction of such equipment is not to be undertaken lightly, but by reference to published designs[4] some of the problems of temperature control, agitation and other procedure may be overcome. In a well-designed machine the orientation of the strips in the tank or the size of the processed batch does not affect the results.

Many of the normal development techniques tend to give inconsistent results, particularly some of the manual methods used for processing lengths of aerial or cine film. They should not be used for sensitometric work unless absolutely necessary, and then only after rigorous testing to establish the best technique and to indicate the degree of variability inherent in the system.

1.3.2 FIXATION AND WASHING. In normal circumstances, fixation should not affect the results of sensitometric tests. Reasonably fresh solution must be used to ensure that a stable image is produced and excessive fixation should be avoided to prevent any reduction of density. For conventional hypo solutions a time of 15 minutes is suggested;* rapid fixers will probably require only 5 minutes. ASA PH2–2 recommends that fixing solutions for bromide paper sensitometry should be seasoned before use.[10]

Normal washing procedures are sufficient for sensitometric films and the use of wetting agents is recommended to ensure even drying. The procedure should be standardised, as it may affect the drying rate, which in turn has an effect on the final density.

Washing at high temperatures or any process which unduly softens the gelatin may affect the covering power** of the silver image.

*The standards for determining film speed specify the conditions for fixation, washing and drying.

**Covering power is defined as $\dfrac{\text{Density}}{\text{Mass of silver}}$

35

1.3.3 DRYING. A wet emulsion can contain 10 times its own weight of water and the considerable physical changes caused by the evaporation of this water causes differences between the wet and dry densities. The amount of silver is not altered but changes in its structure affect its covering power.

In the early stages of drying, the density increases rapidly as the silver grains tend to orientate themselves parallel to the surface; further drying causes collapse of the gelatin layer, crushing the filamentary grain formation and reducing the covering power and density below the wet values.[43]

These density changes can vary according to the temperature and relative humidity, but the general pattern is shown in Fig. 1.6.

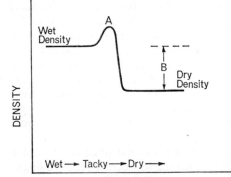

Fig. 1.6. Variation of photographic density during drying (after Blake and Meerkamper – ref. 43). A, The initial rise in density is reversible, provided that drying has not gone too far (i.e. the density may return to the original level if tacky film is re-wetted). B, The difference between wet and dry density depends on the drying conditions.

Emulsions differ somewhat in their drying characteristics and those with large grains are more likely to show variations in density. A wet density of 2·5 can change to a dry density in the range from about 3·0 (high temperature, high relative humidity) to about 2·4 (ambient temperature, low humidity).

Drying marks of higher density are often produced in areas where water droplets reduce the drying rate; films should always be wiped before drying.

The preceding points make clear the need for consistent drying conditions; over-rapid drying is to be avoided. Process control strips should preferably always be placed in the same position and orientation in a drying cabinet.

1.4 *Measurement of density*

The density of a photographic image is principally due to light absorption by the metallic silver. However, some of the incident light is scattered by the silver grains and the measured density depends to a considerable extent on how much of this diffusely scattered light is collected by the detector system.

1.4.1 TYPES OF DENSITY

1.4.1.1 *Specular density*. Fig. 1.7a shows a collimated beam being used for illumination with a relatively small collecting aperture; virtually all the scattered light is deviated outside the optical path and is not detected. Densities measured under these conditions are described as specular densities (D ∥).

36

This arrangement is similar to that in a condenser enlarger, where the collecting aperture is the projection lens diaphragm. In extreme cases (e.g. vesicular films) adjustment of the lens aperture can alter the effective density range of the negative by varying the proportion of scattered light transmitted by the lens.

Because of difficulties in specifying the exact nature of this sort of measuring system and relating it to the variety of printing and viewing systems in use, specular density values are rarely quoted.

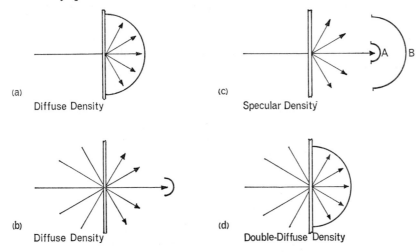

Fig. 1.7. Different types of density. (a) Collimated illumination: total collection (e.g. point-source contact printing). (b) Diffuse illumination: partial collection (e.g. diffuse enlarger). (c) Collimated illumination: partial collection (e.g. condenser enlarger) (*A* will collect less scattered light than *B* and will therefore give a higher density reading) (d) Diffuse illumination: total collection (e.g. diffuse-source contact printer).

1.4.1.2 *Diffuse density.* Fig. 1.7a shows a hemispherical detector system which collects *all* the scattered and transmitted light giving a *diffuse density* value (D#). The arrangement is optically equivalent to that in Fig. 1.7b in which diffuse illumination is used together with a collimated collection system (as in diffuser enlargers).

The degree of 'diffuseness' may be specified by the angle of collection. Diffuse densities are given by 180° collection; typical specular values correspond to 5–10° collection angle; intermediate angles give 'semi-specular' densities.

It is not possible to achieve *total* collection (because of reflections in the system and the lack of a *perfect* diffusing medium), so it is not correct to speak of totally diffuse densities, although this condition is approached in contact printing with a point source. BS 1384:1947* specifies the conditions for measuring British Standard diffuse density (BS D#) which closely approaches the total diffuse value.

A system such as Fig. 1.7d, with diffuse illumination and total collection is termed *double diffuse*. Densities measured in this way are slightly higher than total diffuse densities, because some of the rays travel further through the medium and are thus more likely to be absorbed. This arrangement is frequently used in contact printing.

Densitometers give different readings according to their design and the relevance of

*In addition to describing the standards, this publication gives a good introduction to the principles of densitometry and its applications.[44]

any density figures to a particular situation depends on the printing or viewing system in which the image is to be used. Most densitometers read a diffuse type of density and the better models may be calibrated to give BS D# figures. The complete BS specification calls for consideration of the spectral response of the detector.

1.4.1.3 *Callier coefficient.* The ratio between the specular density and the diffuse density of a particular material is called the Callier coefficient (Q). Values for Q are close to 1·0 for Lippmann plates and colour transparencies (which produce virtually no scattered light) so that $D \parallel \approx D\#$, but Q reaches about 1·7 for high-speed emulsions.[45]

Taking a typical value of Q=1·6 for medium-speed emulsions, the implication of the Callier coefficient in simple terms is that a negative with a density range 0·2–1·0 in diffuse light (DR=0·8) will have a density range 0·32–1·6 (DR=1·28) in a collimated light system. This is borne out in general terms by the fact that condenser enlargers give prints of higher contrast than diffuser enlargers.

Simple calculations of the type made above are not entirely valid bcause the value of the specular density $D \parallel$ is very dependent on the measuring conditions. In addition, the coefficient Q for a particular film varies considerably with the degree of development and the density level (Fig. 1.8); the highest value is found at a level of about D=0·3.

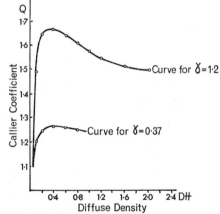

Fig. 1.8. Variation of Callier coefficient with density and development (By courtesy of Morgan & Morgan Inc – based on data from *Fundamentals of Photographic Theory* by James & Higgins) (Ref. 6).

The effect of this type of variation is shown in Fig. 1.9, where curves are plotted for the simple case (a constant value of Q) and the realistic case (Q varies with the density level).

The Callier effect also varies with the wavelength of light used for measurement. Specular densities are always lower with long wavelength light, while diffuse densities sometimes tend to increase with longer wavelengths; the combined effect is to reduce the Callier coefficient slightly with red light.

The vesicular Kalvar emulsions exhibit the Callier effect to a marked degree. With diffuse light measurement the D_{max} is about 0·6, but specular densities of $D \parallel$ 2·0 to $D \parallel$ 4·0 may be achieved, according to the aperture of the projection lens or measuring system.[46]

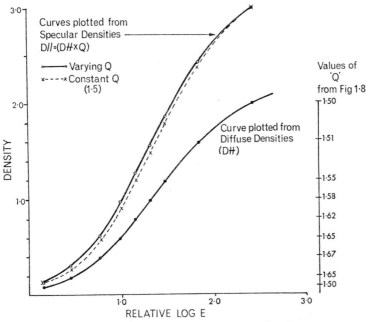

Fig. 1.9. Effect of Callier coefficient on measured D/Log E curve.

1.4.1.4 *Colour coefficient.* The normal silver image is reasonably neutral over the visible spectrum and receptors of different spectral response (emulsion, eye, or photocell) give substantially similar results (but see pp. 56 and 66).

However, most intensifiers and some fine-grain developers produce a brownish image which gives a higher effective density with a blue-sensitive detector (e.g. bromide paper) than with visual assessment or measurement by a standard photocell.

The colour coefficient of an image is denoted by χ (the Greek Chi) and is defined by

$$\chi = \frac{\text{Printing gamma}}{\text{Visual or densitometric gamma}} \qquad \text{Eq 1.1}$$

Typical values for χ, as given by Nietz and Huse (1918) are 2·5 for uranium intensifier and 1·4 for mercuric iodide intensifier;[47] with pyrogallol developers the colour coefficient ranges from 1·16 to 2·75, according to the sulphite content. Normal MQ developers may have a value for χ of about 1·02–1·05.[48]

For this reason the BS method for determining density specifies the spectral response of the detector and the spectral quality of the illuminant. For example, BS D# V1b means a BS diffuse density evaluated by the normal photopic eye (V1) with light of 3000K (b). BS D# P2b means that the measurement has been made with a spectral response corresponding to that of standard printing paper. The appropriate type of density (visual or printing) is used according to the application.

Photographic methods may be used to establish the colour coefficient for specific conditions (see p. 66) but in practice most difficulties arising from image colour can be avoided by using a blue filter in the densitometer. Some densitometers have an optional blue-sensitive photocell with a spectral response corresponding to that of bromide papers.

39

1.4.1.5 *Colour densitometry*.[8, 9, 49, 50] Colour densitometry is normally concerned with the measurement of colour tripack materials, either to determine the density of an individual layer (analytical density) or the combined density of all three layers (integral density).

Analytical density is of great interest to the film manufacturer, who wants to study the response of individual layers (as though they were stripped apart). However, the user of the film is concerned with the combined effect of all three layers (including any interaction between the emulsions at the processing stage); this is expressed by the integral density, as normally measured in a colour densitometer or colour-printing analyser.

Integral tri-pack colour photography involves three separate receptors (the superimposed emulsion layers or the tri-chromatic sensors of the eye). In colour densitometry, each area of the film is measured in three separate wavebands, each of which is closely matched to the spectral response of the relevant receptor. The filters used to isolate the wavebands must be designed to suit the illuminant and the spectral response of the densitometer and the colour printing material; special filters are recommended by the film manufacturer for this purpose. A common problem is that in addition to their primary transmission band, colour filters often transmit infrared radiation; the photocell has some response to this waveband and may therefore indicate an integral density lower than the true value. For this reason, IR rejection filters are often used in colour densitometers.

It is important to distinguish between integral *printing* densities (the density in a particular printing equipment), integral *colorimetric* densities (which is concerned with the visual appearance of a colour) and the sort of arbitrary integral *three-colour* densitometry which is carried out for process control purposes. The latter values may not give an accurate indication of the visual appearance of a colour patch, but are intended simply to check that the colour quality is consistent.

Within the main classification of analytical and integral colour density there are several other types for special purposes (e.g. spectral density, equivalent neutral density).

1.4.1.6 *Reflection density*. Reflection densities are easily measured on a suitable densitometer (see Table 1.1). The instrument is usually set to give a reading of $D = 0 \cdot 0$ from an unexposed area in the rebate of the print to be measured. All readings are then in relation to this arbitrary choice of a 100 per cent reflecting surface. In fact, this area will have an absolute reflectance of only about 90 per cent and it may vary with different samples of paper or if chemical fog is present. If it is necessary to show differences in maximum reflection density, a standard white surface must be retained for setting a consistent zero reading on the densitometer. The Macbeth Corporation supply calibrated density reference tablets with their densitometer for this purpose.

Reflection density measurements must avoid errors due to specular reflections from the print surface by illuminating the surface at 45° and making the measurement at 90° to the paper surface. This is known as the CIE condition; an alternative arrangement, known as the Inverse CIE condition uses 90° illumination and 45° measurement. The geometrical factors of affecting reflection densitometry, including the possible directional effects caused by the paper fibres, have been discussed by Tupper.[51]

As a first approximation, the reflection density is twice the transmission density that would be obtained if the emulsion were stripped from its support. However, the

scatter of light within the emulsion plays a considerable part in increasing the value of lower densities.

The reflection density for a given silver content depends on the surface of the paper; typical values of D_{max} are 2·0 for glossy paper and 1·4 for matte paper.

1.4.2 DENSITOMETERS. There are two basic types of equipment for reading photographic densities: null point densitometers and direct reading densitometers. In practical terms, however, densitometers may be classed as visual, photo-electric, or automatic recording.

1.4.2.1 *Visual densitometers.* The best-known visual densitometers are the obsolete Capstaff-Purdy models and the Kodak Colour Densitometer; the SEI photometer can also be adapted for this purpose with an auxiliary lamp base.

These instruments operate on the null point principle, which relies on the visual comparison of a reference beam and a beam passing through the sample density. They offer the unique advantage of close visual inspection of the sample field; allowing pinholes and other blemishes to be excluded from the measurement area.

Visual instruments are rather slow and tiring in use and they are apt to give rather poor correlation between different operators. However, they are cheap and reasonably consistent results can be obtained with a practised operator using a standardised procedure.

TABLE 1.1

CHARACTERISTICS OF COMMERCIAL DENSITOMETERS

Model	Density range	Aperture diam.	Accuracy	Remarks
Kodak Reflection-transmission colour densitometer	0–3·0 (up to 4·0 with aux. filter)	1·25mm	Scale divided to 0·05	Visual type. Colour filters.
Baldwin Transmission density unit	0–3·0 ⎫ 3·0–4·0 ⎭	1·6mm	⎰ ±0·02 ⎱ ±0·02–0·1	Measures approx. BS D ⫫ densities.
	0–5·0 ⎫ 5·0–6·0 ⎭	4·8mm	⎰ ±0·02 ⎱ ±0·02–0·1	Colour filter holder.
Reflection density unit	0–3·0	3·8mm	±0·02	Colour filter holder.
Wide range densitometer	0–4·0 (up to 6·0 with aux. filter)	1·6mm or 4·8mm	±0·02 (±0·005 for densities up to 0·5)	Colour filter holder. Reflection unit available.
Line densitometer	0–4·0	Slit 0·1 × 0·02″ 0·1 × 0·045″	±0·02	For line spectrograms and sound tracks
Evans Electroselenium EEL Model 133 Colour densitometer	0–3·0 (colour) 0–4·0 (B&W)	1·5mm 2·75mm 4·0mm		Reflection head available
Ozalid Model R	0·6–1·4		±0·02	Battery model for microfilm quality control

Model	Density range	Aperture diam.	Accuracy	Remarks
Photolog Model T	Colour 0–2·0 ⎫ (B&W to 3·0) ⎭ Colour 0–3·0 ⎫ (B&W to 4·0) ⎭ Colour & B&W ⎫ 0–4·0 ⎭	0·4mm 1·0mm 2·5mm	±0·02	Single meter scale Six built-in filters with trimming control
Reflection head (Reflection Model R also available)		1·5mm 3·0mm		Plug-in unit for Model T
Macbeth				Single meter scale Measures ASA D#
Quantalog TD-100 (Transmission)	0–4·0	$\frac{1}{32}''$ (0·8mm) 2mm 3mm	±0·02	Colour model available
Quantalog RD-100 (Reflection)	0–2·5	$\frac{5}{32}''$ (4mm)	±0·02	Colour filter turret with individual trimmers
Welch Densichron	0–4·5	0·125″ (3·2mm) $\frac{9}{32}''$ (7·1mm) 0·4″ (10·1mm)		Transmission, reflection or combination models 6-position filter wheel with individual trimmers Accessory meters available scaled for direct reading in 'per cent dot'
Joyce Loebl Recording densitometers	0–3·5	2mm	±0·01 (up to 2·0) ±0·02 (2·0–3·5)	A range of drum-recording machines for B&W and colour 35mm and 16mm film
Double-beam recording Microdensitometer	Range up to 6·0 available	Resolution down to 1μm		Many accessories including reflectance attachment, digital print out, Isodensitracer
Gossen Lunasix	0·05–2·8	1mm	±0·05	Photoelectric exposure meter used as densitometer
Gretag Model D3		1–3mm	±0·02	Transistorised 3 colour filters with trimmers

1.4.2.2 *Direct reading photo-electric densitometers.* Photo-electric instruments can be used for long periods without any loss of accuracy and are normally preferred to visual instruments because of their greater sensitivity and better density discrimination. Some of the more common densitometers are listed in Table 1.1. In addition, some colour analysers and the more sensitive exposure meters can be used as densitometers. In photomechanical work, specialised reflection densitometers are sometimes used to check the printed colour densities of inks while running up for large-scale printing.

Some of the points for consideration when choosing a densitometer are:

(1) Stability: some instruments show a continual drift when reading the higher densities.
(2) Sensitivity: the majority of units will read up to 3·0, but only the most sensitive units will read to this level (a transmission of 1/1000) through a small aperture with the narrow-cut filters used for colour work.
(3) The type of density measured (specular or diffuse).
(4) Spectral response of the photocell (matched to visual or photographic sensitivity).
(5) The provision of colour filters, preferably with individual zero-setting trimmers for each filter.
(6) The maximum width of film that can be accommodated on the machine.
(7) The availability of an auxiliary reflection density unit.

1.4.2.3 *Recording densitometers.* The Joyce Gevaert Recording Densitometer is a double-beam null point instrument. The sample is placed in one beam and the machine adjusts the intensity of the other beam until a match is obtained in the photocell detector circuit. The sample is driven past the measuring beam and the automatic adjustment made by the machine to equalise the two beams is used to operate a pen recorder.

The more advanced colour version of this instrument has three narrow-cut filters and matched recording pens; it produces in succession a set of three colour density graphs within 45 seconds.

The Joyce Loebl Microdensitometer is a recording densitometer giving image resolution down to $1\mu m$; instruments of this type are used for studies of image quality and granularity or for quantitative densitometric scanning of any photographic record. An isodensitometer attachment is available which programmes the densitometer to draw the contours of equal density (equi-densities, see p. 27) over an image.

The problems of measuring line densities and the general subject of density control in microfilm have been discussed by Nelson.[52]

1.4.2.4 *The use of densitometers.* Even the best densitometers cannot be assumed to give absolute accuracy without routine maintenance.[53] The standard procedure is to keep a reference step wedge and to check the instrument performance regularly against the known wedge densities.[9] Calibrated transmission and reflection wedges are supplied with some instruments.

In every-day use it is wise to re-check the zero setting of the meter at regular intervals during a set of readings.

The aperture used should be the largest that will fit into the step width and each step should be read at least three and preferably five times, if there is any evidence of unevenness. The mean value is then taken, but the cause of any widely varying reading should be investigated.

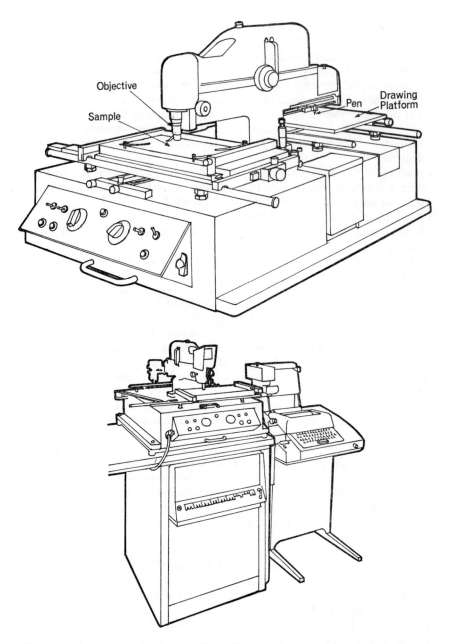

Fig. 1.10. Commercial densitometers (a) Joyce Loebl Mark IIIc double-beam automatic recording microdensitometer (b) Joyce Loebl computer controlled Autodensidater.

Materials must be inserted into a densitometer in a standardised way. The customary method is to face the emulsion towards the diffuse element of the optical system

44

(normally the photocell), which generally requires the film to be placed emulsion up on the densitometer surface.

Densitometric measurement at intervals during development has been suggested, using a visual comparator or a photocell with a 'safelight' filtered illuminating beam[54]; infrared densitometry has been similarly used. Provided that conditions are standardised, the density of the unfixed emulsion can be related to the final dry density with reasonable accuracy.

1.4.2.5 *Plotting results.*[55] The principle of standardisation should be extended to the graph paper used within an organisation; the Society of Motion Picture and Television Engineers (SMPTE) have recommended a layout to help comparison between different laboratories.[56]

The use of a standard format encourages the regular recording of details such as the film batch, operators name and image regression period in addition to such major factors as development time and temperature etc.

The aim in sensitometric work is to draw a *smooth* curve that gives the best average 'fit' to the plotted points. It is unwise to attach too much significance to any single point.

1.5 *Expression of sensitometric results*

1.5.1 CHARACTERISTIC CURVES. The relationship between exposure and density is shown by the familiar characteristic D/LogE curve. In most cases the absolute exposure values (lux-seconds) are not known and *relative* Log exposure is plotted.

It is not always easy to make a visual comparison of curves of different shape and it may be useful to plot a separate graph showing the density differences (ΔD) against Log Exposure, as in Fig. 1.11.

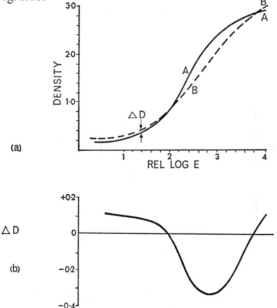

Fig. 1.11. Graphical comparison of curves of different shape. (a) Overlaid D/Log E curves. (b) Density difference curve.

45

1.5.1.1 *Derivative curves.* In the first derivative curve shown in Fig. 1.12, the slope at each point of the D/LogE curve is plotted against the LogE values; the linear region of the D/LogE curve gives a horizontal line on a derivative curve, showing a constant slope. This method of presentation shows the variation of contrast in different parts of the exposure scale and is useful in tone reproduction analysis and other work where study of gradient variations is important. The point of maximum gradient G_{max} on a non-linear characteristic curve is known as the inflexion point of the curve.

A similar method can be used to show the reduced contrast given by images of fine detail (high spatial frequency). This point is discussed further on pages 97–101, but is

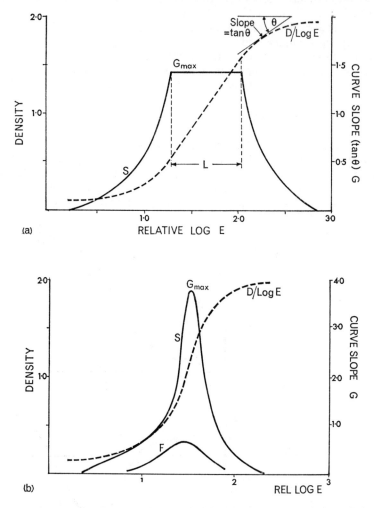

Fig. 1.12. Slope/Log E curves derived from D/Log E curve. (a) Basic derivative curve. Curve S (G/Log E) shows the slope (tan θ) at each point of the D/Log E curve. In the linear region L the slope is at a constant value. (b) The conventional derivative curve (S) shows the contrast of large areas (macro contrast). A similar curve for small areas (F) shows the reduced contrast in fine detail (micro contrast). In this example there is no linear region to the D/Log E curve.

introduced here to emphasize that conventional sensitometric data is obtained from large areas (usually steps of several millimetres wide) whereas many image details are much smaller and are affected by image spread and development adjacency effects. The contrast characteristics at higher spatial frequencies (micro contrast) are of more interest for many purposes than those for large areas (macro contrast); Ilford have published curves of this type for their range of recording films.[57]

1.5.2 CONTRAST. The overall contrast of photographic images may be expressed in several ways.

1.5.2.1 *Gamma*. The slope of the linear part of the characteristic curve is termed its gamma ($\gamma = \Delta D / \Delta \text{LogE}$). Despite its historical importance, gamma is not usually the most useful way of expressing the contrast because it does not describe the important toe region of the curve and cannot be used with the many modern emulsions that have no straight line region. It is, however, applicable in negative duplication and other processes requiring exclusively linear characteristics.*

The symbol G is used to denote the local gradient; it is the tangent to the slope at any point. This parameter is plotted against exposure in derivative curves (see Fig. 1.12).

1.5.2.2 *Average gradient* (\bar{G}) (also termed the average gamma $\bar{\gamma}$).

The slope of a curve can be expressed by the tangent of the average angle of slope. This is useful with bromide paper and colour reversal materials, which have little or no linear region.

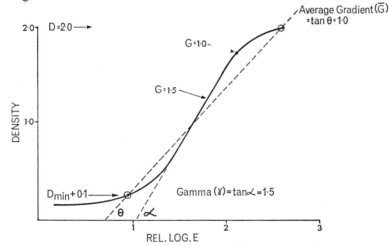

Fig. 1.13. Methods for expressing the slope of D/Log E curves (γ, G and \bar{G}). In this example \bar{G} is measured over the range ($D_{min}+0.1$) to ($D=2.0$).

If the limiting points H and S are properly chosen, the \bar{G} method is probably the best method for general laboratory work. Some of the commonly accepted criteria for H and S are shown in Figs. 1.13–15. (See also p. 53.)

Ilford quote \bar{G} values for lith film over the negative density range 0.2–2.2 (typical values for these films are $\bar{G}4.0$ to $\bar{G}9.0$).

*A method for improving curve linearity by use of pre-exposure high intensity flashing has been mentioned by Wyant and Givens.[58]

47

Fig. 1.14. A number of average gradient criteria. (a) \overline{G} criterion for negative B & W films (ASA PH 2.5) (\overline{G} is measured over a Log E range of 1.3 from the point where D=0.1). (b) \overline{G} criterion for colour reversal film (ASA PH 2.21). The shadow limit point (S) is taken at either (1) the curve tangent point from H *or* (2) D=2.0 (if the tangent point is higher than 2.0). (c) \overline{G} criterion for bromide paper (Jones and Nelson, 1942). (d) \overline{G} criterion for bromide paper (ASA PH 2.2). An overlay bearing the parallel lines is adjusted until it fits at two tangent points.

The exposure scale of bromide papers is probably a better method of expressing its performance than by gradient values alone*; the ASA definition of Exposure Scale is shown in Figure 1.15a.

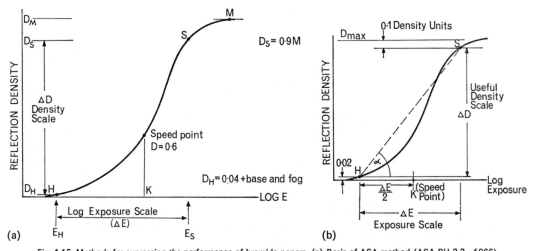

Fig. 1.15. Methods for expressing the performance of bromide papers. (a) Basis of ASA method (ASA PH 2.2–1966). M is the point where G=0.05. (b) Basis of Russian GOI method (Gilev 1944) – see ref. 34. $\overline{G}=\tan\alpha$. Paper sensitivity expressed by 100/K.

*ASA PH 2–2 1966[10] suggests a method for classifying paper contrast grades on the basis of the Log exposure range; the values quoted extend from 0·5 (very hard) to 1·7 (very soft).

The variations in curve shape of different bromide papers sometimes makes comparison difficult and methods have been described for specifying the shape of strongly bowed curves in simple numerical form.[59]

The subject of exposure scale and exposure latitude and their relation to the total information content is discussed in Chapter 2.

1.5.2.3 *Contrast Index.* In recent years, a specifically defined form of average gradient, called the Contrast Index (CI), has come into use.[60] The method for deriving the Contrast Index has been described by Niederpruem *et al*[61] and the basis for its measurement is shown in Fig. 1.16

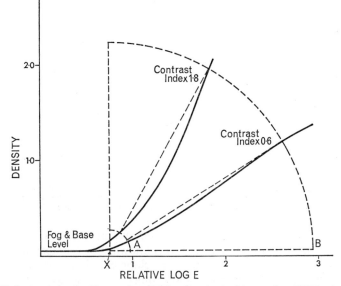

Fig. 1.16. Contrast index. Arc A has a radius of 0.2 Density units. Arc B has a radius of 2.2 Density units.

The rapid assessment of Contrast Index is carried out with a transparent overlaid grid which is shown in simplified form in Fig. 1.16. The grid position is adjusted until the centre point of the grid (X) is on the base+fog level and one of the radial lines simultaneously intersects the characteristic curve at points on the arcs A and B; the tangent of the slope of the radial line fulfilling this condition is quoted as the Contrast Index.

This method is intended to evaluate the contrast of the modern black-and-white films in the toe region of the curve, which is used for optimum results in many applications.

1.5.3 GAMMA/TIME CURVES. Increased development of photographic materials produces higher contrast, as conventionally shown by a family of characteristic curves of increasing gamma (see Fig. 1.17). This can best be summarised by plotting the gamma obtained for each development time in a gamma/time curve (also termed the development kinetics curve).

As indicated, gamma is not always the most appropriate measurement of contrast; \bar{G}/time curves or CI/time curves may be more useful.

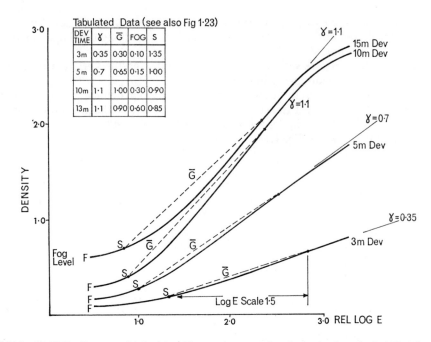

DEV TIME	γ	Ḡ	FOG	S
3m	0·35	0·30	0·10	1·35
5m	0·7	0·65	0·15	1·00
10m	1·1	1·00	0·30	0·90
13m	1·1	0·90	0·60	0·85

Fig. 1.17. Family of D/Log E curves and derived data. (Gamma, average gradient, fog level and speed point.) The following arbitrary definitions are made in this instance: Speed point (S) – Relative Log E value for D=0.1 above fog. Average gradient (Ḡ) – measured over a Log E scale of 1.5 from the speed point.

This type of curve can be used to find the development latitude if the permissible tolerance for the final Ḡ (or gamma, or CI) is known. For example, if the Ḡ value is specified as 0·8±0·02 the corresponding development time tolerance is shown in Fig. 1.18 as 6 minutes ±15 seconds. Rapid-acting developers have very little development latitude and should not be chosen for sensitometric standardisation.

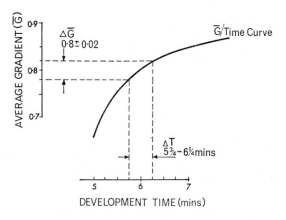

Fig. 1.18. Ḡ/Time curve and the development time tolerance (ΔT) corresponding to a given contrast tolerance (ΔḠ).

50

In continuous processing machines the development time is usually governed by the machine speed. In such cases a gamma/machine-speed curve is plotted as a basis for contrast control.

Gamma depends on the wavelength used for exposure and in colour separation work different gamma/time curves may be drawn for each of the filters in use. Reciprocity failure (see p. 26) also causes variations in contrast and standard manufacturer's gamma/time curves cannot be applied to very long or very short exposures.

In many cases the pre-exposed process control strips supplied by manufacturers contain only two image areas. They do not permit the plotting of characteristic curves but are entirely adequate for monitoring the relative contrast and fog level of developed strips (see p. 53).

1.5.4 TEMPERATURE/TIME GRAPHS. Adjustment of the development time is necessary when temperature variations arise; the correction can be calculated from manufacturers' published curves or practical tests can be carried out with the film and developer in use.

1.5.5 FILM SPEED. Speed is a numerical expression of emulsion sensitivity in a form that can be applied to exposure calculations. Many speed systems have been used in the past, based either on a 'minimum useful gradient' or a 'fixed density' criterion, and a study of the gradual developments in attitude to film speed determination will give a useful background to current practice.[4]

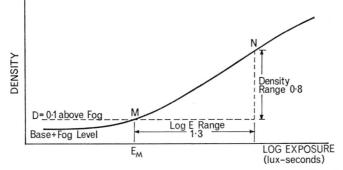

Fig. 1.19. Speed determination of negative monochrome emulsions (Basis of ASA PH 2.5 – 1960 and BS 1380 Part 1: 1962). Development conditions are adjusted to give a density range of 0.8 over a Log E scale of 1.3. The exposure necessary to give $D = 0.1$ above fog (point M) gives the defined speed point E_M lux-sec. The ASA speed is given by $0.8/E_M$.

Since the publication of the current standard,* a fixed density criterion of $D = 0.1$ (obtained under closely specified gradient conditions) has been generally accepted as the basis for measuring the speed of black-and-white materials for daylight 'pictorial' purposes (Fig. 1.19). A different 'mid-density' criterion is specified for reversal colour films.

*ASA PH 2·5–1960[11] and the equivalent DIN 4512–1961 and BS 1380: Part 1: 1962.[35]
The specified conditions of test include:
1 Film environment of test sample (20±5°C and 60± 10 per cent r.h. for three months before test)
2 Exposure time (between 1/20 and 1/80 sec)
3 Light source (2850K filtered to daylight quality)
4 Exposure increment of the wedge and its neutrality
5 Developer and all the conditions of processing.
The standard for colour reversal film (ASA PH 2·21–1961 and BS 1380: Part 2: 1963) makes slightly different stipulations in some respects. For example the exposure time shall be either in the range 1/10 to 1/100 sec (for instantaneous exposures) or in the range 1 to 5 seconds for films intended for time exposures. Various standard light sources are specified to simulate daylight, flash bulbs and studio tungsten lamps.

These methods are the result of decades of development and standardisation but are not considered appropriate for *every* purpose; Todd and Zakia have listed over 40 different criteria that are applied in various branches of applied photography.[64] Some of the current methods are listed in Table 1.2.

<div align="center">

TABLE 1.2

CRITERIA FOR THE COMPARISON OF THE SPEED OF
PHOTOGRAPHIC MATERIALS

</div>

	Speed criterion	Source
Monochrome negative materials	D=0·1 above fog under specified conditions	ASA PH 2·5[11]
Colour reversal films	Mid-scale criterion	ASA PH 2·21–1961[62]
Bromide paper	D=0·6	ASA PH 2·2–1966[10]
Colour negatives	D=1·0	ASA PH 2·27 1965
Radiography (industrial)	D=1·5	ASA 2·8 1964
(medical)	D=1·0	ASA 2·9 1964
Microfilm	D=1·2	US Federal Standard
Polaroid prints	D=0·5	
Spectroscopy	D=0·6	
Continuous-tone copying	D=1·0 or lowest density on the 'straight line'	
C.R.T. recording	D=1·0	Kodak quote relative CRT speeds based on this criteria
Photorecording sensitivity	D=0·1	Kodak (based on reciprocal of tungsten exposure in lux-seconds to give D=0·10 above fog; exposure time is specified as 100 μsec.)
Lith films	D=2·2	Ilford Ltd

Film speed figures are generally derived from an expression of the form:

$$S = k/E \qquad\qquad \text{Eq. 1.2}$$

where k is an arbitrary constant which gives a number suitable for insertion into an exposure meter (including an acceptable safety factor)

E is the exposure (in lux-seconds) necessary to give the density which satisfies some defined criterion of picture quality.

For example, in the ASA specification the value for k is 0·8. A film requiring E=0·01 lux-seconds to give the required density (D=0·1) is given an ASA speed of

$$S = 0·8/0·01 = 80 \text{ ASA}$$

The basis for the standard methods of speed determination for bromide papers is shown in Fig. 1.15.

The reasons for the adoption of the current ASA speed determination system and the factors that are included in the speed derivation have been discussed by Nelson.[65]

In many sensitometric applications it is not necessary to measure the absolute value of E but simply to compare the speed of different films or processes. This involves measuring the LogE separation of two D/LogE curves, which is simple enough if the

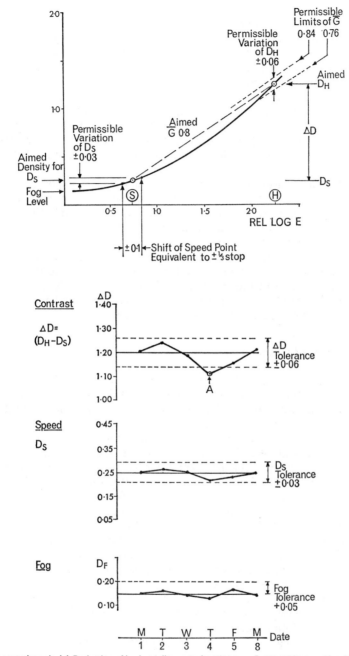

(a)

(b)

Fig. 1.20. Process control graph. (a) Derivation of basic quality control parameters. *Contrast* Measured by ΔD for chosen Log E range S – H (Tolerance chosen to give \bar{G} 0.8±0.04) *Speed* Measured by D_S (Tolerance chosen to give nominal speed±$\frac{1}{3}$ stop). The exposure S should give a density of 0.25; if it does not do so the processing has been incorrect. (b) Typical control graph. Plotted for sensitometric control strips from 3 steps only (H, S and Fog). The fog tolerance has been arbitrarily set at +0.05. At point A the contrast has dropped outside the tolerance and corrective action is required.

53

curves are parallel. However, in many cases the curves are of a different shape or are not parallel and the LogE separation depends on the density level used for the comparison. Table 1.2 gives some of the density criteria that have been found suitable for specific applications; the principle is to choose a density level related to that which is necessary for optimum performance for the task in hand.

No type of film is entirely consistent in its characteristics and the accurate assessment of film speed cannot be based on a single sample; speed determination of a product is based on at least 12 samples obtained on at least four separate occasions (i.e. not of the same batch). Monochrome films must be kept under normal conditions ($20\pm5°C$ and 55 ± 5 per cent RH) for a period of three months before speed tests are made.[35]*

1.5.6 Fog. Any density not due to the primary camera exposure is termed fog. A slight fog level is always produced by the development process and increases with extra development, as shown by the conventional family of D/LogE curves. Fog/development-time curves are normally plotted in conjunction with the relevant gamma/time curve (see Fig. 1.23).

In general practice the fog level (and the base density) may be discounted by measuring the density of an unexposed margin and deducting this figure from any density reading made in the image area. This is not entirely accurate, because the effect of fog is less at higher densities and various methods have been proposed to allow for this factor in critical quantitative work.[66]

1.6 *Applications of sensitometry*

1.6.1 Process control. Sensitometric methods are used to ensure consistent results from continuous processing machines and deep-tank installations. Chemical tests are also necessary in installations with circulatory replenishment systems, but they cannot replace sensitometric tests.

Pre-exposed control strips are available from film manufacturers for most processes and process control graphs of the type shown in Fig. 1.20 can then be plotted on a daily or weekly basis. Whatever replenishment system is used, whether it is based on replacing a certain quantity of solution each week or is continuously adjusted according to the area of film processed, control strips allow the efficiency of the system to be monitored so that corrective action can be taken. Carlu[67] has discussed the application of batch (i.e. intermittent) replenishment in achieving long-term stability and has given an equation covering the replenishment rate for continuous-tone negative materials.

Process control has its place even in the smallest photographic unit; it gives the camera operator greater confidence and assists correct diagnosis of any sub-standard results. It is possible to make a simple assessment of the control strips by visual comparison with a standard strip and thus achieve a measure of control with a minimum of time or equipment. Sensitometric methods are a basic necessity in process control but it is important to recognise their inherent limitations; variations in speed etc. can be measured sensitometrically but the *causes* of change are not shown directly. For this reason, the important process parameters (machine speed, temperature, pH etc.) should also be recorded.

*Essentially similar conditions are specified in the USA standard for papers[10], reversal colour films[61] and negative colour films[12].

54

Kodak Ltd supply pre-exposed control strips for all their colour processes and include a processed strip to act as a reference for the user's processing. Detailed advice is given on the interpretation of the control graphs; the colour density tolerances are quoted for the density patches and possible reasons are suggested for any sudden changes in colour balance or any long-term trends. Strips of this type can be exposed by the photographer in a suitable sensitometer or, if extreme care is taken, in the user's own printing equipment. Horn has described some of the problems in producing control strips for the Ektacolor print process.[68]

Hornsby[69] has discussed systems suitable for small-scale users. The sensitometric and chemical control methods for large scale processing plant have been outlined by the SMPTE.[7] The application of simple statistical methods in process control has been most usefully described by Todd and Zakia[9].

1.6.2 X-RAY SENSITOMETRY. The reponse of photographic emulsions to nuclear particles,[70] electrons[71] (see p. 206) and X-rays[72] can be studied by following similar principles to conventional sensitometry. For exposure to X-rays and gamma-rays no reciprocity failure occurs, so that time-scale and intensity-scale exposures give identical results and no intermittency effect occurs. This does not apply to 'screen' X-ray films, which are largely exposed by blue fluorescence from intensifying screens (see p. 289) and for which 'visible light' sensitometric methods are applicable.[73]

Direct X-ray exposure gives a D/LogE curve that is exponential up to high densities; over this region the gradient (G) increases with density (D) in the relationship $G = 2 \cdot 3D$.[72] Apart from exposure to low energy X-rays and with very slow emulsions, all direct X-ray exposures produce a D/LogE curve of this shape; variations in development or exposure conditions tend simply to alter the position of the curve along the Log E axis.

The principle of the early time-scale sensitometer has been applied to X-ray and gamma-ray work, using a rotating lead shutter. Kastner *et al* have described a unit in which the film is rotated on a turntable under a lead sector disc, giving a 9-step exposure with $2 \times$ increments.[24]

Intensity-scale X-ray sensitometers normally use a metal step-wedge (e.g. aluminium or lead, depending on the radiation energy) of different thickness. Kowalski has described the use of a wedge of Plexiglas in studying the tone reproduction of medical radiographs.[74]

McIninch and Cleare have described an automatic gamma-ray sensitometer using contact exposure with foils of Cobalt-60.[25]

Despite the differences between response to X-rays and light, the latter can be used for process control purposes in radiographic departments.

1.6.3 SPECTROSENSITOMETRY. The response (speed and contrast) of photographic materials varies with the wavelength of the exposing radiation. This is normally shown by a wedge spectrogram and is produced by exposure of the material in a conventional prism or grating spectrograph, or in a specially designed spectrosensitometer. The main feature of the latter instrument is that exposures are made in succession to a range of narrow wavebands.

A commercial instrument of this type is the Tech/Ops Spectral Sensitometer Model 710, which covers the spectral range 400–700 nm with optional extension up to $1 \cdot 4 \mu m$. The time scale exposure covers the range 1msec to 1000 seconds.

Tupper has discussed the general basis of spectral sensitivity measurement[75] and

Gorokhovskii and Levenberg[76] have given full details of a number of spectrosensitometers.

TABLE 1.3

CONVERSION OF INTEGRATED DENSITY READINGS TO
EQUIVALENT 'PERCENTAGE DOT SIZE'

Integrated density (\bar{D})	Opacity (Antilog \bar{D})	Percentage dot size (approx.)	
2·00	100	99%	
1·70	50	98	
1·50	32	97	
1·30	20	95	Negative highlight region
1·10	13	92	
1·00	10	90	
0·90	7·9	87	
0·06	1·15	13	
0·04	1·10	9	Negative shadow region
0·02	1·05	5	
0·01	1·02	2	

1.6.4 REPROGRAPHY.

1.6.4.1 *UV densitometry*. The principles of sensitometry are applicable to any photo-sensitive process and can be used to compare reprographic materials or equipment. Many of these processes are predominantly sensitive to the ultraviolet and some problems may arise in this region of the spectrum.[77]

A basic requirement in sensitometry is some form of exposure modulator; in common practice this is a 'photographic' silver step-wedge. However, silver has a sharp transmission band below about 350 nm (see Fig. 1.21) and the printing density may be lower than the visual densities measured on a standard densitometer.[78] This sort of discrepancy sometimes causes an unexpected loss of contrast when printing silver negatives on UV-sensitive materials such as diazo microfilm; it is distinct from the loss of contrast normally resulting when silver halide emulsions are exposed to UV radiation (see p. 273). Fortunately, in many cases the band below 350 nm is not of great significance, because of absorption by glass elements in the printing system, but the effective printing densities for any process can be found by a photographic method (see p. 66) if a neutral (aluminised) step-wedge is available for comparison. Alternatively, silver step-wedges could be recalibrated in terms of their effective UV density by using a specially constructed UV densitometer.[79]

Some of the design aspects of a UV sensitometer for use in the 300–500 nm band have been discussed by Drummond and Habib[23] and the use of this equipment with photo-resist materials has been reported by Htoo.[80]

The increasing use of diazo microfilm materials (because of their cheapness, high resolution and rapid processing) has aroused interest in their tonal and spectral characteristics[81] and their use for printing on to electrostatic and other materials. The spectral transmission of diazo films and the characteristics of diazo-coated pre-sensitised litho plates have been discussed by Tyrell.[82]

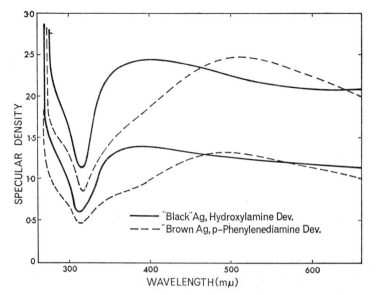

Fig. 1.21. Spectral absorption of photographic silver (James and Vanselow, 1958 – ref. 34). Two density levels are shown for each of two developers.

1.6.4.2 *Integrated half-tone dot densities.* Photo-mechanical processes reproduce graduated densities by half-tone dots of varying size. These are usually described in terms of percentage dot size and the tonal quality of the negative is judged largely by the range of dot sizes; for example, it may be necessary to keep the negative dots within the range from 10 per cent (shadows) to 90 per cent (highlights). The negatives are commonly assessed by eye, but for process control or critical work, such as colour separation processes, it may be preferable to use photo-electric measurement.

Although the image consists solely of dots, the integrated density \bar{D} of screened image areas can be measured with a normal densitometer and if required this can be converted to the equivalent percentage dot size by use of the following formula:

$$\text{Percentage dot size} = 100 - \left(\frac{100}{\text{Antilog } \bar{D}} \right) \qquad \text{Eq. 1.3}$$

For example, if the integrated densitometric reading is 0·3 the percentage dot size is given by $100-(100/\text{Antilog } 0\cdot3)=100-(100/2)=50$ per cent; other examples are given in Table 1.3. It can be seen that small errors in density reading (or dust spots) will considerably affect the calculated dot size where the dots are small (negative shadow region).

It is necessary in this method to use a large densitometer aperture to give a satisfactory integrated reading; a 3 mm or 4 mm aperture should be sufficient even for the coarsest screens (50 lines per inch).*

1.6.5 FILTER FACTORS. Filter factors can be estimated from a series of practical tests, but a sensitometric method is more precise and is the basis of published filter factors.

*To allow for any slight halo of low density round the dots, the densitometer may be set to zero on a region containing very weak half-formed dots.[83]

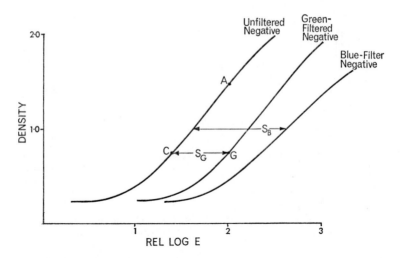

Fig. 1.22. Sensitometric determination of filter factors. The unfiltered negative will have a density of 1.45 (point A) after exposure to 2.0 Log E units. Because of the filter absorption the green filtered negative receives less exposure and a lower density is produced (point G). A measure of the reduced exposure is given by $S_G=0.6=4\times$ factor. Similarly the blue filter factor $S_B=1.0=10\times$ factor.

The photographic conditions can affect the filter factor in several ways (illuminant colour, gamma-lambda effect, reciprocity failure). A standardised procedure for pictorial and graphic arts work (Table 1.3) is laid down in BS 1437:1948[84] but it is expected that users will make their own specification to suit different applications.

TABLE 1.4

CONDITIONS FOR THE SENSITOMETRIC DETERMINATION OF
FILTER FACTORS (BS 1437:1948)

	General daylight exterior photography	*Graphic arts colour separation work*
Light source	2850K filtered to daylight quality	2850K tungsten lamp or other source in use (e.g. carbon arc or 3200K tungsten)
Exposure time	Not specified (1/50 sec. normally suggested)	10 seconds for the unfiltered exposure
Development	Filtered and unfiltered exposures to have the same development time	(a) Screen negatives: Negatives developed for the same *time* (b) Continuous-tone work: Negatives to be developed to the same *contrast*
Density level used for comparison	D=1·0	(a) Screen negatives D=2·0 (b) Continuous-tone work D=1·0

58

Once the filter factor has been determined, it must be applied in a consistent way, particularly if it is a large factor. In exterior work the increased exposure should be given by opening the lens aperture; for graphic arts work, where alteration of the lens aperture is often undesirable, the exposure *time* should be increased. There may be a two-fold or four-fold difference between the intensity correction factor and the time correction factor for the normal tri-colour filters.

The sensitometric method outlined in Fig. 1.23 calls for two exposures of a neutral step-wedge, one with and one without the filter under test. The conditions should be identical for both exposures and no attempt should be made to apply a filter correction factor at this stage.

The filtered exposure often has a different contrast (due to the gamma-lambda effect—see p. 28), so that the curves are not parallel (curve B in Fig. 1.22). A choice must then be made of the density level at which the curve separation is to be measured; the level of $D = 1 \cdot 0$ is normally chosen in such cases, but it may be preferable to adjust the development time until a matched contrast is obtained before attempting any filter factor determination.

Hornsby has discussed the determination of filter factors for colour separation work and the addition of neutral densities to give a balanced set of filters.[85]

1.6.6 APPLICATION OF GAMMA/TIME CURVES AND SPEED/TIME CURVES. In the preparation of duplicate negatives, unsharp masks and other copying work, it is usually necessary to produce an intermediate positive of a prescribed density range.

From the density range of the original negative (DR_n) and the stipulated positive density range (DR_p) the required gamma of the positive (γ_p) can be calculated ($\gamma_p = DR_p/DR_n$). The development time necessary to give this gamma value can be found from a gamma/time curve.

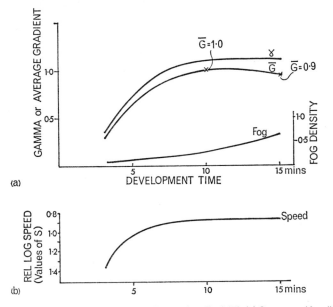

Fig. 1.23. Graphs derived from a family of D/Log E curves (see Fig. 1.17). (a) Contrast and fog. (b) Speed.

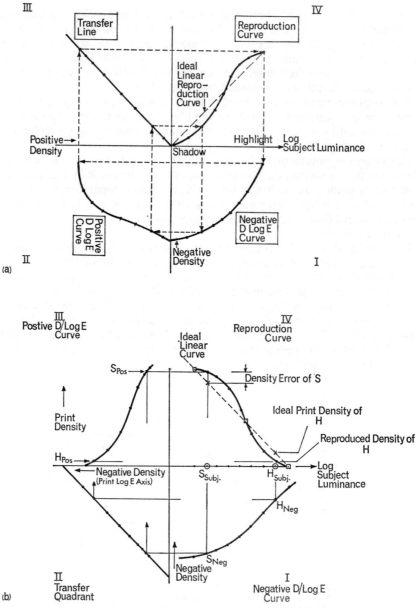

Fig. 1.24. Tone reproduction. (a) Quadrant diagram (after Jones). (b) Alternative form of quadrant curve. In this typical example, the reproduced density is correct at only three points and the contrast is only correct in two regions (mid-highlights and mid-shadows).

Alteration of the development time affects the speed of the emulsion. In Fig. 1.17 this is shown by the varying speed points (S), corresponding to the fixed density criterion ($D_{min} + 0 \cdot 1$) for each curve.

Whenever the development time is adjusted to produce a different contrast, the exposure correction factor (logarithmic) can be estimated from the speed/development time curve shown in Fig. 1.23b. This type of curve can easily be derived from the family of D/LogE curves necessary to produce the more familiar gamma/time curve and its use ensures that the minimum density of the positive remains at the optimum level.

Gamma is the appropriate expression of curve shape in this case, because the films used for continuous-tone copying (e.g. Ilford N5.31, Kodak CF 8) have a long straight-line characteristic curve. The exposure is confined to this linear part of the curve to give undistorted tone reproduction in negative duplication.

In a two-stage (negative-positive) copying process the product of the gamma values of the two stages ($\gamma_{neg} \times \gamma_{pos}$) gives the overall reproduction gamma which, for linear tone reproduction, should equal 1·0. It is unwise to base such calculations on manufacturers' gamma/time curves because of the variations in contrast caused by the exposure conditions and the effect of the printing optical system on the effective density range (Callier effect and colour coefficient).

1.6.7 TONE REPRODUCTION. The relationship between the tonal characteristics of a scene and a photographic reproduction can be shown by a quadrant diagram. The densities of each step in the process are plotted and the reasons for tone distortion can be seen.

Jones' original diagram is shown in Fig. 1.24a, but for some purposes the alternative given in Fig. 1.24b is preferable. The first method allows Quadrant III to be used for showing variations in viewing conditions and subjective viewing effects. The second method presents the print curve in a more familiar upright fashion and allows Quadrant II to be used for introducing the effects of variations in the printing equipment (lens flare, Callier effect etc.).

In each case Quadrant IV shows the original subject luminance values plotted against the final print densities. Ideally this print reproduction curve should lie at 45° to the graph axis; any parts of the tone scale plotted above the ideal 45° line are too dense and any points below the line are too light for perfect reproduction. Areas where the curve is steeper than 45° are too contrasty and areas with a lower reproduction slope are too flat. The preferred reproduction in reflection prints is given when the reproduction curve has densities about 0·25 below the 45° line and the mid-tone slope is about 1·2–1·1.[90] Somewhat different characteristics are necessary for transparencies.

The use of quadrant diagrams for predicting tone reproduction in printing and duplicating and consideration of the effects of contrast masking has been discussed by Langford.[86]

An approximation to tonal fidelity is often required in record photographs and the best method of assessing the accuracy is to include a calibrated step-wedge in the scene; with continuous-tone copying and other flatly-lit subjects, a normal reflection step wedge with a density range of 2·0 (luminance range 100:1) has a sufficient density range. For many purposes it is not necessary to plot the entire reproduction cycle and Quadrant IV can be drawn by direct comparison of the print densities against the calibrated wedge densities.

The quadrant principle can be extended (as in Fig. 1.25) to cover multi-stage applications, such as duplicating processes and the electron-optical systems used in high-speed photography, Corbett has shown the application of this principle in a discussion of tone reproduction in cinematography and television.[87]

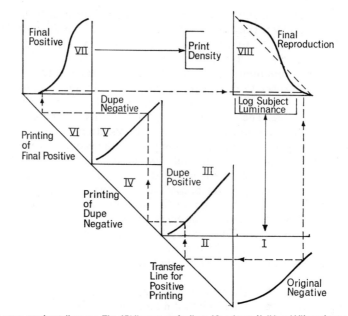

Fig. 1.25. Multi-stage quadrant diagrams. The 45° linear transfer lines (Quadrants II, IV and VI) apply to contact printing operations. Projection printing will cause flare (lower contrast) and a Callier effect (higher contrast), so that a more complex transfer curve will be required.

The plotting of tone reproduction diagrams has been applied in many fields, such as the standard representation of lighting installations[88] and the study of tone reproduction in medical radiography[74] and in photomechanical printing.

In optical sound recording the fidelity of sound reproduction largely depends on the use of the correct part of the film characteristic curve. Quadrant diagrams of the negative and positive film curves have been used to show the relationship between exposure and development of the film and the final reproduction.[89]

A thorough study of pictorial tone reproduction, including various subjective factors, has been given by Nelson.[90] A number of applications of this principle, including the comparison of colour images and the optimum reproduction curves for different viewing conditions have been discussed by Todd and Zakia.[9]

1.7 *Photographic photometry*

1.7.1 PRINCIPLES. Photometry is the measurement of light, normally carried out by photo-electric methods or by visual comparators. In photographic photometry the radiation intensity is assessed from the measured density in a photographic image.

The basis of the technique is that two sources are of equal intensity or two surfaces are of equal luminance if they produce the same density in the same photographic material. This is true only if the strictest precautions are taken to ensure identical conditions for the two exposures; some of the practical points to observe are:

(1) The exposures must be of equal duration and of equal frequency (if intermittent).

(2) The environment (temperature etc.) of the two exposures and the storage history and post-exposure treatment of the film can affect the speed or contrast; any differences in latent image regression must be avoided.

(3) The sources must have the same spectral characteristics.

(4) Processing must be identical in every respect.

(5) The image points should be positioned similarly in relation to the lens axis to avoid the effects of uneven camera image illumination (cos $^4\theta$ law).

(6) The image areas should be of similar size, to avoid complications due to development adjacency effects and reduced MTF in small images.

Many of the above problems are avoided if the points to be compared can be recorded on a single exposure.

In comparative work the purpose may simply be to find areas of greater luminance than a given reference level, which can be achieved with a high-contrast photograph including the reference area as a mid-tone. In absolute photometry, the intensity (or luminance or density etc.) of reference objects must be measured by physical photometry under the experimental conditions at the time of the photograph.

In the simplest such case, a surface of unknown reflectance is photographed together with a step-wedge which has known reflection densities. The resultant negative wedge densities are plotted against the original reflection densities to give a characteristic curve for the photograph. The negative density of the test object is then measured and a vertical line is drawn to the exposure axis from this density point (P) on the curve (Fig. 1.26). The exposure axis is scaled in wedge densities and the reflection density of the unknown surface can be found below the point P. Accuracy is improved if the linear part of the curve is used, but it is not necessary to work at a gamma of 1·0; in general the most accurate results are achieved over a fairly restricted exposure range, of the order of 10:1 to 20:1.

High densities ($D \gg 2·0$) should not be used, mainly because of reduced contrast in the shoulder region of the curve, but also to avoid the possibility of solarisation (reversal of density) in grossly over-exposed areas.

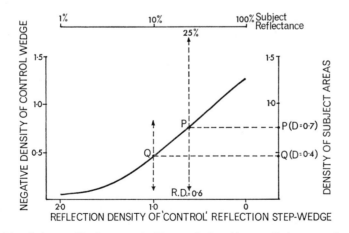

Fig. 1.26. Principles of photographic photometry. In this example the subject area P gives a negative density of 0.7. The D/Log E curve for the control wedge shows that this density is only produced (under the given test conditions) by areas reflecting 25% of the incident light (Reflection density=0.6). Similarly, the subject area Q has a reflectance of 10%.

63

The development conditions must ensure that the entire film receives identical treatment; any possibility of localised effects by bromide streamers must be eliminated.

There are certain advantages in a photographic method compared with physical photometry, notably that a large number of subject points can be recorded simultaneously over a reasonably wide luminance range. By applying special techniques of posterisation or equidensitometry (see p. 428) the photograph can be converted to give a luminance 'map' of the subject.

1.7.1.1 *Calibration steps.* Whatever the subject to be measured, areas of similar but known characteristics should preferably be included in the picture to act as calibration references. These areas should match the test subject as closely as possible in size and should not be confined to the margin of the field.

It is sometimes necessary to expose the calibration steps on a separate film, but this demands very close control over storage, exposure and processing conditions.

The calibrated reference densities can be imposed on the film by a separate contact exposure (e.g. in a sensitometer) but it may then be difficult to relate the densities to those of a camera exposure because the latter is affected by camera flare.

1.7.1.2 *Precautions.* The comparison is affected by the spectral sensitivity of the emulsion and the spectral characteristics of the illuminant, but for a monochrome subject the reflection density derived by this method gives a good measure of the mean reflectance over the measured waveband. With panchromatic emulsions and tungsten lamps a Wratten 11 (yellow-green) filter may be used to adjust the spectral response to roughly that of the human eye.

Even if the processing is perfectly standardised, slight variations in emulsion thickness can give measurable errors in the observed density. This and the possible effects of local blemishes can be avoided only by exposing additional films and averaging the results. Thickness variations are more likely to arise at the edges of photographic material and these areas should be avoided for accurate sensitometry.

Even with a suitable microdensitometer, meaningful measurement of small isolated areas (<1mm dia.) is difficult because of the Eberhard effect which causes an increased density of small image areas. Guttman has reported errors up to six-fold in intensity assessments of spectral lines due to this factor; he has also discussed methods for applying corrections to the measurements.[91] The effects of halation may also cause trouble in areas close to small bright images.

If the reference surfaces are front-illuminated (as in the simple example mentioned above) care must be taken to ensure that they receive the same illumination as the subject and that specular reflections are not present on either surface. Trans-illuminated wedges should be shielded from frontal illumination.

1.7.1.3 *Image illumination.* A fundamental difficulty with camera images is that the illuminance of off-axis areas (E_c) is considerably less than the axial image illuminance (E_a).

$$E_c = E_a \times \cos^4\theta \qquad\qquad \text{Eq. 1.4}$$

This arises from similar considerations to those governing the $\cos^3\theta$ law (see p. 120), with an additional cosine term as indicated above. Values for $\cos^4\theta$ quoted in Table 3.3 show that this can be a serious problem, particularly with wide-angle lenses. Some lenses overcome this to a limited extent (achieving a $\cos^3\theta$ loss only), but another approach is to use a radially graduated filter in such a position that it will reduce the central image illumination. Filters of this type for the Schneider Super

Angulon *f*8 lenses give reasonably good correction for the cosine effect up to a field angle of 100°, maintaining the corner illuminance at about 75 per cent of the central value.

Vignetting by the lens mount causes similar difficulty with some lenses although the effect is reduced at smaller lens apertures.

The normal remedy for these difficulties is to measure the variation in image illumination by photographic means. The camera is used to photograph an evenly illuminated surface and, after careful development, the density variation is used as the basis for compensation of future photometric density readings in different zones of the field.

1.7.1.4 *Wedge neutrality.* In work over a wide spectral range the neutrality of the reference wedge must be considered. For example, in the study of the near IR reflectance of paints and fabrics the wedge densities should preferably also be calibrated by measurement in the near infrared. Fortunately, silver images are reasonably neutral in this region and densities measured in visible light are probably valid in the near IR to within about 0·05 reflection density units at the maximum density level. For absolute assurance on this point, metallised wedges can be used.

1.7.2 APPLICATIONS. Photographic photometry was probably first used in spectrography but can be used in many other fields and is particularly useful in non-visible parts of the spectrum or with high-speed phenomena; its extension to photographic thermometry is discussed in Chapter 7.

Sandford *et al*[92] have described the determination of the absolute luminance of clouds and other objects by photography of the television displays from TIROS the meteorological satellite. The complex nature of such a system, with its optical, electronic, radio transmission and photographic stages, requires careful analysis of the possible sources of error. Nevertheless, if the calibration reference information also passes through the same chain, the non-linearities and non-uniformities are largely discounted and meaningful measurements can be made.

Quantitative study of the solar X-ray spectrum by use of rocket-borne spectrometers has been achieved by adapting the principles of photographic photometry to X-ray films and short-wave radiation.[93, 94]

A photometric method for the study of high development rates has been proposed by Lloyd.[95] The system is based on the photography of the developing emulsion at the end of the prescribed development time; a calibrated step-wedge is included in the field to allow estimation of the densities in the test material by the principles outlined above. Densitometry during development is mentioned on p. 45.

The use of cine photography for absolute measurement of radiation in the visible and near IR regions has been discussed by Overington.[96]

In all such applications the accuracy of the results depends on the relationship between the reference control and subject and the degree to which standardisation is achieved. The inherent problems of this technique tend to be increased when dealing with small images; Curtis has outlined the approach to qualitative density assessment in photomicrography.[97]

1.7.2.1 *Determination of liquid film thickness.* By the application of photographic photometry, Dombrowski and Routley[98] were able to study the variation in thickness of kerosene sheets given from a spinning cup atomiser; the liquid was dyed to increase its opacity. A reference object was provided by a wedge-shaped glass cell containing

similar liquid, so that negative density could be related directly to the liquid depth; a reproducibility of ± 5 per cent was claimed in sheet thicknesses measured over the range 5–500 μm.

1.7.2.2 *Determination of effective printing densities.*[99] As pointed out on p. 39, some processes give printing densities that are higher (by a colour coefficient X) than the densitometric measurement suggests. Because the effective negative densities cannot be accurately measured, a meaningful D/LogE curve cannot be drawn for the subsequent printing process (in which the negative densities form the LogE axis).

This problem is often minimised by using a blue filter in the densitometer (see p. 39), but in view of the many spectral factors affecting densitometric measurement, it may be more satisfactory to carry out calibration tests with the emulsion and light source used in practice. This may be particularly relevant when investigating the printing of silver negatives on UV-sensitive materials, because of the anomalous UV transmission band at about 320 nm (see p. 56).

The method suggested by Fabry (1925) for the study of the colour coefficient of intensified images may be applied as follows:

(1) A series of step densities is made by the process to be studied. Any step-exposure method can be used, provided that a full density range is achieved.

(2) This non-neutral wedge A is contact-printed together with a conventional neutral step-wedge B on to the print material in use.

(3) The print is developed to a normal contrast and a D/LogE curve is plotted for the print of neutral wedge B.

(4) The print densities given by the wedge A are measured and are marked off along the density axis of the curve mentioned at (3) above. As shown in Fig. 1.27 these print densities can be related to the exposure axis values (expressed as wedge A original densities) that produced them.

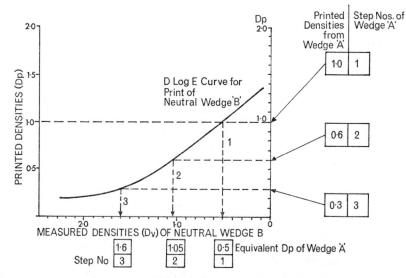

Fig. 1.27. Determination of printing density. Wedge A is a non-neutral image for which printing densities are to be determined (see text); Wedge B is a standard neutral step-wedge.

For example, in Fig. 1.27 step 1 on the wedge A produced a print density of 1·0. From the D/LogE curve it is known that under the conditions of test, a neutral density (wedge B) of 0·5 is necessary to give this print density; step 1 of wedge A therefore has an effective printing density of 0·5. Following this procedure the effective densities of each step of wedge A can be found.

The relationship between the printing densities (D_p) and the visual (or photo-electric) densities (D_v) is usually a constant for a particular process (the colour coefficient χ mentioned on p. 39). In the example above, for step 1 of wedge A, $D_p = 0·5$, but the densitometric density might be, say, $D_v = 0·4$ and the constant χ would then be $D_p/D_v = 0·5/0·4 = 1·25$.

If it can be established that the factor χ is constant over the whole density range, any densitometric values (D_v) in future work are simply multiplied by this factor to find the effective printing density D_p for the combination of materials and light source in use.

One of the standard methods for determining the diffuse transmission density uses a contact printing system based on photographic photometry.[44]

1.7.2.3 *Dosimetry.* A common application of photographic methods to quantitative measurement of exposure is in the field of dosimetry. The use of film badges for this purposes is standard practice in every radiographic laboratory and establishment handling radioactive sources or contaminants.[100, 101]

The film badge is worn throughout the working day and therefore receives the same dose as the operative; at the end of each period (weekly, monthly etc.) the films are processed by a central radiation monitoring service. From the measured density of the film the integrated dose received over the period can be assessed from known density/ dose curves (D/LogE, where E is expressed in rads or other dose unit). By the use of different materials as filters within the film holder it is possible to quantify the dose over quite a large range and, to some extent, identify the various types of radiation received.[103]

Quantitative dose assessment on a microscopic scale is also used in autoradiography (see Chapter 9).

1.7.2.4 *Stellar photometry.* Photography is widely used in astronomy to record the position, brightness and spectral composition of celestial bodies. Many of the early studies of photographic image structure and sensitometry arose from interest in astronomy and it remains one of the most exacting applications of photography.[104, 105, 106, 107] Astronomical telescopes are mentioned in Chapter 18.

The use of photographic photometry to determine star magnitudes dates from the work of Bond (1857). Janssen (1880) introduced the extra-focal method, in which an out-of-focus image is recorded; with suitable control, this retains photometric validity and avoids some of the problems associated with small images.

Photo-electric detectors are now generally used, but photographic photometry may have advantages, provided that suitable precautions are taken. Racine has outlined the history of this subject and has described a method giving accurate calibration images within the telescope.[108]

A prism is set within the image beam to give displaced secondary images which are fainter by a constant amount (ΔM) than their corresponding primary star images. Bright stars of known magnitude (M_P) are included in the field and the effective magnitude of their secondary images (M_S) can be deduced ($M_S = M_P + \Delta M$). The

magnitude* of any unknown star can be found by comparison of its primary image density with the known secondary calibration images.

This system has features that are desirable for any photometric work:

(a) The reference images are exposed simultaneously with the images of unknown objects; processing and storage conditions are also identical.

(b) The reference images are of similar size and brightness to the star images and are not confined to the margins of the field.

(c) The system can readily be tested with known star fields to establish a statistical level of confidence in the results.

References

General

1 GOROKHOVSKII, Y. N. and LEVENBERG, T. M., *General sensitometry*, Focal Press, London (1965).

2 HORNSBY, K. M., *Sensitometry in practice*, Greenwood, London (1957).

3 LOBEL, L. and DUBOIS, M., *Basic Sensitometry*, 2nd Ed, Focal Press, London (1967).

4 TUPPER, J. L., *The theory of the photographic process*, Ed C. E. K. Mees and T. H. James, 3rd Ed, Ch 19, 20, Macmillan, New York (1966).

5 SIMONDS, J. L., *ibid*, Ch 21.

6 JAMES, T. H. and HIGGINS, G. C., *Fundamentals of photographic theory*, 2nd Ed, Ch 9, 10, Morgan & Morgan, New York (1960).

7 *Control techniques in film processing*, SMPTE, New York (1960).

8 *Principles of color sensitometry*, 2nd Ed, SMPTE, New York (1963).

9 TODD, H. N. and ZAKIA, R. P. *Photographic Sensitometry*, Morgan & Morgan, New York (1969).

Specific

10 ASA PH2.2–1966 *Sensitometry of photographic papers*

11 ASA PH2.5–1960 *Method for determining speed of monochrome continuous-tone negative materials.*

12 ASA PH2.27–1965 *Speed of colour negative film for still photography.*

13 GUTOFF, E. B. and TIMSON, W. J., *Phot Sci Eng*, 13, 134–40 (1969).

14 HOAG, A. A. and MILLER, W. C. *Appl Opt*, 8, p 2417–30 (1969).

15 VON WARTBURG, R., *Third International Congress of High-speed Photography*, London, 1956, Ed R. B. Collins, pp 214–8, Butterworth, London (1957).

16 HAMILTON, J. F., *The theory of the photographic process*, Ed C. E. K. Mees and T. H. James, Ch 7, Macmillan, New York (1966).

17 FARNELL, G. C., *J. Phot Sci*, 7, 83–92 (1959).

18 CREE, D. A., *Phot Sci Eng*, 13, 18–23 (1969).

19 TUPPER, J. L., *op cit*, p 415.

20 CORBETT, D. J., *Motion picture and television film: image control and processing techniques*, pp 96–98, Focal Press, London (1968).

21 GOROKHOVSKII, Y. N. and LEVENBERG, T. M., *General sensitometry*, Ch 18, Focal Press, London (1965).

22 *Control techniques in film processing*, pp 62–6, SMPTE, New York (1960).

23 DRUMMOND, A. J. and HABIB, D. P., *Phot Sci Eng*, 9, 228 (1965).

24 KASTNER, J., CIBULA, W. G., MACKIN, J. and ROSUMNY, M. R., *Phot Sci Eng*, 6, 287–289 (1962).

25 MCININCH, V. G. and CLEARE, H. M., *Phot Sci Eng*, 4, 75–85 (1960).

26 ALFAYA, R., *Phot Sci Eng*, 4, 74–77 (1960).

27 SCHUMANN, G. W., *Phot Sci Eng*, 6, 298–302 (1962).

28 AFTERGUT, S., GAYNOR, J. and WAGNER, B. C., *Phot Sci Eng*, 9, 30–5 (1965).

29 CURRENT, I. B., *Phot Sci Eng*, 7, 104–8 (1963).

*A star magnitude represents a brightness increment of $\sqrt[5]{100}$ ($\sim 2 \cdot 5 \times$); a higher magnitude indicates a fainter star. The present limit of detection is about $M = 23 \cdot 5$, compared to a limit of about $M = 6$ for the naked eye.

68

30 JACOBS, J. H. and McCLURE, R. J., *Phot Sci Eng*, 9, 82–5 (1965).

31 CORBETT, D. J., *op cit*, p 92.

32 MARRIAGE, A, *International Conference*, London 1953, Ed R. Schultze, pp 220–222, Royal Photographic Society, London (1955).

33 HORNSBY, K. M., *op cit*, p 30.

34 JAMES, T. and VANSELOW, W., *Phot Sci Eng*, 1, 104–18 (1958).

35 BS 1380, *Method for determining the speed of sensitised materials*, Part 1: 1962 *Negative monochrome material for use in daylight*.

36 *Control techniques in film processing*, pp 78–81, SMPTE, New York (1960).

37 ASA PH4.1–1962 *Manual processing of black-and-white photographic films and plates*.

38 ASA PH4.29–1962 *Manual processing of black-and-white photographic paper*.

39 STEVENS, G. W. W. *J Phot Sci*, 14, pp 153–58 (1966).

40 GOROKHOVSKII, Y. N. and LEVENBERG, T. M., *op cit*, p 143.

41 GOROKHOVSKII, Y. N. and LEVENBERG, T. M., *ibid*, Section XIV.

42 BAKER, C. W. and KAGE, E. W. JSMPTE, 71, 838–41 (1962).

43 BLAKE, R. K. and MEERKAMPER, B., *J Phot Sci*, 9, 14–25 (1961).

44 *Measurement of photographic transmission density*, BS 1384: 1947.

45 JAMES, T. H. and HIGGINS, G. C., *op. cit*, 192.

46 NELSON, C. E., *Microfilm technology*, pp 205, McGraw-Hill, New York (1965).

47 LOBEL, L. and DUBOIS, M., *op. cit*, pp 139.

48 GOROKHOVSKII, Y. N. and LEVENBERG, T. M., *op cit*, pp 168–9.

49 TODD, H. N., *Photography: its materials and processes*, 6th Ed, Ch 21, Van Nostrand, Princeton, N.J. (1962).

50 HORNSBY, K. M., *op cit*, Ch 10.

51 TUPPER, J. L., *op cit*, pp 428–30.

52 NELSON, C. E., *op cit*, p 286.

53 *Control techniques in film processing*, pp 81–3, SMPTE, New York (1960).

54 BIEDERMANN, K and STETSON, K. A., *Phot Sci Eng*, 13, pp 361–70 (1969).

55 *Proposed SMPTE recommended practice RP14 JSMPTE*, 78, pp 647 (1969).

56 *JSMPTE*, 75, 1198 (1966).

57 *Contrast transfer data for Ilford recording films*, Ilford Ltd, London.

58 WYANT, J. C. and GIVENS, M. P., *J Opt Soc Amer*, 58, pp 357–61 (1968).

59 TUPPER, J. L., *op cit*, pp 448–9.

60 *Kodak Data Book*, Ref. SE1.

61 NIEDERPRUEM, C. J., NELSON, C. N. and YULE, J. A. C., *Phot Sci Eng*, 10, 35–41 (1966).

62 ASA PH2.21–1961 *Determining speed of reversal colour films for still photography*.

63 BS 1380: Part 2: 1963, *Reversal colour films for cine photography*.

64 TODD, H. N. and ZAKIA, R. D., *Phot Sci Eng*, 8, 249–53 (1964).

65 NELSON, C. N., *Phot Sci Eng*, 1, 48–58 (1960).

66 GOROKHOVSKII, Y. N. and LEVENBERG, T. M., *op cit*, pp 64–6.

67 CARLU, P., *J Phot Sci*, 12, 61–70 (1964).

68 HORN, T. H., *JSMPTE*, 70, 39–41 (1961).

69 HORNSBY, K. M., *op cit*, Ch 12.

70 SPENCE, J., *The theory of the photographic process*, Ed C. E. K. Mees and T. H. James, Ch 9, Macmillan, New York (1966).

71 HAMILTON, J. F., *ibid*, Ch 10 Part I.

72 CORNEY, G. M., *ibid*, Ch 10 Part II.

73 ASA PH2.8 1964, *Sensitometry of industrial X-ray films*.

74 KOWALSKI, P., *J Phot Sci*, 14, 311–20 (1966).

75 TUPPER, J. L., *op cit*, pp 430–4.

76 GOROKHOVSKII, Y. N. and LEVENBERG, T. M., *op cit*, Ch 13.

77 HORNSBY, K. M., *op cit*, pp 217–24.

78 JAMES, T. H., *J Phot Sci*, 13, 84 (1965).

79 BLANC, A. J. and REESE, W. B., Paper No. 37 in *Unconventional photographic systems—Symposium' Washington, 1964*, SPSE, Washington, D.C. (1964).

80 HTOO, M.S., *Phot Sci Eng*, 12, 169–74 (1968).

81 SMITH, G. W., *J Phot Sci*, 10, 83–91 (1962).

82 TYRELL, A., *J Phot Sci*, 17, 96–101 (1962).

83 *Monochrome Photography for web-offset newsprint*, Ilford Graphic Systems Data Book No. 7.

84 *Methods of determining filter factors of photographic negative materials*, BS 1437:1948.

85 HORNSBY, K. M., *op cit*, pp 117–24.

86 LANGFORD, M. J., *Advanced photography*, Ch 10, Focal Press, London (1969).

87 CORBETT, D. J., *op cit*, pp 198–204.

88 CALLENDER, R. M., *B J Phot*, 108, 636–40 (1961).

89 LOBEL, L. and DUBOIS, M., *op cit*, pp 218–55.

90 NELSON, C. N., *The theory of the photographic process*, Ed C. E. K. Mees and T. H. James, Ch 22, Macmillan, New York (1966).

91 GUTTMANN, A., *J Opt Soc Amer*, 58, 545–50 (1968).

92 SANFORD, L. C., HARVEY, D. I. and KOHLER, R. J., *Phot Sci Eng*, 8, 2–6 (1964).

93 ATKINSON, P. A. and POUNDS, K. A., *J Phot Sci*, 12, 302–6 (1964).

94 POUNDS, K.A., *J Phot Sci*, 13, 20–4 (1965).

95 LLOYD, M., *J Phot Sci*, 13, 277–9 (1965).

96 OVERINGTON, I., *J Phot Sci*, 15, 11–21 (1967).

97 CURTIS, A. S. G., Ch 12 in *Photography for the Scientist*, Ed C. E. Engel, Academic Press, London (1968).

98 DOMBROWSKI, N. and ROUTLEY, J. H., *J Phot Sci*, 10 96–99 (1964).

99 ASA PH2.25–1965, *Photographic printing density*.

100 BECKER, K., *Photographic film dosimetry*, Focal Press, London (1967).

101 HEARD, M. J., *J Phot Sci*, 13, 32–37 (1965).

102 ASA PH2.10–1965, *Evaluating films for monitoring X-rays and gamma rays*.

103 JONES, B. E. and MARSHALL, T. O., *J. Phot Sci*, 12, 319–27 (1964).

104 RUDAUX, L. and DE VAUCOULEURS, G., *Larousse Encyclopaedia of Astronomy*, Batchworth Press (1959).

105 DE VAUCOULEURS, G. *Astronomical photography*, Faber, London (1961).

106 SELWYN, E. W. H., *Astronomical photography*, Eastman Kodak, Rochester (1950).

107 *Photometry, celestial*, Encyclopedia Britannica, London (1961).

108 RACINE, R., *Astr. J*, 74, 1073–8 (1969).

69

2. INFORMATION CAPACITY AND RESOLUTION

2.1 *Introduction*

Photographic film may be regarded as an information store which is chosen for a particular task in competition with other recording systems, ranging from magnetic tape to a pencil and note-book. This chapter discusses the extent to which photographic methods can resolve the various aspects of an event; the emphasis is generally on spatial resolution but the subject will first be introduced in broader terms.

When photography is used as a recording medium the information can be qualitative (type of behaviour, sequence of events, presence of certain features etc.), or it may be quantitative (permitting numerical assessment of subject size, shape, position, velocity, light emission etc). It is the latter points that are of primary interest in this chapter (see also 11.4.8).

In order to extract the maximum information, enhancement of the photographic record may be necessary. This is commonly achieved in everyday work, for example, by increasing contrast, or enlarging the image. In some fields, specialised equipment is used as standard practice, either for enhancement (e.g. image intensifiers, electronic masking printers) or for correction of known distortion (e.g. geometrical rectification printers). More sophisticated techniques, such as spatial frequency filtering and computer image processing[1, 2] may be used to enhance fine detail, to isolate certain density levels and to suppress various forms of image degradation.[3, 4, 5]

Altman[6] has pointed out three main classes of photographic recording and, although we may not often be concerned with some of these aspects, it is useful to make the basic distinction:

(1) In analogue recording the density of the image is analogous to the luminance pattern of the subject; this is the normal pictorial form of photography.

(2) In alpha-numeric recording the image is in the form of letters and numbers (e.g. microcopying); tonal representation is not required.

(3) In digital recording the information is coded and stored in the form of image cells, rather like a chess-board pattern.

2.1.1 DIGITAL RECORDING. If binary recording is used, the presence or absence of density in an array of image cells can convey information very economically. Fig. 2.1 shows the simple case, in which there are two storage cells A and B; by appropriate combination any of four numbers (e.g. 0, 1, 2, 3) can be stored. The pattern can be scanned by a photo-electrical system and, if required, can then be displayed in alpha-numeric form. A digital instrumentation recording system might similarly use an array of five cells across the edge of a cine frame to convey any one of 32 (2^5) predetermined numbers or other pieces of information (see p. 361). The most advanced systems attain very high spatial resolution and can store millions of binary digits (bits) per square centimetre.

The application of photo-optical systems to computers is a specialised subject[7] and will not be given further consideration in this book.

Fig. 2.1. Binary coding in digital recording. (a) 2 cells can carry 2^2 bits of information (b) 5 cells can carry 2^5 bits of information.

2.2 *Resolution*

We normally expect a photograph to give a record of two subject dimensions (height and width); if the third space dimension is required, we use stereo methods to record the subject depth. The ability to resolve depth variations (stereoscopic resolution) is discussed in Chapter 13.

In addition to spatial information (size, shape and position) other aspects of a subject may be regarded as dimensions:

(1) Time (event duration, sequence of events etc.).

(2) Tone (reflectance, transmittance, luminance).

(3) Spectral characteristics (dominant wavelengths, colour saturation etc.).

Within each category there is a property analogous to spatial resolution; photography can sometimes enhance our ability to detect small variations in these properties.

2.2.1 SPATIAL RESOLUTION. Resolving power is normally quoted in line pairs per millimetre (l/mm) in the image plane; a line pair consists of an opaque line and a clear space.

A photographic system resolving 50 l/mm uniformly over a 24×36 mm negative is producing 1200 distinguishable image points across one dimension and 1800 points across the other. This gives a total of 2,160,000 data points over the whole negative.

The subject resolution can readily be deduced once the image resolving power is known. For example, with a 50 mm lens and a subject distance of 50 m (164 ft.), the image magnification is 1/1000; with a negative 24 mm high and $M = 1/1000$ the vertical subject field is $1000 \times 24 \text{mm} = 24$ m (approx. 80 ft.). If the system will resolve 1200 image points across this field, each image point corresponds to $24000/1200 \text{mm} = 20 \text{mm}$ in the subject plane. The subject resolution may therefore be expressed as 20 mm (0·79 in.) at a distance of 50 m.*

In the previous example, the subject resolution would be improved to 0·2 mm by setting the camera at a distance of 500 mm; the vertical field would then be reduced

*The effects of atmospheric turbulence upon subject resolution and considerations arising from subject contrast are ignored in this simple example.

to 240 mm. A lens of longer focal length produces a larger image and gives a similar effect, but the resolution of the new lens would have to be considered afresh.

The spatial resolution can also be expressed in terms of the angular separation of resolvable object points. For instance, with a 24×36 mm negative a 50 mm lens covers an angular field of approximately $27° \times 40°$: in the example given previously the angular resolution is given by:

$$\frac{\text{Angular field (vertical)}}{\text{Data points (vertical)}} = \frac{27°}{1200} = 1·35 \text{ minutes of arc (about 390 micro radians)}$$

Many factors affect the spatial resolution of a system and it must not be assumed that it is necessarily the best expression of image quality (see p. 97).

2.2.2 TIME RESOLUTION. A sequence of pictures enables a subject to be studied as it exists at a number of separate moments in time; the number of pictures taken per second is quoted as a measure of the time resolution or temporal resolution. The exposure duration is a separate factor that affects the image blur and hence the spatial resolution (see p. 323).

The streak camera (see p. 334) has the unique feature that it records only one space dimension (across the *width* of the film). The *length* of the film records the time dimension and the time resolution of these cameras depends on the film velocity (and the slit width).

The information capacity of high-speed photography, with special reference to high-speed shutters and image tubes has been discussed by Clark and Zarem.[8]

2.2.3 TONAL DISCRIMINATION. The ability of a film to distinguish tonal variations can be reviewed under two headings:

(1) The extent of the tonal range that can be recorded.

(2) The number of tonal steps that can be detected.

2.2.3.1 *Exposure scale*. The term exposure scale is used here to describe the range of subject tones that can be recorded by a photographic system. Similar phrases such as 'useful Log E range', 'maximum subject tonal scale' and 'dynamic range' are also used in this context. When these terms are used quantitatively they must be defined in relation to chosen points on the emulsion characteristic curve. Fig. 2.2 shows an example where the criterion is quoted between limits set at $(D_{min}+0·1)$ and $(D_{max}-0·1)$. The available exposure scale (ES) for this arbitrary criterion can be compared with a known image illuminance range (IR); from these terms the exposure latitude can be found:

$$\frac{\text{ES}}{\text{IR}} = \text{Exposure latitude} \qquad\qquad \text{Eq. 2.1}$$

For example, in Fig. 2.2 ES is 100:1 and IR is 25:1. The exposure latitude for these conditions is 4·0, which implies that the minimum exposure (negative A) could be quadrupled and still give a printable negative (B). Despite the similarity in their overall density range, these two negatives would give markedly different results. The denser negative (B) would give a grainier print and would have lower resolution; it would also suffer from highlight tone compression and might show halation, whereas negative A would have compressed shadow tones. Negative B might also be too dense to print on automatic equipment; in such a case the exposure range would have to be re-defined in terms of a lower maximum density.

In some circumstances, the useful exposure scale may be defined as the Log E range over which the resolution exceeds a certain level (see Fig. 2.16).

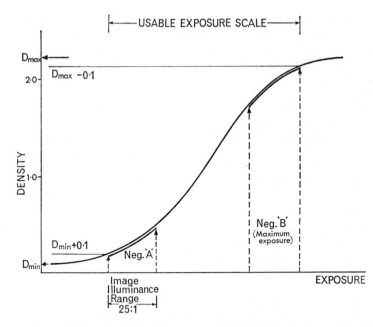

Fig. 2.2. Exposure scale and exposure latitude. The usable exposure scale is defined in this instance as the exposure scale between $D_{min}+0.1$ and $D_{max}-0.1$.

2.2.3.2 *Increase of exposure scale.* Most of the techniques for increasing the effective exposure scale have been developed for pictorial purposes, but their usefulness in applied photography should not be overlooked. The general aim is to prevent loss of highlight detail and to reduce image spread in overexposed areas. These methods can give greatly increased information content, particularly where the optimum exposure cannot be determined before the event and where heavy over-exposure is unavoidable.

Most of the procedures listed may involve the sacrifice of some emulsion speed:
(1) Compensating developer.
(2) Shortened development to reduce overall contrast.
(3) Heavily-diluted developer.
(4) Still-bath development.
(5) Water-bath development.
(6) Two-bath development.
(7) Surface-acting developer (e.g. Pyro 'surface developer' or metol-sulphite—Kodak D 165). Levy has used a Phenidone-sulphite developer[9] of this type to record an exposure range in excess of 10^6 to 1.

 EG & G Extended Range film is specially designed for this type of work (see p. 77).

Similar development techniques can be used when printing negatives of very long density range. However, the print image colour may suffer and the following methods are more commonly used:
(1) Simple shading.
(2) Unsharp masking.

74

(3) Printing on electronic masking printer.

(4) Pre-flashing of the paper to reduce the final print contrast (this is standard practice in some D & P equipment).

(5) Chemical reduction of negative (proportional or super-proportional reducer).

(6) Latent image bleaching (Sterry effect).

2.2.3.3 *Available exposure levels.* It is sometimes necessary to be able to assess the smallest density increment (ΔD) that can be discerned in a negative. Fig. 2.3a shows how this is related to the number of distinguishable exposure levels (N_e), assuming a given negative density range DR.

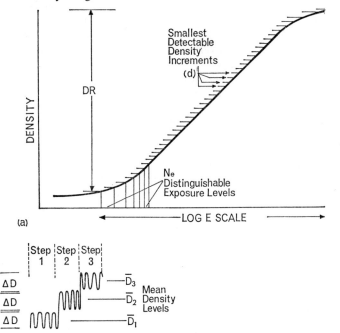

(a)

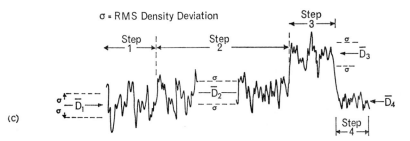

(b)

(c)

Fig. 2.3. Distinguishable exposure levels. (a) Idealised case ignoring the effects of granularity ($N_e = DR/d$). (b) Hypothetical case with regular granularity fluctuation (ΔD). The step separation ($\bar{D}_3 - \bar{D}_2$) and ($\bar{D}_2 - \bar{D}_1$) just exceeds ΔD and each step can be reliably distinguished. (c) The effect of irregular granularity fluctuations. There is insufficient separation between Steps 1 and 2 ($\bar{D}_2 - \bar{D}_1 = \sigma$) and these exposure levels could not be reliably discriminated. Steps 2 and 3 are more widely separated ($\bar{D}_3 - \bar{D}_2 = 3\sigma$) and there is little risk of overlapping.

75

With a straight line characteristic curve, the density range DR = $\gamma \times$ Log E scale, so that in this simple case

$$N_e = \frac{\gamma \times \text{Log E scale}}{d} \qquad \text{Eq. 2.2}$$

High contrast materials have a high value of gamma, but the effective Log E scale is then very small and N_e tends to be reduced to two levels only; the image density provides one level and the clear film provides another, to give a two-level (binary) system.

Most people can detect density differences in adjacent areas of about 0·03 and normal densitometers can be read to an accuracy of 0·02 or 0·01. Using figures of 0·02 for ΔD, a Log E scale of 2·0 and a gamma of 1·0, it might be assumed from Eq. 2.2 that a typical value of N_e would be 100. This simple approach may be justifiable in pictorial photography but it is not valid in high resolution work, because it ignores the effects of granularity in very small areas. Subjective effects may arise in the interpretation of photographs, and, in the case of small areas in a complex subject, even a density increment of 0·3 may escape recognition.

Fig. 2.3b shows a simplified case in which granularity causes a regular density variation. If $\Delta D = 0.05$ and Log E scale = 2·0 a total of 40 different density levels could be detected. Furthermore, the density of any isolated image areas would unambiguously show the image luminance.

In practice, however, the granularity variation is very irregular and Fig. 2.3c shows the effects of an overlap between density levels: in this case D_4 is the mean density of a small image of unknown luminance and, because of the uncertainty caused by the granularity, it is impossible to say to which level the image really belongs.

There must be a distinct density difference (D_s) between two mean density levels before they can reliably be separated. There is no strict rule about this, but D_s is usually expressed in terms of a multiple of the RMS density fluctuation σ (see Fig. 2.9).

If the mean density levels are $\pm 3\sigma$ apart the error rate is 0·27 per cent; with a separation of $\pm 5\sigma$ the error rate is only 0·0001 per cent; in the latter case only one grain clump in a million has a density which might be misinterpreted. This standard or even higher may be required in computer photo-optical systems.

If it is insisted that D_s must be very large in order to get a very low error rate, the number of possible exposure levels N_e is very small. This aspect is further discussed in connection with total information capacity on p. 78.

In communication theory it is normal to quote binary values (see Eq. 2.5). The number of exposure levels is converted to luminance bits (L_b) as follows:

$$L_b = \log_2 N_e \qquad \text{Eq. 2.3}$$

For example, eight distinguishable exposure levels can be expressed as three luminance bits ($\log_2 8 = 3.0$).

Typical values for available density levels in some Kodak films are given in Table 2.2.

2.2.3.4 *Signal to noise ratio.* The situation described above has a very close parallel in the signal/noise ratio (SNR) familiar to radio engineers. It can be defined in photographic terms as indicated in Fig. 2·4, where the signal S is the difference between the mean image density \bar{D}_I and the mean background density (\bar{D}_B); the noise (N) is caused by granularity, normally expressed as σ. The S/N ratio is therefore given by:

$$SNR = \frac{D_I - D_B}{\sigma} \qquad \text{Eq. 2.4}$$

76

The significance of SNR in various aspects of photography has been discussed by Altman;[10] he found that in microcopying a SNR of 11:1 is necessary for a barely decipherable image, whereas a SNR of 30:1 should give excellent quality.

In pictorial recording the SNR is at a maximum for a fairly narrow exposure range at the top of the toe of the D/LogE characteristic curve. In this region of the curve the slope approaches the maximum value, which gives a high signal and the density is relatively low, which leads to low noise (granularity).

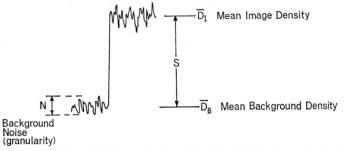

Fig. 2.4. Signal to noise ratio (SNR=S/N). S is the Signal level ($\bar{D}_1-\bar{D}_B$). N is the background noise due to granularity.

2.2.3.5 *Extended Range film*. The XR film marketed by Edgerton, Germeshausen & Grier Inc. has a special tri-pack emulsion in which each layer has the same spectral sensitivity but a different speed. As shown in Fig. 2.5, the overall exposure range is about 10^9:1. The speed range is quoted as being equivalent to the range ASA 400 to ASA 0·004.[11]

If the superimposed layers contained silver images the maximum density would be about 8·0, but this film is designed to form a different dye image in each layer (after development by the standard Kodak C 22 process). The images can be viewed with tri-colour filters for separating different parts of the tonal range; they may also be printed separately on to panchromatic bromide paper (e.g. Kodak Panalure).

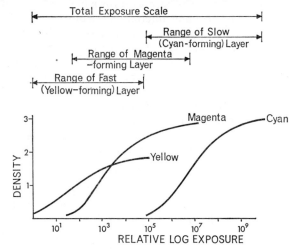

Fig. 2.5. XR Film Characteristics of Edgerton, Grier and Germeshausen Extended Range film.

77

In some self-luminous events, the luminous intensity may change enormously and unless the camera exposure settings can be changed during the event, a normal emulsion may fail to show the tonal structure at critical phases. It is virtually impossible to over-expose XR film and it will give a complete record under many circumstances where the subject illuminance is not known in advance.

The performance of this film has been studied by Lehmbeck[12] who reported over 200 distinguishable exposure levels, and a spatial resolution in the range 70 l/mm to 30 l/mm depending on the exposure level. The total information capacity (spatial bits ×luminance bits—see Eq. 2.5) is rather less than some conventional monochrome emulsions which have very high spatial resolution.

2.2.4 COLOUR DISCRIMINATION. In certain applications the use of colour emulsions can provide additional information channels; the requirement is not necessarily for accurate colour reproduction* but to achieve positive differentiation of certain aspects. For example, in the photography of flames, a monochrome record may do little more than show the overall extent of the flame, whereas the colour of various zones may have vital experimental significance. The use of colour to enhance photographic visualisation is discussed in Chapter 15.

Visual colour discrimination varies across the spectrum and several factors affect colour vision under practical conditions. Wright has concluded that, according to the circumstances, the maximum wavelength discrimination could be between 0·2 nm and 1 nm; he estimates that at least 150 wavelengths can be discerned.[16] Each of these pure colours (hues in the Munsell system) may be present at different levels of saturation and brightness (Munsell chroma and value). There are many possible combinations of these colour attributes, although by no means all can be detected in a photograph. Colour densitometry and the Munsell notation have been used for describing the colours in aerial survey photographs.[17]

Colour tri-pack materials have a relatively low spatial resolution and, despite the extra channels provided by a colour display, these emulsions are not used where the highest data packing density is required.

The Lippmann colour process has been used for a high-capacity memory store. This process records colours by forming interference bands within the emulsions; it is possible to isolate 10 different spectral wavebands, each with a band width of 15 nm.[18]

2.2.5 TOTAL INFORMATION CAPACITY. The preceding sections have introduced the concept of data points in various dimensions and it is interesting to consider finally the total amount of information that can be carried in a photographic image. The concept of information packing density is mainly relevant to the field of microphotography, although the emphasis in that case tends to be confined to spatial resolution. The exploitation of all the available dimensions of space and time and tone is likely to be of greatest interest in the fields of instrumentation and high-speed photography.

The basic formula for expressing information content (I) in binary form is:

$$I = S \times (\log_2 N) \text{ bits/cm}^2 \qquad \text{Eq. 2.5}$$

where S is the number of data points per cm² and N is the number of density levels that can be distinguished with sufficient reliability for the task in hand. For example, a system with an overall resolution of 50 l/mm will give 250,000 separate data points per cm²; if this system can detect 4 tonal steps in the subject, the value for I is given by

*The factors affecting colour *fidelity* are covered in standard works on colour reproduction.[13, 14, 15]

78

$250,000 \times (\log_2 4) = 5 \times 10^5$ bits/cm². The relationship between resolution and information capacity has been further discussed by Riesenfeld.[19]

In Table 2.1 the number of density levels (N) has been quoted for the case where very high reliability is required and $D_s = 10\sigma$.

TABLE 2.1

INFORMATION CAPACITY OF SOME KODAK MATERIALS

	Spatial 'bits' Spatial capacity (cells/cm²) S	Luminance 'bits' (Available density levels) ($Log_2 N$)		Total information capacity I
Royal X Pan	$1\cdot4\times10^5$	2	1	$1\cdot4\times10^5$
Plus X Pan	$2\cdot1\times10^5$	3	1·6	$3\cdot3\times10^5$
Microfile (Type 5454)	$6\cdot4\times10^5$	6	2·5	$1\cdot6\times10^6$
Kodak High Res. plate (Type 649)	$1\cdot6\times10^8$	2	1	$1\cdot6\times10^8$

Values taken from *Photographic Systems for Engineers*[21] (By courtesy of the Society of Photographic Scientists and Engineers.

These figures[20] show that both Royal X Pan film and Kodak High Resolution plates have only two exposure levels available for digital recording; in the first case this is due to the high granularity within a relatively short density scale and in the second case it is due to the high contrast of the emulsion.

A general conclusion[21] is that where the data points are very small, such as in computer digital recording, the optimum performance is obtained from binary (two-level) recording on a high resolution material. The use of multiple density levels in this work may give two or three times the information capacity but causes difficulties when reading out; on balance, a higher reliability is often obtained with a binary system, where the image is either present or absent. In the particular case of computer storage, tonal discrimination is therefore normally surrendered for greater spatial resolution.

In other forms of photographic recording, where large image areas are involved, the densitometric measurements are not affected by granularity and 100–200 tonal steps may be discriminated (Fig. 2.3a).

If a sequence of pictures is recorded, the total information must be reckoned in bits per cm² per second. Unfortunately, the cameras giving the highest time resolution usually yield a low spatial resolution. In high-speed work a fast (grainy) film is normally required and this further reduces the spatial resolving power of the system. Despite this fact and the preceding emphasis on information capacity, a fast film may often be the best choice from the point of view of overall efficiency. Increased film speed may permit a higher framing rate and this often outweighs the disadvantages of low spatial resolution in high-speed photography.* On the other hand, Davies [22] has shown that in astronomy the slower emulsions with inherently high SNR give the best performance, despite the inconvenience of long exposures.

*When the optical image quality is relatively low (due to image movement etc.) there is less advantage in using a high resolution emulsion. With techniques such as image dissection (see p. 348), spatial resolution is sacrificed for greater time resolution.

It will be seen that, although different subject dimensions can be recorded in combination to give a high information content, it is not possible to achieve the ultimate performance in all dimensions (space, time etc.) simultaneously.

2.2.6 INFORMATIONAL SENSITIVITY. There is considerable interest in methods for expressing the information capacity in terms which take into account the emulsion speed. The practical significance of these methods has been discussed by Higgins.[21]

Fisher[23] has expressed the efficiency of an emulsion as its 'information speed'; this is derived from the formula $(RP)^2/E$ where RP is the resolving power and E is the exposure energy level required to give the optimum results. Fisher has discussed certain applications (e.g. bubble chambers and lunar photography) in which the balance between speed and resolution of different films must be studied carefully for optimum efficiency.

The exposure energy necessary to give the minimum detectable density for a particular emulsion is termed the noise-equivalent energy (NEE) and the reciprocal (1/NEE) is called the informational sensitivity (IS).[24] The derivation of this term includes such factors as the film speed and the slope of the characteristic curve, the granularity and the point spread function (see p. 91).

In certain work the ability to detect an image is affected by the random rate of arrival of the exposing photons (as well as their varying actinic effect). The efficiency with which an emulsion produces a detectable image can be expressed as its detective quantum efficiency (DQE);* this concept is applied to give a basis for comparison between photography and other detector systems.[25] The efficiency of different sensors, including the eye, photographic films, television and image intensifier tubes has been considered by Soule.[26]

2.3 The photographic system

A photograph may be considered as a means of transferring information from the subject to the brain. The first requirement is to detect the subject by producing an adequate image density above the background; once this has been achieved, the interest lies in the amount of resolved information.

The information is initially in the form of electromagnetic radiation reflected or emitted by the subject: this passes through a number of stages of image processing before analysis takes place in the eye or in a data analyser. The sequence given in Table 2.2 shows some of the factors that can affect the information content of a monochrome photograph; this formidable list by no means covers all the possible cross-relationships.

The major factors affecting performance are treated separately in this chapter, but in practice all these matters are inter-related in a complex way. Optimum performance can come only from consideration of the complete system: no step can be ignored, whether it is a conventional precaution such as standardising agitation or a physiological factor such as colour-blindness in the interpreter. Even a step such as emulsion storage, which may not seem to be an 'event', can affect the speed and contrast of the material and its dimensional properties.

*Also known as equivalent quantum efficiency (EQE).

80

TABLE 2.2
SEQUENCE OF EVENTS IN A PHOTOGRAPHIC SYSTEM

Principal stages in system	Type of information	Governing factors
1. Source	Detection	Quantity of luminous flux
		Efficiency of reflectors
		Spectral emission
	Spatial resolution*	Flash duration
	Time resolution	Flash repetition rate
2. Subject	Detection	Reflectance, transmittance
		Self-luminous emission
	Spatial resolution*	Subject size, contrast, movement etc.
	Tonal discrimination	Subject contrast etc.
	Time resolution	Movement, event duration
	Stereo resolution	Subject distance
3. Atmosphere	Detection	Atmospheric absorption
	Spatial resolution*	Scattering, turbulence, etc.[27]
4. Camera	Spatial resolution*	Mechanical precision, film registration, shutter speed etc.
	Time resolution	Shutter speed, framing rate
	Stereo resolution	Stereo camera separation
	Dimensional accuracy	Film flatness
5. Optics	Detection	Aperture, focal length, covering power, depth of field, etc.
		Spectral transmission
	Spatial resolution*	Aberrations, Flare
		Aperture (diffraction limitation)
	Tonal discrimination	Flare
	Dimensional accuracy	Curvilinear distortion
6. Emulsion	Detection	Emulsion sensitivity
		Granularity
		Spectral sensitization
	Spatial resolution*	Granularity
		Turbidity, halation
	Tonal discrimination	Contrast index, gamma etc.
		Granularity
		Useful exposure scale
	Dimensional accuracy	Base stability
7. Exposure	Detection	Intensity/time relationship
	Spatial resolution*	Density level
	Time resolution	Exposure duration
8. Processing	Detection	Developer activity
	Spatial resolution*	'Fine grain' development
		Adjacency effects
	Tonal discrimination	Gamma etc.
	Dimensional accuracy	Processing and drying conditions
9. Printing	The complete cycle of events is repeated using the negative as the subject (light source-printer-optical system-emulsion-exposure-processing)	
10. Observer's eye (physiological level)	All factors	Eye performance
		Viewing conditions
		Viewing apparatus
11. Observer's brain (psychological level)	All factors	Experience and interpretative skill
		Adaptation to viewing environment, fatigue, etc.

*The term spatial resolution is used loosely here to include the modulation transfer function and related factors.

2.4 *Spatial resolution of lenses*

The following sections cover points of interest in the general discussion of photographic resolution: the basis of the optical theory and factors affecting the performance of diffraction limited lenses are covered more fully on pp. 164–6.

2.4.1 ABBE FORMULA. Abbe's formula for the resolving power of a perfect microscope objective may be adapted to general photographic terms as follows:

$$\text{Resolution} = \frac{1}{\lambda f} \text{ lines per mm} \qquad \text{Eq. 2.6}$$

Here, λ is the wavelength of light used, expressed in millimetres, and f is the relative aperture of the lens.

If we assume that $\lambda = 500$ nm (green light) a useful rule of thumb can be stated:

$$\text{RP} = \frac{2000}{f} \text{ lines/mm} \qquad \text{Eq. 2.7}$$

We can quickly estimate, for example, that a resolving power of 500 l/mm will require a diffraction limited lens of *f*4. In practice, a somewhat wider aperture would be required because of emulsion losses, but the value of this expression is that it shows immediately, for instance, that an *f*5·6 lens could never meet this particular specification, whatever its state of correction.

Such figures offer a 'rule of thumb' for the theoretical axial resolution, the off-axis astigmatic images are slightly worse in theory and considerably worse in practice.

2.4.2 DIFFRACTION LIMITED LENSES. If aberrations are minimised by the use of very small apertures and monochromatic light, all lenses tend to approach the theoretical limit of performance. A small aperture necessarily gives low resolution (see Eq. 2.7) but the performance is relatively close to the theoretical limit (Fig. 2.6). In this sense, even a pinhole is diffraction limited, but this term is normally used as a mark of excellence, indicating a lens that closely approaches the theoretical performance at a large aperture.

Curve B in Fig. 2.6 shows how the resolution might be plotted against aperture for a hypothetical *f*2 lens giving 200 l/mm at the optimum aperture of *f*5·6. This permits comparison with Curve A which shows figures plotted from Eq. 2.7 for a diffraction limited lens with light of 500 nm. Despite the fact that Curve B shows a resolution well below the theoretical limit at *f*2 and *f*4, this lens is shown to be virtually diffraction limited at apertures below *f*8. Curves of this type have been used by Washer to illustrate the predicted performance of lens design.[29]

2.4.2.1 *Practical considerations.* Much of the preceding discussion and calculations is concerned with the effects of diffraction, but this should not be allowed to disguise the fact that in most cases the lens performance is governed more by aberrations than by diffraction.

All such figures relate to the aerial image and do not include any photographic degradation; the net resolution on any normal film would be much less than these calculated figures (Curve C in Fig. 2.6).

Curve B in Fig. 2.6 shows the initial effect of stopping down (using a smaller aperture) in reducing spherical aberration and coma; however, beyond a certain point (in this case *f*16) a rapid decline is caused by diffraction. Lenses are not normally marked with *f*-numbers that would give this inferior performance.

In some lenses a decrease in performance at small apertures may arise from zonal spherical aberration, which causes the principal focal plane to shift as the lens aperture is reduced (Curve Z in Fig. 2.6).

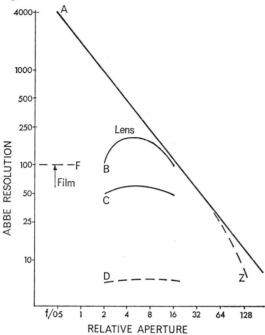

Fig. 2.6. Comparison between theoretical (Abbe) lens resolution and a practical lens film combination at different apertures. A Theoretical resolution of a diffraction-limited lens (calculated for $\lambda=500$ nm. B Resolution figures for the aerial image of a typical f/2 lens (high contrast target, axial image). C Combination of lens and film (calculated from curves F and B using Eq. 2.10a). F Approximate resolution limit of medium speed film. D Areas of low subject contrast away from the lens axis will give a resolution far below the level of curve C, particularly if exposure is not at the optimum level. Z Illustrates the possible further degradation of lens resolution at small apertures due to zonal spherical aberration.

The above factors should make it clear that a lens cannot properly be described by a single figure of resolution. Furthermore, the resolution figures for an aerial image must not be taken to imply that this performance will be recorded photographically.

2.4.3 SUBJECT RESOLUTION AND IMAGE RESOLUTION. The formulae given above indicate that the theoretical resolution is controlled by the f-number; this factor in turn depends on the lens diameter and the focal length. However, it is sometimes stated that lens resolution is solely dependent on the lens diameter and is independent of the focal length or camera extension. This contradiction has some practical implications and merits an explanation.

In the case of visual instruments (telescopes, microscopes etc.) the criterion of performance is the ability to resolve object points at very small angular separations ($\Delta\theta$); at a given distance this depends entirely on the lens diameter (D) and the radiation wavelength (γ): (see also Chapter 18.1.2).

$$\Delta\theta = 1 \cdot 22 \times \frac{\lambda \ (mm)}{D \ (mm)} \ \text{radians} \qquad \text{Eq. 2.8*}$$

*A common expression[28] for visual telescope resolution is: $\Delta\theta = \dfrac{140}{D(mm)} \simeq \dfrac{5}{D \ (in.)}$ seconds of arc.

83

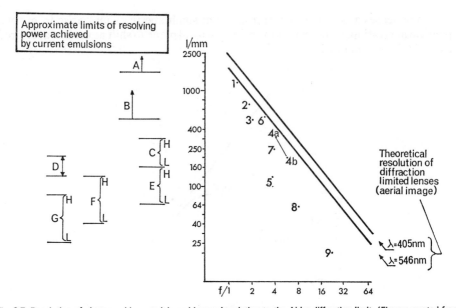

Fig. 2.7. Resolution of photographic materials and lenses in relation to the Abbe diffraction limit. (Figures quoted from published data by Rank Precision Industries Ltd.(Wray Optical Division), Nippon Kogaku K.K. and Kodak Ltd.).

*Key to lenses and field covered** (Aerial image resolution figures)

1	30mm f/1.2 Ultra Micro Nikkor		(2mm dia. field)
2	28mm f/1.8 Ultra Micro Nikkor		(4mm dia. field)
3	55mm f/2 Ultra Micro Nikkor		(12mm dia. field)
4	155mm f/4 Ultra Micro Nikkor	(a) at f /4	(56mm dia. field)
		(b) at f /5.6	(80mm dia. field)
5	75mm f/5 Micro Nikkor		(24×36mm)
6	75mm f/2.8 Wray Copying lens		(8×8mm)
7	75mm f/4 Wray Copying lens		(25×25mm)
8	7in f/5.6 Wray HR Lustrar		(quoted as an example of a standard large format camera lens)
9	Typical process lens at f/22		

*The optimum lens performance of specialised lenses is only achieved at a closely specified magnification and wavelength.

Key to film types
A Lippmann emulsion
B Diazo materials, photopolymers
C Microfilm, duplicating film
D Lantern plates, lith film
E Slow pictorial film
F Meduim speed film
G High speed film

H figures for a high contrast target (1000:1)
L figures for a low contrast target (1.6:1)

A lens of larger diameter receives more of the incident wavefront from the subject and is able to discriminate smaller subject details (see p. 164); a full account of this aspect of Abbe's diffraction theory is given in the standard works on physical optics.

However, in photographic work we normally think in terms of the number of lines resolved per millimetre in the focal plane. The limiting factor affecting resolution is the size of the Airy disc, which is caused by interference in the image plane between refracted and diffracted rays. The size of the Airy disc is governed by λ and D and also by the lens-to-image distance, which is equal to the focal length (F) or to some greater distance (v), depending on the subject distance (u). A lens giving 100 1/mm in the

84

principal focal plane (i.e. when focused on infinity) will give only 50 1/mm in the image plane when set to give a magnification of 1:1. The linear size of the image is doubled in this case (see Fig. 2.8), while the total number of lines resolved in the image is the same. In this case the lens diameter is unchanged and the angular resolution is not altered, but the linear resolution in the image plane is halved.

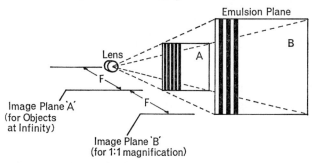

Fig. 2.8. Resolution and image magnification. If the lens will resolve 100 1/mm in plane A it resolves 50 1/mm in plane B.

There are, then, two aspects of resolution:

(1) As far as subject resolution is concerned, the lens diameter is the important factor (assuming that the subject distance is constant).

(2) As far as image resolution is concerned, the lens-to-image distance is important and the effective *f*-number (V/D) rather than the nominal *f*-number (F/D) is used for any theoretical calculation of resolution.[28]

2.5 *Spatial resolving power of emulsions*

Apart from the optical factors mentioned above, the photographic recording of small details is dependent on two properties of the emulsion:

(1) Granularity, which breaks up the image.

(2) Turbidity, which causes image spread.

A full account of emulsion properties would be out of place here, but we are concerned with certain aspects having a practical bearing on photographic resolution.

2.5.1 GRAININESS. Granularity is based on the objective measurement of microscopic density variations. Graininess is a mental sensation which is largely decided by the emulsion granularity, but it is affected to a marked extent by the negative density level, the viewing conditions and such factors as the printer illumination system and the surface texture of bromide paper. Graininess is at a maximum at a density of about 0·4; it is more noticeable in large areas free from detail and particularly in unsharp pictures; it is also affected by the picture content.

Graininess is the complete index of visual assessment but, because of all the subjective factors it is not easily measured. The modern practice is to measure the emulsion granularity and then to express it in such a way that it correlates well with the subjective impression of graininess. This subject has been discussed in detail by James and Higgins[30].

ASA PH 4-14 describes a method for evaluating fine-grain developers by comparison with a standard MQ–borax formula.[31]

85

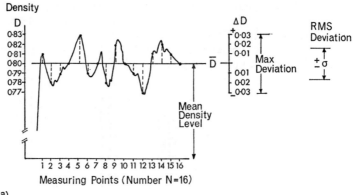

Fig. 2.9. Basis for the expression of granularity by σ (sigma). (a) Microdensitometer trace. (b) Calculation of RMS deviation (σ).

Measuring Point	1	2	3	4	5	6	7	8	9	10	11	12	13	14	15	16
Density D	0 81	0.78	0.79	0.80	0.83	0.79	0.80	0.78	0.82	0.80	0.79	0.77	0.81	0.82	0.81	0.80
Deviation ΔD	+0.01	−0.02	−0.01	0	+0.03	−0.01	0	−0.02	+0.02	0	−0.01	−0.03	+0.01	+0.02	+0.01	0
Squared Deviation (ΔD)²	0.0001	0.0004	0.0001	0	0.0009	0.0001	0	0.0004	0.0004	0	0.0001	0.0009	0.0001	0.0004	0.0001	0

Arithmetical mean $\overline{D} = 0.80$

Sum of squares $\Sigma(\Delta D)^2 = 0.004$

(b)

$$\text{Mean square} = \frac{\text{Sum of squares}}{\text{Number of observations}} = \frac{\Sigma(\Delta D)^2}{N} = \frac{0.004}{16} = 0.00025$$

Standard deviation $(\sigma) = \sqrt{\text{Mean square}} = \sqrt{0.00025} = 0.016$ RMS granularity $= 16$.

(c) Distribution curve. Histogram of the number of observations (N) for each value of ΔD in the simple example 2.9a In practice a large number of observations gives a smooth curve approximating to a normal (Gaussian) distribution.

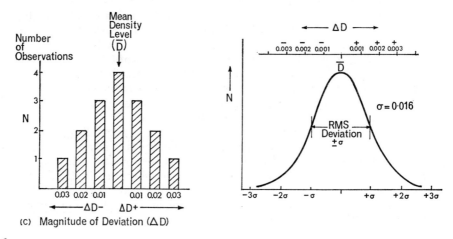

(c) Magnitude of Deviation (ΔD)

86

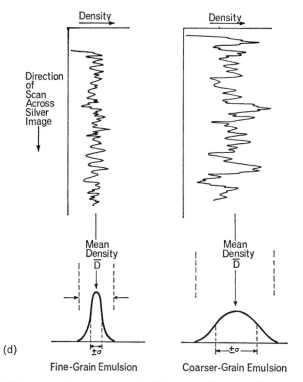

Density Density

Direction
of
Scan
Across
Silver
Image

Mean Mean
Density Density
$\bar{\mathrm{D}}$ $\bar{\mathrm{D}}$

(d)

$\pm\sigma$ $\pm\sigma$

Fine-Grain Emulsion Coarser-Grain Emulsion

(d) Comparison between granularity of fine-grain and coarse-grain emulsions.

2.5.2 GRANULARITY.[38] A microdensitometer trace shows the size and spacing of the grain clumps and also the microscopic variations in density (\varDeltaD) about the mean density level ($\bar{\mathrm{D}}$).

The term 'RMS granularity' is often used and a simple explanation of its derivation is given in Fig. 2.9.

(1) A microdensitometer trace is analysed by measuring the deviation D–$\bar{\mathrm{D}}=\varDelta$D for each deflection from the mean level $\bar{\mathrm{D}}$.

(2) If the number (N) of deflections for each value of \varDeltaD is plotted, a curve is given which closely follows the normal or Gaussian distribution (Fig. 2.9c)

Because the curve is similar to the normal distribution, the random density fluctuations can conveniently be expressed by the root mean square density deviation, signified by σ (Greek sigma)*.

A fine grain image has a small value of σ but a coarse-grain image with a wide spread of grain sizes has a large value of σ. (Fig. 2.9d).

*The spread of values in a normal distribution is usually expressed in statistical work by the *root mean square deviation* (or *standard deviation*), indicated by the symbol σ. In mathematical terms $\sigma = \dfrac{\sqrt{\Sigma(\varDelta\mathrm{D})^2}}{\mathrm{N}}$, where $\Sigma\,(\varDelta\mathrm{D})^2$ is the sum of the squares of the observed values of $\varDelta\mathrm{D}[(\varDelta\mathrm{D_1})^2+(\varDelta\mathrm{D_2})^2\ldots$ etc.] and N is the number of observations. The calculation of the RMS deviation for a simple case is outlined in Fig. 2.9b. In practice this process is carried out directly by computer analysis of the densitometric fluctuations.

87

Granularity increases at higher densities; an average value (σ) is sometimes quoted over the density range, but the RMS granularity is normally measured for a medium density (D=0·8—1·0) and is quoted for a specific scanning aperture (e.g. 50 μm). The area of the densitometer aperture (a) is of vital importance when making granularity measurements. In Selwyn's formula the granularity $G=\sigma\sqrt{a}$ is a constant for a given sample.[30]

A typical value of sigma for a medium-speed film would be $\sigma=0·01$; following the practice of Eastman Kodak, this would be multiplied by 1000 (to make a whole number) and expressed as an RMS granularity of 10. According to Kodak data[69, 70] a difference of 6 per cent in RMS granularity would probably be perceived as a significant change in graininess.

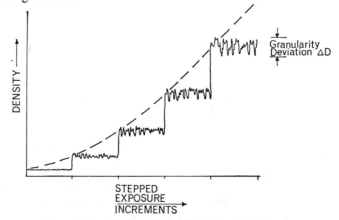

Fig. 2.10. Variation of granularity with density (representation of microdensity trace across a step-wedge). The dotted line shows the conventional (macroscopic) D/Log E curve.

Fig. 2.10 shows a simplified characteristic 'curve' produced by a series of stepped exposures. At low densities the grain clumps are relatively uniform in size, but at higher densities the microdensity trace becomes more irregular as the granularity increases.

The practical implication of this is that prints from an overexposed negative tend to show greater graininess than prints from a low-density negative, even when the print densities are matched in each case. The denser (and more granular) parts of a negative correspond when printed to the highlight areas of the positive and it is in these areas (density about 0·4) that graininess is also at a maximum. The two factors, both physical and subjective, thus combine to make the graininess more pronounced in the lighter print tones.

Granularity is of great significance when trying to detect small objects of low contrast and increasingly affects the resolving power of an emulsion at high exposure levels.[32]

The question of graininess in colour emulsions is complex, although it has been found to depend to a large extent on the granularity of the magenta image. Zwick[33] has described the relationship between the developed silver grain and the relatively diffuse dye cloud that is produced by colour coupling. Lehmbeck[12] has discussed the subject of colour granularity with particular reference to Extended Range film (see p. 77).

2.5.2.1 *Wiener granularity spectrum*. Jones[34] proposed the use of a Wiener spectrum, similar to the noise-power/frequency curve in electrical communication, to express emulsion granularity. A microdensitometer trace is subjected to Fourier analysis to show the grain noise as a function of grain-size spatial frequency (see Fig. 2.11). The area under the curve is related to the RMS granularity; factors such as increased development and high density produce a higher curve, showing increased noise.

This approach is not as commonly used as RMS granularity but offers a fuller description for some purposes; its real advantage lies in the fact that Wiener spectra values for negative and positive emulsions can be combined directly with lens MTF data to predict the final print graininess.[35] Doerner[36] has applied this method in the study of 'transferred' granularity through a negative-positive process.

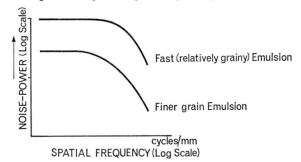

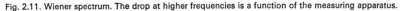

Fig. 2.11. Wiener spectrum. The drop at higher frequencies is a function of the measuring apparatus.

2.5.3 TURBIDITY. Photographic emulsions are turbid media and image-forming light is always scattered to some extent within the emulsion. This is affected by three main factors:

(1) The size of the silver halide crystals.
(2) The emulsion thickness.
(3) The opacity of the emulsion to the exposing radiation.

It is sometimes necessary to distinguish between the *optical* turbidity of the undeveloped emulsion and the *photographic* turbidity, which relates to the developed image.

Even when a perfect knife-edge is used as a contact-exposure mask with collimated light, the emulsion beneath the mask is affected by light diffusing sideways (due to reflection, refraction, diffraction and multiple scattering).

If the emulsion opacity can be increased, the lateral spread of the radiation is reduced. In some cases, plates can be bathed in yellow dye to reduce the spread of blue light; this naturally reduces the effective film speed, but greatly improves the resolution. This principle has been applied in the manufacture of duplicating and micro-copying films.

An emulsion that absorbs the scattered actinic light has a low photographic turbidity and has high definition (high acutance). The spectral absorption of silver halides decreases at longer wavelengths; for this reason the resolution and acutance of normal emulsions tends to be slightly lower for green and red light. This does not apply to the maximum resolution Lippmann emulsions, in which short-wavelength Rayleigh scatter is the predominant factor (see p. 218).

89

When recording ultraviolet radiation, the emulsion turbidity is low because the silver halides absorb the UV quite strongly. The latent image tends to be confined to the surface of the emulsion, which gives a developed image of low density range but good resolution. Ilford recommend the use of UV exposure in some graphic arts work to minimise the spread of half-tone dots.[37] X-rays behave in yet another manner: they penetrate the whole emulsion but are not scattered by the silver halide crystals. Perrin[38] has shown that X-rays can give a much cleaner knife-edge image than visible light.

In a discussion of the sharpness of paper-based print images, Stapleton has shown the increased spatial frequency response obtained by dyeing bromide paper emulsions; an even greater effect was observed with colour tri-pack papers. For the sample studied the MTF response at 5 l/mm was increased from 35 per cent to 69 per cent.[39]

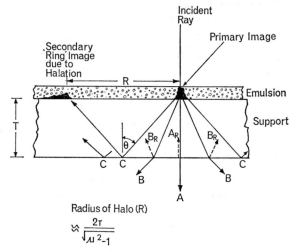

$$\text{Radius of Halo (R)} \approx \frac{2T}{\sqrt{\mu^2 - 1}}$$

Fig. 2.12. Halation in the emulsion layer. A Directly transmitted beam. B Scattered rays suffering only minor Fresnel reflection (B_R) at the support/air interface. C Scattered rays showing total reflection because the internal angle of incidence (θ) is greater than the critical angle of the glass or film support (refractive index μ).

2.5.3.1 *Halation.* Halation is a special case of image spread which is caused by scattered light which is totally reflected within the base material.[40] This adversely affects the emulsion MTF and in some cases prevents 100 per cent modulation at any spatial frequency. Some method for controlling halation is incorporated in most high resolution materials, a novel instance is the Kodak Bromide High Resolution paper.

2.6 Spread function and Acutance

2.6.1 EMULSION SPREAD FUNCTION. In theory, an exposure made with a collimated light and a knife-edge slit in contact with an emulsion should give a perfectly square density trace. In practice, turbidity effects cause lateral spread of the light and the density trace for image points is of the general form shown in Fig. 2.13b.

The density trace shows the spread function of the emulsion, which is caused by the spread of light during exposure. It may be modified by latent image effects and by various exposure and development conditions (e.g. adjacency effects).

90

Fig. 2.13. Emulsion point spread function (PSF). (a) Ideal point spread function. (b) General form of emulsion point spread function. A – Fine grain emulsion. B – Coarser grain material with higher turbidity

Acutance is the subjective measurement of edge-sharpness. A single figure cannot fully express the slope of an edge trace, but the normal method of calculating acutance[41] agrees well with the visual assessment of sharpness. Good acutance plays an important part in maintaining reasonable contrast in fine detail (micro-contrast) and is often more important than high resolution.

Thinly-coated emulsions with low turbidity have a high acutance, which can be enhanced by development techniques producing adjacency effects. The acutance depends to some extent on the wavelength of light and the exposure level.

The point spread function (PSF) of an emulsion shows the size and shape of the smallest image point; it is usually expressed by the width of the spread function at the 10 per cent intensity level. Higgins[42] has quoted spread function figures for some Kodak materials, ranging from 27 μm for Royal-X Pan to <1μm for the High Resolution plate (Type 649); he concludes that the spread function diameter is a rough measure of the minimum bit size that can be recorded in the emulsion.

2.6.2 LENS SPREAD FUNCTION. The PSF of a lens describes its ability to produce a point image. For a perfect lens the PSF would have the symmetrical form of the Airy disc and this would be the same over the entire image field. However, all lenses suffer from aberrations and this causes an image spread which is not only larger than the theoretical diffraction pattern, but is also of irregular shape. Fig. 2.14 shows the difference between the simple spread function normally formed on the lens axis and the complex off-axis spread functions caused by the interaction of coma, astigmatism and lateral chromatic aberration. There is an obvious difference here from the emulsion spread function, which is always symmetrical.

The point spread function of a lens is not easy to measure directly and it is more usual to measure the line spread function, or the ability to reproduce a clean edge trace. There is a mathematical correlation between these properties and they can be used to calculate the lens acutance.

Lens resolution and acutance are primary factors in optical image quality but there is no reliable correlation between the two properties. It has been established that for many lenses the focal plane for optimum resolution is different from the plane for maximum acutance. Kuwabara has discussed the fact that the plane of best visual focus is not necessarily the plane of best resolving power.[43]

Cox[44] has given examples showing that a high acutance lens of relatively low resolving power can give a more acceptable result than a low contrast lens of twice the

resolving power. The narrower central core of the image patch produced by lens A in Fig. 2.14a leads to higher resolution, but the low intensity tail tends to reduce the edge-sharpness of the image. The impression given by a lens of high acutance (lens B) is of overall crispness and good contrast of large image details; this is often preferred subjectively for pictorial work, despite the fact that really fine details cannot be reproduced.

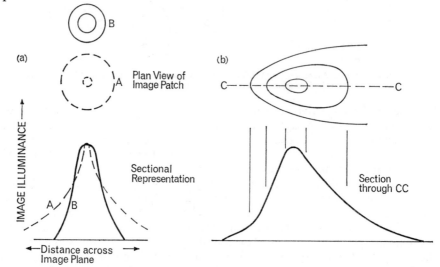

Fig. 2.14. Lens point spread function. (a) Idealised (symmetrical) form of point spread function. A–Lens of high resolution. B–Lens of higher acutance. (b) Assymmetrical image patch formed in off-axis areas. This is a simplified case. With the interaction of coma, astigmatism and lateral chromatic aberration the PSF can assume almost any shape. De-focusing also affects the light distribution.

The effect of lens spread can sometimes be reduced in microphotography by the careful control of exposure and processing, giving fine lines in the negative that may sometimes be crisper than the aerial image that produced them. For this reason it is sometimes possible to obtain better results in terms of line width than the lens performance would theoretically suggest. Stevens[45] has described the effect of exposure level and the lens f-number on the width of line achievable in microphotography.

2.7 Resolution testing

As there are always small variations between lenses of the same nominal performance, some form of resolution test is desirable for critical work. Resolving power tests have several unsatisfactory aspects but they give an index of performance in terms suitable for many purposes; Brock has discussed current image evaluation techniques and has concluded that further standardisation of resolving power tests is highly desirable.[46]

In some cases lens tests are purely comparative, for the purpose of choosing the better lens for a certain job; the actual resolution figures are then relatively unimportant. However, numerical values of resolution are sometimes required and this

calls for a more carefully designed procedure;[47] it is important that any test chart should match the geometrical and tonal properties of typical subject matter. The assessment of the resolution of microfilm systems has been discussed by Nelson.[48]

2.7.1 PRACTICAL CONSIDERATIONS. Standard resolution tests involve photography of an array of bar charts at a specified magnification. This may seem to be a simple operation, but there are many factors requiring consideration in critical work:

(1) Resolution figures for a lens alone can be assessed from inspection of the aerial image, but such figures are of little value photographically, because the resolution of the aerial image may bear little relation to the resolution of the developed image.

(2) Because of chromatic aberrations, the wavelengths used for the test should be approximately the same as those encountered in practice. This is essential when selecting a lens for UV or IR photography or for high resolution microphotography (see Chapter 6).

(3) It is most important to control the density range (contrast) of the test chart. High contrast bar patterns always produce the highest resolution figures but give an unrealistic idea of the resolution under other conditions. The chart contrast should match the luminance range of the average subject detail (see Table 2.3).

TABLE 2·3

DENSITY RANGE OF RESOLUTION TEST CHARTS FOR DIFFERENT APPLICATIONS

Application	Density range
Microphotography	3·0
Process photography	2·0
Microfilming	1·4
'Pictorial' photography	0·2
Aerial photography	0·2

Lenses with identical high contrast resolution may not be judged to be the same under low contrast conditions. If a single-figure rating of resolution is required for pictorial purposes it is more realistic to base it on the low contrast performance; this gives the best correlation with ratings by normal visual assessment.

(4) The bar charts should be arranged both radially and tangentially in order to show up astigmatism over the whole field. The radial and tangential figures should be quoted separately in any full description of the lens; if only a single figure is to be quoted it should be the lowest astigmatic figure observed anywhere in the field.

Variation of resolution over the field may be shown as a curve (see Fig. 2.15).

(5) The criterion for resolution of a bar pattern depends on whether the bars can be distinguished as separate images along their whole length. Different observers may set different standards varying by as much as 20 per cent, so that there is always a little doubt about the absolute accuracy of resolution figures. Even the same observer will give a 'scatter' of values from the same negative on different occasions.

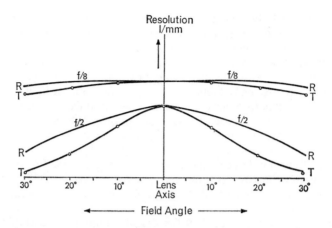

Fig. 2.15. Variation of resolution across the lens field, showing radial and tangential images for a hypothetical lens at f/2 and f/8. In a correctly centred lens these curves will be symmetrical; in general, therefore, only one side of the lens field is shown.

(6) Different test charts can give different results. The ratio of bar width to length can affect the results because a long bar is more readily distinguished against a 'noisy' background than a short bar. The number of bars in each pattern must also be standardised when comparing the results from different sources.

The fact that the observer knows in advance what the bar pattern is like, may pre-dispose him to recognise a pattern when it is not truly resolved. For this reason there is some interest in using groups of test patterns that are not all identical. In the ISO 'mire' system developed for microcopying, the observer must state correctly the orientation of 7 out of 8 test characters.[49]

(7) Lens flare reduces the shadow contrast and can seriously affect the low contrast resolution. It is usual to reduce the effects of flare during testing by the use of negative charts which have clear bars on a dark ground. For certain applications, such as missile photography, the subject is normally seen against a large bright background; resolution tests should then be made with a controlled amount of subject flare.

(8) In critical lens assessment it is usual to make a series of exposures with the test charts at different distances. The lens focus setting is not altered and in each exposure the plane of best focus is therefore altered with respect to the film plane. If the lens exhibits curvature of field it may be found that although the nominally correct focal plane gives the best axial resolution, the best average figures are given in another plane. In such a case the camera body length might be adjusted or the lens focusing datum could possibly be altered.

(9) If exposures are made over a range of apertures, an array of charts at different distances may show changes in the optimum plane of focus at different f-number settings; this shows spherical aberration.

(10) When a lens has very high resolution it is usually designed for a particular image magnification. Most of the specialist microphotographic lenses show a marked deterioration in performance with relatively minor changes in the lens conjugates.

94

(11) It is necessary when testing emulsion performance to use a high-resolution lens: similarly, a high resolution emulsion should be used when testing lens performance. In many cases, of course, it is appropriate to test a practical lens-film combination, rather than to try to isolate the performance of each stage in the system.

Unless the test conditions are specified, it is probably safe to assume that commercially-quoted lens resolution figures have been maximised by high contrast test charts and by the use of the optimum emulsions. This is accepted practice in some fields, but any attempt to judge a lens solely on the basis of a single figure obtained under unspecified conditions is to be deprecated.

2.7.2 EXPOSURE AND PROCESSING FACTORS. The resolution obtained in the negative depends to a considerable extent on the exposure level,[50] as shown in Fig. 2.16. High contrast always plays an important part in maximising resolution and this is shown by the rise in resolving power for densities above the toe region. With still greater exposure (shoulder region) the image contrast decreases, while the effects of scatter within the emulsion further degrade the resolution. BS 1613[47] specifies that for normal lens resolution tests the negative background density should be between 0·6 and 0·8 above fog. For aerial films, an exposure giving a density of 0·85 above fog has been found to give the best resolution.[51]

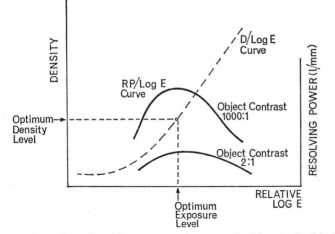

Fig. 2.16. Dependence of resolving power upon the exposure level (see also Fig. 2.21a).

It is clear that optimum resolution can be obtained only over a fairly narrow exposure range; accurate exposure control is necessary whenever resolution is a critical requirement. The influence of exposure and processing on the line widths achieved in lith and maximum resolution emulsions has been studied by Stevens.[52]

With a given emulsion which is to be developed to a given contrast, the resolving power cannot be greatly improved by choice of developer. Fine-grain developers might be expected to improve resolution, but in practice the gain may be quite small; in some cases the acutance may be reduced by solvent fine-grain developers. Techniques giving extended dynamic range (e.g. surface developers—see p. 74) give good resolution over a wider exposure scale, even though the macro contrast is reduced.

The use of chemical reducers can reduce resolution by the removal of very fine detail at the emulsion surface. Over-exposed negatives may, however, be improved by the reduction of density in the fine lines. Chemical intensification frequently leads to increased granularity, but the visual resolution may possibly be increased as a result of the enhanced contrast, particularly in underexposed regions.

Typical values for emulsion resolving power are given in Table 2.4 and in Fig. 2.7; such figures can only be regarded as approximate, especially when they are obtained from different sources.

TABLE 2.4

APPROXIMATE RESOLVING POWER OF DIFFERENT CLASSES OF EMULSION

	High contrast resolution	*Low contrast resolution*
High speed film	80 1/mm	25 1/mm
Medium speed film	110	40
Slow 'pictorial' film	180	60
Process film	150	
Microfilm	300	
High resolution materials	2000	

Putora has described a densitometric method for resolution assessment, based on the fact that the integrated density of grid image areas depends to some extent on their sharpness.[53]

2.7.3 FILM AND LENS COMBINATION. It must not be thought that the combination of a lens with a 50 1/mm resolution and a film with 50 1/mm resolution will give a total resolution of 50 1/mm on the developed negative. The assessment of the combined performance is not a straightforward matter, but the following formula is sometimes used:

$$\frac{1}{RP_{combined}} = \frac{1}{RP_{emulsion}} + \frac{1}{RP_{lens}} \qquad \text{Eq. 2.10a}$$

In the example quote above, $1/RP_c$ would be given by $(1/50+1/50)=1/25$ so the indicated final resolution would be 25 1/mm. A similar rough calculation for an alternative system using a lower quality lens (33 1/mm) shows that a similar resolution may be obtainable if a better film (100 1/mm) can be used $(1/100+1/33=1/25)$.

This type of calculation has little to recommend it on theoretical grounds, but it has been found useful as a rule of thumb; some workers prefer the following expression which uses the square of the reciprocals:

$$\frac{1}{(RP_c)^2} = \frac{1}{(RP_e)^2} + \frac{1}{(RP_l)^2} \qquad \text{Eq. 2.10b}$$

With this version, the final figures for the previous examples would be 35 1/mm and 31 1/mm respectively.

A fundamentally better method for estimating the final resolution given by a number of stages is offered by MTF methods (see Fig. 2.20).

2.7.4 LIMITATIONS OF RESOLUTION TESTING. Conventional resolution tests fall far short of the ideal requirements, but the method is likely to remain in common use by the practising photographer, for whom the more sophisticated methods are not available.

The main virtue claimed for the normal resolution test is its simplicity, although as explained above, the procedure for really thorough testing is far from simple. However, in fields such as microcopying, where the conditions are closely standardised, resolving power figures provide a useful index of performance.

The aperture and magnification of the examining microscope can have a marked effect on the evaluated resolution figures. As a general rule, if the estimated resolution is R, the microscope magnification should be between R and R/3. For example, if the resolution is expected to be about 100 1/mm, the microscope optics should be chosen to give a total magnification in the range 100X to 30X.

Finally, despite the emphasis on spatial resolution in this chapter, it must be remembered that a complete lens specification would include curves for distortion (see Fig. 14a), light distribution across the image plane (see p. 120) and spectral transmission, in addition to resolution or MTF curves.

2.8 *Modulation Transfer Function*

The concept of modulation transfer offers a way of comparing the image (output) with the subject (input) and has a close analogy with the frequency response curves used for sound reproduction equipment.

The MTF test procedure has been described in the literature[54], [55], [56], [57] and will not be explained here in detail; an outline of the operation of the Beck Eros OTF equipment has been given by Crawley.[58]

The MTF principle can readily be extended to evaluate systems incorporating image intensifiers, fluoroscope screens or other image tubes.[59] This approach allows the analysis of competitive systems to find the optimum design for a particular purpose before the components of the system are assembled.

2.8.1 BASIC MTF THEORY. MTF tests are made with test objects having a sinusoidal density variation (Fig. 2.17a), but the simpler case of a square wave test bar chart is also illustrated. The important aspects of the profile are the amplitude of modulation and the spatial frequency (number of bars per millimetre).

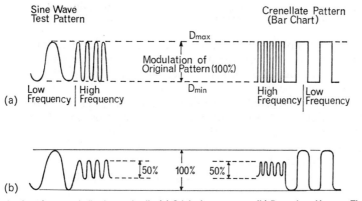

Fig. 2.17. Reduction of contrast in fine image details. (a) Original test patterns. (b) Reproduced images. The low frequency pattern (coarse detail) retains the full modulation of the original, but the high frequency pattern is reduced to 50% of the original modulation.

Fig. 2.17b shows in schematic form how a really good lens might reproduce the bar chart patterns; some loss of edge-sharpness has taken place at low frequencies, but the maximum trace modulation* has not deteriorated. However, when the spatial frequency is increased (closer line spacing), any image degradation reduces the contrast of the bar images. Eventually they become unrecognisable at a mean density level, in which case the modulation is zero.

When the modulation is plotted for a range of spatial frequencies, a modulation transfer function (MTF) curve is obtained. The abscissa values for these curves are measured in line pairs per millimetre and may be plotted either on a logarithmic or arithmetical scale (Fig. 2.18). In mathematical terms the MTF curve of a lens is the Fourier transform of the lens spread function.

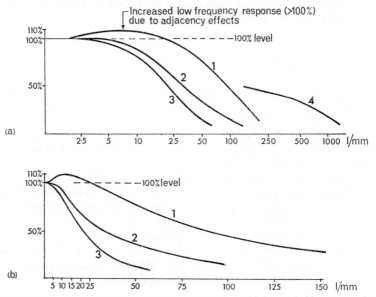

Fig. 2.18. Typical emulsion MTF curves. (a) Logarithmic frequency scale. (b) Arithmetical frequency scale. Emulsion 1 Fine grain emulsion. 2 Medium speed emulsion. 3 High speed emulsion. 4 Lippmann emulsion.

This type of curve is often loosely termed an OTF curve (optical transfer function) but this term should be reserved for the special case where the phase of the optical image is taken into account (see p. 101). Other phrases in use are frequency response curve and sine-wave response curve.

Brock has shown the considerable differences of MTF given with different test targets and has pointed out certain advantages of a single-bar test chart.[60]

Ideally, MTF curves would consist of a horizontal line showing 100 per cent modulation at all frequencies, but even with a perfect lens the effect of diffraction reduces the response at higher frequencies, as shown in Fig. 2.19; the curve drops to zero modulation at a limiting frequency which can be calculated by adaptation of Abbe's formula (Eq. 2.6).[61]

*Contrast or modulation is defined in this case by the term
$$\frac{\text{Maximum modulation} + \text{Minimum modulation}}{\text{Maximum modulation} - \text{Minimum modulation}}$$

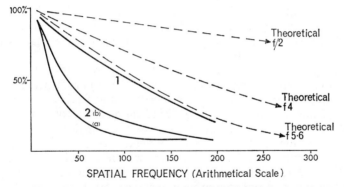

SPATIAL FREQUENCY (Arithmetical Scale)

Fig. 2.19. MTF curves for theoretical and real lenses. Curve 1 Special high resolution lens (Based on data for Wray 75mm f/4 Copying lens at f/5.6; axial image; λ=546nm). (By courtesy of Rank Precision Industries Ltd.). Curve 2 Typical miniature camera lens (white light, axial image). (a) f/2 (b) f/5.6.

2.8.1.1 *Adjacency effects.* It is well known that development adjacency effects can enhance the edge-sharpness of an image. Curve 1 in Fig. 2.18 shows an MTF curve illustrating modulation in excess of 100 per cent due to adjacency effects; this is a characteristic feature of certain developers and development techniques.

When this enhanced contrast is produced, it normally reaches a maximum at a fairly low spatial frequency (in the region of 5–15 l/mm), although it may extend to higher frequencies in high resolution emulsions. Tregillus,[62] in a study of the image characteristics of Kodak Bimat film, has shown that the conditions of diffusion-transfer development can produce increased edge-sharpness and improved high-frequency response compared with conventional processing.

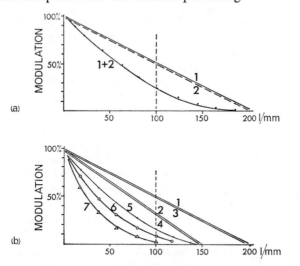

Fig. 2.20. Cascading of MTF curves (illustrated with simplified 'straight line' MTF curves). (a) For film and lens both having a limiting resolution of 200 1/mm e.g. At 100 1/mm the combined modulation is 50%×50%=25%. (b) For complete negative/positive cycle e.g. At 100 1/mm the cascaded print modulation is 50% (lens)×33% (film)×50% (enlarger lens)×33% (print) ≈ 3%. Curve 1 Camera lens (aerial image). 2 Camera negative. 3 Printer lens (aerial image). 4 Print material 5 Developed negative (resultant of 1+2). 6 Aerial image in printer (resultant of 5+3).

99

2.8.2 MTF CASCADE PROPERTIES. A primary advantage of MTF curves is that the effect of each stage in a system can be added in the so-called cascade fashion to show the net performance curve: this is greatly superior to the combination of resolving power figures given by Eq. 2.10.

Each point in the combined curve is given simply by multiplying the modulation figures of the two component curves (for example at 100 1/mm, 50 per cent × 50 per cent =25 per cent). This process can be extended to any further stages (duplication, printing, projection etc.) and gives a graphic indication of the total image degradation. In a case where the emulsion curve is not known it can be derived by subtracting the measured values of the combined curve from the known lens MTF curve.

This type of analysis immediately shows the weakness of simple resolution figures as a guide to the performance of any photographic system and can be extended to cover factors such as atmospheric turbulence and scatter, both of which cause loss of response at high spatial frequencies. Brown[63] has shown a study of this type, giving MTF curves for:

(1) The original lens design.
(2) A production-line lens.
(3) The effects of lower image contrast.
(4) Focusing error.
(5) Image smearing due to aircraft movement.

The final MTF curve in this particular case showed that a design modulation of 60 per cent at 100 1/mm was reduced to an actual aerial image modulation of 9 per cent in the camera under operational conditions.

2.8.3 VARIATION OF MTF WITH EXPOSURE LEVEL. Apart from adjacency effects, the emulsion MTF is relatively unaffected by processing variations, but the density level (exposure level) is an important factor because of the differences in emulsion contrast at different levels of the characteristic curve. Strictly speaking, the MTF approach is valid only with a linear film response, but it is generally accepted that the measurements will be carried out at density levels corresponding to those used in practice. Various theoretical implications have been discussed by Wall and Steel.[64]

Fig. 2.21 shows how the three factors of image contrast, subject frequency and exposure level are inter-related. The three-dimensional surface can be sectioned in different planes to show three conventional two-axis graphs:

(1) Contrast v Log Exposure. A family of these curves shows the different levels of modulation attainable with objects of different spatial frequency. The optimum exposure level is clearly shown and from the superimposed Density/ Log E curve, the optimum density level can be found (see also Fig. 2.16).

(2) A normal MTF curve of modulation v spatial frequency. A family of these curves cut at different sections shows the effect of varying exposure; under- or over-exposed areas can never reach the modulation level given by optimum exposure.

(3) Spatial frequency v Log Exposure. A curve of this type shows that a given modulation level is achieved only for objects of a certain spatial frequency over a restricted exposure scale; This might lead in certain cases to the definition of exposure scale (see p. 73) in terms of MTF response at a particular spatial frequency.

100

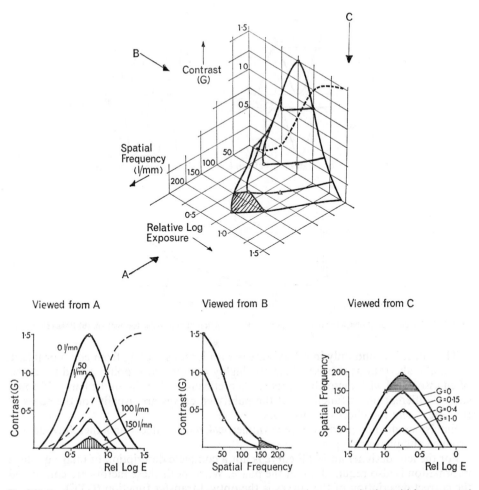

Fig. 2.21 Emulsion response curves, showing the inter-relation between the exposure level, spatial frequency and contrast of the developed image. (a) Three dimensional graph. (The dotted line shows a conventional D/Log E characteristic curve in relation to the G/Log E curve). (b) Derivative curves (G/Log E) for different image spatial frequencies. (c) Contrast (G/Frequency) curves for different exposure levels (illustrates the MTF characteristics). (d) Frequency/ Log E curves for different contrast (G) levels. The shaded area, for example, shows the limited exposure range (0.5 Log E units) within which a frequency response of 150 l/mm is possible and the low contrast (G<0.15) with which such a pattern is reproduced.

2.8.4 PHASE. Frequency response has so far been considered solely in terms of amplitude. However, as in the field of electrical communication, the phase of the reproduced pattern must also be considered in any complete description of the system.

Fig. 2.22a shows an image profile of different frequency in which the profile peaks at higher frequencies become laterally displaced from their ideal position. This progressive change of phase is shown by an increase in the value of ϕ at the higher frequencies; a phase shift curve can be plotted as in Fig. 2.22b. When a series of lenses (camera, enlarger etc.) is employed in a photographic system the phase curves for each lens can be added together to show the combined phase transfer function.

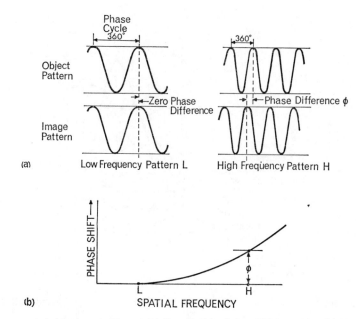

Fig. 2.22. The concept of phase in optical images. (a) Reproduction of sinusoidal test pattern. (b) Phase shift curve.

This effect is found only in off-axis areas with lenses suffering from coma or lateral chromatic aberration; it arises from the highly asymmetrical point spread functions often associated with these aberrations. Theoretically each point in the lens field could show a different phase function but the published curves are usually for the edges of the field where the effect is at its worst.

Emulsions do not produce any asymmetrical image effects and therefore do not produce any phase changes.

For the lens designer an MTF curve is not a complete description of image quality; information is also required about the phase. When both these factors are considered the correct description of the curves is the optical transfer function (OTF).

2.8.5 SINGLE-FIGURE EXPRESSION OF MTF VALUES. Despite the growing acceptance of MTF curves by photographers, there seems to be an instinctive desire to find a simple conversion between MTF figures and the more familiar concept of resolving power. This may appear to be a retrograde step, but Brock has discussed the justification for it and, in a study of the current philosophy of image evaluation, has pointed out that both systems have their applications and limitations.[46]

The equivalent pass band (EPB) has been proposed by Schade[53] as a method of expressing MTF and is worthy of brief explanation. In Fig. 2.23a the dotted line is drawn so that the area under the line is equal to the area under the MTF curve EL. The limiting spatial frequency in this case is about 200 1/mm, but the EPB is said to be 120 1/mm, which is the value for B_L.

Other attempts at single-figure expression are based on finding the contrast level below which images become unrecognisable. The eye is able to detect image modulation as low as 2 per cent under suitable conditions, but various criteria from 5 per cent

102

to 20 per cent have been suggested by different workers. Such a criterion might be appropriate in a visual system, but where photographic recording is involved, a more satisfactory approach is offered by the threshold modulation curve (Fig. 2.23b). Charman and Olin[65] have discussed a number of image evaluation methods and compared the threshold criterion with other single-figure methods such as equivalent pass-band and low contrast resolving power. Scott[66] has described a method for determining the threshold curve which is based on the correlation of lens MTF data and standard film resolution figures.

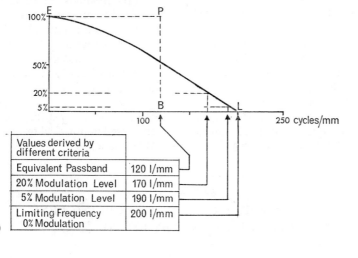

Values derived by different criteria	
Equivalent Passband	120 l/mm
20% Modulation Level	170 l/mm
5% Modulation Level	190 l/mm
Limiting Frequency 0% Modulation	200 l/mm

(a)

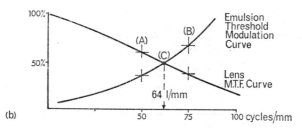

(b)

Fig. 2.23. Single-figure expression of MTF curves. (a) Equivalent pass-band (EPB) and various criteria based on arbitrary modulation levels. (b) Emulsion threshold curve. (A) A frequency of 50 l/mm will be resolved because the optical image will have a modulation of 60%, which is above the 35% level required to record on the film at this frequency. (B) At 75 l/mm the lens modulation (40%) is below that required by the film (65%). (C) The limiting frequency for the lens-film combination is shown where the curves cross; in this case at 64 l/mm.

Fig. 2.23b shows an emulsion threshold curve (also called the film detectability curve), which illustrates the simple fact that fine details must be at a higher level of image contrast if they are to remain visible on the negative. For example, although a 5 per cent modulation is adequate for coarse details, a high frequency image pattern of 75 1/mm will require a modulation of at least 65 per cent to retain a detectable image on this particular film.

103

The application of emulsion threshold curves arises when they are overlaid on a lens MTF curve. In Fig. 2.23 the image modulation given by the lens is shown to drop to 50 per cent at 64 l/mm and this is just equal to the minimum contrast required by the film at that frequency. The system may be said to have a limiting resolution of 64 l/mm; at higher frequencies the emulsion requires a higher contrast than can be provided by the lens.

In a recent paper,[67] Williams has questioned the validity of the 'emulsion threshold' concept and has proposed the use of a three-bar response (TBR) curve.

2.8.6 INTERPRETATION OF MTF CURVES. Apart from the methods mentioned above there is no general agreement as to the best criterion for interpreting MTF curves. However, it is possible to describe a photographic system in a simple MTF-derived notation. For example, the user of a camera might specify that at a given working aperture and with illumination of a specified quality a lens should give no less than 60 per cent modulation at 30 l/mm over an angular field of 20°. A MTF curve would also be required for a full analysis, but this initial description would be far more useful than simply asking for a resolving power of 30 l/mm.

Table 2.5 gives an extract of MTF data published for the Wray 3 in. *f*4 copying lens; this is an example of how MTF values can be expressed in practical terms; it also illustrates the difficulty of deriving a single figure MTF value.

TABLE 2.5

MTF FIGURES FOR WRAY 3 IN. F/4 COPYING LENS
(MEASUREMENTS BY BSIRA)

Semi-field angle		0° (optical axis)			4°			8°		11½°	
Spatial frequency (1/mm)		50	100	200	50	100	200	50	100	50	100
Response at f/4	R	76%	62%	—	74%	59%	—	70%	49%	56%	35%
	T	76	58	—	76	56	—	64	44	47	32
Response at f/5.6	R	73	51	20	75	54	20	75	55	73	50
	T	75	54	20	74	52	15	69	47	58	38
Response of a diffraction-limited lens at f/4		85%	70%	41%	(for comparison only)						
Response of a diffraction-limited lens at f/5.6		78%	58%	21%	(for comparison only)						

Conditions of measurement:
Magnification set at designed value of 10:1.
Wavelength 546nm (this is the waveband normally used in microphotography).
The focal plane was chosen to give the optimum results over the designed field of 23°.
Measurements were made at 0°, 4°, 8° and the required maximum (11½°) both for radial images (R) and tangential images (T).
(Figures quoted by courtesy of Rank Precision Industries Ltd.)

104

These figures only relate to the tested specimen of the lens but they enable a prospective user to calculate the image contrast on microphotographs taken with these lenses. It can be stated from these figures that the response on the lens axis at $f5.6$ is virtually that of an ideal (diffraction-limited) lens; the figure for 100 1/mm frequency (38 per cent for a tangential image at the edge of the 23° field) is only 20 per cent less than a diffraction-limited lens.

The lens MTF is usually shown for an axial image only, but a fuller MTF description would call for curves covering the following parameters:

(1) Different f-numbers.
(2) Different field angles (both for radial and tangential images).
(3) Different spectral bands.
(4) Different image magnifications.

As indicated previously, different focus settings can often give either optimum resolution or optimum acutance; this would be shown most clearly by differences in the OTF curves at different lens-to-film distances.

The MTF concept has permitted more thorough evaluation of photographic systems, for example in photo-reconnaissance.[68] However, although the information is more complete, considerable skill is necessary to assess it in practical photographic terms.

2.9 *Inter-related properties of emulsions*

Fig. 2.24 illustrates in broad terms the inverse relationship between film speed and image quality, using the criteria of resolving power and granularity.

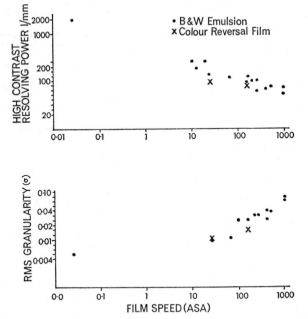

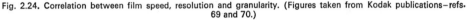

Fig. 2.24. Correlation between film speed, resolution and granularity. (Figures taken from Kodak publications—refs. 69 and 70.)

105

It is clear that films of high resolution incur a distinct penalty in terms of speed. From Fig. 2.24 it appears that a reduction of $8 \times - 10 \times$ in film speed must be accepted in order to obtain a two-fold increase in emulsion resolving power. However, we should not be tempted to assess an emulsion solely on the basis of its speed. There is appreciable scatter in the points of Fig. 2.24, indicating that some films may give better performance than others of similar or lower speed.

This chapter has explored a number of ways in which photographic performance can be expressed quantitatively. Such data can help greatly in the selection of materials and equipment, but it is rarely that our decisions can be based entirely on this academic level. The need for practical tests will always remain; the images can then be realistically assessed for the purpose in hand.

References

1 EFRON, E, *Photogramm Engng*, 34, 1058–62 (1968).

2 NEWTON, A. M. and LAVIN, E. P., *J Phot Sci*, 16, 148–53 (1968).

3 MCGLAMERY, B. L., *J Opt Soc Amer*, 57, 293–7 (1967).

4 HUANG, T. S., *Opto-Electronics*, 1, No. 1, 49–59 (1969).

5 LUGT, A. V., *Optica Acta*, 15, No. 1, 1–33 (1968).

6 ALTMAN, J. H., *JSMPTE*, 76, 629–34 (1967).

7 TIPPETT, J. T., BERKOWITZ, D. A., CLAPP, L. C., KOESTER, C. J. and VANDERBRUGH, A., *Optical and electro-optical information processing*, M.I.T. Press, Cambridge, Mass (1965).

8 CLARK, G. L. and ZAREM, A. M., *JSMPTE*, 76, 1183–88 (1967).

9 LEVY, M., *Phot Sci Eng*, 11, 46–53 (1967).

10 ALTMAN, J. H., *op cit*.

11 *Photo Lab Index*, pp 23.23 to 23.35, Morgan & Morgan, New York (1964).

12 LEHMBECK, D. R., *Phot Sci Eng*, 11, 270–78 (1967).

13 HAMWORTH, VISCOUNT and MANNHEIM, L. A., *Spencer's Colour Photography in Practice*, Focal Press, London (1969).

14 HUNT, R. W. G., *The Reproduction of Colour*, Fountain Press, London, 2nd edn (1967).

15 YULE, J. A. C., *Principles of Color Reproduction*, Wiley, New York (1967).

16 WRIGHT, W. D., *The measurement of colour*, 3rd edn, Hilger & Watts, London (1964).

17 GOWLEY, J., RIB, H. T. and MILES, R. D., *Phot Sci Eng*, 12, 27–35 (1968).

18 FLEISHER, H., PENGELLY, P., REYNOLDS, J., SCHOOLS, R. and SINCERBOX, G., *Optical and electro-optical information processing*, Ch 1, M.I.T. Press, Cambridge, Mass (1965).

19 RIESENFELD, J., *Phot Sci Eng*, 11, 415–8 (1967).

20 ALTMAN, J. H. and ZWEIG, H. J., *Phot Sci Eng*, 7, 173 (1963).

21 HIGGINS, G. C., *Photographic systems for engineers*, Ed F. M. Brown, H. J. Hall, and J. Kosar, Ch 10, SPSE, Washington (1966).

22 DAVIES, E. R., *J Phot Sci*, 16, 217–28 (1968).

23 FISHER, M. G., *J Phot Sci*, 10, 65–73 (1962).

24 HIGGINS, G. C., *op cit*, pp 193–7.

25 HIGGINS, G. C., *op cit*, pp 190–2.

26 SOULE, H. V., *Electro-optical photography at low illumination levels*, Ch 12, Wiley, New York (1968).

27 MARTZ, E. P., *JSMPTE*, 67, 228–31 (1958).

28 WASHER, F. E. and GARDNER, I. C., *Method for determining the resolving power of lenses*, NBS Circular 533 (1953).

29 ANON, *B J Phot*, 115, 604–5 (1968).

30 JAMES, T. H. and HIGGINS, G. C., *Fundamentals of photographic theory*, Ch 13, Morgan & Morgan, New York (1959).

31 ASA PH4.14–1964, *Evaluation of developers with respect to graininess of black and white films and plates*.

32 BARROWS, R. S., *Phot Sci Eng*, 1, 15–22 (1957).

33 ZWICK, D., *J Phot Sci*, 11, 269–75 (1963).

34 JONES, R. C., *J Opt Soc Amer*, 45, 799–808 (1955).

35 KLEIN, E. and LANGNER, G., *J Phot Sci*, 11, 177–85 (1963).

36 DOERNER, E. C., *J Opt Soc Amer*, 52, 669–72 (1962).

37 *Monochrome photography for web-offset newsprint*, Graphic Systems Data Sheet No. 7, Ilford Ltd.

38 PERRIN, F. H., *The theory of the photographic process*, Ed C. E. K. Mees and T. H. James, p 510, Macmillan, New York (1966). [This book gives a thorough coverage of most of the subjects relevant to this chapter and a comprehensive bibliography.]

39 STAPLETON, R. E., *J Phot Sci*, 12, 289–95 (1964).

40 VENDROVSKY, K and PAKOUSHKO, I., *J Phot Sci*, 12, 71–5 (1964).

41 PERRIN, F. H., *op cit*, pp 511–12.

42 HIGGINS, G. C., *op cit*, p 205.

43 KUWABARA, G., *Jn Opt Soc Amer*, 45, 309–19 (1955).

44 COX, A., *Photographic optics*, pp 164–6, 266–7, Focal Press, London (1966).

45 STEVENS, G. W. W., *J Phot Sci*, 16, 250–55 (1968).

46 BROCK, G. C., *J Phot Sci*, 16, 241–49 (1968).

47 *Method of determining the resolving power of lenses for cameras*, BS 1613:1961.

48 NELSON, C. E., *Microfilm technology*, Ch 13, McGraw-Hill, New York (1965).

49 *Conventional typographical character for legibility tests*, BS 4189:1967.

50 Scott, F. and Rosenau, M. D., *Phot Sci Eng*, **5**, 266–69 (1961).

51 Levy, M., *Phot Sci Eng*, **5**, 159–65 (1961).

52 Stevens, G. W. W., *J Phot Sci*, **14**, 153–58 (1966).

53 Schade, O. H., *JSMPTE*, 73, 385–97 (1965).

54 Cox, A., *A system of optical design*, Focal Press, London (1964).

55 Langner, G. and Muller, R., *J Phot Sci*, **15**, 1–10 (1967).

56 Lamberts, R. L. and Straub, C. M., *Phot Sci Eng*, **9**, pp 331–9 (1965).

57 Lamberts, R. L. and Garbe, W. F., *ibid*, pp 340–2.

58 Crawley, G., *B S Phot*, **115**, 584–9 (1968).

59 Soule, H. V., *op cit*, Ch 13.

60 Brock, G. C., *Phot Sci Eng*, **11**, 356–62 (1967).

61 Cox, A., *Photographic optics*, p 182, Focal Press, London (1966).

62 Tregillus, L. W., *J Phot Sci*, **15**, 129–35 (1967).

63 Brown, E. B., *JSMPTE*, **76**, 100–104 (1967).

64 Wall, F. J. B. and Steel, B. G., *J Phot Sci*, **12**, 34–46 (1964).

65 Charman, W. N. and Olin, A., *Phot Sci Eng*, **9**, 385–97 (1965).

66 Scott, F., *Phot Sci Eng.*, **10**, 49–52 (1966).

67 Williams, R., *Phot Sci Eng*, **13**, 256–61 (1969).

68 Jensen, N., *Optical and photographic reconnaissance*, Wiley, New York (1968).

69 *Motion picture film reference book*, Eastman Kodak Ltd.

70 *Kodak plates and films for science and industry.* Eastman Kodak publication P–9 (1967).

3. LIGHT SOURCES

3.1 *Properties of electromagnetic radiation (EMR)*

The term radiation is used in this chapter to imply electromagnetic radiation (light, ultraviolet, X-rays etc.); however, it may also be applied to charged particles (α radiation, β radiation etc.) and should be qualified whenever any doubt may arise.

Light is defined as visible EMR, although the limits of visual sensitivity vary slightly with some individuals (see p. 113). Photographic emulsions have a markedly different spectral response and this must be remembered when applying photometric data to photography (see p. 126).

3.1.1 THE DUAL NATURE OF LIGHT. Electromagnetic radiation is a form of radiant energy with both electrical and magnetic properties. The transfer of energy may be regarded in either of two ways:

(1) A continuous transverse wave (Huyghens' theory, 1678).

(2) A beam of discrete quanta of energy, each quantum being an indivisible photon of EMR (Newton's corpuscular theory, 1672).

These two concepts are so different that it is very difficult to form a simple mental picture of the radiation. However, modern studies of quantum mechanics have evolved a unified theory of the nature of light, which also covers its relationship with matter. An introduction to current ideas on this subject has been given by Feinberg[1] and by Keeling[2].

For most purposes it is permissible to apply either the wave or the quantum model to explain any observed effect. The photon concept is appropriate for radiation of very short wavelength and for explaining the interaction between EMR and matter. In the classical approach to physical optics, however, phenomena such as polarisation and interference are more easily understood by assuming that light is a form of wave motion.

3.1.2 WAVELENGTH. The most important property governing the effects of EMR is its vibration frequency, usually expressed in terms of the wavelength. Even when the radiation is considered as a quantised beam (a stream of photons), the concept of wavelength (the interval between the quanta) is usually retained.

The relationship between the radiation velocity (c), the frequency (v) and the wavelength (λ) is given by $c = v \times \lambda$. In a dense optical medium the velocity and the wavelength are reduced but the radiation frequency remains unaltered. Although the *frequency* is the constant factor, the *wavelength* is almost invariably quoted in photographic and optical work as the fundamental characteristic.

The units normally used to express the wavelength are the micro-metre (μm = 10^{-3} mm) and the nano-metre (nm = 10^{-6} mm). Other wavelength units are listed in Appendix A (p. 481).

3.1.3 QUANTUM ENERGY. Each quantum or photon has an electromagnetic energy which is solely dependent on the frequency of the radiation (v). The quantum energy (Q) is expressed in electron volts (eV) and is given by :

$$Q = h \times v = h \times \frac{c}{\lambda} \text{ where h is Planck's constant}$$

109

This may be used in simplified form to find the quantum energy for radiation of any wavelength (λ is here expressed in nano-metres):

$$Q = \frac{1235}{\lambda} \text{ eV} \qquad \qquad \text{Eq. 3.1}$$

There is a vital distinction between the intensity of radiation (which is governed by the number of photons) and its quantum energy (which depends on the frequency or wavelength). To take a photographic example, a few 'blue' photons may produce a latent image in circumstances where millions of longer wavelength 'red' photons will produce no photo-chemical effect; the energy of the red light is too low to excite photo-electrons within the silver halide crystal.

3.1.4 COHERENCE. Radiation is not emitted as a continuous wave, but in random bursts, each giving a wavetrain of finite length. The average duration of the bursts is termed the *coherence time* (T_c) and the corresponding length of the wavetrain is the *coherence length* (L_c). There is no fixed connection between the total length of the wavetrain (L_c) and the component wavelength (λ) as defined previously.

No source gives perfectly coherent light but if (as with lasers) the radiation maintains a reasonably well-defined phase relationship it is described as having good coherence. Most sources are incoherent, although this can be improved to some extent by restricting the source size and spectral band width.

The coherence of a source is closely associated with its monochromaticity (emission band width $\Delta\lambda$). For quasi-monochromatic light, such as a mercury discharge, $\Delta\lambda$ may be 10^{-3} nm and L_c about 10 cm: some lasers have a coherence length of many kilometres and a correspondingly narrower band width.

Good coherence is normally an important property in sources for interferometry and holography (Chapter 15), because the visibility of interference fringes approaches zero if the path difference of the interacting beams greatly exceeds the coherence length of the source.

3.1.5 GENERATION OF EMR. Electromagnetic radiation is produced either by incandescence or by luminescence; this latter term embraces a number of emission processes which are designated according to the method of excitation (e.g. electroluminescence, photo-luminescence): Leverenz has explained the various points of terminology in this field.[3]

3.1.5.1 *Incandescence* (*thermal radiation*). All bodies produce incandescent radiation, with an emission spectrum of the general form shown in Fig. 3.1a. With an ideal thermal source (termed a full radiator*) both the emitted waveband and the total emitted energy would depend solely on the temperature:

(1) The peak wavelength (λ_p) is given by Wien's Displacement Law as:

$$\lambda_p = 2900 \text{ micron-degrees } (\mu K)** \qquad \qquad \text{Eq. 3.2}$$

The constant factor of $2900\mu K$ indicates that, for example, a full radiator at 2900K has its peak emission (λ_p) at a wavelength of 1μ ($1\mu m$). A source with a temperature of 3400K has its peak emission at 2900/3400 microns (or $0.85\mu m$). If a full radiator were required to have its peak emission at $0.5\mu m$, the temperature would have to be 2900/0.5 or 5800K.

*The more popular term 'black body' is not part of the standardised terminology.
**More accurately, the accepted value is $2897.8\mu K$

Fig. 3.1. Spectral energy distribution curves. (a) General form of SED curves for incandescent sources. Peak wavelength $\lambda_p \sim 2900\mu K$. Half-peak wavelength $\lambda_S \sim 1800\mu K$
$$\lambda_h \sim 5100\mu K$$
Emission curve for full radiators at 2900K (A) and 2000K (B). (b) General form of emission from luminescent sources. (Several phosphors may be blended to cover a wider emission band). (c) Generalised spectral characteristics of photo-luminescence. Any spectral line in the excitation band will produce the fluorescent emission.

111

(2) The amount (E) of radiation emitted by a full radiator is proportional to the fourth power of the absolute temperature. The Stefan-Boltzmann law states:

$$E = cT^4 \text{ (where c is Stefan's constant)}$$

This factor is shown by the different areas under the curves in Fig. 3.1a.

3.1.5.2 *Luminescence.* There are many forms of luminescence (including X-rays and lasers), but the best-known example is perhaps the discharge lamp (see p. 132). An electric current between two electrodes gives a stream of electrons, which produce photons by the excitation of atoms in the filling gas or vapour. The excitation causes electron energy-level transitions within the excited atom; the gap between these energy levels governs the quantum energy (wavelength) of the emitted radiation. In some cases, only a few discrete levels are involved and a line spectrum is produced (see Fig. 3.1b). In many cases, however, a wide range of transitions is possible and a broader band or continuous spectrum is emitted.

Electro-luminescence is produced when an electric current is passed through certain phosphors;[4] this effect (Destriau, 1936) so far gives only a low luminous efficiency but has been used to produce electro-luminescent panels for contact printers and darkroom rulers. Electro-luminescent diodes, which have an entirely different form, are mentioned on p. 141.

Photo-luminescence is light (or UV) emitted by 'phosphor' materials excited by short-wave EMR. If the emission ceases (within a fraction of a second) when the excitation stops, it is termed fluorescence; an emission with a long decay time (minutes, or even days) is termed phosphorescence. The spectral characteristics of fluorescence are shown in simplified form in Fig. 3.1c. Some phosphors (e.g. zinc sulphide, calcium tungstate) have an excitation spectrum extending with varying efficiency from the middle UV to the X-ray region, but the emission band is not affected by the wavelength used for excitation.

Luminescent processes are used as a means of visualisation in infrared phosphorography (Chapter 7), UV-excitation of fluorescence (Chapter 8), X-ray fluorroscopy (Chapter 9) and in all forms of cathode ray tube, including television display tubes and image converters.

3.2 *The electromagnetic spectrum*

There is no basis for universal agreement on the subdivision of the spectrum shown in Table 3.1 and it is not intended here to establish any arbitrary dividing lines; in many cases there is an overlap between the commonly defined wavebands.

3.2.1 COSMIC RAYS. The primary cosmic rays are particles originating partly from the sun, but chiefly from unknown sources within our galaxy or beyond. Collision processes in the atmosphere dissipate the primary particle energy, giving rise to showers of particles (electrons, mesons etc.) and photons; these are collectively described as secondary cosmic rays. Primary cosmic ray energies in the range $10^8 - 10^{19}$ eV have been recorded, but the quantum energy of the cosmic ray photons seems to be in the region of $10^8 - 10^{11}$ eV. Current theories of cosmic ray origin have been discussed by Rossi.[5]

In addition to cosmic rays and the light from visible stars, a wide range of wavelengths is received from sources such as 'X-ray stars' and 'radio stars'. Recent astrophysical work using X-ray, γ-ray and extreme UV spectroscopy in solar and stellar studies has been described by Emmin *et al.*[6]

TABLE 3.1
THE ELECTROMAGNETIC SPECTRUM

Waveband		Wavelength	Quantum energy

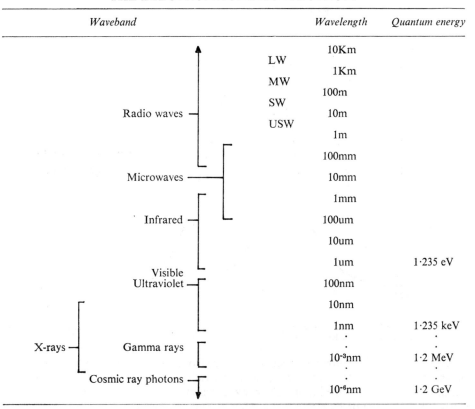

LW	10Km	
	1Km	
MW	100m	
SW	10m	
USW	1m	
	100mm	
Microwaves	10mm	
	1mm	
Infrared	100um	
	10um	
Visible	1um	1·235 eV
Ultraviolet	100nm	
	10nm	
	1nm	1·235 keV
X-rays / Gamma rays	10⁻³nm	1·2 MeV
Cosmic ray photons	10⁻⁶nm	1·2 GeV

3.2.2 GAMMA RAYS AND X-RAYS. Gamma rays are emitted by nuclear disintegration within radio-active materials. X-rays are produced by the collision of high-energy electrons with a metal target. (See Chapter 9.)

3.2.3 ULTRAVIOLET. There is no sharp division between X-ray and ultraviolet wavelengths. Radiation in the 1 nm–10 nm region can be produced either by electron-target collisions involving 'inner' electrons (X-rays) or by electrical discharge processes involving 'outer' electron energy transitions (UV radiation). (See Chapter 8.)

3.2.4 LIGHT. The visible spectrum is defined by the spectral response of the human eye and the CIE (1924) have drawn up agreed standard figures for the average observer (Fig. 3.2).

At normal luminance levels the eye's cone receptors are used (*photopic vision*) and the sensitivity then covers the range 400–760 nm; the trichromatic receptors have three different sensitivity bands, but the effective peak is at 555 nm. A dark-adapted eye (*scotopic vision*) uses the rod receptors and is sensitive to wavelengths from about 380–700 nm (peak at 507 nm). The extent of human vision is usually quoted as 380–760 nm, but under certain conditions these limits can be exceeded. It has been shown,

113

for example,[7] that with intense infrared sources visual response can extend beyond 900 nm; in the ultraviolet, some individuals can detect wavelengths below 350 nm.

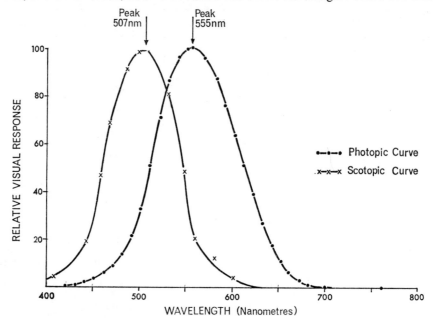

Fig. 3.2. Spectral luminous efficiency curves (plotted from CIE standard values). Approximate visual response bands (measured to 0.05% of peak level) Daytime (photopic) 400–730nm. Low light level (scotopic) 380–660nm.

3.2.5 INFRARED. The infrared spectrum extends from about 760 nm up to wavelengths of about 1 mm. There is an overlap with the radio spectrum in the sub-millimetre band, which can be produced either by thermal radiation or discharge sources (infrared radiation) or by electronic oscillators (microwaves).

The term 'photographic infrared' is used loosely to describe the region 760–1350 nm, which is the range to which silver halide emulsions can be sensitised; most IR emulsions are only sensitive up to about 900 nm. (See Chapter 7.)

3.2.6 RADIO WAVES. Electronic transmitters produce wavelengths from about 100 μm to 10 km and beyond, which are known as the microwave, radar and radio wavebands. None of this radiation has a direct photographic effect, although certain methods of visualisation are mentioned in Chapter 15.

All EMR has the same basic nature, exhibiting both wave and quantum properties and obeying the same optical laws, but the techniques for generation, control and detection are vastly different. (See Chapters 7–9.)

3.3 *Photometry*[8]

Photometry is the science of measuring light; it enables us to express the performance of light sources in standard units. Photometric performance is not always relevant to the photographer, because it is evaluated according to visual response rather than

114

emulsion response (see p. 125), but an understanding of the language of photometry is necessary when translating the lamp manufacturer's data into practical terms. Standard books on illumination engineering[9, 10] offer many useful examples of the application of photometric principles to the lighting of interior and exterior areas.

Fig. 3.3 shows the four basic aspects of photometry.

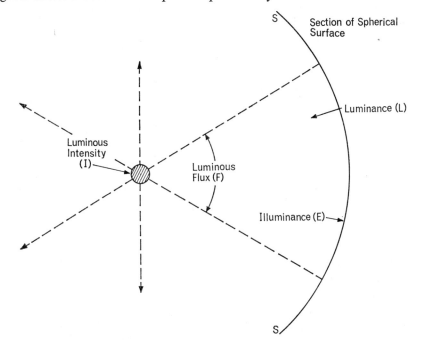

Fig. 3.3. The four basic concepts in photometry. If I=1cd the total spherical flux is 4π lumens (12.57lm); the flux within each steradian (unit solid angle) is then 1 lumen. If the spherical surface S is at a distance of 1 metre, the illuminance on the surface is 1 lux. If S is a perfectly reflecting diffuse surface it will have a luminance of 1 nit (cd per sq. metre).

The photometric units in common use are shown in Table 3.2; this also gives the equivalent terms used in the wider field of radiometry, which covers the whole of the spectrum. The same symbols are normally used for both photometric and radiometric purposes; if it is necessary to avoid ambiguity, the subscripts $_v$ and $_e$ are used (e.g. I_v denotes luminous intensity, I_e denotes radiant intensity).[11]

3.3.1 LUMINOUS INTENSITY. The candela (cd) is the standard unit of luminous intensity (I)*; it differs by about 2 per cent from the old international candle, which it replaced in 1948. The terms candle (c) and candle-power (cp) are still used in the USA, but now refer to the candela.

An ideal point source would have a uniform 'spherical' emission, but in practice the luminous intensity varies in different directions and is plotted in a polar diagram or candle-power distribution curve (Fig. 3.4). These curves often show only half the beam, which is assumed to be symmetrical; a lighting unit with an elliptical or irregular beam cross-section requires curves for both horizontal and vertical planes.

*The candela is defined on the basis that the luminance of a full radiator at the melting point of platinum (2047K) is 60 candelas per cm².

115

TABLE 3.2

PHOTOMETRIC AND RADIOMETRIC UNITS

Photometric concept	Symbol	Photometric units	Abbrev.		Radiometric concept	Radiometric units
Luminous intensity	I	Candela	cd		Radiant intensity	Watts per steradian (W/sr)
Luminous flux	F also Φ	Lumen	lm	(cd sr)	Radiant flux	Watts (W)
Illuminance	E	Lux Foot-candle Phot	lx fc ph	(lm/m^2) (lm/ft^2) (lm/cm^2)	Irradiance	Watts per sq. metre (W/m^2)
Luminance	L	Nit Foot lambert Apostilb Candelas per ft² Candelas per in²	nt ft-L asb	(cd/m^2) $(cd/\pi ft^2)$ $(cd/\pi m^2)$	Radiance	Watts per steradian per sq. metre $(W/sr\ m^2)$

In this table the complex unit symbols are given in the 'popular' style, using the solidus (/). For example, 'watts per steradian' is written W/sr and 'lumens per square metre' is written 1m/m². An alternative form, which is often used in scientific work, expresses the denominator units as 'negative powers' in the style W sr⁻¹ and lm m⁻²; in the same way W/sr m² may be written as W sr⁻¹ m⁻². The solidus should never be used twice (for example, W/sr/m² is ambiguous).

Instead of showing the complete polar diagram as in Fig. 3.4 the centre-beam candle-power and the effective beam angle may be expressed in numerical form: for example 8000 cd/60°. The beam width is usually expressed for photographic purposes as the angle where the intensity is half the central value, so these figures imply a central value of 8000 cd, dropping to a level of 4000 cd at 30° on either side of the beam axis.

Fig. 3.4. Luminous intensity data. These curves show alternative ways of plotting the same information.

116

In normal reflected-light work the photographer is not directly concerned with the luminous intensity of the source, but with the illumination falling on the subject. The derivation of the illumination level from luminous intensity figures or from polar diagrams is explained on pp. 120 and 122 (Eqs. 3.7 and 3.9).

3.3.2 LUMINOUS FLUX. The quantity of light flowing in a certain direction is measured in lumens (lm). A uniform source with a luminous intensity of 1 cd emits 1 lumen in each steradian (sr) (by definition, 1 lm=1 cd sr). There are 4π steradians to a sphere and the total luminous flux from a uniform source of 1 cd is therefore 4π lumens or 12·57 lm.

The total luminous flux from a source is a good index of performance for some purposes (e.g. domestic lighting) and permits a rapid catalogue comparison of different lamps. However, there is no guarantee that the light is emitted in a useful manner; for example, extended sources such as fluorescent tubes may have a high luminous flux that cannot be used effectively for small subjects.

The luminous flux tends to drop over the life of a lamp and any quoted values should be specified either as 'initial', or 'after 100 hours' or 'average through life' (ATL) figures.

The lumen-second (Q), formerly known as the lumerg, is the luminous energy emitted in one second by a source with a total flux of 1 lumen.

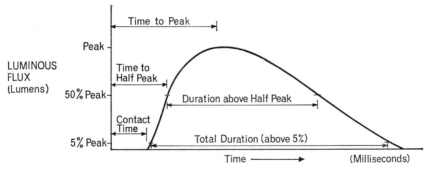

Fig. 3.5. Performance criteria for flash sources. The total luminous energy (lumen-seconds) is indicated by the area under the curve.

Fig. 3.5 shows the key performance criteria of flash sources; details of typical flash bulbs are shown in Tables 3.10–3.11.

3.3.3 ILLUMINANCE. Illuminance (E),* often called incident light, refers to the amount of light falling upon a surface. The term illumination is used in a general sense, but for quantitative statements the correct term is illuminance.

A surface with an area of 1 square metre which is 1 metre distant from a source of 1 candela receives an illuminance of 1 lux (lx). There is a total flux of 1 lumen falling on this surface and the lumen per square metre (lm/m²) is synonymous with the lux.

If F is the luminous flux (lumens) and A is the illuminated area, the illuminance (E) is given by:

$$E=F/A \hspace{4cm} \text{Eq. 3.3}$$

*Image illuminance within a camera or projection system is a special case in which several other factors play a part.[12]

117

When A is measured in square metres the value for E is in lux (lm/m²); when A is measured in square feet the value for E is in foot-candles (lm/ft²). The foot candle (fc) is the unit of illumination commonly used in Britain and the USA; it is the illuminance given by a uniform point source of 1 candela at a distance of 1 foot and is equal to 10·76 lux.

The basic photometric formulae (e.g. Eq. 3.3) apply to point sources, whereas many lighting units are broad sources. In illumination engineering, where the sources are often windows and trans-illuminated panels, formulae related to Eq. 3.3 are used to calculate the luminous flux necessary to achieve a specified illuminance on working surfaces. Factors such as the coefficient of utilisation for the lamp fitting and dirt depreciation must be included in the calculation.[13]

Fig. 3.6 shows illumination curves of the type often published for focusing spotlights. At a distance of 10 feet and at the full spot setting the central illumination is 10,000 lux, with a half-peak beam diameter of 6 feet. In the flood position the illuminance of 3500 lux is maintained over a beam diameter of 8 feet. The illuminance at greater lamp distances can be calculated by applying the inverse square law (Eq. 3.5).

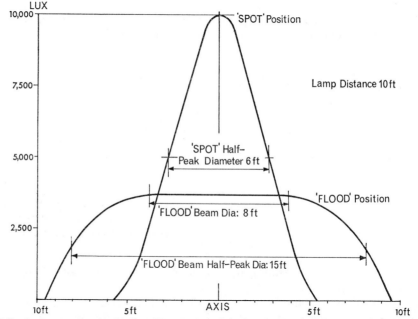

Fig. 3.6. Illumination curve showing the effect of focusing a spotlight. Spot position: 10,000 lux centre-beam illuminance at 10 feet. Beam width (half-peak) 6 feet. Flood position: 3,500 lux centre-beam illuminance at 10 feet. Beam width 8 feet; half-peak width 15 feet.

3.3.4 LUMINANCE. Luminance is a measure of the light emitted from a surface.* This is normally due to reflected illumination, but the term also applies to self-emitting and trans-illuminated diffuse surfaces.

*The word 'brightness' is often used in this context, but it refers, strictly speaking, to the visual sensation rather than to an objective property. Luminance is a physical quantity that can be measured by a reflected-light exposure meter. Brightness refers to the mental response and cannot easily be estimated; it can vary with viewing conditions and certain psycho-physical factors. The terms 'subjective brightness' or 'luminosity' are preferable.

The S.I. unit of luminance is the candela per square metre (cd/m²), known as the nit.

A unit commonly used in Britain is the foot-lambert (ft-L); this is the luminance of an ideal diffuser* emitting 1 lm/ft²; it is equal to $1/\pi$ candelas per square foot (0·318 cd/ft²) or 3·426 nit.

3.3.4.1 *Reflection factor.* The light reflected from an ideal surface depends on the illumination (E) and the reflection factor (ρ).

$$\text{Luminance (L)} = E \times \rho \qquad\qquad \text{Eq. 3.4}$$

The factor ρ is the ratio of reflected to incident flux; for an ideal surface, ρ would be 1·0, but in practice the values found for diffuse surfaces range from about $\rho=0\cdot8$ (white paper) to about $\rho=0\cdot04$ (black cloth).

The ideal surface mentioned above would be a uniform diffuser, with a luminance independent of the viewpoint and lighting angle. All surfaces have a certain specular quality and exhibit different reflection factors under different conditions; the reflection factor (ρ) cannot therefore be assumed to be constant and the term luminance factor (β) is sometimes used in this context. β is the ratio between the luminance of a surface in a particular direction and the luminance of a uniform diffuser under similar illumination conditions. In the case of specular surfaces β may be greater than 1·0.

Methods based on exposure tables and incident-light exposure meters make assumptions about a subject's luminance based entirely on its illumination. Despite the variable factors ρ and β mentioned above these methods are successful in the great majority of cases: details are given in the standard works on exposure determination.[14]

3.3.5 FACTORS AFFECTING SUBJECT ILLUMINATION.

3.3.5.1 *Inverse square law.* When the luminous intensity (I) of a point source in any given direction is known (probably from a polar diagram such as Fig. 3.4), the illuminance (E) on a plane normal to the beam at any distance (D) can be calculated:

$$E = \frac{I}{D^2} \qquad\qquad \text{Eq. 3.5}$$

Extended sources give a more gradual fall-off in illumination; for a line source of infinite length it can be shown that $E=I/D$.

3.3.5.2 *Cosine law.* If, as shown in Fig. 3.7, a light beam of cross-section BB falls at an oblique angle θ to a surface, it illuminates a larger span AA; the luminous flux is thus spread over a greater area and the illuminance (lumens per square metre) is reduced. The ratio of BB/AA is equal to $\cos\theta$ and the illuminance is therefore reduced in proportion to $\cos\theta$. This is termed the cosine law and its significance for oblique lighting angles can be seen from the $\cos\theta$ values in Table 3.3.

3.3.5.3 *Cos³ θ law.* If a plane surface is lit by an overhead point source (Fig. 3.7b) the corner illumination is less than that at the centre for two reasons:

(1) SC is greater than SA (inverse square law).

(2) θ_c is greater than θ_a (cosine law).

The combined effect of these obliquity factors for off-axis rays is expressed by the $\cos^3\theta$ law, which may be derived from Fig. 3.7b as follows:

*A uniformly diffusing surface is one that appears equally bright for any viewing direction.

119

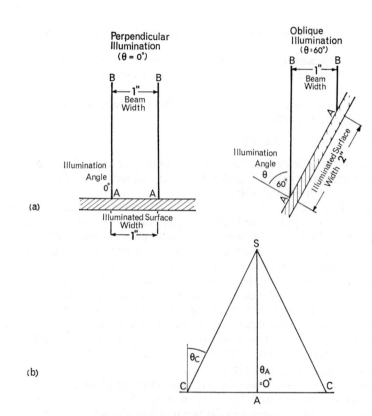

Fig. 3.7. Cosine laws of illumination. (a) Cosine law: $(AA=BB/\cos\theta.$ Cos $60°=0.5 \therefore AA=2\times BB)$ (b) Cubed cosine law. Illuminance at $C=$ Illuminance at $A\times \cos^3\theta.$

(1) Because of the inverse square law, the corner illumination E_c is less than the axial illumination E_a by a factor SC^2/SA^2.

$$E_c=E_a\times\frac{SA^2}{SC^2}$$

However, $SA/SC=\cos\theta$, so that $E_c=E_a\times\cos^2\theta$

(2) The illumination in the corners is oblique; therefore from the cosine law:

$$E_c=E_a\times\cos\theta$$

(3) Combining factors 1 and 2:

$$E_c=E_a\times(\cos^2\theta)\times(\cos\theta)=E_a\cos^3\theta \qquad \text{Eq. 3.6}$$

If the axial illumination (E_a) is not known, the calculation can be made from the axial luminous intensity of the source (I_a) and the source-to-surface distance (D):

$$E_c=\frac{I_a\times\cos^3\theta}{D^2} \qquad \text{Eq. 3.7}$$

The $\cos^4\theta$ law, which is related to the above effects, describes the theoretical fall-off in the illumination in the plane of an optical image (see p. 64).[12]

120

TABLE 3.3

COSINE VALUES

Angle θ	0°	10°	20°	30°	40°	50°	60°	70°	80°	90°
cos θ	1·0	0·98	0·94	0·87	0·77	0·64	0·50	0·34	0·17	0
cos³ θ	1·0	0·95	0·83	0·65	0·45	0·27	0·12	0·04	0·005	0
cos⁴ θ	1·0	0·94	0·78	0·56	0·34	0·17	0·06	0·01	—	0

3.3.6 CALCULATION OF THE EVENNESS OF ILLUMINATION ($\cos^3 \theta$ LAW). A single point source is sometimes used for illuminating a relatively large area (e.g. contact printing). Reasonably uniform illumination can be obtained only when the subtended angle θ at the corner of the field is small. This can be achieved by using a large source-to-film distance, but it is inconvenient and wasteful to have the source too far away, so it may be useful to calculate the nearest distance required to satisfy a certain criterion of uniformity.

It might be decided, for example, to accept a 5 per cent loss of illumination in the corners of the field, which implies that the $\cos^3 \theta$ factor should not be less than 0·95.

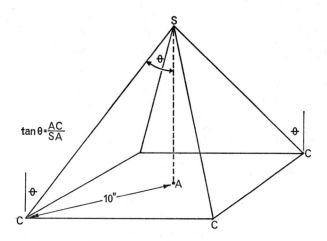

Fig. 3.8. Illumination from a point source.

Fig. 3.8 shows a field diagonal of 20 in. (AC=10 in.). The problem in this case is to find the distance SA where $\cos^3 \angle ASC = 0.95$.

(1) The limiting angle θ where $\cos^3 \theta = 0.95$ is given by:
$\cos \theta = \sqrt[3]{0.95} = 0.983$: θ is therefore $10\frac{1}{2}°$

(2) The source distance (SA) can now be found from SA=AC/tan θ:
From the preceding figures AC=10 in. and $\theta = 10\frac{1}{2}°$, so that SA=10 in./tan $10\frac{1}{2}° = 10$ in./0·185=54 in.

It can be seen that a point source distance of about three times the field diagonal is necessary to give a $\cos^3\theta$ loss of less than 5 per cent.

121

The more complex calculations necessary to find the illuminance given by multiple sources is a common requirement in architectural design and other fields. [8, 9, 10, 15]

3.3.7 EXPOSURE CALCULATION FROM ILLUMINANCE DATA. For photographic purposes the essential items of illumination data are:

(1) The illuminance level (in lux or foot-candles).

(2) The beam angle.

This information may be given by the manufacturer in numerical form (Table 3.4) or by an illuminance curve (Fig. 3.6) or as an exposure guide number. Alternatively, the illuminance may be calculated from luminous intensity data using Eq. 3.5 or Eq. 3.7.

TABLE 3.4

ILLUMINATION FIGURES FOR TYPICAL PHOTOGRAPHIC LIGHT SOURCES (230V LAMPS AT A DISTANCE OF 6 FEET)

	Centre-beam illuminance Foot-candles (lm/ft^2)	Lux (lm/m^2)	Beam diameter (half-peak)
500 W Photoflood No. 2			
Bare lamp*	32	320	—
In flood reflector	140	1400	8 feet
In spot reflector	300	3000	4 feet
Reflector 'Photolita' lamps			
275W Type SM†	90	900	7 feet
500W Type NM†	220	2200	7 feet
375W Type KM†	360	3600	$3\frac{1}{2}$ feet
Clear noon sun (mid-summer)			
United Kingdom	8000	80000	—
Cloudy dull noon (U.K.)	800	8000	

*Calculated from total lumen figure (14500lm).
†Figures derived from Philips polar diagrams.

A general formula[16] may be used for exposure determination once the illuminance (E) is known:

$$f\text{-number} = \sqrt{\frac{\text{Exposure time (sec)} \times E \text{ (fc)} \times S \text{ (ASA film speed)}}{20}} \qquad \text{Eq. 3.8}$$

Example: One of the 500 W photofloods quoted in Table 3.4 is to be used at a distance of 6 ft (giving an illuminance of 300 fc). Film of 125 ASA is to be used and the exposure time is to be 1/50 sec.

$$f\text{-number} = \sqrt{\frac{1/50 \times 300 \times 125}{20}} = \sqrt{37\cdot5} \approx f/6\cdot3$$

The formula may be re-arranged to find the illuminance (E) necessary for given working conditions.

$$\text{Illuminance required (E)} = \frac{20 \times (f\text{-number})^2}{\text{Exposure time} \times \text{ASA film speed}} \qquad \text{Eq. 3.9}$$

Additional factors, such as the lighting angle, the subject reflectance and its surroundings will influence the exposure required in practice but these formulae may give a general guide for planning purposes.

3.3.8 GUIDE NUMBERS. In flash photography the required lens aperture (f) is usually calculated by the manufacturer's guide number and the desired flash distance (D).

$$GN = D \times f \qquad \text{Eq. 3.10}$$

Typical flash bulb guide numbers for both feet and metres are quoted in Table 3.9.

The guide number for a flash of known luminous energy (Q) can be estimated for a film of given ASA speed (S) by use of the following formula:

$$GN = \sqrt{0.004 \times M \times Q \times S}$$

M is a reflector utilisation factor with a value normally in the range from 4 to 8.*
If the value for M is taken to be 6, the expression can be simplified for most purposes as:

$$GN = 0.15 \sqrt{Q \times S}$$

Example: If Q is 40,000 lm-sec. and S is 100 ASA the guide number would be calculated as:

$$GN = 0.15 \sqrt{40,000 \times 100} = 300$$

It is assumed above that *all* the luminous energy is used but where fast shutter speeds are necessary to reduce image movement, the value of Q has to be re-assessed.

Published guide numbers normally take into account any losses due to emulsion reciprocity failure, but necessarily make certain assumptions:

(1) Standard reflector performance, covering the whole lens field.
(2) A subject of average reflectance in a medium-sized room with light ceiling and walls.
(3) Negligible image magnification factor $(M+1) < 1.1$.
(4) The recommended development is given to the film.
(5) The subject lies in one plane facing the source.
(6) The source gives frontal illumination from close to the lens axis. A cos θ correction factor should be applied (see Table 3.3) when an oblique main light is used.

3.3.8.1 *Guide numbers for tungsten lamps.* If the centre-beam candle-power (C) of a tungsten lamp (or any other source) is known, the GN can be estimated for the film of ASA speed (S) as follows (the exposure time is here assumed to be 1/50 second).

$$GN = p \sqrt{C \times S} \text{ (a typical value for the constant } p \text{ is } 0.025) \qquad \text{Eq. 3.11}$$

Example: If C is given by the manufacturer as 8000 cd and S is 100 ASA.

$$GN = 0.025 \sqrt{8000 \times 100} = 0.025 \times 894 = GN\ 22$$

This example corresponds approximately to a No. 2 photoflood with integral reflector.

3.3.9 POWER REQUIREMENTS. The illumination that can be produced from mains-powered lighting ultimately depends on the current rating of the power supply.

The luminous efficiency of the lamps is usually known and this gives a rough indication of the total luminous flux that can be produced. For example, on a 5 amp. 230 volt circuit, two 500 W lamps could be used. If they give, say, 29 lm/W the total luminous flux would be 29,000 lumens. However, the simple photometric laws cannot be used to apply this figure to the calculation of illuminance (Eq. 3.5) or exposure setting (Eq. 3.11) because we have no information about the reflector performance or the subject surroundings.

*Methods for establishing the reflector factor and the half-angle of coverage are given in ASA PH 2.4.[17]

123

Nevertheless, Hyzer[18] has quoted a practical formula for finding the lamp wattage (W) required to produce a given level of illuminance (E, in foot-candles) over a square subject area (A, in sq. ft.).

$$W = \frac{E \times A}{k}$$

Eq. 3.12

The factor k depends on the reflector efficiency and the evenness of illumination required. In developing this formula from the basic photometric equations, Hyzer states that a typical value for k is 20, using the high-efficiency (34 1m/W) American 110 v photofloods. For the English equivalent (29 lm/W) k would be 17.

3.4 *Spectral quality*

3.4.1 SPECTRAL ENERGY DISTRIBUTION CURVES. The emission spectra of a radiation source falls into one or more of three categories:
 (1) A continuous spectrum, which can be either a very broad band (e.g. incandescent sources) or more restricted in band-width (e.g. 'white' phosphors in fluorescent tubes). Within the limits of the continuum all wavelengths are generated, although not all equally.
 (2) A simple line spectrum (e.g. sodium vapour discharge, laser).
 (3) A band spectrum, which consists of groups of narrow lines very close together; this luminescent emission is produced by excitation of a complex molecule or by gases such as oxygen and nitrogen.
Some sources have a mixed quality and show a continuum superimposed with characteristic lines (e.g. high pressure mercury lamp).

TABLE 3.5

COLOUR TEMPERATURE AND MIRED VALUES

Source	K*	Mireds	Source	K*	Mireds
Household lamp 100W	2800	357	English daylight standard (CIE Illuminant B)	4800	208
Photopearl lamps 500W	3200	313	Mean noon sunlight	5250	190
Photoflood lamps 500W	3400	294			
Flash bulbs (aluminium)	3800	263	World average daylight (CIE Illuminant C)	6500	154
Flash bulbs (zirconium)	3950	253	Overcast sky	up to 8000	down to 125
Flash bulbs (blue)	5500	182	Blue sky	10000– 20000	100– 50
Xenon pulsed lamp	5400	185			
Electronic flash	5000– 6000	200– 167			

*In 1967 the name of the SI standard unit for temperature was changed from 'degrees Kelvin' (°K) to 'kelvin' (K).

124

3.4.2 COLOUR TEMPERATURE. The use of colour temperature as a description of light quality and the mired system* of calculating the CT correction filter required for specific circumstances are described in many photographic hand-books.[19, 20] A few values are quoted in Table 3.5 for convenient reference.

For colour photography with reversal materials the lighting colour temperature should be within 10 mireds of the specified value for the film in use; with tungsten-balanced film this is equivalent to a tolerance of 100K.

The colour temperature of tungsten lamps is subject to variation for several reasons and, unless precautions are taken, the tolerance may easily be exceeded:

(1) Lamp batch variation can approach ±50K.
(2) Reflector discoloration can give a loss of 50–100K.
(3) A drop of 1 per cent in the line voltage causes a colour change of about 12K.
(4) The CT can drop by 100K over the life of the lamp, although this ageing factor is much reduced in tungsten-halogen lamps.

The colour temperature of daylight varies over an even wider range (Table 3.5) and a range of CT correction filters should be retained by all photographers for exterior use.

If several sources are used it is even more important that they should match each other both with reversal and negative-positive film. An area of different colour balance in a colour photograph is far more objectionable than a slight overall colour cast. The eye can detect local variations of about 50K in tungsten-light photographs and these cannot easily be corrected, whereas a slight overall cast can be compensated by filtration during colour printing or, in the case of transparencies, by binding up with a pale complementary filter.

3.5 Efficiency of light sources

3.5.1 LUMINOUS EFFICIENCY. Electrical lamps convert electrical power (watts) into luminous flux (lumens) and the luminous efficiency** is expressed in lumens per watt (lm/W). As with all photometric quantities, the luminous efficiency is related to visual response and may bear little relation to its photographic usefulness. The maximum luminous efficiency would be obtained if all the radiant energy was emitted as monochromatic radiation at the wavelength of peak visual response (555 nm for photopic vision). It can be shown that under these conditions 1 watt of radiant energy would give a total flux of 686 lm; although this monochromatic source would be of little use for many purposes. An ideal source emitting equally at all visible wavelengths would produce about 200 lm/W and this might be regarded as the theoretical maximum where colour vision is required.

The figures in Table 3.6 fall short of the theoretical values partly because of electrical and thermal losses, but also because most of the emitted EMR is at wavelengths of relatively low visual response. The practical limit for fluorescent lamps is about 76 lm/W; this includes losses in conversion from short-wave UV to visible fluorescence.

*Micro-reciprocal degree (mired) value $= \dfrac{1,000,000}{\text{Colour temperature (K)}}$

**The quantitative expression (lm/W) is sometimes termed the luminous efficacy; the term luminous efficiency is then reserved for use in a generalised sense.

TABLE 3.6

LUMINOUS EFFICIENCY OF LIGHT SOURCES

Source	lumens per watt	Percentage of theoretical maximum 686 lm/W
230v 500W GLS Tungsten (2800K)	15	2%
230v 500W Photopearl (3200K)	22	3
230v 500W Photoflood (3400K)	29	4
110v 500W Photoflood (3400K)	34	5
High intensity carbon arc (6000K)	30–40	4–6
Studio 'flame' carbon arc (4700K)	73	11
Fluorescent tubes (de luxe)	43	6
Fluorescent tubes (high efficiency)	65	9
MB/U Mercury discharge lamps	35–56	5–8
MBF/U Fluorescent lamps	35–56	5–8
MBI Mercury-halide lamps	60–110	9–16
Pulsed xenon discharge lamps	25–40	4–6
Sodium discharge lamps	70–140	10–20

3.5.2 ACTINIC EFFICIENCY. It cannot be assumed that a source with good luminous efficiency will have good actinic efficiency. For example, the yellow sodium discharge emission at 589 nm gives a high visual response but has very little effect on an ordinary blue-sensitive emulsion. The actinic efficiency of this source would be higher with a panchromatic emulsion.

UV-emitting fluorescent 'black-lamp' tubes (see Chapter 8) offer the reverse situation. These tubes have a spectral emission well suited to most sensitised materials, but they cannot be described in photometric terms because they have an integral filter which removes virtually all the visible radiation.

The extent to which a source is matched to the response of an emulsion can be deduced only by comparing the spectral curves for each source-film combination. When a photo-electric meter is used to assess the exposure for an unfamiliar source, its spectral response must be considered and practical tests are necessary to establish a suitable film speed setting for the meter. A photographic method for comparing the actinic efficiency of light sources is specified in ASA PH 2.3–1956.[21]

3.5.3 OPTICAL EFFICIENCY. The design of lamp reflectors and spotlight condensers has a marked effect on the efficiency with which the flux is delivered to the subject. With adjustable spotlights the beam shape can be altered to suit the subject requirements. Some lamp units give a beam of rectangular cross-section, which can fill the subject area without wasting too much light on the surroundings.

3.5.4 REFLECTOR EFFICIENCY. A lamp placed close to the camera should have a beam angle of 60° to cover the normal picture field. A bare point source emits only about 1/12 (8 per cent) of its flux in this solid angle but a well-designed diffuse reflector can increase the flux by a factor of $4\times$ or $8\times$. A higher factor usually implies a narrow-beam reflector.

126

The ratio of the illumination from a reflector unit to the illumination from a bare lamp is described as the reflector efficiency.[17] Dunn has compared the performance of different types of reflector and spotlight with the illumination from a bare lamp.[22]

3.5.5 SOURCE SIZE. The size and shape of a source has an important bearing on its suitability for many tasks. The shadow quality is often very important: a small source forms a well-defined shadow, whereas a broad source can give an almost shadowless effect.

3.6 Duration and lamp life

3.6.1 DURATION OF FLASH SOURCES. The flash duration is normally measured between the half-peak values (see p. 117), although the total duration (above the 5 per cent level) is sometimes quoted. When shutter or event synchronisation is required, the *rise time* to peak or half-peak flux must be known (although with electronic flash the delay is short enough to be ignored).

Air sparks and similar discharges may change their spectral characteristics during the flash; the initial emission may be predominantly blue, but the tail of the flash may be yellow or red.

3.6.2 LIFE OF CONTINUOUS SOURCES. The life of tungsten sources is largely governed by the rate of filament evaporation and can be increased only at the expense of lower efficiency and lower colour temperature. Tungsten-halogen lamps now offer improved performance in this respect (see Table 3.7).

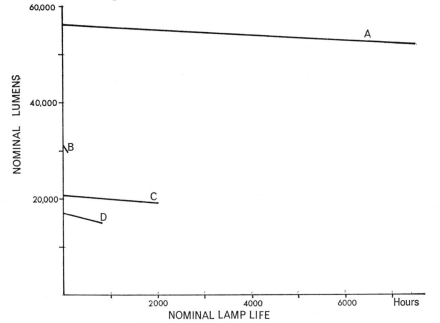

Fig. 3.9. Typical lumen maintenance curves for a number of 1000W lamps. A MB/U Mercury lamp (also applies to MBF Fluorescent lamp). B Tungsten-halogen lamp (3400K). C Tungsten-halogen 2000 hour lamp (3000K). D GLS Domestic tungsten lamp.

127

The life of tungsten lamps can be extended if the initial current and thermal surges can be minimised. Replacement costs are reduced if lamps are switched on through a stepped transformer and are set up at reduced voltage; this applies particularly to lamps that are moved while switched on, when the risk of filament failure due to mechanical shock is greatest. The preferred practice is to switch off all lamps when they are moved.

3.6.3 LAMP FLICKER. Sources on an AC supply show a variation in luminous flux at twice the supply frequency.

The radiation from discharge lamps is emitted in well-defined pulses, with the output falling to a very low value (5–10 per cent of peak intensity) every half-cycle.[23]

Fluorescent lamps show the basic mercury discharge flicker, but the phosphor coating has a small luminescent decay, which tends to smooth out the 100 Hz flicker. The flux still shows a variation of at least 20–50 per cent[24] depending on the phosphor and, unless these lamps can be specially wired into a 3-phase supply, they cannot reliably be used for exposures shorter than about 1/30 second. In the case of focal-plane shutters, where the whole negative is not exposed simultaneously, even longer exposure times may produce uneven bands due to flux variations.

Lamp flicker is detectable with some very low-power tungsten lamps, but causes no difficulty in normal photography. For example a domestic 500 W lamp filament has flux rise (incandescence) and fall (nigrescence) times of 0·4 sec. and 0·2 sec. respectively; on 50 Hz mains frequency the current cycle is 0·02 sec. so that complete nigrescence never occurs and the flux variation is negligible.

3.7 *Types of light source*

Rather than cataloguing all the lamps and lighting units available, this section provides background data for applications mentioned elsewhere in the book. Typical

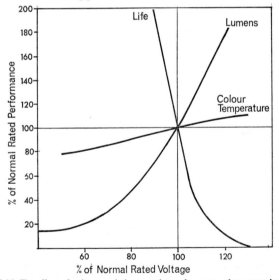

Fig. 3.10. The effect of voltage variations on the performance of tungsten lamps.

performance figures have been freely drawn from the publications of British Lighting Industries Ltd. and Philips Electrical Ltd.

The properties of daylight as a light source have been covered in the standard works on photometry and illumination.[8, 9, 25]

3.7.1 TUNGSTEN LAMPS. The continuous spectrum of tungsten lamps is a decisive advantage for many photographic purposes and, together with the relative cheapness and simplicity of installation, often outweighs the rather low luminous efficiency and the considerable heat output.

3.7.1.1 *Performance.* The luminous efficiency of any tungsten lamp is increased if the filament is run at high temperature, but a reduced life is then inevitable. The increased evaporation of the tungsten causes reduced wire thickness, which in turn leads to increased heating and increased evaporation until local failure takes place. The effect of increased voltage on the luminous flux and the lamp life is shown in Fig. 3.10.

Table 3.7 indicates the performance of a number of 230 volt tungsten lamps. All these figures are nominal only; in addition to any batch variations, the luminous flux of conventional bulbs may drop by 20 per cent during its life owing to blackening of the envelope by evaporated tungsten.

TABLE 3.7

LUMINOUS FLUX AND EFFICIENCY OF TUNGSTEN LAMPS

Source	Colour Temperature	Luminous flux (lm)	Luminous efficiency (lm-watt)	Life (hours)
100W Domestic GLS lamp	2800K	1160	12	1000
1000W Domestic GLS lamp	2900	17300	17	1000
275W Photoflood No. 1	3400	7500	27	3
500W Photoflood No. 2	3400	14500	29	6
500W Photopearl	3200	11000	22	100
500W Spotlight bulb	3200	11500	23	25
1000W Spotlight bulb	3200	23000	23	100
1000W Tungsten-halogen flood	3200	22000	22	2000
1000W Tungsten-halogen flood	3400	33000	33	15
5000W Spotlight bulb	3200	145000	29	150
5000W Tungsten-halogen spot-light	3200	145000	29	300

These figures relate to 230v lamps: in many cases the 110v equivalent lamp will have 10% greater efficiency and output, without any decrease in lamp life.

Tungsten-halogen lamps, although more expensive, offer longer life than conventional lamps without loss of luminous efficiency. The operating principle of these lamps has been described by Langford;[26] they are now available in a range of sizes and fittings for most studio lighting and projection purposes.

The luminous efficiency of tungsten lamps is greater for low-voltage types. This is the reason that American lamps are more efficient than British lamps. For example, a 110v 500 W Photoflood gives 34 lumens per watt (a total of 17,000 lm) compared to 29 lumens per watt (14,500 lm) for the equivalent 230v lamp.

3.7.1.2 *Spectral emission.* The SED of tungsten lamps is described with sufficient accuracy for practical purposes by the colour temperature (see p. 125). Tungsten is a

129

TABLE 3.8

PROPORTION OF ULTRAVIOLET, VISIBLE AND INFRARED
RADIATION EMITTED BY PHOTOGRAPHIC LIGHT SOURCES

Source	Col. temp. (K)	Ultra-violet	Visible	Infrared*	Approx. peak emission
Tungsten 10W Domestic	2400	0·005%	7%	93%	1·2μm
100W Domestic	2800	0·2	10	90	1·04
500W Photoflood	3400	1·5	30	68	0·85
Photographic 'white flame' carbon arc	7400	4·5	15	80	0·4
'W' type carbon 'flame arc'	—	15	10	75	
Sun†	5250	4	44	52	0·5
Xenon discharge lamps	6000	5	35	60	0·48
Mercury high pressure lamp	—	15	45	40	Several mercury lines

*Most of this infrared is thermal emission at wavelengths beyond the 'direct' IR photographic spectrum.
†These figures relate to the mean noon solar illumination after atmospheric attenuation.

selective radiator, emitting slightly more blue radiation than would be expected from a full radiator[15] and the colour temperature is about 100K higher than the actual filament temperature. The emission of tungsten-iodine lamps is also slightly affected by green absorption bands of the halogen vapour, but this is not detectable in normal practice.

Table 3.8 and Fig. 3.11 show that the proportion of visible light increases markedly with higher colour temperature.

Fig. 3.11. Spectral energy distribution curves of tungsten sources at different colour temperatures.

3.7.1.3 *Integral reflectors.* Integral reflectors cannot become misaligned or discoloured and can be designed to give high efficiency for specific purposes. Most lamp manufacturers offer a number of these lamps for film projectors.

For general photographic lighting, the reflector photofloods lack the versatility of adjustable spotlights but avoid the need for expensive fittings. For many purposes the compactness of these lamps outweighs the disadvantage of higher costs.

TABLE 3.9

PERFORMANCE DATA FOR EXPENDABLE FLASH BULBS

Type	Total output (lm-sec)	Peak flux (mega-lumens)	Total duration (m-sec)	Duration above ½-peak	Time to peak (m-sec)	Time to ½-peak	Guide number for ASA film† Feet	Metres
Philips								
*PF1	7500	0·6	20	8	15	10	130	40
PF5	18000	1·4	24	12	20	15	210	64
PF38	30000	1·8	30	16	20	13	270	80
*PF60	62000	2·8	35	20	20	11	400	120
*PF100	95000	3·6	40	22	30	19	500	150
Mazda								
AG 1B (Blue)	7500	0·45	30	15	13	8		
M3 (Clear)	16000	1·0	30	15	17	12		

*Blue lacquered 'daylight' versions are available (PF1B, PF60/97, PF100/97) having about 2/3 the output of the clear bulbs listed here; the time factors of these bulbs are similar.
†Exposure time 1/30 second.

3.7.2 FLASHBULBS. Flashbulbs provide very high luminous energies from simple and portable equipment. They have uses in high speed photography[27] (see chapter 11) and infrared photography (see Chapter 7) as well as in normal industrial and commercial work.[28]

TABLE 3.10

COMPARISON BETWEEN A MINIATURE ELECTRONIC FLASH
AND A SMALL FLASH BULB

	Miniature electronic flash unit (40 watt-sec)	Philips PF1 B bulb
Colour temperature	6000°K	5500°K
Equipment weight	250 g.	85 g.
Guide No. (100 ASA film)	50	130 (1/25 sec)
		60 (1/250 sec)
Output (lumen-seconds)	2000	7500
Duration (half-peak)	1 m-sec	8 m-sec
		20 m-sec total duration
Equipment cost	£20	£3
Running cost (per 1000 shots)	—*	£38*
Re-cycle time	8 sec	—

*Battery replacement also possibly required.

Table 3.10 offers a comparison between a small flash bulb and a small electronic flash unit. Other general points of comparison are:

(1) Electronic flash has the advantage of a much shorter flash duration.
(2) Electronic flash units are relatively expensive, although the running costs are much lower. The increased complexity of the circuitry may, however, call for more frequent and more expensive servicing; neither this factor nor the cost of battery replacement is included in Table 3.10.
(3) Flashbulbs give much greater luminous energy (lm-sec.), even when using a blue-filtered bulb to give daylight colour quality. They can be used to cover an area of almost any size, because of the ease with which additional bulbs can be used.
(4) The more powerful electronic flash units can be operated only from a mains supply and are much heavier than equivalent flash bulb units.
(5) In some situations there is no opportunity for replacing flashbulbs between exposures and remote electronic flash units must be used, possibly with a photo-electric slave trigger unit.

3.7.3 CARBON ARCS. The carbon arc offers a small high-intensity source with substantial UV output and it is still used occasionally in graphic arts processes and printed circuit manufacture.

The daylight colour quality (6000K for the high-intensity arcs) and the high luminous intensity may sometimes outweigh the disadvantages of complicated electrical control gear, the tendency to flickering and the need for electrode replacement. However, in all the earlier applications, such as studio spotlights, photomicrography and cine-projectors, carbon arcs have largely been replaced by discharge sources. Xenon discharge lamps, in particular, offer high intensity and daylight colour quality without the heat, dust and fumes associated with carbons.

3.7.4 PYROTECHNIC SOURCES. Magnesium powder and flash powder usually a mixture of powdered metal (aluminium or magnesium) and an oxidant (e.g. potassium perchlorate) have an application in the photography of very large areas (CT~2900K). A smokeless powder is available from Johnson's of Hendon Ltd.

Precautions must be taken against accidental ignition of the highly explosive powder, but a few grammes of flash-powder can produce more light than a flashbulb and can be spread out in a trough to give a reasonably shadowless lighting effect. Practical guidance on the subject has been given in the *Focal Encyclopedia*[29] and by Taylor.[30]

Pyrotechnic sources now find their most frequent application in high speed photography (see 11.2.1.4).

3.7.5 DISCHARGE LAMPS. Gas discharge lamps and vapour discharge lamps offer a higher luminous efficiency than any other source and are used in many forms for floodlighting and photographic purposes. Despite the fact that these lamps are relatively expensive and normally require special starting circuits and control gear, they are used for many photographic applications:

(1) The compact-source mercury and xenon lamps have a very high intensity and give a small discharge (a few mm) which is well-suited to use in optical systems.
(2) Mercury vapour discharge lamps have a high output in the near UV and blue regions and are commonly used in reprography and photography.
(3) Xenon discharge lamps give a very high level of illumination of daylight colour

quality and are used in colour separation processes and in high-intensity spot-lights for high-speed cinematography. The use of Xenon gas arcs for film studio lighting and film projection has been discussed by Cumming.[31]

(4) A range of low-pressure discharge lamps is available for spectroscopic applications requiring narrow spectral lines. Sodium and other lamps are used as monochromatic sources for interferometry (see Chapter 15).

(5) Miniature neon discharge lamps are used as pulsed timing lamps in high-speed cine cameras (see Chapter 11).

Details of the operation and construction of the many types of discharge lamp are given in the specialist books on the subject.[32, 33]

3.7.5.1 *Designation of mercury discharge lamps.* The agreed British code for describing mercury lamps is given in Table 3.11.

TABLE 3.11
DESIGNATION CODE FOR MERCURY DISCHARGE LAMPS

Code	Lamp type
M	Mains voltage mercury discharge lamp
A	Glass envelope
B	Quartz (fused silica) envelope, low arc loading
E	Quartz envelope, high arc loading
D	Quartz envelope with liquid cooling
C	Low pressure mercury discharge
I	Metal halide additive
F	Internal fluorescent coating
T	Combined tungsten filament and mercury discharge lamp
R	Integral reflector (this may be a titanium dioxide diffuse reflector or a metallised 'spot' reflector)
/D	Vertical burning position (cap down)
/V	Vertical burning position (cap up)
/H	Horizontal burning position
/U	Universal (any burning position)

The use of this system will be apparent from the following examples:

MB/U Mains voltage mercury discharge lamp (M) with a quartz envelope (B); can be operated in any position (U).

MBR/U MB/U lamp with integral reflector (R).

MBF/U Similar to MB/U but with internal fluorescent coating (F).

MBFR/U MBF/U lamp with integral reflector.

3.7.5.2 *Spectral emission.* Fig. 3.12 shows examples of the SED for typical discharge lamps.

The dominant spectral lines are characteristic of the filling gas or vapour, but the emission is also affected by the filling pressure. For example, the SED of low pressure mercury lamps is almost entirely confined to the resonant emission at 254 nm. At higher pressure this line is largely absorbed and other lines become dominant; the lines tend to broaden and a continuous spectrum also appears.

Mercury lamps are often used for floodlighting, but give an unsatisfactory colour rendering. The main problem is that there is little red emission from a mercury discharge and various methods are used to remedy this deficiency:

(1) Cadmium or zinc can be added to give additional red lines.[34]

(2) In the mercury halide (MBI) lamps a number of spectral lines throughout the visible spectrum is given by the inclusion of metallic halides (e.g. lithium iodide, indium iodide, sodium iodide).[35] These lamps offer luminous efficiencies 80–110 lm/watt compared to a maximum of about 60 lm/watt for normal mercury lamps. Ainsworth & Beeson[36] have described a compact iodide discharge lamp designed for projection system.

(3) In the conventional fluorescent lamps a phosphor coating gives a strong 'white' fluorescent emission.

(4) The so-called blended lamps incorporate a mercury discharge, a tungsten filament and a red-emitting phosphor. Elenbaas has compared the performance of these MBTL lamps with the normal MB/U and tungsten lamps.[37]

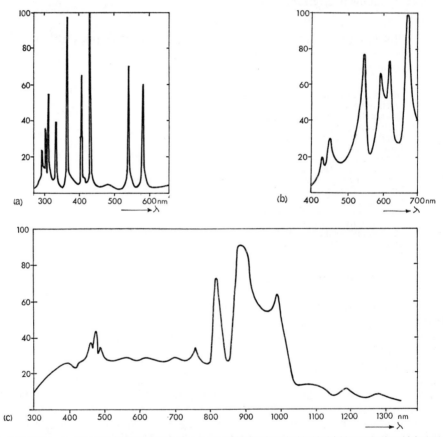

Fig. 3.12. SED curves of typical discharge lamps (by courtesy of Philips Electrical Ltd.). (a) Mercury vapour high pressure discharge (Philips compact source CS lamp). (b) Mercury-halide discharge (Philips CSI lamp). (c) Xenon high pressure discharge (Philips CSX lamp).

3.7.6 FLUORESCENT LAMPS. Fluorescent tubes have several desirable features for domestic and industrial lighting and some of these advantages are valid in photographic applications:

134

(1) The length of the tubes tends to give an even illumination with soft shadows.

(2) The luminous efficiency is high and the heat output is low.

(3) The long life (over 5000 hours) minimises the cost and inconvenience of replacement.

(4) The 'daylight' tubes give good visual colour rendering, although they are generally unsuitable for critical colour photography.

Fluorescent tubes with UV-emitting phosphors are mentioned in Chapter 8; other special phosphors giving a green emission are fitted to certain reprographic equipment.

3.7.6.1 *Construction.* These lamps are basically low-pressure mercury discharge sources; UV radiation of 254 nm from the discharge excites a phosphor coating inside the glass envelope.

A linear tubular construction is normally used, although ring tubes are also available. Fluorescent bulbs (MBF/U) are used in ratings up to 2000 W for floodlighting; similar bulbs with internal reflectors (MBFR/U) offer advantages in certain installations.

Elenbaas has described in detail the principles and applications of modern fluorescent lamps[38] and many aspects of performance have also been discussed by Bourne.[39]

3.7.6.2 *Spectral quality and luminous efficiency.* Normal fluorescent tubes fall into two categories:

(1) High-efficiency lamps (over 60 lm/W).

(2) De-luxe lamps, which have a better visual colour balance, but a lower efficiency (about 42 lm/W).

Fluorescent lamps normally reach about 80 per cent of their peak output within a few seconds, although some types may take several minutes to reach full intensity. Low ambient temperatures tend to affect the efficiency of the phosphor, but voltage variations have much less effect than in the case of tungsten lamps. The flux may drop by 10 per cent over the life of the tube, which depends to some extent on the number of times it is switched on and off.

The visible emission from a fluorescent lamp consists of the mercury line spectrum (typically the lines at 405, 436, 546 and 579 nm) superimposed on the phosphor continuum (see Fig. 3.13).

It is usual to express the colour quality of these lamps by the equivalent colour temperature. This description is based on visual matching and does not imply that the lamps are suitable for colour photography, although acceptable results can often be achieved by filtration with certain combinations of colour film and fluorescent tube;[40, 41] in general, the requirement is to absorb some of the strong blue and green mercury emission lines. For critical work it is necessary to establish the optimum colour correction filter for a particular subject and batch of film.

3.7.7 ELECTRONIC FLASH. Electronic flash tubes are basically xenon discharge tubes in which the power is applied in a single pulse rather than continuously. The range of this equipment varies greatly in its designed purpose, but all have the same basic properties:

(a) Short duration (over the range from about 2 msec. to about 2 nsec.).

(b) Reproducibility and reliability.

(c) Daylight colour balance (for standard tubes).

(d) Low operating costs (the tube life usually exceeds 10000 flashes).

(e) Very little subject heating.

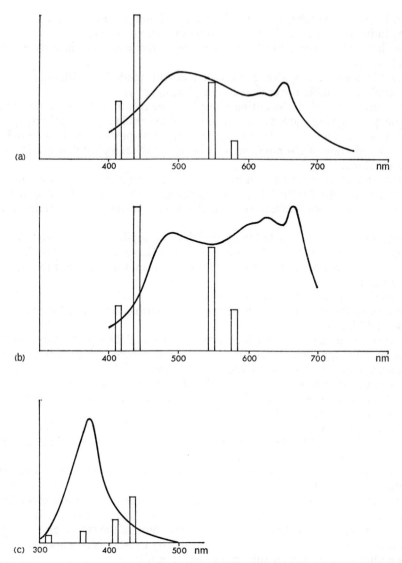

Fig. 3.13. SED curves for fluorescent tubes (by courtesy of Philips Electrical Ltd.). (a) Philips Colour Matching 55 (correlated colour temperature 6500K). (b) Philips GraphicA 47 (correlated colour temperature 5000K). (c) Philips Actinic 05 (long-wave UV printing lamp).

Some comparison between electronic flash and flashbulbs is made in Table 3.10. The selection of flash units should be based on the published data for:

(1) Luminous energy (lumen-seconds); a range of power settings may be available.
(2) Beam angle, which may be adjustable.
(3) Flash duration, which may vary at lower power settings.
(4) Flash re-cycle time, which is shorter at lower power settings.

(5) The ability to divide the power among a number of flash heads; in some cases these heads can have different spot or flood properties.

(6) The need for tungsten guide lights in many applications.

(7) Power supply required (mains or battery).

(8) Flashes per charge for battery-powered units.

(9) Weight.

(10) Cost.

Figures for the power consumption of a flash in watt-seconds (joules) are not reliable guides for exposure purposes. The total luminous energy (lm-sec.) is a useful index of performance (point 1 above), but the illumination level is even better because it takes into account the reflector efficiency. These figures are expressed in beam candle power seconds over a certain beam angle; this is written, for example, as 5000 BCPS/60°. Neblette[42] has given details of a method for measuring the BCPS rating of a flash source with a flash meter.

In American usage, all electronic flash units are described as 'strobe' lamps; in this book the term stroboscopic has its normal European meaning of a repetitive flash source (see 11.2.1.6).

Details of the operation and high-speed applications of flash discharges and air-spark sources are given in Chapter 11.

3.7.8 LASERS. The unique properties of laser radiation may be summarised as follows, although no single laser exhibits all these features in the highest degree. In many cases high performance is obtained only at low temperatures.

(1) Very narrow spectral band-width.

(2) High intensity.

(3) Radiation with a high degree of coherence (see p. 110).

(4) The emitted beam is almost parallel.

The original ruby laser (Maiman, 1960) could be operated only in single pulses, but many continuous-wave (CW) lasers are now commercially available.

Solid-state materials (such as ruby and neodymium) are mainly used for high-power or pulsed lasers (see p. 139). Gas lasers (e.g. helium-neon) giving CW operation at room temperature are widely used in interferometry and other aspects of metrology.

Semi-conductor lasers (also called junction lasers or injection lasers) offer a very compact device with relatively high efficiency; they can also be modulated at high frequency for communication purposes.

Dye lasers offer the possibility of wavelength selection (frequency tuning) and very short pulses ($\sim 10^{-12}$ sec.). These lasers are usually pumped by a 'giant pulse' laser (see p. 139).[53]

3.7.8.1 *Principles*. The operation of lasers can most easily be explained by reference to the ruby laser.

The ruby is a 'host' substance (Al_2O_3) containing a small proportion of chromium ions (Cr^{+++}). A high-power xenon flash pumps EMR into the chromium ions, which absorb some of the green and blue light. The following sequence of events can be shown in a form of energy-level diagram (Fig. 3.14).

(1) The chromium atoms are in the normal state (G).

(2) Pumping radiation is absorbed and raises the Cr atoms to an excited state (E).

137

(3) The excited atoms relax to an intermediate metastable energy level (M_1).

(4) A metastable atom spontaneously drops back to the ground state (G_2) and a fluorescent photon (P_1) is emitted. The wavelength of this photon is solely dependent on the energy gap (M–G) and is a characteristic of the material. In a ruby crystal, the difference between the metastable and ground energy levels is 1·8 eV and the emitted photon has a wavelength of about 694 nm. This conforms to the relationship shown in Eq. 3.1.

(5) If the photon P_1 strikes an atom in the metastable state (M_2), it causes the atom to drop back to the ground state (G_3), emitting a *stimulated* photon (P_2) which is identical in wavelength, phase and direction of travel to the original photon.

(6) Further photon-ion collisions take place (M_3, M_4), each stimulating an identical photon.

(7) After returning to the ground state the Cr^{+++} ions can once more absorb pumping radiation and the stimulated emission can be repeated as long as the pumping continues.

Fig. 3.14. Energy level diagram for laser operation. The ions M_1 M_2 M_3 M_4 are all at the same excited energy level; similarly, all the stimulated photons (P_1 etc.) are of the same energy.

The laser action can take place once the majority of the chromium ions have been pumped into the metastable state; this is a condition known as population inversion.

The stimulated photons would be emitted in all directions if it were not for the optical system associated with the laser. In the simplest arrangement (Fig. 3.15) the ruby rod is placed between two plane mirrors which are parallel and spaced apart by an exact number of wavelengths, thus forming a resonant optical cavity. A photon travelling along the rod axis is reflected to and fro between the mirrors, colliding with metastable ions and stimulating a coherent axial beam which is rapidly amplified. Owing to the exact spacing of the mirrors all the reflected photons interfere constructively and a standing wave is set up.

Photons can escape in other directions and then cause no further stimulation but, as the axial photons rapidly increase in number, more and more of the emission is

138

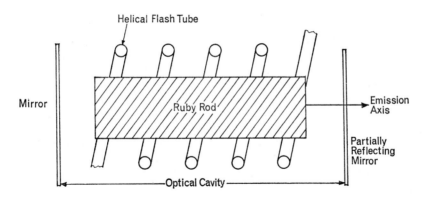

Helical Flash Tube

Mirror

Ruby Rod

Emission Axis

Partially Reflecting Mirror

Optical Cavity

Fig. 3.15. Basic construction of a ruby laser.

stimulated along the rod axis. One of the cavity mirrors is only partly reflecting (about 99 per cent) so that some of the beam can escape and become available for use.

3.7.8.2 *Q-switched lasers.* The efficiency of the laser optical cavity reflection system is termed the Q-factor. In the so-called Q-spoil systems the optical cavity is not allowed to function (Q is kept to zero) until the pumping radiation has raised virtually every active ion to the metastable state. A shutter is then opened to restore the Q of the cavity and permit almost simultaneous stimulation of all the available photons. Kerr cell and Pockels cell shutters (see p. 333) have been used for Q-switching; another common method is to spin one of the cavity mirrors so that the cavity is resonating only for the brief instant when the mirrors are parallel. Saturable dyes, which are bleached by high intensity radiation, are also used for Q-switching and for the pulse-sharpening technique known as mode-locking.

This giant pulse principle can produce a radiant power of several gigawatts (1 GW = 10^9 watts) for a few picoseconds (1ps = 10^{-12}s). This may be compared with, say, 5 milliwatts for a typical commercial He-Ne CW laser, about 1 watt for semiconductor diode CW lasers and several kilowatts for the CO_2 CW infrared laser.

3.7.8.3 *Spectral bandwidth.* The spectral emission band of lasers is generally narrower at low temperatures. A typical ruby laser might have a line width of 10^{-2} nm at room temperature, reducing to 10^{-3} nm at 77K. Gas lasers usually have much narrower lines; in the case of the He-Ne lasers the line width may be as little as 10^{-6} nm.

The design of the laser and its mode of operation (pulsed or CW) can affect the spectral line width, so quoted values may differ slightly.

3.7.8.4 *Optical properties.* Laser radiation normally exhibits a high degree of coherence (see p. 110), although the high-power pulsed lasers lose this property to some extent. The coherence length is an important property of lasers used for holography (see Chapter 15). Elion[43] has discussed the characteristics of coherent light with special reference to laser radiation.

The emitted beam is almost parallel, though a very slight divergence is inevitable owing to diffraction at the exit face; random emission from the end face usually causes additional beam-spreading. Beam divergences as low as 0·3 milliradians have been achieved (this is equal to a spread of 18 in. over a beam length of 1 mile) though

values of 1·0 mrad are more common. Semiconductor diode lasers tend to have a more divergent elliptical beam cross section, typically $1° \times 5°$ (17×87 mrad).*

Auxiliary optics are used for better collimation or to broaden the beam for applications where a large field must be covered (e.g. holography). Where very high power densities are required (e.g. microwelding) the beam may be focused by microscope objectives to a spot size of about 1 μm.

Most gas lasers are constructed with the ends of the tube cut at the Brewster angle to the optical axis; with the repeated passage of the beam this acts rather like a 'pile of plates' polariser, leaving the emitted beam linearly polarised and suffering very little reflection loss on each pass through the end face. This offers the almost unique feature of a laboratory source of plane polarised light. Solid-state lasers can also emit 100 per cent plane polarised light if the rod axis is suitably cut with respect to the crystal axis.

The lasers in current use are too numerous to list fully. Table 3.12 gives some of the better-known examples of each type.

TABLE 3.12

EMISSION WAVELENGTHS OF TYPICAL LASERS

Laser type	Emission wavelengths*
Solid state	
Ruby (Al_2O_3 doped with Cr+++)	694·3nm
Calcium tungstate ($CaWO_4$) doped with	
Neodymium (Nd+++)	1065
Yttrium aluminium garnet (YAG)	
doped with (Nd+++)	1060
Gas	
Helium-neon (He-Ne)	632·8 and many IR lines
Argon ion (Ar+)	457·9–514·5
Nitrogen (N_2)	300–400 (max. 337nm)
Semi-conductor	
Gallium arsenide (Ga As)	840
Gallium-arsenic-phosphorus (Ga-As-P)	710
Silicon carbide (SiC)	456
Liquid and plastic	
Chelate doped with Europium (Eu+++)	612·9

*These are representative figures only, most lasers emit over a small range of wavelengths, depending on the temperature and the operating mode of the laser.

All laser wavelengths depend to some extent on the temperature and other operating conditions. For example, ruby lasers emit at 694·3 nm at 300K (room temperature) but at 77K the emission is at 693·4 nm.

In some cases the laser material has more than one metastable energy state and emits a number of wavelengths; these laser systems can sometimes be frequency tuned to select the required wavelength.

*The radian (rad) is the SI standard unit of plane angle.

$1 \text{ rad} = \frac{180°}{\pi} = 57° \ 17' \ 44 \cdot 8''$ or $57 \cdot 29578°$

1 milliradian (mrad) $= 0° \ 3 \cdot 4'$ or $206''$ or $0 \cdot 057°$ (approx)
1 microradian (μrad) $= 0 \cdot 2''$ or $0 \cdot 000057°$ (approx)
The obsolescent centesimal system of angular measurement is described in the footnote on p. 395.

The wavelengths available from lasers now extends throughout the near IR, the visible and near UV regions. Each laser emits only its characteristic wavelength, although there are several ways in which the laser emission can be modified to produce another wavelength. In one method known as frequency doubling the laser radiation is passed through a crystal (e.g. ammonium dihydrogen phosphate (ADP) or lithium niobiate (Li NbO$_3$) which converts some of the radiation to a wavelength that is half that of the incident beam. In this way, the 694 nm ruby radiation can be used to generate UV radiation of 347 nm and an infrared laser emission of say 1 μm can be converted to the visible wavelength of 500 nm.

3.7.8.5 *Applications of lasers.*[44] Lasers are currently used in medicine, industry, science and communications. The best-known photographic applications are in the field of holography (Chapter 15) and high-speed photography. The extremely high intensity of laser emission over a narrow spectral band has led to the use of lasers in the photography of incandescent surfaces. The self-luminous radiation is largely absorbed by use of narrow-band filters matched to the laser emission and the surface can be observed by cross-lighting from the laser.[45] (This subject is also mentioned on p. 280.)

Useful sources of reference on the principles of lasers are given by Eaglesfield[46] and Brown[47], but the only way of keeping abreast of fresh developments in this very active field is to read the appropriate technical journals.[48, 49]

3.7.9 ELECTRO-LUMINESCENT DIODES (OPTICAL SEMI-CONDUCTORS). Junction diodes of the p–n type are used in lasers, but similar materials e.g. gallium phosphide (GaP), gallium arsenide (GaAs) can also be used. In a less critical geometrical form they produce radiation that lacks the extremely high intensity and coherence of a laser beam, but is reasonably monochromatic (the band-width is usually about 20–40 nm). These sources are small and robust and in many cases are very efficient. Their principles and recent developments in this field have been described by Epstein and Holonyak[50]. Morehead[51] has discussed the various excitation mechanisms and has listed semi-conducting compounds emitting over the range from the near UV to the far IR. In some cases the emitted wavelength can be changed by suitable doping of the semi-conductor; green or yellow diodes are now available in addition to the earlier red-emitting GaP diodes.

EL diodes are small (typically 2 × 1 mm or less) but they have a very high luminance (up to 7000 cd/m²) and may replace other small lamps for visual displays, computer data transmission and other applications where fast switching and very high reliability are essential over a long life. These lamps require a relatively small power supply and they have been used for coded data displays in contact with the film in aerial and instrumentation cameras (see p. 361).

Kerr[52] has favourably compared silicon carbide EL diodes with the conventional neon discharge lamps used for time-base marking in cine cameras (see Chapter 11).

Electroluminescent panels, which have a completely different form and method of operation are mentioned on p. 112.

3.8 *Economic factors in the choice of lighting equipment*

The selection of the best equipment for a task calls for a full knowledge of the available alternatives. A realistic comparison can then be carried out, with the factors

of cost or specialised performance taking precedence according to the circumstances.

Most of the technical factors involved in the choice of lighting equipment have been mentioned in this chapter, but the following points are made briefly as a reminder of the economic factors in lighting installations. Similar considerations affect the cost-effectiveness of other photographic equipment.

Capital outlay: The relative merits of outright purchase, credit purchase, short-term or long-term hire must be considered.

The loss of potential interest on the capital employed in purchase is a significant factor and is normally included as a cost.

Special installation costs must be included.

Depreciation: The value of equipment is normally transferred to a capital assets account and is written off over a period of perhaps 7 or 10 years.

A change in technical requirements may call for the replacement of equipment before it is fully depreciated.

Running costs: In the case of lighting this is mainly the cost of electrical power. Charges for servicing and repairs must also be considered.

Materials: Lamps and batteries are the only consumable materials connected with lighting installations.

Labour costs: Labour costs are usually the most expensive aspect of any process and any equipment that increases productivity merits serious consideration. Light-weight lighting equipment can greatly reduce setting-up time and transportation problems. On another level, the installation of efficient safe-lighting can increase the output of a printing dark-room. In some installations access to the lamps may be difficult or hazardous and the cost of lamp replacement may then be out of all proportion to the price of the lamps.

Overheads: Indirect costs are notoriously easy to overlook. Even apparently minor aspects such as re-ordering and storage space have associated costs.

The need for economy in planning photographic work requires no further emphasis; in applied photography the costs of lighting and all the other equipment must be assessed in relation to the experiment or research project. There is an irreducible minimum of light that will permit photography on a given emulsion with a given *f*-number and shutter speed (see Eq. 3.11); failure to provide suitable lighting, either in quantity or in quality, can reduce or distort the recorded information and can be both misleading and expensive.

References

1 FEINBERG, G., *Sci Amer*, **219**, 50–59 (1968).

2 KEELING, D., *B J Phot*, **116** Nos 5660 et seq. (1969).

3 LEVERENZ, H. W., *Luminescence of solids*, Chapman & Hall, London (1950).

4 IVEY, H. F., *Sci Amer*, **197**, 40–47 (1957).

5 ROSSI, B., *Cosmic rays*, Allen & Unwin, London (1966).

6 EMMIN, J. G. (Ed), *Electromagnetic radiation in space*, D. Reidel Publishing Co., Dordrecht (1967).

7 GRAHAM, C. H. *et al*, *Vision and visual perception*, Wiley, New York (1965).

8 WALSH, J. W. T., *Photometry*, 3rd Ed, Constable, London (1958).

9 KAUFMAN, J. E. (Ed), *IES Lighting Handbook*, 4th Ed, Illuminating Engineering Society, New York (1966).

10 HOPKINSON, R. G., *Architectural physics: lighting*, HMSO, London (1963).

11 MEYER-ARENDT, J. R., *Appl Opt*, **7**, 2081–84 (1968).

12 KINGSLAKE, R. (Ed), *Applied optics and optical engineering*, Vol II, Ch 5, Academic Press, New York (1965).

13 KAUFMAN, J. E., *op cit*, Section 9.

14 DUNN, J. F., *Exposure manual*, 2nd Ed, Ch 5, Fountain Press, London (1958).

15 MOON, P., *The scientific basis of illuminating engineering*, Dover Publishing, New York (1961).

16 KAUFMAN, J. E., *op cit*, p 24.

17 ASA PH2.4–1965, *Determining exposure guide numbers for photographic lamps*.

18 HYZER, W. G., *Engineering and scientific high-speed photography*, pp 292–4, Macmillan, New York (1962).

19 *Wratten filters*, Kodak Ltd., London.

20 LANGFORD, M. J., *Advanced photography*, Ch 15, Focal Press, London (1969).

21 ASA PH2.3–1956, *Determining the activity or the relative photographic effectiveness of illuminants*.

22 DUNN, J. F., *op cit*, pp 82–5.

23 BOURNE, H. K., *Discharge lamps for photography and projection*, pp 279–283, Chapman & Hall, London (1948).

24 KAUFMAN, J. E., *op cit*, pp 8–23.

25 MIDDLETON, W. E. K., *Vision through the atmosphere*, University of Toronto Press (1963).

26 LANGFORD, M. J., *op cit*, p 92.

27 HYZER, W. G., *op cit*, pp 276–82.

28 GILBERT, G., *Photo-flash in practice*, Focal Press, London (1954).

29 *Focal Encyclopedia of Photography* (Flash powder), Focal Press, London.

30 TAYLOR, A. F., *Photography in commerce and industry*, pp 237–40, 337, Fountain Press, London (1962).

31 CUMMING, H. W., *B K S Journal*, **28**, 5–22 (1956).

32 BOURNE, H. K., *op cit*.

33 ELENBAAS, W. (Ed), *High pressure mercury vapour lamps*, Philips, Eindhoven (1965).

34 HYZER, W. G., *op cit*, p 283.

35 ELENBAAS, W. (Ed) *op cit*, pp 294–8.

36 AINSWORTH, T. S. and BEESON, E. J. G., *Phot J*, **107**, 324 (1967).

37 ELENBAAS, W., *op cit*, 110–12, 173–4.

38 ELENBAAS, W. (Ed), *Fluorescent lamps and lighting*, Philips Technical Library, Eindhoven (1959).

39 BOURNE, H. K., *op cit*, Ch 11.

40 VAN SCHAIK, W. C. L., *B J Phot*, **115**, 1128–9 (1968).

41 *Kodak Data Sheet CL-8*, Kodak Ltd., London.

42 NEBLETTE, C. B., *Photography: its materials and processes*, 6th Ed, p 26, Van Nostrand, Princeton, N.J. (1962).

43 ELION, H. A., *Laser systems and applications*, Pergamon, Oxford (1967).

44 MURRAY, R. D. (Ed), *Application of lasers to photography and information handling*, SPSE, Washington (1968).

45 CHRISTIE, R. H., *Perspective world report: 1966–69*, Ed L. A. Mannheim, pp 175–84, Focal Press, London (1968).

46 EAGLESFIELD, G. C., *Laser Light*, Macmillan, New York (1967).

47 BROWN, R., *Lasers*, Aldus Books, London (1968).

48 *Laser focus* (monthly), American Technology Publications Inc., Newtonville, Mass.

49 *Laser Weekly*, Lowry-Cocroft Abstracts, 905 Elmwood Avenue, Evanston, Illinois.

50 EPSTEIN, A. S. and HOLONYAK, N., *Sci J*, **5**, 68–74 (1969).

51 MOREHEAD, F. F., *Sci Amer*, **216**, 109–22 (1966).

52 KERR, M. A., *JSMPTE*, **78**, 631–5 (1969).

4. MACROPHOTOGRAPHY

4.1 *Forming a macro image*

Macrophotography (photomacrography) is the technique of making larger-than-life photographs with a single camera lens. Although there is no theoretical limit to the magnification* obtainable, the useful practical limit is around 20–50×.

At greater magnifications photomicrography using a compound two stage magnification becomes increasingly more useful because of more efficient use of illumination and the higher resolution attainable.

Fig. 4.1 shows the transition from conventional photography to macrophotography as the object approaches the lens.

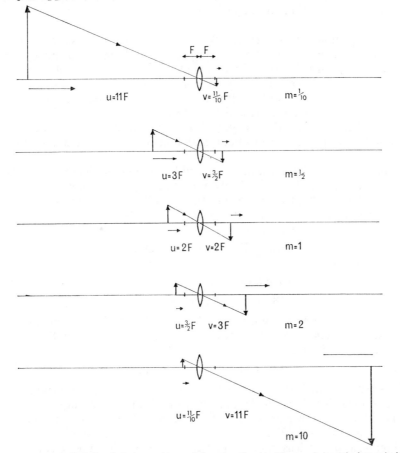

Fig. 4.1. Lens conjugates. Variations in image position and size when the object is moved along the lens axis. Length of arrows parallel to lens axis shows corresponding movement of object and image.

*Magnification (or scale) is defined as $\dfrac{\text{image size (linear)}}{\text{object size (linear)}}$ and refers to the negative unless otherwise stated

When the scale is equal to 1 the movement of the object and image are equal, the total object-image distance being a minimum of 4 focal lengths. Fig. 4.1 also shows that for other object-image distances (greater than 4 focal lengths) there are two positions which give sharp focus, one with a reduced and the other with a magnified image.

4.1.1 CAMERAS FOR MACROPHOTOGRAPHY.[2, 3] For close-up photography at scales up to about 1/5, hand held miniature cameras fitted with simple positive supplementary lenses are adequate providing that the lens aperture used is not greater than about $f5\cdot6$. Large power supplementaries or wider apertures usually involve loss of image quality, although high quality, corrected supplementary lenses are available for some cameras. True macro scales, however, generally require either extension tubes or a bellows unit. These are ideally used with single lens reflex cameras, but for other miniature cameras bellows units with their own reflex housing are available. An example is the Leitz Visoflex unit which provides reflex focusing with standard Leica cameras, although the minimum extension obtainable imposes some restriction with a short focus lens.

Large format monorail (or technical) cameras are generally suitable, the prime requirement being adequate extension, but specially designed macro cameras are available. These are usually vertically mounted and take 5×4 in., $\frac{1}{4}$ plate or 9×12 cm film (an international 5×4 in. back accepting Polaroid and roll-film holders is extremely useful) have an available lens extension of about 30 in., a specimen stage with its own focusing movement and a range of interchangeable lenses with focal lengths from 1 to 5 in. Unfortunately, and strangely, most of these cameras have no swing or shift movements and this point may favour the use of a standard monorail camera.

Any camera used with long extension should be rigid in itself (bellows units sometimes lack rigidity) and should be firmly mounted. (See also Chapter 17.)

4.1.2 RELATION BETWEEN EXTENSION, FOCAL LENGTH AND MAGNIFICATION. The extension required (v) for a magnification (m) is given by

$$v = F(1+m) \qquad \text{Eq. 4.1}$$

where F is the focal length.

Thus a technical camera with a lens of 6 in. focal length and a maximum bellows extension of 18 in. can provide a magnification of 2:

$$18 = 6(1+m) \therefore m = 2$$

If greater magnification is required (say 10) a shorter focal length lens is necessary. If the maximum extension of 18 in. is used, the necessary focal length (F) to give a magnification of 10 is given by:

$$18 = F(1+10) \quad F = 1\cdot63 \text{ in.}$$

4.1.3 IMPORTANCE OF SWING MOVEMENTS. The use of swing movements to control the plane of focus is very valuable, but the principles involved must be fully understood. The three relevant planes, subject plane, film plane and lens principal plane, must meet in a single line (Fig. 4.2). This can be achieved by swinging either the film plane (Fig. 4.2a) or the lens panel (Fig. 4.2b). Although the latter method displaces the image from the lens axis, making greater covering power necessary, it is usually preferable in macrophotography because it requires less angular movement and avoids the distortion which can arise from excessive movement of the film plane.

146

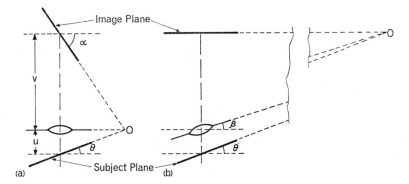

Fig. 4.2. Condition for uniformly sharp focus of an oblique plane (a) using swing back (b) using swing front.

As an example, if the angle θ of the subject is 20° with a magnification of 4, the angle of backswing needed $a=55\frac{1}{2}°$ but the angle of lens panel swing $\beta=16\frac{1}{4}°$ only.

Shift movements (rise, fall and cross front) are also useful for the same purposes as in general studio photography.

4.1.4 LENSES FOR MACROPHOTOGRAPHY. The designer of a compound lens aims at minimising aberrations under particular conditions of use. If the lens is used for purposes other than those for which it is intended, the results may be poor, particularly in the case of wide aperture, highly corrected types. However, realisation of the factors which affect performance enable the best use to be made of any lens which might be available.

Most general purpose camera lenses are corrected to give their best performance when producing a much reduced image—up to about 1:10, although some intended for copying are designed for image scales of about 1:4, and can be obtained corrected for use at 1:1 reproduction. Enlarger lenses typically give optimum performance at ratios up to 4:1, depending on the focal length. The corrections of copying and enlarging lenses are essentially similar, because a ray of light follows an identical path through a lens if its direction is reversed. Enlarging lenses are usually equally suitable for copying and vice versa.

If then we take a standard camera lens and use it reversed (so that its normal 'back' faces the object) to form an image of magnification about 10 or 20, we may well get acceptable results (Plate 1).

Use of a lens reversed in this way, although valuable at times, may not be convenient if the aperture scale (and shutter if fitted) become inaccessible, but several manufacturers of miniature equipment supply adaptors for mounting the lens reversed when the image scale is greater than 1:1. Lenses specially computed for macrophotography are commercially available in focal lengths ranging typically from about 1 in. to 5in.

4.1.4.1 *Choice of focal length.* This is primarily dependent on the size of the subject to be photographed, the magnification required and the camera extension available. The minimum focal length is that necessary to cover the subject—say roughly the diameter of the subject; the maximum possible is that given by $v=F(1+m)$ where v is the greatest possible extension. Within these limits there are other factors which may affect the final choice.

TABLE 4.1(a)

LENSES DESIGNED FOR LARGE FORMAT MACROPHOTOGRAPHY

Manufacturer	Name	Focal lengths available (max. aperture)	Notes
Leitz	Summar	24, 35, 42, 80, 120mm (f4·5)	
	Milar	50, 65, 100mm (f4·5)	
Nippon Kogaku	Macro Nikkor	35, 65mm (f4·5) 120mm (f6·3)	
Olympus	Micro-Zuiko	45mm, 75mm (f4·5)	
Projectina	—	11·5, 17, 25, 45, 61, 76, 102mm	Magns. 50, 30, 20, 10, 7, 5, 3X on Projectina microscope
Vickers	—	48mm, 66mm, 127mm (f4·5)	Magns. 15, 10, 5X on Vickers 55 microscope
Zeiss (Oberkochen)	Luminar	16mm (f2·5), 25mm (f3·5) 40, 63mm (f4·5), 100mm (f6·3)	
Zeiss (Oberkochen)	Luminar 2·5–5X	Variable Focus (approx 11–18cm)	Magn. 2·5–5X on Ultraphot II microscope

TABLE 4.1(b)

MACRO LENSES FOR 35MM CAMERAS

Manufacturer	Name	Focal Length	f No.	Camera fittings	Max. scale on focusing mount*
Asahi	Macro Takumar	50mm	f4	Pentax/Edixa	1
Kilfit	Macro Kilar	40mm	f2·8	Edixa/Pentax	0·9
Leitz	Macro Elmar	100mm	f4	Leicaflex (with bellows)	1
Minolta	Macro Rokkor	50mm	f3·5	Minolta	0·5
Nippon Kogaku	Micro Nikkor	55mm	f3·5	Nikon	0·5
Nippon Kogaku	†Medical Nikkor	200mm	f5·6	Nikon	Fixed focus. Scales of $\frac{1}{15}$, $\frac{1}{8}$, $\frac{1}{6}$, $\frac{1}{4}$, $\frac{1}{3}$, $\frac{1}{2}$, $\frac{2}{3}$, 1, 1·5, 2, 3 obtained by special supplementary lenses supplied
	†Lens includes electronic ringflash				
Novoflex	Noflexar	35mm	f3·5	Exakta or Edixa/Pentax	0·5
Schacht	Macro Travenar	50mm	f2·8	Exakta or Edixa/Pentax	1

*Extension tubes or bellows needed for higher magnifications. Most have adaptors available to allow reversing, for magnifications greater than 1.

(1) *Perspective.* The perspective obtained is governed entirely by the viewpoint, the distance of which *at any particular magnification* depends on the focal length.

(2) *Working distance.* This is greater with longer focal length. A greater distance is often useful when illuminating by reflected light.

(3) *The relationship between depth of field and magnification* The depth of field obtained is dependent only on the magnification and f-number (see p. 149). However, if more depth of field is required it may be convenient to obtain a lower magnification by changing to a longer focal length lens. This may also allow the use of smaller apertures which are more often available on longer focus lenses.

It follows that the best choice is often, but not necessarily, the longest focal length that allows the magnification required.

For example, if we wish to photograph a $\frac{3}{4}$ in. disc at a magnification of 4, a 1-in. lens would cover the subject satisfactorily. Using the formula

$$u = F\left(1 + \tfrac{1}{m}\right) \qquad\qquad\text{Eq. 4.2}$$

we find that $u = 1\ (1 + \tfrac{1}{4}) = 5/4$ in.

This means that the clear distance between the subject and the *front* of the lens is less than $1\frac{1}{4}$ in. (because the nodal point is usually situated *within* the lens). If, however, a bellows extension of 15 in. is available, we can use the formula $v = F\ (1+m)$ to find the longest useful focal length:

$$15 = F\ (1+4),\ \text{therefore}\ F = 3\ \text{in.}$$

and in this case:

$$u = 3\ (1 + \tfrac{1}{4}) = 15/4 = 3\tfrac{3}{4}\ \text{in.}$$

This shows that a working distance of 3 in. or more would be available, giving more space for providing illumination. Also a smaller angular field would be used, which may help to provide uniform resolution over the picture area.

4.1.4.2 *Resolution, Aperture and Depth of Field.* The conception of numerical aperture (NA) and the dependence on it of the theoretical resolution limit is described in relation to microscopy in Chapter 5. Numerical aperture is found from *f*-number (f) by the formula:

$$NA = \frac{m}{2f(m+1)} \qquad\qquad\text{Eq. 4.3(a)}$$

or if m is fairly large

$$NA = \frac{1}{2f} \qquad\qquad\text{Eq. 4.3(b)}$$

The formula $S = \dfrac{\lambda}{2\ NA}$ (page 166) becomes $S = \lambda f$ and shows that the resolution is better at large apertures (see also Chapter 2, p. 82).

Although the resolution of macro lenses is not particularly close to the diffraction limit, most do give their best resolution at nearly full aperture, particularly in the centre of the field. However, with a three-dimensional specimen, depth of field becomes important and may necessitate a small aperture. When a choice must be made between large aperture, high resolution and poor depth of field on the one hand, or small aperture, poorer resolution and greater depth of field on the other, the problem is often solved by stopping down to increase the depth of field and accepting regretfully the more limited resolution which results. Before making the choice however one should consider whether:

(1) It is necessary to render all parts of the subject sharply, and

(2) The increased depth could be better obtained by reducing the camera magnification and resorting to greater enlargement in printing.

The most useful formula relating to depth of field in macro work is:

Total depth of field (i.e. distance between nearest and furthest points appearing

$$\text{sharp)} = \frac{2\ c\ f\ (m+1)}{m^2} \qquad\qquad\text{Eq. 4.4}$$

where f = *f*-number of lens used
 m = magnification
 c = maximum permissible diameter of circle of confusion.

For this purpose the criterion of the permissible circle of confusion should be based on the intended enlargement of the negative when printed and not on the focal length of the lens used as is sometimes suggested for pictorial or general photography.

The maximum diameter circle of confusion usually accepted on a print is 1/100 in. (0·25 mm), so that if, for instance, a 5×4 negative is to be enlarged by a factor of 2 a circle of 1/200 in. is permissible on the negative. If, however, a whole-plate print is required from a 35 mm negative, the enlargement factor of 6 indicates that a circle of confusion no greater than 1/600 in. would be required.

Suppose that a final magnification on the print of 20 is required using a lens aperture of $f16$. If the camera magnification is 10, the enlargement factor will be 2, indicating that a circle of confusion of 1/200 in. would be acceptable in the negative. So

$$\text{Depth of field} = \frac{2 \times 1/200 \times 16\,(10+1)}{100}$$

$$= \frac{176}{10,000} = 0\cdot0176 \text{ in.}$$

In order to increase depth of field we can make the negative magnification smaller, say 4. The enlargement factor needed is now 5 and to get an equally sharp print the acceptable circle of confusion will be 1/500 in., so now

$$\text{Depth of field} = \frac{2 \times 1/500 \times 16\,(4+1)}{16}$$

$$= \frac{10}{500} = 0\cdot02 \text{ in.}$$

The figures given above assume that the print is to be viewed from the normal distance of 10 in. If the viewing distance is greater the permissible circle of confusion is correspondingly greater and so is the effective depth of field.

Although the reduction in camera magnification necessitates a better standard of negative definition, the overall effect is a small increase in depth of field. However the increased enlargement factor from a smaller negative image gives lower resolution in the final image, and this may be noticeable in the areas of best focus (Plate 2). This effect, together with film resolution and graininess, limits the extent to which reduction in camera magnification is practicable.

4.2 Illumination

The fact that the subject is small affects the lighting equipment employed but *not* the basic principles required to show shape, texture, etc. A useful form of illumination is the conventional microscope lamp using a variable intensity low voltage compact filament bulb with a focusing condenser and iris. A small spotlight is a fairly good alternative. Electronic flash is less easy to control but is valuable with moving or heat sensitive subjects (e.g. living specimens). (See also Chapter 4.2.5.)

Heat absorbing or reflecting (dichroic) filters can be used in the light beam to lessen the heating effect of tungsten (or flash) lighting. Dichroic interference filters are available which reflect infra-red and transmit visible light or in the form of 'cold mirrors' which transmit infrared and may be used to reflect visible light on to the specimen without heating it.

4.2.1 BRIGHT FIELD REFLECTED (OR VERTICAL INCIDENT) ILLUMINATION. This type of lighting is used mostly for flat polished specimens, particularly in metallographic work. Any departure from the flat surface is shown dark on the light field. Fig. 4.3 shows two methods for obtaining bright field illumination. The first uses a condenser which should be positioned so that it converges the beam to form an image of the source in the camera lens. With flat highly-polished specimens the alignment and focus of this condenser (which must be larger in diameter than the subject) is quite critical, any error giving an uneven illumination field. Subjects with a less perfect surface, e.g. coins, demand less critical illumination and are usually rendered satisfactorily if the incident beam is parallel. It is also possible to use a diffuser instead of the condenser (Fig. 4.3b) but this tends to show very small imperfections in the surface less well, a property which may be desirable or not, depending on the purpose of the photograph. This illumination gives, with any type of specimen, the only true shadowless lighting possible and is often useful for lighting inside narrow cavities.

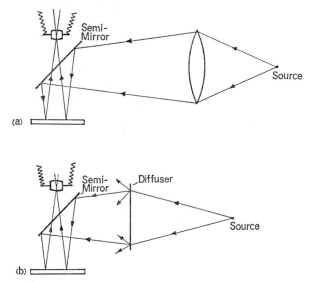

Fig. 4.3. Bright field reflected illumination. (a) Using condenser. (b) Using diffused beam.

4.2.2 DARK FIELD ILLUMINATION. In this case the light is directed at the specimen at an angle greater than the half angle of acceptance of the lens, so that if it is specularly reflected from a flat polished surface none enters the lens (Fig. 4.4a). Thus we have the reverse of bright field; irregularities in the surface appear bright on a dark field. Ideally the light should come from all sides of the specimen in the form of a hollow cone, which is achieved with small subjects by using a spherical or parabolic mirror with the central area removed (Fig. 4.4b). Alternatively two or three individual lamps are directed at the specimen from angles around it.

4.2.3 TRANSMITTED ILLUMINATION. For transparent or translucent subjects either bright or dark field transmitted illumination can be used, with a transparent stage, and most of the reflected light principles apply (Fig. 4.5). The bright field methods are essentially the same as in condenser and diffuse enlargers.

151

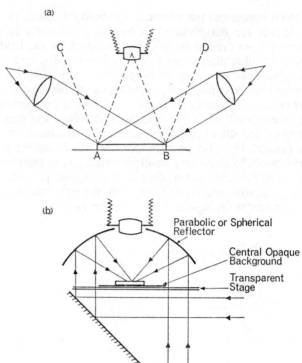

Fig. 4.4. (a) Dark field reflected illumination must come from outside CA and DB. (b) Method of obtaining hollow conical beam for small specimens.

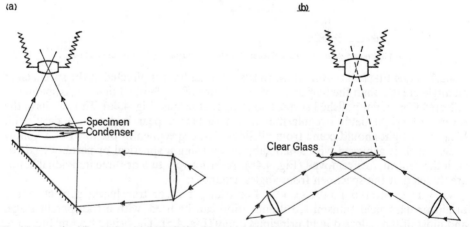

Fig. 4.5. Transmitted illumination. (a) Bright field, using condenser to focus image of source into objective. Alternatively a diffuser could be used. (b) Dark field using two separate lamps.

152

4.2.4 ILLUMINATION FOR MODELLING. Many subjects are encountered to which the above lighting techniques are inapplicable, and which require a conventional photographic lighting to show their texture, form or variations in tone or colour. The main obstacle (literally) to providing such illumination in the normal way is often the close proximity of the camera to the subject. A longer focal length lens is helpful particularly if the lens is mounted on a tapered snoot fixed to the lens panel (Fig. 4.6). Such a device also gives an increase in available camera extension.

Modelling and suitable fill-in light can be provided from awkward angles by small mirrors or white paper diffusers, while the 45° cover glass described for 'bright field' will provide a good fill-in for a separate modelling lamp. Fig. 4.7 shows four ways of obtaining different lighting effects in a limited space. In b, c and d where two or more lamps are used the relative intensities can be varied to modify the effect; or holes may be cut to allow the addition of some direct undiffused light.

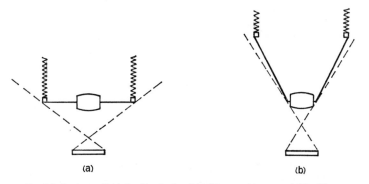

Fig. 4.6. Angles available for illumination (a) with normal lens panel (b) with snoot.

It is easy to underestimate the amount of fill-in needed when a spot or microscope lamp is used undiffused as a modelling light. Empty shadows are no more desirable in macro work than in other types of photography. The fact that a subject is small in size does not imply any need to increase (or decrease) the lighting contrast.

Illumination using beams of light parallel to the plane of focus can be restricted by narrow slits to illuminate only parts of the subject in that plane (Fig. 4.8). With this illumination a great apparent depth of field can be recorded by moving the object steadily backwards or forwards through the plane of focus during the exposure. This technique is not suitable for all objects, being useless, for instance, for opaque hollow specimens, but can be very successful with conical or spheroid shapes (Plate 3). Lateral movement or vibration of the stage must be avoided.

4.2.5 RING ILLUMINATORS. Ring illuminators employ either a number of tungsten lamps in a circular housing or circular discharge tubes (fluorescent or electronic flash). These are normally used surrounding the camera lens. On miniature reflex cameras they form a reliable and consistent form of illumination for modest magnification macrophotography, particularly of plant or insect life where it may be convenient to use a hand-held camera. They do not necessarily give shadowless lighting.

The effectiveness of a ring illuminator is a function of:

(1) The effective diameter of the illuminating ring.

153

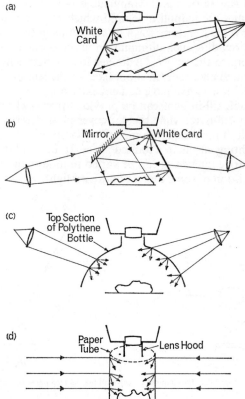

(a)

White Card

(b)

Mirror White Card

(c) Top Section
of Polythene
Bottle

(d) Paper
Tube Lens Hood

Fig. 4.7. Methods of achieving suitable illumination of solid objects.

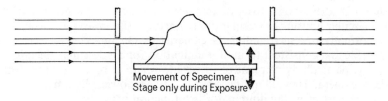

Movement of Specimen
Stage only during Exposure

Fig. 4.8. Illumination through slits restricts light to areas in sharp focus, allowing vertical 'scanning' of the specimen
(see text and Plate 3).

154

(2) The distance of the illuminator from the subject, which is likely to be governed by the focal length of the lens used and magnification.

(3) The size of the subject.

(4) The dimensions and shape of any cavities or protrusions on the subject.

While suitable for photographing inside relatively large cavities e.g. oral photography with a 35 mm camera, ring illuminators are often unsuitable for narrow cavities or tubes.

The problem of illuminating cavities is illustrated in Fig. 4.9. With other subjects it is possible to get effects which approximate closely the results obtained from the arrangements shown in Fig. 4.4 and Fig. 4.7c and d, possibly by obscuring part(s) of the ring.

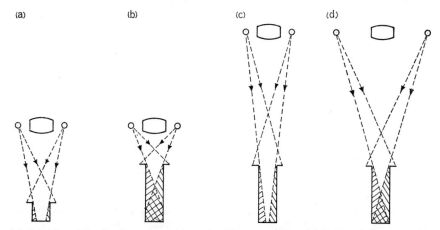

Fig. 4.9. Suitability of ring illuminator for cavities under different conditions. (a) Shallow cavity—useful. (b) Deep cavity—bottom not illuminated. (c) Deep cavity with longer working distance—better than (b). (d) Larger diameter illuminator—bottom not illuminated.

4.3 *Exposure*

4.3.1 EFFECT OF MAGNIFICATION. In macro work the lens to image distance is greater than the focal length, and the *f*-number is no longer an accurate guide to image illumination, which now depends on the *effective f*-number,

$$\text{effective } f\text{-number} = \frac{\text{lens-image distance}}{\text{diameter of aperture}} = \frac{vf}{F} = (1+m)f \qquad \text{Eq. 4.5}$$

where v=lens-image distance
 f=*f*-number
 F=focal length
 m=magnification

Thus if an *f*8 lens forms an image with a magnification of 4 the effective *f*-number is $(4+1)\times 8 = f40$. The exposure must therefore be calculated as if an aperture of *f*40 were being used, although the aperture set on the scale is *f*8.

The use of effective *f*-number becomes confusing at high magnifications and it is simpler to multiply a normally calculated exposure by a factor based on magnification.

155

This factor is:

$$(1+m)^2 \qquad \text{Eq. 4.6}$$

Table 4.2 shows how effective f-number and exposure factors vary with magnification.

Many macro lenses are not scaled with f-numbers but have apertures expressed in figures which are directly proportional to the exposure time required e.g. Leitz use 2 as being equivalent to $f4\cdot5$, so that 6 and 12 are equivalent to $f8$ and $f11$ respectively. Zeiss scale the maximum aperture of each Luminar lens as 1 with 2, 4, 8, 15, 30 denoting successive 'stops' below this.

TABLE 4.2

VARIATION OF EFFECTIVE F NOS. AND EXPOSURE WITH MAGNIFICATION

Magnification m	Lens-image distance (v) $(1+m)$ F.L.	Effective f No. $(1+m) f$	Exposure factor $(1+m)^2$
$\frac{1}{2}$	$1\frac{1}{2}$ F.L.	$1\frac{1}{2}$ f	$2\frac{1}{4}$
1	2 F.L.	2 f	4
2	3 F.L.	3 f	9
3	4 F.L.	4 f	16
4	5 F.L.	5 f	25
5	6 F.L.	6 f	36
10	11 F.L.	11 f	121
20	21 F.L.	21 f	441

F.L.=focal length f=marked f No.

If a supplementary lens is used the focal length is shortened, reducing the true f-number so that the marked f-number remains effective.

4.3.2 EXPOSURE DETERMINATION. Because the illuminated area is small, use of conventional photo-electric meter techniques can be misleading, particularly with high magnifications. Guide numbers quoted for flash are also unreliable at very close range.

Spot photometers, such as the SEI photometer can, with practice, be used successfully for a large percentage of macro work. Care has to be taken, however, when bright or dark field techniques are being used with polished specimens, to ensure that the correct amount of specularly reflected light is received by the meter. Removal of the camera lens and back allows the subject to be viewed along the camera axis.

Perhaps the best method of determining exposure is to measure the illuminance of the image rather than that of the subject, by using a suitable meter either immediately behind or immediately in front of the focusing screen. Photo-conductive meters sensitive enough to be used in this way are available, some of which (e.g. Sinarsix) give exposure time directly. Others give readings in arbitrary units and must be calibrated in terms of exposure by the user.

Meters with a small receptor used in the image plane of large format cameras can be moved around to take readings from any part of the image, allowing the photographer to select a representative area. Measurements taken in this way have already taken account of the magnification factor and lens aperture. However, in practice it may sometimes be necessary to open the lens to full aperture in order to get a satisfactory reading and then to calculate the increase required on stopping down.

156

Miniature cameras with through the lens (TTL) metering also compensate for the lens aperture and magnification factor, but usually take an integrated reading from the whole image area. This can cause unsuitable exposures of subjects with unusual tonal distribution.

On many occasions it will be found that the most reliable method of obtaining the best exposure is to make a test, preferably in test-strip form or possibly on Polaroid film. This has the advantage of compensating for reciprocity failure and (except with Polaroid) processing conditions. In miniature work a number of bracketed exposures can be given, as the film is relatively cheap.

4.4 Practical Operation

4.4.1 BACKGROUNDS. These should generally show as little detail as possible unless it is intended to record the subject in its natural surroundings (e.g. an insect on a plant). Paper or card can be used but should be sufficiently out of focus to avoid showing the texture. Transilluminated opal glass, is good for light tones, eliminating cast shadows, but areas not included in the image should be masked with black paper to reduce flare. Mounting the specimen on clear glass with a separately illuminated background some distance below allows greater control of its brightness. Control of background illumination with transilluminated specimens can be obtained by use of polarising filters.[4]

For colour photography neutral backgrounds are preferable for most scientific purposes. Saturated background colours make visual appreciation of the specimen colour more difficult and are best avoided except for pictorial effect.

4.4.2 HOLDING THE SUBJECT. Methods of holding the subject in a suitable position for photography depend very much on the nature of the specimen. Simply placing on a horizontal surface is satisfactory in many cases, but miniature clamps, pins, Plasticine, magnets or vacuum tweezers may be used on occasions, ingenuity being the most valuable asset. For living, moving specimens a stage mounted on ball-bearings allowing rapid movement in any direction is most useful.

4.4.3 FOCUSING SCREENS. Although a normal ground-glass screen and focusing magnifier is often satisfactory, a clear screen with crosslines in the centre is helpful with low brightness images. The magnifier is then used to find a position of no parallax between the aerial image and crosslines. The normal method is to move the eye from side to side, adjusting the lens focus until there is no relative movement between the image and the crosslines.

The most useful screen on miniature SLR cameras is a finely etched ground glass, either perfectly plain or with a clear centre and crosslines. Fresnel screens are satisfactory if limited extensions are used, but sometimes give poor visual screen illumination owing to over-refraction when the incident rays are more nearly parallel. Microprism screens, except for the very finest ones, tend to obscure depth of field. Both these and split image rangefinders darken at increased extensions (smaller effective apertures) and are of limited value.

4.4.4 FOCUSING THE IMAGE. It is desirable to have a means of varying in a controlled manner the distance of the subject from the camera, either by having a specimen stage with focusing movement or by moving the camera bodily along its axis. This method

of focusing is the best universal method for all macrophotography. With ordinary monorail cameras a spare lens standard can be mounted on the rail in front of the camera section. Fitted with either an opaque or glass panel this serves as a stage for reflected or transmitted light work. If an exact magnification (m) is required the best method is to substitute a millimetre scale for the specimen and set the camera extension to about (1+m) focal lengths. Focus the image, use dividers to measure on it the distance between two suitable points (e.g. 5 mm or 10 mm) and so calculate the magnification obtained. The difference between the measured and required magnifications is the distance (in focal lengths) by which the extension should be altered (increased to raise magnification). After this, refocus the image by varying the object distance and check the magnification. Repeat the procedure if necessary until the exact image size is obtained. *The camera extension is now fixed.* The specimen is placed on the stage and its position varied until the image is sharp on the screen.[5]

Any number of specimens may be photographed at this same magnification, merely by placing them on the stage and adjusting their distance from the camera until a sharp image is produced.

The magnification is, of course, only exact for one particular plane in the subject and is greater or less for parts respectively nearer or further from the lens. This is the natural effect of perspective and the extent of the variation in a particular subject depends on the subject-lens distance (see page 148).

If an exact magnification is unimportant, final focus can be adjusted by moving only the lens, provided the magnification is greater than about 3 or 4. This method, however, alters both the conjugates and therefore results in a greater change in magnification during the operation. In the region of 1:1 reproduction, focusing in this way is most insensitive and should be avoided. Fig. 4.10 shows the variation of image size possible with a total image-object distance of just over four focal lengths. If, when attempting

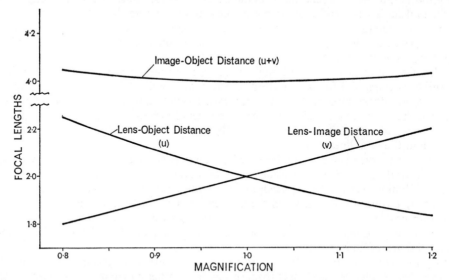

Fig. 4.10. Variation of image and object distances with magnification about 1. Change of image sharpness when object-image distance is just over 4 focal lengths is very small over a wide range of magnification.

to focus at 1:1, a sharp image cannot be found it is due to the object-to-screen distance being less than four focal lengths, and the first procedure suggested should be adopted.

4.4.5 MAGNIFICATION MARKERS. It is usual to include in the photograph a scale which serves in the print to show the magnification of the image. This must be in the same plane as the subject and with high magnifications the positioning of a suitable scale may be impossible. In such cases a scale in the form of a glass plate, with clear markings on opaque ground, can be photographed *with the camera extension unaltered*. The resulting negative is bound with that of the specimen to produce a light scale on the print. With care in positioning it is possible to expose both specimen and scale on the same negative provided the background is not too light. Alternatively the magnification can be measured and recorded, and a suitable scale superimposed on the image at the correct magnification by a double printing technique. This gives a dark scale image.

4.4.6 FILTERS. Colour filters are used in macrophotography for any of the purposes applicable to general photography. Whenever possible it is good practice to place filters over the light source(s) rather than the lens. This makes filter quality unimportant and avoids any focus shift due to the thickness of glass filters.

It is still advisable however, to check the focus with the filter in position to avoid any small effect of chromatic aberration in the lens (noticeable with red or blue filters).

4.4.7 NEGATIVE MATERIALS. Any black-and-white or colour material used for general photography is equally suitable for macrophotography, the choice depending on the nature of the subject and the type of result required. The majority of black-and-white work is carried out with medium-speed panchromatic or orthochromatic material, but high speed or process film may be required on occasion.

Where exposures are long (more than 5–10 seconds) it may be found that an additional effect of reciprocity failure is an increase in contrast. With some materials the development time for a given contrast is only half as much for a 1 minute exposure as for a 1/25 sec. exposure.

References

General

1 HEUNERT, H. H. and MARTINSEN, W. L. M., *Photography for the scientist*, Ed C. E. Engel, Ch 10, 11, Academic Press, London (1968).

Specific

2 ENGEL, C. E., *J Phot Sci*, **4**, 40 (1956).
3 CAUDELL, P. M., *Med Biol Ill*, **11**, 168 (1961).
4 MARSHALL, R., *Med Biol Ill*, **7**, 13 (1957).
5 WILSON, E. T., *J Phot Sci*, **12**, 328 (1964).

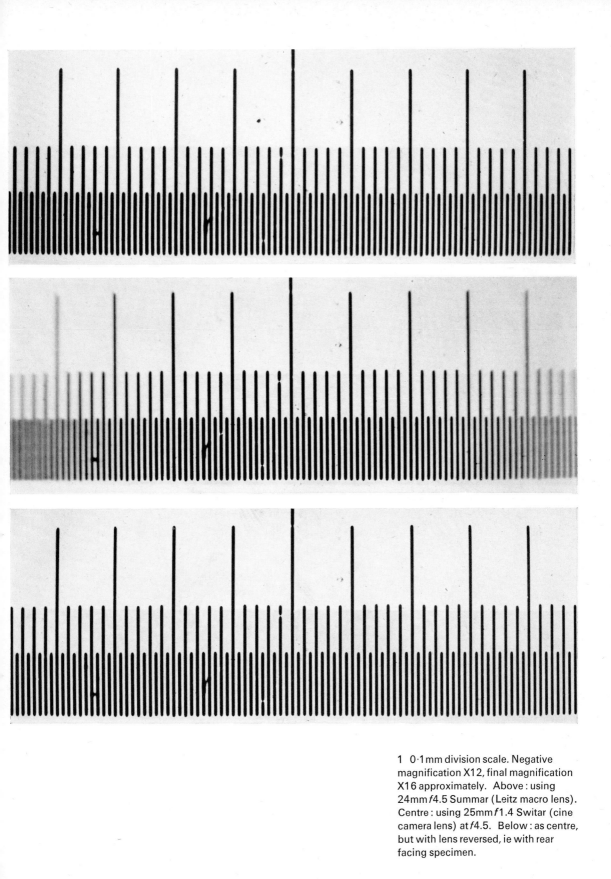

1 0·1mm division scale. Negative
magnification X12, final magnification
X16 approximately. Above : using
24mm f4.5 Summar (Leitz macro lens).
Centre : using 25mm f1.4 Switar (cine
camera lens) at f4.5. Below : as centre,
but with lens reversed, ie with rear
facing specimen.

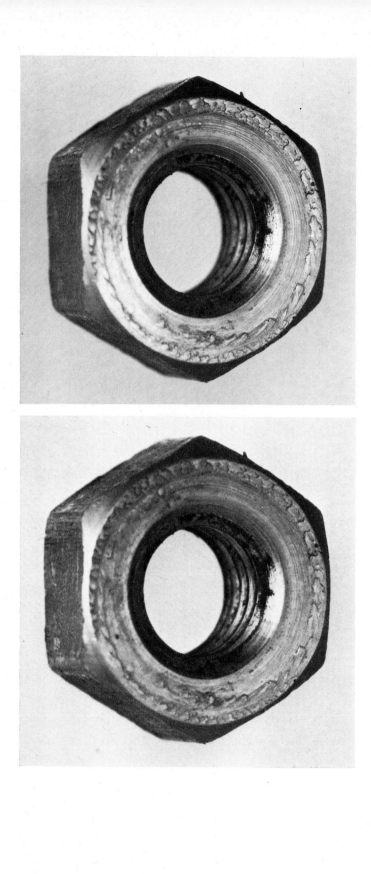

2 Comparison of depth of field and resolution with different negative magnifications. Final magnification 7·2. Above: negative magnification X6 at f16. Enlargement factor 1·2. Below: negative magnification X1·5 at f16. Enlargement factor 4·8. The lower image has greater depth of field but, because of the greater enlargement, poorer resolution in the sharpest areas is apparent under close examination. This is less noticeable from normal or longer viewing distances.

3 *Above* Rock sample photographed with focus scanning technique shown in Figure 4.8. Subject depth shown in this photograph is 12mm. Negative magnification X2·8 at *f*8. Final magnification X8 approx.

4 *Below* Comparison of illumination techniques. Negative magnification X3, final magnification X2·5 approx. Left : bright field. Centre : dark field. Right : modelling illumination.

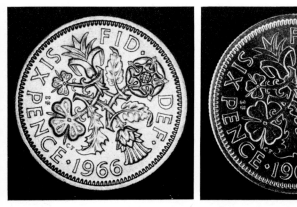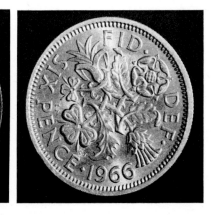

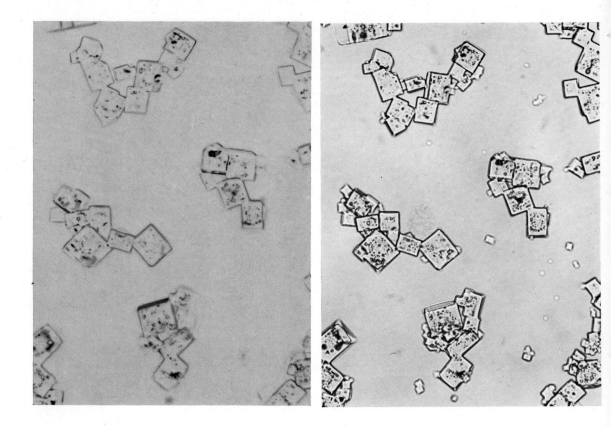

5 Sodium chloride crystals mounted
in xylene, X275, with incorrect substage
condenser diaphragm settings (see
p 183). Left : substage aperture open
too far giving flare and poor image
contrast. Right : substage aperture
too small, giving poor resolution and
showing diffraction effects around
image. Compare these with Plate 8.

6 *Opposite* Spherical particles
photographed using oblique
illumination to show surface texture
(X35). Transmitted background
illumination used to show overall
shape. Top : using 'normal' substage
condenser aperture. Bottom : with
substage condenser aperture reduced
to increase sharpness of silhouette
(see p 184).

7 Section thyroid gland of dog X250.
Top: bright field transmitted illumination
Centre : phase contrast. Bottom :
interference contrast. (Courtesy C Zeiss,
Oberköchen)

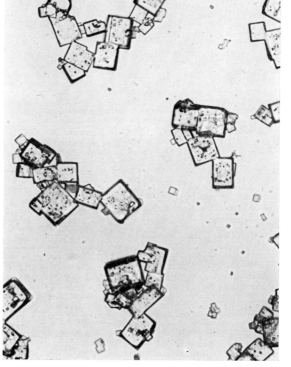

8 Sodium chloride crystals (refractive index 1.54) photographed in different mounting media, X275. Top left: in air, showing poor transparency and poor depth of field. Top right: in xylene (refractive index 1.49) showing good transparency and greater depth of field. Bottom: in monobromonaph-thalene (refractive index 1.655) showing fairly good transparency and even greater depth of field (see p 204).

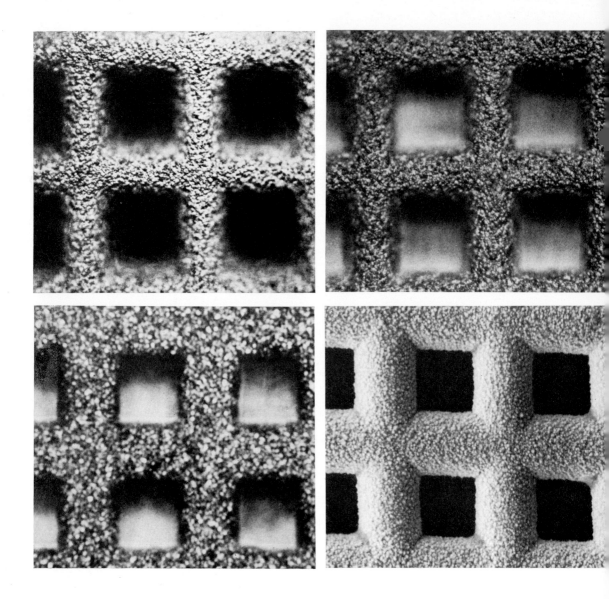

9 500 mesh/inch silver grid
photographed on optical and scanning
electron microscopes, X715. Top left :
optical microscope with best attainable
resolution and limited depth of field.
Top right : optical microscope with
reduced objective aperture showing
compromise between resolution and
depth of field. Bottom left : optical
microscope with greatly reduced
objective aperture showing maximum
depth of field but poor resolution.
Bottom right : Stereoscan microscope
showing good resolution and depth
of field. (Courtesy Cambridge
Scientific Instruments Ltd)

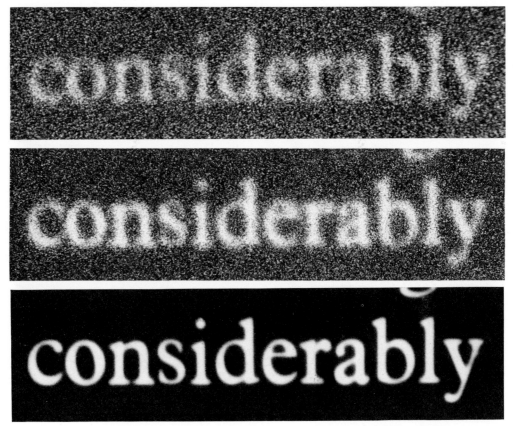

10 *Above* Comparison of image graininess with different negative materials, magnified X135. Top : medium speed film (FP4). Centre : microcopying film (Microfile). Bottom : concentrated Lippmann plate (Maximum Resolution).

11 *Below* X55 magnification of images produced by a 150mm Componon lens at f16. Left : image on Maximum Resolution plate. Right : image on Kodalith film. This shows the value of the enhanced edge gradient produced by lith materials, when used with conventional photographic optics of moderate resolution.

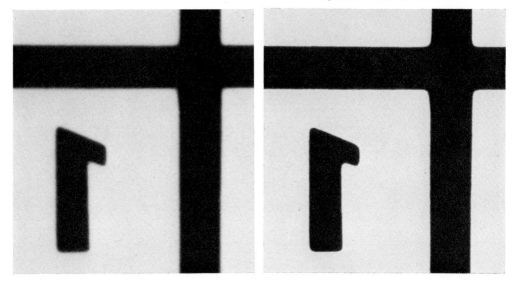

12 *Above* X100 magnification of
image produced by a 0·25NA
achromatic microscope objective.
Left : image on Maximum Resolution
plate. Right : image on Kodalith plate.
Compare with Plate 11.

13 *Below* Distribution microform
transparency produced by National
Cash Register Co Ltd photochromic
micro-image (PCMI) system. This is a
second generation contact copy of
the master photochromic plate, and
may contain 3000 pages of information.

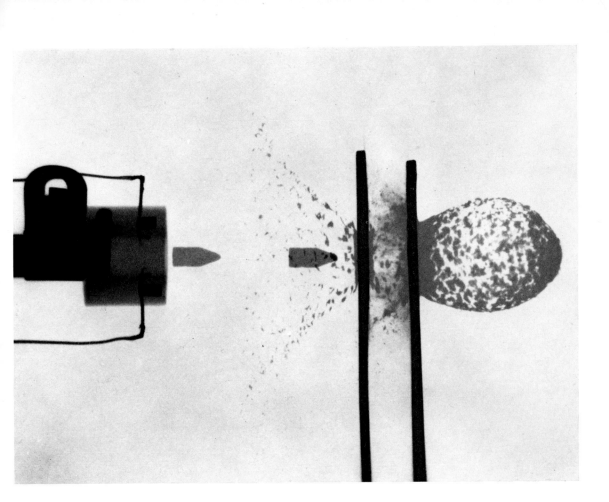

14 *Above* Flash radiography (see
p 301–2). Sequence of three exposures
recorded on a single sheet of film with
an X-ray tube pulsed at 10^5 pps. From
the separation of the first two images
of the bullet, the velocity can be
calculated (in this case 1150 m/s).
The target is a pair of 1/8-inch
lead plates. (Courtesy Field Emission
UK Ltd)

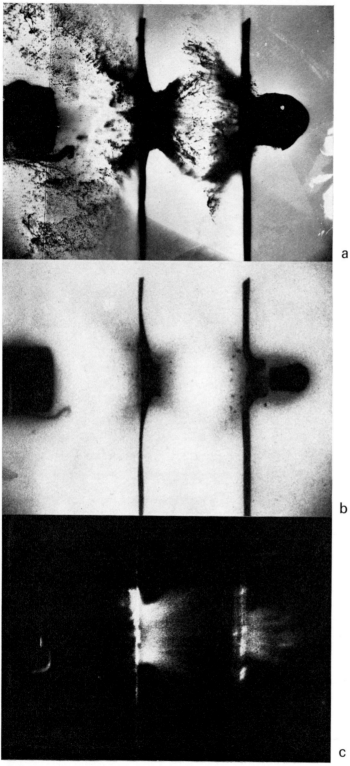

a

b

c

15 Simultaneous recording in three modes with a Febetron electron beam source (see p 287, p 302) (a) Electron shadowgraph (betagraph) showing gas cloud and small particles (b) X-radiograph showing projectile and target penetration (c) Fluorescent emission from the target, excited by the electron beam. (Courtesy Field Emission UK Ltd)

16 *Above* Buckshot and wadding
from shotgun, in flight. Photographed
by reflected light from a 2 nanosecond
pulse of light from an electron
stimulated CdS source (Super Radiant
Light). Note the very fine detail
visible in the wadding where critically
focused. (Courtesy Field Emission UK
Ltd)

17 *Right* Kerr cell photograph during
the detonation process of an annular
cylinder of explosive, initiated from a
centrally positioned exploder system.
The exposure duration was 0.3μ sec
and an argon flash bomb was used to
provide background illumination.
(Crown copyright reserved. Reproduced
by permission of the Controller of H.M.
Stationery Office)

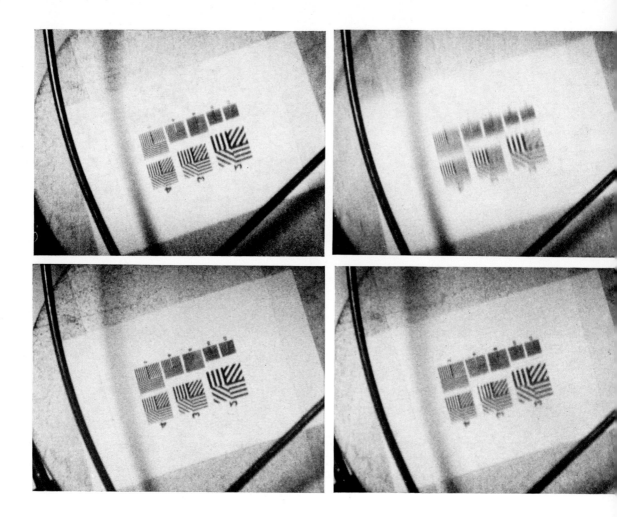

18 Comparison images from rotating
prism camera (Fastax) with continuous
tungsten illumination and stroboscope
illumination. Subject is a resolution
chart fixed to the blade of an electric
fan. Average linear velocity of chart
12 metres/sec, camera speed 3,100 fps.
Top left : tungsten illumination, fan
stationary. Top right : tungsten
illumination, fan rotating. Bottom
left : stroboscope illumination, fan
stationary. Bottom right : stroboscope
illumination, fan rotating. The area
shown is enlarged X14·5 from the
negative, so that the chart is actual size.

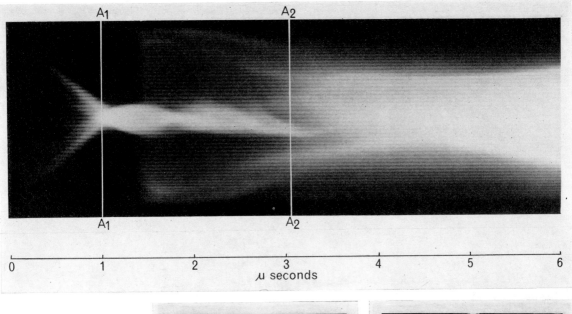

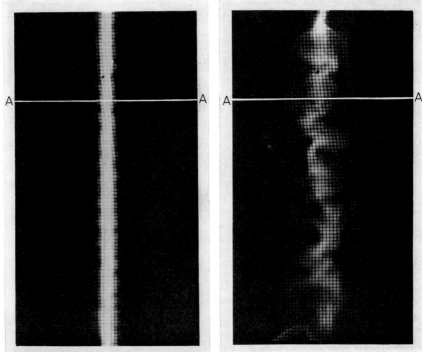

19 Streak and framed records showing the complementary information provided by the two forms. The event is a linear pinched discharge in a deuterium/oxygen mixture. Top: rotating mirror streak camera record showing the growth and changes occurring in one plane continuously during the discharge. A^1A^1 and A^2A^2 indicate the equivalent times of the still records below. Left: Kerr cell photograph (0.1μ sec duration) taken at $t = 1.0\mu$ sec. Right: Kerr cell photograph taken at $t = 3.1\mu$ sec. Section AA in these records shows the sampling plane of the streak record.

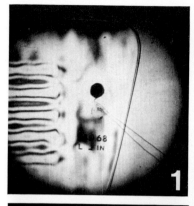

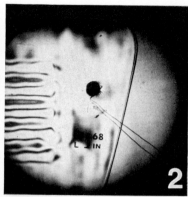

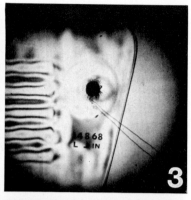

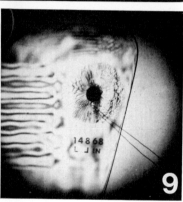

20 *Above* Fracture of a toughened glass windscreen photographed by polarised light on a rotating mirror camera : the first 9 of a series of 23 frames, exposed at a frequency of 200,000 fps on a modified Barr & Stroud C5 camera, (Courtesy Pilkington Brothers Ltd)

21 *Below* Sequence from an image tube camera (TRW) showing five images of the point-to-plane breakdown of a 200kV electric arc. Exposure frequency 6.7×10^6 fps, exposure duration per frame 50 nsec. (Courtesy Marchwood Engineering Labs CEGB)

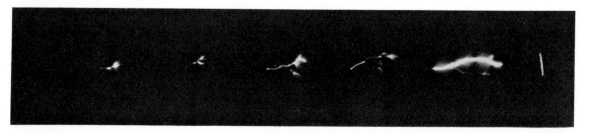

Top to bottom 22 Trace, with screen graticule, of typical transient event with wide range of writing speeds : pressure drop in a liquid caused by rapid operation of a piston. (Courtesy K Thiru)
23 Trace with z-axis (intensity) time scale superimposed. This method is particularly suitable for continuous trace records which cannot include a graticule.
24 Continuous film drive used in conjunction with, but at right angles to, normal time-sweep of oscilloscope. This method allows recording of high frequency phenomena over a long period.
25 Continuous trace recorded with moving film camera to show the variation in pulse shape, visible on 2nd and 12th pulses. Note the slight streaking caused by the use of P11 phosphor with high film velocity (23 metres/sec.)

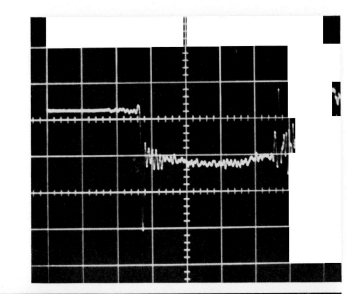

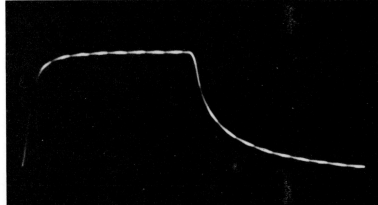

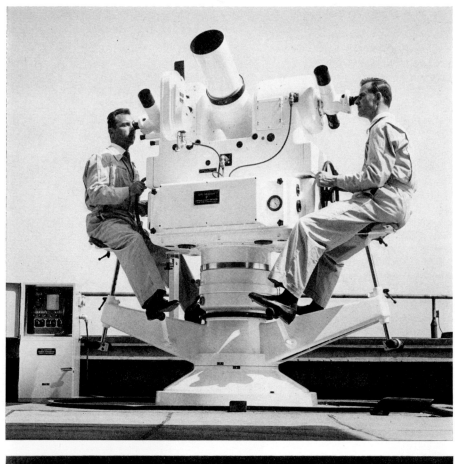

26 *Above* Contraves EOTS Digital
Theodolite Model E, controlled by two
operators.

27 *Below* A frame from the
cinetheodolite record, showing the
coded time and positional data display
to the left of the picture. (Courtesy
Contraves AG, Zurich)

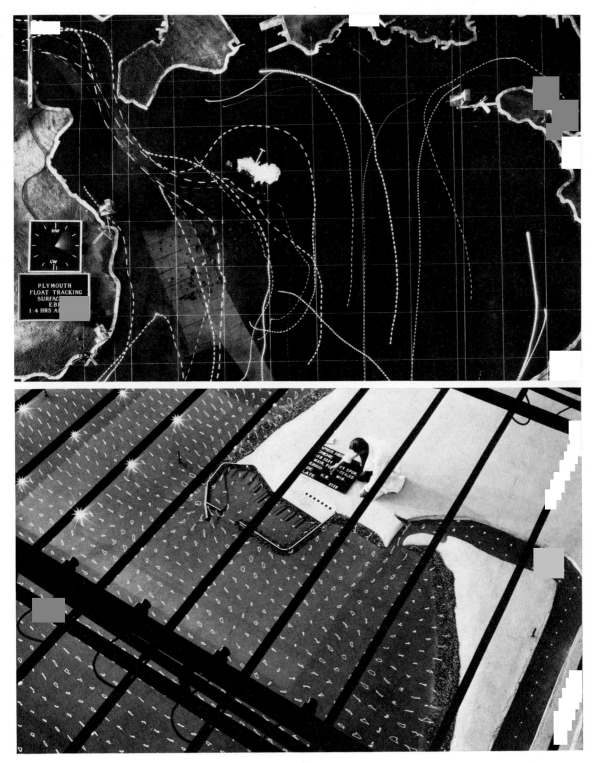

28 *Above* Visualisation of tidal currents on a model (see p 413). The tracks are given by a floating candle, with 'time-base' interruption by a rotating shutter in front of the overhead camera.

29 *Below* The 'starry sky' technique for water surface studies (see p 412) (Both pictures : Crown copyright). (Courtesy Hydraulics Research Station, Wallingford)

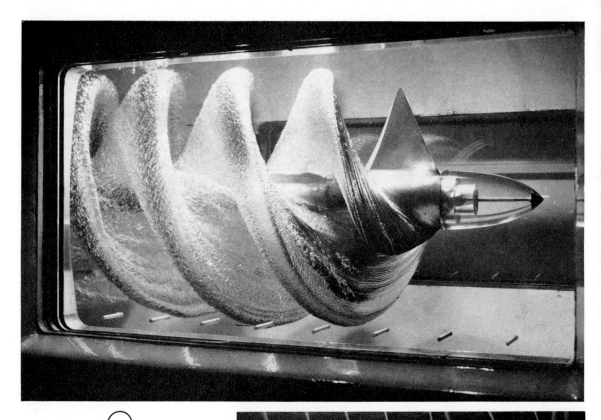

30 *Above* Marine propellor cavitation study in a water tunnel at the NPL Ship Division, Feltham. Crown copyright (Courtesy National Physical Laboratory, Teddington)

31 *Below* The recording of oscillatory movements (eg sewing machine mechanism) with a repetitive flash and a rotating 'still' camera. Crown copyright. A, Subject. B, Opaque screen. C, Repetitive flash source. D, Slit aperture limiting field of view. E, Lens node (rotation axis of camera). F, Film plane. G, Image of subject. H, Direction of rotation of camera back. (Courtesy Central Unit for Scientific Photography, RAE Farnborough)

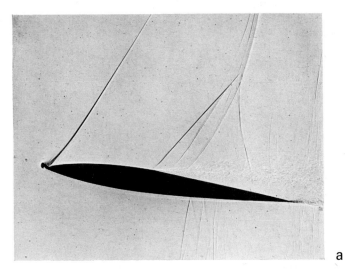

a

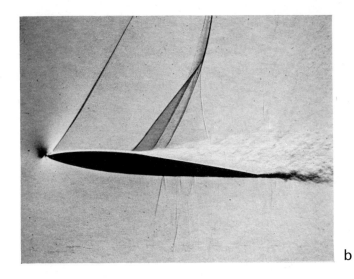

b

32 Airflow past a two-dimensional aerofoil. Comparison of visualisation techniques. (a) Direct-shadow photograph (see p 414) (b) Toepler schlieren photograph (see p 416) (c) Interferometer photograph (see p 419). Exposure duration approximately 1 μs for all three records. Crown copyright (Courtesy National Physical Laboratory, Teddington)

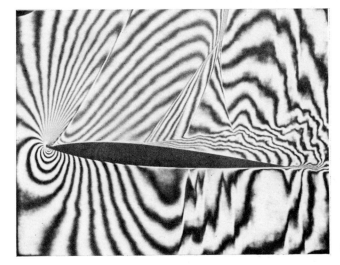

c

33 *Above* Deposit on process vessel
photographed to show two views using
the camera and stand described in
Figure 17.2 (Courtesy UKAEA)

34 *Below* Typical introscope (endoscope)
photograph using distal illumination :
weld on the interior surface of steel
tube, magnified X3.

35 *Above* R.E. Periphery camera set to photograph the circumference of a piston. (Courtesy Research Engineers Ltd)

36 *Below* Complete circumference of piston, photographed as above, showing areas of greatest wear. (Courtesy Research Engineers Ltd)

37 *Above* Interior of nuclear reactor
vessel photographed through a 3-inch
diameter periscope, using independent
lighting suspended in the vessel.
One of the illumination units is seen at
the bottom right of the picture.
(Courtesy UKAEA)

38 *Below* Part of a reactor fuel rod
photographed in a concrete active-
handling cell using a telephoto camera
and the apparatus shown in Figure 18.9
to show three views of the circumference.
This is a black and white print taken
from an original 35mm colour
transparency. (Courtesy UKAEA)

5. PHOTOMICROGRAPHY

5.1 *Microscope Image Formation*

The principle upon which the compound microscope depends is shown in Fig. 5.1. The objective forms a real primary (magnified) image of the subject, and the eyepiece (or ocular) produces a magnified virtual image of this primary image. It is this virtual image which the eye sees.

The total magnification is:

$$\frac{\text{the angle subtended at the eye by the final virtual image (O)}}{\text{the angle subtended by the object O, at the normal viewing distance of 10 in.}}$$

and is the product of the individual magnifications of the objective and eyepiece.

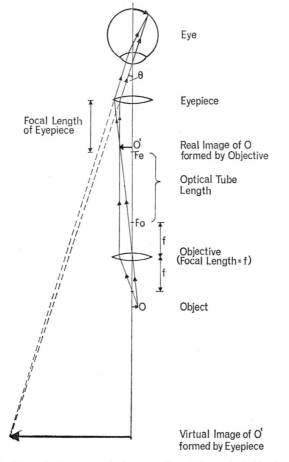

Eye

Eyepiece

Focal Length of Eyepiece

O'
Fe — Real Image of O formed by Objective

Optical Tube Length

Fo
f

Objective (Focal Length = f)
f

O — Object

Virtual Image of O' formed by Eyepiece

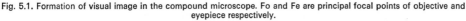

Fig. 5.1. Formation of visual image in the compound microscope. Fo and Fe are principal focal points of objective and eyepiece respectively.

161

$$\text{The objective (or primary) magnification} = \frac{\text{Optical tube length}}{\text{Focal length}}$$

$$\text{and eyepiece magnification} = \frac{\text{Normal viewing distance (10 in.)}}{\text{Focal length of eyepiece}}$$

The optical tube length is the distance between the rear principal focal plane of the objective and the front focal plane of the eyepiece.

Fig. 5.2 shows a compound objective and eyepiece, and illustrates the following additional features:

 working distance of the objective—physical clearance between front of objective and subject.

 mechanical tube length—the distance between the locating shoulders of objective and eyepiece. Compare this with optical tube length in Fig. 5.1.

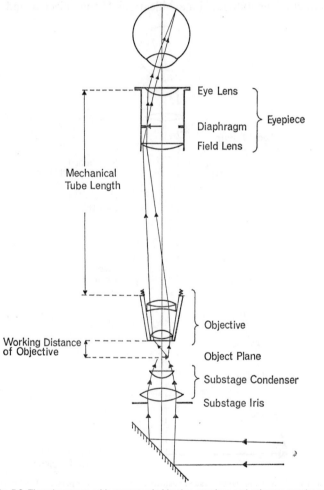

Fig. 5.2. The microscope with compound objective, eyepiece and substage condenser.

162

the substage condenser, which provides suitable illumination by focusing light into the object plane. Proper illumination is an extremely important aspect of photomicrography and will be treated in detail later (5.3.2).

Fig. 5.3 shows the adjustments and controls on a typical 'traditional' bench microscope. Configurations vary between manufacturers and modern designs tend to depart from the traditional shape shown, commonly including beamsplitters, inclined tubes, binocular viewing or built-in illuminators. However, the principles remain the same.

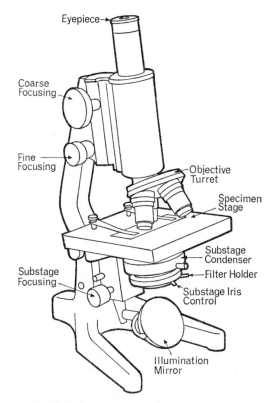

Fig. 5.3. Important controls of a laboratory microscope.

5.1.1 FORMING A REAL IMAGE. In order to record the microscope image on a photographic plate or film, a real image must be formed on the emulsion. A simple way of achieving this is to use a complete camera with its lens focused at infinity in the position the eye would normally occupy. Although an image can be obtained in this way, the difficulty of locating the camera lens at the exit pupil of the microscope eyepiece often causes vignetting. Moreover the magnification is dependent on the focal length of the lens and the additional air/glass surfaces never improve image quality.

The normal method is to remove the camera lens and alter the position of the primary image relative to the eyepiece so that it falls just *outside*, instead of inside, the focal plane (Fig. 5.4). A real image is then formed by the eyepiece on the film. The

163

position of the primary image is usually altered by refocusing the objective (away from specimen) so that the image is formed nearer to the objective.

The magnification of the real image obtained depends on its distance (D) from the eyepiece.

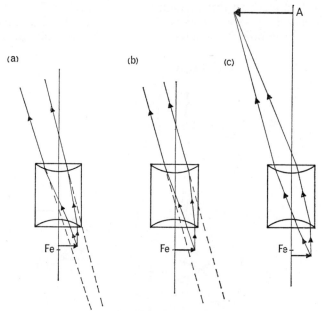

Fig. 5.4. Position of primary image to form: (a) virtual image at normal viewing distance (250mm), (b) virtual image at infinity, (c) real image on photographic material at A.

Total magnification on screen=

objective magnification × eyepiece magnification × $\dfrac{D}{10\ \text{in.}}$

For accurate work the magnification should always be checked by measuring on the focusing screen the image of a scale (stage micrometer) placed in the object plane.

5.1.2 NUMERICAL APERTURE. The most important property of the objective is its *numerical aperture* or NA. This is a measure of the angular cone of light accepted by the objective from a point on the object, and is defined as

$$NA = n \sin \theta$$

where n is the refractive index of the medium between objective and object and θ is half the angle of acceptance of the objective. When more than one medium is involved it is usual to take the lower value of n and the value of θ in that medium (Fig. 5.5).

The NA is an effective measure of the light-gathering power of the objective. It is

related approximately to the *f*-number by the function $NA = \dfrac{1}{2 \times f\text{-number}}$ Eq. 4.3(b)

and also governs the resolution obtainable, taking account of factors 1 and 2 below.

5.1.3 RESOLUTION OF THE OBJECTIVE. The performance of a microscope system is determined primarily by the objective, and although microscope objectives suffer in

164

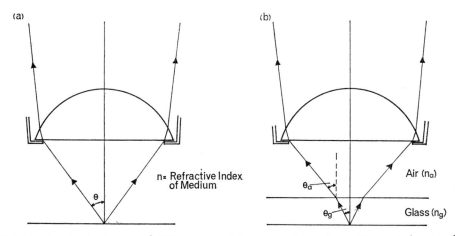

Fig. 5.5. (a) Numerical Aperture $= n \sin \theta$. (b) When two media (e.g. glass and air) are involved NA $= n_a \sin \theta_a$ or $n_g \sin \theta_g$. Since $n_g = \dfrac{\sin \theta_a \times n_a}{\sin \theta_g}$ these values are identical.

the same way as ordinary camera lenses from aberrations, the major factor which limits the resolution obtainable is diffraction. Resolution is the minimum separation between two points which can be distinguished as such, and depends primarily on three factors:

1 The angular cone of light accepted by the objective
2 The medium between objective and subject, and
3 The wavelength of light used (λ).

Abbe's theory of resolution considers adjacent points in the subject as similar to lines in a diffraction grating and suggests that to resolve the points the objective must accept at least two of the diffracted rays including the zero order ray. Fig. 5.6 shows the conditions for resolving two such points with axial and oblique illumination. In the

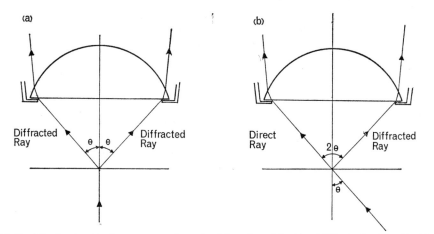

Fig. 5.6. Condition for the objective to accept a first order diffracted ray (a) with axial illumination (b) with oblique illumination at angle θ matching objective aperture.

165

latter case (Fig. 5.6b) the angle of the first order diffracted ray accepted is twice that with axial illumination, indicating better resolution. Abbe quoted the separation of two points which can just be resolved as:

$$S = \frac{\lambda}{NA} \text{ with axial illumination}$$

or with oblique illumination, i.e. with the illumination cone matching the objective aperture

$$S = \frac{\lambda}{2\,NA} \qquad\qquad\qquad Eq.\ 5.1$$

Abbe's theory of resolution provides a simple, convenient formula and is widely accepted. An alternative formula, due to Lord Rayleigh, is derived from Airy's formula for the diameter of the diffraction image of a point (Airy disc). Rayleigh's formula for resolution, assuming illumination to match the acceptance cone of the objective is:

$$S = \frac{1 \cdot 22\lambda}{2\,NA} \qquad\qquad\qquad Eq.\ 5.2$$

Although the figures produced from Abbe and Rayleigh's formulae differ by 22 per cent this is neither surprising nor very significant when it is considered that we are dealing with detail which is either *just* visible or *just not* visible and there is no clear-cut division between these two states. The nature, in particular the contrast, of the object points will almost certainly make a practical difference to resolution. The figures relate to maximum theoretical resolution and are not necessarily achieved in practice (see also Chapter 2).

The important feature of these formulae is the agreement that resolution improves proportionally with shorter wavelength and higher NA, and that the best resolution is obtained when the illumination cone matches the angular aperture of the objective.

5.1.4 USEFUL MAGNIFICATION. Human eyes differ in their ability to resolve fine detail and the viewing conditions and nature of the subject influence the visibility of such detail. However, it is generally accepted that under ideal conditions a good eye might be expected to resolve points which subtend an angle of 1 minute arc. This corresponds to a separation of 0·072 mm at normal viewing distance of 250 mm. Fig. 5.7 shows other standards of visible resolution in terms of angular and linear separation.

The useful magnification of a microscope is that required to make the smallest detail resolved by the objective large enough to be resolved by the eye, whether viewed as a virtual image or projected and recorded photographically. In either case a viewing distance of 250 mm can normally be assumed, but in the case of a photographic image any enlargement of the negative must be included in the magnification.

Taking Abbe's formula for resolution and working an example for a NA of 0·25 (typical $\times 10$ objective) with green light (550 nm), we find that:

$$\begin{aligned}
\text{resolution} &= \frac{\lambda}{2\,NA} \\
&= \frac{550}{2 \times 0 \cdot 25}\ \text{nm} \\
&= 1100\ \text{nm} \\
&= 1 \cdot 1\ \mu\text{m}
\end{aligned}$$

166

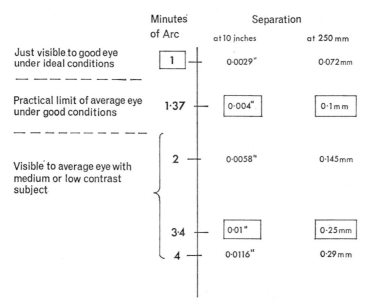

Fig. 5.7. Standards of visible resolution with the naked eye.

In order to make a separation of $1\cdot 1 \mu m$ *just* visible to the eye (taking one minute of arc as the standard) the magnification necessary is $\dfrac{0\cdot 072 \text{ mm}}{1\cdot 1 \mu m}=\dfrac{72}{1\cdot 1}=66$ (or $264 \times NA$).
To make the separation of $1\cdot 1 \mu m$ easily visible to the eye (taking 4 minutes of arc as the standard) the magnification necessary is $\dfrac{0\cdot 29 \text{ mm}}{1\cdot 1 \mu m}=\dfrac{290}{1\cdot 1}=264$ (or $1056 \times NA$).

We can say that:
(1) A magnification of less than about 250 NA cannot make full use of the resolving power of the objective.
(2) A magnification of about 1000 NA is the maximum needed to make the resolved detail visible. This is commonly termed the maximum useful magnification (MUM) and the figure of 1000 NA is an easily remembered rule of thumb.

Further magnification beyond the MUM will not reveal more detail in the specimen and is known as *empty magnification*. This is generally to be avoided as the image produced will be of a 'woolly' nature. A small degree of empty magnification is however sometimes justified in order to make a detail larger and therefore more easily identified. When the viewing distance is greater than 250 mm, e.g. when a photomicrograph is projected as a lantern slide or enlarged for exhibition purposes the image size may be proportionally greater without empty magnification becoming apparent.

5.1.5 DEPTH OF FIELD. In any photographic record the depth of field is governed by the angular cone of light from an object point which is accepted by the lens and the criterion of sharpness applied. In photomicrography the sharpness criterion is related to the objective resolution (this being the basis of acceptable image sharpness at the MUM) and the angular cone is dependent on the objective NA and the refractive index of the medium *surrounding the object*.

167

The depth of field is given by the following formula where n is the refractive index of the medium in the object space (*this may be different from the value used in defining NA*):

$$D = \frac{\lambda \sqrt{n^2 - (NA)^2}}{(NA)^2}$$

Eq. 5.3

If λ, the wavelength of light used, is measured in μm the depth of field (D) is found in μm, also.

So for a typical $10 \times /0{\cdot}25$ NA objective used with a specimen in air (assuming $\lambda = 500$ nm)

$$D = \frac{\frac{1}{2}\sqrt{1 - 1/16}}{1/16} = \sim 8\ \mu m$$

but if the specimen is mounted in canada balsam (n$=1{\cdot}5$ approx.)

$$D = \frac{\frac{1}{2}\sqrt{9/4 - 1/16}}{1/16} = \sim 12\ \mu m$$

Visual observation through the eyepiece provides an *additional* field depth arising from accommodation of the eye, which can focus comfortably on the virtual image at any distance between 250 mm and infinity. Instinctive visual refocusing gives a depth of field equal to $\dfrac{250\ mm}{M^2}$ where M is the total magnification. If M$=100$, this is 25μm, making the total visual depth of field 33μm or 37μm, to be compared with 8 or 12μm above. This accounts for some of the more critical requirements for photomicrographic work.

Possible methods for increasing the apparent practical depth of field using multiple exposures or continuously varying focus position on a single exposure have been suggested. [8, 9, 10] The best of these uses a very narrow slit illumination at right angles to the optical axis which confines the light to the part of the subject in the focal plane. This method, which is similar to that described on p. 153 for macro work, can be applied only to subjects where illumination at right angles is practicable.

TABLE 5.1

SPECIFICATIONS OF TYPICAL MICROSCOPE OBJECTIVES

Type	Magn./NA	Working distance	Typical object field diameter*
Achromat	3·5/0·07	25mm	5mm
	10/0·25	5mm†	1·5mm
	20/0·50	1·5mm	0·8mm
	40/0·65	0·5mm	0·4mm
(Oil)	40/0·95	0·3mm	0·4mm
(Oil)	100/1·30	0·15mm	0·15mm
Apochromat	10/0·35	2·0mm	1·5mm
	20/0·65	1·0mm	0·8mm
	40/0·90	0·2mm	0·4mm
(Oil)	100/1·40	0·1mm	0·15mm

*Practical figure depends on eyepiece used. Useful limit may be higher especially with apochromatic objectives.
†Some manufacturers produce 10X objectives with about 10mm working distance.

5.2.1 OBJECTIVES. The most important part of the microscope optical system is the objective.

A quick glance through a manufacturer's list of objectives shows what appears at first sight to be a bewildering selection, thirty or forty different examples being quite common. We can, however, simplify such a list by reference to certain important characteristics.

(1) Magnification.

(2) Numeral aperture.

(3) Working medium (air or liquid—immersion oil, water, etc.).

(4) Cover glass thickness.

(5) Mechanical tube length.

(6) Degree of correction: (a) Colour; (b) Flatness of field.

5.2.1.1 *Primary magnification* (*nominal*) The nominal magnification or power of an objective (as defined on p. 162) is engraved on its mount. This is the magnification of the primary image when the objective is used at its intended tube length. Actual values may vary slightly from those marked, and can be checked by comparing the image of a stage micrometer with an eyepiece scale.

5.2.1.2 *Numerical aperture.* The NA (see page 164) is usually marked on the mount, immediately after the magnification and separated from it by an oblique line, e.g. 10/0·25. In this case the NA is 0·25 which is typical for a $10 \times$ objective. The NA and magnification of a microscope objective are analogous to *f*-number and focal length of a lens in ordinary photography.

5.2.1.3 *Working medium.* Practically all medium and low power objectives are intended to be used 'dry', that is with air as the medium immediately in front of the objective, the NA being dependent only on the half angle of acceptance θ.

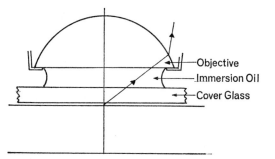

Fig. 5.8. Oil immersion objective. Rays from the object pass undeviated through cover glass, oil and front component of objective.

The largest half angle of acceptance which can be achieved in practice is about 71°. As sin 71°=0·95 the largest 'dry' NA obtainable is 0·95. However, if the medium between the objective and object has a refractive index significantly higher than that of air the value of NA can be raised in proportion. Special immersion oils are used, which have a refractive index virtually identical to glass (1·524 is most common). Fig. 5.8 shows that light from the object now passes into the front component of the

objective without any refraction taking place. So that if θ is again 71°, a NA of $n \sin\theta = 1\cdot5 \times 0\cdot95 = 1\cdot42$ (approx.) can be obtained.

Objectives have been designed for immersion in other media such as water ($n = 1\cdot333$), glycerol ($1\cdot463$) and monobromonapthalene ($1\cdot656$) but these are comparatively rare.

Practically all manufacturers offer high-power, oil-immersion objectives of $90\times$ or $100\times$ with a NA of between $1\cdot25$ and $1\cdot40$ and some lower power (e.g. $40\times/0\cdot95$) immersion objectives. The latter have the advantages over dry objectives of a slightly longer working distance, and of being less critical to cover glass thickness (see below).

Objectives designed for oil immersion are usually marked Oil or Oel and must not be used dry, because this completely upsets their correction, particularly for spherical aberration.

5.2.1.4 *Cover glass thickness*. A cover glass is necessary for a large proportion of microscope specimens (particularly biological and chemical preparations to be viewed by transmitted rather than reflected light). This thin glass slip serves to keep the specimen flat or in one plane and provides a distortion-free surface through which to view. It also protects the specimen from dust, damage and unwanted drying out. A preparation mounted with cover glass can be effectively sealed to allow permanent storage.

Because the cover glass is a thickness of optical material between the object and the objective it plays a part, and at times a very important part, in the image quality of the microscope. Fig. 5.9 shows rays of light refracted into air appearing to have come from different points above the object. This is the effect of spherical aberration, and must be compensated for in the design of the objective by introducing a similar but opposite aberration. As the effect increases with the angle of the ray, it is most serious with high NA objectives. Most current objectives intended for use with cover glasses are corrected for a thickness of $0\cdot17$ or $0\cdot18$ mm (with refractive index of $1\cdot524$) but the thickness tolerance depends on the NA as follows:

up to $10\times/0\cdot30$	with or without cover glass
up to $45\times/0\cdot65$	$\pm0\cdot05$ mm
up to $70\times/0\cdot95$ dry	$\pm0\cdot01$ mm
oil immersion objectives	$\pm0\cdot05$ mm or not critical at all
water immersion	$\pm0\cdot05$ mm

In the case of oil immersion objectives the medium between the objective and object is virtually homogeneous whether a cover glass is used or not (Fig. 5.8), although some manufacturers quote a tolerance of $0\cdot05$ mm.

Some high power dry objectives are available in an adjustable mount which allows correction for cover glass thickness by varying the spacing of components.

Since the object plane to be examined cannot always be in contact with the cover glass a supply of rather thinner glasses is useful. The effective thickness is equal to:

actual glass thickness $+$

$$\left(\text{depth of object within mountant} \times \frac{\text{refractive index of mountant}}{\text{refractive index of glass}} \right)$$

The specified cover glass thickness is engraved on the objective, usually separated from the tube length by an oblique stroke e.g. $160/0\cdot17$ or sometimes $0\cdot17/160$. A

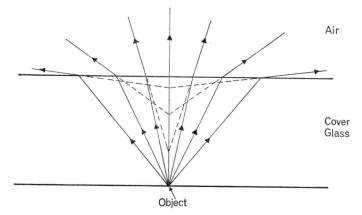

Air

Cover
Glass

Object

Fig. 5.9. Light rays from object point, after refraction from cover glass into air.

dash (e.g. 160/—) indicates use with or without cover glass. Zero (e.g. 160/0) indicates use with uncovered specimens.

Chance Brothers offer cover glasses of RI 1·524 ±0·001in five thicknesses as follows:

$$\text{No. 0} \quad 0\cdot085\text{--}0\cdot130 \text{ mm}$$
$$\text{No. 1} \quad 0\cdot130\text{--}0\cdot160 \text{ mm}$$
$$\text{No. } 1\tfrac{1}{2} \quad 0\cdot155\text{--}0\cdot185 \text{ mm}$$
$$\text{No. 2} \quad 0\cdot190\text{--}0\cdot250 \text{ mm}$$
$$\text{No. 3} \quad 0\cdot250\text{--}0\cdot350 \text{ mm}$$

5.2.1.5 *Mechanical Tube length.* As with cover glass thickness the correction of spherical aberration is obtained for one particular value of MTL and that value is engraved on the objective as indicated above (usually 160 mm but 170 mm for Leitz transmitted light objectives—sometimes longer for reflected light).

Because both tube length and cover glass thickness affect the correction for spherical aberration it is possible to use one to compensate for error in the other. However, few modern instruments allow the tube length to be varied, so it is usually necessary to use objectives on a microscope of appropriate tube length, and with correct cover glass.

In many modern microscopes, especially the more complex instruments, the concept of tube length is complicated by the introduction of prisms to give inclined viewing or beam splitting facilities, or sometimes by amplifying lenses. In such cases the ancillary optics of the microscope are made to give the optical equivalent of that length. Some objectives for reflected light work are corrected for infinite tube length. This system has the advantage that any semi-reflecting glass introduced behind the objective interrupts the image forming rays where they are parallel and therefore introduces no aberration. A further lens beyond the reflector converges this beam to form the primary image.

5.2.1.6 *Degree of correction.* Microscope objectives are generally categorised primarily according to their basic colour correction and secondarily by their flatness of field. This gives us the following types of objective:

(1) Achromatic.

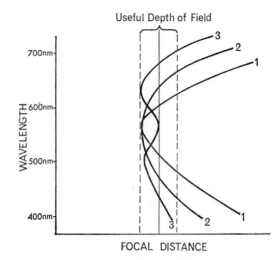

Fig. 5.10. Secondary spectrum of 1, achromatic; 2, fluorite; 3, apochromatic objectives.

(2) Fluorite or semi-apochromatic.
(3) Apochromatic.
(4) Flat field (achromatic and apochromatic).

An *Achromatic* objective is corrected to bring light of two different wavelengths to a common focus on its axis. Fig. 5.10 shows the variation in focal length plotted against wavelength. The spreading of focus which remains is known as the secondary spectrum, and obviously this curve should be as flat as possible. However, the correction of an objective is complicated by the variation of spherical aberrations with

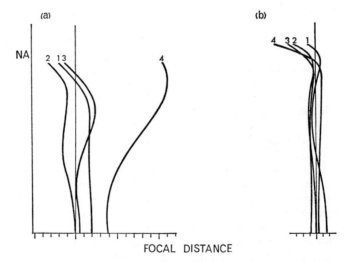

Fig. 5.11. Focal distance plotted against angle of ray (NA) for spectral lines 1, 656 nm; 2, 546 nm; 3, 486 nm; 4, 405 nm (a) achromat (b) apochromat (Leitz).

172

wavelength (sphero-chromatism) and achromatic objectives generally have optimum correction for spherical aberration at one particular wavelength (about 550 nm). The rather complex relationship of colour and spherical corrections is shown in Fig. 5.11 which compares the corrections of achromatic and apochromatic objectives.

Achromats are the most common type of microscope objectives, being moderately priced and quite satisfactory for most visual and many photographic purposes. Where possible it is desirable to use a green filter to restrict the waveband of light to that where correction is best. Unless specially corrected for flatness of field most achromats give a somewhat curved image, recognised by the inability to focus the centre and edge of the image simultaneously. This is less noticeable in visual work owing to accommodation of the eye and the possibility of focus adjustment, but in photographic images made at a single focus position the effect is greater.

High power achromats, together with all fluorite and apochromats commonly suffer from *lateral* chromatic aberration or chromatic difference of magnification. This defect, which is not corrected together with *axial* chromatic aberration, causes the image of a bright spot away from the lens axis to have a red fringe on its inner side and a blue fringe on the outer side (Fig. 5.12). This is corrected in the final image by use of a compensating eyepiece which has an opposite effect. High power achromatic objectives, fluorite objectives and apochromatic objectives should always be used with compensating eyepieces for best results (see 5.2.3.3). Some low power achromats are also left with lateral colour errors so that the same compensating eyepiece can be used for all magnifications. Manufacturers' catalogues indicate when this is the case.

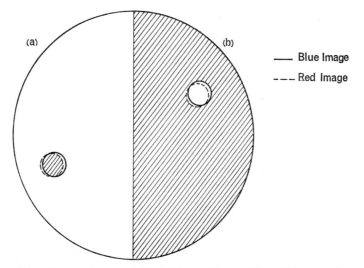

Fig. 5.12. Effect of lateral chromatic aberration. (a) Dark object on light ground has red fringe away from axis. (b) Light object on dark ground has red fringe towards axis.

Fluorite or semi-apochromatic objectives use one or more components of the mineral fluorite in the design which is otherwise similar to that of the achromat. The secondary spectrum is considerably reduced and an effective correction intermediate between achromatic and apochromatic is achieved.

173

Apochromatic objectives use fluorite components, but in larger numbers and more complex optical designs than fluorite objectives. Three wavelengths of light have equal focal distances and the secondary spectrum is very small indeed. Spherical aberration is corrected for two wavelengths instead of one. Because of the extremely high degree of correction possible, apochromats may have larger NAs than achromats of similar magnification and are therefore capable of resolving finer detail. All apochromats (and fluorites) suffer from chromatic difference of magnification. This could be corrected only at the expense of other aberrations, which could not be compensated for at the eyepiece stage, and is therefore allowed to remain, necessitating the use of compensating eyepieces.

Ordinary apochromats (and fluorites) may also suffer from curvature of field and the remarks made concerning achromats with this defect apply.

Because of the complexity of design the cost of apochromats is usually about 4 to 5 times that of achromats.

Flat field objectives are offered by most manufacturers under various names which almost invariably include 'plan' e.g. Leitz Plano, Zeiss Plan, Vickers Microplan, Beck Aplanar.

They are designed to overcome the problem of field curvature and are particularly suited to photomicrography where the image must be received on a flat film or plate. Some microscopists maintain that the resolution of flat field objectives is less than that of good apochromats. However, there is little doubt that for photographic rather than visual use they give a more acceptable performance with flat specimens.

Originally flat field objectives were of achromatic colour correction but examples with apochromatic correction have recently been introduced.[11]

5.2.2 SPECIAL OBJECTIVES

5.2.2.1 *Reflecting objectives*. Catoptric objectives using entirely reflecting surfaces have two special properties which make them most suitable for use with ultra-violet (or infra red) radiation:

(1) Complete freedom from chromatic aberration.

(2) Comparative freedom from spectral absorption of near UV and IR.

Reflecting objectives can also be made with much longer working distances than conventional refracting systems. For instance the $36 \times$ objective shown in Fig. 5.13a has a working distance of about 8 mm, with a NA of 0·5.

Catadioptric objectives (with both refracting and reflecting elements) are also available, often using quartz and/or fluorite to give transmission of ultra-violet (Fig. 5.13b). These, unlike catoptric systems, are liable to suffer from chromatic aberration.

A long working distance can be achieved with medium high power objectives by using a reflection relay system built on to the front to project a same size image into the object plane of the objective. Such a device is shown in Fig. 5.14.

All reflecting objectives have an obstruction of the central area (usually between 10 and 20 per cent) which reduces the image illumination. The resolution, however, because it is dependent on the maximum angle of the cone of light entering the objective, is unaffected and is related to the NA in the usual way.

5.2.2.2 *Objectives for reflected incident light*. Subjects examined in bright field illumination are normally uncovered, so that objectives suitable for use without cover glass are required. Because reflections from air-glass surfaces are much more troublesome

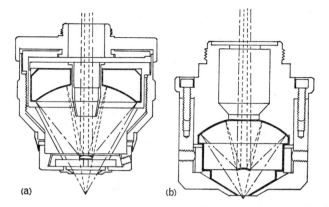

(a) (b)

Fig. 5.13. (a) X36/0.5 Catoptric objective (Beck). (b) XI72/0.9 Catadioptric, water immersion objective using, in effect, a single quartz block (Beck).

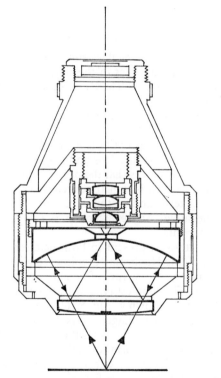

Fig. 5.14. Long working distance attachment fitted to refracting objective (X20 or X40, Vickers).

than with transmitted light work, anti-reflection coatings on all such surfaces are very desirable. Correction for infinite tube length is sometimes used (see p. 171).

For dark field work some manufacturers produce objectives which provide an annular illumination cone around the 'outside' of the image forming objective. In

175

low power versions the illumination, in the form of a parallel beam in the outer sleeve, is focused on to the subject by an annular condenser lens. With higher powers a reflection system is used (Fig. 5.15).

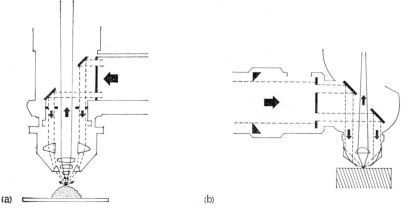

Fig. 5.15. Dark field reflected light objectives. (a) Low power Ultrapak (Leitz). (b) High power Epiplan HD (Zeiss).

5.2.3 EYEPIECES. Any eyepiece (or ocular) suitable for visual observation can be made to give a real image by adjustment of the objective focus (see Fig. 5.4), and in many cases this method is satisfactory. There are, however, other means of obtaining a real image (see p. 177).

Most of the eyepieces in common use are derived from two basic types, the Huygenian and Ramsden oculars.

5.2.3.1 *Huygenian eyepiece*. The essential feature of the Huygenian eyepiece (Fig. 5.16a) is that the separation between eye lens and field lens is always greater than the focal length of the eye lens. This means that the primary image of the microscope must be formed within the ocular, which is sometimes referred to as being negative. This is an unfortunately confusing term and in this sense does *not* signify that the *optical power* of the ocular is negative. Any eyepiece of this type has its field diaphragm between the optical components.

Chromatic aberration, although present in both field lens and eye lens can easily be made self cancelling, enabling Huygenian eyepieces to give very good image quality; and their use with lower power objectives is frequently recommended.

5.2.3.2 *Ramsden eyepiece*. The simplest type of Ramsden eyepiece (called positive in opposition to the Huygenian) is shown in Fig. 5.16b. The separation of the elements is less and the position of the primary image is outside the ocular.

This design does not have the advantage of self correction for chromatic aberration and is not commonly used in simple form for serious work, particularly photomicrography. However, the basic principle is one which lends itself to development and achromatised versions can offer both wide field view and a high eyepoint, this latter feature being particularly useful to spectacle wearers.

5.2.3.3 *Compensating eyepiece*. The lateral chromatic aberration of apochromatic, fluorite and some achromatic objectives is corrected by introducing an opposite characteristic in the eyepiece. A compensating eyepiece when used alone to view a white field shows a yellow or orange fringe around the inside of its diaphragm.

176

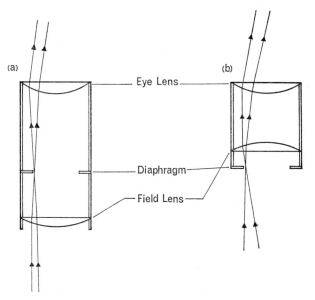

Fig. 5.16. (a) Huygenian eyepiece. (b) Ramsden eyepiece.

The degree of compensation is almost always the same for the relevant objectives of any particular manufacturer, so different compensating eyepieces are not required. However, it is advisable, though not always essential, to use an eyepiece and objective of the same manaufcturer, as these are matched to each other.

Compensating eyepieces may be derived from either of the two types (positive or negative) already discussed.

5.2.3.4 *Flat field and wide field eyepieces*. Although these terms are not synonymous, they tend to go naturally together. Most manufacturers offer oculars in these categories. The minimum magnification is usually $10\times$ and may give a field of view 50 per cent greater than normal eyepieces. They are most useful in conjunction with flat field objectives which give good image sharpness over a wide field.

5.2.3.5 *Projection or photographic eyepieces and amplifying projection lenses*. Some eyepieces sold as projection oculars are in fact more or less conventional oculars corrected to give a flat field suitable for reception on a photographic film or plate. These are essentially no different from the flat field oculars above and can also be used for visual examination.

A second class of projection lenses are quite different in principle from conventional eyepieces. Often described as amplifying lenses, they are truly *negative* systems, i.e. the lens as a whole is divergent (Fig. 5.17) unlike the Huygenian eyepieces which although often called negative are in fact convergent. This method gives a final projected image reversed with respect to the specimen or the same way as the objective primary image. Compare this with Fig. 5.4c.

The exit pupil of such a lens is situated well inside the microscope tube, so that any attempt at visual observation results in only an impracticably small field being visible at one time.

177

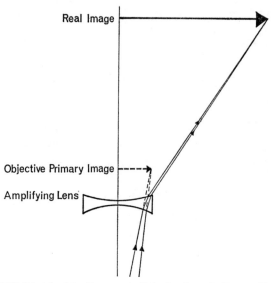

Real Image

Objective Primary Image

Amplifying Lens

Fig. 5.17. Principle of the divergent amplifying lens for projecting a real image.

Perhaps the best known amplifying lenses were the Homal range of Zeiss, but these are no longer made. Bausch & Lomb Ultraplane and two Leitz photographic eyepieces for use with medium and high power objectives are examples currently available. Several of the more complex research microscopes with integral camera facility (e.g. Zeiss Ultraphot) have negative projection lenses of this type built into them (see p. 200).

Amplifying lenses can be made to have the same colour compensation as ordinary compensating eyepieces.

5.2.4 SUBSTAGE CONDENSERS. The best resolution is obtained when the cone of illumination matches the acceptance cone of the objective (p. 165). A substage condenser is used to focus the illumination into the object plane. This condenser is to the illuminating beam what the objective is to the image forming beam and it should have a NA nearly as high as the objective being used. The optical correction of the condenser is not, of course, as critical as that of the objective but nevertheless with large aperture systems a reasonable degree of correction is highly desirable. Many condensers have a removable or swing-out top element to allow the focal length to be increased for low power work (see p. 183). As with objectives the maximum NA is about 0·95 used dry, or 1·4 with immersion oil. An iris diaphragm is normally fitted below the condenser to allow its aperture to be controlled.

5.2.4.1 *Bright field condensers.* The basic types of condenser available for bright field illumination are Abbe, aplanatic and achromatic.

The simple two-lens Abbe condenser (Fig. 5.18a) is uncorrected for spherical and chromatic aberrations and although often available with a NA of 1·2 it is not suitable for critical use, which includes photomicrography.

The aplanatic condenser is corrected for spherical aberration and coma, usually with NA of up to 1·4. Even at high aperture it provides a uniform illuminating cone and is suitable for many photomicrographic applications especially if used with a green filter.

178

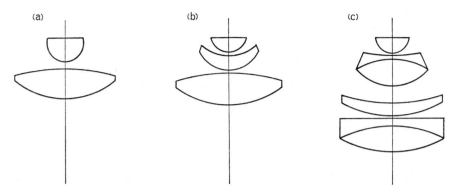

Fig. 5.18. Substage condenser lenses (a) Abbe (b) Aplanatic (c) Achromatic, aplanatic.

The achromatic condenser is corrected for two wavelengths of light, which gives an image of the field iris almost entirely free of colour fringing. Achromatic condensers are generally also aplanatic up to their limit of NA. These have the best available correction with apertures of 1·3 or 1·4.

5.2.4.2 *Dark field condensers*. In order to achieve proper dark field illumination an annular cone of light is required which has a minimum angle greater than the acceptance angle of the objective, so that only light deviated by detail within the specimen will enter the objective. Dark field condensers usually rely on reflecting surfaces to obtain a wide angle illumination cone (Fig. 5.19). The NA of the central obscured aperture is usually quoted, and should be used with objectives of lower aperture than this. The maximum such aperture obtainable is about 1·25 (using oil immersion), which could be used with an objective of 1·20 satisfactorily.

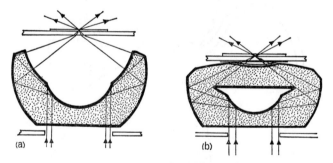

Fig. 5.19. Dark field condensers (Leitz). (a) Dry 0.8 NA. (b) Cardioid oil immersion 1.2 NA. Internal limited apertures are quoted.

5.2.4.3 *Condensers for reflected light*. Both bright and dark field reflected illumination can be used. In bright field work the objective acts also as illumination condenser, while dark field illumination is obtained using special objectives such as Ultrapak or Epiplan HD (see 5.2.2.2, Fig. 5.15).

5.2.5 BERTRAND LENS. The function of a Bertrand lens is to allow the objective rear focal plane to be viewed through the eyepiece. Situated above the objective in the

179

microscope tube and mounted on a sliding or rotating device, it is a positive lens which forms an image of the objective rear focal plane in the front focal plane of the eyepiece. The image seen through the Bertrand lens is sometimes referred to as the *conoscopic* image, as opposed to the normal microscope image which is *orthoscopic*.

The Bertrand lens is particularly valuable for polarised light and phase contrast work and is also useful in setting up proper microscope illumination (p. 183).

5.3 *Microscope Illumination*

5.3.1 LIGHT SOURCES. The properties of light sources generally are discussed in Chapter 3. For photomicrography the source should be of such a configuration that its output can be efficiently concentrated to illuminate a very small area with an even, high intensity. In general, sources of small physical size are preferable. The types commonly used include:

(1) Tungsten filament (compact or 'solid' source).
(2) Mercury vapour arc.
(3) Carbon arc.
(4) Xenon arc (continuous).
(5) Electronic flash.
(6) Sodium vapour discharge (for interference techniques).

Whatever source is used, mounting which provides controlled illumination is most important. With many research microscopes the source together with the illumination

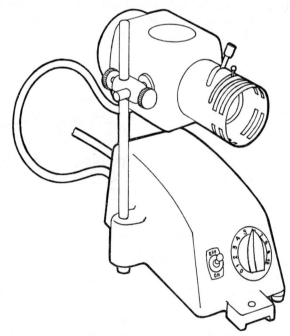

Fig. 5.20. Microscope lamp. Low voltage compact tungsten filament source with variable resistance (Vickers).

optics are built into the microscope body. However, a separate portable lamp is required for use with other bench microscopes. A typical lamp including transformer and variable resistance is shown in Fig. 5.20.

Various types of arc can be mounted with a centring adjustment so that the source occupies the correct position in the optical system. With carbon arcs provision must also be made for adjusting carbons during use, e.g. by automatically controlled servo motor. Carbon arcs are generally being replaced by Xenon arcs and illumination systems are often built into the microscope body. Most arcs are now designed in this way rather than as lamps in their own right.

Electronic flash units designed for microscope use are particularly valuable with living subjects, with which movement is likely or damage by excessive heat possible. For alignment and focusing purposes a low voltage tungsten filament lamp is included, of which an image is formed coincident with the flash tube (Fig. 5.21).

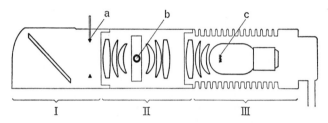

Fig. 5.21. Sectional view of microflash illuminator (Zeiss). I Mirror housing with iris diaphragm. II Flash housing with condensers. III Low voltage illuminator. (a) Luminous field iris. (b) Flash tube in slide. (c) Incandescent filament.

5.3.2 ILLUMINATION TECHNIQUE. Proper illumination of the specimen is possibly the most important aspect of practical photomicrography. A large proportion of sub-standard results can be attributed to a lack of understanding of illumination principles; although proper illumination is quite simple if a number of steps are taken systematically. For consistently successful photomicrography these steps *must* be mastered completely.

5.3.3 BRIGHT FIELD TRANSMITTED ILLUMINATION. In this case the basic aim is to illuminate the specimen with a cone of light which is:

(1) Uniform throughout its angle.
(2) Focused to its smallest diameter in the plane of the specimen.
(3) Confined to the area of specimen being examined.
(4) Coaxial with the microscope objective and eyepiece, which means with the microscope tube.
(5) Of angular aperture (NA) similar to or rather less than that of the objective. This important point is dealt with fully below.

5.3.3.1 *Kohler illumination*. The most useful method of bright field illumination is the Kohler method shown in Fig. 5.22. Its principles can be applied to either low or high power microscopy and it fulfils all of the five conditions above. Normally a plane mirror is used to reflect the beam through about 90° with the lamp axis more or less horizontal. The mirror has been omitted to show the system more clearly. Proper alignment (centration) of the components is a vital part of the setting-up procedure.

181

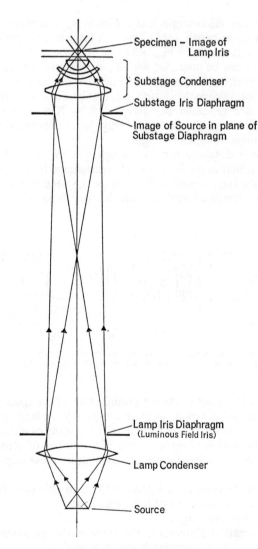

Fig. 5.22. Principle of Kohler illumination.

The two other important points to note are:
 (1) The lamp filament is imaged by the lamp condenser into the plane of the sub-stage iris.
 (2) The lamp iris is imaged by the substage condenser into the specimen plane. The lamp distance should be sufficient to make the image of the lamp filament fill the open area of the substage iris.

Assuming the use of a suitable microscope lamp with focusing condenser and iris diaphragm, the complete procedure for setting up a microscope with Kohler illumination is as follows:

182

(1) Start with objective, ocular and substage condenser removed from microscope stand, but with plane mirror in position.

(2) Place the microscope lamp (at low intensity) in a suitable position about 25 cm away with the diaphragm open and direct its beam on to the centre of the mirror.

(3) Adjust the angle of the mirror so that the beam is reflected up the centre of the microscope tube. This is facilitated by the use of pinhole alignment apertures in the objective and eyepiece positions.

(4) Insert substage condenser (without disturbing the mirror) and focus the lamp condenser so that the filament image is obtained in the plane of the substage iris.

When using a research microscope with built-in illumination system steps (1) to (4) can be omitted. The instrument handbook will say what alignment (if any) is necessary.

(5) Open the substage iris fully. Insert medium low power (say 10×) objective, eyepiece and specimen slide. Focus the microscope image through the eyepiece.

(6) Close the lamp iris to its smallest aperture and focus the substage condenser so that the image of this aperture is formed in the object plane. This will be seen by viewing through the eyepiece, the lamp iris appearing superimposed on the specimen.

(7) Adjust the condenser centring screws to bring this image central in the visible field and open the lamp iris (sometimes referred to as the luminous field iris) until the area visible is just completely illuminated.

(8) Set the substage iris to achieve the best compromise between resolution and image contrast. Too wide an opening will allow flare to degrade the image, too small an opening will spoil the resolution and cause diffraction effects to become visible (Plate 5). Careful examination of the image as the diaphragm is manipulated will show these effects and it is possible to set the substage iris while viewing through the eyepiece. However, this method requires a fair amount of experience, the tendency being to close the iris too far in order to increase contrast, resulting in a poorly resolved image. The recommended method, which good microscopists often use anyway as a check, is to remove the eyepiece and observe the rear exit pupil (or rear focal plane) of the objective. Here will be seen an image of the substage iris. The most generally satisfactory setting is when this image is about 4/5 the diameter of the exit pupil. It should normally not be larger than the exit pupil although it should be kept as large as possible consistent with reduction of flare. A Bertrand lens, if fitted, can be used to observe the exit pupil instead of removing the eyepiece.

The microscope is now properly set for visual observation. For photographic recording the focus must be adjusted to give a sharp image in the film plane and the field iris checked to ensure that the entire field of view is (just) evenly illuminated. Whenever the field of view is altered, either by changing of optics or camera extension the field iris should be readjusted.

If the objective is changed the setting of the substage iris must also be altered to suit the NA of the new objective. If an oil immersion objective is used (particularly with NA above 1·20) the condenser as well as the objective should be oiled to give the necessary illuminating aperture. Only a *small* drop of oil is required in each position. An oiled condenser also helps to reduce flare.

With low power objectives it may be found that the area illuminated by the condenser is too small. In this case a condenser of longer focal length is required to give a

larger image of the lamp iris. This may be achieved by removing or swinging aside the top element of some condensers or inserting a negative supplementary lens in others. The condenser will need refocusing, of course, after this modification.

When using Kohler illumination it is important to remember that:

(1) The lamp iris controls the size of field illuminated.

(2) The substage iris controls the NA of the illuminating beam.

(3) The brightness of illumination is controlled by varying the voltage to a tungsten lamp or by using neutral density filters. The illumination must *not* be reduced by closing the substage iris to a very small aperture.

The only occasion where closing of the substage iris to a small aperture is acceptable is when transmitted illumination is used to provide a light background while *opaque* particles are illuminated by reflected light to show surface detail. In such cases the microscope is focused near the uppermost parts of the subject so that as much surface as possible is sharp. If background transillumination from a small aperture is used the edges of the particles can be appreciably sharpened giving the appearance of greater depth of field (Plate 6). This technique is permissible only because important detail is not illuminated through the small aperture and should be used only when this is the case: even so care must be taken to avoid any obvious diffraction effects which can still be objectionable.

5.3.3.2 *Critical illumination.* The term 'critical illumination' is currently used in two ways: in a general sense, for any illumination method which fulfils the requirement of properly matching the acceptance cone of the objective, and specifically for a method which images the light source in the object plane.

This is similar to Kohler illumination except that the lamp condenser is set to focus the source image at infinity, giving a parallel beam to the substage condenser. Because an image of the source is focused in the specimen plane this method requires a source with a uniform intensity over a reasonable area (perhaps 3 or 4 mm diameter with $10 \times$ objective). This requirement makes it less generally useful than the Kohler method although it is used in slightly modified form (e.g. with a diffuser over the source) in some research instruments where long light paths are unavoidable.

5.3.4 DARK FIELD TRANSMITTED LIGHT. This illumination technique is particularly useful for studying fine structures or very small particles, which stand out clearly against a dark background. For low and medium power objectives it is possible to use an ordinary substage condenser with a central opaque stop in place of the normal iris diaphragm. Opaque discs of varying sizes on lith film provide a useful set of darkfield stops. The objective exit pupil should appear uniformly dark when viewed down the microscope tube, any light edges indicating that either the size or alignment of the central stop is incorrect.

With high power objectives special dark field condensers (Fig. 5.19) are needed which are used with immersion oil to obtain a very wide angular cone. Objectives of very high NA (e.g. 1·4) require a reduction in aperture to allow dark field illumination. Some have iris diaphragms fitted, or a funnel stop can be inserted.

5.3.5 REFLECTED ILLUMINATION—BRIGHT FIELD OR VERTICAL INCIDENT. In the reflected bright field technique the microscope objective acts as its own condenser, with some form of vertical incident illumination attachment. Two methods are shown in Fig. 5.23; (a) using a semi-reflecting surface covering the entire aperture of the objective and (b) using a totally reflecting prism over half of the objective aperture.

184

This latter system uses one half of the objective to illuminate the specimen and the other half for image formation. The result is not strictly vertical illumination because the light reaches the specimen as a slightly oblique beam. However, as all this light specularly reflected enters the objective the effect is bright field illumination. This system reduces the useful aperture of the objective, restricting resolution *in one direction*.

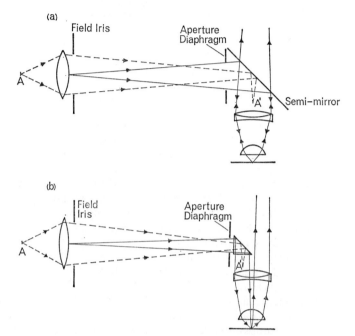

Fig. 5.23. Reflected bright field illumination (vertical incident). (a) With semi-reflecting mirror. (b) With off-centre prism

The other more common method, using a semi-reflecting mirror (or glass plate), gives a centred illumination cone in the same way as with transmitted illumination. An image A′ of the lamp filament A is formed in the rear focal plane of the objective. If the lamp condenser (and iris diaphragm) are at a distance approximately equal to the tube length, the objective forms an image of this diaphragm in the subject plane. It will be noticed that the aperture diaphragm is not quite in its ideal position in the focal plane of the objective, but this discrepancy causes little trouble in practice.

Many vertical illumination devices, particularly those built into metallurgical microscopes have an extra lens in the optical system (Fig. 5.24). This has the effect of reversing the functions of the diaphragms, making the lamp iris work as the aperture diaphragm with the luminous field iris nearer the objective.

The critical adjustment of the two diaphragms in the illumination beam is as important as for transmitted light.

The control of unwanted reflections which cause flare is one of the problems of vertical incident illumination. Whether or not flare becomes objectionable depends largely on the nature of the specimen surface and cleanliness of the optics.

185

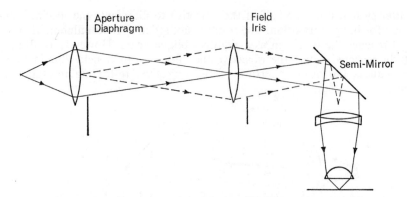

Fig. 5.24. Vertical incident illuminator with additional lens element enabling the lamp iris to control the aperture (NA) of the illuminating beam.

A well-polished metallurgical specimen reflects light very efficiently, so that the ratio of image forming to non-image forming light is usually high. Subjects of lower reflectance such as coal samples or ores are more likely to cause difficulty even when well polished. Modern microscope objectives have anti-reflection coatings on air-glass surfaces which reduce flare considerably but never eliminate it completely.

Illumination via an off-axis prism (Fig. 5.23b) generally gives less flare as much of the unwanted reflections direct the light away from the microscope axis.

A method used by Zeiss for overcoming flare in objectives up to 16× is called 'antiflex'. This uses crossed polarising filters (polariser and analyser) in the illumination and imaging beams, and a quartz plate mounted in front of a rotatable objective.

5.3.6 Dark field reflected illumination. Dark field illumination of opaque subjects is a very effective way of showing slight surface blemishes or structure of a worked surface. A simple dark field illumination can be obtained with low power objectives by directing lamps obliquely on to the specimen. Almost any number of such lamps may be used, but three or four of equal or different brightness spaced around the specimen are usually adequate.

The best dark field illumination, usable at high or low powers, is that given by specially designed objective systems such as Leitz Ultrapak and Zeiss EpiHD (Fig. 5.15). These give an almost complete annular cone of illumination which is particularly suitable for studying the texture or surface quality of opaque specimens.

The illumination system is similar to bright field except that the aperture diaphragms must be opened to allow maximum light through the annular aperture and the illumination to the centre of the objective is obscured. Because the illuminating and imaging beams are separated no problems with flare arise.

5.4 *Special Techniques*

5.4.1 Polarised Light. Polarised light microscopy can significantly increase the information obtainable, particularly in crystallography, petrology and mineralogy. The essential extra features of a polarising microscope are shown in Fig. 5.25. These are equally applicable to reflected illumination. The mounting of optical components

186

has a tendency to introduce strain, particularly in fluorite elements, and for critical work selected objectives in special strain-free mounting are to be preferred.

The polariser and analyser of similar material (Polaroid sheet or calcite prisms) transmit light waves vibrating in one plane but absorb those in the perpendicular plane. Therefore, when their axes are crossed light does not pass directly through both polariser and analyser, unless modified in some way by the specimen (and/or a compensator).

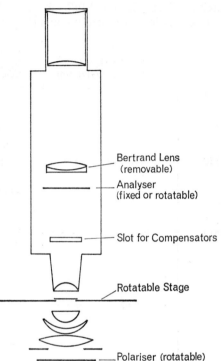

Fig. 5.25. Essential features of a polarising microscope.

Different materials, because of their different molecular structures, vary in their appearance when observed between crossed polarisers.

Isotropic materials have no effect on polarisation of transmitted light, having a single refractive index which is independent of the plane of vibration of the illumination. Such materials include glass, cubic crystals and some plastics.

Anisotropic materials have different refractive indices in different directions (birefringence). When an anisotropic specimen is examined between crossed polarisers the incident plane polarised light is split into two components vibrating at right angles to one another, each component having a different velocity within the specimen (i.e. different refractive index). After emerging from the specimen these two components are recombined by the analyser, but because of their different velocities inside the specimen their phase relation is disturbed, i.e. one is retarded in relation to the other, and interference takes place.

187

If we have a specimen with its optic axis at 45° to the plane of polarisation and producing a relative retardation of one wavelength ($\lambda=550$ nm, green) constructive interference with no rotational effect occurs, and the analyser produces extinction for this wavelength. However, if white light is used, absorption of longer or shorter wavelengths is less complete, giving transmission of red and blue, producing a bright magenta (minus green), characteristic of full wave retardation.

The magenta colour produced by a full wave retardation for green light is known as the first order tint of passage. Each additional full wave retardation is referred to as an *order*, successive orders giving less saturated colours (Fig. 5.26).

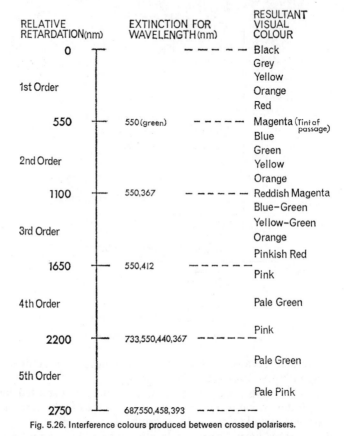

Fig. 5.26. Interference colours produced between crossed polarisers.

If the optic axis of the specimen is parallel, or at right angles to the plane of polarisation, only light vibrating in this plane is passed to the analyser and the result is extinction for all colours. This is true no matter what the retardation of the specimen. Angles close to this give colours of low saturation. This is why a rotating stage is important on a polarising microscope.

The most prominent feature of the image from a polarising microscope is the presence of colour, often brilliant colours from quite neutral specimens. The most

188

saturated and 'useful' colours occur between the first and third orders, the fourth and subsequent orders consisting only of progressively paler pinks and greens. Small retardations up to $\frac{1}{2}\lambda$ produce little colour variation—only shades of grey, and variations in the retardation are difficult to show. To overcome this a uniform birefringent plate, known as a *full wave compensator* (or sensitive tint plate) is inserted with its axis at 45° to the plane of polarisation. This adds an artificial retardation to that of the specimen, bringing the total retardation into the region around the first order where even small differences produce marked changes in colour.

The full wave compensator is the most commonly used for photographic purposes, but others are sometimes useful.

The *quarter wave plate* has a relative retardation of $\frac{1}{4}\lambda$ (or \sim112 nm). A pair of such plates can be used to give a system of circularly polarised light, which is useful when examining strained specimens (see Chapter 15).

The *Quartz wedge* provides a variable retardation effect which can be used to match and evaluate the retardation of the specimen or alternatively to supplement the specimen retardation to achieve a desired effect, as in the case of the full wave plate.

Examination and colour photography by polarised light is likely to be useful for any anisotropic specimen, which includes all crystalline structures other than cubic, many plastics and most fibres. The birefringence may be small, making a full wave compensator necessary to detect it easily. In addition to these intrinsically anisotropic substances, it is possible to make normally isotropic compounds become birefringent by the application of stress. Applied to plastic materials this forms the basis of photoelastic stress analysis (see Chapter 15). The use of this technique on a micro scale is quite feasible. Other typical applications include the study of the structure of chemical compounds, mineral ores, metals and metallic alloys, ceramics and fibres, as well as the recognition of impurities of, or in, such substances.[12, 13, 14]

5.4.2 PHASE CONTRAST. Phase contrast methods of illumination make detail visible in transparent specimens where the local variations in refractive index are very small.[15, 16] It is applied mostly to biological studies where it eliminates the need for fixing and staining of the specimen and therefore allows examination of living cells, using either still or cinemicrographic techniques. Such subjects transmit most of the incident light directly but some is diffracted by virtue of small differences in thickness and refractive index associated with their structure. This diffracted light also undergoes a small phase change and such phase changes can be modified to give variations in intensity in the image.

The most common phase contrast system is that proposed by Zernike, about 1934. This uses an *annular* illumination aperture in the lower focal plane of the substage condenser and a *phase plate* in the rear focal plane of the objective. The phase plate is transparent with an annular ring of a size which just completely covers the image of the illumination aperture in the objective focal plane. This *phase ring* is made to provide a quarter wavelength ($\lambda/4$) acceleration (or retardation) relative to the rest of the plate, and to absorb a proportion (usually about 80 per cent) of the light passing through it (Fig. 5.27).

Fig. 5.28 shows that all the light from the annular aperture which passes directly through the specimen reaches the phase ring where some is absorbed and some transmitted. The phase of this light is unaffected by the specimen.

189

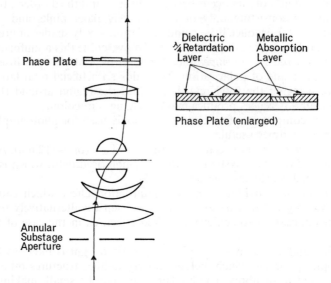

Phase Plate

Dielectric ¼ Retardation Layer

Metallic Absorption Layer

Phase Plate (enlarged)

Annular Substage Aperture

Fig. 5.27. Phase contrast system with 'positive' phase ring.

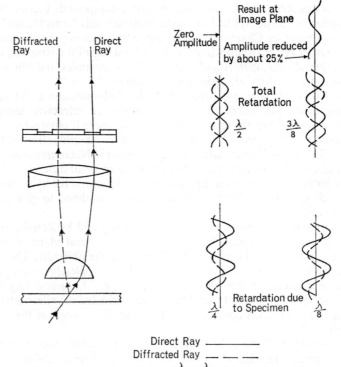

Diffracted Ray

Direct Ray

Result at Image Plane

Zero Amplitude

Amplitude reduced by about 25%

Total Retardation

$\frac{\lambda}{2}$

$\frac{3\lambda}{8}$

$\frac{\lambda}{4}$

Retardation due to Specimen

$\frac{\lambda}{8}$

Direct Ray ————
Diffracted Ray — — —

Fig. 5.28. Effect of specimen retardations of $\frac{\lambda}{4}$ and $\frac{\lambda}{8}$ in a positive phase contrast system.

Light which passes through specimen detail (areas of differing refractive index or thickness) has its phase disturbed and, owing to diffraction passes mostly through areas of the phase plate other than the phase ring. In passing through these parts of the phase plate it is retarded $\lambda/4$ in relation to the direct light. So, a diffracted beam which is retarded $\lambda/4$ by the specimen has a total retardation of $\lambda/2$ and is capable of destructive interference with the direct beam when the two combine in the plane of the primary image. A specimen retardation of $\lambda/8$ produces partial interference and a reduced amplitude.

The absorption of the phase ring is simply to reduce the intensity of the direct beam to match more nearly that of the diffracted beam. Totally destructive interference only occurs when the intensities are equal.

Specimen retardations above $\lambda/4$ will produce a lesser destruction so that above this value tones may be reversed. However, most typical specimens for phase contrast microscopy have only small retardation and the use of a $\lambda/4$ accelerating phase ring, as described, gives a *positive* phase effect, making areas of relative retardation (caused by higher refractive index or greater thickness) appear dark and areas of acceleration (lower RI or less thickness) appear light.

A *negative* phase plate (less commonly used) has a retarding phase ring and gives a reversed tonal effect.

5.4.2.1 *Equipment for phase contrast.* Objectives for phase contrast microscopy are similar to those for normal transmitted light work (the optical corrections are the same although the range available may be limited) with the addition of the phase ring mounted in the rear focal plane. In some high power objectives the phase ring may be situated between, or sometimes on one of the components. Each objective must have a corresponding substage annulus, although it is possible for phase rings in more than one objective to be designed to use a single annulus. Provision for centring the annulus in relation to the objective phase ring (Fig. 5.29) is necessary. In order to view the objective rear focal plane to make this adjustment a Bertrand lens (see p. 180) is ideal if fitted; or alternatively a viewing microscope which fits into the eyepiece can be used.

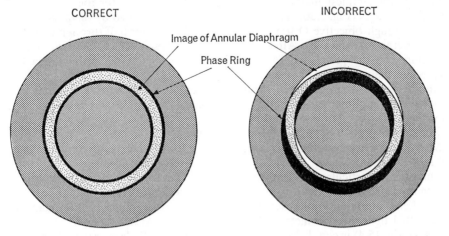

CORRECT INCORRECT

Image of Annular Diaphragm

Phase Ring

Fig. 5.29. Correct and incorrect alignment of phase contrast illumination as seen in the objective rear focal plane.

191

5.4.2.2 *Phase contrast with reflected light.* A reflected light phase contrast system can be used to show changes in path length caused by very small variations in height in a polished specimen.

The aperture diaphragm of a normal incident illumination system can be replaced by an appropriate annulus and an objective with phase ring used. However, the conventional metallic phase ring reflects a considerable amount of the incident beam, causing flare in the image. It is possible to overcome this by using a non-reflecting phase ring or by arranging for the 45° semi-reflector to be positioned between the objective and the phase ring. The latter method usually means that the phase ring will not be in its ideal position in the objective rear focal plane, but satisfactory results can be obtained in this way.

5.4.3 INTERFERENCE MICROSCOPY. Methods of producing interference images, which essentially show path length differences, in the microscope have received increasing attention in recent years. [17], [18], [19] The phase contrast image is, of course, the result of interference but this relies largely on the diffraction effect of fine detail. The phase-contrast image is not good where little detail is present, because much of its value lies in the exaggeration of edge effects, and is not suitable for quantitative assessments. Interference systems do not depend on diffraction by the subject and can therefore give a better impression of coarser features and gradual variations (see Plate 7).

5.4.3.1 *Double beam interferometry.* The principles of interferometry are described in Chapter 15, and there are several methods of applying these to produce interference images in a microscope. In most of these systems the reference and subject surfaces may be parallel in order to make detail producing the smallest phase difference visible against a uniform tone background (this is sometimes referred to as interference contrast), or may be slightly angled to show an overall contour pattern which will be modified by the specimen surface. Either monochromatic or white light can be used; the former allows more accurate quantitative analysis but white light produces fringes of interference colours and allows the zero order fringe to be positively identified. This is sometimes difficult with monochromatic light.

Perhaps the simplest method is that proposed by Linnik, for the examination of reflecting surfaces (Fig. 5.30). The illumination beam is divided by the prism, one half passing through objective O to the sample A and the other half through objective O′ to the reference surface A′. After reflection from these surfaces the two beams are recombined in the prism and form the interference image which is viewed by the eyepiece in the usual way.

An alternative when the free working distance of the objective can be reasonably large (several millimetres) is shown in Fig. 5.31. This device has the advantage of allowing use with almost any microscope and is supplied complete with its own objective (either ×10 or ×20) by Messrs. Watson.

Many other arrangements have been suggested for producing interference images. [20] Of these, methods using polarised light and birefringent elements are growing in popularity; in particular a system suggested by Nomarski [21] which can be applied to transmitted or reflected light, is now available commercially.

The Leitz interference microscope is one of the most sophisticated instruments for transmitted light interferometry. The principle of the Mach-Zehnder interferometer (see also Fig. 15.4) is coupled with the general features of a large research microscope

192

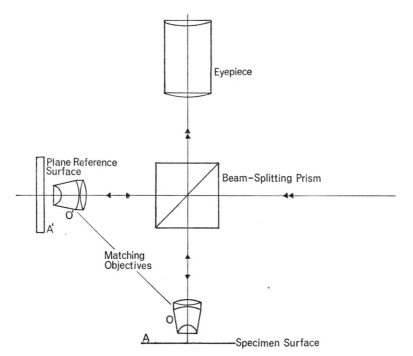

Fig. 5.30. Linnik double beam interference microscope.

using two matched optical systems in the interfering beams (Fig. 5.32). Because the object and reference beams are completely separated the system is independent of the nature or size of the specimen and is very suitable for quantitative interpretation. The instrument contains a series of optical compensators which allow the spacing and angle of the interference fringes to be varied, and the relative phase of the two beams to be adjusted and measured.

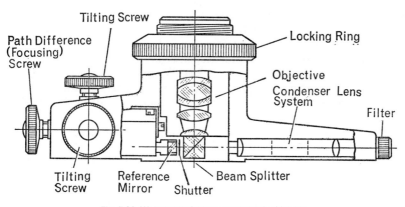

Fig. 5.31. Watson interference system with objective.

193

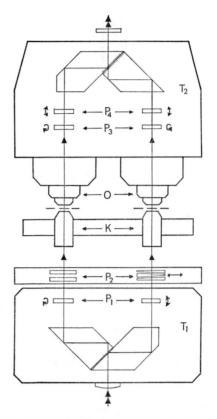

Fig. 5.32. Ray diaphragm of Leitz transmitted light interference microscope. T_1 and T_2 beam splitting prisms. O objectives K condensers, P_1, P_2, P_3, P_4 compensator plates.

5.4.3.2 *Multiple beam interferometry*. Multiple beam methods of producing interference fringes, although of less general use microscopically than double beam systems are particularly valuable for the accurate measurement of surface contours. Multiple beam Fizeau fringes are produced between reflecting surfaces as shown in Fig. 5.33. The reflected beams, a, b, c etc., interfere when focused by the objective, and the greater the number of beams of a practical intensity the sharper and narrower the interference fringes produced. Each fringe *spacing* represents a separation difference of half a wavelength and under ideal conditions using monochromatic light the fringes may be defined well enough to allow measurements as small as 1/500 of a fringe spacing (\sim0·5 nm).

Because of the sideways shift produced with the multiple reflections the resolution is reduced in proportion to the number of reflections. This means that with a 0·5 NA objective the lateral resolution may be only 5–10 μm (using 10–20 reflections) instead of 0·5 μm although the vertical resolution would be very much better.

Multiple beam methods have been developed and applied extensively, particularly by Tolansky,[22, 23] to the study of a very wide variety of surfaces.

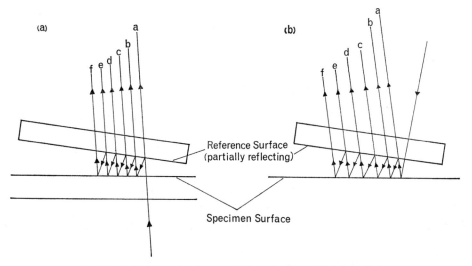

Fig. 5.33. Multiple beam interference. (a) Transmitted light. (b) Reflected light.

One commercial piece of apparatus of interest on the grounds of its simplicity and usefulness is the Surface Finish Microscope of Hilger & Watts. This is a simple and robust microscope using the multiple-beam interference principle for the study of manufactured components in the workshop. A semi-reflecting comparator plate is used (either flat or curved, depending on the surface being examined), the angle of which is adjusted to give a suitable fringe pattern. Estimation to 1/10 of a fringe spacing (25 nm) is possible and a 35 mm camera attachment can be substituted for the eyepiece to record images when required.

5.4.4 ULTRA VIOLET PHOTOMICROGRAPHY. An attraction of this technique is the higher resolution obtainable. Resolution has been quoted (p. 166) as $\dfrac{\lambda}{2\,\text{NA}}$ where λ is the wavelength used. If visible light ($\lambda=500$ nm) is replaced with UV radiation of 250 nm, resolving power is doubled. Much of the earlier interest in ultra violet microscopy has been reduced by the development of the electron microscope, which offers much higher resolution, but there still exist fields, particularly in biological research, where examination by UV is of great value due to differences in spectral absorption. An example is the study of living chromosomes.

The general difficulties and methods of using ultra violet radiation are dealt with in Chapter 8. Reflecting (catoptric) objectives (5.2.2.1) and quartz enveloped mercury vapour lamps are most convenient for UV microscopy. Some quartz and fluorite objectives are used but these are confined, because of their chromatic aberration, to a narrow spectral band making monochromatic illumination necessary. Spark sources have often been used in this context to provide intense illumination with the spectral lines of cadmium, zinc or tin.

Focusing of catoptric objectives can usually be carried out satisfactorily using visible light but with refracting systems chromatic aberration makes examination of the direct UV image on a fluorescent focusing screen valuable. A procedure favoured by some workers using quartz optics, is to view and focus by phase contrast with visible

light, exchange the source, remove the phase annulus and make a predetermined focus adjustment for recording by UV.[24, 25] This method requires a very fine focusing movement (calibrated to 0·1 μm) but has the advantage that searching can be carried out easily and exposure of the specimen to UV (which may be harmful) is minimised. Phase contrast illumination is used because many structures studied under UV have little absorption of visible light, e.g. living cells in which the nuclei and protein have selective UV absorption.

Land's Colour Translation microscope is designed to take successive records at 263, 258 and 237 nm. Normal monochrome emulsions are used but after processing the records are used to make colour prints in which each UV band is represented by a different colour.[26]

5.4.5 UV FLUORESCENCE PHOTOMICROGRAPHY. Many substances fluoresce under ultra-violet excitation and their fluorescence bears no relationship either in intensity or colour to their visual appearance. This means that a completely different picture is obtained by fluorescence, often revealing features otherwise undetectable.[27, 28] Many biological tissues have a natural fluorescence which aids their examination, but the use of fluorescent stains or tracers (fluorochomes) which are selectively absorbed by the specimen is of even greater importance, being of value in the study of diphtheria, tuberculosis, cancer and other diseases and in a number of industrial and chemical applications.

The microscope imaging system is concerned only with visible light so that most of the problems associated with ultraviolet are avoided. However, efficient UV illumination must be provided and although normal optics are satisfactory for most work, some applications may demand an exciting wavelength less than 300 nm in which case quartz, fluorite or reflecting illumination systems are necessary.

Exciter and barrier filters are used in the illumination and imaging beams respectively as described in Chapter 8.9.2. It is most important that these two filters combined produce total extinction, otherwise the fluorescence image is degraded by direct illumination.

A large illumination cone is useful to improve the normally low image intensity. With transmitted illumination immersion oil can be used between the condenser and slide and the substage iris should be opened fully. Flare will not occur providing non-fluorescent oil and mountant are used but cleanliness is essential to keep fluorescent dust or other particles out of the system between the exciter and barrier filters.

5.5 *Photographic Recording*

5.5.1 CAMERA EQUIPMENT. The fixing of a camera to a microscope for photomicrography can be optically very simple, as shown in Fig. 5.4, only a light-tight adapter being necessary. Either 35 mm or large format cameras may be used. Of the latter, 4×5 in., 9×12 cm, ¼ plate and Polaroid versions are common. No camera lens is needed but a shutter is useful. Any camera with a ground glass screen, either large format or miniature reflex can be used with no other viewing device, although an eyepiece for visual examination is most convenient and usually provided.

Fixed extension cameras (giving a constant magnification factor) of large or small format are supplied by most manufacturers and are used with a beam splitter which

196

allows viewing and focusing (Fig. 5.34). Either the camera or beam splitting unit contains a supplementary lens which makes the camera and the visual images parfocal.

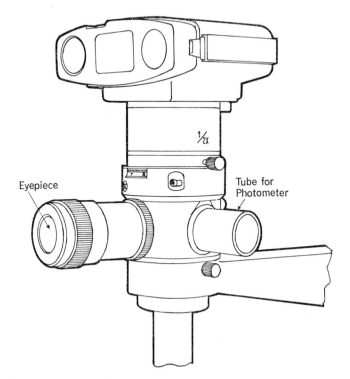

Fig. 5.34. Typical 35mm fixed extension camera attachment with eyepiece (Vickers).

A graticule helps to locate the visual image, offsetting the effect of eye accommodation (5.1.5), and shows the recorded field. The smaller attachments may be fixed directly to the microscope tube above the eyepiece but larger, heavier ones are best supported separately on a vertical column to avoid undue strain on the microscope and to reduce the risk of vibration.

Variable extension cameras using bellows and a focusing screen are usually of large format. They contain no optics of their own and although often used together with a beam-splitter and inclined viewing tube, the camera image must be visually focused on the screen. Some cameras have a reflex screen for this purpose (Fig. 5.35). The magnification can be continuously varied so that any precise value may be obtained by using a stage micrometer and measuring the screen image.

Specially made graticules (opaque with clear lines) can be used to provide a scale marker on the negative by double exposure.[29]

Depth of *focus* of the camera image is quite large, being equal to depth of field (Eq. 5.3) multiplied by the magnification squared.

197

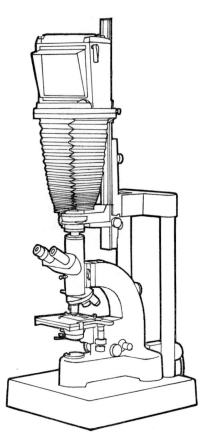

Fig. 5.35. Large format bellows camera with relfex screen (Leitz Aristophot).

i.e. $\text{Depth of focus} = \dfrac{\lambda \sqrt{n^2 - (NA)^2}}{(NA)^2} \times M^2$ Eq. 5.4

In the example on p. 168 (NA=0·25, λ=0·5 μm M=100, n=1)

$$\text{Depth of focus} = \dfrac{0\cdot 5\sqrt{1-\frac{1}{16}}}{\frac{1}{16}} \times 100^2\,\mu\text{m}$$

$$= \sim 80\,\text{mm}$$

Because of this, film flatness and accurate registration are not very important to the focusing of the photomicrographic image.

Exposure metering systems which operate through the lens (TTL) on miniature cameras are reasonably satisfactory when used for photomicrography. However, many modern microscopes with camera attachments have their own provision for light metering. This is usually at the beam splitter stage, a fixed proportion of the light being reflected to a photoconductive cell. The reading obtained may be an integrated one from the whole picture area or from a small central area of the image. Cadmium sulphide exposure meters are available which fit in place of a standard eyepiece to take

198

an integrated reading or can be used in the final image plane (with different calibration) to give a small area reading. The success of any integrated reading from the whole image area depends on a normal tone distribution in the subject. Several manufacturers now supply photomultiplier systems which both measure the illumination and control the camera exposure automatically.

5.5.2 PHOTOMICROSCOPES. A number of instruments exist which have been designed and built specifically for photomicrography rather than being visual microscopes adapted or added to for photographic work. These have built-in lighting, camera facilities and, usually, automatic exposure control. Table 5.2 lists the features of some of these instruments.

Fig. 5.36. Ultraphot II microscope, showing light path with reflected illumination (Zeiss).

5.5.3 CINEPHOTOMICROGRAPHY. Cine recording of the microscope image at normal speed (or using time lapse[30] or high speed techniques) is possible and particularly useful for the study of living organisms.

Basically the still camera is simply replaced with a cine version but some practical differences and problems may arise, such as:

(1) The secondary magnification will usually be fairly low due to the small frame area.

(2) It is generally necessary to view the subject during filming, which requires a beam splitter and parfocal viewing system. These are available for use with several microscopes and cameras but alternatively a mirror reflex camera can be used with almost any microscope.

(3) Rigidity of the apparatus is essential and it is advisable to support the camera separately to avoid vibration being transmitted to the microscope.

(4) A high illumination level may be required to allow the restricted exposure times. Heat filters in the form of water cells, heat absorbing glass or dichroic filters are often needed, especially with living specimens. Electronic flash is particularly useful for time-lapse and stroboscopic flash can be synchronised for normal (or high) speed recording (see Table 11.1).[31]

(5) Cameras with TTL meter systems are particularly convenient with continuous sources.

199

TABLE 5.2
PHOTOMICROSCOPES

Model	Basic illumination (R or T)	Illuminant	Tube length of objectives	Projection lens	Magnificati changers (si
Olympus PMG	R	L.V. Tungsten, Xenon, Mercury Vapour	200mm	Positive	Projection ey turret 10, 15,
Projectina	T or R	L.V. Tungsten	160mm	Positive	None (chang or eyepiece)
Reichert MeF2	R	L.V. Tungsten, Xenon, Mercury Vapour	250mm	Positive	None
Union NUM-B	R	L.V. Tungsten, Xenon	170mm	Positive	Projection ey turret 10, 12 15, 20×
Vickers 55	R or T	L.V. Tungsten, Xenon, Mercury Vapour	∞ (160mm for transmitted illumination)	Positive	1, 1·4, 2·0× rotating turr
Neophot 2 (Zeiss-Jena)**	R	L.V. Tungsten, Xenon	∞	Positive	Projection ey turret 8, 10, 16, 20×
Photomicroscope II (Zeiss-Oberkochen)***	T or R	L.V. Tungsten, Mercury Vapour	160mm	Negative	1·25, 1·6, 2× on rotating t
Ultraphot II (Zeiss-Oberkochen)***	T or R	L.V. Tungsten, Mercury Vapour, Xenon, Carbon Arc	160mm	Negative	1·25, 1·6, 2× on rotating t

*Not effective with 35mm camera.
**British agents C.Z. Scientific Instruments Ltd.
***British agents Degenhardt & Co. Ltd.

5.5.4 COLOUR FILTERS. There are various uses for colour filters in photomicrography, including the following:
 (1) Restricting the waveband used to that at which objective performance is best (green).
 (2) Isolating ultra violet (absorbing visible light) for UV micrography.
 (3) As exciter and barrier filters in UV fluorescence.
 (4) Isolating the 546 nm line from mercury vapour lamp for monochromatic interference micrography.
 (5) Correcting colour temperature of light source for colour photomicrography.
 (6) Modifying tone rendering of coloured or stained specimens recorded on black and white film.

continuously ...iable magn.	Exposure meter	Macrophotography facility (with single objective only)	Film size	Remarks
e	Automatic integrated reading	No	35mm, ¼pl. Polaroid roll or sheet film	Inverted. Transmitted light as accessory
e	Separate reading from screen	Yes	5″ × 4″	Shutter speeds B.T. 1–1/125 sec.
able extension ...ws* (Zoom ...iece for 35mm)	Integrated reading non-auto (accessory) Auto for 35mm	Yes	Up to 5″ × 4″ or 35mm	Inverted. Transmitted light as accessory. Shutter speeds B.T. 1–1/125 sec.
e	Integrated reading non-auto (accessory)	No	¼ pl. or 35mm Polaroid film pack	Inverted. Transmitted light as accessory. Shutter speeds B.T. 1–1/250 sec.
...m projection ...iece*	Integrated Automatic with visible indicator	Yes	Up to 5″ × 4″ or 35mm	Inverted
	Automatic integrated reading	No	Up to 13 × 18cm 6 × 6cm, 35mm	Inverted
	Automatic Integrated or from selected area (5 % of total)	Yes	35mm	Automatic film transport coupled to shutter action
able mirror ...m controlling ...ction distance*	Automatic from small area just outside 5″ × 4″ frame area	Yes	Up to 5″ × 4″, 35mm	

For all these purposes (except fluorescence barrier filter) the filter should be placed in the illuminating beam, where its position and quality are not critical. The same principles of tone modification by filters apply to photomicrography as to general photography, colours being apparently lightened by a filter of like colour and darkened by one of complementary colour. The most common requirement is to accentuate contrast between different areas of the specimen, particularly in conjunction with staining techniques, and for this purpose filters with highly selective absorption are usually needed. Kodak have published the spectral transmission of the wide range of Wratten filters.[32]

Gelatin filters, often cemented between glass, are used in most instances although dyed glasses can also be used. Dielectric or metallic interference filters can give more efficient transmission of a narrow waveband and are particularly useful for isolating a monochromatic spectral line.[33]

Heat absorbing or reflecting filters may be used to protect both specimen and optical components when very intense illumination is necessary.

5.5.5 SENSITIVE MATERIALS. Most orthochromatic and panchromatic general purpose emulsions are suitable. Blue sensitive (non-colour sensitive) materials are not commonly used owing to the preference for green illumination when colour is unimportant. The final choice of material (and its processing) is often governed by the contrast of detail in the specimen. Normal treatment is generally adequate but occasionally high contrast, process or even lith films are valuable with low contrast specimens.

Colour negative or reversal films may be used, providing the colour temperature of the source (filtered if necessary) is compatible with the type of film used. High pressure xenon arcs or electronic flash are suitable for daylight colour film. Tungsten lamps used at their correct voltage generally have a colour temperature around 3,100–3,200K. For critical work with reversal materials this can be checked with a colour temperature meter. If measured at the film plane with no specimen in position, any absorption by the microscope optics can also be compensated for by suitable filtration. With negative film exact colour temperature is less critical, although making a colour print to match the memory of a microscope image seen several days earlier is not a task to be taken lightly. Exposure of a transparency as a colour guide is one method but this presupposes accuracy of the transparency. An alternative is to make a negative of a standard neutral specimen with each batch of negatives taken. This will show the corrections needed in printing.

Fortunately absolute fidelity of colour is only rarely necessary in photomicrography.

5.6 *Specimen Preparation*

The various techniques of specimen preparation and their application is far too wide a subject to be considered in detail here. Many photographers engaged in photomicrography are commonly presented specimens in a suitably mounted form by the scientist (biologist, metallurgist etc.) carrying out experimental work. Others, who have regular need to prepare their own specimens should refer to one or more of the textbooks which deal with this subject.[34-40] The purpose of this section is to discuss the reasons why special preparation is necessary and outline the basic principles involved, an understanding of which is desirable for any photomicrographer.

There are two most important requirements of a specimen:

(1) It should be substantially flat and, for transmitted light, thin in section.
(2) The features of interest in the subject should be suitably visible for examination by the technique intended.

Considering the very small depth of field of the photomicroscope, flatness is obviously necessary if a reasonable area is to be sharply focused at one time. A thin specimen allows less possibility of misinterpretation due to defocused images of detail within the specimen thickness. For reflected light examination of metallurgical and similar opaque specimens grinding and polishing is usually necessary to produce a suitably flat surface.

The second requirement, of obtaining adequate visibility of subject detail, needs consideration of such factors as the mounting medium, staining and use of reagents;

202

but attention must also be paid to the avoidance of obscuring or falsifying structural detail by improper preparation or handling.

5.6.1 SPECIMENS FOR TRANSMITTED LIGHT. Transmitted light specimens are normally mounted in a transparent medium on a 3×1 in. glass slide and protected by a smaller, either circular or rectangular, thin cover slip (see p. 170). The mount may be either permanent or temporary. A permanent mount has the specimen completely sealed between the glass slide and cover slip. Resins, such as canada balsam, which set hard after mounting are commonly used, although non-volatile liquids such as glycerol are also suitable.

A temporary mount is adequate for most photomicrography where its purpose is simply to allow a permanent photographic record to be made. A much wider range of mounting media is available with a better choice of refractive indices. Mounts using volatile liquids such as alcohol can be sealed with wax and are useful for several hours or possibly days.

The actual procedures for mounting depend very much on the nature of the specimen concerned. Some small biological specimens may be mounted whole, but thin sections are commonly cut for examination. To cut such sections without distorting the tissue usually necessitates hardening it. This process, commonly termed 'fixing' inevitably kills the tissue, but the important aim is to select a fixative which does not itself distort fine cell structures. An alternative to chemical fixing is to harden the specimen by freezing.

In most cases fixed specimens are washed, dehydrated and embedded in a molten material such as paraffin wax which, when allowed to harden into a block, acts as a support during the cutting process. Thin sections of the specimen are cut using a manual or mechanical microtome. Sections less than 20 μm are very difficult to cut reliably by hand, but mechanical microtomes will cut sections a few μm thick, while some specially sophisticated instruments can produce sections of 20 nm or 1/50 μm thickness (one twentieth of the wavelength of blue light).

Many histological specimens require staining to make apparent the structural detail and sometimes to differentiate between different parts of the specimen (selective staining). Innumerable stains and procedures are used.[36]

Many mineral and ceramic substances can also be examined as thin sections although, of course, the method of preparation is rather different.[37, 38] Other useful techniques for transmitted light examinations are:

(1) Smear—very commonly used for blood samples.

(2) Squash—specimen literally squashed between slide and cover glass.

(3) Dispersion—small solid particles dispersed in a suitable liquid medium.

(4) Hanging Drop—useful, particularly for living bacteria in their natural fluid; applied to the underside of a cover slip, supported by its edges away from the slide (or on a cutout 'dimpled' slide).

5.6.1.1 *Mounting Media.* The most significant optical property of a mounting medium is its refractive index; in particular the refractive index *difference* between it and the specimen.

A smaller refractive index difference gives greater transparency to the specimen. Carried to the extreme of equal indices for specimen and medium, the subject becomes optically homogenous and the specimen is not visible. A condition of near equality is

good for showing internal structures of the specimen, when these are of a different refractive index.

The greater the index difference the higher is the image contrast produced. This is particularly relevant when imaging small transparent particles, the smallest of which become invisible if the refractive index difference is too small. In general, smaller particles require a greater refractive index difference to give a satisfactory compromise between visibility and transparency.

Stained sections rely principally on differences in absorption to make detail visible and an index close to that of the specimen is usually preferred to give a high degree of transparency.

The refractive index of the mounting medium also has a direct influence on the depth of field. From the formula given for depth of field (Eq. 5.3), it is evident that with constant values of numerical aperture (NA) and wavelength (λ), D will increase in value with (n) the refractive index of the medium (see Plate 8). This is explained by the smaller angle of the cone of light in a higher index medium for any particular NA.

Other considerations when making a choice of medium for use with a particular specimen are as follows:

(1) Whether a temporary or permanent mount is required.
(2) Viscosity; liquids of high viscosity tend to give more difficulty from trapped air bubbles, although less subject motion is likely with small particles than when a less viscous fluid is used.
(3) Chemical compatibility; the media should be inert both to the specimen and to any stain used. Media which are slightly acid cause fading of many stains. A medium may sometimes act also as a useful preservative.

A few of the most common mounting media and their refractive indices are given in Table 5.3.

TABLE 5.3
USEFUL MOUNTING MEDIA

Medium	Approx. Refractive Index
Distilled Water	1.33
Ethyl Alcohol	1.36
Paraffin Oil	1.45
Glycerol	1.465
Turpentine	1.475
Xylene	1.49
Immersion Oil	1.515 or 1.524
Canada Balsam	1.53
Monobromonaphthalene	1.655
Methylene iodide	1.74

5.6.2 SPECIMENS FOR REFLECTED LIGHT. The most common reflected light specimens are metallurgical, although similar principles apply to a large variety of other materials including ceramics, plastics and mineral ores.

Natural surfaces such as a fracture faces may require examination, in which case little real preparation is necessary. But such examinations are likely to be restricted to low magnification because of the difficulty of limited depth of field.

An essentially flat surface, obtained by grinding and polishing, is necessary to study the structure of a metallurgical sample at high magnification. Unfortunately, the grinding and polishing often produce strain in the specimen surface and distort it, thus obscuring or falsifying the detail being examined. Therefore, when an optically flat surface has been produced it is usually necessary to etch away the surface layer to reveal the true structure of the material. The variety of different polishing and etching techniques is extremely wide[39, 40] and the combination of treatments most suitable for a particular specimen is often found only by experiment.

Specimens are generally moulded into cylindrical mounts (typically of Araldite, Bakelite or similar plastic) to allow ease of handling during the grinding, polishing and etching processes.

Cleanliness is all important in specimen preparation, as blemishes caused by even minute particles of coarse abrasive are only too apparent in the magnified image.

5.7 Electron Micrography

5.7.1 TRANSMISSION MICROSCOPE. The basic principle of the transmission electron microscope is very similar to the optical instrument although the appearance and operation are quite different.[41, 42] The essential advantage is the increased resolution which can be obtained with an electron image, making higher useful magnifications possible. Electron microscope resolution can be better than 1 nanometre (nm), compared to about 200 nm with visible light.

A schematic layout is shown in Fig. 5.37. Electro-magnetic lenses focus the electron beam rather as optical lenses focus light. The electron beam is focused into the specimen plane by the condenser system, but there are usually *three* magnification stages, each producing a real image. This is necessary to obtain the high magnifications possible in a reasonably limited length. The last of these images is focused on to a fluorescent (usually reflecting) screen for visual observation, or on to the photographic material. The fixed electro-magnetic lenses are of variable power, control of magnification and focus being achieved by adjusting their current. The intensity and size of the electron beam on the subject is governed by the source voltage and condensers.

A typical electron gun requires a voltage of 50–100 kV (up to 1 MV on recent large instruments) which must be very accurately stabilised (± 0.001 per cent). This necessitates complex and bulky electronics which are a feature of electron microscopes. Personal protection from high voltages and X-rays produced is also vital. A further basic requirement, of some significance is the efficient evacuation of the electron beam path, necessary because of the very low penetration of electrons in air.

The electron microscope, unlike the optical version, is not a diffraction limited instrument, i.e. it does not approach the resolution predicted by diffraction theory, taking account of wavelength and aperture. If it were and similar angular apertures were possible, the resolution obtainable would be of the order of 0·003 nm (a 60 kV beam having an electron wavelength of 0·005 nm[44]). Unfortunately electron lenses

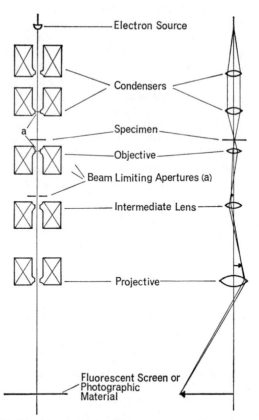

Fig. 5.37. Principle of the transmission electron microscope showing optical equivalent.

cannot be well corrected, particularly for spherical aberration, making minute apertures necessary and actual performance several hundred times poorer than the ideal. The small apertures do make the depth of field comparatively large, but little use can be made of this feature in the conventional transmission instrument because of the nature of the specimen requirements for electron penetration.

Specimens for electron microscopy must be extremely thin, typically 10–100 nm, and special methods for preparing and supporting samples are needed.[43, 44] To study the surface (particularly rough surfaces) of bulk materials a replica can be made, either by evaporating a suitable material (e.g. aluminium) or coating a thin plastic film (e.g. Formica) on the surface, and this replica examined in the microscope. By oblique vacuum deposition of a very thin metallic layer on the replica surface a shadow lighting effect can be created which allows the depth of surface detail to be judged.

5.7.1.1 *Photographic materials for electron microscopy*. To record a photographic image the fluorescent screen is removed from the beam path and the electron image formed directly on the emulsion surface. The following factors, some of which are conflicting, are relevant to the choice and use of suitable photographic material:

(1) The sensitivity to electrons is roughly proportional to that to blue light. The

206

added light sensitivity due to the wide spectral response of ortho and panchromatic materials is quite irrelevant. Electron speed is defined as the reciprocal of the exposure (in electrons per μm^2) which produces a net density of $1 \cdot 0$.

(2) Owing to the desirability of limiting beam current and the conflicting requirement of adequate screen brightness, the magnification obtained is invariably below the maximum useful magnification (5.1.4). This indicates the use of a slow material exhibiting low granularity (see below) and a thin emulsion layer to keep electron scattering to a minimum.

(3) Exposure time needs to be short enough to avoid blurring of the image due to electrical or mechanical instabilities in the microscope or specimen. (3–5 seconds is usually satisfactory, above 10–20 seconds may well give lower resolution.) Reciprocity failure is generally considered irrelevant to electron exposures although there is evidence that this is not universally so.[45]

(4) Contrast values assessed by exposure to light are not very significant when exposure is to electrons. Fig. 5.38 shows that the slope of the D/LogE curve with electrons is more dependent on density and it can be shown that the contrast, *irrespective of the material used*, is proportional to density (up to a value of $D \sim 2$).[46] Because of this effect, variation in development produces a change of *speed* but contrast, as shown by the *shape* of the characteristic curve, does not alter. Use can be made of this effect to vary the speed of a material over a wide range by modification of the degree of development. The contrast produced by a standard exposure will rise of course, with increased development because of the density increase.

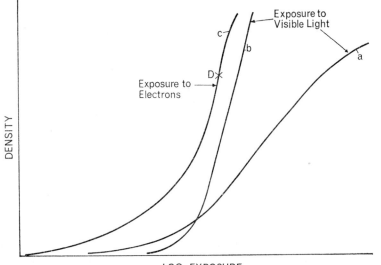

Fig. 5.38. Characteristic curves with exposure to visible light and electrons. Curves a and b show high and medium contrast films exposed to visible light. With exposure to electrons both these will produce a curve similar to c, in which contrast increases with density up to the point D.

207

(5) Granularity, in images produced by exposure to light, is due to the random distribution and size of the silver grains. With exposure to electrons, however, a greater granular effect arises from the random distribution of electrons reaching the emulsion. Granularity from this source is clearly greater the smaller the number of incident electrons and, for a constant density, can be shown to be proportional to the square root of the emulsion speed. With any particular material granularity increases with density (see p. 88).

(6) The evacuation or pumping down time necessary to obtain a sufficiently high vacuum depends both on the thickness of the emulsion and the type of base. Thin emulsions on glass are best; polyester film requires longer pumping while cellulose acetate films are particularly slow and often curl badly, owing to the presence of volatile solvents in the base. Efficient evacuation is particularly difficult with roll film. Desiccation prior to insertion in the microscope reduces the pumping down time for all material.

Materials which have been found most generally suitable are slow fine-grain blue sensitive emulsions, typical examples are:

Ilford	Contrasty Special Lantern plate
	N50 Halftone film
Agfa-Gevaert	23D50 plate
	19D50 film (70mm only)
Kodak	B10 plate
	Kodaline, CF7 and Kodalith LR films
Eastman Kodak	Electron Image plate
	EM film type 4489

Electron speeds for some thirty different materials have been published.[46]

Several devices have been suggested for assessing exposure times necessary in electron microscopes. Some of these measure the fluorescence of the viewing screen[47] while others measure the electron beam current[48, 49] or X-rays scattered from the photographic plate.[50]

Difficulty often arises owing to the extremes of exposure which occur with specimens of non-uniform thickness or when detail is examined close to specimen support bars or the specimen edge. Negatives from this type of subject can, with advantage, be processed in a low activity Metol developer which restricts the maximum density (and therefore the density range) without significantly reducing the detail contrast.[51] This has the effect of increasing exposure latitude and giving a density range more acceptable for printing. Without such processing (and sometimes even with it) the density range of negatives often calls for heavy shading in printing and unsharp or electronic masking techniques are useful (see pp. 74–5).

5.7.1.2 *Cine-Electron Micrography*. There are three basic methods of cine recording electron microscope images.

(1) The cine camera (without lens) can be housed behind the fluorescent screen, which is either provided with an aperture or can be moved aside to allow the electron beam to fall directly on the film. This method does not usually allow viewing of the image during recording and higher than normal beam current is required to permit the necessary short exposure. De-gassing of the photographic material is necessary to maintain an adequate vacuum and this is less easy with rolls of cine film than with sheet films or plates.

(2) Cinematography of the fluorescent screen overcomes the difficulties of evacuation and viewing but has its own disadvantages. Large aperture lenses and high speed films are generally necessary and these factors together with the limitations of the screen make overall resolution lower. With many microscopes the screen can be filmed only obliquely, giving a distorted picture and a depth of field problem.

(3) The microscope image can be displayed on an external phosphor screen via an image tube. This method, use of which is increasing, overcomes the previous difficulties except that resolution is still limited, in this case by the image tube system.

5.7.2 SCANNING ELECTRON MICROSCOPE. This instrument (Fig. 5.39) works on a quite different principle[52, 53] from the conventional electron microscope already described. It is essentially a reflection instrument in which a very small electron spot is focused and made to scan across the surface of the specimen, rather like a television tube scan, only slower. Electrons reflected (and secondary electrons emitted) from the specimen are collected and counted, and a corresponding electrical signal is amplified and fed to a cathode ray tube with a synchronised scan. In this way the electron

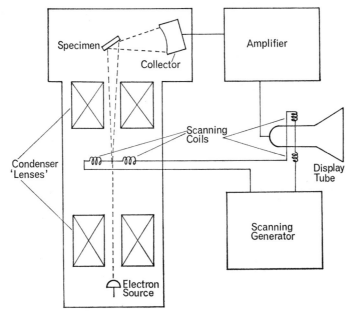

Fig. 5.39. Schematic diaphragm of the scanning electron microscope.

reflectivity variations of the subject are shown as light and shade on the screen. Two screens may be used, one with a long persistence phosphor to give a visual image during the scan, the other a high resolution, high efficiency, short persistence type for photographic recording.

The instrument requires a much smaller beam current than other electron microscopes and the specimen surface is exposed only intermittently during the scan. This allows examination of the surface texture of quite delicate materials such as fibres and

209

plastics, which would be damaged by a continuous heavy current, as well as metals and ceramics.

The depth of field of the image is extremely large, being dependent on the (narrow) angle of the focused electron beam and is several hundred times greater than with an optical instrument at the same magnification (Plate 9).

The resolution is dependent on the size of the focused electron spot which at present is limited to about 10–20 nm making the maximum useful magnification in the order of 15,000–30,000, midway between that of the optical and conventional electron microscopes. Because of the advantage in depth of field the instrument is used quite extensively for examination of coarse specimens at quite modest magnifications (even 100) and its use for stereo pairs (two separate exposures with the specimen rotated through a known angle) is particularly valuable. The instrument also has particular value for studying microcircuits since it is able to show visually conductivity of the specimen.

Very little specimen preparation is needed because thin sections and polished surfaces are not required. Non-conducting surfaces require a thin evaporated metallic layer of gold or gold/palladium.

With all its advantages the scanning electron microscope is unlikely to replace the optical version because it cannot record colour and its cost is very high indeed (~£20,000).

The choice of photographic material is not governed by the factors listed for conventional transmission electron microscopy because the exposure is to the fluorescent output from the cathode ray tube. The photographic requirements for oscilloscope recording (p. 353) are more relevant. Polaroid film is often used for convenience.

References

General

1 ALLEN, R. M., *Photomicrography*, 2nd Ed, Van Nostrand, Princeton, New Jersey (1958).
2 SHILLABER, C. P., *Photomicrography in theory and practice*, Wiley, New York (1944).
3 BIRCHON, D., *Optical microscope technique*, Newnes, London (1961).
4 MARTIN, L. C. and JOHNSON, B. K., *Practical Microscopy*, 3rd Ed, Blackie, London (1958).
5 PAYNE, B. O., *Microscope design and construction*, 2nd Ed, Cooke, Troughton & Simms, York (1957).
6 VICKERS, A. E. J. (Ed) *Modern methods of microscopy* (reprinted from 'Research'), Butterworth, London (1956).

Specific

7 FRANCON, M., *Progress in Miscroscopy*, Pergamon, Oxford (1961).
8 McCOMB, S. J., *J Biol Phot Ass*, 29, 45 (1961).
9 McLACHLAN, D., *Med Biol Ill*, 16, 98 (1966).
10 McLACHLAN, D., *Applied Optics*, 3, 1009 (1964).
11 CLAUSSEN, H. C., *Applied Optics*, 3, 993 (1964).
12 CHAMOT, E. M. and MASON, C. W., *Handbook of chemical microscopy*, 3rd Ed, Vol 1, Ch 10, Wiley, New York (1959).

13 HARTSHORNE and STUART, *Crystals and the polarising microscope*, 3rd Ed, Arnold, London (1960).
14 WAHLSTROM, E. E., *Optical Crystallography*, 3rd Ed, Wiley, New York (1960).
15 BENNETT, A. H., JUPNIK, H., OSTERBERG, H. and RICHARDS, O. W., *Phase microscopy*, Chapman & Hall, London (1951).
16 BARER, R., *Modern methods of microscopy*, Ed A. E. J. Vickers, p 66, Butterworth, London (1956).
17 FRANCON, M., *Optical interferometry*, Academic Press, New York (1966).
18 TOLANSKY, S., *An introduction to interferometry*, Longmans, Green & Co., London (1960).
19 KRUG, W., RIENITZ, J. and SCHULZ, G., *Interference microscopy*, Hilger & Watts, London (1964).
20 SMITH, F. H., *Modern methods of microscopy*, Ed A. E. J. Vickers, p 76, Butterworth, London (1956).
21 NOMARSKI, G., WEILL, A. R., *Revue de metallurgie*, 52, 121 (1955).
22 TOLANSKY, S., *Multiple beam interferometry*, Clarendon Press, Oxford (1948).
23 TOLANSKY, S., *Surface microtopography*, Longmans, London (1960).
24 KING, R. J. and ROE, E. M. F., *Phot J*, 90B, 94 (1950).
25 DAVIES, H. G. and WALKER, P. M. B., *Phot J*, 90B, 92 (1950).

26 LAND, E. H., *Med Biol Ill*, **2**, 118 (1952).

27 KING, J., *Modern methods of microscopy*, Ed A. E. J. Vickers, p 34, Butterworth, London (1956).

28 RADLEY, J. A. and GRANT, J., *Fluorescence analysis in ultra-violet light*, 4th Ed, Chapman & Hall, London (1954).

29 KARLSRUHER, H., *J Roy Micr Soc*, **80**, 99 (1961).

30 SHAPIRA, J., *JSMPTE*, **74**, 1002 (1965).

31 EDGERTON, H. E. and CARSON, J. F., *Applied optics*, **3**, 1211 (1964).

32 *Wratten filters*, Kodak Ltd., London.

33 BAUMEISTER, P., *Applied optics and optical engineering*, Ed R. Kingslake, Vol I, Ch 8, Academic Press, New York (1965).

34 GRAY, P., *Handbook of basic microtechnique*, McGraw-Hill, New York (1958).

35 GRAY, P., *Microtomists formulary & guide*, Blakiston, Philadelphia (1954).

36 GURR, E., *A practical manual of medical and biological staining techniques*, Leonard Hill, London (1956).

37 WEATHERHEAD, A. W., *Petrographic microtechnique*, Barron, London (1947).

38 RIGBY, G. R., *The thin section mineralogy of ceramic materials*, British Ceramic Research Assn, Stoke-on-Trent (1953).

39 GREAVES, R. H. and WRIGHTON, H., *Practical microscopical metallography*, Chapman & Hall, London (1957).

40 CHALMERS, B., *Physical examination of metals*, Vol I, Arnold, London (1941).

41 HAINE, M. E., *The electron microscope*, Spon, London (1961).

42 COSSLETT, V. E., *Practical electron microscopy*, Butterworth, London (1951).

43 KAY, D. H., Ed, *Techniques for electron microscopy*, 2nd Ed, Blackwell, Oxford (1965).

44 THOMAS, G., *Transmission electron microscopy of metals*, Wiley, New York (1962).

45 HAMILTON, J. F., *The theory of the photographic process*, 3rd Ed. Ed C. E. K. Mees and T. H. James, p 181, Macmillan, New York (1966).

46 VALENTINE, R. C., *Advances in optical and electron microscopy*, Ed R. Barer and V. E. Cosslett, Academic Press, London (1966).

47 VIENNE, G., *Bull Microscop Applic*, **11**, 99 (1961).

48 CURCIO, P. and NANKIVELL, J. F., *J Sci Instr*, **39**, 175 (1962).

49 HAMM, F. A., *Rev Sci Instr*, **22**, 895 (1951).

50 CARTWRIGHT, J. and BISHOP, A. E., *J Sci Instr*, **36**, 303 (1959).

51 FARNELL, G. C. and FLINT, R. B., *J Micr Soc*, **89**, pt 1, 37 (1969).

52 COSSLETT, V. E., *Modern Microscopy*, p 134, Bell, London (1966).

53 THORNTON, P. R., *Scanning electron microscopy*, Chapman & Hall, London (1968).

6. MICROPHOTOGRAPHY

Microphotography is the photographic recording of small images containing very fine detail which requires magnification for inspection. Actual image areas vary from small fractions of a square millimeter up to standard 35 mm frame size of 24×36 mm. Some larger images, e.g. engineering drawings reduced on to 70 mm film also comply with this definition.

Routine document microcopying is the most practised single application of microphotography, but demands a lower resolution (100–200 lines/mm) than other work. Although much of what follows is applicable to this field it is convenient to consider microcopying separately (p. 225).

6.1 *Extreme Resolution Microphotography*

6.1.1 OPTICAL CONSIDERATIONS. The first requirement in producing a microphotograph from a subject is a lens capable of forming an image of the desired size with the necessary resolution. The image sharpness of any lens depends on its degree of correction of the various aberrations and on its relative aperture. With conventional camera lenses the correction is the more important factor, while with microscope objectives the standard of correction is very high and the aperture is more critical. Microphotographic applications use objectives of both these types but particularly the intermediate range where aperture and correction are more nearly equal in importance.

The remarks in Chapter 5 concerning the resolution limits of microscope objectives are equally valid in this context. The fact that the objective is forming a finely resolved image instead of detecting and imaging fine subject detail is immaterial. Methods of assessing lens performance (e.g. resolution test charts and modulation transfer function) and their limitations are discussed in Chapter 2.

A lens which just gives visual resolution of subject detail with, say, a modulation of 20 per cent may be unsuitable for microphotography where the requirement is for an easily decipherable image or, as in the case of graticule production, where a very high standard of line sharpness is needed.

The focal length is commonly governed by the diameter of the image required. Although for document microcopying angular coverage of 70° (i.e. focal length $\simeq \frac{3}{4}$ of image diameter) is possible with suitable lenses, for more critical requirements the useful field is often very small. For medium-high resolution, say 5–10 μm line width over a field of 5 mm, high quality cine camera lenses designed for 8 mm film are often useful. Microscope objectives offer the highest resolution but only over a very restricted field. Achromats generally perform as well as fluorites or apochromats provided green light is used. Medium power (e.g. $\times 10$) achromats may give satisfactory results used alone at distances several times greater than their intended tube length, but high power objectives (which must be corrected for use without cover glass) should be used only at object distances which match the tube length, i.e. with reduction factor equal to objective nominal magnification. If a greater reduction than this is required a suitable eyepiece (compensating if necessary, see Chapter 5.2.3) should be used as in a compounded microscope to give a two stage reduction.

TABLE 6.1
TYPICAL PERFORMANCE OF ACHROMATIC
MICROSCOPE OBJECTIVES

Focal length (Nominal Magn.)	NA	Minimum Line width	Field diameter
64mm (2·5×)	0·06	6μm	8mm
32mm (5×)	0·10	3μm	4mm
16mm (10×)	0·25	1μm	1·6mm
8mm (20×)	0·50	0·5μm	0·8mm

The rapid growth of micro-electronics has led to the production of lenses designed specifically for microphotography. These lenses generally offer an extremely high resolution over a comparatively large field and are particularly suitable for recording an array of micro-images. This quality is achieved by restricting their correction to a single monochromatic wavelength and one particular reduction ratio. In England, Wray have produced a series of $f4$ lenses of this type with an angular field of about 25° (Table 2.5). The Japanese Ultra-Micro Nikkor objectives are mostly of wider aperture giving higher resolution, but have considerably narrower fields. Their physical size is particularly large relative to their image size. The most spectacular Ultra-Micro Nikkor is the 30 mm $f1\cdot2$ version which is claimed to give resolution of 1200 lines/mm over a 2 mm field (see Fig. 2.7), comparing very favourably with a 10 or 20× microscope objective.

For use with photo-resist materials (p. 218) which have a high ultra-violet sensitivity, reflecting (catoptric) microscope objectives may be useful owing to their absence of both chromatic errors and ultra-violet absorption.

6.1.1.1 *Focusing. Depth of focus*, the distance by which the sensitive material may be displaced either side of its best focus position without appreciably affecting sharpness, is given by the formula:

$$\text{Depth of focus} = \frac{\text{cv } f\text{-number}}{\text{F}} \text{ or } \frac{\text{cv}}{2\text{ NA} \times \text{F}} \qquad \text{Eq. 6.1(a)}$$

where c is the permissible circle of confusion, v is the image distance, F is the focal length and the aperture is expressed as either f-number or NA.

If v is nearly equal to F this becomes:

$$\text{Depth of focus} = \text{c} \times f\text{-number or } \frac{\text{c}}{2\text{ NA}} \qquad \text{Eq. 6.1(b)}$$

Calculations using such formulae are not very reliable when working close to the resolution limit of the objective. However, they serve to show that with all high resolution work, where the acceptable circle of confusion is necessarily very small* and apertures are fairly large, the depth of focus is extremely small, typically a few micrometres (μm).

If c = 5 μm and NA = 0·25, depth of focus = $\frac{5}{2 \times 0\cdot25}$ μm = 10 μm.

*A value of c equal to the objective resolution $\left(\frac{\lambda}{2\text{NA}}\right)$ given in Eq. 5.2 is a practical value for extreme resolution work and, used in Eq. 6.1(b), gives: Depth of focus = $\lambda/4\text{NA}^2$.

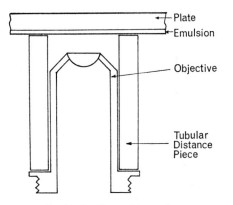

Fig. 6.1. Fixed focus distance piece.

One of the practical problems of high resolution microphotography is obtaining and then accurately maintaining critical focus. Ground glass or similar screens are generally too coarse for any purpose other than initial rough focusing.

The prime requirements are:

(1) An accurate and repeatable means of locating the emulsion *surface* relative to the objective.

(2) A fine focusing movement with sensitive control (preferably graduated).

(3) A means of viewing the image formed on the sensitive surface.

The simplest device which can be used to maintain accurate focus of a microscope objective is a distance piece or spacer in the form of tube which fits over the body of the objective, locating on the mounting flange, and accurately machined so that a plate resting on the end surface is in the plane of focus. Such a distance piece (Fig. 6.1)

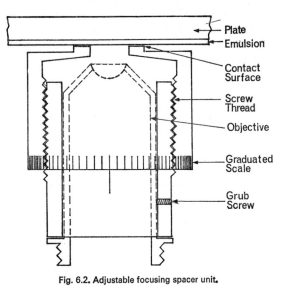

Fig. 6.2. Adjustable focusing spacer unit.

215

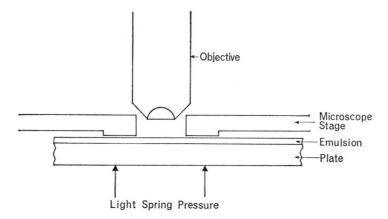

Fig. 6.3. Using microscope stage, plate should be held underneath stage to locate emulsion surface.

is suitable only for one reduction with one objective and its manufacture demands a high degree of machining accuracy, especially if a specified exact reduction factor is required. However, once produced such a device should last indefinitely.

The adjustable version shown in Fig. 6.2 has a screw thread and can be graduated to allow easy adjustment and re-setting of focus. Other, more sophisticated versions of this spacer principle are possible.[1]

If a microscope is used to hold the plate, the emulsion *surface* should be located against the *underneath* of the stage (Fig. 6.3). If placed on top, the thickness of the glass becomes important and variations will certainly cause difficulty in critical work.

Another method using a microscope body, horizontally, is to mount the objective in the substage condenser holder. The plate can then be held normally on the stage and the microscope itself used for viewing and focusing the image on the emulsion surface (Fig. 6.4). The microscope should first be focused on the emulsion surface and then the

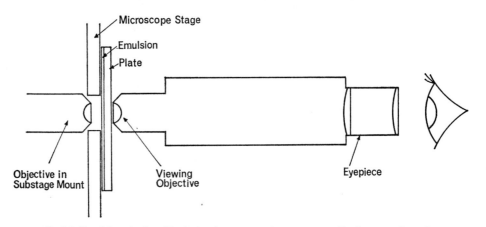

Fig. 6.4. Use of the reduction objective in microscope condenser mount enables image on plate to be examined through microscope.

216

reducing objective adjusted until its image falls in the same plane. The drawback to this useful method is that substage focusing movements are comparatively coarse and not graduated.

A second method of achieving a reasonably accurate visual focus is to use a high power magnifier to view the image. A crossline or some other mark is used on the glass surface (this is preferably a fine image on a plate similar to that in use) and focus is adjusted until the position of *no parallax* is found when the eye is moved sideways. Practice and a critical eye are necessary but with experience the method can be quite accurate. A third alternative is to illuminate the crosswire (or plate as above) from behind and form an enlarged image in the plane of the object. This image, because it is large, can be more easily examined visually.

Whatever method of visual focus is used it is advisable with all very critical work to regard the focus as unproven until a practical test result has been examined. It is for the purpose of making such tests at slightly different focus positions that some form of graduated focusing scale is strongly recommended.

A simple but effective pneumatic method of monitoring focus is used in the Watson step and repeat camera (see p. 451). A constant pressure of filtered air is fed to the almost enclosed space around the objective (Fig. 6.5). Air escapes only through the small gap between the objective housing and the emulsion surface, and the pressure loss, which depends on the size of the gap is measured on a manometer. The system is sensitive enough to measure variations in focus position of about 1 μm.

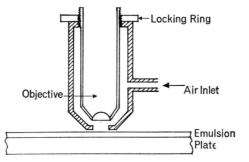

Fig. 6.5. Objective housing to allow pneumatic gauging of focus. The position of the objective in the housing is adjusted so that the distance of the housing from the emulsion surface, when properly focused, is very small.

6.1.2 SENSITIVE MATERIAL

6.1.2.1 *Concentrated Lippmann emulsions.* Although a wide variety of materials have been used for high resolution recording the field is currently dominated by one type, the concentrated Lippmann emulsion, consisting of extremely fine grained silver halide dispersed in gelatin. Whereas the mean grain size in most photographic emulsions is about 1 μm, that of a concentrated Lippmann emulsion is 0·01 to 0·1 μm allowing a resolution of well over 1000 lines/mm. Assessment of emulsion resolution of this order is very difficult because results achieved in practice are necessarily due to a combination of emulsion, processing and optical system characteristics.

High resolution materials available include:

Maximum Resolution Plates—Kodak Ltd.

High Resolution and Spectroscopic 649 GH Plates—Eastman Kodak.

High Resolution and He Ne Holographic Plates—Ilford Ltd.

8E56 Plates and 10E56 plates or film—Agfa-Gevaert Ltd.

Such plates are of fairly high contrast (gamma~3) with a maximum density of over 3·0 produced by normal development. Attempts to reduce contrast by modifying development usually result in poor density range and image colour. Contrast of the final result is best controlled by using a low contrast original.

The speed of all extreme resolution materials is very low by normal photographic standards, but concentrated Lippmann emulsions are amongst the fastest for the resolution they give, being very roughly 100–1000 times slower than bromide paper (see Fig. 2.24). Although this may appear to be a limiting factor it rarely proves so in practice. Originals are usually fairly small and commonly transparent so that efficient transmitted illumination can be used; the image is formed by a high aperture lens and gains in intensity from being reduced. Exposures of a few seconds are common and 1/50 second by no means impossible.

High resolution emulsions are commonly made orthochromatic, with a high green sensitivity extending to about 580 nm. This allows monochromatic illumination by the 546·1 nm mercury line, for which some special lenses are computed, and permits achromatic objectives to be used with green light. Although the turbidity of the material is low, there is inevitably some scattering of light (Rayleigh scatter) within the emulsion layer. The effect is much greater at the blue end of the spectrum and can be reduced, with consequent improvement in resolution, by using a yellow filter.

Concentrated Lippmann emulsions are conventionally coated on glass plates, which although selected and quite adequate for most purposes, are not perfectly flat. Plates of higher standards of flatness can usually be supplied to special order. The most common difficulty with glass plates arises because of their rigidity when it is required to print by contact an image of one plate on to another. The slightest lack of flatness (or dust or surface scratching) prevents perfect overall contact. The effect can be minimised by using a collimated, rather than diffuse, illumination.

Kodak Ltd. supply a 'pre-stripping' plate from which the emulsion can be stripped, melted and recoated by the user on to his own glass material.

6.1.2.2 *Photoresists.* (See Chapter 16.2.) A process which has become very important to high resolution recording, particularly in the field of microelectronics, is that described generally as 'photoresists'. Bichromated gum was the earliest useful process of this type, but has now been replaced by organic compounds which on exposure become insoluble in a 'developing' solution. These resists can be coated on to practically any metal, many plastics, glass or silica and provide a positive or negative image which is resistant to etching, metal deposition, dyeing or plating processes. If very thin layers of resist are employed, the resolution obtainable is superior to that of concentrated Lippmann emulsions.

6.1.2.3 *Other Sensitive Materials.* Sensitive materials which have been employed in the past for microphotography include:

Wet collodion process.

Silver halide sensitized Cellophane.

'Print-out' process using silver chloride.

Silver-albumen process.

Newer materials which appear to have potential for high resolution work in some fields are:

218

Various forms of diazo process including the Kalvar vesicular film.
Photochromic materials.
Photosensitive glass which becomes etch sensitive after exposure.
Thermoplastic recording materials.
Photoconductive materials.

6.1.3 THE ORIGINAL. The term original as used here refers to the object of which a finally reduced image is to be formed, which may actually be a second or third generation copy of a master drawing. It is usually convenient to have the original in the form of a transparency, negative in relation to the final microphotograph, although reversal processing is possible if both original and image are required to be of similar sign (p. 223). Opaque originals such as a book page or solid three-dimensional objects can be microphotographed by reflected light but they form a small proportion of very high resolution work.

When preparing a transparency for micro-reduction the factors to be considered include:

(1) The size of transparency required, bearing in mind the convenient reduction factors possible with the optics available.

(2) For continuous tone subjects, the degree of contrast required. Most high resolution materials are of high contrast and therefore originals of very limited tonal range may be necessary. If the original is a line subject the high contrast produced by process or lith materials is usually suitable.

(3) Fineness of detail. The resolution of detail on the original must obviously be at least as good as that required in the result, after allowing for the appropriate reduction factor. This may not always be as straightforward as it may seem. Small originals may have to be made on Maximum Resolution plates using carefully chosen optics. Where less fine detail is required and conventional photographic optics are suitable a better result will often be obtained on 'lith' material. This, due to its high contrast and enhanced edge effect, gives a sharper edge gradient than a M.R. Plate (Plate 11).

In some cases where lines of differing width are to be reproduced on a single image it is advantageous to mask the original so that the wider lines show a higher density than the narrower ones (assuming an original of low density lines on a high density ground). This is necessary because a greater exposure is required to record very fine lines to densities equal to wider ones. A similar effect occurs where there is 'isolated' detail and areas of closely adjacent detail. If the original is suitable, masking can be carried out by cutting neutral density filters and applying locally as required. When this is impractical unsharp masks made from the original can be used. The effects described are dependent on the proximity of the line width to the resolution limit of the system, but are most troublesome with image line widths below 10–20 μm.

The original transparency will usually be made from some form of master drawing of larger size to ensure greater accuracy (see p. 444). There are instances when it is helpful to modify this drawing to compensate for characteristics in the process. Allowances can be made for variations of line thickness and for the rounding which occurs at outside and inside corners (Fig. 6.6).

6.1.4 ILLUMINATION OF THE ORIGINAL. The basic principles of illumination of a transparent original are the same as those for ordinary enlarger illumination and either condenser or diffuse systems can be used.

219

Fig. 6.6. Master drawing. External serifs and cutting in of corners compensate for rounding on reduction.

Condenser illumination has the great advantage of high intensity, which becomes even greater when large reduction factors are used. However, the attainment of perfectly even illumination over the area of an original is not easy. The principle of having light source, condenser and objective coaxial, and focusing the image of the source on to the aperture of the objective is simple enough. Unfortunately the adjustment of the components is critical and difficulty can be caused by spherical aberration of the condenser lenses. The conjugates at which the condenser operates may be substantially different from those in an enlarger. In addition, the diameter of the objective aperture is smaller and, for even illumination, light from *all areas* of the condenser must be focused into this aperture (Fig. 6.7). A single condenser used as shown in

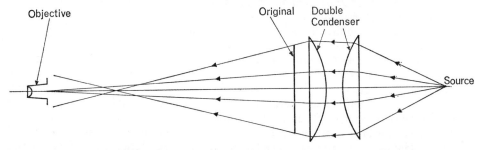

Fig. 6.7. Spherical aberration in double plano-convex condenser, producing uneven illumination.

Fig. 6.8a often exhibits less spherical aberration and may be useful, but in other cases a more highly corrected aplanatic condenser may be necessary. A larger light source such as an opal lamp helps, but allows less efficient use of the light.

Even, diffuse illumination is easy to achieve, but its intensity is much lower for a given lamp output. However, a fairly high intensity source such as a photoflood permits typical exposures of only a few seconds with a Maximum Resolution plate. Large originals can often be illuminated by one of the commercially available X-ray type viewing boxes, containing a number of fluorescent striplights.

220

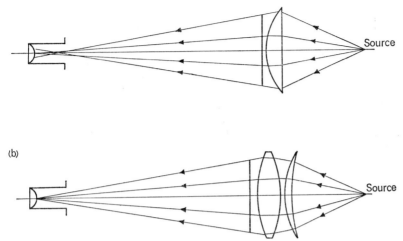

(a)

Source

(b)

Source

Fig. 6.8. Reduced spherical aberration in illuminating system using (a) single condenser (b) aplanatic condenser.

Image illuminance is almost independent of the reduction factor when diffuse illumination is used.

It is sometimes suggested that the resolution obtained with diffuse lighting is inferior to that using condensers. However the illumination from any object point fills the aperture of the objective (which is the principal requirement) and the suggestion is not substantiated by any real evidence.

6.1.5 EXPOSURE TECHNIQUE. Successful microphotography depends, more than any other type of photography, on accurate exposure. As the only way of finding the exposure required is by practical test, it follows that *precise control of all factors related to exposure is vital.* Apart from the more obvious factors, particular attention should be paid to variations in power supply voltage, batch differences of sensitive material and exact reproducibility of processing conditions (see Chapter 1).

When making and subsequently examining test micro images it is helpful to understand the effects encountered. We will assume the original has clear lines which will be dense in the microphotograph. (It is not difficult to deduce the effects with a 'reversed' original.)

(1) The image of a fine line has a lower illuminance, owing to lower MTF response (Chapter 2) than that of a wider one and therefore requires greater exposure to produce equal density (p. 219).

(2) The intensity profile of a line image is not square; so the line width depends on the exposure level (Fig. 6.9). This effect is greater with narrower lines as the intensity gradient is wider in proportion to the line width. Scattering of light within the emulsion is greater at higher exposure levels and also increases image size, as well as reducing sharpness.

(3) Because a focused image is more intense than a defocused one, exposure cannot be accurately assessed until precise focus has been achieved.

221

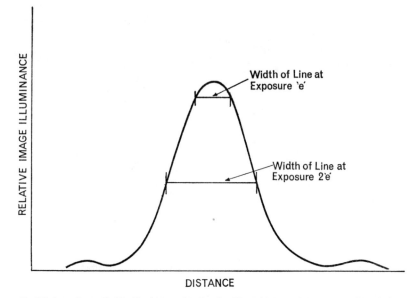

Fig. 6.9. Intensity profile of a line image, showing the effect of increased exposure on line width.

(4) The emulsion thickness may well be greater than the depth of focus of a microscope objective. This allows the sharp image to be formed at varying depths in the emulsion and also causes line thickening at higher exposure levels (Fig. 6.10).

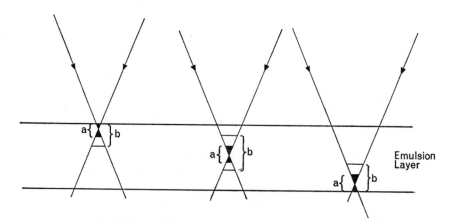

Fig. 6.10. Images formed at different depths within the emulsion. 'a' and 'b' show the extent of the processed image for low and high level exposures, respectively.

The above factors make the testing procedure a somewhat involved one, which needs to be tackled methodically—working notes are essential. A suggested routine is as follows (examination of processed images being through a suitable microscope):

222

(1) Obtain as good a visual focus as possible.

(2) Give a series of exposures (preferably on one plate) covering as wide a range as possible, making sure that the longest is over- rather than under-exposed (it may be impossible to see the result of an under-exposed image). Regular spacing in a line across the plate helps to identify very small images. From this series the approximate exposure can be decided.

(3) Make a further exposure test series closely spaced around the indicated level. Choose the best of these.

(4) At this exposure make a series of images at different focus settings.

(5) Repeat (3) and (4) if necessary at improved focus and exposure settings until the optimum is achieved.

In the later stages of this procedure it is wise to watch out for irregularities which are not explained by the points already mentioned but which may arise from inconsistencies of focus (e.g. backlash), exposure or processing.

The slightest vibration of the apparatus during exposure will impair or ruin the image produced. The disturbance which can result from the closing of a door or movements in an adjacent room is surprising and anti-vibration mountings may need to be considered. It is safest to make the exposure without touching the apparatus at all; either by remote switching of the light source or by removing a black card which can be held in the light path while vibrations die out.

Cleanliness of the emulsion surface is important in keeping the failure rate low. Sharply tapping the plate on a rigid bench or brushing gently with a camel-hair brush are simple, fairly effective methods; but for critical requirements more sophisticated means have to be used.[1]

6.1.6 PROCESSING. Processing of high resolution material is not very different from that of a conventional type of plate. The process is rather more critical and some of the chemical effects occurring are rather different, but carried out in accordance with manufacturers instructions the procedure is very similar.

The most generally recommended developers are high contrast formulae e.g. Kodak D178 (D158 for slightly lower contrast) or DG10 available in liquid form.

The use of an acid stop bath and fixer-hardener should be standard practice. Avoidance of dirt particles throughout the process and particularly in final washing and drying demands special attention. Very fine filtering of water is most desirable and careful wiping of the emulsion surface before drying is helpful. A final soaking in 75–80 per cent industrial spirit increases the resistance to surface damage. Drying with the emulsion facing downwards reduces the risk of particles settling on it.

Reversal processing using a bleach and redevelop system[5] is useful for some applications. In particular, when clear lines on an opaque background are required, such a process allows a similar (clear on opaque) original to be used, reducing the risk of trouble from flare while the density of the background, produced by the fogging reversal exposure, is very high. Unfortunately the clear lines require complete exposure all through the emulsion layer and this limits the usefulness of the process to line widths above 2–5 μm.

High resolution images can be chemically reduced to clear low densities or intensified to give greater contrast or improved image colour. Tests are advisable to ensure obtaining the effect required. A slow-working cutting reducer (e.g. Farmer's) is the most commonly useful after-treatment.

6.1.7 APPLICATIONS

6.1.7.1 *Graticules*. An obvious application of microphotography is in the manufacture of graticules (or reticules). These range in design from a single hair-line to extremely complicated arrays of straight and/or curved lines. Depending on the pattern the graticule may be made by either a single or multiple exposures. In the latter case accurate registration of the separate images may be very critical indeed, but quite large complex designs can be built up. Some designs are made by moving the sensitive material relative to a fixed image point, during a continuous exposure—literally drawing with light on the plate. Stevens[1] devotes a whole chapter to graticule techniques and states that this could be expanded to a complete volume.

The dimensional accuracy requirement for graticules depends on their intended purpose. In general the factors which affect the accuracy (in decreasing order of importance) are:

(1) The accuracy of the original drawing.

(2) Attainment of the exact reproduction scale necessary.

(3) Freedom from optical distortions at all stages. Such distortions may be due to (i) lack of proper alignment of object and image planes at right angles to lens axis or (ii) characteristics of any of the objectives used.

(4) Dimensional stability of the materials used at all stages, including the original drawing (see Chapters 14.5.1 and 16.4.2.1).

(5) Local distortion of line thickness (see p. 219).

(6) Stability of the emulsion on its base (see Chapter 14.5).

Photoresist processes may be used for graticule making, enabling the image to be either etched or deposited onto metal, glass or plastic. Such images can be more hard-wearing than a gelatin emulsion.

6.1.7.2 *Coded scales and gratings*. A logical extension of graticule techniques is the production of scales and gratings which form an essential part of many automatic recording instruments. Binary coded discs (Fig. 6.11) can be produced by multiple exposure methods using a dividing engine and are used in mechanical and optical digitizers.

Gratings, consisting simply of closely spaced parallel lines, have a special application in the measurement of very small movements by moiré fringe methods (see Chapter 15).

6.1.7.3 *Production of small components*. Microphotography is commonly used in conjunction with photoresist and etching or electro-forming techniques for the production of small, mainly two-dimensional components, such as electron microscope meshes (Chapter 16).

6.1.7.4 *Microelectronic devices*. The production of microcircuits is discussed in Chapter 16. The economic production of some of these devices requires an array of micro images to be formed on a single wafer perhaps an inch across. Such an array can be produced in three ways:

(1) From a single original, using an array of 'lenses' in the form of a lenticular screen.

(2) By a single lens, from an original produced in a step and repeat camera and consisting of an array of larger images.

(3) By the formation of successive single images directly on to the wafer, using a step and repeat action at this final stage.

Fig. 6.11. Typical binary coded disc (Optical Works Ltd.). This is an optical reduction of a master produced on a dividing engine. Where the finest spacings are required (discs with at least 13 tracks have been produced) optical reduction of the complete disc is not possible due to inadequate resolution over the comparatively large area. Only contact reproductions are then possible.

Methods 1 and 2 have the advantage that successive image arrays produced have exactly the same positions relative to one another, making registration easier. Method 2 in particular has led to the development of high resolution lenses of wide field (p. 214). Method 3 is capable of giving the finest resolution when this is vital but the step and repeat process requires very high precision to obtain consistent registration.

To avoid the limitation of resolution available from optical methods, sharply focused electron beams can be used to expose resist materials giving line widths of $0.1\,\mu m$.

6.1.7.5 *Image Evaluation.* A very useful application of microphotography is for the production of minute resolution test charts which can be used to assess the information transfer characteristics of particular imaging systems. The performance of optical systems is the most obvious example, although this is increasingly being assessed by electronic MTF methods (Chapter 2). Less obvious are the methods applied to microradiography and autoradiography for which micro images are produced respectively with high X-ray opacity or radioactivity (see Chapter 9).

6.2 *Document Microcopying*

This particular application of microphotography is by far the largest in terms of exposures made and is expanding very rapidly. Many of its problems are economic and production rather than technical ones. The Microfilm Association of Great Britain can advise on up-to-date methods.

The prime purpose of this form of document copying is to store information in a reduced space and with reduced weight. Its advantages lie in considerations of security,

possible destruction or loss of the original, and convenience in permitting wide and economical distribution of information.[6] The principal applications are concerned with engineering drawings, business systems and records and library uses.

While documents may be copied at extreme resolutions (e.g. pages of print concealed in a full stop), most routine work is of only medium high resolution over a 16 mm or 35 mm frame. The aim here is an efficient information storage system which allows easy retrieval when necessary. To demand of any system greater performance than is necessary makes it more complex and less easily handled. The reduction factors most commonly used vary between 12 and 20 which, with an image resolution of about 100–200 lines/mm give good legibility. Factors of 50–100 are possible under favourable conditions.

6.2.1 THE DOCUMENTS. Before microfilming is carried out it is essential to consider the documents to be copied from several points of view. They should be sorted into suitable order to avoid unnecessary changes in camera settings (e.g. reduction ratio) and so that any image can be easily located in the film. Some form of index or coding on the film and/or individual frames is often used to allow easy retrieval. The use of coding systems which allow selected frames to be located automatically is increasing.

6.2.2 PHOTOGRAPHIC FACTORS. The choice and control of optics, reduction factor, sensitive material, exposure and processing are interdependent and governed by the nature of the originals to be copied.

Lenses specifically designed for document copying should give a flat, anastigmatic image of good resolution over a reasonably wide field. The shorter the focal length the more compact the equipment can be made for a given reduction ratio. Compactness is often aided by 'bending' the optical system with mirrors or prisms. If the equipment is required to produce only first generation copies for visual examination by projection, resolution requirements and exposure accuracy are not excessively critical. However, higher standards are needed where duplicated micro records or enlarged 'hard copy' paper prints are required. The American COSATI standard specifies a resolution of 127 l/mm for camera originals and 90 l/mm for distributed copies.

The quality of the original, particularly regarding line density and width affects exposure latitude. Originals with wide variation in line and background quality present a particular problem because high contrast film will not give a satisfactory image of all parts, e.g. where cheques are to be copied the various tones and colours of paper and inks make it necessary to use a film giving an average gamma little more than 1. It is generally advised that the background density of microfilm negatives (corresponding to white paper) should be between 0·9 and 1·2, higher densities being avoided because of image spread and loss of resolution.[7] Many originals contain coloured information or background and the majority of microcopying film is therefore panchromatic.

Film speed is important because although low speed helps to achieve high image quality, exposure must be short enough to allow a rapid turnover of documents. Typical films are about one tenth the speed of normal fine-grain panchromatic and copying equipment usually relies on efficient illumination to achieve short exposures.

Processing of exposed microfilm should be accurately controlled but is not significantly different from conventional roll or miniature film. Fixing and washing must be particularly thorough if archival permanence is required.

226

6.2.3 MICROFILM CAMERAS. Standard 16 mm or 35 mm film is most commonly used for microcopying. Actual image sizes vary according to the documents and the equipment used.[8] On 35 mm film, image formats between 24×36 mm and 12×18 mm are used, sometimes recording two adjacent pages on each image. Images on 16 mm may conform to the cine-frame size ($10 \cdot 22 \times 7 \cdot 42$ mm) but often depend on the shape of the document (e.g. in flow cameras). The larger 70 mm or 105 mm films are occasionally used, particularly for engineering drawings and other large originals.

Images on other material such as flat film or paper have particular advantages for some purposes (see p. 228).

6.2.3.1 *Flat-bed cameras.* Also known as stand or planetary cameras, flat-bed cameras consist of a horizontal platform which holds the document suitably illuminated with tungsten or fluorescent lamps, and a vertical column which carries the camera assembly above it. The position of the camera on its column is used to vary the reduction factor and focusing is often automatic. Some form of photoelectric exposure assessment is now generally included, often relying on adjustment of the illumination intensity until the measured reflected light from the document is of a standard value. As each document is located on the platform, operation of a single control exposes and advances the film ready for the next exposure. The copying of books requires that the pages lie flat in a single plane. Special book holders which locate the pages against a glass plate are available.

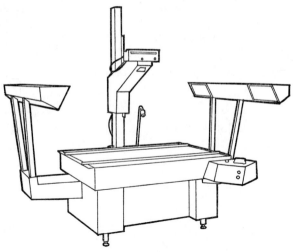

Fig. 6.12. Vertical stand camera with automatic focus and exposure control, for engineering drawings (Recordak).

6.2.3.2 *Flow cameras.* The essence of a flow camera is that it makes the exposure while both document and film are moving past a long narrow aperture, each being driven so that the image of the document formed by the lens is stationary on the film. Any length of original with a limited width can be copied. Illumination to cover the narrow exposed strip is built-in and, together with the film drive, is automatically switched on and off as the documents are fed through. Most cameras of this type have automatic indicators to show defects such as lamp failure or film run-out. Mirror systems allow both sides of a document to be recorded side by side on the film.

227

The operation of flow cameras can be extremely rapid, particularly if a large number of similar size documents (e.g. cheques) are involved, because several exposures per second can be made with automatic feed equipment. The limitations of such cameras are the restricted width of document acceptable and operation at one fixed reduction factor. Only single sheets can be copied; books cannot be accommodated.

6.2.3.3 *Step and Repeat Cameras.* Sets of documents can be exposed on a single sheet of film with a special step and repeat camera. *Microfiche* negatives may contain between 30 and 60 images of pages of a technical report on a sheet of film 5×3 in. or 6×4 in. with a large easily read title at the top.[9]

6.2.4 UNITIZED SYSTEMS. Microfiche (which can also be produced by 'stripping in' of related negative images) and similar systems offer the advantage of presenting limited quantities of related information in a much more conveniently handled form than is possible with rollfilm, and are very suitable for library filing or postal distribution.[10] Microfiche duplicates may be made from negatives by contact on to silver halide film or, more commonly, diazo film. *Microcards* are printed on to white card which is easily handled and viewed in suitable readers. Micro-opaques is a general term for various forms of micro images on card.

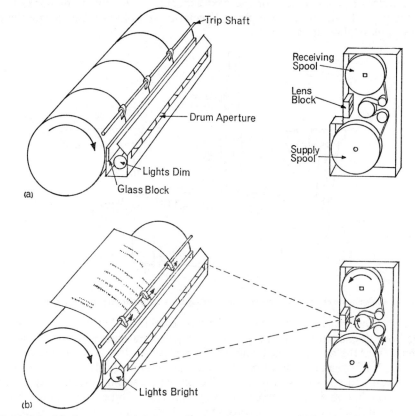

Fig. 6.13. Principle of the flow camera. (a) Quiescent situation with no document. (b) Insertion of document operates lamps and film drive.

228

Fig. 6.14. Layout of typical microfiche.

Other unitized systems use small lengths of roll film cut into strips and inserted into transparent envelopes to achieve similar handling convenience. Single microfilm frames particularly of engineering drawings, produced on planetary cameras may be mounted in *aperture cards* which allow handling and projection for viewing with a much reduced risk of damage to the film. The rest of the card contains filing data either written or in punched form suitable for automatic handling.

6.2.5 NON-SILVER PROCESSES. Silver halide, although the major, is not the only sensitive material for recording micro images. In particular, the Kalvar vesicular process[11] and thermo-plastic recording offer very high resolution and both have the advantage of being completely dry processes.

Photochromic materials[12] are capable of very high resolution (>1000 l/mm) and have certain attractive features e.g. no processing is necessary and unsatisfactory images can be erased. The National Cash Register Company's PCMI system uses this type of material for the final reduction stage in the production of microfilmed technical catalogues. Masters and subsequent duplicates for distribution are made by contact from the photochromic image on to Lippmann type film (Plate 13).

References

General

1 STEVENS, G. W. W., *Microphotography—photography at extreme resolution*, 2nd Ed, Chapman & Hall, London (1968).
2 *Technique of microphotography*, Revised Ed, Eastman Kodak Co., Rochester (1967).
3 NELSON, C. E., *Microfilm technology*, McGraw-Hill, New York (1965).
4 VERRY, H. R. and WRIGHT, G. H., *Microcopying methods*, 2nd Ed, Focal Press, London (1967).

Specific

5 Kodak data book Vol III, Sheet PR4.

6 WILLIAMS, B. J. S., *Evaluation of microrecording techniques for information and data storage and retrieval*. Hertfordshire Technical Information Service (1967).

7 DE BELDER, M., JESPERS, J. and VERBRUGGHE, R., *J Phot Sci*, 12, 296 (1964).
8 BALLOU, H. W. (Ed.), *Guide to microreproduction equipment*, National Microfilm Assoc., Annapolis, Maryland (1965).
9 *Specification for Microfiches*, BS 4187:1967.
10 HAWKEN, W. R., *Enlarged prints from library microforms*, American Library Assoc, Chicago (1963).
11 NIESET, R. T., *J Phot Sci*, 10, 188 (1962).
12 TANBER, A. S. and MYERS, W. C., *Proc Ann Conv Nat Microfilm Assoc*, 11, 256 (1962), Reprinted in *Am Doc*, 13, 402 (1962).

Technical Journal

NRCd Bulletin, published quarterly by the National Reprographic Centre for Documentation, Hatfield Polytechnic.

7. INFRARED PHOTOGRAPHY

7.1 *Introduction*

All electromagnetic radiation (EMR) has the same basic nature (see p. 109) but different problems arise in the generation, optical control and detection of the various wavebands. The variety of techniques necessary for recording throughout the spectrum is outlined in this chapter and in Chapters 8 and 9.

Whatever radiation is to be recorded, whether on a conventional film or as an electrical impulse in an image tube, all stages of the system must be reasonably well matched in spectral terms. This requires knowledge of several factors if an efficient system is to be designed:

(1) The spectral reflection or transmission band of the subject (or the emission band, if the subject is self-luminous or fluorescent).
(2) The spectral emission band of the illuminant.
(3) Atmospheric transmission characteristics, including the effects of scatter.
(4) Spectral transmittance and chromatic correction of the camera lens and any associated filters.
(5) The spectral sensitivity of the emulsion or other detector.

Traditional infrared photography is concerned with recording infrared radiation reflected or transmitted by the subject (mainly to enhance the visual image contrast), or to obtain photographs in 'darkness'. These basic IR techniques are fairly simple extensions of normal practice (see p. 250).

Post-war developments in infrared visualisation have produced improved methods for photographing thermal IR radiation (see p. 244). This work normally implies the recording of emitted IR from the human body and other objects at relatively low temperatures; these wavelengths are far beyond the range of infrared emulsions and the more sophisticated 'image conversion' techniques must be used (see pp. 243–50).

A system which records self-emitted radiation is termed 'passive' because it needs no external source of radiation; conversely, an 'active' IR system is one which requires infrared 'illumination'.

The physical aspects of infrared sources and detector systems are given in general references on infrared technology.[1-6]

7.2 *Infrared sources*

Most direct infrared photography is concerned with the near infrared because normal IR emulsions are sensitive only up to about 900 nm. The most efficient sources are photoflood lamps (peak at about 900 nm) and flash bulbs (peak at about 760 nm); in special circumstances an infrared laser may be suitable.

If it is necessary to irradiate the subject by infrared alone (as in nocturnal applications—see p. 251), the source can be covered by a Wratten 88A or the equivalent Kodak non-photographic filter No. 573, which make a flash source almost invisible.* Kodak suggest that for their IRER plates with a filtered flash bulb, the lens should be

*'Home made' IR filters can be made by dyeing Cellophane.[11]

opened up three stops compared with the correct aperture for 100 ASA film and an unfiltered flash bulb.

Daylight is a variable source of infrared. Direct sunlight has a fairly high content in the near infrared, but under cloudy conditions the IR content is lower in proportion to the visible radiation and may show variations that would be unsuspected from measurements of the visible daylight. As a practical measure for exterior IR photography, the meter film speed setting may be halved under dull conditions to make some allowance for the lower proportion of infrared.

Xenon discharge lamps have a strong emission in the 800–1000 nm band (see Fig. 3.12), depending to some extent on the voltage, the gas pressure and the current density. Most electronic flash sources use xenon and are a useful source of near IR radiation.[13]

Mercury discharge lamps are of little use for normal IR photography, although they are useful for infrared spectroscopy, including the far IR band beyond 100 μm.

7.3 Optical properties of materials in the infrared

7.3.1 ATMOSPHERE. The earth's atmosphere is a complex optical medium and a full account of the factors affecting absorption, scattering, refraction and polarisation cannot be given here. However, infrared recording has a special role in long-distance photography and certain points are of practical importance.

7.3.1.1 *Absorption.* The earth's atmosphere absorbs certain wavelengths, so that, although the sun emits over the entire near UV, visible and IR regions, some wavebands cannot reach the earth and are missing from the solar irradiation at sea level. Furthermore, most of these wavelengths cannot be transmitted for any great distance over the earth's surface. There are, however, well-defined atmospheric transmission bands and the most important of these 'windows' are as follows:

0·3–1·38 μm　This covers the near UV and visible regions, as well as the photographic infrared. There are minor O_2 and H_2O absorbtion bands at 0·74 μm, 0·94 μm and 1·13 μm but these cause no difficulty in normal practice.

1·4–1·9 μm ⎤
2·0–2·6 μm ⎟ These transmission bands are used for thermal imaging of bodies too
2·9–4·3 μm ⎬ cool to emit in the near infrared. Some IR communication systems
7·5–14 μm ⎦ also employ these wavelengths.

Like any other body, the atmosphere emits thermal radiation; this can cause complications in work in the 7·5–14 μm band.

7.3.1.2 *Scattering.* Radiation scattered by the atmosphere between the subject and camera impairs the contrast of the image; yellow, orange and red filters are used in landscape photography to give limited haze-penetration by absorbing the preferentially scattered shorter wavelengths. The near infrared wavelengths show even greater haze-penetration and some very striking examples of long-range oblique aerial photography were produced in the 1930's, showing for instance the opposite coast of the English Channel.

This led to popular belief in the ability of infrared films to produce photographs regardless of haze, mist, fog, smoke or rain. This misconception has been exposed by Brock[14] and others.

232

There are three possible scattering mechanisms, each with a different relationship between particle size and wavelength.

(1) Rayleigh scattering in which the scatter is proportional to the fourth power of the wavelength.

(2) Mie scattering, which is a complex function of wavelength.

(3) Non-selective scattering, which is completely independent of wavelength.

The overall scattering characteristics depend on the prevailing state of the atmosphere. Under very clear conditions (visibility say 30 miles) the Rayleigh scatter predominates and the use of infrared photography can then double the effective range. In more normal conditions the scattering particles are larger, Mie scattering becomes more important and IR photography is less effective. When visibility is poor (less than about ½ mile) the particles are so large that all visible and near IR wavelengths are subject to non-selective scattering and there is no purpose in using infrared photography. The only way of transmitting EMR through dense fog is to use a wavelength much longer than the fog particle size (which ranges from 1–100 μm); radar transmission ($\lambda \simeq 1$ mm) is virtually unaffected by fog.

Haze reduces image contrast and therefore tends to have an adverse effect on the photographic resolution. If conditions are such that IR emulsions can improve contrast by haze penetration, an effective increase in image resolving power might be expected. This has to be set against the relatively low resolution of most infrared emulsions.

7.3.2 LENSES. Factors for consideration in an optical material are:

(1) Transmission in the spectral region of interest.

(2) Refractive index (which varies throughout the spectrum).

(3) Physical properties (hardness, surface finish, homogeneity, solubility, melting point, thermal expansion, long-term darkening by radiation).

7.3.2.1 *Conventional lenses.* Normal optical glasses transmit freely up to about 2·7 μm, so that standard lenses can be used for all direct IR photography (which is limited to a maximum of 1·35 μm by the emulsion sensitivity).

Chromatic aberration in simple lenses causes the IR image to be formed further from the lens than the visible image (see Fig. 5.10). It is sometimes suggested that, after visual focusing, the lens should be racked out by 1/250 of the focal length in order to place the infrared focal plane on the emulsion. This rule of thumb may be adequate in some cases, but the exact adjustment depends on the designed chromatic correction of the lens. Freytag has quoted IR correction values for the range of Zeiss Hasselblad lenses at different wavelengths.[15] At 800 nm the necessary extension ranges from 0·9 per cent to 0·3 per cent of the nominal focal length.

The usual practice in occasional laboratory work is to focus through a red filter and then to work at a small aperture, thus increasing the depth of focus and minimising the unsharpness of the IR image. For a continuous programme of IR work, or where large apertures are necessary, a simple focus calibration exercise, preferably using a resolution test target, is worthwhile.

A method suggested by Naumann for infrared photomicrography is based on the assumption that the difference in focus between infrared and red is the same as the difference between red and green. The focus is set first in green light (G_f) and then in red light (R_f) and the difference in reading on the focus control (R_f–G_f) is noted; for the IR photograph the focus control is altered by an equal amount and set at $R_f + (R_f - G_f)$.

Some lenses are chromatically corrected for both the visible and the near IR regions; for example, the Pentax Ultra-achromatic Takumar 300 mm *f*5·6 is designed for the range 320–850 nm and the Canon 200 mm and 300 mm Fluorite lenses are corrected for the near IR up to about 850 nm. However, a more common practice, particularly with longer focal-length lenses, is to provide a separate IR focusing datum; this allows the extra extension to be rapidly set after noting the visual focus setting.

Mirror lenses (catoptric lenses) are free from chromatic aberration and are therefore well suited to IR work. However, many such designs are catadioptric (having additional refractive elements) so that they may not be entirely free from focusing problems.

A lens with a longer focal length in the infrared produces IR images that are larger than the visible images; this causes difficulties in IR aerial photogrammetry (see Chapter 14) and full chromatic correction is then required.

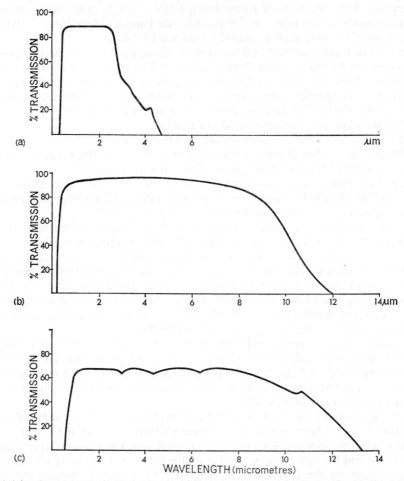

Fig. 7.1. Infrared transmission of optical materials. (a) Typical optical glass. (b) Calcium fluoride (3 mm thick). (By courtesy of Barr & Stroud Ltd.) (c) Arsenic trisulphide glass (3 mm thick). (By courtesy of Barr & Stroud Ltd.)

234

7.3.2.2 *Special IR optical materials.* Table 7.1 lists a few of the more common materials used for making infrared lenses, prisms, fibre optics and other components.

In some cases the refractive index is much higher than is available with normal glasses. This can facilitate the design of simpler lenses, but also increases the reflection losses at each surface; for this reason a low-reflectance coating is essential, although there is only a limited range of suitable coating materials for this region.

TABLE 7.1

OPTICAL CHARACTERISTICS OF INFRARED TRANSMITTING MATERIALS

Material	Transmission band (μm)	Typical refractive index (at $\lambda=2\mu m$)
Normal optical glasses	0·35– 2·8	1·5
Fused quartz (Si O_2)	0·2 – 4·8	1·5
Calcite (Ca CO_3)	0·3 – 5·5	1·6
Fluorite (Ca F_2)	0·12– 9	1·45
*Irtran-1 (Mg F_2)	0·45– 9·2	1·4
Arsenic tri-sulphide (As$_2$ S$_3$)	0·6 –11	2·4
*Irtran-2 (Zn S)	0·57–14·7	2·2
Rock salt (Na Cl)	0·2 –20	1·5
Germanium (Ge)	2·0 –50	4·1

*Kodak trade mark.

7.3.2.3 *Resolution.* Many lenses corrected for use in the visible spectrum give an infrared image of somewhat lower quality, even when the optimum IR focus has been set. In addition, infrared photographs of sub-surface detail often appear unsharp because of scattering within the specimen.

In the far infrared, the theoretical optical resolution is lower (Eq. 2.6). However, none of the thermal detectors in general use has a high resolution, so the optical system is not normally an unduly limiting factor once the correct focus has been set.

7.3.3 FILTERS. All IR emulsions have a basic panchromatic sensitivity (Fig. 7.3), so that for an infrared photograph a filter must be used which absorbs visible radiation and freely transmits the infrared. For some purposes, when a record is required of both the red and the infrared, a tri-colour red filter may be used.

Table 7.2 and Fig. 7.2 show the properties of typical IR transmitting filters; the 10 per cent transmission level is arbitrarily quoted here as defining the cut-off wavelength.

Exposure correction factors are not quoted for these filters; the manufacturer's speed figures for IR films usually includes the filter factor for a given illuminant.

For work in the far infrared, interference filters are normally used (see Fig. 7.2); the available range permits the selection of almost any cut-off wavelength or pass-band.*

The term infrared filter is also used, rather confusingly, to describe filters designed to remove IR radiation; these are mainly intended for heat reduction in optical systems. They may be of the absorbtion type (e.g. Chance ON-22, Kodak 500/00/HR1) or of the dichroic interference type, transmitting visible light but reflecting infrared.

*Infrared interference filters are available from Barr & Stroud Ltd., Balzer High Vacuum Ltd., Ealing Beck Ltd., Optical Coatings Ltd. and Bellingham & Stanley Ltd.

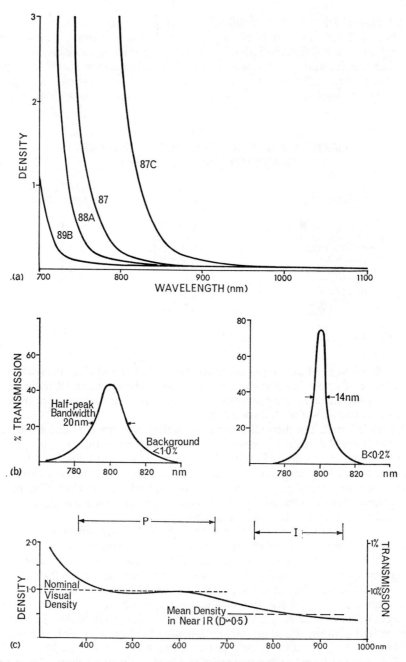

Fig. 7.2. Infrared transmission of photographic filters. (a) Wratten Infrared filters. (By courtesy of Kodak Ltd.) (b) Typical narrow-band IR interference filters. (By courtesy of Barr & Stroud Ltd.) (c) Typical neutral density filter (colloidal carbon). (Based on data published by Ilford Ltd.) P—Typical effective sensitivity band of panchromatic emulsion. I—Effective sensitivity band of filtered standard IR emulsions.

TABLE 7.2
INFRARED TRANSMISSION FILTERS

Filter	10% cut-off wavelength (nm)	Mean transmission (800–900 nm)
Ilford 207	730	84%
Wratten 88A	735	85%
Wratten 87	760	77%
Ilford 207+813	765	65%
Wratten 87C	820	40%
Chance OX–5	880	—

TABLE 7.2A
POLARISING FILTERS FOR THE INFRARED

	Recommended working range (nm)	Mean transmission in the 800–900 nm band
Polaroid HN 7	700–900	45%
Polaroid HR	700–2700	35%

The standard neutral density filters have a reduced absorption in the infrared and these filters therefore have a lower IR density value (perhaps only half the nominal value). Semi-reflecting metallised filters may be preferred.

Normal polarising filters operate by the dye-absorption of light polarised in one plane.[16] However, the IR absorption of these dyes is low and a transmitted beam of infrared is therefore largely unpolarised. Special IR polarisers are listed in Table 7.2.

7.3.4 CAMERA MATERIALS. Some visually opaque substances used in camera construction transmit infrared radiation:

(1) Many types of wood, even in thicknesses of several millimetres, transmit IR quite freely; wooden cameras and dark slides must therefore be regarded as suspect for this work. Fortunately, the black paint commonly used inside such equipment is opaque to IR and thorough re-painting normally cures any leakage.

(2) IR transmission by leather or rubber bellows is another possible cause of fogging, although most bellows seem to be satisfactory when new. If there is any doubt, a thick cloth can be used to enclose the camera for occasional work, or the bellows can be wrapped in tinfoil.

(3) Plastics often have a high IR transmission, but fortunately they are rarely used in technical cameras. A common difficulty is that dark slide sheaths are often unsafe for IR photography and must be replaced by brass or aluminium sheaths.

The use of metal cameras obviously has much to recommend it in this context, but even then a thorough fogging test should always be carried out together with the routine focus checking and other preparations for infrared photography.

7.4 *Infrared emulsions*

The limit of infrared response achieved in silver halide emulsions is about 1·35 μm, although the emulsions in common use are sensitised only up to about 0·9 μm. There is always a relatively high blue sensitivity and a low green response (see Fig. 7.3).

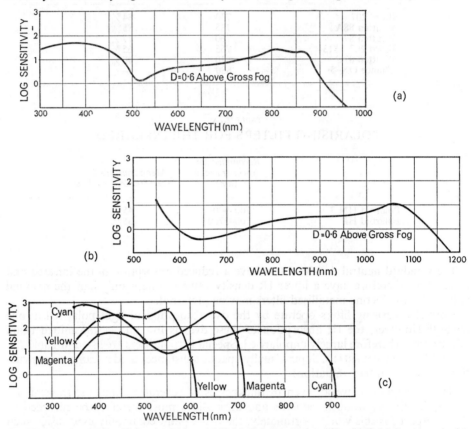

Fig. 7.3. Spectral sensitivity of infrared emulsions. (a) Kodak High Speed Infrared film. (b) Kodak Spectroscopic plate Type 1–Z (hypersensitised). (c) Kodak Ektachrome Infrared Aero film.

Apart from the problem of finding suitable dye sensitisers, the wavelength of about 1·35 μm is unlikely to be greatly extended, because of inherent film manufacturing difficulties. An emulsion capable of recording longer wavelengths would absorb thermal IR radiation from the air or from warmer parts of the coating plant and would become fogged.

Infrared emulsions fall into three categories:

(1) General-purpose emulsions of moderate contrast, with speed sufficient for exterior photography and sensitised up to about 900 nm.

(2) High contrast process emulsions of similar spectral sensitivity, but much lower speed.

238

(3) Spectroscopic plates sensitised to the longer wavelengths. These materials often have a low speed and the plates for work beyond about 1 μm require hypersensitisation, carefully following the manufacturer's recommendations. Barker[17] has described the use of a 6 per cent ammonia solution or a plain water pre-bath to increase the speed of Kodak IV N plates by a factor of $14 \times$ to $20 \times$.

All infrared emulsions should be kept under cool conditions; 65°F is an upper limit and even then an increase of fog and a serious loss of speed can occur in a few months. Kodak recommend storage at 40–50°F and 40–60 per cent RH.

No special precautions are necessary when processing infrared films unless 'development by inspection' is required. Infrared safelights (e.g. Wratten No. 9) are available, but must be used with caution; some workers prefer to desensitise the emulsion before development, so that it can be handled under a normal safelight.

Table 7.3 gives brief details of infrared emulsions currently available in Britain; in most cases these are 'special order' products. It will be noted that IR films allow a higher film speed meter setting with tungsten lamps than with daylight.

TABLE 7.3
INFRARED EMULSIONS

		ASA Speed* Day. Tung.		IR waveband of greatest sensitivity	Contrast	Granularity
Kodak						
Infra Red Extra Rapid (IRER)	Plates	6	10	670–880nm (limit about 950)	Medium	Moderate
Infrared film	35mm	(similar to IRER)				
High Speed Infrared film	16mm 35mm	32	100	770–840nm (limit about 950)	Medium	Medium-coarse
Scientific Plates Class L (II L)	Plates (films also available)	—	—	up to 880nm	Medium	Moderate
Class N (II N)		(similar to IRER)			Medium	Moderate
Class R (III R)		10% of II N		740–850nm	High	Low
Class Z (IZ)		—	—	1020–1150nm (limit about 1200)		
Class M (IM)		—	—	850–980nm (limit about 1000)		
Ektachrome Infrared	Film	100**	50***	Green sens.–600nm Red sens. –700nm I.R. sens. –900nm	High	
Polaroid						
Infrared film Type 413	4¼ × 3¼ prints	200	200	up to 820nm (limit about 900)	Fairly high	
Agfa-Gevaert						
Scientia 52 A 86	Films & plates	80	100	780–800nm (limit about 900)	Fairly high	
Ilford						
I R Process	Plate	—	—	740–880nm	High	Very fine
Long Range Spectrum	Plate	—	—	up to 880nm	High	Fine

*Recommended meter setting for selenium meter when using 88A filter on camera.
**With Wratten No. 12 (Yellow) filter.
***With Wratten No. 12 plus colour correction filters.

3 M Thermofax materials have their peak response in the region $0 \cdot 7–1 \cdot 0 \, \mu m$ and will not record pigments that transmit a high proportion of near IR. This may prove useful for a rapid check in forensic and other work where it is necessary to show the use of different inks in forgeries, or to penetrate deletions or over-writing. The principles of thermographic copying processes and other infrared visualisation techniques have been described by Tyrell.[18]

7.4.1 EKTACHROME INFRARED FILM. Fig. 7.3b shows the spectral sensitivity of Kodak Ektachrome Infrared film which is used in aerial survey (see p. 252), medicine (see p. 254) and other fields where a simultaneous record of visible and the near IR wavebands is required. The film was basically designed for aerial photography (short exposure times); exposures of 1/10 second or longer require a correction for reciprocity failure and a colour compensation filter. Processing is in standard Ektachrome solutions.

The film is always exposed through a Wratten No. 12 yellow filter, which removes the inherent blue sensitivity of all the layers. The wavebands are recorded as follows:

Near IR cyan image layer
Red magenta image layer
Green yellow image layer

A subject reflecting all of these wavebands equally records as a neutral area, but, for example, a visually dark subject with high IR reflectance (e.g. deciduous foliage) appears red (magenta+yellow) in the transparency after reversal processing. Gibson has given advice on adjusting the colour balance of these records in clinical work.[19]

7.4.2 HERSCHEL EFFECT. The Herschel effect embraces a number of closely-related phenomena in which the photographic latent image is destroyed by red or infrared radiation. The effect was useful to the early spectroscopists, who were able to record an infrared image on pre-fogged ordinary emulsions (Sir John Herschel, 1840). However, the effect is not always easy to produce and requires a prolonged exposure to the long-wave 'bleaching' radiation in order to form an image.

The same principle has been applied in an enhanced form in some document-copying materials in which yellow or red light is used to destroy a pre-formed latent image, thus yielding a direct reversal positive image by normal print processing.

7.5 Detectors

7.5.1 CLASSIFICATION. Radiation sensors are normally classified as thermal detectors or photon detectors. They may alternatively be divided into point detectors and image-forming detectors; the latter are of primary photographic interest and are described in Section 7.6, but point detectors are also used, for example, in the IR scanning thermograph (p. 244). An array of point detectors (e.g. photo-electric cells) can be arranged to cover the image plane of a lens[20] and offers the advantage of direct and continuous electrical transmission of the image information; however, the spatial resolution of these mosaic systems is so far rather low.

7.5.1.1 Thermal detectors. In thermal detector systems the absorbed radiation raises the detector temperature and causes a variation of a physical property; the simplest example is the thermometer.

The response time of thermal detectors tends to be long and they are also fragile, but they have the advantage of response to a very wide spectral band. The sensitivity

is often very high; for example, a super-conducting bolometer at the focus of a suitable lens can detect the heat from a candle at a range of one mile.

Conventional thermal detectors have no direct application in IR photography and need only be listed here. However, some of the infrared imaging systems (e.g. evaporography and the liquid crystals, see pp. 246–50) rely on thermal changes within the detector medium.

<div align="center">TABLE 7.4</div>

<div align="center">THERMAL DETECTORS</div>

Thermocouple (e.g. Bismuth-Antimony bi-metal strip) Bolometer (e.g. Platinum ribbon) Semi-conducting bolometer (thermistor) (e.g. thin slice of Manganese or Nickel) Super-conducting bolometer (e.g. Evaporated thin-film of Gallium-doped Germanium, operated at cryogenic temperatures)	The electrical properties of these materials are changed by the temperature rise caused by absorbed infrared radiation
Golay cell	Pneumatic detector. Operates by the expansion of gas warmed by the absorbed radiation

7.5.1.2 *Photon detectors.* In photon detectors (also termed quantum detectors), absorbed photons act on the individual atoms of the detector material, causing electron transitions which effect a change in the electrical properties.

In general, photon detectors are compact and robust and tend to give a greater response than thermal detectors. A fundamental difference is that photon detectors have a well-defined cut-off wavelength to the spectral sensitivity (see Fig. 7.4).

7.5.2 PHOTO-ELECTRIC CELLS. In photographic work, photon detectors are more commonly known as photocells. This term is not very explicit, as there are three distinct devices falling in this category: photo-voltaic, photo-emissive, and photo-conductive cells. Some materials (for example, selenium and indium antimonide) can be used in more than one mode, either as photo-voltaic or photo-conductive cells.

All three types are used in conventional photography and their principles have been described by Corbett,[21] but the following points are relevant to IR photography and IR detection systems.

7.5.2.1 *Photo-voltaic (P/V) cells.* The primary advantage of the photo-voltaic cell is that it needs no external power supply. Its ability to generate an electric current from incident radiation is applied in solar-cell power systems.

The selenium barrier-layer P/V cells used in many exposure meters have a spectral sensitivity from about 350–700 nm (see Fig. 7.4). Although there is no IR response, these meters can be used indirectly for IR exposure assessment with sources having a known relationship between IR and visible emission (for instance the sun and tungsten lamps).

The photo-voltaic silicon diodes have response in the range 400–1100 nm and with suitable filtration would seem to be well suited for IR exposure measurement.

Photo-transistors are P/V devices based on junctions of semi-conductors.

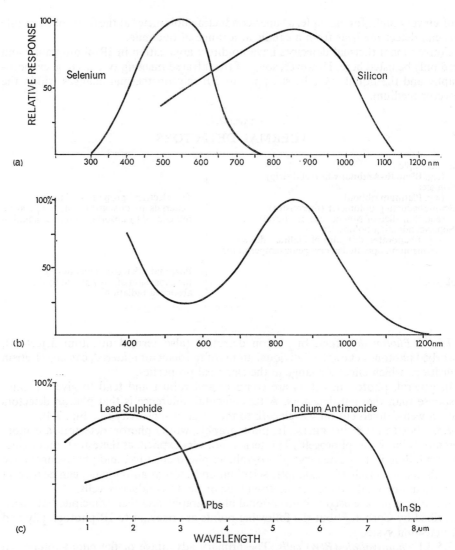

Fig. 7.4. Spectral sensitivity of typical photo-electric cells. (a) Selenium and silicon photo-voltaic cells. (b) Silver-oxygen-caesium (Ag-O-Cs) photo-emissive cell. (c) Typical IR response curves of photo-conductive detectors (room temperature).

7.5.2.2 *Photo-emissive (P/E) cells*. A photo-cathode inside a gas-filled or evacuated envelope emits electrons under irradiation of a suitable wavelength. The electrons are accelerated across to an anode and a 'photo-current' flows in the circuit.

The spectral response of P/E cells depends on the cathode material; most of these cells respond only to UV and visible radiation, but an Ag-O-Cs photo-cathode (known as the S1 surface) responds to wavelengths up to about $1 \cdot 2 \, \mu$m.

The image converter tube, which is an image-forming photo-emissive device, is mentioned in Section 7.6. Similar tubes, designed primarily to give image intensification

242

rather than wavelength conversion, are used in astronomy, radiography (Chapter 9) and high-speed photography (Chapter 11).

7.5.2.3 *Photo-conductive (P/C) cells.* Some materials show an increased electrical conductivity when exposed to EMR. These materials form the basis of the great majority of modern IR detectors. Well-known examples are lead sulphide (response $0.2–3.5$ μm) and indium antimonide (response up to 8 μm). In every case the high sensitivity is further enhanced by operation at low temperature.

The photo-conductive cadmium sulphide cells used in many exposure meters are sensitive from about 450–790 nm; they may thus be slightly superior to selenium cells for conventional infrared photography. Excessive red and IR sensitivity is normally a disadvantage in an exposure meter. It is recommended that the IR response (>700 nm) should not exceed 5 per cent of the visible response.[22]

7.6 *Infrared imaging systems*

7.6.1 IMAGE CONVERTER TUBES. Any device sensitive to non-visible radiation which displays a visible image may be called an image converter, but the term is usually reserved for photo-emissive electron image tubes of the type shown in Fig. 7.5. The infrared response of photo-emissive materials is limited at present to that of the

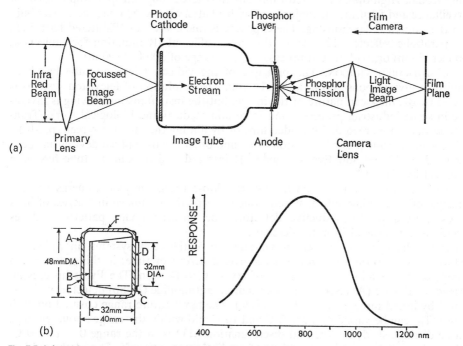

Fig. 7.5. Infrared image convertor tubes. (a) Schematic layout of IR image convertor and associated camera optical system. (The primary lens is frequently a catoptric mirror lens). (b) Dimensions and spectral response of EMI Type 9606 IR image convertor tube. A—Photo cathode contact ring. B—Anode screen. C—Anode contact ring. D—Rear window. E—Photo cathode and front window. F—Envelope (By courtesy of EMI Electronics Ltd.)

243

Ag–O–Cs photo-cathode shown in Figure 7.4; IR image convertor tubes are therefore restricted to the waveband up to about 1.2 μm.

Image converter tubes are free from the scanning lines of television displays and in some cases may have a central resolution up to 50 l/mm although the edge resolution may be only 5–10 l/mm. However, the image is usually only about an inch in diameter, so the total number of resolved lines is rather low by photographic standards. The resolution of image tubes depends on the image illumininance; this and other aspects of their performance has been discussed by Soule.[23]

As shown in Fig. 7.5, a conventional lens focuses an image on the tube photo-cathode; the liberated electrons are accelerated down the tube and form an image pattern in the plane of the phosphor; this fluoresces under the impact of the electrons. The operation of these tubes is similar to that of the image tubes described in Chapter 11, differing mainly in the photo-cathode material used.

A high operating voltage is required but battery-operated tubes are readily available. Bateman and Killick have described a hand-powered piezo-electric generator for a pistol-grip IR telescope.[24]

These tubes are often used purely for visual purposes, but the image can readily be photographed. Leitz and Wild supply IR image converters specifically for use in microscope systems (see p. 271).

The Asahi Pentax Nocta 35 mm camera is designed for nocturnal photography using Kodak High Speed Infrared Film. An IR-filtered tungsten spotlamp is used for surveillance and focusing, in conjunction with a battery-powered image converter built into the camera reflex housing. The exposure is made with an IR-filtered flash bulb in a parabolic reflector (12° beam); this gives sufficient IR radiation for subjects at 100 feet (30 m) or, with forced processing, at a range of 300 feet (90 m).

7.6.2 INFRARED VIDICON. The principle of the vidicon television tube has been applied to give response up to about 1·5 μm. The resolution of television systems is limited by the line-scan nature of the image, but the instantaneous viewing is invaluable in some industrial processes and in certain medical and biological work. Transient events can be recorded on video tape or by filming the monitor screen (p. 310).

The general principles of television tubes and other electro-optical devices has been discussed by Vine[25] and Evans[26]; an EMI infrared vidicon camera tube has been described by Taylor.[27]

7.6.3 THERMOGRAPHIC SCANNING SYSTEMS. Most thermographic cameras use the principle of a scanning optical system which sweeps the IR image in a series of lines across a fixed photo-conductive detector. The infrared image pattern produces variations in the signal from the detector.

The Smiths Pyroscan camera is an example of the early systems, in which the picture is built up on a recording paper over a period of time; in this case a video storage tube unit allows the progress of the scan to be seen. The Pyroscan uses an arsenic trisulphide ($As_2 S_3$) lens and an indium antimonide (In Sb) detector, which is cooled by liquid nitrogen to −196°C (77K). The temperature range covered on each record (T_R) can be varied between 2°C and 10°C and within this range about ten steps can be distinguished; the thermal discrimination (ΔT) is in the range 0·2° to 1·0°C. This equipment is used for a variety of medical applications[28, 29] and the subject resolution quoted for this work is about 0·12 in. (3 mm) at a patient placed 36 in. (910 mm) from the camera.

244

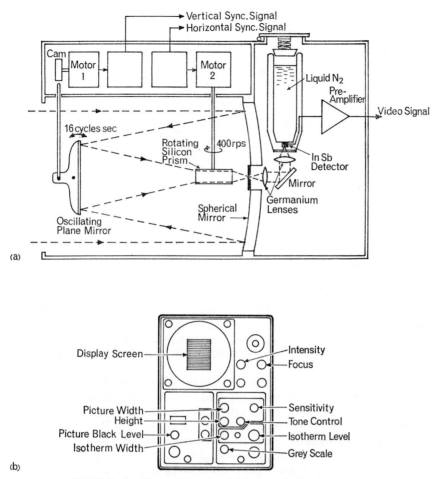

(a)

(b)

Fig. 7.6. The Aga Thermovision camera. (a) Camera unit. (b) Display unit.

7.6.3.1 *Real-time thermography.* The relatively long scanning time of the Pyroscan and similar cameras (e.g. Barnes Model 332) gives good optical and thermal resolution along each scan line but requires close control of the environment to avoid cold draughts on the subject during the exposure; moving subjects are precluded and rapid temperature fluctuations cannot be studied. Recently-developed designs use fast-response detectors and rotating prisms for high-speed scanning. The basis of the Aga Thermovision is shown in Fig. 7.6; it records 16 scans a second to give an instantaneous display on a video display tube; photographic recording is optional. The Thermovision camera can be linked to a video tape recorder to store the information for subsequent thermographic presentation on the display unit. The equipment can be operated by batteries to allow its use in moving vehicles and helicopters; it has been widely used in this way for the study of overheating in electrical transmission lines.

245

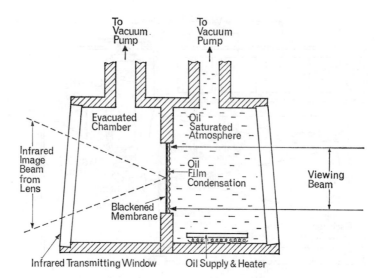

Fig. 7.7. Principle of the Evaporograph. The evacuated chamber is maintained at a lower temperature than the oil chamber in order to assist condensation on the membrane.

7.6.3.2 *Colour thermography*. The temperature discrimination is often enhanced if the thermographic display is in colour. Astheimer[32] has pointed out that a monochrome record may contain as much information as a colour thermogram, but often requires densitometric evaluation to extract details that would be readily visible in a colour display.

 (1) In the Barnes T-6 Thermograph the film exposure is modulated according to the detector signal by a moving grey wedge in front of constant-intensity lamp, instead of a 'glow lamp' as in earlier models. If a colour wedge is substituted, a 10-step colour thermogram is produced on colour film.[32]

 (2) The Aga Thermovision camera can give a colour thermogram by eight successive exposures of the CRT display through different colour filters.[33] Each exposure is of a separate temperature band (iso-thermal level); the complete cycle of eight exposures is made automatically over the required temperature range in 15 seconds.

 (3) Nichols and Lamar[34] have described a system using 3 separate detectors which modulate separate glow lamps; each lamp is filtered to expose a different primary colour on to the film. The detectors cover an unusually wide range: $0 \cdot 5$–$1 \cdot 0\ \mu$m, $3 \cdot 0$–$5 \cdot 5\ \mu$m and 8–14 μm.

7.6.4 EVAPOROGRAPHY.[35] This method, due to Herschel (1840), was developed by Czerny (1929) and is now offered as a commercial instrument (Baird-Atomic Inc.) for thermography or for IR spectroscopy.

The detector element is a thin membrane, which is blackened to ensure absorption over a wide IR band. An oil film about 500 nm thick is formed on the membrane and is quickly evaporated in areas that are warmed by the absorbed IR image. The resulting variations in film thickness are viewed by an interferometer.

The evaporograph is a thermal detector (see p. 241) and has a relatively long response time. A high-temperature object may produce an IR image which evaporates the oil

246

TABLE 7.5

COMMERCIALLY AVAILABLE THERMOGRAPHIC SYSTEMS

	Aga Thermovision	E.M.I. Thermoscan[30]	Smith's Pyroscan Model II B	Bofors IR camera[31]
Detector Scan time	In Sb (N$_2$ cooled) Real time display 16 p.p.s.	In Sb (N$_2$ cooled) 2 frames per second or 2 seconds per frame	In Sb (N$_2$ cooled) 20–30 seconds	In Sb (N$_2$ cooled) 4 frames per per second
Subject field	4 models 5° × 5° to 20° × 20°	21° × 8°	25° × 25°	25° × 12·5°
Lines per frame	100	100 or 25	150 lines	
Total working range	−30 to +2000°C	−20°C to 100°C (can be extended)	−20°C to +200°C	−20°C to +150°C (can be extended)
Temperature range on each frame	1–2000°C	6 steps between 2° and 100°C	2°–10°C	6 steps between 5° and 150°C
Temperature discrimination at 30°C	0·2°C	0·2°C	0·2°C to 1°C	0·2°C
Spectral response band	2·0–5·4µm	3·0–5·5µm	up to 5·5µm	1–5·5µm
	Colour display filter attachment takes 15 sec. to record 8-band colour presentation	Can be switched to line scan mode (A scan) giving temperature profile display	Video display and photographic record built up over scan time	Can be set to give iso-thermal display covering 2·5% to 20% of the temperature range set
	Can be set to give isothermal display covering any required temperature band			Colour thermograms can be made from the isothermal display

film in a fraction of a second, but the image of a cooler body may take several seconds to generate sufficient temperature in the membrane. Wavelengths up to about 9 µm have been recorded by this method.

7.6.5 PHOSPHOROGRAPHY. Phosphors are used for IR visualisation in two ways: the extinction of visible fluorescence by infrared and the stimulation of visible fluorescence by infrared.

7.6.5.1 *Extinction of fluorescence.* The luminous efficiency of phosphors decreases at high temperatures (see Fig. 7.8). If a fluorescing surface is irradiated by an infrared image, the local heating caused by the absorbed IR extinguishes the fluorescence and the warmer parts of the image appear darker.

The simplicity of this method has led to the development of a range of special phosphors with enhanced temperature-dependence. For example, the response band of activated zinc sulphide phosphors extends up to 2 µm, with quenching maxima at 0·7 µm and 1·6 µm.[36, 37] Temperatures over the range −180°C to +500°C can be recorded with suitable phosphors.

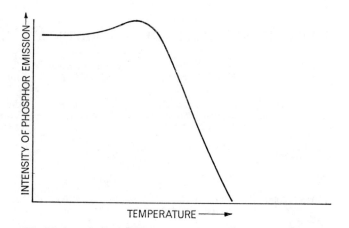

Fig. 7.8. General pattern of phosphor quenching with increased temperature.

In 'contact phosphorography' the subject is coated with the phosphors and irradiated with ultraviolet. The overall fluorescence of the coating is quenched in warmer areas and the surface temperatures can be estimated within a few °C by photographic photometry. The phosphors can be applied in the form of fluorescent tape or as an aerosol.

Lawson and Alt[38] have used an aerosol phosphor to detect skin temperature abnormalities and have reported a temperature discrimination of 1°C. The phosphor display can be photographed at any required interval or relayed by television. Similar techniques have been used in wind tunnel work.[39]

'Projection phosphorography' (see Fig. 7.9) has lower sensitivity than the contact method, but it is more suitable for objects that cannot conveniently be coated; furthermore it does not require a darkened room.

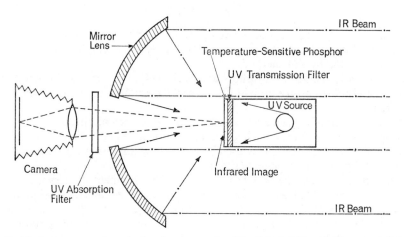

Fig. 7.9. An arrangement for projection phosphorography. (After Urbach, Nail and Pearlman—ref. 40.)

248

The thermal infrared from the subject is focused by a mirror lens on to a fluorescent surface (which is continuously excited by a UV source). The fluorescence is extinguished in the warmer image areas and this surface is then photographed through the aperture in the mirror. A Wratten 18A filter ensures that no visible radiation from the source reaches the film through the fluorescent screen; a Wratten 2A filter prevents any UV radiation from reaching the camera.

In their original paper on this subject, Urbach, Nail and Pearlman made general comparisons between the contact and projection methods and described the application of projection phosphorography to quantitative thermometry.[40]

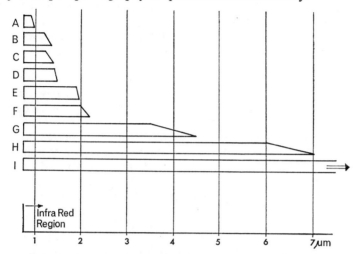

Fig. 7.10. Approximate spectral sensitivity limits of infrared detectors. *Key*: A 'Normal' IR films. B 'Special order' IR films. C Ag-O-Cs image convertor. D IR-stimulable phosphors. E IR extinction of fluorescence. F IR vidicon television tubes. G Lead sulphide photo-conductor. H Indium antimonide photo-conductor. I Thermal detectors.

7.6.5.2 *Stimulation of visible luminescence by infrared.* Fluorescence normally follows Stokes' law, which states that the exciting radiation is of shorter wavelength (higher quantum energy) than the emission waveband. According to this law, UV radiation can excite visible fluorescence and (with a few materials) visible wavelengths can excite IR fluorescence (see p. 253), but the near infrared can stimulate only invisible IR wavelengths.

However, certain phosphors can be made to exhibit an anti-Stokes effect, in which infrared stimulates the emission of visible radiation. Vasko has listed certain advantages over the more common IR-extinction phosphors.[41]

A typical cycle of events is as follows:

(1) The phosphor is excited for a period by blue or ultraviolet radiation. Any phosphorescent emission that takes place at this stage is allowed to decay.
(2) The IR image beam is focused on the phosphor surface and stimulates visible emission (usually green or red) in the areas receiving IR radiation. This is a positive image, compared to the negative image of the IR extinction phosphors.
(3) The visible image can be photographed if required.

Leverenz[42] has listed a number of IR-stimulable phosphors based on zinc sulphide, calcium sulphide or strontium sulphide, of which the B1 phosphor is typical; this has

pre-excitation peak of 460 nm, a stimulation peak of 930 nm and an emission peak of 570 nm. Other phosphors have a stimulation spectrum up to about 1·6 μm.

Paul[43] has described the use of IR-stimulable phosphors coated on normal photographic plates after the initial phosphorescent decay; this is a similar technique to the more common UV phosphor coatings (see p. 274).

7.6.6 LIQUID CRYSTALS. As certain cholesteric substances reach a critical temperature they change from a crystalline state to a liquid and show a marked colour change. A typical crystal of this type which changes to red at, say, 30°C passes through a green phase and finally appears blue at about 32°C: within this range the temperature can be visually estimated to within about 0·2°C. A range of crystals is available with critical temperatures in the range from 0°–75°C.

The colour transition arises from changes in the scattering properties of the crystal and is dependent to some extent on the viewing and lighting angle.[44]

7.6.7 EXPANSION OF PHOTOGRAPHIC GELATIN LAYER. McCamy has described a very simple method for IR visualisation which relies on a change of humidity caused by an IR image focused on a photographic plate.[45] The plate bears a series of closely-spaced layers of developed silver, formed by interference, as in Lippmann's original colour process.

When the plate is viewed by diffuse reflected light, interference effects cause an apparent colour which is governed by the spacing of the layers; this spacing depends on the moisture content of the gelatin. If an IR image is formed on the plate, it warms the gelatin layer and causes local variations in thickness. This changes the layer separation and the observer sees the infrared image as a pattern of interference colours.

7.6.8 FREQUENCY SUMMING. By use of a non-linear optical crystal (e.g. lithium niobiate), it is possible to mix two beams of radiation in such a way that the frequencies are summed, giving a beam of higher frequency (shorter wavelength) than the components. In this way an IR image beam of 10·6 μm (3×10^{13}Hz) from a CO_2 laser can be mixed with a ruby laser beam (0·69 μm or 43×10^{13}Hz) to give a visible image of about 0·65 μm (46×10^{13}Hz). This method has low efficiency at present, but requires no IR detector or scanning system; further details have been given by Warner.[46]

7.7 Applications of infrared photography

Infrared recording is normally used for one of the following reasons:
(1) Improved penetration of turbid media by the longer wavelength.
(2) Different transmittance or reflectance of the subject in the IR band.
(3) Recording without exciting a visual response.
(4) Recording of thermal radiation (including quantitative pyrometry).

Despite the frequent mention of sophisticated equipment in the earlier parts of this chapter, most photographic applications in categories (1), (2) and (3) above are carried out with a normal camera fitted with a suitable filter and using the standard IR emulsions sensitive up to about 900 nm.

Some materials that absorb light reflect or transmit freely in the near infrared; this means that obscuring layers of tissue or pigment may be penetrated or that visually similar specimens can be shown to be of a different nature.

One of the earliest pictorial applications was to produce the effect of moonlight: the characteristic dark rendering of sky and water, the very light appearance of some foliage and the heavy shadows in areas lit only by blue sky combine to give a reasonably good impression of a moonlit scene.

Conventional selenium exposure meters may be used for some IR work, despite the fact that they are not sensitive to infrared. The radiation from an incandescent body such as a tungsten lamp shows a constant ratio (at a given temperature) between visible and infrared emission and, once preliminary tests are made, measurement of the incident light gives a valid basis for calculating the infrared exposure.

7.7.1 NOCTURNAL PHOTOGRAPHY. IR filtered flash bulbs have been used for photography under wartime blackout conditions and the same principle is applied in police and military surveillance, using filtered searchlights and IR image converters for continuous visual study.

The reactions of cinema audiences and the habits of nocturnal creatures have been studied by IR photography. This is useful if a series of pictures is required of animals that would be frightened by the first visible flash. In some cases an IR source has been fitted inside the animal's burrow for cinematography over a long period.

Photography of the dark-adapted eye is another application where the use of infrared is necessary to avoid upsetting the experimental conditions. Barstow[46] has described the use of an IR-filtered electronic flash for cock-pit instrument recording without disturbing the aircrew's night vision.

Using thermographic techniques any living creature can be photographed by its emitted infrared radiation. Wormser[47] has illustrated an extension of this idea, whereby the previous position of a person sitting in a chair was shown from the warmth remaining in the wood after the chair had been vacant for 15 minutes.

7.7.2 INDUSTRIAL APPLICATIONS. Processes such as photographic emulsion manufacture must be carried out in the dark. Any inspection of the product or work-study of the operation can be carried out only by IR photography, IR television or image converters.

The photography of texture or stains in dark fabrics can be difficult because of the low reflection factor of the surface; however, many dark dyes transmit infrared freely and the basic fabric substance may thus reflect a considerable proportion of the infrared. Not all black fabrics appear alike in an IR photograph and this can be used to differentiate materials that are visually identical.

The structure of thin sections of wood and defects in layers of some plastics and rubbers can sometimes be revealed by IR transillumination.[48] Some opaque glasses and plastics are transparent to the near infrared and can be studied by IR adaptation of conventional schlieren or photo-elastic methods.

IR emulsions have also been used for the photography of rusted tin plate; thin layers of rust can be penetrated by infrared and the rust centres may be more clearly shown in large areas of corrosion that would appear uniformly dark on panchromatic records.[50]

7.7.3 PHOTOGRAPHIC THERMOMETRY (PHOTOGRAPHIC PYROMETRY). The wavelengths emitted by a thermal radiator depend on its temperature (see Chapter 3, p. 110). Bodies above about 600°C (870K) give appreciable visible emission and this can be recorded on panchromatic films. The range 450–600°C (720–870K) can also be recorded with

conventional emulsions, but the exposure is lengthy and the room must be darkened in order to avoid confusion from surface reflections.

Cooler surfaces can be recorded only by infrared methods. The normal IR films sensitised up to about 900 nm can record objects down to about 350°C (620K) and, with prolonged exposure, even lower temperatures can be recorded (Vasko[49] quotes an exposure time of 15 hours for a subject at 250°C (520K)). Some of the indirect thermographic methods (Section 7.6) can be used to record subjects at sub-zero temperatures.

Accurate photographic thermometry calls for the same sensitometric control as any other form of photographic photometry (see p. 62) and calibrated temperature reference surfaces are required. Overington,[52] in discussing the role of photography as a pyrometric instrument, has stated that the film exposure scale should be able to cover a range of 200–300°C (470–570K) at a subject temperature of 1000°C (1270K). Densitometric measurement should then be able to give a temperature discrimination of about 1°–1·5°C; the discrimination at 2000°C (2270K) would be about 3°C.

There are many methods for temperature measurement[53] (e.g. thermometers, visual or photo-electric pyrometers, heat-sensitive paints etc.) but photography has certain advantages if the time delay of processing and analysis can be tolerated:

(1) A permanent record of the complete subject field is obtained.
(2) Rapid thermal changes can be shown with cinematographic recording.
(3) There are no connections to cause thermal leakage from the subject or coatings that might affect the emissivity of the material.
(4) With suitable precautions, an unexpected rise in temperature will not damage the camera, whereas it might destroy attached instruments and prevent recording of subsequent events.

Overington[52] found that photographic methods can be marginally more accurate and repeatable than an optical pyrometer.

7.7.4 AERIAL PHOTOGRAPHY. Infrared photography is used in air-to-ground reconnaissance or in satellite surveillance systems for three reasons:

(1) The penetration of thin haze increases the ground visibility from high altitudes.
(2) Variation in IR reflectance may show differences in ground features.
(3) If the thermographic systems responding to longer wavelengths can be used, areas of differing temperature or emissivity can be shown.

The IR false-colour films (see p. 240) were originally designed for camouflage detection but they are now increasingly used for forestry and agricultural studies,[54] providing a simultaneous record of three wavebands, including the near infrared. This multiple spectral zone principle has been extended in an American 9-lens camera. Each of the matched lenses is filtered to record a different spectral band (about 50 nm wide) on to monochrome film; the complete record covers the range 400–900 nm. Comparison or multiple combination printing of these records can yield more information than normal panchromatic or infrared surveys.

7.7.4.1 *Forestry*. The broad-leaved deciduous trees appear as light tones on an IR record, whereas coniferous trees tend to appear in shades of much darker grey. The age of the leaves, the solar illumination angle, cloud shadows and the terrain are possible complicating factors, but infrared photographs are widely used as an adjunct to conventional photography in forest mapping and tree-type analysis. Similar principles may be applied to the study of grassland and soil characteristics.

Infrared aerial surveys may offer the only means of large-scale crop inspections and Myers and Allen have given an extensive bibliography of agricultural applications of IR photography.[55]

7.7.4.2 *Camouflage detection.* Some of the cruder forms of camouflage can be revealed by normal IR photography; the reflectance of dummy foliage and paint is lower in the near infrared than that of live vegetation.

Modern thermographic techniques have given a new approach to military surveillance and can detect people and vehicles in total darkness without giving any indication that investigation is taking place.

7.7.4.3 *Geological survey.* Differences in ground structure may be shown clearly by aerial IR surveys. Water is shown with particular clarity; with properly controlled photography it is possible to estimate the depth of water down to about 20 ft to within 10 per cent. Even in a non-quantitative sense, IR records are useful in hydrographic surveys of shallow water and in studying contaminated water.[10]

With thermographic techniques the thermal emission of land and water surfaces can be studied. Hot and cold ocean currents can be plotted and ice-bound coast-lines may be charted; volcanic regions can also be studied and surface temperatures measured.

7.7.5 BIOLOGY AND BOTANY. It is often difficult to show the structure of black insects by normal photography; in some cases, however, the IR reflectance is fairly high and surface details can be seen more clearly on an infrared photograph. In a similar way, heavily stained photomicrographic specimens may also be penetrated more easily with near IR radiation.

In the field of plant pathology, infrared photographs can show incipient disease before it is visible to the naked eye; Gibson[56] has listed several references in this field and has described the use of IR luminescence recording in biology and medicine. For this technique the subject is lit by blue-green light and an IR transmitting filter is fitted over the camera lens.[10]

7.7.6 ASTRONOMY AND SPECTROSCOPY. Spectrography is one of the oldest applications of infrared photography. Infrared spectra are of great importance in planetary and stellar studies, especially with stars that are too cool to emit much visible radiation. A survey in the 2·0–2·4 μm band[57] has shown many stars that are invisible; conversely, some of the most intense visible stars are not shown on IR records. Infrared radiation has also been used to give some penetration of planetary atmospheres and the luminous haze associated with certain nebulae.

Recent work in IR astronomy has been covered in survey articles in the popular scientific press.[58, 59]

7.7.7 FORENSIC WORK. Forged insertions on documents or alterations to paintings may show unexpected variations in near infrared reflectance and can be recorded on normal IR emulsions; wavelengths of about 2 μm have also been used with thermographic equipment to study the underdrawing of oil paintings.[60] In some cases age-darkened varnish, ink obliterations or stains may be penetrated by near IR radiation. The heat sensitive document processes or an IR image converter tube may be suitable for a rapid assessment of this type of subject.

Infrared is also used in the photography of charred documents[61] and for detecting the particles left after mechanical erasure of type matter.

Infrared luminescence has been found to be of value in differentiating between inks and pigments and in the study of the Dead Sea Scrolls.[62]

7.7.8 MEDICINE.[11] The traditional medical IR photographs use normal IR emulsions to reveal certain skin diseases. The outer layers of the skin are relatively transparent to the near IR and, although the tissue tends to act as a scattering medium, some sub-surface features and venous conditions can be photographed. Gibson[63] has referred to a number of specific applications, including the use of Ektachrome Infrared film.

The study of blood vessels (angiography) in the brain and other areas has been helped by the injection of IR-absorbing dye into the arteries. The emptying and filling of arteries has been recorded on IR Ektachrome film using rapid-sequence stills or cine recording at rates up to 64 fps.[64]

Following the work of Lawson (1957), a new diagnostic tool has been provided by using the infrared scanning thermograph (see p. 244) to study thermal patterns in the human body. This method has been used in the diagnosis of cancer and in the study of wounds, arthritis and other conditions causing abnormal blood circulation. The history of developments in this field has been discussed by Barnes.[65]

References

General—Infrared technology

1 BAUER, G., *Measurement of optical radiation*, Focal Press, London (1963).
2 SIMON, I., *Infrared radiation* Momentum Book No. 12, Van Nostrand, Princeton, N.J. (1966).
3 SMITH, R. A., JONES, F. E. and CHASMAR, R. P., *The detection and measurement of infrared radiation*, OUP (1968).
4 VASKO, A., *Infrared radiation*, English trans., Ed P. S. Allen, Iliffe, London (1968).
5 LEVINSTEIN, H., *Applied optics and optical engineering*, Ed R. Kingslake, Vol 2, Ch 8, Academic Press, New York (1965).
6 HUDSON, R. D., *Infrared system engineering*, Wiley, New York (1969).

General—Infrared photography

7 CLARK, W., *Photography by infrared*, 3rd Ed, Wiley, New York. (in preparation).
8 GIBSON, H. L., *Photography for the scientist*, Ed C. E. Engel, Ch 7, Academic Press, New York (1968).
9 *Kodak Data Sheet SC-7*, Kodak Ltd., London.
10 *Applied Infrared Photography*, Eastman Kodak Publication M-28 (1968).
11 *Medical Infrared Photography*, Eastman Kodak Publication N-1.

Specific

12 HANSELL, P. and OLLERENSHAW, R., *Longmore's Medical Photography*, Focal Press, London (1969).

13 FRUNGEL, F. and PATZKE, H. G., *Proc 8th Int Congr H.S. Phot, Stockholm 1968*, 222–6, Wiley, New York (1968).
14 BROCK, G. C., *Physical aspects of aerial photography*, Longmans Green, London (1952).
15 FREYTAG, H. *The Hasselblad Way*, 411, Focal Press, London, 2nd edn (1969).
16 SHURCLIFF, W. A. and BALLARD, S. S., *Polarised light* Momentum Book No. 7, Van Nostrand, Princeton, N.J. (1964).
17 BARKER, E. S., *J Opt Soc Am*, 58, 1378–82 (1968).
18 TYRELL, A., *Perspective*, 7, 28–46 (1965).
19 GIBSON, H. L., *op cit*, pp 352–5.
20 BALLARD, S. S. and MARQUIS, D. C., *Proceedings of the 1961 conference on optical instruments and techniques*, Ed K. J. Habell, Chapman & Hall, London (1962).
21 CORBETT, D. J., *Motion picture and television film*, Ch 8, Focal Press, London (1968).
22 ASA PH2.15–1964, *Automatic exposure controls for cameras*.
23 SOULE, H. V., *Electro-optical photography at low illumination levels*, Ch 3, Wiley, New York (1968).
24 BATEMAN, D. A. and KILLICK, D. E., *J Sci Instrum*, 2, 212–5 (1969).
25 VINE, B. H., *Applied optics and optical engineering*, Ed R. Kingslake, Vol 2, Ch 6, Academic Press, New York (1965).
26 EVANS, C. H., *ibid*, Ch 7.
27 TAYLOR, S., *Photo-electronic image devices—Symposium, London 1958*, pp 263–275, Academic Press, New York.

28 Lloyd Williams, K., Cade, C. M. and Goodwin, D. W., *J Brit Inst Rad Engrs*, 25, 241–50 (1963).

29 Delius, P., *B J Phot*, 111, 278–83 (1964).

30 Orrin, J. N., *Bio-medical Eng*, 4, 166–9 (1969).

31 Bowler, S. W., *B J Phot*, 116, 276–8 (1969).

32 Astheimer, R. W., *Phot Sci Eng*, 13, 127–33 (1969).

33 Borg, S. V., *Appl Opt*, 7, 1697–1703 (1968).

34 Nichols, L. W. and Lamar, J., *Appl Opt*, 7, 1757–62 (1968).

35 Vasko, A., *op cit*, pp 266–74.

36 Vasko, A., *op cit*, p 256.

37 Shionoya, S., *Luminescence of inorganic solids*, Ed P. Goldberg, pp 264–6, Academic Press, New York (1966).

38 Lawson, R. N. and Alt, R. L., *Can Med Ass J*, 92, 255 (1965).

39 Czysz, P. and Dixon, W. P., *JSPIE*, 7, 77–9 (1969).

40 Urbach, F., Nail, N. R. and Pearlman, D., *J Opt Soc Am*, 39, 1011–19 (1949).

41 Vasko, A., *op cit*, p 259.

42 Leverenz, H. W., *Luminescence of solids*, Chapman & Hall, p 308, London (1950).

43 Paul, F. W., *J Opt Soc Am*, 36, 175 (1946).

44 Fergason, J. L., *Appl Opt*, 7, 1729–37 (1968).

45 Fergason, J. L., *B J Phot*, 115, 1147 (1968).

46 Warner, J., *New Sci*, 44, 452–4 (1969).

47 Barstow, F. E., *JSMPE*, 55, 485–95 (1950).

48 Wormser, E. M., *Appl Opt*, 7, 1667–72 (1968).

49 Gibson, H. L., *op cit*, p 302.

50 Tupholme, C. H. S., *Photography in engineering*, pp 257–8, Faber & Faber, London (1945).

51 Vasko, A., *op cit*, p 375.

52 Overington, I., *Perspective world report: 1966–69*, Ed L. A. Mannheim, pp 201–7, Focal Press, London (1968).

53 Watson, G. G., *A survey of techniques for measuring surface temperature*, N E L Report No. 153, National Engineering Laboratory, East Kilbride (1964).

54 Tarkington, R. G. and Sorem, A. L., *Photogramm Eng*, 29, 88–95 (1963).

55 Myers, V. I. and Allen, W. A., *Appl Opt*, 7, 1819–38 (1968).

56 Gibson, H. L., *op cit*, 312–321, 349–51.

57 Forbes, F. F. and Johnson, H. L., *Sci J*, 4, 65–69 (1968).

58 Murray, B. C. and Westphal, J. A., *Sci Amer*, 213, 20–29 (1965).

59 Neugebauer, G. and Leighton, R. B., *Sci Amer*, 219, 51–65 (1968).

60 Van Asperen de Boer, J. R. J., *Appl Opt*, 7, 1711–14 (1968).

61 *Kodak Sheet Data SC-9*, Kodak Ltd., London.

62 Ref 10 above, pp 73–4.

63 Gibson, H. L. *op cit*, pp 307–10.

64 Choromokos, E., Kogure, K. and David, N. J., *J Biol Phot Ass*, 37, 100–4 (1969).

65 Barnes, R. B., *Appl Opt*, 7, 1673–85 (1968).

8. ULTRAVIOLET PHOTOGRAPHY

8.1 *Introduction*

8.1.1 TERMINOLOGY. The ultraviolet spectrum extends from approximately 1 nm to 380 nm (see p. 113). It is possible to suggest several sub-divisions of this region,* but in this book only three terms are commonly used:

(1) Near UV (sometimes called 'black light'): the spectral band 320–380 nm.

(2) Middle UV: the range 200–320 nm.

(3) Vacuum UV (VUV): UV wavelengths shorter than about 200 nm. This region can be studied only in a vacuum, because of strong atmospheric absorption; it is usually quoted as extending from 200 nm to about 1 nm, overlapping the region of soft X-rays.

The band from 120–200 nm is sometimes called the Schumann region, and is the shortest waveband in which refractive lenses (usually fluorite) can be used. The term extreme ultraviolet (XUV) is used to describe wavelengths from about 1–100 nm.

Photometric units (candelas etc.) are not applicable to UV sources and special units (e.g. Finsen and E-viton) are used in medical and bactericidal work. The irradiance of UV lamps is normally expressed in microwatts per square centimetre (μW/cm^2).

8.2 *Sources of ultraviolet radiation*

8.2.1 INCANDESCENT SOURCES. The sun (colour temperature 6200K, peak emission at 480 nm) emits about 10 per cent of its radiation in the UV. However, only about 4 per cent of the solar radiation reaching sea-level is ultraviolet and this is subject to the atmospheric conditions and to seasonal variations. The sun is not, therefore, regarded as a useful source of UV (although there is often sufficient scattered UV to be a nuisance in exterior photography). The subject of solar UV radiation has been discussed by Koller.[7]

As indicated in Table 3.8, tungsten lamps are very inefficient as UV sources. Nevertheless, as shown in Table 8.7, tungsten lamps can be used for the UV photography of small areas if no other source is available. The main difficulty arises from the excessive heating of the subject and camera caused by a tungsten lamp at close range; the heat also precludes the use of a UV-transmission filter on the lamp.

Despite their inefficiency, tungsten lamps have been used by the US National Bureau of Standards as standard sources of UV because of their consistent operation.

Flash bulbs have been used successfully for direct UV photography. Kodak have suggested a Guide Number of 24 for a flash cube with Tri-X film and a Wratten 18A camera filter.[6]

High-intensity carbons usually have their peak emission at about 390 nm; they are a good source of near UV and are still used in some photo-mechanical work; core additives are sometimes used to enhance the UV output with intense emission bands.

*A classification sometimes used by lamp manufacturers is as follows:
UV A (320–400nm) Glass transmission region
UV B (280–320nm) Erythemal (sunburn) region
UV C (185–280nm) Bactericidal or germicidal region
The Joint Committee on Nomenclature in Applied Spectroscopy has recommended the terms Far UV for the 10–200nm band and Near UV for the 200–380nm band.

Open arcs give substantial emission at erythemal wavelengths and may cause damage to unprotected eyes (see Section 8.8).

8.2.2 GAS DISCHARGE LAMPS. Many discharge lamps, each giving UV lines characteristic of the filling gas, are available for spectrographic work, but the most useful source for general UV photography (and for many reprographic purposes) is the mercury vapour discharge lamp. The proportion of UV emitted by a mercury lamp varies considerably with current density and other factors, but the spectral quality is mainly governed by the operating pressure of the lamp. Low pressure MV lamps emit about 90 per cent of their output in a single line at 254 nm, whereas high-pressure MV lamps emit a continuous spectrum in the near UV, with dominant lines at 365 nm and certain blue and green wavelengths.

Several mercury lamps for UV work are listed in Table 8.1. In some cases a Wood's glass envelope (see p. 265) is used to confine the emission to the UV; these are often called *black lamps* and are given the designation W (see Table 3.11).

Germicidal lamps (e.g. Philips TUV) are low-pressure MV tubes emitting principally at 254 nm. In addition to their primary function of killing bacteria, these lamps are useful for exciting fluorescence in certain materials. Safety precautions are necessary when using these short-wave UV sources (see Section 8.8).

8.2.3 ELECTRONIC FLASH. High pressure xenon lamps have a visible and UV emission closely matched to that of the sun; they have their peak emission in the region of 400–450 nm and they are a reasonably good source of near ultraviolet.

Electronic flash tubes normally have a xenon filling, which gives them a useful near-UV emission. Furthermore, electronic flash is free from the warming-up period required for mercury lamps and its portability and short exposure duration makes it a very convenient source of UV for biological and medical work. Some flash units (e.g. the Hico Corporation DP2 300 joule equipment) are designed with integral filters specifically for ultraviolet and fluorescence work. Perhaps the only disadvantage of a flash unit for fluorescence work is that the fluorescent areas cannot be assessed visually while the camera is set up.

Assessment of a flash guide number for direct UV recording can be made only by practical test, taking into account the UV response of the film and the UV transmission of the lens (see Table 8.7). *The guide number for fluorescence work depends on the nature of the subject and its luminescence.

8.2.4 UV-EMITTING FLUORESCENT TUBES. The domestic fluorescent tube is not an efficient source of ultraviolet, but *actinic tubes* with a UV-emitting phosphor are available for reprographic equipment. The emission peak of these tubes is in the region of 360 nm (see Fig. 3.13c), but there is also considerable violet and blue emission; in the 'blacklight' fluorescent tubes (MCFW) (Fig. 8.1e) the visible emission is absorbed by an envelope of cobalt glass (Wood's glass).

These fluorescent tubes do not match the total output of the larger mercury lamps, but they are cheap and efficient sources of ultraviolet and they give a very even illumination. In many cases the tubes can be used in standard domestic fittings. The Philips TW 6W lamp is unique in that it has a standard ES cap for direct use in a 200–250 volt supply without any ballast or starting gear.

*Under the conditions relating to Fig. 8.9, the use of a Wratten 18A filter required an exposure increase equivalent to 7 stops (128:1). The guide number of the flash was thus reduced by a factor of $\sqrt{128}$, or about $11\times$.

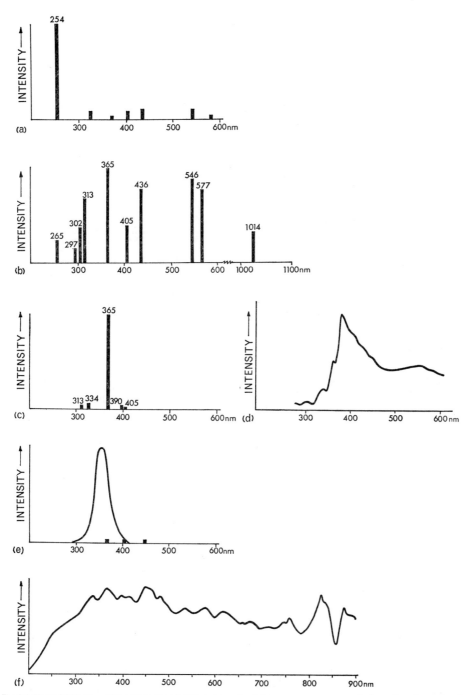

Fig. 8.1. Typical SED curves for sources used in UV photography. (a) Low pressure mercury discharge (quartz envelope). (b) High pressure mercury discharge (quartz envelope). (c) MBW/U 'Black lamp' High pressure mercury lamp with integral Wood's glass envelope. (d) High intensity carbon arc. (e) MCFW UV-fluorescent 'Black lamp' tube with integral Wood's glass envelope (e.g. Philips TL/08). (f) Xenon flash discharge.

TABLE 8.1
SOURCES IN COMMON USE FOR UV PHOTOGRAPHY AND REPROGRAPHY

Type	Shape	Specification		Application
Mercury printing lamps				
Philips HOGK	Tubes	700W–2500W		
HOK	Tubes	1200W–3000W		Reprography
HOQ	Tubes	400W–2500W	(non-ozogenic)	(diazo)
HTQ	Tubes	1000W–4000W	(non-ozogenic)	
Mercury-halide printing lamps				
Philips HP/AB	Tube	400W		Reprography
Hanau PQ series	Tubes	300W–700W		(diazo)
Compact source mercury lamps				
Philips CS	Bulbs	100W–1000W	Arc length 0·2–4·2mm	Microscopes
SP	Capillary tube	500W–1000W	Arc length 12·5mm	UV microfilm printers
Hanau ST series	Tube	36W– 90W	Arc length 8–25mm	Optical instruments. UV densitometers
Mercury lamps with integral reflector				
Philips MLU	Bulb	300W	Built-in filament acts as ballast	Irradiation and sunlamp
Philips MBR/U	Bulb	125W	Beam angle 70° ($\frac{1}{2}$ peak)	Reprographic lamp
Fluorescent lamps with UV-emitting phosphor				
Philips Actinic 05	Tube	6W– 140W	Peak emission at 360mm	Printing equipment
Philips Actinic 08 (Fluorescent blacklamp)	Tube	20W– 40W	Similar to the Actinic 05 tubes but with Wood's glass filter	Fluorescence
Philips TW 6W	Tube	6W	Similar to TUV lamp but with phosphor emitting at 360nm and integral Wood's glass filter	Fluorescence
Philips Fluorescent Sunlamp 12	Tube	20W	Phosphor emits in erythemal band (peak at 310nm)	Medical use
British Lighting Industries				
'Long-wave' UV blacklamps	Tube	4W– 40W	MCFW (Integral Wood's glass)	Fluorescence
Standard UV Fluorescent lamp	Tube	8W– 80W	Similar, but without integral filter	Fluorescence
Low-pressure mercury lamps		(*These lamps are also used for some fluorescence work*)		
Philips TUV	Tubes	6W– 30W	Emits primarily at 254nm	Germicidal lamp
B.L.I. 'Shortwave'	Tubes	15W– 30W	Emits primarily at 254nm	Germicidal lamp
Hanau NK series	Tubes	4W	Emits primarily at 254nm	Optical instruments
Hanovia Model 12	Tube	15W	Emits primarily at 254nm	Germicidal lamp
Medium-pressure mercury lamps with integral Wood's glass filter				
Philips MBW/U	Bulb	125W		Fluorescence
Osram GEC	Bulb	125W		Fluorescence
B.L.I.	Bulb	125W		Fluorescence

This list excludes an extensive range of UV spectroscopic lamps and a large number of xenon and mercury discharge lamps that are used primarily for their visible emission rather than their considerable UV output (see Fig. 3.12).

8.2.5 COMMERCIAL UV LAMP UNITS. All the UV units in common use employ mercury lamps (high-pressure for 365 nm radiation or low-pressure for 254 nm radiation) or UV-emitting fluorescent tubes (peaking at 360 nm). Examples are shown in Fig. 8.2.

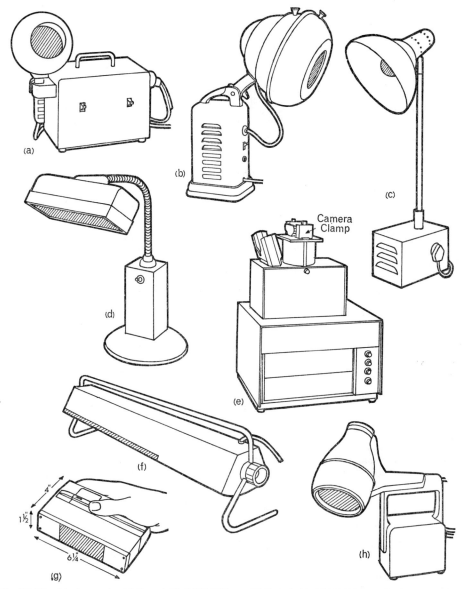

Fig. 8.2. Ultraviolet lamp units. (a) Hanovia Model 16 UV lamp. (b) Hanovia Model 11 UV lamp. (c) Allen Type 417 UV Floodlight. (d) Allen Type A409 UV Bench light. (e) Hanau Fluotest Universal cabinet (with photo head-piece). (f) Hanau Fluotest Special Analysis lamp (emitting 254nm). (g) Shandon M-0015 combination short-wave and longwave UV Hand lamp (battery operated). (h) Shandon B-0100A Blak-Ray Long-wave UV Spotlight.

261

TABLE 8.2

ULTRAVIOLET LAMP UNITS

Model	UV source	Quoted irradiance and Working details
*Hanovia Model 16	80W MV lamp (with Wood's glass on 5″ reflector)	Separate lamp head and control unit Lamp head weight 2 lb. Total weight 19 lb.
Hanovia Model 11	80W MV lamp (with de-tachable Wood's glass on 11″ reflector)	Bench model Total weight 20 lb.
Hanovia Chromatoscope	UV sources for both 254nm and 365nm also Tungsten viewing lamp	Viewing and copying cabinet for fluorescent chromato-grams etc.
Hanovia Chromatolite	UV source for 254nm	Bench and portable unit
**Allen Bench light (Model A 409)	Two 9″ UV-fluorescent tubes with Wood's glass screen	Bench light with flexible support arm
Allen Hand lamp (Model A 405)	Similar to A 409	Portable mains model in carrying case
Allen Hand lamp (Model A 407)	Similar to A 409	Portable model for 12v DC
Allen Suspension light (Model A 402)	Four 2-foot 20W UV-fluorescent tubes (integral filters)	For installation over benches and work areas
Allen Suspension light (Model A 404)	Similar to A 402 but with four 4-foot 40W tubes	
***Hanau Fluotest Special Analysis lamp	20W Low-pressure mercury tube (254nm)	Bench model Weight 4kg (9lbs)
Hanau Fluotest Piccolo	4W UV lamp	Portable mains model for philatelists etc. Weight: 950g (2 lbs)
Hanau Fluotest Forte	200W High-pressure MV lamp (near UV)	2000μW/cm^2 at 7″ Table or portable mains model for forensic or industrial use Weight: 7·5kg (16$\frac{1}{2}$lbs)
Hanau Fluotest Universal	Two low-pressure MV tubes (short UV) plus two UV-fluorescent tubes (near UV) and tungsten viewing lamp	Table cabinet with camera attachment 30 × 30cm work-ing area Weight 15kg (33lbs)
Shandon† *Mains Hand lamps* UVS-0011 'Mineralight' Short-wave UV lamp	4W mercury low-pressure tube	80μW/cm^2 at 18″ Hand lamp (weight 1lb (450g)) (Two-tube model UVS-0012 also available)
UVL-0022 'Mineralight' Long-wave UV lamp	Two 4W high-pressure MV tubes	120μW/cm^2 at 18″ Hand lamp of similar design to UVS-0011
UVSL-0025 Combination UV lamp	4W low-pressure MV 4W high-pressure MV	131μW/cm^2 at 18″ Similar to UVS and UVL but with both short-wave and long-wave UV tubes
Battery hand lamps M-0014 'Mineralight' Short-wave lamp	Low-pressure MV tube	115μW/cm^2 at 6″ Operated from internal re-chargeable Ni-Cd batteries (Weight 1$\frac{1}{2}$lb (680g))

Model	UV source	Quoted irradiance and working details
M-0016 'Mineralight' Long-wave lamp	UV-emitting fluorescent tube	150μW/cm^2 at 6″
M-0015 'Mineralight' Combination lamp	Mercury tube emits both short-wave and long-wave UV (sliding filter isolates long-wave UV when required)	
Bench lamps R-0051 'Mineralight' Short-wave UV lamp	Low-pressure MV tube	155μW/cm^2 at 18″ Bench model with separate lamp head and transformer
B-0100A Blak-ray Long-wave Spotlight	High-pressure sealed-beam 100W MV reflector lamp	8400μW/cm^2 at 18″ Bench model with separate lamp head. Spot beam (7° angle) 100W Flood bulb also available
Wall lamp XX-0015 Blak Ray	Long-wave UV; two 18″ 15W tubes	393μW/cm^2 at 18″ Wall or suspension unit 108° beam angle
UV transilluminator C—0050	Long-wave UV; 8 tubes	⎰ For study of translucent fluorescent materials
C—0051	Short-wave UV; 6 tubes	⎱ (52 × 19 × 9cm deep)

*Engelhard Hanovia Lamps, Bath Road, Slough, Bucks.
**P. W. Allen & Co., 253 Liverpool Road, London, N.1.
***Hanau Quarzlampen GmbH, Hanau, West Germany.
†Shandon Scientific Co. Ltd., 65 Pound Lane, Willesden, NW10.

Larger UV sources are used for water sterilisation, photo-chemical processes and accelerated ageing tests on fabrics, but these units are not used for photography.

8.2.6 LIGHTING TECHNIQUE. UV sources are available which fulfil all the usual requirements for spotlights and floodlights. The latter are more often used for photography, as the intention is usually to irradiate the subject evenly with ultraviolet rather than to produce any modelling or cross-lighting.* In fluorescence work any unevenness in the UV beam must be avoided, otherwise there will be variations in the fluorescence which might be misinterpreted. The Hanau Fluotest Universal cabinet is claimed to have a flux variation of no more than 10 per cent over a 30 × 30 cm field.

If an intense narrow beam of UV is required, the best method is probably to use one of the compact-source mercury units (with a quartz condenser) that are designed as accessories for UV microscopy. A similar unit is used in the Optec UV Endoscope.

For many purposes the compactness and even illumination of tubular UV lamps is ideal. Large mercury discharge tubes (up to 7 kW) are used in diazo printing machines but for normal photographic UV copying the actinic lamps may be more suitable. The integrally filtered MCFW tubes are well suited for fluorescence work and may be useful in home-made UV lighting units for special purposes.

UV-fluorescent tubes reach full output almost immediately, but the normal mercury discharge lamps require 5–10 minutes to reach full intensity. For consistent exposure it is important that photography should not be started until full output is reached. The

*But see p. 280 for an instance in which UV texture lighting is useful.

time-intensity characteristics for a particular discharge lamp and circuit can be plotted from a series of test exposures.

A small tungsten lamp is needed to set up the camera and subject; this lighting is often used for a supplementary exposure to show the subject outline or other general features.

Many white paints and white papers have a relatively low UV reflectance and, if fill-in reflectors are needed for UV photography, it is preferable to use aluminium.

8.3 *Optical materials*

Difficulties arise in recording short-wave UV because all materials have very strong absorption bands in this region. Conventional photographic techniques are used in the near UV, but the components of a photographic system, including the air, impose a series of absorption limits on recording at shorter wavelengths.

In the UV band below 120 nm there are no suitable materials for making transmission (dioptric) lenses, spectrographic prisms or diffraction gratings. Furthermore, the reflectance of all materials is very low in this region so that mirror (catoptric) lenses and reflection gratings are inefficient. These optical difficulties are a primary reason for our relative ignorance of this spectral band, despite its great interest to spectroscopists and physicists.

Optical performance in the extreme ultraviolet and soft X-ray regions is mentioned on p. 269.

TABLE 8.3

THE UV TRANSMISSION LIMITS OF VARIOUS OPTICAL MATERIALS

Material	Approximate Transmission limit	Material	Approximate Transmission limit
Window glass (various)	320–340nm	Lithium fluoride	110nm
Optical glasses (various)	320–380	Canada balsam (lens cement)	300
Special high-silica glass	220	Atmospheric ozone	295
Fused silica	200	Oxygen	190
Quartz	185	Water	170
Fluorite (calcium fluoride)	120	Gelatin	250

Many textbooks give absorption figures such as those in Table 8.3; but confusion sometimes arises because different authorities quote different values. There are several reasons for this:
 (1) It is impossible to express complete curves such as those in Fig. 8.3 by a single value and there is no agreement on the absorption percentage figure that represents the cut-off figure. The 5 per cent, 10 per cent or 90 per cent transmittance levels are often quoted but other figures are equally permissible (and equally misleading).

 For example, photographic gelatin may be quoted as having a cut-off wavelength at 250 nm or 210 nm. Both of these figures are correct in a sense, although

they may relate to 90 per cent transmission, and 90 per cent absorption respectively.

(2) The sample thickness also affects the quoted figure; in many cases the figure for a 2 mm sample is given, or the percentage absorption is quoted per unit thickness (e.g. 10 per cent per mm).

A compound lens may have a total glass thickness of 20 mm and will reach a given absorption level at a wavelength 10–20 nm longer than for a thin glass sample.

(3) Even with a very low transmission (say 1 per cent), it is still possible to produce a record if a sufficiently long exposure can be given. The effective cut-off wavelength may therefore depend on the experimental conditions, such as emulsion sensitivity or subject movement.

(4) In the case of gases the extent of the absorption band depends partly on the temperature and pressure.

(5) The term glass includes many hundreds of products, each having a different chemical composition. There is a wide variation in the UV transmission of camera lenses; a dense flint glass may have a cut-off limit of 380 nm, while crown glasses often transmit down to 310 nm.

(6) Samples of an optical crystal can vary greatly in their spectral transmission; the figures quoted in text books are usually for the best specimens. These materials are invaluable in UV spectroscopy, but it should not be assumed that they are readily available in sufficient size or quality for large components, or that their physical properties are well suited for optical work.

In the case of quartz (SiO_3), differences between synthetic quartz (e.g. Vitreosil and Suprasil) and the natural fused and crystalline varieties account for variations in quoted values from 160 nm to 185 nm; the latter is the most commonly accepted value.

(7) Extended exposure to UV can induce darkening (solarisation) of many transparent materials; in the case of synthetic optical materials, variations in processing can cause additional discrepancies. Atmospheric ageing can also cause a drop in transmission; for example, lithium fluoride must be protected from the air because of its water absorption.

8.4 *Filters*

The term UV filter covers a number of quite different products (see Fig. 8.3): it does not indicate whether the filter absorbs or transmits UV and must be qualified.

8.4.1 UV TRANSMITTING FILTERS. Most UV sources emit some visible light, so that a UV transmission camera filter (e.g. Wratten 18A or 18B) is used if the photographic record is to be confined to the ultraviolet. For UV-excitation of fluorescent specimens a filter must be fitted to the lamp house. The filters have a secondary transmission in the far red and infrared.

Gelatin filters are not available, although a solution of cobalt chloride can be used for some purposes. The generic term 'Wood's glass' is used for filters having spectral transmission of the form shown in Fig. 8.3a.

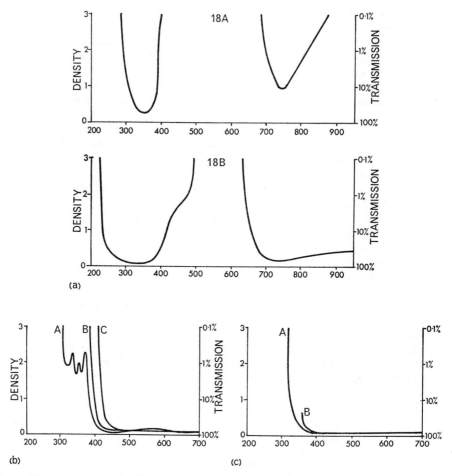

Fig. 8.3. Filters for UV photography. (Filter curves by courtesy of Kodak Ltd.) (a) UV transmission filters (Wratten 18A and Wratten 18B). (b) UV absorption filters. A Wratten 1A. B Wratten 2B. C Wratten 2E. (c) A Plain optical glass (two cemented Wratten 'B' filter glasses). B Typical lens transmittance (quoted from ASA PH2.20).

There are no dye-absorption filters for the middle UV, but interference filters are available (see Table 8.4). Thin-film filters and mirror coatings for the UV have been discussed by Hennes and Dunkelman.[8*]

8.4.2 UV ABSORBING (BARRIER) FILTERS. To photograph fluorescence, the camera filter must completely absorb the exciting radiation. Filters made for this purpose (e.g. Wratten 2B, 2E) must not be confused with the UV haze-cutting filters (e.g. Wratten 1A) which are intended simply to attenuate the UV for pictorial purposes. Haze filters have only about 1 per cent residual transmission in the 310–380 nm band, but even this is excessive for fluorescence photography using high-power UV sources.

*Low-reflectance (blooming) and high-reflectance coatings for work in the UV are offered by Optical Coatings Ltd., Hillend Estate, Dunfermline and by the firms listed with Table 8.4.

Plain filter glass absorbs all wavelengths below about 330 nm and this imposes a lower limit on all conventional filters.

8.4.3 ACCESSORY FILTERS. Conventional neutral-density filters begin to show strong absorption below about 390 nm and semi-reflecting aluminised filters (on a quartz substrate) may be used for the middle and near UV. Silvered filters would not be suitable because of the sharp transmission band of silver at 300–330 nm (see p. 57).

Normal polarising filters absorb all wavelengths below about 370 nm and may be bleached by intense UV irradiation. The Polaroid Corporation market a HNP'B

TABLE 8.4

UV-ABSORPTION AND UV-TRANSMISSION FILTERS

	Approximate pass-band	Transmission
A. UV transmission filters		
Dye-absorption type		
Wratten 18A Ilford 828 Chance OX-1 Schott UG 1 (2mm)	310–390nm and 690–880nm	50% at 360nm Visible transmission 0·02%
Wratten 18B Chance OX-7 Schott UG 5 (3mm)	240-410nm and above 650nm	85% at 360nm Visible transmission 0·3%
Interference type		
Barr & Stroud† 　Narrow-band UV	Any required band between 210–390nm Band-width approx. 13–18nm Side-band transmission <1% Wavelength tolerance ± 5nm	Peak value of 15–27% at selected wavelength
Balzers†† 　Filtraflex R-UV	Any required band between 254–390nm Band-width approx. 20–30nm Side-band transmission ⩽ 0·01% Wavelength tolerance ± 0·5–1·0%	Peak value 15–30%
Schott††† 　UV line filters	Any band between 310–390nm Band-width approx. 10nm Wavelength tolerance ± 2nm	Peak value 30%

	Transmission band*	Integrated visual transmission	Appearance
B. UV-absorption filters			
Plain filter glass 　(Two Wratten 'B' glasses cemented)	Above 320nm	92%	Colourless
Wratten 2A	Above 405nm	90%	Very faint yellow
Wratten 2B	Above 390nm	91%	Very faint yellow
Wratten 2E	Above 415nm	90%	Very faint yellow

The full range of yellow, orange and red colour filters may be required as 'barrier' filters with subjects requiring violet-blue excitation.

*1% transmission or more.
†Barr & Stroud Ltd. Caxton St., Anniesland, Glasgow.
††Balzers High Vacuum Ltd., Northbridge Rd., Berkhamsted.
†††Jena Glaswerk Schott & Gen.

267

polariser for use down to about 280 nm and Ealing Beck offer a UV polariser for use in the range 230–400 nm.

8.5 *Ultraviolet optical systems*

8.5.1 LENSES. Conventional UV photography normally uses the 365 nm emission from a mercury discharge lamp. Many lenses have good transmission (30–50 per cent) at this wavelength, although it should not be taken for granted, especially with multi-element lenses. Some lenses (e.g. the UV Topcor) are specifically designed to exclude the near UV, which causes a blue cast in normal colour photography.

A simple lens shows a progressive increase of focal length with wavelength (Fig. 8.4). However, most camera lenses have an achromatic correction for blue and green light; shorter wavelengths then come to a focus farther from the lens. With some lenses the error is relatively small and may be virtually eliminated by stopping down, but some form of focus pre-calibration is to be recommended for critical work. In other cases, such as the UV Nikkor, the lens is focused visually and the distance setting is then transferred to a separate UV focus datum. A similar UV focus shift is automatically applied in the Caps microfilm diazo printers, avoiding the expense of a lens fully achromatised for both the UV and visible wavelengths.

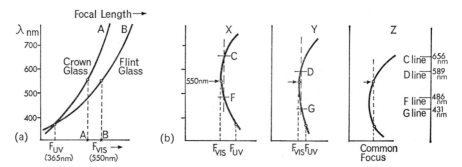

Fig. 8.4. Effects of axial chromatic aberration on focusing for ultraviolet. (a) Simple positive lenses. Lens B shows greater dispersion (change of focal length with wavelength). (b) Achromatic lenses. Lens X corrected to give balanced results for visual work (C and F lines). Lens Y corrected for normal photographic work (D and G lines). Lens Z corrected for UV work with visual focusing.

There are certain advantages in using UV for photomicrography (see Chapter 5); because of the difficulties of achieving chromatic correction in the ultraviolet, some *monochromat* objectives are designed for use at one UV wavelength only (e.g. 254 nm and 546 nm).

The difficulty of focusing is overcome in some UV microscopes by use of a fluorescent focusing screen; this is excited by the image in the UV focal plane and permits viewing and accurate focusing even with uncorrected lenses. Alternatively, catoptric objectives can be used; these are free from chromatic aberration and may be used for work down to about 150 nm. The mirror lenses available for miniature cameras normally have some refractive elements and are not necessarily well-suited to UV photography.

Some enlarging and process lenses are designed to have good transmission in the near UV in order to give maximum speed with the majority of reprographic materials;

these lenses may therefore be useful for direct UV photography. A similar requirement arises in oscilloscope recording with CR tubes having the P16 phosphor (peak emission 385 nm—see p. 354).

Table 8.5 lists some of the camera lenses that are suitable for direct recording in the near UV with standard cameras.

TABLE 8.5
ULTRAVIOLET LENSES FOR CONVENTIONAL CAMERAS

Lens	Focal length	Aperture (f)	UV working band	Camera
Quartz Takumar	85mm	3·5	200–400nm	Asahi Pentax
Ultra-achromatic Takumar	85mm	4·5	254–862nm	Asahi Pentax
UV Planar	50mm	2	200–400nm	Zeiss Contarex
UV Planar	60mm	4	320–450nm	Zeiss Contarex
UV Nikkor	55mm	4	300–400nm	Nikon
UV Sonnar	100mm	f/4·3	210–650nm	Hasselblad

8.5.2 PINHOLES AND ZONE PLATES. These two devices operate on quite different principles, but share the important property that they do not cause any spectral absorption. They may be used for work in the visible spectrum but have specialised application in the vacuum UV and soft X-ray regions, where normal lenses are useless. Pinhole collimators are used in gamma ray cameras (p. 301).

8.5.2.1 *Pinholes.* Pinholes give images of a wide angular field and are free from any curvilinear distortions.

The small aperture (normally about $f/100$ to $f/300$) demands long exposures and also causes low resolution because of diffraction. The optimum pinhole diameter is given by the formula quoted on p. 459.[10]

A study of pinhole image quality using MTF methods has been made by Sayanagi;[11] this paper also gives general references on the subject of pinhole cameras.

8.5.2.2 *Zone plates.*[12] In some respects a Fresnel zone plate behaves like a normal refractive lens; divergent wave-fronts from the subject are diffracted by the concentric annular rings of the plate and are converged to a focus. A number of foci are produced, rather like the different orders of spectra given by a diffraction grating, but with the difference that the zone plate produces recognisable images rather than single spectral lines. The position of the focus varies with the wavelength, so that the zone plate suffers from marked chromatic aberration. This has been turned to advantage in some spectroscopic work, because an emulsion placed at the correct focus for a particular wavelength records other wavelengths unsharply; the image formed thus tends to emphasise one spectral zone.

The resolution and image illumination given by a zone plate are far superior to those of a pinhole. However, there is a practical limit to high performance, which demands a large number of rings: the diminishing size of the outer rings causes manufacturing problems. The pattern is normally produced by photographic reduction on to a high resolution plate,[13] but metal plates with self-supporting rings must be fabricated for the shorter wavelengths. Pounds[14] has described a copper zone plate for producing solar X-ray images in the 5 nm region.

Fig. 8.5. Enlarged plan of Fresnel zone plate (only the first four rings are shown). The zones are alternately clear and opaque with radii in the progression $\sqrt{1}$, $\sqrt{2}$, $\sqrt{3}$, $\sqrt{4}$, ...

Baez[15] has shown that the resolution given by zone plates (which can be comparable to that of a simple refractive lens) increases at shorter wavelengths, thus following the trend of Abbe's expression for lens resolution (Eq. 2.6).

8.6 *UV detectors*

Ultraviolet radiation has a high quantum energy and produces a photo-electric effect in many materials; the detectors available for UV work include photo-voltaic, photo-conductive and photo-emissive types.[16]

Most cadmium sulphide exposure meters have little response to the UV, but conventional selenium exposure meters have response down to about 300 nm; the half-peak band width is from about 400–650 nm. To use these meters for UV measurement, all visible light must be excluded from the cell; the exposure calculator must be re-calibrated for the UV source, emulsion and optical system in use. Wavelength conversion meters have been produced, using a normal light-sensitive cell with a phosphor coating which is excited by the UV waveband under study.

In certain fields, chemical UV detectors (actinometers) have been used; a bleaching or darkening takes place in proportion to the UV dose and a comparator strip is used for dose assessment.

For the measurement of visible fluorescence, normal spot photometers (for example, the SEI) can be used. With the photo-electric photometers it may be necessary to fit a UV-absorbing filter over the meter.

Shandon Scientific* offer UV meters for both long-wave and short-wave ultraviolet; they are used for checking that the output of UV sources is maintained and for studying the efficiency of reflectors.

8.6.1 UV IMAGE CONVERTERS. The general principles of electronic image tubes have been mentioned in Chapter 7 and the subject has been thoroughly covered by Soule.[17]

*'Blak-ray' UV meters: Shandon Scientific Co. Ltd., 65 Pound Lane, Willesden, London NW10.

Samson[3] has quoted performance figures for UV detectors sensitive down to a few nanometres and has given details of UV image converter tubes and television tubes for work in the vacuum UV. For work in this region, the glass face-plate of image tubes must be replaced with quartz or some other material that will admit the short-wave radiation to the photo-cathode.

The Hadland Imacon camera (framing rates up to 2×10^7/sec.) has an optional UV-sensitive photo-cathode.

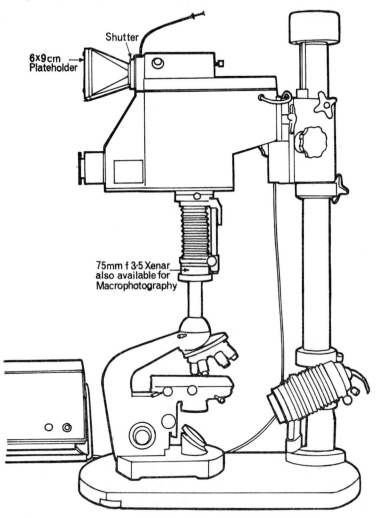

Fig. 8.6. Wild M 500 IR/UV image convertor camera.

The Wild M 500 image converter is available for macrophotography or photo-micrography. Interchangeable IR or UV image tubes allow the range 350–1200 nm to be recorded on the built-in camera unit.

271

8.7 *Emulsions for UV photography*

8.7.1 SPECTRAL SENSITIVITY. The peak spectral response of silver halide emulsions is usually in the region 350–400 nm. Many published spectrograms do not show the full UV sensitivity; first, because the curves often relate to tungsten sensitivity, in which case there is relatively little UV emission from the source; secondly, because the spectrographic equipment usually has glass components, which strongly absorb UV radiation. Modern data sheets (Fig. 8.7) give a realistic idea of the UV response of the film, although this does not represent the effective spectral response in a camera with normal UV-attenuating lenses.

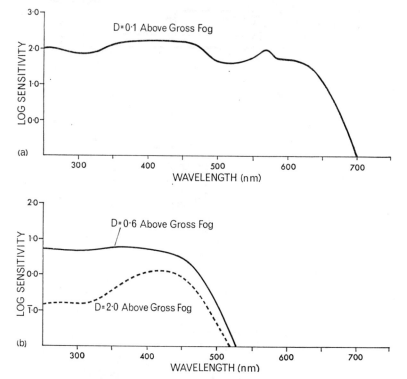

Fig. 8.7. Spectral sensitivity curves of photographic emulsions. (By courtesy of Kodak Ltd.) (a) Normal panchromatic emulsion (Kodak Tri-X Pan). (b) Kodak Process plate.

Fig. 8.7 shows that the shape of emulsion spectral response curves varies considerably according to the density level used for film speed measurement. The natural tendency for reduced contrast in the UV often means that greatly increased exposure is necessary to give a high density and this curve therefore shows a markedly lower response than the low density curve.

The difference in UV speed between ordinary blue-sensitive emulsions and the dye-sensitised high-speed emulsions is less than might be supposed. For example, Ilford have stated that their HP3 and N5.31 films, which normally have a speed ratio of about 20:1, have a UV speed ratio of about 3:1.

272

The UV print-out paper used in instrumentation systems is sensitive over the range down to about 270 nm. The evaluation of these materials has been discussed by Jacobs and McClure.[18]

8.7.2 GAMMA-LAMBDA EFFECT (GRADIENT-WAVELENGTH EFFECT). Photographs taken with short-wavelength light are generally of lower contrast than those made with longer wavelengths (see p. 28). This is far from being a simple rule[19] and there are considerable variations throughout the visible spectrum (see Fig. 8.8). There is nevertheless an inherent tendency towards lower contrast in the ultraviolet, although some

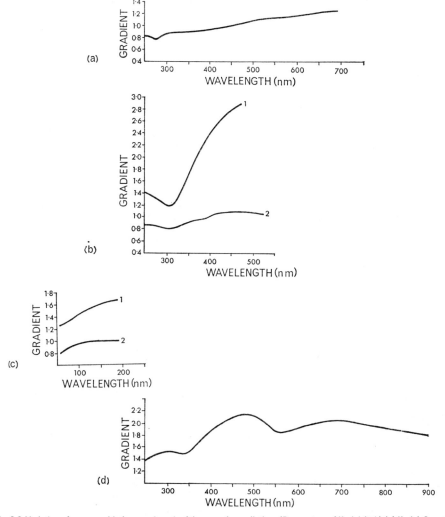

Fig. 8.8. Variation of gamma with the wavelength of the exposing radiation. (By courtesy of Kodak Ltd.) (a) Kodak Spectroscopic plate, Type 103–F (panchromatic emulsion). (b) Typical emulsions for UV spectrography (1) Kodak Spectrum Analysis plate No. 1. (2) Kodak Spectrum Analysis plate No. 3. (c) Special ultraviolet emulsions (1) Kodak SWR Film (Schumann type emulsion). (2) Kodak Spectroscopic plate, Type 103–O UV (emulsion with fluorescent coating). (d) Kodak Spectroscopic plate, Type 1–N (infrared emulsion).

of the UV spectrographic materials are especially designed to maintain reasonably constant contrast in the near UV. This gamma/lambda effect is an important matter in spectroscopy, where the line densities are sometimes measured for analytical purposes. Latham found that a number of Kodak Spectroscopic plates showed a 2 per cent increase in gradient for every 10 nm wavelength interval, over the near UV and blue region (340–490 nm).[20]

Time-gamma curves can be prepared for UV work by normal sensitometric methods, but the complete camera system should be used for exposure, because the spectral transmission of the lens and filters will determine how much of the low-contrast UV is used to form the image

Fig. 8.9 shows the characteristics of two films: apart from a lower D_{max}, Film A shows little difference between exposure to the near UV (approx. 360–390 nm) and the normal photographic spectrum (approx. 360–670 nm). Film B shows the more common characteristics of reduced contrast in the near UV, as illustrated by the γ/λ curves of Fig. 8.8.

8.7.3 GELATIN ABSORPTION. Gelatin has a strong UV absorption band (beginning at about 235 nm and extending to the soft X-ray region) which inhibits the natural actinic response of silver halides in the short-wave UV. Some emulsions (e.g. the Kodak B 10 plate) have a fairly low gelatin content and can be used for work in the 250–210 nm region, but this is the limit for any normal emulsion.

Schumann (1892) overcame the problem by depositing the silver halide on to a thin layer of gelatin, so that the crystals lay on the surface. Plates of a similar type are marketed by Ilford (Q plates), Kodak (Short Wave Radiation plates and films), Kodak-Pathe (SC-5 and SC-7 films) and Agfa-Gevaert (Schumann plates). They have been used to record wavelengths down to 7·5 nm, a figure probably limited more by the experimental apparatus than by the inherent sensitivity of the emulsion. All Schumann type plates require very careful handling both before and after exposure; Kodak[21] recommend the application of an anti-abrasion coating after exposure.

Vacuum-deposited layers of silver halide are completely free from gelatin and have been used as an alternative to Schumann plates for ion detection in mass spectroscopy.[22]

8.7.4 FLUORESCENT EMULSION COATINGS. The UV absorption of gelatin can be circumvented by coating a normal emulsion with a thin fluorescent layer, to convert the ultraviolet into a visible image which is readily recorded by the emulsion.

Mineral oils (Duclaux and Jeantet, 1921) can be used for this purpose, but must be removed with a suitable solvent before processing can take place. Sodium salicylate (e.g. a 0·5 per cent solution in methyl alcohol) is more commonly used because it dissolves in the developer and does not affect the processing.[23] The spectral response extends well below 100 nm and gives an emission band in the violet-blue region. A thin layer gives better resolution (up to 100 1/mm has been recorded) but a thicker layer gives a better fluorescent yield and requires less exposure.

Eastman Kodak will supply any of their spectroscopic films with a fluorescent coating which gives response below 100 nm and produces fluorescence in the 290–350 nm region; the company will supply a similar Ultraviolet Sensitising Solution for workers to treat their own plates.[21] These coatings are highly efficient but are water-resistant and must be removed after exposure.

8.7.5 NON-SILVER PHOTO-SENSITIVE MATERIALS. Most of the diazo and photo-polymer materials used in reprographic and photo-mechanical work are sensitive to the near

274

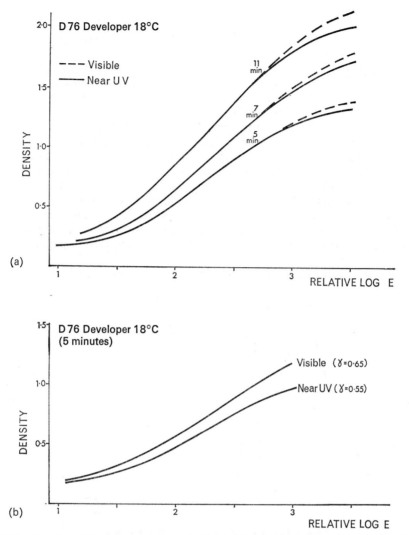

Fig. 8.9. The effect of near UV radiation on sensitometric characteristics. (a) Film A shows only a reduction of highlight contrast. (b) Film B shows an overall reduction of contrast. Exposure conditions for (a) and (b): *Source:* Miniature electronic flash. *Lens:* Zeiss Jena Tessar 50 mm. *Camera filter (for UV exposures):* Wratten 18A. *Subject:* Silver transmission wedge on opal diffuser.

ultraviolet. They usually have a very low speed, but for some purposes the diazo materials for example, may offer a quick and cheap method of UV recording by contact exposure.

8.8 *Medical and biological effects of UV radiation*

Short-wave UV radiation has damaging effects on human tissue and most living organisms. All wavelengths below about 310 nm cause discomfort and possible permanent damage from conjunctivitis (inflammation of the eye) and erythema (reddening

275

and blistering of the skin). Under medical supervision, controlled doses of erythemal radiation can have beneficial effects on the skin; however, in photographic work all unnecessary exposure to UV should be avoided.

Most photographic UV lamps are fitted with a Wood's glass filter (see p. 265) which transmits only the harmless near UV. However, unfiltered lamps are sometimes required (e.g. 254 nm mercury radiation for fluorescence work) and the manufacturer's safety precautions must then be observed, using goggles and gloves or UV-absorbent screens (e.g. glass or Perspex VA) to protect the eyes and skin.

The characteristic smell from mercury lamps with quartz envelopes is due to UV radiation in the 180–220 nm band, which produces ozone (O_3) from the air. This can have unpleasant effects in a confined space, but is not toxic in the quantities produced in normal photographic work. Many mercury lamps are described as non-ozogenic; this is because the lamp envelope is designed to absorb the short wave radiation.

The near UV causes a slight fluorescence in the eye, which tends to give the disturbing effect of looking through a haze. For this reason, workers continually using UV lamps for fluorescence work sometimes wear UV-absorbing glasses, even though the filtered lamps are quite safe.

The physical effects of ultraviolet radiation have been discussed in more detail by Koller.[24]

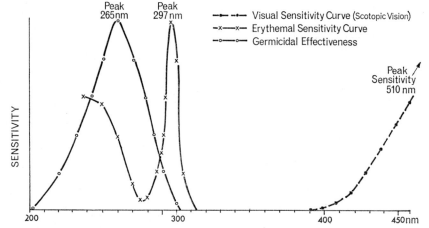

Fig. 8.10. Biological sensitivity curves for ultraviolet radiation.

8.9 *Practical requirements in UV photography*

8.9.1 DIRECT UV RECORDING. Normal laboratory and medical UV photography is concerned with the near UV band down to about 350 nm, which is the approximate transmission limit of normal camera lenses. The requirements for direct UV recording in this waveband may be summarised as follows:

Surroundings A darkened room is not needed if the camera lens is fitted with a Wratten 18A or similar filter.

UV source Mercury discharge lamps or electronic flash are normally used; a low power tungsten lamp is also required for setting-up.

276

Source filter　Mercury lamps should be fitted with a Wood's glass screen to remove the dangerous short-wave UV.

Camera filter　If the source is screened with a Wood's glass, a camera filter is not essential. However, such a filter is often used in order to exclude all visible light from the camera and allow work in normal lighting conditions. Both filters are sometimes used because this virtually eliminates the small visible transmission of the lamp filter and the contrast of the UV photograph may be slightly improved.

Camera　Any film or plate camera can be used. The lens must freely transmit the UV band in use and the focus setting must be correctly adjusted.

Film　All films are suitable for UV recording but it is often difficult to achieve sufficient contrast in UV records (see p. 273); for this reason the slower emulsions with higher inherent contrast may be preferred to the high-speed films.

Processing　If normal gamma values ($\gamma = 0.8$ to 1.0) are required it may be necessary to use the more energetic developer formulae rather than fine-grain development.

UV transmission filters can be fitted either to the camera lens, or to the lamp, or to both, according to the circumstances. The possible permutations are summarised in Table 8.6.

TABLE 8.6
THE USE OF LAMP AND CAMERA FILTERS IN UV RECORDING

	Wood's glass screen fitted to UV source	UV source used without screen
UV-transmission filter fitted to camera (e.g. Wratten 18A)	UV recorded only	UV recorded only
No filter fitted to camera	UV recorded, also any visible fluorescence (this will usually be swamped by the UV)	Full UV and visible output recorded

Electronic flash units can be used without filtration for direct UV recording, but they are often fitted with a Chance OX-1 filter to confine the emission to the UV. This has the advantage that the unit can be used without further adaptation for either direct UV or fluorescence work, according to whether a UV-transmitting (Wratten 18A) or UV-absorbing (Wratten 2B) filter is fitted to the camera.

8.9.2 RECORDING FLUORESCENCE. Some specimens emit visible fluorescence under 254 nm mercury radiation and others are excited by blue light to emit yellow or red fluorescence. However, most fluorescence work is concerned with materials excited by the 365 nm mercury emission band; this normally gives a blue or green emission.

The requirements for this work may be summarised:

Surroundings　A darkened work area is essential to avoid uncontrolled visible reflection from the subject.

UV source　Mercury discharge lamps, UV-emitting fluorescent tubes or electronic flash tubes are normally used.

277

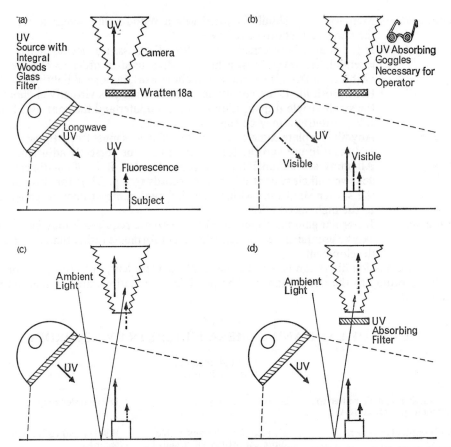

Fig. 8.11. Arrangement of equipment for UV and fluorescence recording. (a) Direct UV recording: double filter technique. The lamp filter absorbs visible and dangerous short-wave UV radiation; the camera filter absorbs ambient visible radiation. (b) Direct UV recording: camera filter technique (requires goggles). (c) Direct UV recording: lamp filter technique (requires darkened room). (d) Fluorescence recording (requires darkened room).

A supplementary exposure with visible light may be necessary to show the general location of the fluorescent areas.

Source filter (exciter) The lamp must be filtered to produce only the required excitation band.

Camera filter (barrier) A UV-absorption filter is always needed for fluorescence work. In some cases it may be helpful to adjust the relative contrast between the fluorescence and the background by the use of additional contrast filters.

It is essential that the transmission bands of the exciter and barrier filters do not overlap. Some UV lamps are fitted with filters that transmit a certain amount of blue light; a pale yellow camera filter is then required instead of the normal colourless UV-absorption filter.

In some subjects a red fluorescence is produced by a blue excitation; in this case a red barrier filter is used and a blue-violet filter is fitted to the light source.

The efficiency of any filter combination for fluorescence work can be tested by the photography of a specular metallic reflection from the source and exciter filter in use.[25] Ideally, the specular short-wave reflection should be entirely absorbed by the barrier filter on the camera, but a small leakage of blue light is not normally objectionable.

Camera No special problems arise in focusing, the fluorescent emission band falls within the chromatic correction band of most lenses.

Film High speed films may be necessary for the weak fluorescence of some organic materials. Colour recording is often valuable in identifying a characteristic fluorescence and films such as High Speed Ektachrome and Anscochrome 500 are often used with forced processing to increase speed.

Either artificial light or daylight colour films can be used, but according to Hansell[26] the latter is preferable because of its lower sensitivity to stray ultraviolet. The contrast within the fluorescent areas is often rather low and care must be taken not to compress any subtle variations by incorrect exposure.

8.9.3 EXPOSURE SETTINGS. Subjects vary greatly in their UV reflectance and their fluorescence characteristics; exposure tests are always necessary when undertaking new work. The following figures may give some general guidance.

8.9.3.1 *Direct UV photography.* The figures given in Table 8.7 were obtained primarily to compare the usefulness of the different sources. In each case a single unscreened lamp was used at a distance of 18 in. and at an angle of 45° to the lens axis: Pan F film was used. The lens was a Zeiss Pancolar 50 mm *f*2, with a Wratten 18A filter.

TABLE 8.7
TYPICAL EXPOSURE FIGURES FOR DIRECT UV RECORDING

Source	Filter	Exposure
UV fluorescent tubes (Allen 409 unit)	Integral filter	2 seconds *f*2·8
Electronic flash* (Multiblitz Press)	No lamp filter	*f*5·6 (open flash)
Tungsten lamp (Philips PF 800R 1000W QI lamp)	No lamp filter	½ second *f*2·8

TABLE 8.8
TYPICAL EXPOSURE FIGURES FOR UV FLUORESCENCE

Source	Filter	Exposure
UV fluorescent tubes (Allen 409 unit)	Integral filter	1 second *f*2.8
Electronic flash (Multiblitz Press)	Fitted with 2in. Wratten 18A filter	*f*2.8 (open flash)
Source distance 6 in. angle 45°	Lens filter Wratten 2E	Image scale 1:1 Pan F film

8.9.3.2 *Fluorescence recording.* The figures in Table 8.8 give a guide to the exposure necessary for recording a typical oil contamination. In other cases much longer exposures may be needed.

In addition to the examples mentioned below, UV and fluorescence photomicrography is covered in Chapter 5 and UV densitometry is mentioned in Chapter 1.

8.10.1 MEDICINE. Pigmented areas of the skin (freckles etc.) and blood vessels have a high UV absorption and are given increased contrast in a UV record; certain skin conditions also stand out clearly. The near UV gives little penetration of the skin (0·1–1 mm) and surface detail is often shown with great clarity; this is the converse of the effect in IR photographs, in which penetration up to 10 mm is achieved[27] and sub-surface features may be shown.

Some fungoid conditions have a characteristic fluorescence. Ring worm can readily be shown and some cancer cells can also be distinguished by their red fluorescence.

Artificial fluorescent tracers have been introduced into the retinal artery for study of the blood vessels in the eye; this shows up some of the fine capillaries that are normally of too low contrast to be seen clearly.[28] In a similar way, injections into the carotid artery have been used to produce fluorescence in blood vessels of the head.

8.10.2 UV CHROMATOGRAPHY. Paper chromatograms may contain substances that are colourless and yet have a characteristic absorption in the ultraviolet (often in the 254 nm region). Direct UV photography can be used to record these areas but a simpler method, which avoids the need for a quartz camera lens, is to make a contact print (using UV radiation) on document reflex paper.

Many chromatogram constituents are fluorescent and viewing cabinets (see Fig. 8.2 and Table 8.2) are available with UV tubes for excitation at both 254 nm and 365 nm; fluorescence records in colour or monochrome are then made with a camera mounted over the viewing window.

Barron[29] has described a simple apparatus using UV-filtered electronic flash for the standardised reproduction of chromatograms.

8.10.3 INDUSTRIAL APPLICATIONS. Fluorescent dye-penetrants are widely used for flaw detection in metals, plastics, ceramics and other materials. The basic technique is to clean the specimen and then to coat it with the penetrant oil; the surface is then wiped clean, but the oil remaining in cracks and other surface defects fluoresces strongly under UV irradiation. This method is particularly useful for showing cracks in dark surfaces and in polished metallic specimens, where all the problems of harsh specular highlights are avoided. UV endoscopes (e.g. Optec and Shandon Blak-ray) are available.

Fluorescent additives can be used in droplet studies to improve visualisation of the drop outline (see p. 413); Groeneweg *et al* have described the use of a pulsed UV laser to record droplets down to 10 μm diameter at velocities of 50 m/sec.[30]

The natural fluorescence of most oils makes it easy to show oil splashes and similar contamination on fabrics. In other cases the cloth may contain artificial fluorescent brighteners and the effect of contamination may be to reduce the fluorescence in affected areas.

Tupholme has described photo-lofting methods in which fluorescent drawings or scribed markings on a fluorescent plate are used to transfer an image by contact exposure (using X-rays or UV to produce fluorescence) on to photo-sensitised metal.[31]

It can be very difficult to show the surface texture of high-temperature incandescent materials, because the intense red and yellow thermal emission from the surface

swamps any cross-lighting from normal light sources. The extremely high intensity of lasers has led to their use in this application[32] but an older idea is to use ultraviolet cross-lighting and a UV transmitting filter on the lens, the principle being that most incandescent subjects emit very little UV. For the same reason, UV has been used in the high-speed photography of welding and other self-luminous subjects.[33]

UV recording has also been used to study the behaviour of high-voltage sparks; in the initial stages the discharge may emit more UV than visible light.[34]

8.10.4 UV ASTRONOMY. The atmosphere normally degrades optical images by turbulence and scatter, but one of the greatest difficulties to the astronomer has been the absorption of wavelengths below about 300 nm, owing primarily to an ozone layer in the upper atmosphere. The amount of ozone is very small, but the absorption is so strong that the solar and stellar UV spectra can only be studied from heights above 20 miles. In recent years, many rocket and balloon-borne experiments have been flown for X-ray and UV spectroscopy.[14]

There is great scientific interest in orbiting observatories which will permit a continuous study over the full electromagnetic spectrum, and Hutter[35] has described methods for television transmission of UV images from satellites.

Goldberg has summarised results from the Orbiting Solar Observatory OSO 1V (1967) and the Orbiting Astronomical Observatory OAO II (1968) and has discussed plans for future work in UV astronomy.[36]

8.10.5 FORENSIC WORK. The recording of fluorescence and direct UV photography can be useful in the study of forged documents and paintings. Superimposed brush-work or inks inserted on a document may be shown to be of a different origin and chemically bleached areas may also be revealed. However, extended exposure to UV causes many pigments to fade and there is some risk that works of art could be irreparably damaged during a lengthy exposure.

All body fluids are fluorescent to some extent and can be detected by UV examination, even when present only in small traces.

The photography of fingerprints on patterned or polished surfaces can be assisted by the use of fluorescent powder. Any UV reflections from the surface are absorbed by the camera filter and only the fluorescent prints are visible.

8.10.6 NOCTURNAL PHOTOGRAPHY. After-dark photography of wild-life and some industrial processes can be carried out by direct UV methods. This work is perhaps more often carried out with infrared, but UV recording has the advantage that conventional films can be used. It may be noted that some insects have pronounced visual sensitivity to the near UV and may therefore react unfavourably to a series of UV flashes.

Aspden has mentioned an application of this principle to the recording of aircraft instruments; a 56 W/sec flash unit fitted with Chance OX–filters enabled standard recording cameras to be used throughout the flight without disturbing the aircrew's night vision by bright lights: a flash guide number of about 14 was found to be suitable for Ilford HP3 film.[37]

References

General references in UV technology

1 SUMMER, W., *Infrared and ultraviolet engineering*, Pitman, London (1962).
2 KOLLER, L. R., *Ultraviolet radiation*, 2nd Ed, Wiley, New York (1965).
3 SAMSON, J. A. R., *Techniques of vacuum ultraviolet spectroscopy*, Wiley, New York (1967).

General references in UV photography

4 HANSELL, P., *Photography for the scientist*, Ed C. E. Engel, Ch 8, Academic Press, London (1968).
5 *Kodak Data Sheet SC-3*, Kodak Ltd., London.
6 *Ultraviolet and fluorescence photography*, Eastman Kodak publication M-27 (1968).

Specific references

7 KOLLER, L. R., *op. cit*, pp 70–81.
8 HENNES, J. and DUNKELMAN, L., *The middle ultraviolet, its science and technology*, Ed A. E. S. Green, Ch 15, Wiley, New York (1966).
9 LORANT, M., *B J Phot*, 111, 140 (1964).
10 FJELD, J. H., *JSMPTE*, 74, 320 (1965).
11 SAYANAGI, K., *J Opt Soc Amer*, 57, 1091–99 (1967).
12 DITCHBURN, R. W., *Light*, 2nd Ed, Appendix 6c, Blackie, London (1963).
13 CHAN, H. H. M., *Appl Opt*, 8, 1209–11 (1969).
14 POUNDS, K. A., *J Phot Sci*, 13, 20–4 (1965).
15 BAEZ, A. V., *The encyclopedia of microscopy*, Ed G. L. Clark, pp 552–61, Reinhold, New York (1961).
16 KOLLER, L. R., *op cit*, Ch 8.
17 SOULE, H. V., *Electro-optical photography at low illumination levels*, Wiley, New York (1968).
18 JACOBS, J. H. and McCLURE, R. J., *Phot Sci Eng*, 9, 82 (1965).
19 FARNELL, G. C., *The theory of the photographic process*, Ed C. E. K. Mees and T. H. James, 3rd Ed, Ch 4, Macmillan, New York (1966).
20 LATHAM, D. W. *Astr J*, 73, 515–17 (1968).
21 *Kodak plates and films for science and industry*, Kodak Publication P-9, Eastman Kodak, Rochester, N.Y. (1967).
22 HONIG, R. E., WOOLSTON, J. R and KRAMER, D. A., *Rev Sci Instrum*, 38, 1703–13 (1967).
23 SAMSON, J. A. R., *op cit*, pp 209–11.
24 KOLLER, L. R., *op cit*, Ch 7.
25 HANSELL, P., *op cit*, p 378.
26 HANSELL, P., *ibid*, p 375.
27 KOLLER, L. R., *ibid*, p 8.
28 ROSE, E. S., *Fluorescence photography of the eye*, Butterworths, London (1969).
29 BARRON, J. C., *B J Phot*, 111, 216–7 (1964).
30 GROENWEG, J., HIROYASV, H. and SOWLS, R., *Brit J Appl Phys*, 18, 1317–20 (1967).
31 TUPHOLME, C. H. S., *Photography in engineering*, pp 22–8, Faber & Faber, London (1945).
32 CHRISTIE, R. H., *Perspective world report: 1966–69*, Ed L. A. Mannheim, pp 175–84, Focal Press, London (1968).
33 ANDERSON, R. W., *Proceedings of the 5th International Conference on high-speed photography*, Ed J. Courtney Pratt, SMPTE (1962).
34 WATERS, R. T. and DYSON, J., *J Phot Sci*, 10, 116–128 (1962).
35 HUTTER, E. C., *Light and heat sensing*, Pergamon, Oxford (1963).
36 GOLDBERG, L., *Sci Amer*, 270, 92–102 (1969).
37 ASPDEN, R. L., *Electronic flash photography*, p 143, Temple Press, London (1959).

9. RADIOGRAPHY

9.1 *Introduction*

Radiology is the study of ionising radiation (charged particles, X-rays and γ-rays) in the broadest sense, including the effect on living organisms and other materials.

Radiography covers techniques for recording images of ionising radiation on photographic emulsions, either directly or by use of a fluorescent screen. The traditional radiographic applications are still of importance primarily in medicine and industry, but the more recent developments in micro-radiography and auto-radiography (Section 9.7) are also of great interest to biologists and other scientists.

General text-books on radiographic practice[1], [2], [3], [4], [5], [6] and the various X-ray analytical techniques, such as X-ray crystallography,[7] X-ray spectroscopy[8] and radiation dosimetry[9] are given in the references.

The regulations in this field stipulate that X-ray and γ-ray sources can be used only by trained personnel.* It is unlikely, therefore, that the photographer will be directly involved in medical or industrial radiography, particularly in view of the considerable professional experience needed for interpretation. However, radiography is sometimes a useful experimental adjunct to photography and a knowledge of radiographic principles is appropriate for the photographer working in support of scientific research.

9.2 *Radiographic sources*

9.2.1 X-RAY SOURCES. X-rays are produced by a stream of high-velocity electrons striking a target, losing energy which is partly emitted in the form of short-wave electromagnetic radiation (although a far greater proportion is dissipated in the form of heat). A simplified X-ray tube layout is shown in Fig. 9.1.

High energy X-ray sources, such as the betatron and the linear accelerator (linac), are basically similar to normal tubes, differing mainly in their size and the methods used to produce the higher voltages required.

The voltage level applied across the tube electrodes controls the electron velocity and this governs both the quantity and quality of the X-ray output. The radiation intensity increases roughly in proportion to the square of the voltage and the penetrating power (quantum energy) is also controlled by the tube voltage.

If an electron gave up all its energy upon collision with the tube anode, the emitted photon would have a quantum energy equal to the full accelerating voltage across the tube. Such an electron in a 120 kV tube would give a photon of 120 keV (which, from Eq. 3.1, would have a wavelength of approximately 0·01 nm). However, most of the electrons are not of the maximum velocity and do not necessarily give up all their energy in a single impact. The total effect is to produce a continuous spectrum† of the

The ionising radiation (sealed sources) regulations, 1969.

†This broad band X-radiation is sometimes called Bremsstrahlung (German: 'braking radiation'); this term is also applied to certain other radiation produced by particle interactions.

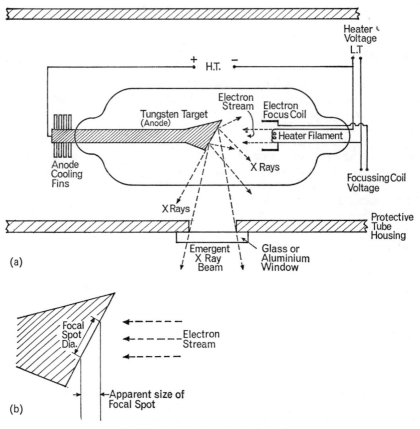

Fig. 9.1. Basic construction of an X-ray tube.

pattern shown in Fig. 9.2, the longer wavelength 'tail' corresponding to electron-target collisions of lower energy. Any radiation of less than about 12 keV (>0·1nm) is loosely termed soft X-radiation or Grenz radiation. (This latter term is taken from a Greek word meaning border, implying that this is the border region between X-rays and the ultraviolet region—see Table 3.1.)

The peak (Q_p) of the spectral curve is usually at an energy about 40–50 per cent of that of the most energetic photons (Q_m); the photons of lowest energy have a much longer wavelength than those of Q_p. The sharp peaks in the curve are characteristic of the target material (which is usually tungsten): if the tube voltage is altered, the continuum moves to longer or shorter wavelengths but the characteristic line radiation does not shift.

The X-ray spectrum has no specific limits; the softest radiation produced by an X-ray mechanism has a wavelength of about 30 nm; the hardest is of the order of 0·00002 nm (60 MeV).

Ideally, the electron beam should be focussed to give the smallest possible source area (to minimise penumbral unsharpness—see p. 292) but a limit is set by the risk

284

of melting the anode if the current density is too high. The normal target configuration shown in Fig. 9.1b helps in this respect, giving a focal spot that is effectively smaller than the electron beam diameter. The larger tubes are water cooled or use a rotating anode.

Although all X-ray sources operate on the same basic principles, the size and shape of the equipment for different purposes range from the micro-focus sources used for X-ray diffraction cameras to linear accelerators weighing hundreds of tons. Some of the more conventional X-ray units are shown in Fig. 9.3; X-ray flash sources are mentioned in Section 9.7.

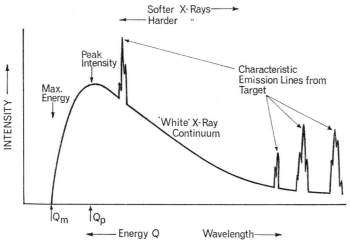

Fig. 9.2. Typical X-ray emission spectrum.

9.2.2 GAMMA RAY SOURCES. The atoms of a radioactive substance spontaneously disintegrate, liberating alpha particles (helium nuclei) or beta particles (electrons) and, in many cases, also emitting gamma ray photons. Each gamma ray photon has a quantum energy (wavelength) which is characteristic of the atom concerned.

There are three important properties of gamma ray sources: energy, activity and half-life.

9.2.2.1 *Energy*. Gamma ray emission is always in the form of sharply-defined spectral lines, although the source is described in terms of its quantum energy (eV) rather than in wavelength units. From this description the radiographer can approximately relate the penetrating power (keV) of the gamma source to that of an X-ray tube at a given voltage (kV).

The penetrating power of each photon is indicated by the quantum energy. From the list given in Table 9.1, it can be seen that some gamma ray sources offer far greater penetration than the normal range of X-ray tubes, which operate in 50–500 kv region. Various comparisons between X-rays and gamma rays are made in Section 9.6 and their relation to the rest of the electro-magnetic spectrum is shown in Table 3.1.

9.2.2.2 *Activity*. The disintegration rate of the radioactive material gives a measure of the 'activity' of the source. The unit of activity is the curie (1 curie $= 3 \cdot 7 \times 10^{10}$ disintegration per second) and gamma-ray sources are listed in terms of curies for a

285

Fig. 9.3. Typical X-ray equipment. (a) Industrial X-ray unit (Pantak 250 kV equipment). A—Tube shield. B—X-ray window. C—HT generator. D—Control unit.* (b) Table-top radiographic unit (Faxitron 804 110 kV equipment). A—Exposure timer. B—KV meter. C—Voltage control (10–110 kV). D—Exposure button. E—Lead shielding. F—Filter support shelves. (c) Flash X-ray unit (Fexitron 730 300 kV equipment).** A dual tube-head is available for stereo work. *Key*: A—Power supply B—Trigger amplifier. C—Nitrogen regulator. D—Freon regulator. E—Tube head cable. F—Tube head. G—Source tube. H—Pulser. (d) Pulsed electron and X-ray source (Febetron 701 600 kV equipment).** *Key as for* (c).**

***By courtesy of Pantak Ltd., Vale Road, Windsor, Berks. **By courtesy of Field Emission (UK) Ltd.**

certain size. For example, a 4×4 mm cylinder of Cobalt-60 might have an initial activity of 24 curies. (24Ci).

Another property is the specific activity, which is defined as the number of curies per gram of the radioactive material. A source of high specific activity offers the advantage of compactness with high radiation output.

The activity is a measure of the number of gamma ray photons emitted per second, it varies with the size of the source and its age (see below); this is quite different from assessing the penetrating power, which depends on the quantum energy of the photons and is an unvarying property of the material.

9.2.2.3 *Half-life.* A gamma ray source contains a very large number of atoms (1×10^{22} atoms per gram for Cobalt-60) but, as each atom can emit its characteristic radiation only once, the number of radioactive atoms steadily decreases and the activity of the source is gradually reduced. The rate of decay is known and a corrected activity value should be calculated periodically. The life of the source is usually quoted in terms of the half-life, which is the time taken for half of the atoms to decay. The decay is exponential and after two half-lives a quarter of the material remains active. It may be possible to use the source for several half-lives, depending on the exposure time that can be tolerated. Sources of some materials can be sent for re-activation in a nuclear reactor.

TABLE 9.1

GAMMA RAY SOURCES IN COMMON USE FOR RADIOGRAPHY

Material	Half-life	Specific activity (curies/ gram)	Principal emission lines	X-ray tube voltage required for equivalent energy	Approximate penetration of steel
Radium Ra-226	1620 years		1·76 1·12 0·6 MeV	2 MeV	70–200mm
Radon Ra-222	3·8 days		1·76 1·12 0·6 MeV	2 MeV	70–200mm
Cobalt Co-60	5·3 years	150	1·33 1·17 MeV	2 MeV	50–150mm
Caesium Cs-137	34 years		0·667 MeV	900 KeV	25–100mm
Iridium Ir-192	74 days	300	0·6 0·47 0·31 MeV	800 KeV	10–60mm
Thulium Tm-170	127 days		0·084 0·052 MeV	180 KeV	2·5–12·5mm

9.2.3 ELECTRON SHADOWGRAPHS (BETAGRAPHS). The use of an electron beam to penetrate thin specimens is applied in the electron microscope, which is discussed in Chapter 5.7. A portable electron beam source (such as the Febetron units listed in Table 9.2) can be used to give direct electron shadowgraphs in a similar manner to normal X-radiographs. The advantage is that very small objects (down to a few microns) and low-density subjects (such as gas clouds and liquid films) can be recorded although they are beyond the range of normal X-ray techniques. The reason is that the electron absorption and scattering of these materials is much higher than their X-ray absorption.

This method has been applied with an electron beam giving a simultaneous electron shadowgraph and flash X-radiograph (see pp. 301–2) in impact studies. The former records the low-density aspects of the event and the latter penetrates the thick parts of the specimen; a thickness or density range of 10,000 to 1 has been covered in this way.[10]

Some materials emit visible fluorescence under electron bombardment and camera recording of high-speed events has been achieved (beta-fluorographs) with a short-duration electron beam (see Plate 15c).

9.3 *Radiographic materials*

9.3.1 SENSITISED MATERIALS

9.3.1.1 *X-ray films.* Photographic emulsions are sensitive both to light and to X-rays and the relative response is adjusted in manufacture to suit the purpose of the film.

There are two classes of X-ray film:
(1) Screen films are intended for use in contact with salt intensifying screens (see p. 289) and make use of the inherent blue and near UV sensitivity of the emulsion.
(2) Direct or non-screen films are used where the lower definition given by salt screens cannot be tolerated. They are designed for maximum response to direct X-radiation and are also used with lead intensifying screens.

There is sometimes confusion over the term screen film; these are intended for use with *salt* screens and not with *lead* screens. Both types of film may be used in medical radiography, but screen films are rarely used in industrial work because of the lower sharpness given by the salt screen. In both cases the emulsion is coated on two sides of the support (duplitised film) to increase the effective speed and contrast.

Fig. 9.4 shows the basic differences in the characteristic curves of these two types of film; certain aspects of X-ray sensitometry are mentioned in Chapter 1.6.2.

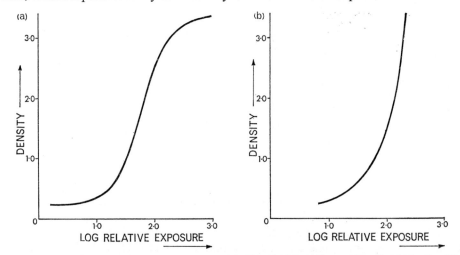

Fig. 9.4. Characteristic curves of X-ray films. (By courtesy of Kodak Ltd.) (a) Typical 'screen' film—Kodak 'Blue Band' film. (b) Typical 'non-screen' film—'Kodirex' film.

Bromide paper and special X-ray papers have been used for radiography with salt screens. The lower cost of paper permits economical large-scale inspection and the image contrast is reasonably good over a short range; the speed is approximately the same as the slower X-ray films. In the case of Kodak QF paper a stabilisation process is used, which gives a finished paper radiograph in about 2 minutes.

Polaroid film packs can be used for the radiography of small specimens and may be useful in the bench-top X-ray cabinets to give rapid results without the need for a dark-room or special film cassettes. The use of colour materials in radiography is mentioned in Chapter 15.7.5.

The entire X-ray spectrum produces a photographic effect, although the peak

spectral response is in the region of 40–50 keV. There is a reduced sensitivity to energies in excess of 200 keV, which results in a loss of contrast in high-energy radiographs of many materials.

Reciprocity failure and the contrast of radiographs are affected by the differences in latent image formation when using X-rays, electrons and other ionising radiation.[11]

9.3.1.2 *Xero-radiography.*[12] Xerographic recording of X-radiation uses a charged selenium plate and forms the image with a powder deposit in the same way as the Xerox document copying process. The selenium plate can be used for hundreds of exposures, which gives a low running cost, but the chief advantage is that the results can be viewed on the plate in less than a minute. The image can be transferred to a paper support if required.

Intensifying screens cannot be used in contact with the charged plate and the process has a relatively low working speed, which prevents its use for medical work. The overall contrast is rather low and the process cannot correctly reproduce large areas, but there is fairly good sensitivity for fine defects because the characteristic edge effect of xerographic images improves the recognition of small details.

9.3.1.3 *Solid-state detectors.* Shackel and Watson[13] have referred to a number of solid-state X-ray image intensifiers and image converters (the conventional photo-emissive image tubes are mentioned on p. 297).

Solid-state image-retaining panels are available* which are sensitive to light (peak response at 400 nm) and X-rays and will retain a luminescent image for 20–30 minutes; the resolution is about 8 l/mm. The properties of the IRP and solid-state X-ray image intensifiers (image retention only a few seconds) have been compared by Ranby.[14]

9.3.2 INTENSIFYING SCREENS. Intensifying screens are normally used in pairs, one in contact with each side of the double-coated film.

9.3.2.1 *Salt screens.* X-rays cause some salts (e.g. calcium tungstate, lead barium sulphate) to emit a blue-violet fluorescence. These salts are coated on to a plastic or card support and provide the main source of exposure with screen films, the contribution from direct X-ray exposure being only a few per cent.

The image spread within the screens leads to relatively poor resolution but the intensification factor (in the range from $10\times$ to $100\times$) is very important in reducing the subject X-ray dose in medical radiography; it may also be useful with very thick industrial specimens.

These salt screens are used for X-ray tube voltages up to about 400 kV; radiation of higher energy tends to penetrate the screen without causing fluorescence and the intensification factor is therefore reduced with higher voltages.

9.3.2.2 *Metal screens.* Thin foils of lead (0·004–0·01 in.) are used in the X-ray film cassette in a similar way to salt screens, but the intensification process and the field of application is quite different.

An X-ray photon produces several photo-electrons upon collision with the lead foil and each electron can cause exposure of the film; alternatively, the photo-electrons may be absorbed within the lead foil, producing secondary low-energy X-rays which then produce a latent image in the film.

An X-ray tube voltage of about 120 kV is necessary to generate a perceptible intensifying effect in a standard pair (0·004/0·006 in.) of lead screens. The intensification factor reaches a peak level of about $4\times$ in the region of 400 kV.

*Image Retaining Panel Mark II (Thorn Special Products Ltd.).

Radiographic definition is very little impaired by lead screens; the contrast of small details is usually improved, owing to the absorption of scattered X-rays that would otherwise affect the film. For this reason, lead screens are often used to improve image quality even when intensification is not required,or with high-energy radiation, where relatively little intensification is produced.

9.4 *Basic factors in radiographic technique*

The listed text-books[1, 2, 3, 4, 5] show many ways in which misinterpretation can arise in radiographs. Each subject requires a technique designed to permit a full and reliable coverage of the specimen and allow correct identification of any defects; several radiographs may be necessary.

9.4.1 EXPOSURE. Radiographers do not use an exposure meter, the various factors usually being expressed in an exposure chart (see Fig. 9.5). Specimens made of several different materials require special calculation.

The thickness and composition of the specimen are the primary factors affecting the selection of voltage and exposure time, but preliminary tests are necessary for each installation because different tubes and generator circuits may give a slightly different output.

When preparing to take an industrial radiograph there are at least as many factors to be considered as when setting up any technical photograph, with the added difficulty that the subject defects cannot be assessed visually:

(1) The direction of the X-ray beam is largely decided by the shape of the specimen and by the nature and location of the suspected defects.

(2) The tube voltage governs the penetrating power of the radiation; excessive penetration reduces the contrast of the radiograph.

(3) The tube current and the exposure duration are associated factors which govern the total film exposure; they are adjusted in order to record the important areas of the subject at the optimum radiographic density (about $D=2\cdot0$).

The intensity of the radiation is governed by the tube current, which is quoted as a combined current-time factor (mA-sec or mA-min). This factor is held constant to give a constant film density with a given specimen.

(4) The tube distance should be as great as possible to give the best geometrical sharpness. Unfortunately the radiation level decreases according to the inverse square law and a large focus-to-film distance (FFD) requires excessively long exposures; typical figures for the FFD are in the range 3–6 ft. Gamma sources have a lower output and are normally used at about 2–3 ft.

(5) The X-ray film is chosen to give the desired compromise between speed, contrast and granularity.

(6) Either salt screens or lead screens may be used to reduce the required exposure, but the unsharpness given by the former type normally precludes their use in industrial work.

9.4.2 PROCESSING. The processing of radiographs must be closely standardised to ensure consistency of contrast. John[15] has fully covered the subject of processing from the radiographer's viewpoint.

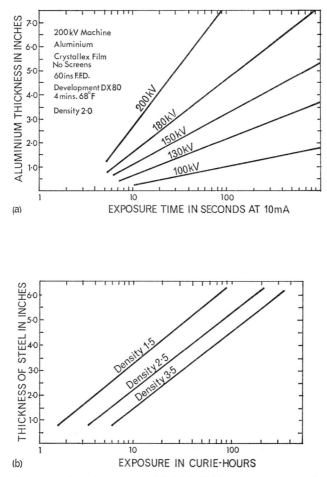

Fig. 9.5. Radiographic exposure charts. (By courtesy of Kodak Ltd.) (a) X-ray exposure chart for Crystallex film and aluminium specimens. (b) Typical gamma-ray exposure chart.

Deep tank installations with temperature control are normally used, but many radiological laboratories are equipped with automatic processors such as the Ilford Rapid R, or the Kodak X-omat, which can process several hundred films an hour with a dry-to-dry time of 90 seconds. This rapid access to the results is especially valuable in medical radiography.

9.4.3 RADIOGRAPHIC SENSITIVITY. The extent to which a radiograph shows small variations in specimen thickness is termed its radiographic sensitivity. It is expressed as the percentage variation that can be detected: for example, a 1 per cent sensitivity in 10 cm thick material implies that a thickness variation of 1 mm could just be seen in the radiograph. The sensitivity with a light material such as aluminium may be as good as 1 per cent, but in general this sort of figure is only achieved with denser elements.

291

To check the sensitivity of a radiograph it is common practice in industrial radiography to include an image quality indicator (IQI) or penetrameter placed on top of the specimen; the penetrameter must be of the same material as the specimen and is usually either a step tablet with drilled holes in each step, or a series of wires of different thickness. The step penetrameter gives results relevant to gross defects, but wire penetrameters are more appropriate in relation to the image quality of fine details.

The sensitivity of a radiographic technique is very important in the inspection of fine details, such as cracks and porosity in metal, but it is not the same as resolving power in the photographic sense. Sensitivity is an indication of measurable thickness changes and is often applied to large areas, in which spatial resolution is not a limiting factor.

As with similar photographic applications, this type of test must be interpreted with caution; the recognition of real defects at the limit of discrimination is much less certain than the detection of a well-defined artificial defect at a known location.

The information content of radiographs has been discussed in terms of visual perception by de Ben.[16]

9.4.4 RADIOGRAPHIC SHARPNESS. The definition of radiographs often appears to be low by photographic standards; there are several contributory factors to this unsharpness:

9.4.4.1 *Geometrical factors*

(1) The width of the X-ray source (S in Fig. 9.6) has a critical effect on the width of the projected penumbra (P); this also varies with the source distance (A) and the object-to-film distance (B):

$$P = S \times B/A \hspace{3cm} \text{Eq. 9.1}$$

Internal defects furthest from the film are the least sharp and any calculation should be for this maximum value of B.

The density gradient in the penumbral region of the finished radiograph is affected by the film contrast and processing.

(2) The projected shadow (Z in Fig. 9.6) is always larger than the object (Y) because of the object-film separation (B). With a point source:

$$Z = Y \times (A+B)/A \hspace{3cm} \text{Eq. 9.2}$$

Identical objects appear to be of different size if they are at different levels in the specimen (different values of B).

(3) For objects smaller than the source, the ray geometry does not give a true shadow and the recorded core of the penumbra may be misleading as to the size and density of small defects.

All these drawbacks can be minimised by the use of small sources and large source distances, provided the consequent long exposures are practicable; this is normally impossible in medical work.

9.4.4.2 *Scattered radiation.* X-rays and gamma rays are propagated from the source in straight lines and, apart from diffraction effects, should produce the predictable geometric shadows shown in Fig. 9.6. Unfortunately, radiation is always scattered from surrounding surfaces and within the specimen, so that the thicker subject areas often become undercut and the true outlines tend to be obscured.

The mechanism of scattering is complex: the energy of some X-rays is reduced (modified scattering) while others are deflected without loss (unmodified scattering).

292

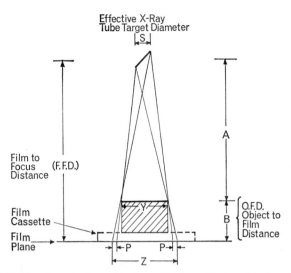

Fig. 9.6. Geometrical factors in radiography. In practice: S may be a few millimetres. A is often about 1 metre. B may be several centimetres. P is therefore typically a fraction of a millimetre.

Some photo-electrons ejected within the specimen by the primary X-rays may excite secondary X-rays of low energy, which are completely random in direction.

The softer X-rays, which tend to predominate among the scattered radiation, can be absorbed to a large extent by a thin filter of copper, aluminium or lead. This can be fitted in front of the X-ray tube window or between the specimen and the film. Lead sheets are always used behind the film cassette to minimise back-scatter from the support table and a blocking paste can also be packed around the specimen.

In medical work a Potter-Bucky grid is frequently used between the subject and the film cassette to reduce the effects of lateral scatter; the grid is kept moving throughout the exposure so that its shadow is not recorded.

9.4.4.3 *Subject movement*. Industrial radiographers do not normally have to deal with moving subjects and exposures of several minutes are normally acceptable. In medical work the heart and chest are subjects most likely to show involuntary movement; fortunately, these are not dense areas and the exposure time can usually be kept below about 0·1 seconds.

9.4.4.4 *Salt-screen unsharpness*. There is a marked spread of the fluorescent image within salt screens although the modern high definition screens have a finer phosphor grain which helps to reduce this problem. In every case good contact between film and screen is essential if an effect known as screen mottle is to be avoided.

Rossmann[17] has derived MTF curves for typical salt screen-film combinations which show a limiting resolution of about 6–10 l/mm; the frequency corresponding to the 50 per cent contrast level was about 1–2 l/mm.

9.4.4.5 *Film sharpness*. Apart from the grain size of the emulsion, the apparent graininess of radiographs is due to randomly scattered secondary X-rays and electrons, which cause the effect of a single X-ray photon to be distributed over a path of several silver halide crystals. The effect becomes worse with increased radiation energy.

293

With fast film and efficient intensifying screens only a few X-ray quanta may be necessary to form an adequate density. Under these conditions the random distribution of the photons may be evident from a non-uniformity known as quantum mottle.

The fact that X-ray films are double-coated tends to affect the geometric sharpness of the image. If the X-ray beam is oblique to the film the twin emulsion images can be noticeably displaced; in some cases oblique viewing of corner areas is helpful.

9.4.5 FILM SPEED. Film manufacturers do not use a standard method of expressing X-ray film speeds, although exposure tables are always published for typical working conditions (Fig. 9.5).

In all cases where film-speed comparison is required it is necessary to find a criterion suited to the practical application of the material; speed comparisons at $D=1 \cdot 5$ are suggested for industrial radiography and $D=1 \cdot 0$ for medical work.[18], [19]

Radiographers sometimes plot a curve showing the variation of effective film speed with change of development time (see p. 59).

9.4.6 EXPOSURE SCALE. The radiographic exposure scale is the range of specimen densities that can usefully be recorded on a film. Before the exposure scale can be quoted, the usable density range of the film must be defined. The use of double-coated film gives a D_{max} of about $6 \cdot 0$ for direct X-ray films and about $3 \cdot 0$ or $4 \cdot 0$ for screen films. However, the usable density range is much more restricted than these figures suggest. With normal X-ray illuminators the highest density that can be viewed is about $3 \cdot 0$, although special high-intensity viewers allow densities up to about $4 \cdot 5$ to be used. Furthermore, the toe of the curve is flat by radiographic standards and a minimum density of $1 \cdot 0$ is often arbitrarily quoted as the lower useful limit. From a given film characteristic curve the exposure scale relating to a specified density scale of $1 \cdot 0$–$3 \cdot 0$ can be estimated, as shown in Fig. 9.7 for a typical non-screen film.*

Ultimately, the thickness range that can be recorded on a single film depends on the energy of the radiation used. Typical values are about 3:1 for light metals and about 1·5:1 for dense metals.

A low contrast may be useful in covering a wide subject range, but because good radiographic sensitivity is normally required, it is usual to work at high contrast. This implies a reduced exposure scale, so that a wide range of thicknesses cannot then be recorded. For this reason a series of films may be taken, each with a different exposure and each therefore covering a different part of the subject thickness range. Alternatively, a pack of two or more films of different speed may be exposed simultaneously to cover a wide exposure scale without loss of contrast. The use of colour radiography in this context is mentioned in Chapter 15.

Devillers has discussed factors affecting the viewing of radiographs and has pointed out the advantages of moderate development in medical radiography.[20]

9.4.7 REPRODUCTION OF RADIOGRAPHS. Radiographs are negatives in the normal photographic sense; a print or intermediate copy negative of the radiograph is a positive representation of the original specimen.

Projection transparencies can be made by conventional negative-positive copying or by use of reversal materials; in some cases colour reversal films are the most readily available and will often give acceptable results; if the radiograph density scale is too great it may be possible to pre-flash the copying film in order to reduce the contrast.

*The \bar{G} of industrial X-ray films is measured over the density scale $D=0 \cdot 5$ to $D=2 \cdot 5$[18].

294

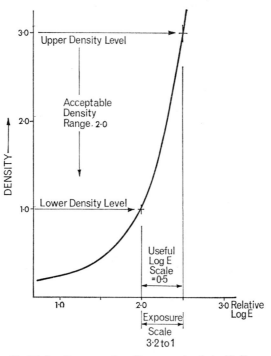

Fig. 9.7. Density range and working range of radiographic film.

For full-size film duplicates, one of the auto-reversal films such as 3M's Direct Positive film offer a one-stage process with good tonal characteristics and minimum loss of resolution. Kodak Radiograph Duplicating film is a similar material which has a blue-tinted base in order to give copies with the same general appearance as medical X-ray films.

Practical details of radiographic copying, including the use of contrast-reducing masks, have been given by Ollerenshaw.[21]

9.5 *Fluoroscopy*

The basis of the fluoroscope and associated methods of photographic recording (fluorography) are shown in Fig. 9.8. The resolution and sensitivity of fluoroscopes are limited, but they are used in many fields because they offer cheap and rapid inspection. For example, foreign objects can be detected on a food production line, or enclosed assemblies can be tested for correct operation; micro-fluoroscopy is mentioned on p. 299.

In medicine, the fluoroscope may be used in conjunction with a television system during operations such as bone-setting, or in studying the movements of internal organs. The picture can then be relayed to a group of students if required and video-tape records can be made for immediate play-back.

295

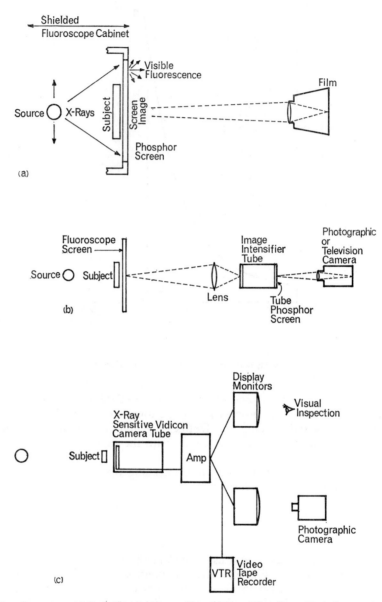

Fig 9.8. X-ray fluoroscopy. (a) Basic fluorographic recording. (b) Use of image intensifier in fluorography. (c) Use of television tube directly sensitive to X-rays.

9.5.1 FLUOROGRAPHY. A fluoroscope screen can normally be photographed without difficulty provided that reflections on the screen surface can be avoided.

The screen luminance is often low and exposures tend to be lengthy, but for living subjects, where the X-ray dose must be minimised, an image intensifier can be used

296

(Fig. 9.8b). This method is widely used in mass miniature radiography of the chest, using 70 mm or 35 mm film. Even with these small negatives and the comparatively low resolution of image tubes, the image quality is good enough to permit positive clearance in the great majority of cases.

The cine recording of fluoroscopes (cine-fluorography) and other methods for cine-radiography are mentioned on p. 302.

9.5.2 X-RAY IMAGE TUBES. Another form of immediate radiographic display is offered by television camera tubes which are directly sensitive to X-rays. The main disadvantage of this method and the similar approach of using an X-ray sensitive image convertor tube is that the field is limited to the diameter of the tube. Shackel and Watson[22] have compared the cost and performance of a number of methods for X-ray television display, including the use of storage tubes which can retain an image for study over a period of several minutes. Chester et al have described an X-ray sensitive tube using an array of silicon diodes and have discussed other X-ray television tubes.[23]

9.6 Gamma radiography[24]

Radium is the most energetic gamma ray source (2·2 MeV) and for many years offered greater penetration than X-ray tubes. This situation has now changed to some extent and high-voltage X-ray generators (e.g. betatrons, linear accelerators) can produce radiation of 30 MeV or more, with intensities far higher than any radioactive source. However, this type of equipment is very large and expensive and has in no way replaced gamma radiography in industry.

Gamma sources have the important advantages of compactness and portability; the source requires no power supply or cooling and can be freely taken to remote installations (although battery-powered X-ray sets are also available). Gamma sources are much cheaper than X-ray equipment and, despite certain disadvantages mentioned below, are often purchased when there is only an occasional need for high-energy radiation.

The energy figures in Table 9.1 show that the penetrating power of most gamma-ray sources is greater than is available from the X-ray sources in common use (which cover the range 50 kv–500 kv). However, even if the gamma ray photons are more energetic, they are fewer in number and exposures are often measured in hours or even in days. The gamma ray dose can be increased by use of a larger source or by placing the source very close to the specimen; unfortunately, in both cases the rendering of fine detail suffers from the inferior geometric conditions.

Gamma rays and X-rays of equal energy are identical and would give identical results; however, an exact comparison cannot be made because gamma radiation is monochromatic whereas an X-ray emission of equal peak energy (Q_p in Fig. 9.2) is always part of a spectral continuum. The majority of the X-ray emission is at longer wavelengths, which give lower penetration and a tendency to higher contrast. It is, for example, necessary to run an X-ray tube at 800 kV to give an average penetration equal to a gamma source of 600 keV.

Gamma sources emit radiation in all directions, whereas conventional X-ray tubes emit over a limited angle. Gamma radiography is therefore often used for annular

objects, such as welded joints in pipe-work, which can be recorded on a length of film wrapped in a paper envelope around the outer wall.*

9.6.1 NEUTRON RADIOGRAPHY.[25, 6] It is normally difficult to achieve radiographic differentiation between elements of adjacent atomic number, because the X-ray absorption coefficients are very similar. The absorption of neutrons does not follow the same pattern and neutron radiography can give much better contrast in some cases.

Neutrons have very little direct effect on radiographic emulsions (although they may be studied in nuclear track emulsions) and a converter foil must be used to produce alpha particles or gamma rays that will be recorded by film in contact with the foil. Alternatively, an image intensifier camera may be used to record a 'neutron conversion screen'.[26]

9.7 *Special radiographic techniques*

Reference is made in Chapter 13 to methods for stereo-radiography and depth-localisation using X-rays. The techniques used for the photography of radioactive materials are mentioned in Chapter 18.3.

9.7.1 MICRO-RADIOGRAPHY. Techniques of X-ray microscopy have been developed to the point where the resolution can compare favourably with optical microscopy. Apart from the basic purpose of examining the micro-structure of materials, it has been possible to differentiate between the constituents of metallic and other specimens. Micro-radiography is now a major research tool and has been thorough discussed by Cosslett and Nixon.[27]

Several ingenious methods have been proposed, including X-ray holograms (see Chapter 15), but the most important are contact microradiography,[28, 29] projection microradiography[30] and reflection X-ray microscopy.[31]

9.7.1.1 *Contact micro-radiography*. The earliest work in this field (Burch, Ranwez, 1896) used photographic enlargement of conventional films, a simple approach that is seriously limited by the relative unsharpness and graininess of normal radiographs. However, by the use of high-resolution emulsions and final inspection in a high-power microscope the method can be used to give a final magnification up to about $1000\times$.

The specimens are cut into thin slices (500 nm or less) and are held in contact with the recording emulsion; the X-ray tube is set at a distance to minimise penumbral unsharpness.

Metallic specimens may require voltages up to 50 kV, but the thin organic materials call for special low-voltage tubes operating in the range 1–10 kV. Very soft X-rays below about 5 kV are absorbed by the air and the path of the X-ray beam must be evacuated or filled with helium.

For some analytical work it is possible to use special target anodes in order to obtain a characteristic X-ray emission at a particular wavelength.

Resolution of details down to about 250 nm have been achieved by contact micro-radiography; the performance ultimately depends on the examining microscope and this may be a greater limitation than the emulsion used.

*Some of the newer X-ray tubes also offer this facility by emitting a radial or hemi-spherical beam and are used in 'crawling' X-ray units which can be driven inside pipe runs. For example the Picker-Andrex battery-operated unit can be used for radiography inside pipes of 18-24 in. diameter.

In the allied technique of contact micro-fluoroscopy the specimen is placed on a fine-grained phosphor screen and the fluorescent image is viewed by a microscope. This method has been used for magnifications up to 1000× and permits immediate inspection without the need for radiography.

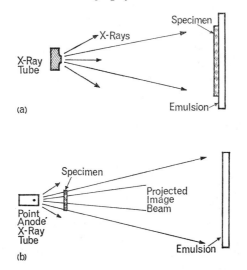

Fig. 9.9. Principles of microradiography. (a) Contact microradiography. (b) Projection microradiography.

9.7.1.2 *Projection micro-radiography*. With X-ray projection (Fig. 9.9b) the specimen is placed close to the source and the film distance is increased to give the desired magnification. Special emulsions are not essential, although the use of fine-grained materials permits further optical enlargement of the micro-radiograph.

This projected shadowgraph system demands an extremely small source. The smallest tube targets normally available are too large (about 0·5 mm) and the earliest workers in this field, dating from Czermak (1897) used a pinhole in front of a conventional X-ray tube. Modern techniques, following the work of Cosslett and Nixon (1951–55) use an electron beam focused on to a thin metal target, giving X-ray emission over an area as small as 100 nm. Special X-ray tubes have also been made with needle-point anodes down to 500 nm diameter.

Magnifications of 2000× have been achieved by this method and a resolution of between 100 nm and 200 nm has been reported; this compares well with optical microscopy, for which an approximate limit of 150–200 nm might be quoted. Both techniques fall well short of the best results achieved in electron microscopy (resolution about 1 nm).

The contact method uses simpler apparatus and may be preferred for occasional or low-power work; however, the projection method offers the better resolution and shorter exposure times and the results can be evaluated without a microscope.

X-ray stereo microscopy can be carried out by the projection method; the specimen is tilted or shifted between the two exposures.

9.7.1.3 *Reflection X-ray microscopy*.[31] Lenses have been constructed for X-ray image formation, usually working on the principle of grazing-incidence reflection

299

because this is one of the few ways in which X-rays can be optically deviated. Large X-ray lenses (up to 1 m²) made from arrays of gold-plated glass plates have been used for rocket-borne stellar X-ray studies.[32] Trurnit and Hoppe (1946) devised an annular mirror lens for X-ray microscopy and Kirkpatrick and Baez (1948) used a series of cylindrical mirrors designed to give some correction of aberrations. The latter technique has been developed to give micro-radiographs with resolution better than 1 μm and there are theoretical possibilities of resolution down to 10 nm.[31]

Diffraction at the lattice planes of curved crystals has been the basis both of mirror lenses (von Hamos, 1934) and transmission lenses (Cauchois, 1946).

All of these techniques require very specialised apparatus and are confined to relatively low magnification, although direct X-ray magnification up to about 100× has been achieved.

The Fresnel zone plate has also been considered as a possible approach to X-ray image formation (see p. 269).

9.7.1.4 *X-ray scanning microscopy* (*X-ray microanalysis*). The X-ray scanning microscope operates on broadly similar principles to the scanning electron microscope (p. 209). An electron beam excites characteristic X-radiation which is detected by an X-ray spectrometer: this gives an electrical signal which can be used to build up a CRT display of the constituent distribution.[27]

9.7.2 AUTORADIOGRAPHY.[33, 34] If a radioactive specimen is placed in contact with a photographic emulsion the radiation from the specimen (alpha, beta or gamma rays) exposes the emulsion, revealing any local variation in activity. Radio-isotopes are used in this way to study segregation within metallic alloys and may be introduced as tracers in plant and animal circulatory systems. The precautions necessary in quantitative biological autoradiography have been most fully described by Rogers.[34] The autoradiograph may be examined by bright field or dark field methods in a microscope and, if high-resolution emulsions are used, a resolving power of 1 μm may be achieved. Herz[35] has discussed recent work in which the autoradiograph is studied by electron microscopy; a resolution of 70 nm may be achievable by this method.

The isotopes are used in very small quantities and have a low specific activity, so that exposures of days or weeks are common. There are three basic methods:

(1) Contact exposure with film or a lantern plate.
(2) Coating or spraying the specimen with a liquid emulsion[36] (available from Agfa-Gevaert, Ilford and Kodak).
(3) Stripping an emulsion from its support and mounting it on to the specimen; instructions for this technique are given by the film manufacturer (e.g. Kodak AR 10;[37] Ilford Nuclear Research Emulsions—types G, K and L).

The first method offers the use of faster emulsions and is the only choice for opaque subjects; the other techniques, in which the emulsion is processed in contact with the specimen, give better resolution and are used in biological and histological work. The subject tissue can be stained to show the general structure in relation to the radioactive areas. Dye-coupled stripping film can be superimposed to show the distribution of two different isotopes.[38] Kodak make a thin stripping layer (Scientific Plate V1062) especially for this technique of colour differential autoradiography.

Nuclear track emulsions are often used for autoradiography because they have a high silver halide content, with closely-packed small grains. In track autoradiography thick layers (up to 1 mm) are used when studying the path of charged particles in

300

cosmic ray research or high-energy physics; different types of particle can be recognised by the characteristics of the track. The use of photographic materials in the study of elementary particles is a major topic which is outside the scope of this book; an introduction to the subject has been given by Powell et al.[39]

Resolution charts[40] and sensitometric step-wedges[41] have been produced in radioactive form for the study of autoradiographic techniques. Methods for the quantitative assessment of radiation level are mentioned in Chapter 1, p. 67.

The distribution of diagnostic radioisotopes can be recorded by a mechanical scanner or a camera using a pinhole and scintillation counter.[†41]

9.7.3 HIGH SPEED RADIOGRAPHY.[42] Radiography is used to study internal movements in medical and industrial applications and is also well established for high-speed recording in ballistics and explosives research.[43] The advantage is that X-rays can penetrate smoke and flame and shock-waves that would obscure normal photographs of impact or explosion. Short-duration flash X-rays have also been used to show the movement of a shell inside a gun barrel and to study the burning of solid propellant rocket motors.

9.7.3.1 *Flash radiography*. If the high-voltage supply to an X-ray tube is delivered in a short pulse the X-ray emission is produced in a flash of approximately equal duration. Table 9.2 gives details of commercially-available X-ray flash equipment.

TABLE 9.2

FLASH X-RAY SOURCES

	Tube voltage	Half Duration (ns)	Remarks
Hivotronic*	150 kV	100	Battery-powered portable unit $16 \times 10 \times 7$ inches. Records on Polaroid film
Fexitron 730–235**	100–150 kV	70	Repetitive operation available
			Single tube: 20 frames at 10^2/sec (single power-pulser unit); 3 frames at 10^5/sec (multiple power-pulser units)
			Multiple tubes: 4-tube or 16-tube systems giving rates up to 10^6/sec
Fexitron 730–1/2710	300 kV	20	Twin-tube operation available for stereo-radiography
*Febetron electron beam sources***			
701 system	170–600 kV	3 or 16 ns	Can be used with auxiliary target to give 2 ns X-ray pulses. Can be operated at 10 pulses/sec for a few seconds
705 system	0·6–2·3 MV	50	External beam focus unit available. Can be used to give 20 ns X-ray pulse. Can be operated at 10 pulses/sec for a few seconds
706 system	500 kV	3	X-ray targets available giving 2 ns X-ray pulses. Can be used in multi-tube mode to give a train of up to 8 pulses at rates up to 10^6/sec

*Hivotronic Ltd., Wella Road, Basingstoke, Hants.
**Field Emission U.K. Ltd., 209 Crescent Road, New Barnet, Herts.
†e.g. The Scinticamera, made by Nuclear Enterprises Ltd., Sighthill, Edinburgh.

301

The Field Emission Febetron sources produce a short-duration beam of electrons that can be used for direct electron shadowgraphs (Plate 15a, b and c) or can be directed on to a tungsten target to produce a short pulse of X-rays for normal X-radiographs. Brewster et al[44] have also applied the Febetron 706 unit to produce so-called super-radiant green light by the electron bombardment of a cadmium sulphide phosphor target; this was used together with a tungsten target in the electron beam to give simultaneous 2 nsec pulses of electrons, X-rays and light from the same electron beam.

9.7.3.2 *Cine-radiography*. Sequences of radiographs can be recorded directly on film in two ways:

(1) With a repetitively-pulsed X-ray tube and moving film (e.g. on a rotating drum). The number of successive pulses is limited by anode heating, but framing rates up to 10^3/sec have been achieved. As indicated in Table 9.2 the Fexitron 730 tube head can be used with triple pulse units to give a train of 3 pulses at rates up to 10^5/sec. (Plate 14).

(2) With separate X-ray tubes pulsed in rapid succession. As shown in Table 9.2 the Fexitron 730 units can be used to give up to 16 pulses at rates up to 10^6/sec. This method gives a different viewpoint for each flash, but lends itself to the sequential coverage of ballistic trajectories and similarly extended events.

These methods give full-size radiographs but offer a limited number of frames; for most purposes requiring a lower framing rate an indirect fluorographic method is used:

(3) Conventional cine-recording methods can be used to film a fluoroscope screen. It is usually necessary to reduce the X-ray dose on living subjects. The camera system therefore requires fast films and large-aperture copying lenses ($f/1$ or faster); an image intensifier is often used. In medical work the total X-ray dose is sometimes reduced by pulsing the X-ray tube only when the recording camera shutter is open.

It is possible that video-tape recording (VTR) from a fluoroscope→image intensifier→ television chain (Fig. 9.8b) will replace the use of cine film in some applications. Halmshaw and Lavender[45] have described a system giving optional VTR or cine recording (up to 50 frames/sec) for the study of metal pouring in the casting of turbine blades; X-ray energies up to 15 MV were used and, despite the complexity of the recording chain, excellent radiographic sensitivities of the order of 0·6 per cent were reported.*

The use of image-dissection techniques (see Chapter 11) to give radiographs at rates up to 10^5/sec has been proposed by Courtney Pratt.[46]

The general subject of low-light photography, including the applications of television and image intensifiers in X-ray fluoroscopy has been discussed by Soule.[47]

*The use of closed circuit television is discussed further in Chapter 18.5.

302

References

General

1 HALMSHAW, R., *Physics of industrial radiology*, Heywood, London (1966).
2 *Industrial radiology*, Kodak Ltd., London.
3 CHESNEY, D. N., and CHESNEY, M. O., *Radiographic Photography*, Blackwell, Oxford, 2nd edn (1969).
4 ROCKLEY, J. C., *An introduction to industrial radiology*, Butterworth, London (1967).
5 SEEMAN, H. E., *Physical and photographic principles of medical photography*, Wiley, New York (1968).
6 HERZ, R. H., *The Photographic Action of Ionising Radiations*, Wiley, New York (1969).

Specific

7 *Kodak Data Sheet SC-15*, Kodak Ltd., London.
8 KAEBLE, E. F., *Handbook of X-rays for diffraction, emission, absorption and microscopy*, McGraw-Hill, New York (1967).
9 BECKER, K., *Photographic film dosimetry*, Focal Press, London (1966).
10 *Betagraphy* Technical Bulletin Vol 5, No 2, Field Emission Corp (1968).
11 HAMILTON, J. F. and CORNEY, G. M., *The theory of the photographic process*, Ed C. E. K. Mees and T. H. James, 3rd Ed, Ch 10, Macmillan, New York (1966).
12 DESSAUER, J. H. and CLARK, H. E., *Xerography and related processes*, Focal Press, London (1965).
13 SHACKEL, B. and WATSON, G. R., *Photography for the scientist*, Ed C. E. Engel, Ch 14, Academic Press, London (1968).
14 RANBY, P. W., *Electrical Review*, 27 March 1964, pp 2–6.
15 JOHN, D. H. O., *Radiographic processing*, Focal Press, London (1967).
16 DE BEN, H. S., *J Phot Sci*, 12, 148–55 (1964).
17 ROSSMANN, K., *J Phot Sci*, 12, 279–83 (1964).
18 ASA PH 2.8–1964 *Sensitometry of industrial X-ray films for energies up to 3 million electron volts*.
19 ASA PH 2.9–1964, *Sensitometry of medical X-ray films*.
20 DEVILLERS, G., *J Phot Sci*, 14, 116–23 (1966).
21 OLLERENSHAW, R., *Photography for the scientist*, Ed C. E. Engel, Ch 13, Academic Press, London (1968).
22 SHACKEL, B. and WATSON, G. R., *op cit*, pp 592–3.
23 CHESTER, A. N., LOOMIS, T. C. and WEISS, M. M., *Bell Tech J*, 48, 345–382 (1969).
24 *Kodak Data Sheet IN-16*, Kodak Ltd., London.
25 HAWKESWORTH, M. R., *X-ray Focus*, 8, 23 (1968).

26 SOULE, H. V., *op cit*, pp 251–4.
27 COSSLETT, V. E. and NIXON, W. C., *X-ray microscopy*, Cambridge University Press (1960).
28 BERTIN, E. P. and SAMBER, R. L., *Handbook of X-rays for diffraction, emission, absorption and microscopy*, Ch 45, McGraw-Hill, New York (1967).
29 ENGSTROM, A., *ibid*, Ch 46.
30 ONG, P. S., *ibid*, Ch 47.
31 KIRKPATRICK, P., *ibid*, Ch 48.
32 KANTOR, F. W., NOVICK, R., WING, T. E., *Proc Symposium on Modern Optics: New York 1967*, Polytechnic Press, Brooklyn, New York (1967).
33 *Kodak Data Sheet SC-10*, Kodak Ltd., London.
34 ROGERS, A. W., *Techniques of autoradiography*, Elsevier, Amsterdam, 2nd ed (1969).
35 HERZ, R. H., *Perspective World Report: 1966–69*, Ed L. A. Mannheim, pp 220–23, Focal Press, London (1968).
36 LORD, B. I., *J Phot Sci*, 11, 342–6 (1963).
37 *Kodak materials for nuclear physics and autoradiography* Publication P-64, Eastman Kodak Ltd.
38 DAWSON, K. B., FIELD, E. O., STEVENS, G. W. W., *Nature*, 195, No 4840, 510–11 (1962).
39 POWELL, C. F., FOWLER, P. H. and PERKINS, D. H., *The study of elementary particles by the photographic method*, Pergamon, Oxford (1959).
40 STEVENS, G. W. W., *Microphotography*, 2nd Ed, pp 454–7, Chapman & Hall, London (1968).
41 ASHWORTH, R. S., *J. Phot Sci*, 15, 181–4 (1967).
42 *Proceedings of the 8th International Congress on High Speed Photography*—Stockholm, 1968, Ed N. R. Nilsson and L. Hogberg, pp 237–71, Wiley, New York (1968).
43 JOHNSON, R. F., *Visual*, 8, 1, 12–19 (1970).
44 BREWSTER, J. L., BARBOUR, J. P., GRUNDHAUSER, F. J. and DYKE, W. P., *Proceedings of the 5th International Congress on High Speed Photography*, pp 240–44, SMPTE (1962).
45 HALMSHAW, R. and LAVENDER, J. D., *Non-destructive testing*, 2, 99–102 (1969).
46 COURTNEY-PRATT, JSMPTE, 70, 637–42 (1961).
47 SOULE, H. V., *Electro-optical photography at low illumination levels*, Wiley, New York (1968).

Technical journals

Non-destructive testing, published monthly by Iliffe Science & Technology Publications Ltd.
X-ray Focus, published quarterly by Ilford Ltd.

10. CINEMATOGRAPHY

10.1 *Principles and Methods*

Cinematography depends on the phenomenon known as persistence of vision, by which stationary images, showing successive phases of a movement, if projected or viewed in rapid succession are accepted by the brain as a continuous view of the moving subject.

The minimum projection frequency (see also 10.4.1) to give the illusion of continuous movement is 16 frames per second (fps) and this speed is commonly used for silent films. However if sound is to be included, a higher film velocity is necessary to give satisfactory sound reproduction and 24 fps is used (25 fps for television purposes). If the apparent speed of motion is to be correct the camera and projection frequencies must be the same.

10.1.1 CAMERA AND EQUIPMENT. In a normal cine camera the film remains stationary during exposure and is transported one frame at a time while the shutter is closed. The drive to the film feed and take-up is usually continuous and some form of intermittent mechanism is used between these to take the film through the exposing gate.

Cine camera mechanisms vary widely, but the general principle can be seen from Fig. 10.1.

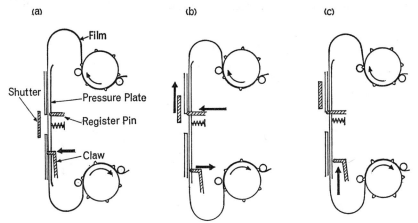

Fig. 10.1. Principle of the cine camera. (a) Register pin just retracted, shutter closed, claw engages at top of stroke. Top loop at maximum length, bottom loop at minimum length. (b) Claw disengages at bottom of stroke, register pin engages, shutter opens. Top loop at minimum length, bottom loop at maximum length. (c) Claw disengaged, moving up ready for next stroke, register pin engaged, shutter open.

10.1.1.1 *Intermittent mechanism.* The intermittent drive through the gate is provided by claw teeth and the upper and lower film loops absorb the difference between this and the continuous drive of the sprockets. To provide accurate location of the film, a register pin may be inserted into a perforation for the period of exposure only, retracting to allow film transport by the claw.

Many of the types of mechanism used to obtain the intermittent drive have been described by Wheeler[1] and Happé.[2]

305

10.1.1.2 *Shutters.* A rotating sector shutter is generally used and the exposure duration for each frame is governed by the framing rate (F) and the sector angle (θ) of the shutter opening, thus:

$$\text{Exposure duration} = \frac{\theta}{360° \times F}$$

The most common sector angle is 180° so that the shutter is open for half of the total time. In some cameras the shutter has two exposing sectors and rotates at half the framing speed. In this case the actual openings may be 90° each but the effect is the same as a normal opening of 180° and the term '180° shutter' is commonly used. Variation of exposure time for a given framing rate is a useful feature and some cameras are provided with a variable sector shutter to achieve this. Alternatively, interchangeable fixed sector shutters are used, particularly in instrumentation recording cameras.

10.1.1.3 *Viewing and focusing.* The simplest cine cameras are fitted with an optical viewfinder and are focused by means of a distance scale. Approximate compensation for parallax error is indicated in the finder but is unlikely to be adequate for close-up work. Cameras having a removable viewfinder system or 'boresight', which allows the view through the taking lens to be seen for setting-up and focusing, are suitable for many scientific purposes but mirror reflex cameras are even more convenient because they allow continuous viewing even while the camera is running. Most cine reflex cameras employ a mirror shutter of the rotating sector type (see Fig. 10.2)

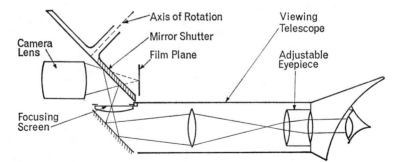

Fig. 10.2. Rotating mirror shutter giving viewfinder image during shutter closed periods.

with a 45° mirror surface facing the lens to allow viewing of the image formed by the taking lens during the closed portions of the shutter cycle. The 16 mm Beaulieu camera uses a vertically reciprocating mirror shutter which has the advantage of compactness but gives a greater exposure to the top of the image (corresponding to the bottom of the subject). In some work such as tilting and photomicrography this unevenness of exposure may be noticed. The Bolex H16 Reflex uses a semi-reflecting prism to form a continuous reflex image using about 20 per cent of the lens transmission.

10.1.1.4 *Motors and magazines.* Camera drive motors may be either clockwork or electric, but the maximum continuous running time of clockwork motors is limited and modern high capacity, lightweight batteries make electric drive more convenient.

Some cameras have spool chambers integral with the camera body, while other use separate film magazines. A useful arrangement is for the camera body to accommodate 100 ft spools and accept magazines for larger quantities, keeping the camera compact but allowing use of large film lengths when necessary.

10.1.1.5 *Film type and size.* The most generally used gauge for applied cinematography is 16 mm although for highest spatial information content 35 mm is normally preferable. The less expensive 8 mm and super 8 mm formats are quite adequate for many types of record.

TABLE 10.1

RUNNING TIMES* FOR VARIOUS FILM CAPACITIES

Capacity	16mm		35mm	
	16 fps	*24 fps*	*16 fps*	*24 fps*
100'	4m 10s	2m 46s	1m 40s	1m 6s
200'	8m 20s	5m 33s	3m 20s	2m 13s
400'	16m 40s	11m 6s	6m 40s	4m 26s
1200'	50m	33m 20s	20m	13m 20s

*Practical figures may be lower due to film length required for lacing purposes.

Two types of film stock are available, intended respectively for conventional negative processing or reversal processing. The main advantages of the reversal system, which produces a positive result on the exposed camera stock, are low cost (because no printing costs are involved) and the shorter time taken to produce the positive result. It is often used in universities and small research departments and, to some extent, for television newsreels. The disadvantages of reversal film are the limited exposure latitude, because of the higher contrast and absence of compensatory printing exposure, and the provision of only a single camera record to be used for projection, analysis and editing. This entails comparatively high risk of scratching on the original, which is transferred to any duplicates subsequently made. Reversal masters can be duplicated for these purposes, of course (this is normal practice with colour reversal materials), but this nullifies the advantages mentioned. For these reasons negative film is preferable where preservation of the record is likely to be important.

10.1.2 APPLIED CINEMATOGRAPHY. Scientific film may be exposed purely as a factual record for examination by the scientist or engineer, either projected to show qualitatively the movement of the subject or using frame by frame analysis.

The applied photographer may also be required to produce simple documentary film either to support and explain a scientific record or to stand in its own right to illustrate, for example, an experimental procedure. Such documentary film should be planned before shooting and a script, as detailed as possible, produced. This script is vital to both the filming and editing stages (p. 315) and should list the separate scenes to be shot, the action they contain, their approximate length and order in the final film. Where possible, scene lengths should vary but be generally fairly short (6–12 seconds is a useful length). A film of a lengthy operation is tedious if shot from a static viewpoint. It should preferably be broken up by changes of viewpoint or by occasional close up views. Such 'cutaway' shots give useful flexibility in editing.

TABLE 10.2

FEATURES OF CINE CAMERAS

Model	Film size	Speed range (fps)	Film transport	Capacity	Shutter opening
Arriflex 16 standard	16mm	4–48	Claw and register pin	100′ internally 400′ magazine	180°
Arriflex 16M	16mm	4–48	Claw and register pin	200′, 400′, 1200′ magazines	180°
Arriflex 16 BL	16mm	24 or 25	Claw and register pin	400′ or 1200′ magazines	180°
Arriflex 35	35mm	2–50	Claw	200′, 400′ magazines	180°
Beaulieu R16	16mm	2–64 and single frame	Claw	100′ internally 200′ magazine	Effective 144°
Bell & Howell 70 DR	16mm	8–64	Claw	100′ internally	204°
Eclair Cameflex CM3	16/35mm Dual gauge	8–48	Claw	100′, 200′, 400′ magazines	Variable 35–200°
Eclair Camematic	35mm	16–50	Claw	100′, 200′, 400′ magazines	Variable 0–160°
Eclair 16mm Professional	16mm	4–40	Claw and register pin	400′ magazine	Variable 0–180°
Kodak K100	16mm	16–64 and single frame	Claw	100′ internally	165°
Kodak Reflex Special	16mm	8–64	Claw	100′ internally 400′ or 1200′ magazines	45°–170° Variable while film
Mitchell Mk II	35mm	Up to 128 and single frame	Claw and register pin	200′–2000′ magazines	Variable 0–170°
Paillard Bolex H16 Reflex	16mm	8–64 and single frame	Claw	100′ internally	15–180° Variable while film
Pathe PR16-AT	16mm	8–80 and single frame	Claw	100′ internally 400′ magazine	0–180° Variable while film

Lens fitting	Focusing/viewfinding method	Remarks
iflex, triple turret	Mirror reflex shutter	Interchangeable motors for variable or fixed speeds. Forward or reverse drive (not with fixed speed D.C. motor). Tachometer. Accessories for single frame operation.
gle Arriflex	Mirror reflex shutter	Self-blimped camera for filming with live sound. Variable motor avaiable for 10–40 frames/sec. Tachometer.
iflex, triple turret	Mirror reflex shutter	Interchangeable motors for variable or fixed speeds. Tachometer. Accessories for single frame operation.
mount, triple turret	Mirror reflex shutter	Vertically reciprocating mirror shutter (see text). Forward or reverse drive. Built-in semi-automatic TTL exposure meter.
mount, triple turret	Critical focusing with lens out of filming position. Optical viewfinder.	Clockwork drive. Model HR convertible to electric drive and accepts 200' or 400' magazines.
air, triple turret	Mirror reflex shutter	Variable speed or synchronous motors. Tachometer. Accessories for single frame operation. Magazine change possible with camera running.
air	Focusing scale Separate viewfinder	As for Cameflex (but tachometer not standard).
air/'C' mount n turret	Mirror reflex shutter	Variable speed or synchronous motors. Self-blimped for filming with live sound.
mount, triple turret	Focusing scale Separate viewfinder	Clockwork drive. Electric drive available as accessory.
mount, triple turret	Mirror reflex shutter	Variable speed or synchronous motors. Special motor for single frames.
onet, triple turret	Mirror reflex shutter	Interchangeable motors for fixed or variable speeds.
mount (RX lenses) le turret	Reflex via beam-splitter in front of shutter	Clockwork drive. Electric drive available as accessory. Non-reflex model also available.
mount, triple turret	Reflex via beam-splitter in front of shutter	Clockwork drive. Electric drive available as accessory. Semi-automatic exposure meter reading through lens on model BTL.

If a commentary is to be included it should be drafted at the same time as the script and the two compared to ensure that they match reasonably. In particular there must be sufficient film length to cover the commentary associated with each scene or group of scenes. Only in this way can even simple documentary film be reliably produced without the danger of disturbing lack of continuity and, more seriously, inadequate or misleading conveyance of information.

Titling is most effective if simple; a lengthy or complex title is easily misunderstood and division into separate title and sub-title is preferable.

10.1.3 TIME LAPSE CINEMATOGRAPHY. Variation of the apparent speed of motion of the subject can be achieved by filming at a rate different from the projection frequency. Accordingly, to slow down the apparent motion film must be exposed at a higher rate (see Chapter 11) or to speed up motion, a lower exposure rate is used. Considerable speeding up can be obtained by taking pictures at long intervals and this technique, known as time lapse cinematography, can provide a useful record of motions far too slow for normal visual perception.

Some cameras may be run continuously at speeds as low as 2 fps. For lower picture frequencies single shot facilities are necessary, either built into the camera (e.g. Bolex, Beaulieu) or available as additional equipment. Manual operation is practical for short periods but automatic triggering in conjunction with an intervalometer is more commonly used. In some cases the intervalometer can control the exposure duration as well as the framing interval and may also serve to operate a lighting switch.

Rigid camera mounting is necessary and unwanted subject movement (e.g. wind on a plant) should be avoided. Illumination must be consistent and may be difficult to provide. Daylight can be most variable over any appreciable period and the heat from tungsten illumination, unless switched repeatedly on and off, may damage or distort the behaviour of biological subjects. Electronic flash is useful when the frame interval is sufficient to allow recycling.

The time lapse technique is common in the study of plant life and, combined with microscope techniques (see Chapter 5), in the examination of living organisms. Its application to work study and flow visualisation is mentioned in Chapter 15.2.3.

10.1.4 FILMING AND TELEVISION

10.1.4.1 *Films for Television Transmission.* Films specifically intended for television presentation should be exposed at 25 fps, because this (in Britain and Europe) is the television scanning frequency.

Films originally shot at 24 fps are often shown on television and the slight increase in image speed and sound frequency passes unnoticed.

10.1.4.2 *Filming Television Images.* The television picture is produced by an electron beam scanning either 405 or 625 lines at 25 fps. In each 40 msec period the beam spot scans alternate lines in the first 20 msec and intermediate lines in the second 20 msec. The two successive scan patterns or fields are termed the *lace* and the *interlace*.

In order to film the television image a synchronous motor drive is necessary to match the camera speed precisely to the television image scan. Also the camera phase must be adjusted so that the shutter opening coincides with the field scan. This avoids any bar line appearing on the film image.

Suppressed field recording is the simplest method of filming and only one field (lace or interlace) of each frame is recorded. This permits normal camera intermittent mechanisms with a 180° shutter to be used. Full resolution is not obtained because

310

each picture consists of only half the total number of lines, but the results are surprisingly good.

For *full information* telerecording both lace and interlace must be filmed. This requires a camera with an extremely fast film transport, which should not exceed the electron beam fly back time of about 1·4 msec. A fast pull-down mechanism produced by Marconi Co. Ltd. transports 16 mm film at about this rate.[4]

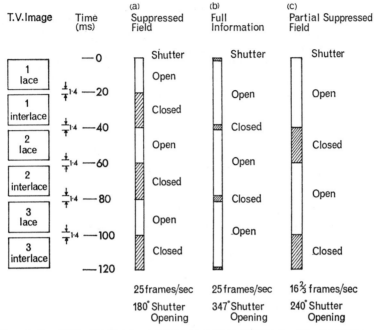

Fig. 10.3. Film recording of 25 fps television image. (a) Suppressed field. (b) Full information. (c) Partial suppressed field.

These and other methods of telerecording, including those applicable to 60 field/sec (USA) television have been reviewed by Palmer.[5, 6]

A useful alternative system, *partial suppressed field*, is employed in the Vinten telerecording camera. This runs at $16\frac{2}{3}$ fps and uses a 240° shutter opening so that each shutter exposure records two successive fields. During the shutter closed period (20 msec) one field is lost, but the total information loss is only $\frac{1}{4}$ and each film image contains the full number of lines. The time resolution is lower because the frame frequency is reduced but, although this makes retransmission by television impractical, normal cine projection (at about 16 fps) is quite satisfactory.

10.2 *Processing*

10.2.1 MANUAL METHODS. Manual methods can be used for short lengths, up to about 100 ft, with various types of frame or drum around which the film is wound for

311

processing in dish or tank. Care must be taken to avoid damage to the film, drying being particularly hazardous owing to shrinkage and tightening of the film on drying and the danger of drying marks. Spiral tanks, similar to those used for miniature rollfilm offer the safest facility, particularly if drying after a wetting agent rinse is carried out in the spiral in one of the special driers available.

Rapid manual processing of small lengths of test film can be useful, e.g. to evaluate exposure, provided the process is simply controlled to give a sensitometric equivalent to the major processing method (see Chapter 1.3).

10.2.2 MACHINE PROCESSING. For film lengths over 100 ft machine processing is necessary and is able to give results of consistently high quality.[1, 3] The machines drive the film continuously through the processing solutions, washing and drying compartments and wind it on to a take-up spool. They are usually permanently laced with unsensitised leader film which is attached as a trailer to the end of each film run processed and becomes a leader for the next processing run.

(a)

(b)

Dark Light

Fig. 10.4. (a) Small continuous processor (Hadland). (b) Large laboratory processing machine (Omac).

The film drive may use either sprocketed rollers or rubber covered friction rollers. The latter have the advantages of being unable to damage film perforations and can

312

also process unperforated film if required, although sprocket drive is more positive and requires less contact with the film surface.

Processing machines generally provide temperature control, recirculation and either manual or automatic replenishment of solutions.

The consequences of film breakage may be serious, several hundred feet of film possibly being spoilt. Great care is therefore taken to ensure that no damaged film, which might subsequently break, is fed into a machine.

Processing is usually controlled to give a low contrast negative (typically $\gamma=0.65$ for average subjects). This is printed onto high contrast print film which is processed to a gamma of about 2·3. Direct reversal film usually provides a gamma of 1·5–1·6.

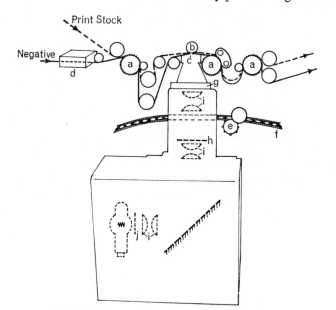

Fig. 10.5. Continuous contact printer (Lawley). (a) Sprocketed drive rollers. (b) Contact roller. (c) Exposing slit. (d) Notch sensing gate for aperture change. (e) Drive for aperture band. (f) Aperture band. (g) Diffuser and filter drawer. (h) Diffuser. (i) Condensers. (j) Heat filter.

10.2.3 CINE FILM PRINTING

10.2.3.1 *Contact Printers*. The majority of cine negative film is contact printed; two main types of printer are in use:

(1) Continuous printers, in which the negative film and the print stock are driven, in contact, over an illuminated slit aperture. The exposing gate usually incorporates a pressure roller or shoe to ensure good contact.

(2) The step or intermittent type of printer, which uses an intermittent mechanism similar to that of a camera and prints each frame individually.

Continuous printers are generally less expensive and complicated than step printers, are often capable of higher output speeds and cause less wear and tear on the negative. Either type is capable of excellent results although impaired resolution is possible owing to slight slippage between negative and print stock on a continuous printer, or uneven gate contact on a step printer.

The exposure is usually controlled by variation of either a grating or an aperture in the illumination system, changes often being triggered automatically by signals on the negative film. Exposure variation may also be possible by means of lamp voltage control (black and white printing only), variable slit on continuous printers, variable sector shutter on step printers, neutral density filters or adjustment of machine speed.

Negative film is graded for exposure by visual or photoelectric assessment before printing and an exposure programme prepared, which controls the exposure for successive scenes as necessary. The signals for these predetermined exposure changes may be either notches on the edge of the negative, or small metal clips inserted between perforations. Alternatively, some printers use a separate control film which is fed simultaneously (at reduced speed) through a separate gate in the machine.

10.2.3.2 *Projection or optical printers.* These are usually of the intermittent type although continuous versions are used, mostly for sound track printing. They are used for special effects such as fades, dissolves etc. as well as for reduction or enlargement of all or part of the frame, or stretch printing of material shot at 16 fps to allow satisfactory projection at 24 fps. Any frame can be held and printed any number of times, or selected (e.g. alternate) frames only printed. Most routine reduction printing, typically 35 mm to 16 mm, is carried out on printers designed for this purpose only.

10.2.3.3 *Sound Printing.* Sound tracks have to be printed continuously. In the production of a normal married sound print both a picture negative and a sound negative are printed on to the same roll of print stock. The two negatives may be printed on different machines at different times, but it is generally quicker to use a machine with both picture and sound heads, capable of handling both negative rolls simultaneously. Such a machine may be continuous on picture and sound, or may combine intermittent picture printing with continuous sound printing, e.g. Debrie Matipo.

Both wound Emulsion in

Winding A Winding B

Fig. 10.6. 16 mm sound film windings.

Sixteen millimetre film for sound use is perforated on one side only and (assuming all film is wound emulsion in) raw stock and sound negatives and prints are supplied in one of two windings, A or B (see Fig. 10.6). This is important because equipment, including cameras, designed for one winding cannot function with the other. Winding B is suitable for most equipment.

10.2.3.4 *Services Provided by Motion Picture Processing Houses.* Apart from routine processing and printing of negative and reversal, black and white and colour film,

314

processing laboratories provide many other services, of which the more important are:

(1) Duplicate negative making, which is a common requirement, serving to preserve an original, possibly irreplaceable negative. The duplicate negative is made from an intermediate (or master) positive. Special master positive and duplicate negative film stocks are used for these purposes, giving gammas of about 1·5 and 0·65 respectively.

(2) Reduction printing, usually the production of 16 mm prints from 35 mm negative, but may also be 8 mm prints from 16 mm or 35 mm negative. When a number of reduction prints are required from the same negative a reduced duplicate negative may be made and contact printed.

(3) Optical printing as summarised on p. 314 and similar optical effects on intermediate positives or duplicate negatives.

(4) The production of optical sound tracks from magnetic tape recordings.

(5) Titling.

(6) Film cutting and editing.

Some laboratories also offer sound recording facilities and an animation service.

10.3 *Editing*

10.3.1 EQUIPMENT. *Editing machines* are essentially a combination of rewind bench, projector, some form of viewing screen and (usually) footage counter. They may be equipped for sound reproduction, and in this case may handle either married sound and picture prints, or alternatively, optical or magnetic sound and picture on separate films.

Such machines usually employ continuous film drive with a rotating optical prism compensator, similar to some high speed cine cameras, and permit forward or backward running at speeds both faster and slower than normal. This system is simpler and causes less film wear than intermittent mechanisms (although these are sometimes used). Simple manually wound editors are also available.

Synchronising units consist of a number of sprocket rollers on a common shaft (or geared to handle 16 mm and 35 mm film), are equipped with footage/frame counters and vertical rewinds capable of handling a number of films simultaneously. Magnetic sound pickups can also be fitted for sound track monitoring.

Film Splicers are available in a wide variety of forms ranging from simple manual types to sophisticated automatic machines. All gelatin coating is removed from the overlapping areas and the film base joined using a suitable film cement. Gentle heating may be applied to promote rapid evaporation of the solvent. Polyester base films cannot be cemented and require either taped splices, in which two film ends are butted together and overlaid with transparent Mylar adhesive tape, or thermal fusion or ultrasonic splicing in special machines.

10.3.2 EDITING PROCEDURES.[7] In many instances scientific film may require no more than simple cutting and joining, e.g. the removal of camera leaders and flash frames which occur between camera sequences, but in the case of documentary presentation (see p. 307), more creative editing in accordance with the script is necessary. The following summary assumes that negative camera film has been used, but is similar with a colour reversal master from which a reversal duplicate is printed.

(a)

(b)

Fig. 10.7. Film editors. (a) Simple manually wound viewer. (b) Motorised model with facilities for separate picture and sound (Acmade).

A print from the negative is obtained for preliminary projection and examination and is used to form an edited 'cutting copy' print. Several successively finer cutting stages may be necessary before the final version is obtained.

Only when the final cutting copy is fully approved and matched to any intended commentary should any editing of the negative be contemplated. The arrangement of the negative in the same length and sequence must now be achieved, with the minimum of handling and exposure to dust or damage. The negative footage numbers are usually printed on to the positive copy and are used to compile a list of all the sequences required so that the negative can be cut consecutively instead of searching back and forth for successive sequences. Clean linen gloves should be worn for

316

negative handling and rapid uninterrupted completion of the cutting and assembly is a great aid to cleanliness.

A and B roll negative cutting is a more sophisticated method which allows optical effects (such as fades, lap dissolves, wipes etc.) to be obtained in printing without the need for a duplicate negative. The principle is shown in Fig. 10.8. The A roll contains the negative of scenes 1, 3, 5, 7 etc. separated by lengths of opaque film corresponding to scenes 2, 4, 6 etc. while the B roll contains the negative of even-numbered scenes separated by opaque film lengths equal to odd-numbered scenes. Synchronisation marks are provided at the ends of each roll and the two are printed either by successive runs on to the same print stock or in special printers which handle the two negative rolls simultaneously. A and B roll **printing can** also avoid the negative splices on 16 mm film being visible on the **screen.**

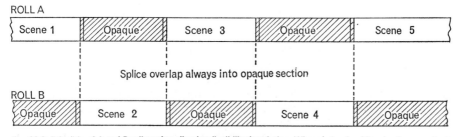

Fig. 10.8. Principle of A and B roll cutting allowing flexibility in printing. Where 'mixes' or 'dissolves' are required scenes must overlap.

10.4 *Projection*

10.4.1 PROJECTORS. The projector, like the cine camera, has an intermittent movement which holds the film stationary while the shutter is open and the image is projected on to the screen. However, to prevent flickering of the image being apparent, the frequency at which the light beam is intercepted by the shutter must be about 48 times a second. For this reason shutters with two or three blades (for 24 fps or 16 fps respectively) are used to double or treble the flicker rate.

Carbon arcs are still used in some 35 mm cinema projectors but are being superseded by xenon discharge lamps. Smaller projectors usually use tungsten illumination. With colour films the difference in colour quality between arcs and tungsten lamps may be quite noticeable and prints should ideally be balanced for the type of projector on which they will be shown.

10.4.2 PROJECTION CONDITIONS. Projection conditions are important to the presentation of any film. Screen brightness must be adequate if the full density range of the print is to be seen and eyestrain avoided, but excessive brightness may cause flicker to be apparent. Screen luminance measurements should be made with the projector running at its normal speed, but without film in the gate.[8, 9] Measurements are usually taken at the centre and four corners of the screen. Screen reflectivity affects the luminance and depends on the type of screen as well as its condition. Beaded and silver screens have high reflectivity over a comparatively narrow angle and a white screen provides an image of somewhat lower brightness over a much wider angle. Although

317

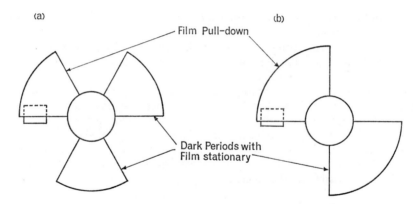

Fig. 10.9. Shutter segments to allow projection flicker frequency of 48 Hz for projection frequency of (a) 16 fps (b) 24 fps.

the room does not have to be in total darkness, no direct light should fall on the screen or shine into the eyes of the audience. Excessive ambient light produces an effect akin to lens flare in a camera, shadow areas being degraded by non-image-forming light.

10.4.3 SOUND FILM PROJECTION. Prints containing both picture and sound track are known as married sound prints. The sound track occupies a standard position along the length of the film so that when a particular frame is in the gate, the corresponding portion of track is passing through the sound head. As the film always passes through the picture gate before reaching the sound head, the sound is printed ahead of the picture (20 frames on 35 mm, 26 frames on 16 mm). Prints should be provided with leaders and trailers for protection, identification, framing and synchronisation purposes.

Standard specifications for leaders and trailers are issued by the Academy of Motion Picture Arts and Sciences (Academy Leader) and by the SMPTE (Society of Motion Picture and Television Engineers). These indicate proper synchronisation when corresponding marks are positioned in the picture gate and sound head.

10.5 *Sound Recording*

Although disc recording, essentially similar to that used in the production of gramophone records, is still used to some extent, the principal sound recording methods used with film are magnetic recording, as used in tape recorders, and optical (or photographic) recording. In either system the original sound is received by a microphone and converted into an electrical signal.

10.5.1 MAGNETIC RECORDING. In magnetic recording,[10, 11] the sound signal is recorded as magnetic variations in a ferromagnetic recording medium (ferric oxide) coated on tape or film. The recording head uses an electromagnetic transducer which also functions for replay and erase purposes. A magnetic stripe may be applied to the original camera material or to subsequent prints either before or after photographic exposure and processing. Pre-striped reversal or negative film may be used in cameras with the facility to record vision and sound simultaneously. Projectors are available which will

318

reproduce either optical or magnetic sound tracks. Magnetic recording has the following advantages:

(1) No processing is required, allowing instant playback.

(2) Economy, because any recording may be erased and the material re-used.

(3) High signal to noise ratio.

(4) High frequency response without distortion.

10.5.2 OPTICAL RECORDING. There are two basic types of optical sound track, variable density and variable area. The *variable density* system relies on the operation of a light valve, comprising one or more pairs of duralumin ribbons vibrating in a magnetic field. The ribbon pair acts as an optical slit which, in the absence of any signal, is virtually closed. The slit opens to a greater or lesser extent depending on the strength of the applied signal, modulating the amount of light reaching the objective and hence the light intensity in the film plane. Thus the processed film track has constant width, with varying transmission along its length. High sound volume gives a track image with high density range.

Variable area sound recording depends on the operation of a mirror galvanometer (Fig. 10.10). An image of the triangular mask is focused on to the slit via the galvanometer mirror and the objective focuses an image of this slit on to the film. Rotation of

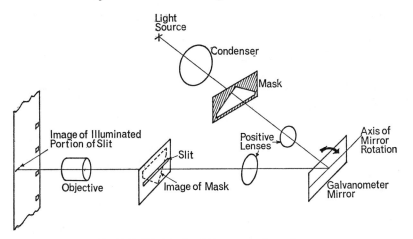

Fig. 10.10. Principle of variable area sound recording.

the mirror causes the mask image to shift in relation to the slit so varying the length of the slit illuminated and the width of the light beam recorded along the film track. The contrast of the track image is always high; sound volume governing the extent of the variation in its width.

Although optimum processing conditions differ for variable area and variable density sound tracks, both types need a standard of process control at least as high as that required for black and white picture negative.

A projection optical sound head consists essentially of an exciter lamp of constant intensity, focused by a cylindrical lens to form a line image across the track, and a photo-electric cell to convert the light variations into electrical changes from amplification and reproduction as sound. Such a system functions equally well with both

319

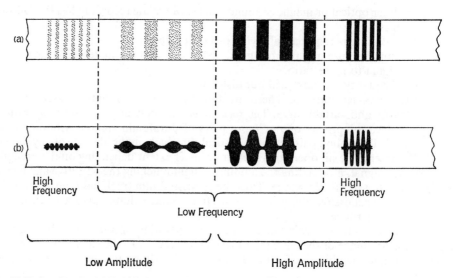

Fig. 10.11. Sound tracks. (a) Variable density—all images full track width. (b) Variable area—all images high contrast.

VA and VD tracks because they both modulate the total light falling on the photo-electric cell (Fig. 10.12).

Although direct optical recording is often less convenient than magnetic recording and the frequency range is more limited, particularly on 16 mm, the presentation of

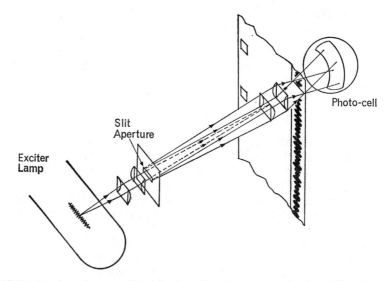

Fig. 10.12. Principle of a projector sound head. Precise configurations vary to suit design of different projectors.

320

the final film (release prints) with an optical track has the advantages of simple production of multiple copies and compatibility with most projection equipment. For these reasons an original magnetic recording is often converted to provide an optical sound track.

References

General

1 WHEELER, L. J., *Principles of cinematography*, 3rd Ed, Fountain Press, London (1963).
2 HAPPÉ, B., *Basic Motion Picture Technology*, Focal Press, London (1971).
3 CORBETT, D. J., *Motion picture and television film*, Focal Press, London (1968).

Specific

4 PEMBERTON, M. E., *JSMPTE*, **68**, 87 (1959).
5 PALMER, A. B., *JSMPTE*, **74**, 1069 (1965).

6 PALMER, A. B., *Visual*, **5**, 4 (1967).
7 WALTER, E., *The technique of the film cutting room*, Focal Press, London (1969).
8 *Screen Luminance for projection of 35mm film*, BS 1404:1961.
9 *Screen luminance for projection of 16mm film*, BS 2954:1958.
10 SPRATT, H. G. M., *Magnetic tape recording*, Temple Press, London (1964).
11 McWILLIAMS, A. A., *Tape recording and reproduction*, Focal Press, London (1964).

11. HIGH SPEED PHOTOGRAPHY

11.1 *Introduction*

Photography is of extreme value in the study of events which occur too rapidly for the eye to follow. These may range from comparatively slow events such as the movements of an athlete, to rapid events such as the detonation of a high explosive.

11.1.1 EXPOSURE DURATION AND SPATIAL RESOLUTION. Image blurring due to subject movement affects the *spatial resolution* (see Chapter 2) of the image and depends on the exposure duration, subject velocity (including direction) and image magnification. If a lens/film combination will resolve 50 lines/mm in the film plane, then at an image magnification of 1/100 the finest resolvable detail in the subject is 2 mm. If the allowable blurring due to image movement is taken as $\frac{1}{4}$ of that due to lens and film limitations then the subject can be allowed to move $\frac{1}{2}$ mm during exposure. Thus for an exposure duration of 5 μsec the maximum permissible object velocity, parallel to the film plane, is $\frac{1}{2} \times \frac{1}{5}$ mm/μsec or 100 metres/sec (about 225 miles per hour).

While this criterion, rendering image movement almost undetectable, would be ideal for still photography a more realistic criterion is related to the size of the smallest detail which it is necessary to record.

The necessary exposure duration (t) is given by:

$$t = \frac{x}{K \, v_s \, \cos\theta} \qquad \text{Eq. 11.1}$$

where x is the size of the smallest detail
v_s is the subject velocity
θ is the angle between direction of motion and film plane
and K is a constant, depending on the quality of resolution necessary. Typical values are 2 or 3.

Thus, if the smallest detail (x) is 3mm and the subject velocity (v_s) is 100 metres/sec (10^5 mm/sec) parallel to the film plane ($\theta = 0°$, $\cos\theta = 1$), then taking K=2, the necessary exposure duration is:

$$t = \frac{3}{2 \times 10^5} = 15 \ \mu\text{sec}$$

11.1.2 TIME RESOLUTION. A sequence of pictures enables an event to be studied at a number of separate moments in time; the frequency at which pictures are taken is a measure of the time (or temporal) resolution.

It is possible to have *too much* time resolution, which results in the normally projected image (16 or 24 fps) showing the motion too slowly to be discernible. For example, a film taken at 10,000 fps of a 1 second event takes more than 6 minutes to project. Although this framing rate may be necessary to study certain high velocity aspects of the event the overall pattern of movement might not be apparent. Analysis of such a record to show overall movement can be carried out by plotting a graph of position against time, taking measurements from (for example) every hundredth frame. As a rough guide, a projection time of about 10 seconds is usually enough to show the overall pattern of a simple event.

In a streak camera record (p. 334) the time resolution is governed by the width of the slit image on the film (W_I) and its velocity relative to the film (V) and is given by:

$$\text{time resolution} = \frac{W_I}{V} \qquad \text{Eq. 11.2}$$

Thus, if the width of the slit image is 0·1 mm and the film travel speed is 20 m/sec then the time resolution is $\frac{0·1}{20,000}$ sec$=5$ μsec. A practical limit to the narrowness of the slit image is imposed by the film resolution.

11.2 Illumination

11.2.1 SHORT DURATION FLASH. The simplest example of high speed photography is the recording of an event by a single short-duration flash exposure. Providing the level of ambient illumination is low enough an ordinary mechanical shutter or an open flash technique is adequate. High speed electronic flash or spark discharges provide adequate illumination but a suitable method of synchronising the discharge with the required stage in the event is necessary. Possible methods include:
(1) Making (or breaking) of an electric contact by a moving part of the subject.
(2) Using a microphone to pick up sound from the event (e.g. impact) and provide an electrical pulse. Fine control can be obtained experimentally by varying the distance of the microphone from the event.
(3) Making or breaking a light beam on to a photo cell or using a self luminous event to provide a signal.
Many variations of these basic methods are possible and ingenuity is often more valuable than elaborate equipment.

11.2.1.1 *Electronic Flash.* Electronic flash units used for routine photography have flash durations of the order of 1 or 2 milliseconds.

The light emission from an electronic flash source is caused by a high voltage discharge between electrodes in an inert gas, usually xenon (although other gases may be used with xenon or alone). The high voltage is attained by charging a capacitor, which is made to hold its charge by ensuring that the voltage is lower than the breakdown voltage of the flashtube. The unit is triggered by a suitable pulse applied to a trigger electrode. This ionizes the gas and makes it conductive so allowing the capacitor to discharge.

Among the factors governing the effective flash duration are:
(1) The length between the electrodes; the longer the tube the higher the impedance and the longer the flash duration.
(2) Cross sectional area of discharge; an increase in cross section shortens flash duration by reducing impedance.
(3) Capacitance of the capacitor.
(4) Voltage.
An approximate guide to $\frac{1}{2}$ peak flash duration is given by:

$$D = \frac{RC}{\sqrt{2}} \qquad \text{Eq. 11.3}$$

where D is the flash duration in μ-seconds, C is the capacitance in μfarads and R is

324

the resistance of the flash tube (when the gas is ionised) in ohms. Typical values of R (which is partly dependent on applied voltage) range from 2 to 10 ohms.

For a single flash system, with flash intervals long enough for heating effects to be ignored, the power of an electronic flash unit is expressed in terms of its discharge energy (E) in joules (watt seconds) thus:

$$E = \frac{CV^2}{2}$$ Eq. 11.4

where C is the capacitance in farads, and V is the voltage on the capacitor. Apart from circuit losses the energy is discharged in the form of both light and heat (about 10 per cent light, 90 per cent heat in a high speed tube) and, because the relative proportions vary, the joule rating of an electronic flash unit is only an approximate guide to its light output.

The tube shape, the gas used and its pressure also affect the light output. The most efficient is a linear shaped tube, but this is unsuitable for many optical systems. The 'U' shape is slightly less efficient in terms of light output, but is more compact for a given discharge length. The compact helix is one of the best optical configurations but according to Aspden,[12] is about 20 per cent less efficient than the straight linear tube, owing to self-absorption as the discharge is opaque to its own radiation. The luminous output increases with gas pressure and with the atomic weight of the gas, being greatest with xenon. However, afterglow also increases with atomic weight, and for this reason argon is sometimes preferred for high speed tubes. The shape of the light pulse is not necessarily the same as the shape of the current pulse (Fig. 11.1).

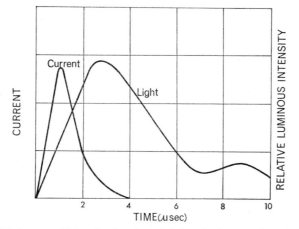

Fig. 11.1. Current and light pulse shape for typical short duration xenon flash discharge.

The trigger pulse may be supplied by a small capacitor, and fired by switch or contacts. It is often necessary to fire by an external pulse. This can be achieved by discharging the trigger capacitor through a thyratron or other valve. Suitable circuitry can then be used to fire by means of a microphone, photo-electric cell, or other external device.

Another triggering system uses a main capacitor voltage in excess of the tube breakdown voltage and is fired by a normally open switch, a mechanical switch, spark gap or a valve (e.g. hydrogen thyratron). This principle is used on high speed stroboscopes.

Several high speed single electronic flash sources are commercially available. Typically the effective flash duration is about 2 μsec, with outputs of 20 to 100 joules. These units require voltages of 7 to 8 kV and capacitors of about 1 to 2 μfarads. This compares with about 1 kV and 200 to 400 μfarads for a typical 200 joule, 1 millisecond 'press' flash outfit. Some units (e.g. Courtenay Microflash) are provided with a variable EHT supply to the capacitor, giving some control over light output. In the Courtenay unit the flash will fire at any setting between 7 and 10 kV, giving an output of from 25 to 50 joules.

11.2.1.2 *Spark Gaps.* The electric spark in air has been used as a high speed light source since the earliest days of photography. Fox-Talbot is credited with being the first worker to use a spark source in 1851.

In its simplest form the spark gap consists of two electrodes, typically about 1 cm apart. A high voltage condenser (about 10 kV), is discharged across the gap as described above, giving a very intense brief spark. The main advantage of the spark source is the ease with which very short flash durations may be obtained; half-peak durations of 0·2 μsec or less are typical. The short flash time is due to the much faster de-ionizations as compared with gas filled discharge tubes.

As with electronic flash discharges short flash duration depends on resistance, capacitance and inductance of the circuit being kept small. However, low capacitance also gives low flash energy ($E = \frac{1}{2}CV^2$, page 325) which means that very high voltages (up to 25 kV) are required for intense discharges of very short duration. Light output can be increased up to six times if the discharge is in a rare gas rather than air.

The light emission from a spark gap usually occurs in three stages:
(1) The initial discharge, giving the characteristic spectrum of the gas used (generally air, but sometimes an inert gas such as argon).
(2) The second stage, a high current arc giving an emission spectrum characteristic of the electrode material.
(3) The afterglow, which is often the longest stage. Although the duration above half-peak may be short (say 0·2 μsec) the total duration including afterglow, may be well in excess of 1 μsec. Because of this the effective stopping power of the flash is improved if the overall exposure level is minimal.

A quenching circuit due to Beams et al,[15] restricts the light output to the initial discharge stage only, using a transmission line instead of the usual condenser in parallel with the spark gap. The line is charged to 20 kV. When the spark is fired, a discharge wave travels from the input to the output end, and is reflected back to the input end thus reducing line potential virtually to zero. The line length chosen is such that zero potential is reached precisely at the end of stage 1. Flash durations of less than 100 nanoseconds may be produced in this way.

Instability of the spark position may be a problem if the source is to be used in an optical system (e.g. a schlieren system, Chapter 15). In some cases the spark is constrained within a tube of insulating material, or between two glass plates. The argon jet is an elegant method of stabilising the spark position. The argon flows through a small hole bored down the length of one electrode and the spark occurs preferentially within the argon jet.

The luminous flux of a spark is proportional to its length and also increases with current intensity. Although too great a length can be undesirable optically, suitable path shaping can minimise this effect and retain a useful increase in luminosity. One method of achieving this is to arrange for the spark to discharge between two electrodes on the outside of an insulation.[13, 14]

A method of increasing spark intensity, due to General Libessart, uses two electrodes E_1 and E_2 (Fig. 11.2), nearly all the space between which is occupied by an insulator with a fine hole drilled through it. Electrode E_2 is ring shaped so as to allow light to be transmitted. The hole in the insulator is aligned between the electrodes, so that the discharge occurs within it producing a very high pressure and current density, resulting in an extremely intense light source.

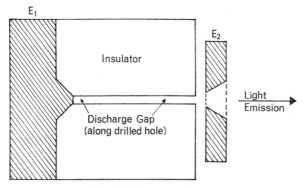

Fig. 11.2. Libessart spark gap.

11.2.1.3 *Multiple Spark systems.* Where a small number of sub μsecond exposures are required at an extremely high repetition rate, a multiple spark gap system may be suitable. Triggering is usually via a multi-channel delay unit and the system can provide either constant or different time intervals throughout a sequence. Alternatively the flashes may be triggered sequentially by the subject (e.g. a projectile) using an acoustic or photo-electric detection system.

An original system by Cranz and Schardin[16, 17] used an eight-channel spark gap unit, in which the light sources were arranged to provide illumination to separate objectives to produce eight separate pictures on a single plate. Subsequent systems have been devised using up to 30 spark gaps. A typical configuration is the *Chronolite, in which the spark spacing is 9 mm on a linear array (Fig. 11.3). The *Flashcascade has the sources arranged behind each other with relay lenses between them (Fig. 11.4), thus eliminating parallax. Another commercially available Cranz-Schardin system is the Lunartron five-fold argon jet spark source; this uses 45° mirrors for four of the sources, and is arranged so that the effective sources are close together.

If different coloured filters are placed over separate, sequentially fired sources, images from these may be recorded superimposed on a single colour film. Inspection of the multicoloured record through equivalent filters shows the separate exposures.

The use of multiple spark systems has been discussed by McVeagh.[18]

*Impulsphysik GmbH.

327

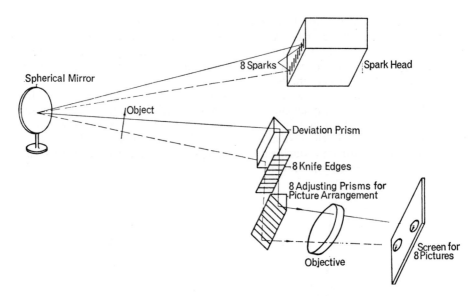

Fig. 11.3. Impulsphysik 'Chronolite' multiple spark system (Aga Standard Ltd.).

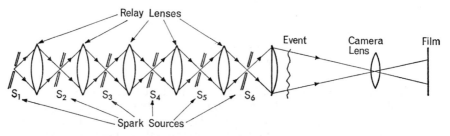
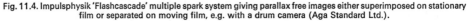

Fig. 11.4. Impulsphysik 'Flashcascade' multiple spark system giving parallax free images either superimposed on stationary film or separated on moving film, e.g. with a drum camera (Aga Standard Ltd.).

11.2.1.4 *Pyrotechnic Light Sources.* Extremely intense illumination of very short duration can be obtained from various pyrotechnic sources.

Pentolite is an explosive chemical mixture which, detonated in an argon atmosphere, can give a flash duration of a few μsec. Other explosives have been used in argon to provide single or multiple flashes with durations as short as 0·4 μsec. Sequences with frame intervals of about 2 μsec are possible using an arrangement similar to the Cranz-Schardin system.[19]

Sultanoff's Argon Flash bomb, consisting of a conical paper reflector with a transparent film across the front and an explosive charge at the apex of the cone, has been used to provide illumination for rotating mirror framing cameras (p. 345) in ballistics research. On detonation a highly luminous shock wave progresses from the apex through the gas filled cone. The duration is approximately 2 μsec per cm of travel through argon and a peak luminous flux of 600 megalumens has been reported (equivalent to more than 150 PF100 flash bulbs (see Table 3.9)).

Bagley[20] has described a source using a flat explosive surface and a thin argon layer with a Lucite window which, on arrival of the shock wave, crazes to become opaque, thus reducing the duration of the illumination to a minimum of about 10 nsec with a peak luminous flux of 80 megalumens.

11.2.1.5 *Electron Stimulated Sources.* Also termed Super Radiant Light (SRL) Sources, this recently developed type of light source is capable of giving extremely short flash durations of very high intensity. The source consists of a semiconducting target (e.g. CdS) which is bombarded with an energetic electron beam of high current density from a suitable electron accelerator. The target emits SRL for only the precise period of electron excitation and pulses as short as 2 nsec, accurately synchronised, are possible. Very small targets (<1mm diameter) allow very sharp shadowgraphs to be obtained and larger sources give sufficient light, even at minimum duration, for photography by reflection. The light output is of a narrow spectral band (~6 nm) but varies with temperature and different target materials. The Febetron accelerators mentioned in Chapter 9 can be used with suitable targets to provide SRL[21] (Plate 16).

11.2.1.6 *Stroboscopes.* These are essentially electronic flash units capable of being triggered repetitively at short intervals. They can usually be controlled either by a variable oscillator included in the unit or by external trigger pulses or contacts. A stroboscope can be applied to still photography in two ways:

(1) A cyclic event (i.e. regularly repetitive, such as the rotation of an engine) can be made to apparently slow down and stop by variation of the flash frequency until it is the same as (or a fraction of) the event frequency. By maintaining this condition, still photographs can be taken of the subject with normal shutter speeds and synchronisation with the desired point in the cycle guaranteed.

(2) A series of successive flashes may be used to illuminate a non-repetitive action so that several images are recorded on a single photograph. This technique requires the subject to have a black background so that the successive images stand out clearly from it. Classic examples widely published are photographs of a golf swing and gymnasts in action.

In cinematography stroboscopes can be synchronised to the shutter opening by providing a suitable contact and used to reduce the effective exposure time for each frame. Shorter exposures than those of mechanical shutters are possible and the light intensity may well be higher than is easily obtained from continuous sources.

With rotating prism cameras (p. 335) the short flash duration, as well as reducing image blur due to subject movement, also restricts the exposure to a short period when the compensating prism faces are normal to the lens axis. This minimises the effect of imperfect compensation and reduces vignetting (exposure variation) at top and bottom of the picture.

Stroboscope tubes (which are not necessarily different from other flash tubes) are classified in terms of capacitor energy and flash frequency:

$$W = En \qquad\qquad\qquad \text{Eq. 11.5}$$

where W is the power in Watts, E is the capacitor energy in joules and n is the flash frequency per second. This shows that a particular tube should be fired at proportionately lower energy with higher flash frequencies.

Much of the input energy is dissipated as heat and any tube flashed rapidly enough at a sufficiently high loading will in time fail owing to overheating.

TABLE 11.1

STROBOSCOPE SPECIFICATIONS

Model	Frequency range (flashes/sec)	Joules per flash	Flash duration (½ peak)	Maximum No. of flashes per operation	Notes
Dawe Microstrobe	0–60	⅛ to 2 (variable)	~10μsec	Continuous	Designed for use in microscope lamp housing
Dawe Cinestrobe 1240A	5–48	2 (up to 25 per sec) 1 (up to 48 per sec)	10μsec 6μsec	Continuous 1000	Suitable for multiple exposure 'stills' or synchronisation with intermittent cine camera
Dawe Strobosun 1203 B	5–250	2·4–0·17 (depending on frequency)	5–10μsec	Continuous	
Turner HSS/60/E	10–250	60 (up to 25 per sec) 10 (up to 75 per sec) 0·4 (up to 250 per sec)	20μsec 8μsec	100 750 Continuous	
Turner HSS/4/G	200–8000	4 (up to 4000 per sec) 2 (up to 8000 per sec)	3μsec 2μsec	1000 2000	Special version
	200–20,000	1	2μsec	1000	
Turner HSS/16/B	200–4000	16	—	—	Output to be divided between several lamps. Specification variable to suit requirements.
Turner Repetitive Spark source	100–10,000	1·25	0·4μsec	100	Can be used with HSS/16/B or HSS/4/G.
Impulsphysik Strobokin	1–100,000 (300,000 with auxiliary 'cascade' unit)	1–10	about 1μsec	400 at 20,000 fl/sec	Provision for alternative gas at variable pressure in spark gap, to adjust spark properties.
Strobokin with 'Nanolite'	1–50,000	0·1	18 nsec	500	

Synchronisation of stroboscopes with high speed cameras may be achieved by use of either a magnetic reluctance pick-up mounted close to the drive sprocket teeth or a lamp illuminating a photoelectric cell through a rotating sector disc. Both methods give a pulse which may need amplification and shaping to make it acceptable.

The Impulsphysik Strobokin lamp and its associated equipment is the highest powered of currently available apparatus.[22, 23] It is a high pressure gas filled spark gap, controlled by a second, quenching spark gap. Unique features include the ability to vary the characteristics of the light source by the choice of different gases and gas mixtures, such as argon, krypton, hydrogen, xenon etc. Spark gap length is adjustable and gas pressure variable up to 3 atmospheres. Maximum energy per flash is 10 joules and flash duration is 1 μsecond. Another unit operable from the Strobokin control is the Nanolite which has a flash duration of 18 nanoseconds.[24]

11.2.2 CONTINUOUS ILLUMINATION. Except with self-luminous subjects, and those techniques where the duration of a pulsed light source is the effective exposure time, some form of continuous lighting must be provided. Even with highly self-luminous events it may sometimes be necessary to swamp the self-luminosity with an external source in order to make visible textural detail on the luminous surface. Laser illumination has been used for this purpose[25] (see Chapter 3.7.8.5).

11.2.2.1 *Methods.* The fundamental principles of modelling, fill-in and background illumination are applicable to high speed work but a higher overall level of illumination is required. This may be difficult to achieve and attention must be devoted to the efficient use of illumination to record the information required. Shadowgraph or silhouette lighting, achieved either by a condenser lens or a translucent or reflecting white screen behind the subject is effective for many subjects where position and shape rather than surface detail are required. Direct specular reflections from metallic surfaces are often useful but require care in analysis—they may not remain stationary throughout the event.

Judicious choice of background, reflectors, and painting of important items white, can all help to improve the final result and make interpretation easier. Scotchlite reflecting material, the reflectivity of which is over 200 times that of a white painted surface,[26] can be attached to important components.

In all instances, illumination is made easier by restricting the area photographed to a minimum. The use of rigidly mounted 'pointers' on moving components can assist in concentrating information into a smaller area (Fig. 11.5). This also allows a larger scale image to be recorded, making more accurate analysis possible.

There are exposure meters available for high speed cinematography which measure either incident or reflected light. However, these are difficult to use with very small subjects and are of only limited value. The most useful instruments are spot photometers with a measuring angle of less than 1°. A formula relating exposure to subject illumination is given on p. 122.

Although such formulae are useful as a rough guide, any calculation (whether by meter or formula) either overlooks or makes an arbitrary correction for reciprocity failure (see Chapter 1). This factor is relevant with extremely short exposures and different films may not be affected to the same degree. Increased development to offset the lower contrast associated with high intensity failure is often necessary.

11.2.2.2 *Light Sources.* Tungsten illumination of sufficient intensity can be used for most work at exposure times down to 10 μseconds.[27, 28, 29] It is important to make

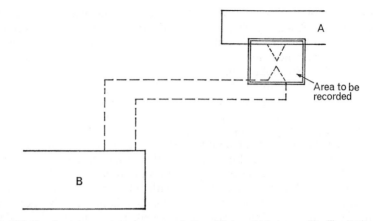

Fig. 11.5. Use of pointers on moving components, A and B, to restrict area requiring illumination and permitting larger image scale.

maximum use of the light by concentrating it only on to the area being photographed and simple condensers are useful for this purpose. Low voltage microscope lamps are efficient for small areas and General Electric PAR 64 Narrow Spot reflector lamps can be overrun to provide very intense illumination over an area several inches wide. Lamp life is improved and heating of the subject reduced by restricting lamp voltage except for the actual camera run. The possibility of heat damage to some subjects is very real and glass or waterbath heat filters may be desirable.

High intensity discharge lamps can be overrun to give output pulses of a few seconds duration. The Mole-Richardson Cine Flash used a mercury/cadmium discharge to give an illumination of more than 1,000,000 cd/m² over a 10 in diameter. More recently xenon discharge lamps have been more popular giving almost as much light with a continuous spectrum.

Expendable flash bulbs should not be ignored, being compact, readily available, convenient and having small power requirements. The peak output of a PF 60 is 2·8 megalumens (equivalent to about 100 kW of tungsten illumination) with a half-peak duration of 20 milliseconds, so that a series of 10 PF 60s fired sequentially would give this illumination for 0·2 seconds; more than enough for many high speed events. Sylvania FF33 flash bulbs are suitable for use with rotating prism cameras having a useful duration of about 1·6 sec. Flashpowder is worth consideration for illuminating large areas.

For use with rotating mirror or image tube cameras, where the total recording time is less than 1 msec, electronic flash or even spark discharges are generally suitable.

11.3 *Shutters*

11.3.1 ELECTRO-OPTICAL SHUTTERS. The fastest mechanical shutters available for still photography have minimum exposure times of the order of 1 msec. This is clearly inadequate for recording many events, so that for high speed photography of self luminous events, with which flash sources are ineffective, some other form of

rapid shuttering is required. This may be achieved by the pulsed operation of an image tube (p. 347) or by a shutter based on either the Faraday magneto-optical effect or the Kerr effect.

The *Faraday shutter*[30] makes use of the fact that polarised light passing through a glass block has its plane of polarisation rotated if the block is in a strong magnetic field. In a typical Faraday shutter the block is mounted in a magnetic coil and between two crossed polarisers. When a high voltage pulse is applied to the coil, a magnetic field is created and the plane of polarisation of the light beam is rotated, so that it is transmitted by the second polariser. The exposure time is therefore approximately equal to the pulse duration, but is limited by switching difficulties to durations of 1 μsec or more. There is a considerable light loss within the glass block which, together

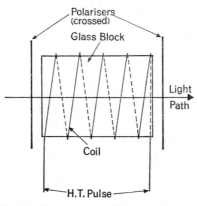

Fig. 11.6. Schematic layout of Faraday cell shutter.

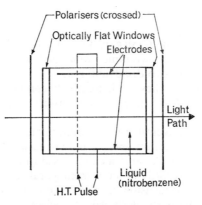

Fig. 11.7. Schematic layout of Kerr cell shutter.

with the absorption of the polarisers, makes the open transmission quite low (perhaps 10 per cent). Also the physical aperture possible is smaller than that obtainable with Kerr cells.

The *Kerr cell shutter* uses a liquid that becomes birefringent when a high potential is applied across two electrodes placed in the cell. The cell is located between two

333

crossed polarisers, so that normally virtually no light is transmitted. When a high voltage pulse is applied to the cell, the plane of polarisation is rotated and light is transmitted.

The Kerr cell efficiency is relatively low, because when open its transmission is rarely better than 15 per cent, and when closed it still transmits a small amount of light. This is generally quite low (typically 0·002 per cent of the open transmission), but may necessitate an auxiliary mechanical shutter. The Kerr cell is also spectrally selective, the nitro-benzene normally used in the cell having high absorption of wavelengths shorter than 450 nm. However, exposure times in the nanosecond range are possible.

Kerr cells have been used in multi-channel framing cameras consisting of a number of single Kerr cell cameras in a common housing. The total number of frames is limited and the method is not very suitable for laboratory work owing to parallax difficulties. This system has, however, the advantage of virtually unlimited choice of framing rate and the framing interval need not be constant throughout a sequence. The method has been used extensively for recording the early stages of nuclear explosions.[31, 32, 33]

11.3.2 CAPPING SHUTTERS. These are often necessary with rotating mirror cameras (p. 347) to prevent rewrite on subsequent mirror cycles. One type, the shatter shutter, comprises a normally transparent glass disc held between clear plastic sheets. The disc is shattered and made opaque by the shock from a detonator and the response time is of the order of 10 μsec. This is reproducible to 1 μsec so that with suitable electronic circuits the operation can be precisely timed. Another variety uses an exploding wire to deposit a black metallic layer on the inside of an optical chamber. The chamber has two parallel glass plates, which are made opaque in about 40 μsec. This system has the advantage that the shutter is re-usable. A similar device uses a special carbonaceous powder which is explosively injected into the chamber.

11.4 *High Speed Cameras*

11.4.1 FRAMING AND STREAK CAMERAS. For the recording of high speed events, framing cameras which produce two-dimensional pictures of an event are not always necessary or desirable having two disadvantages:

(1) For higher framing rates they are increasingly complex and expensive.
(2) There is usually some finite time interval between frames, during which there is no record of the event.

In some applications a conventional, two dimensional record is unnecessary; the main action may be in one direction only, or only one aspect of an event may need to be studied. In such cases a streak camera can be used to provide a continuous record (sometimes called a *smear* record) of movement parallel to the slit only, the result therefore shows time as one dimension, leaving one dimension only for motion. Streak and framing records can be particularly valuable when used in conjunction with one another, since the two techniques give complementary information. The principle of the streak camera is shown in Fig. 11.8. The image is focused into the slit, which is close to or imaged on, the film plane. The film may be driven rapidly past the slit, or alternatively, the slit image is arranged to traverse the length of the (stationary) film.

Most of the high speed camera systems described below have different versions using framing and streak principles.

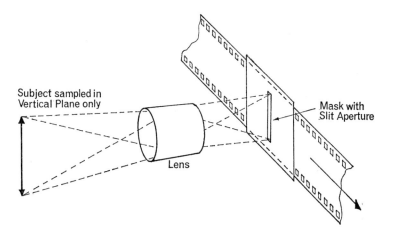

Fig. 11.8. Simple streak camera using moving film. Alternatively the slit image can be swept optically across stationary film (see fig. 11.16.).

11.4.2 INTERMITTENT MOTION CAMERAS. The slowest class of high speed cine camera is a framing system only and uses an intermittent film transport mechanism. This is basically the same as that used in normal speed cine cameras and has the advantage that the film is stationary during exposure. Some 35 mm cameras of this type can achieve framing rates of about 300 fps; 600 fps for 16 mm versions. While it is possible to build intermittent movements capable of running at higher speeds, the film is unable to withstand the high forces imposed upon it during acceleration and deceleration.[34]

A rotating sector shutter is almost invariably used with this type of camera and the maximum sector angle is usually about 170°, giving a maximum exposure duration of slightly less than $\frac{1}{2}$ the reciprocal of the framing rate. However, a variable sector or interchangeable fixed sectors are provided to give much shorter exposure times, down to less than 100 μsec. Still shorter exposure times are obtainable by synchronising the camera with a high speed stroboscope. Details of typical high speed intermittent cameras are given in Table 2.

11.4.3 CONTINUOUS FILM MOVEMENT CAMERAS. This method gives, simply, a streak camera as described above, but the principle of continuous film movement can also be used to give framing rates higher than those possible with intermittent cameras. In addition to blurring caused by subject movement, with a continuous feed camera blurring due to film movement during exposure must be minimised. This is achieved by optical compensation in which image movement in synchronism with the film movement is introduced by an optical element. Although such compensation is never perfect and resolution as good as that of an intermittent camera is not possible, modern systems are capable of resolving more than 50 lines/mm on 16 mm film.

11.4.3.1 Rotating Prism Cameras. Although optical compensation can be achieved in several ways the rotating prism is the only method currently in widespread use. Cameras available allow up to about 10,000 fps (standard 16 mm frames) and may be considered the work-horses of high speed cinematography. The simplest system uses two sides of a rectangular glass block or prism, which is mounted in a cylindrical

335

TABLE 11.2

INTERMITTENT HIGH SPEED CAMERAS

Model	Film size	Speed range (fps)	Film transport	Capacity
Eclair G.V.16	16mm	50–200	Claw and register pin	100′ magazine
Locam 164–5*	16mm	16–500	Claw and twin register pins	400′ internally
Milliken DBM55*	16mm	2–500	Claw and register pin	400′ internally 1,200′ magazine
Mitchell Monitor HS-16E4*	16mm	6–600	Claw and twin register pins	400′ internally 1,200′ magazine
Photo-Sonics 35mm-4E	35mm	24–360	Multiple claw and register pins	400′, 1000′ magaz
Telford 'N' series	16mm	50, 100, 150	Claw	50, 100, 200, 400′ (magazines)
Vinten HS300	35mm	40–275	Claw and register pin	400′ magazine
Vinten RC250	16mm	50–250	Claw	50, 100 or 200′ (magazines)

*Other models available with lower maximum speed and/or smaller capacity.

double aperture shutter (Fig. 11.9). The camera lens focuses the image through the block on to the film as it passes over a driven sprocket. The shutter and prism assembly is geared to the film drive sprocket and rotates in the opposite direction to the sprocket. The rotational speed, optical block thickness and refractive index are chosen so that the image and film velocities are substantially equal. The principle was first used for high speed cameras by Tuttle[35] in 1932 and has been used in editing equipment for many years. It has survived while other methods (p. 343) have fallen into disuse primarily for two reasons:

(1) Comparative simplicity—giving reliability and cheapness.
(2) Ease of lens interchangeability and use of extension tubes for very close range work—giving versatility.

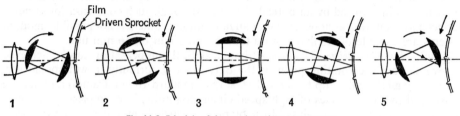

Fig. 11.9. Principle of the rotating prism compensator.

Shutter opening	Lens fitting	Focusing method	Remarks
riable 10–180°	'C' mount	Focusing scale on on lens	Interchangeable motors for 8–50 frames/sec and single frames.
erchangeable 5–180°	'C' mount	Reflex boresight	Continuously variable speed setting ± 1%.
erchangeable 7½–160°	'C' mount	Reflex boresight	Continuously variable speed setting ± 1%.
riable 6–120°	'C' mount	Reflex boresight (continuous reflex available at extra cost)	Continuously variable speed setting ± 1%.
riable –120°	Photo-Sonics	Reflex boresight	Vacuum back to hold film steady during exposure.
erchangeable , 54, 72, 144, 160°	'C' mount	Scale or boresight	Governed speed motor. Low speed motor for 8, 16, 24 frames/sec.
riable 10–170°	Special plates with matched lens pairs	Ground glass image of viewing lens	Tachometer fitted. Low speed motor for 40–140 frames/sec.
riable 30–110°	'C' mount	Scale or boresight	Speed indicator on separate control unit.

A four-sided prism can be used with only half the rotational speed of a two sided one and will also give a full frame image. Eight and sixteen sided blocks allow proportionally faster framing rates with the same film drive speed, but at the expense of frame height (Fig. 11.10).

Most cameras of this type are powered through a variable transformer: the running speed depends on the voltage applied to the motor(s) and varies throughout any camera run. The entire film length (100 or 400 ft) is usually exposed in one run although some cameras may be stop-start operated at low speeds. Operating speed curves (Fig. 11.11) are supplied to enable framing rates to be estimated before running but accurate assessment is only possible by the recording of controlled flashing timing lamps on the film edge (p. 342). At high speeds the film drive has a tendency to snatch and break the film. This is overcome by restricting the initial motor voltage or by using an automatic clutch to reduce the initial load on the film. In any case it is important to avoid any slackness in the film before starting the camera.

A microswitch is usually fitted to interrupt the power to the motor when all the film has been exposed, or in the event of film breakage.

Visual focusing of the image in the film plane is usually possible, before loading of film, by direct or reflex optical viewing.

11.4.3.2 *Features of Fastax and Hycam cameras.* There are some 30 different models of the *Fastax* camera including streak versions with no optical compensation at all Two ¼ h.p. motors drive the film sprocket (and compensator assembly) and take-up spool respectively.

Fig. 11.10. Normal, half and quarter height 16 mm frames.

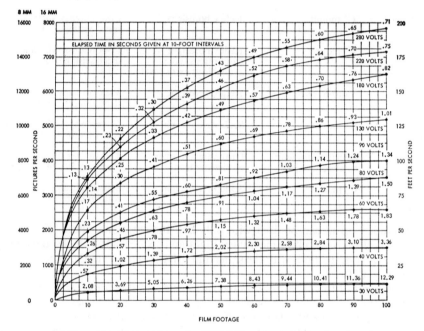

Fig. 11.11. Operating speed curve for 100 ft Fastax camera, showing time elapsed.

Exposure time per frame can be reduced by the use of narrow slits, but owing to their fixed position between the compensating prism and film plane, the height of the image recorded is also reduced (by up to one third) due to vignetting at top and bottom.

Some models have an additional streak or oscilloscope recording facility in the form of a separate lens mounted in the side door of the camera. This lens projects an image, reflected by a fixed 45° prism, on to the continuously moving film at the top of the drive sprocket. If the oscilloscope time sweep is not used, so that the spot moves only parallel to the y-axis this movement is recorded across the width of the film, the film travel providing the time component of the record (see also p. 357). In this way a relevant oscilloscope trace can be superimposed on the 'framed' image of an event but the oscilloscope record is five frames behind the corresponding subject image as the film passes the recording channel before reaching the picture gate.

338

The *Hycam* cameras are of a more unusual configuration (Fig. 11.13). Using a relay optical system, the film drive sprocket and rotating prism are mounted on a common shaft. The prism shaft also carries a segmented rotating shutter, which is interchangeable to allow different exposure times per frame and does not produce image vignetting as do fixed slits in other cameras.

The optical head assembly is separate from the body and film transport unit and can be easily interchanged. The 400 ft camera has an electronic speed control system which operates up to 5000 fps and enables a steady speed to be maintained once the desired level is reached.

On starting, the drive is applied via a centrifugal fluid clutch to reduce initial load on the film to a safe level. For oscilloscope recording the viewing eyepiece is removed and replaced with an accessory lens. The oscilloscope image is focused on to the back of the film, so that it is coincident with the relevant picture. Details of these and other designs are in Table 11.3 and have been given by Fatora.[35]

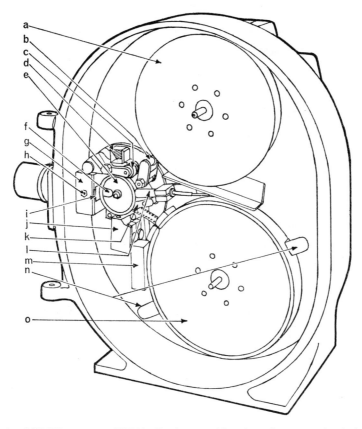

Fig. 11.12. Interior of 400 ft Fastax camera (WF14S with reluctance pick-up for stroboscope synchronisation). (a) Feed spool. (b) Buffer roller. (c) Film hold-down roller. (d) Oscilloscope viewing prism. (e) Film drive sprocket. (f) Viewfinder prism. (g) Housing for rotating prism. (h) Rotating prism shaft. (i) Aperture mask. (j) Timing light housing. (k) Film stripper. (l) Magnetic reluctance pick-up. (m) Cut-off microswitch. (n) Spool ejectors. (o) Take-up spool.

339

TABLE 11.3
ROTATING PRISM HIGH SPEED CAMERAS

Model	Speed range (fps)	Image height	Prism faces	Capacity	Lens fittin
Eclair UR3000 (35mm)	500–3000	18mm	6 ⎫	1000'	Eclair bayone
	1000–6000	9mm	12 ⎭		
Fastax 16mm (various models)	150– 9,000†	7·5mm	*2 or 4	100' or 400'	Fastax bayor
	300–18,000	3·6mm	8	100' or 400'	Fastax bayor
Fastax 35mm	100–6000	9mm	4	100'	Fastax bayor
Hitachi Himac HD	100–8000	7·5mm	4 ⎫	100' or 400' magazines	'C' mount
	200–16,000	3·6mm	8		
	400–32,000	1·7mm	16 ⎭		
Himac HS	20–5000	7·5mm	4 ⎫	100'	Nikon
	40–10,000	3·6mm	8 ⎭		
Hycam	10–11,000†	7·5mm	4 ⎫	100' or 400' or 2000'	'C' mount
	20–22,000	3·6mm	8		
	40–44,000	1·7mm	16 ⎭		
Photo-Kinetics Nova	10–10,000†	7·5mm	4 ⎫	100' or (400'–1200' magazines)	Nova bayone
	20–20,000	3·6mm	8		
	40–40,000	1·7mm	16 ⎭		
Photo Sonics 1B	200–1,000	7·5mm	2	100'–1200' (magazines)	Special plate
Stalex MS-16A	50–3000	7·5mm	2	100'	Fastax bayor

Exposure duration ($\times 1/fps$)				
sic	Minimum (method)	Event trigger	Facility for Oscilloscope trace record	Remarks (Fps figures refer to full frame)
(max)	1/00 (interchangeable rotating sector)	From control unit	—	Stop-start operation Speed control $\pm 2\%$
(max)	1/00 (interchangeable rotating sector)			2000' magazines available.
or 1/3	1/100 (fixed slit) ⎫ 1/50 (fixed slit) ⎬ ⎭	'Goose' control timer	Models WF14, 15, 17, 21 5 frames nearer start than corresponding picture	*Models denoted 'T' †8000 on 100' cameras Stop-start facility on models denoted 'S'. DC supply for speeds below 500 fps.
	1/125 (fixed slit)	'Goose' control timer	—	Model WFS
	⎧ 1/80 (interchangeable rotating sector) 1/80 (interchangeable rotating sector) 1/40 (interchangeable rotating sector) ⎩	Built-in at selected film footage	Simultaneously on emulsion side on same frame as picture	‡Normally supplied but sector ⅓ is available. Stop-start operation possible under 3000 fps. Prism assemblies interchangeable.
	⎰ 1/60 (fixed slit) 1/30 (fixed slit) ⎱	Built-in at selected film footage	Simultaneously on emulsion side on same frame as picture	DC supply and/or geared reduction unit for rates below 500 fps. Speed controller available for 200–3000 fps. ($\pm 1\%$). Brake unit available for stop-start operation at under 2000 fps. Prism assemblies interchangeable.
	⎧ 1/100 (interchangeable rotating sectors) 1/50 (interchangeable rotating sectors) 1/25 (interchangeable rotating sectors) ⎩	Built-in at selected film footage	Simultaneously on back of film on same frame as picture	†9000 on 100' camera body. Electronic speed control up to 5000 fps. Optical units interchangeable on 100', 400' and 2000' bodies. Prism assemblies also interchangeable.
	⎧ 1/100 (fixed slit) 1/50 (fixed slit) 1/25 (fixed slit) ⎩	Separate timing control	—	†8500 on 100' film. Interchangeable prism assemblies Speed control on magazines up to 5000 fps on 400' up to 3000 fps on 1200'.
	1/40 (interchangeable rotating sectors)		—	Stop-start operation. Other models giving up to 4000 fps, 16mm and 3250 fps, 35mm.
	—	Built-in at selected film footage.	—	Stop-start operation up to 1000 fps

341

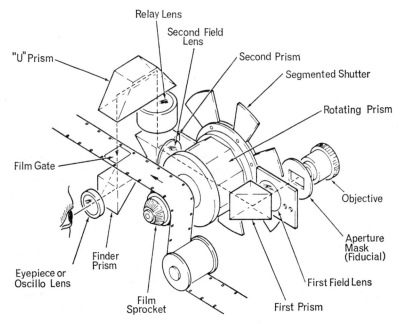

Fig. 11.13. Optical system of Hycam camera.

11.4.3.3 *Event Synchronisation.* In a typical case a 100 ft capacity camera running up to a maximum speed of 3500 fps, has a total running time of about 1·5 seconds. As the camera takes about 1 second to reach 3000 fps, the useful running time above this speed is 0·5 second. If the event lasts 0·1 second, synchronisation has to be accurate within ±0·2 second and, with care and experience, manual firing is feasible. However, many events require far more precise timing and some form of automatic synchronisation is essential. Synchronisation may be based on either elapsed time or film footage passed through the camera (see Table 11.3).

The Wollensak Goose control unit for Fastax cameras incorporates two adjustable external time-switches, one each for camera and event, which allow camera and event triggering in any order. Using speed curves showing time elapsed (a series of curves is prepared to cover a range of voltage settings), suitable timing can be pre-set, e.g. to allow the camera to reach the desired speed before triggering the event.

11.4.3.4 *Time Bases.* Although some cameras can be operated at lower speeds with electronic speed control devices, which are claimed to have 1 per cent accuracy, and other methods for stabilising camera speed have been described,[37] some form of time marker is usually necessary for accurate measurements.

The simplest and most common method is to incorporate a small neon lamp, with an optical system to focus its image on to the edge of the film. Such a lamp, if operated from AC mains (50 Hz in Britain), gives one flash for each half of the AC cycle (Fig. 11.14) i.e. 100 flashes per second. It is a good practice to measure on the film the distance between alternate timing marks, i.e. to measure the full AC cycle, as the two electrodes of a neon lamp may not fire at identical voltages, and therefore two successive 'half-cycles' may be of unequal length.

342

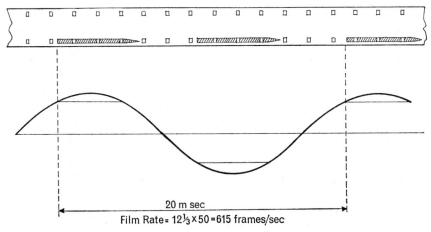

20 m sec

Film Rate = 12⅓ × 50 = 615 frames/sec

Fig. 11.14. Timing marks provided by a 50 Hz AC supply.

This simple system although adequate for many purposes, especially at the lower framing rates, has disadvantages due to restricted intensity of the lamp and uncertainty of locating the start or end of its image at high filming rates.

Modern neon lamps are brighter and have a sharper rise and cut-off than earlier ones but at high framing rates the speed measured is inevitably a mean value over a hundred or so frames (160 at 8000 fps.) An improvement is possible by feeding the neon lamp with a series of sharp pulses, typically at frequencies of 1000 Hz.

Where several cameras are operated at large distances from each other it is a common practice to transmit radio pulses to operate the camera timing lights.

Most cameras have two separate timing lights and it may be useful to use the second to display some action of the event. For example, a pulse may be provided at a certain stage in each cycle of a reciprocating machine or may indicate the electrical triggering of an event so that the operational delay may be measured (e.g. that of a solenoid).

For extreme timing accuracy the neon lamp may be replaced by a spark gap. A typical unit is the RARDE spark timer, which produces 1 μsec sparks at 1000 Hz. The repetition rate is controlled by a crystal oscillator and an accuracy of 1 in 10^6 is claimed. The spark duration is so short that exposure is not significantly affected by film velocity, and it is so intense that it will record on the slowest films likely to be used. Electroluminescent diodes are also used for this purpose (see p. 141).

11.4.3.5 *Other Compensating Systems.* Other methods of optical compensation which have been employed use either:

(1) A series of matched lenses on a rotating drum or disc.
(2) Rotating polygonal mirrors, the mirror surfaces being on either the outer surface of a solid block or inner surface of a hollow drum.

Of these, the 35 mm Pentazet is the most recent and uses a 30 faceted hollow mirror drum to give 2000 fps (18 × 22 mm). Interchangeable drums and image-dividing prisms are available giving up to 40,000 fps (4·5 × 4 mm).

11.4.3.6 *Cameras with Rapid Acceleration.* When recording events which cannot be precisely triggered, difficulty is encountered because of the time taken for a normal

343

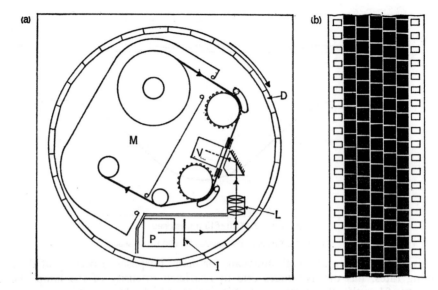

Fig. 11.15. (a) Layout of Pentazet 35 mm camera. (I) plane of primary image formed via prism (P) by externally mounted lens; (field lenses used in this position are omitted to avoid confusion). (L) Fixed relay lens. (D) Rotating mirror drum. (V) Prism for external viewfinder. (M) Film magazine. (b) Arrangement of frames to obtain 40,000 fps.

continuous feed camera to accelerate from rest. Consequently, the Eichner and Acceloloop[38] cameras use a loop or festoon of film, which has low inertia compared with film on a spool. The film passes between two rollers continuously driven at speed. Normally the rollers are not in contact with the film, which is therefore stationary. When the camera is fired, by a signal from the event, the rollers are rapidly clamped together and the film reaches top speed almost instantaneously. These are basically streak cameras but are suitable for use with high speed stroboscopes to give a framed record.

11.4.4 DRUM CAMERAS. The framing rates of about 40,000 fps achieved with some continuous film drive cine cameras entails a reduction of image height, and therefore of the information which can be included on a single frame. The limiting factor is the rate at which film can be driven through the camera. With present day cameras and films the maximum is about 250–300 ft/sec.

When still higher framing rates are required, the film may be located on or in a cylindrical drum, which is rotated at high speed. Since the drum diameter is necessarily limited, the total number of frames rarely exceeds a few hundred, compared with 4000 on a 100 ft length of 16 mm film.

When film is located on the periphery of a rotating drum, the film velocity $V = \dfrac{\pi DS}{60}$ feet/second where D is the diameter of the circle occupied by the film (in feet) and S is the rotational speed of the drum in rpm. Where the highest speeds are required, the film is best located on the inner surface of the drum, so that centrifugal force helps to keep it in place. Higher speeds and a greater number of frames can be obtained by increasing the drum diameter, but practical considerations limit the gain to be achieved in this way. For example, the Suhara camera of 1929 (60,000 fps, drum

344

diameter 67 in.) needed a 100 hp motor to drive it and weighed over a ton! Film capacity can be increased by winding the film in a helical fashion, so that a number of turns can be accommodated, but the lateral movement then required makes the camera more complex.

A great advantage of the drum type of camera is that it can accelerate relatively slowly. When at its operational speed, a shutter, synchronised with the event, is opened for one revolution only and/or a stroboscopic light source is triggered.

The simplest drum cameras do not employ optical compensation at all, and are intended for use with high repetition rate short duration flash sources, and as streak cameras (see p. 334).

A current commercial camera of this type is the Frungel Strobodrum in which the film is mounted on the outside of a 19 in. diameter drum, which rotates at speeds from 200 to 300 rpm, giving film velocities up to 244 ft/sec (0·075 mm/μsec).

The fastest recent rotating drum cameras are those developed by Uyemura.[39] One example, the M2 achieves a film velocity of 1720 ft/sec (0·53 mm/μsec); the drum diameter is 470 mm and a framing rate of 70,000 fps obtained. The drum speed of about 360 rps closely approaches the bursting speed and therefore the limit for this type of camera. Optical compensation is achieved by a multi-faced polygonal mirror mounted on the same shaft as the drum.

The framing rate may be increased for a given film velocity by frame division i.e. forming a larger number of smaller images as in the case of $\frac{1}{2}$ and $\frac{1}{4}$ height continuous feed cameras. The maximum spatial resolution of the subject is reduced, but the time resolution improved. Many frame division optical systems have been proposed for drum cameras, typically extra secondary optical systems, or more channels from one system are used. For example the Uyemura M3 cameras use a 180-faced polygonal prism giving full 16 mm frames. Substitution of a 360-faced prism gives 360 half-height frames and use of twin secondary optical systems yields 720 pictures of normal 8 mm frame size* at 4 times the framing rate of the original camera (3×10^5 fps).

Drum cameras usually require a mechanical capping shutter to restrict the exposure to one revolution.

11.4.5 ROTATING MIRROR CAMERAS. The use of a rotating mirror to achieve rapid movement relies on the optical lever effect by which relatively small angular movement of the mirror can give a large image movement. In the streak version (Fig. 11.16) the event is imaged in the slit which in turn is imaged by a secondary lens via the mirror on to the curved film track. With the mirror rotating, the slit image is swept across the film and image travel speeds (or writing speeds) up to about 40 mm/μsec are possible.

Framing cameras[40, 41] of this type (Fig. 11.17) have an image of the event formed in a plane on the rotational axis of the mirror, either directly or via relay lenses. A number of framing lenses are arranged in an arc with its centre of curvature on the axis of rotation of the mirror. As the mirror rotates, the image is reflected to each framing lens in turn, which refocuses it on to the stationary film. The total number of frames is equal to the number of framing lenses.

For any given array of framing lenses, the framing rate is governed by the speed of mirror rotation. There is, for any mirror, a maximum rotational speed above which it will burst owing to centrifugal force and which depends on the mirror size, the

*These are not positioned on the film in a way which allows projection in a conventional 8 mm cine projector.

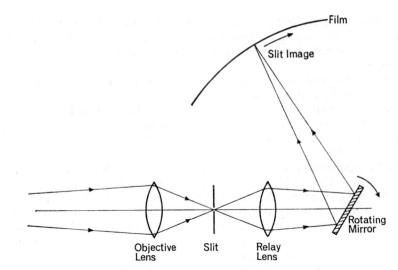

Fig. 11.16. Principle of the rotating mirror streak camera.

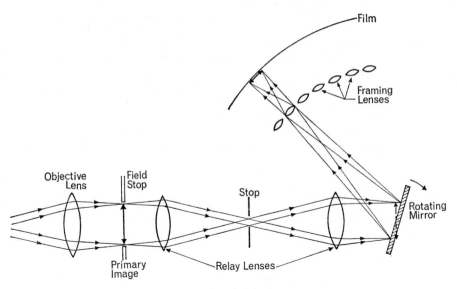

Fig. 11.17. Rotating mirror framing camera.

material of which it is made, and its design. Mirrors used in modern cameras are commonly operated at speeds up to 80 per cent of the bursting speed. They are usually driven by air (or similar) turbine, though electric motor drive is sometimes used. Speeds in excess of 1×10^6 rpm and framing rates of up to 20×10^6 fps have been achieved.

The amount of film that can be exposed in framing or streak cameras of this type is limited to the useful length of the arc on to which the image can be reflected (typically

346

TABLE 11.4
ROTATING MIRROR CAMERAS

FRAMING

Model	Max. frequency (frames/sec ×10⁶)	Picture size	No. of frames	Minimum exp. duration	Effective aperture	Max. Mirror speed (kHz)	Remarks
Barr & Stroud CP5	1·98 3·96 7·92	18mm dia. 13·5mm dia. 8mm dia.	30 59 117	0·48 μsec 0·24 μsec 0·12 μsec	f13 f14·5 f16	5·5	
Beckman & Whitley 189	4·3 2·4 1·2	9×25mm 16×25mm 19×25mm	25 25 25	0·08 μsec (0·04)* 0·15 μsec (0·08)* 0·30 μsec (0·15)*	f14·5 (f20)* f14·5 (f20)* f14·5 (f20)*	18 10 5	*With special half size stops. Maximum mirror speed depends on turbine used.
Beckman & Whitley 189B	20·3	3·2×8mm	120	0·05 μsec	f13	17	Proportionally lower speeds with 5 and 10 kHz mirror turbines
Beckman & Whitley 192	1·4	17×25mm	80	0·12–0·03 μsec	f26	6	Triangular section mirror and 2 arcs of framing lenses give continuous writing

STREAK

Model	Max. Writing speed	Image width	Total duration at max. speed	Max. time resolution	Effective aperture	Max. Mirror speed (kHz)	Remarks
Barr & Stroud CP6	22mm/μsec	50mm	27μsec	10 nsec	f17	3·5	
Beckman & Whitley 339B	9mm/μsec	24mm	131μsec	5 nsec	f8	2·6	Triangular section mirror allows continuous writing

347

about 2–3 feet). Accurate synchronisation of the event is necessary to ensure that it occurs during the correct part of the mirror's cycle. This may be by a photomultiplier positioned so that the mirror reflects light from a lamp on to it when the mirror is at the start of its useful scan. A simple mechanical shutter may be adequate if a non-self luminous event is illuminated by a pulsed light source of short enough duration, but if light from the event persists beyond the time taken for one scan a fast operating capping shutter (p. 334) must be used to prevent subsequent fogging exposure.

11.4.6 IMAGE TUBE CAMERAS.[42] The basic principle of the electronic image tube* is relatively simple:

A photocathode and a fluorescent screen are at opposite ends within an evacuated glass envelope. Light (or other electromagnetic radiation) falling on the photocathode causes photoelectrons to be ejected. A potential between the photocathode and the screen accelerates the electrons towards the screen. The electron pattern emitted by the photocathode has the same distribution as the incident radiation pattern. The photo-electrons are electrostatically or electromagnetically focused on to the screen so that any image on the photocathode is re-imaged on the fluorescent screen. Pulsed operation enables the image tube to act as a shutter and durations of the order of a few nano-seconds may be obtained. Most tubes give a screen image of increased intensity and in

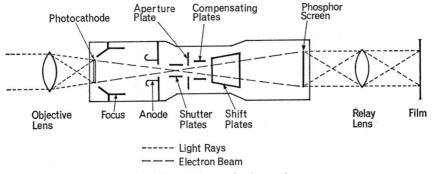

Fig. 11.18. Schematic diagram of an image tube camera.

some instances very high gains may be obtained, about $50\times$ being typical for the single stage tubes used in most cameras. Much higher gains can be obtained using multi-stage tubes. Rapid deflection of the beam enables either a streak image or several distinct time separated images to be displayed on the screen. The screen image can be recorded by conventional photography as in oscilloscope recording (Chapter 12).

Early image tube cameras were capable of providing about three frames with exposure durations as low as 5 nanoseconds, framing rates up to 2×10^7 fps and a resolution of about 10 1/mm. Although the resolution is quite low, it is acceptable because the exposure time is over an order of magnitude shorter and the framing rate several times faster than that of the fastest rotating mirror cameras. Also the overall sensitivity of the system is typically about 100 times greater than with a rotating mirror camera.

*Both image intensifier tubes and image converter tubes are essentially similar. Image converter tubes are also mentioned in Chapters 7.6.1, 8.6.1 and 9.5.2.

348

Improvements in design have increased the total number of frames, up to 32 in some instances, and increased framing rates up to 6×10^7 fps.[43] Special versions have been produced giving a frame rate of 3×10^8 fps with exposure duration of 1·5 nsec and there is no reason to suppose that this is the limit attainable.

11.4.7 IMAGE DISSECTION CAMERAS. All the preceding camera types are limited in framing rate by the requirement of moving either the film or the image one frame width between exposures. However, the total information carrying capacity of any one frame is only rarely used.

Assuming a lens/film resolution of 50 l/mm, 1 cm² can carry $500^2 = 250,000$ 'bits' of information and a standard 35 mm miniature camera frame can carry well over 2,000,000 'bits'. But in some cases as few as 10,000 'bits' may show all the necessary detail, so that only 0·5 per cent of the frame is usefully employed and theoretically 200 different pictures could occupy the same frame area.

TABLE 11.5

CHARACTERISTICS OF FRAMING CAMERA SYSTEMS

Frames/sec	Camera type	No. of frames recorded*	Recording Period*	Typical Applications
10^2	A. Intermittent	4000–16,000	10sec–2 min	Animal movements, medium speed mechanical events.
10^3	B. Rotating prism	4000–16,000	0·5–5 sec	Rapid mechanical actions, vibrations and impacts. Liquid flow and sprays. Electrical discharges.
10^4				
10^5	C. Drum cameras	100–300	10–100 msec	Impacts and ballistic studies.
10^6	D. Rotating mirror	25–100	5–50µsec	Explosions, shock waves, ballistics, high velocity impacts, crack propagation.
10^7	E Image tube	2–20	0·1–1µsec	Fast electrical discharges, plasmas, effects of lasers.
10^8	F. Multiple spark	2–20	50–500µsec	Ballistics, shock waves.
10^9	G. Image dissection	30–300	2–20µsec	High speed mechanical events, ballistics.

*These are typical figures rather than extreme values which are possible.

If the image is broken into a series of dots (or lines) each dot representing one information 'bit' then with a dot to space ratio of 1:200 on each exposure, 200 successive exposures, each displaced by one dot width could, in principle, be made on a single film without exposing any area twice. Subsequently, if the developed plate is viewed in such a way that all the dots produced at any one time are seen together, and each set of dots viewed successively it will be possible to reconstruct the event. This technique is known as image dissection and has the great advantage that the film or

349

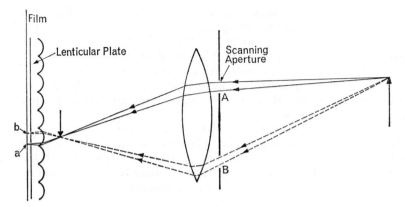

Fig. 11.19. Image dissection camera using lenticular plate and scanning aperture; a and b are the image points when scanning aperture is at A and B respectively.

image need move only one dot or line width instead of one frame width between exposures.

Designs of image dissection camera produced by Courtney-Pratt[44] include the use of a lenticular plate in virtual contact with the emulsion, together with a scanning aperture in front of the lens (Fig. 11.19). This system, in a camera produced by Langham Thompson Ltd. gave 300 frames at 150,000 fps. Other methods [45, 46] include mechanically moved grids in the film plane and a very high speed system using grid image movement via a rotating mirror, capable of 30 frames at 10^8 fps. A fibre optic camera capable of 400,000 fps has also been described.[47]

11.5 *Data Analysis*

Any high speed cine or still record contains a vast amount of information, usually only a small proportion of which is relevant to the phenomenon under investigation. Before the recorded information can be put to use it must be analysed. Analysis may be qualitative or quantitative. In many cases, for the fullest understanding of an event, both approaches may be needed.

Qualitative analysis is usually carried out first. The film is projected or the still picture viewed and a subjective idea of the process is obtained, which often may be sufficient.

When actual values for such factors as velocity, acceleration, growth rate etc. are required the following types of analysis equipment are employed, depending on the accuracy of information required and the amount of data needed.

11.5.1 ANALYSIS PROJECTORS. The simplest form of analyser is an analysis projector, which is perfectly adequate, and often best, for many purposes. Any cine projector with the facility for projecting one frame at a time can be used as an analysis projector but projectors built for the purpose have various refinements, such as a range of speeds, usually from 2 to 16 or 24 fps, reverse running, single frame advance, frame counter, remote control, etc.

Analysis projectors may be used with normal projection screens, or it may be preferable to project on to rigidly mounted graph paper. Rear projection on to a

350

Fig. 11.20. Vanguard film analyser. (a) Direction, advance and speed controls. (b) Frame counter. (c) Cross-hair controls.

glass screen (preferably scaled) is probably the best method, although the magnification is usually limited, as it allows viewing at right angles to the screen. For accurate measurement (particularly of angles), alignment of the projector and screen is critical. This makes film analysers desirable for the most precise work.

11.5.2 FILM ANALYSERS. Available in varying degrees of complexity, film analysers essentially comprise a precision projection system, displaying the magnified image on to a translucent screen. Movable cross-hairs are used to determine x and y co-ordinate positions, or fixed cross-hairs used as a reference for movement of the film or image. The screen may be mounted on a turntable for angular measurement. Some analysers automatically convert co-ordinate and angular measurements into punched tape, card or other digital data storage for computer purposes.

An example is the Vanguard Analyser which comprises a projector with pin registration of frame position. Interchangeable projection heads are available for 16 mm, 35 mm, 70 mm and $5\frac{1}{2}$ in. film and for 5×4 in. plates. The projection case has either a 7 or 11 in. screen, magnification depending on screen and film size. Cross-hairs can be located to an accuracy of 0·001 in. on the screen and their position read on four-figure counters. A special screen is used for angular measurements and digital readout is also available.

The NAC 16S is similar in appearance to the Vanguard, with projection heads for 16 mm cine, 35 mm cine and still, and 70 mm. The projection case has a 24 cm diameter circular screen, angular measurements can be made to ±5′ and cross-hairs for co-ordinate positions can be read down to ±0·05 mm. Digital readout is available if required.

A range of analysers produced by Benson-Lehner[48] include the BOSCAR, which is primarily intended for the analysis of pictorial records. Provision is made for adaptors to accept a range of film sizes from 8 mm to 70 mm. Another unit the OSCAR is available for continuous trace analysis; various types of automatic and semi-automatic readout are available.

351

References

General

1 CHESTERMAN, W. D., *The photographic study of rapid events*, Clarendon Press, Oxford (1951).
2 HYZER, W. G., *Engineering and scientific high speed photography*, Macmillan, New York (1962).
3 SAXE, R. F., *High speed photography*, Focal Press, London (1966).
4 DUBOVIK, A. S., *Photographic recording of high-speed processes*, Pergamon Press, Oxford (1968).
5 *Proc of 2nd Int Congress on H.S. Phot Paris 1954*, Dunod, Paris (1956).
6 *Proc of 3rd Int Congress on H.S. Phot London 1956*, Butterworth, London (1957).
7 *Proc of 4th Int Congress on H.S. Phot Cologne 1958*, Helwich, Darmstadt (1959).
8 *Proc of 5th Int Congress on H.S. Phot Washington 1960*, SMPTE, New York (1962).
9 *Proc of 6th Int Congress on H.S. Phot The Hague 1962*, Tjeenk Willink & Zoom, Haarlem (1963).
10 *Proc of 7th Int Congress on H.S. Phot Zurich 1965*, Helwich, Darmstadt (1967).
11 *Proc of 8th Int Congress on H.S. Phot S.Stockholm 1968*. Almqvist & Wiksell, Stockholm (1968).

Specific

12 ASPDEN, R. L., *Electronic flash photography*, Temple Press, London (1959).
13 FAYOLLE, P. and NESLIN, P., *JSMPTE*, 60, 603 (1953).
14 TAWIL, E. P., *Proc 3rd Congress*, p 9.
15 BEAMS, J. W. *et al*, *J Opt Soc Am*, 37, No 10 (1947).
16 SCHARDIN, H., *High speed photography*, Vol 5, p 291 *SMPTE*, New York (1954).
17 SCHARDIN, H., *Proc 4th Congress*, p 1.

18 MCVEAGH, J. S., *J Phot Sci*, 18, 23 (1970).
19 SEWELL, *et al*, *JSMPTE*, 66, Jan (1957).
20 BAGLEY, C. H., *Rev Sc Inst*, 30, 103 (1959).
21 BREWSTER, J. L., *App Phys Letters*, 13, 385 (1968).
22 FRUNGEL, F., *Proc 2nd Congress*, p 19.
23 FRUNGEL, F., *Proc 3rd Congress*, p 57.
24 FISCHER, H. *et al*, *Proc 6th Congress*, p 152.
25 CHRISTIE, R. H., *Proc 7th Congress*, p 215.
26 HYZER, W. G., *Engineering and scientific high speed photography*, p 324, Macmillan, New York (1962).
27 THACKERAY, D. P. C., *J Phot Sci*, 10, 271 (1962).
28 CAHILL, P. T., *Proc 2nd Congress*, p 200.
29 DAWSON, L., *Proc 2nd Congress*, p 210.
30 EDGERTON, H. E. and GERMESHAUSEN, K. J., *JSMPTE*, 58 (1953).
31 FROOME, K. D., *J Sci Instr*, 25, 371 (1948).
32 WALKER, E. W., *Proc 2nd Congress*, p 91.
33 COLEMAN, K. R., *Proc 4th Congress*, p 32.
34 VINTEN, W. P., *Proc 2nd Congress*, p 135.
35 TUTTLE, F., *JSMPE*, 21, 474 (1935).
36 FATORA, D. A., *JSMPTE*, 74, 911 (1965).
37 CAHLANDER, D. A., *Proc 5th Congress*, p 473.
38 PRUDENCE, M. B., *Proc 3rd Congress*, p 345.
39 UYEMURA, T., *Proc 3rd Congress*, p 300.
40 MILLER, C. D., *JSMPE*, 53, 479 (1949).
41 SKINNER, A., *J Sci Instr*, 39, 336 (1962).
42 SAXE, R. F., *High speed photography*, p 44, Focal Press, London (1966).
43 HUSTON, A. E., *Proc 7th Congress*, p 93, 97.
44 COURTNEY-PRATT, J. S., *Proc 2nd Congress*, p 152.
45 SULTANOFF, M., *Rev Sci Instr*, 21, 653 (1950).
46 SULTANOFF, M., *JSMPE*, 55, 158 (1950).
47 COURTNEY-PRATT, J. S., *Proc 6th Congress*, p 30.
48 BENSON, B. S., *Proc 3rd Congress*, p 251.

12. INSTRUMENTATION AND RECORDING

Photographic instrumentation can be defined as the use of photographic methods for the detection or measurement of some effect in the subject. Its object is to record an event in such a way that the required information can be obtained from the photographic record, more easily than would be possible directly from the subject.

This broad definition covers applications described elsewhere in this book such as high speed photography, time lapse cinematography, infra-red recording and photogrammetry and this chapter is confined to some specific important cases which are not described in other chapters.

12.1 *Oscillograph Recording*

12.1.1 C.R.O. METHODS. In a cathode ray oscilloscope the image is formed by a narrow beam of electrons falling on a phosphor screen, which fluoresces to provide a visible image. Typically the input signal produces a vertical displacement of the spot (parallel to the y-axis) while a variable time base gives the horizontal displacement (parallel to the x-axis); but other arrangements are possible.[2, 3]

The photographic record of the oscilloscope trace takes one of two forms:
(1) A single photograph, of either a repetitive or transient display, taken on a stationary film.
(2) A streak record taken on a continuously moving film, the time base of the record being produced by the movement of the film, the oscilloscope time base not being used.

These two recording methods require different cameras, sometimes use different sensitive materials and possibly different phosphor screens. The camera should be firmly mounted with a hood which excludes the ambient light from the screen, but which allows viewing of the screen for setting purposes and possibly during photography as well. Various systems using hinged or fixed camera mounts with viewing devices ranging from simple 'flap' ports to dichroic mirror beam splitters are available.

12.1.2 PHOSPHOR CHARACTERISTICS. Phosphors used in oscilloscope screens have three major variable characteristics: spectral distribution, persistence or decay time, and efficiency or brightness. These have been classified into groups* (P1-35) according to their properties and the most common of these groups are shown in Table 12.1. The group number does not indicate the composition of the phosphor, only its characteristics.

Decay time is not important for single shot recording but must be short when recording on moving film cameras.

The central resolution of an oscilloscope is typically 2–4 lines/mm which is within the capabilities of most lens-film combinations where the image reduction factor is fairly small (up to about 4). This means that wide aperture lenses can be used without significantly lowering the information content of the result. The 2 in $f1 \cdot 0$ Wray CRO copying lens is an example of a lens designed especially for use at a 4:1 reduction factor. At high reduction factors the lens-film resolution becomes increasingly important.

*By the Joint Electron Device Engineering Council.

TABLE 12.1

CHARACTERISTICS OF OSCILLOSCOPE PHOSPHORS

Phosphor	Spectral peak(s)	Initial Fluorescence	Afterglow (Phosphorescence)	Persistence*	Applications and remarks
P1	525nm	Green	Green	Medium	Low voltage 'scopes. Useful for stationary or re-petitive displays.
P2	535nm	Blue-Green	Yellow-Green	Long (Medium-short if used with deep blue filter)	General purpose high voltage 'scopes. Low speed transients.
P5	415nm	Blue	Blue	Medium–short	Continuous motion recording —but brightness inferior to P11.
P7	440, 555nm	Blue/White	Yellow	Long (shorter with blue filter)	Similar to P2 but more efficient at lower voltages. Radar screens.
P11	460nm	Blue	Blue	Medium–short	Best photographic efficiency. High speed transients. Continuous motion recording (longer persistence than P5).
P15	390, 505nm	Blue/Green	Blue/Green	Short	High speed continuous motion recording.
P16	385nm	Violet–near UV	Violet–near UV	Very short	Flying spot scanners. Highest speed continuous motion recording.
P24	510nm	Green	Green	Short	Similar to P15 but without UV emission.

*Persistence (to 10% peak brightness)
Very long >1 sec.
Long 100 ms–1 sec.
Medium 1–100 ms.
Medium-short 10μs—1 ms
Short 1–10μs
Very short <1μsec.

12.1.3 WRITING SPEED (PHOTOGRAPHIC). This is the speed of movement of the spot image across the sensitive material and decides the effective exposure time for any image point. It equals the writing speed on the 'scope screen times the magnification of the image, and depends on both the horizontal sweep speed (speed of film motion in continuous feed camera) and the *shape* of the trace produced (Fig. 12.1). The maximum writing speed with a particular oscilloscope-camera-film combination is the highest which can be recorded satisfactorily. A density difference from base of 0·1 is sometimes quoted as a suitable criterion.

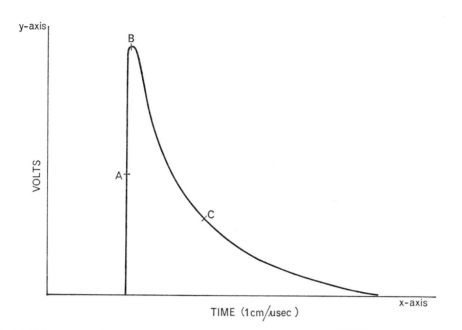

Fig. 12.1. Effect of trace shape on writing speed. At A, slope=100, writing speed=$\sqrt{10,001}$=~100 cm/μsec; at B, slope=0, writing speed=1 cm/μsec; at C, slope =1, writing speed=$\sqrt{2}$=~1·4 cm/μsec.

12.1.4 SINGLE SHOT RECORDING. The time base is provided on the x-axis by the oscilloscope. For repetitive displays with the oscilloscope triggering automatically no special synchronisation is necessary but the exposure time should be equivalent to at least five successive sweeps in order to avoid unevenness of exposure should a part trace be recorded. With transient displays only a single trace is recorded and a B or T shutter setting is often suitable. The event will generally trigger the oscilloscope, but many oscilloscope cameras have a synchronisation contact which can be used for triggering either 'scope or event, as required, so allowing the shutter open time to be kept small (e.g. 1/25–1/100 sec.).

Variation of lens aperture and spot intensity can be used to control the exposure of any particular trace. Exposure time can be varied if required with repetitive traces, but does not help with transients if the time is longer than the phosphor decay period. High intensity settings cause a visual spread of the screen image (blooming), but the photographic image does not necessarily record this if the exposure level is low. On the other hand a photograph which is over-exposed may show a similar image spread (caused by irradiation or halation in the photographic material) even if blooming is not visible on the screen. The optimum exposure is that where all significant detail in the trace is recorded. This must be a compromise when a wide range of writing speed is present on a single display and may occasionally require separate exposures at different levels to show the detail in all parts.

With very high writing speeds it may be necessary to allow visual blooming of the screen image to obtain sufficient exposure but an intense spot should not be allowed to remain stationary on the screen because of the possibility of damaging the phosphor.

Although almost any camera can be used the majority of those designed for single shot recording fall into two categories; one using Polaroid Land film (usually roll or film packs) and the other using 35 mm film. Only isolated examples using other sizes are to be found (16 mm, 70 mm etc.). The attraction of Polaroid film is that the result, a reasonable sized print, can be seen and approved or rejected within seconds of the event without need for darkroom facilities.[4] This is an enormous convenience for the engineer or experimental worker and, together with the availability of very high speed films, is responsible for the claim that Polaroid material is used more than any other for oscilloscope recording. Polaroid films Type 47, 57 and 107 are rated at 3000 ASA and type 410 at 10,000 ASA. Although the exact ASA ratings should not be considered too significant with this type of recording, they do give an idea of the extreme speed readily available with the high contrast necessary for high speed transients.

Most Polaroid oscilloscope cameras are mounted to give an image magnification between 0·4 and 1·0, and many allow horizontal and/or vertical movement of the camera back to several positions so that successive traces may be recorded on one piece of film. Viewing of the oscilloscope screen is by means of either a beam splitting mirror (Fig. 12.2) or direct oblique channel. A ground screen can be inserted to allow

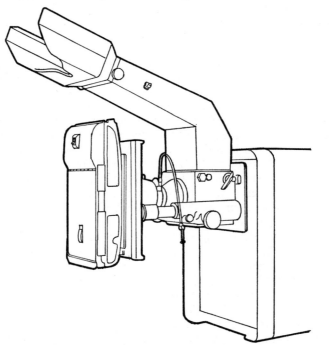

Fig. 12.2. Oscilloscope camera using Polaroid roll-film; viewing provided by beam splitting mirror (Cossor).

critical focusing, which must be done before loading of roll film. It is preferable to focus on a static display, which is itself sharply focused on the oscilloscope screen. Focusing by reverse optics using an illuminated focusing negative in the film plane and allowing the camera lens to form an image on the oscilloscope screen, is useful when a static display is not available.

356

The image of an illuminated graticule in front of the oscilloscope screen may not be perfectly sharp at wide lens apertures, but this is usually of secondary importance. If used, the illumination of such a graticule should be adjusted to give a suitable exposure on the result. This requires a nearly visual match with a repetitive trace, but with transient displays the graticule illumination may need to be much lower as it will be on for the entire exposure time. With *random* transient displays the shutter must be left open until the event occurs and the graticule is best recorded by a separate exposure, on the same film, with no screen image. This type of display also requires efficient elimination of stray light from the oscilloscope screen.

12.1.5 CONTINUOUS FEED RECORDING. This method uses vertical movement of the oscilloscope spot only, the continuous movement of the film at right angles to the spot movement providing the time scale of the record. Its main advantage is that it permits recordings of long duration, limited primarily by the film capacity of the camera

Fig. 12.3. Continous feed camera for perforated or unperforated 35 mm film (DuMont 321A).

dependent on the driven speed of the film. Thus higher frequency variations can be shown in a low frequency waveform. Film feed speeds used vary between about 1 in/sec and 2–6 ft/sec* for the majority of cameras but speeds above 200 ft/sec can be obtained using high speed cine cameras (Fastax type) in the streak mode, with useful film lengths of hundreds of feet (16 mm). Rotating drum cameras can give even higher speeds, but the film length is limited to a few feet (see Chapter 11). The time resolution obtainable, or the maximum frequency which can be recorded depend mainly on the velocity of the film and the image reduction factor. Typical spatial resolution values

*DuMont model 321A (Fig. 12.3) is capable of 15 ft/sec and has 400 ft capacity.

357

are about 100 cycles/in and 200–250 cycles/in for reduction factors of 4 (35 mm film) and 10 (16 mm film) respectively. With a film velocity of 5 ft/sec these correspond to 6,000 Hz (cycles/sec) and 12,000–15,000 Hz, although under good conditions these values may be improved by a factor of 2.

It is important that phosphor persistence should be short, otherwise blurring of the image on the trailing edge will occur (Plate 25). The effect is minimised by low exposure level and for most continuous recording P11 phosphor is quite satisfactory. However, for high frequency, high resolution requirements P15, P24 or P16 are preferable.

The normal squared graticule is not very suitable for imaging on to a continuously moving film, although, with careful control of the illumination, it is possible to record the horizontal lines with little overall fogging from the vertical ones. A graticule with horizontal lines only is preferable. To record a time base, if the exact travel speed is not known, a separate time base signal may be recorded, either on the screen of a dual trace 'scope or in the camera using a pulsed neon lamp. Alternatively a z-axis (intensity) modulation may be applied to the trace.

Film travel speeds possible (0·06 mm/μsec with Fastax) with continuous feed cameras are several orders of magnitude lower than sweep speeds obtainable on most oscilloscopes (10 cm/μsec). Because of this, some high frequency phenomena can be resolved only using the oscilloscope time base (x-axis sweep). In such cases the oscilloscope sweep may be combined with continuous film movement at right angles to it. This means that the film travel must now be vertical (parallel to y-axis) and the image obtained will be in the form of a raster as shown in Plate 24. The normally horizontal baseline will now be broken and angled obliquely across the film, making quantitative assessment more complex. Film velocity should be sufficient to avoid overlapping of the traces.

12.1.6 Sensitive Materials. All Polaroid films (see p. 356) are panchromatic and record satisfactorily from any type of screen phosphor, but the choice of conventional (70, 35 or 16 mm) film from a wider range can be important. The colour sensitivity of the film should cover the spectral output of the phosphor and film resolution is increasingly important with smaller image size. Most manufacturers produce blue sensitive, orthochromatic and panchromatic recording films of low, medium and high speed, in addition to their range of general purpose films all of which could be used. In general, use of a film significantly faster than necessary is inadvisable. The emulsion layer of some recording films contains a dye which absorbs more of the incident light the further it penetrates into the layer. This reduces the effect of over exposure where the writing speed is low without significantly altering the exposure where writing speed is high and light penetration is small. In this way image spread is restricted and resolution improved. Recording films are usually processed to a higher gamma (typically 1·0–1·6) than that used for general photography. Only when critical recording of a wide range of writing speeds is required is it sometimes necessary to use a lower gamma. Most manufacturers now supply recording films incorporating very efficient hardeners which allow rapid processing (develop-fix or monobath) at high temperatures (32°–55°C.) in continuous processing machines (e.g. Kodak RAR Series films).

Various methods are used by film manufacturers for expressing the speed of films used for oscilloscope recording. One method, favoured by Polaroid, is to quote the maximum writing speed recordable. This has to be related to a particular set of

exposing (lens aperture, magnification, 'scope type and phosphor) and processing conditions, which makes useful application of the information somewhat limited. Kodak quote 'Relative CRT Speeds' for their recording films with the common phosphors. These are based on the exposure required to produce a net density of $1 \cdot 0$ (Table 1.2). Although this gives little help to actual exposure assessment, the relative speed of different films is most useful in making a choice of material. Photometry of oscilloscope traces is not a straightforward procedure and a practical test is usually the most satisfactory way of assessing exposure. Conventional film is most useful for the routine recording of large numbers of single traces and once the exposure is established, little or no variation should be necessary. For this work the convenience of processing films in long continuous lengths is valuable and the cost per exposure is very much less than with Polaroid film.

For continuous recording the same range of films are suitable except that Polaroid materials cannot be used. Papers are also available which are satisfactory for lower speed recordings. These provide a readable black on white image very rapidly using machine stabilisation processing and are cheaper than film.

12.1.7 RECORDING IN COLOUR. Oscilloscope traces may be recorded in colour providing a suitable phosphor (and filter) is used to give the trace colour required. Recording of multiple overlapping traces of different colour on one film can be achieved by successive exposures using different filters (and possibly 'scopes with different phosphors) or by simultaneous recording of several 'scopes using beam splitting mirrors (Fig. 12.4). If non-overlapping traces are involved these can be displayed on a dual-beam or dual-trace 'scope and filters fitted over corresponding sections of the screen. Almost all phosphors having useful yellow or red emission have long persistence, so that only low speed continuous recording is practical.

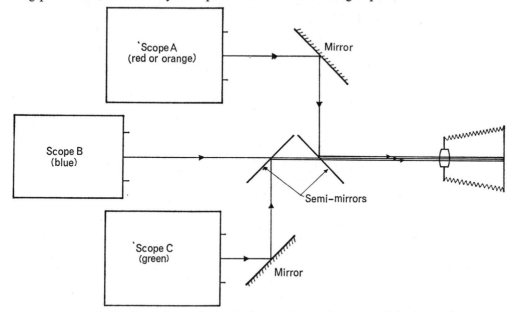

Fig. 12.4. System for recording overlapping traces in colour from three oscilloscopes.

359

12.1.8 RADAR SCOPE RECORDING. Closely resembling ordinary oscilloscope recording, the radarscope display is formed on a similar phosphor screen. One system, A-scope recording, is virtually identical to normal oscilloscope recording except that automatic camera operation is often used. A second method, Plan Position Indicator (PPI) has a continuous rotating arm type of display (sweeping rather like the hand of a clock, but faster). The camera shutter, therefore, has to be open for the complete sweep and rapid film transport between successive pictures is necessary. For visual purposes long persistence P7 phosphor with a yellow filter is usually used but for photographic recording the higher intensity obtained from the blue record without the filter is useful. PPI screens are usually larger than in ordinary oscilloscopes and special cameras for this purpose have provision for simultaneous recording of other relevant information.

12.1.9 DIRECT RECORDING OSCILLOGRAPHS. This class of instrument uses a mirror galvonometer to project an intense spot of light on to a photosensitive paper which is driven at a constant speed. It has a better frequency response (10,000 Hz) than mechanical pen recorders although much lower than cathode ray oscilloscopes ($\sim 10^8$ Hz). The recording paper, up to 12 in. wide, may be of the develop-out type suitable for processing in a continuous feed machine or print-out type which requires only a photo-

Fig. 12.5. Direct recording oscillograph.

developing exposure in normal room lighting to make the trace visible. The latter trace is not permanent but chemical processing can be used to make it so if required. A stabilising lacquer in aerosol form is also available, containing a yellow dye which enhances visual contrast and absorbs UV radiation, the prime cause of image deterioration. Print-out papers are less sensitive than develop-out types and often require either mercury or xenon arc illuminant, although improved papers useful with high intensity tungsten illumination are now produced.[3]

360

Multiple beam recorders allow several traces to be recorded simultaneously on a single paper roll. If different filters are inserted in the respective beams and colour material used, an image with different coloured traces can be obtained. Such a record simplifies greatly the reading of complex overlapping traces. Kodak produce a colour recording paper (Linagraph 705) for this purpose.

12.2 *General Recording*

12.2.1 EQUIPMENT. Recording cameras usually use 16 mm or 35 mm film with either normal cine frame sizes or other formats. The essential feature of a recording camera is that it should be capable of automatic, usually remote operation (i.e. have linked shutter action and film advance) at fixed predetermined speeds or on command from an intervalometer or by manual control (pulsed operation). Many cameras give B or T shutter openings if fed with the appropriate length of pulse or double pulse. A normally open shutter, which closes only during film transport, is also possible.

Intervalometers may be either motor driven with mechanically operated switching, or electronic. The former can be very reliable and permit certain preset irregular intervals (e.g. 10 sec., 2 sec., 10 sec.) but it may be difficult or impossible to alter the interval during running. Electronic intervalometers allow simple variation during running but generally provide only regular intervals without resetting. British recording cameras include models made by Shackman, Telford and Vinten, while models by Agfa/Gevaert and Robot (German) Flight Research, Milliken and Photo-Sonics (USA) and others are available. These, as well as several cine (including 8 mm) and still cameras are suitable for very many straightforward recording applications including traffic surveys, police mobile patrol use (recording traffic or other offences), smoke discharge flow patterns and instrument panels.

Analysis of the films depends on the subject and the information required. When a cine format camera is used cine projection may help interpretation.

Most pulse-operated cameras are limited to rates of about 4 or 5 fps although some sophisticated models achieve much higher operating frequencies, e.g. the Flight Research Multidata camera Model IIIB (16 mm) can be pulse-operated up to 20 fps and the model 207 (35 mm) up to 15 fps (or 19 fps without shutter). Continuous (cine) operation allows much higher frequencies (see Chapters 10 and 11) and this principle is extended to produce *rapid sequence cameras* using 70 mm film. The best known is the Hulcher 70 which can take $2\frac{1}{4}$ in. square (approx) pictures at 50 fps. Photo-Sonics, produce a range of 70 mm sequence cameras which achieve up to 80 fps ($2\frac{1}{4}$ in. sq) using register pins and vacuum back to hold the film stationary and flat. Higher rates are available with reduced picture height, or up to 360 $2\frac{1}{4}$ in. fps are obtained with rotary prism compensation and continuous film transport.

Recording cameras often allow the printing of data, such as time or associated instrument readings, on to the film. An interesting example is the Telford N Model 434 (16 mm) camera in which information may be recorded alongside the cine frame by using 18 solid state gallium phosphide lamps in the camera adjacent to the gate. Sixteen of the lamps operate independently in a simple on/off mode (2 are on continuously for registration) allowing over 65,000 (i.e. 2^{16}) different patterns of coded information to be recorded (see Chapter 2.1.1). Other cameras record dial or digital instrument readings imaged by separate optical path(s) on to the film.

12.2.2 HIGH 'G' CAMERAS. Some recording cameras are designed to operate in conditions of high acceleration and vibration. Such cameras, including several high speed models, are used on rocket and missile flights and applications where survival of impacts or blast damage is necessary.

Acceptable 'g' loadings along any of the three principal axes of the camera are usually quoted. Some examples given by manufacturers are:

Flight Research Model IV–C	(35 mm, 5–40 fps)	20 g
Milliken DBM 4C	(16 mm, 4–400 fps)	25 g
Stalex	(16 mm, 50–3000 fps)	40 g
Telford Type T	(16 mm, 16–60 fps)	40 g
Hitachi, Himac 16 HS	(16 mm, 100–5000 fps)	50 g
Milliken DBM 10	(16 mm, 4–400 fps)	50 g
Milliken DBM 25	(16 mm, 16–64 fps)	180 g

(will withstand 250 g shock non-operational)

Separate ratings for vibration conditions are also given in some instances.

12.2.3 INSTRUMENT PANEL RECORDING. The automatic recording of instruments panels is a common application. Photography permits a fairly large number of instrument readings to be recorded at precisely the same time and repeatedly at almost any time interval for subsequent analysis. A typical example is the automatic observer units fitted in aircraft.[5]

The faces of instruments to be recorded should be as close as possible to one another, preferably with clean white scales and pointers on a black background, to ensure good contrast.

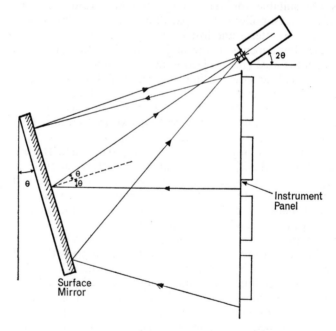

Fig. 12.6. Use of mirror with camera mounted immediately above instrument panel. Note the relative angles of mirror and camera.

Lighting sometimes presents a problem where space is limited. Concealed lights around or in front of the panel between the instruments can be used but even illumination, free from specular reflections in the glasses, may be difficult to achieve when a fairly wide angle lens has to be used. In some cases removal of the glasses may be possible; alternatively crossed polarising filters fitted over lamps and camera lens will eliminate these specular reflections. Errors due to needle parallax can be significant with wide angles of view and calibration exposures may be necessary so that allowance can be made in analysis.

Sixteen-millimetre cameras are compact and will record 12 average instruments comfortably. Thirty-five millimetre and larger formats obviously have correspondingly greater information capacity. Camera positioning depends on the layout and environment of the instruments to be recorded. The use of a mirror allows the camera to be mounted above, below, or to one side of the panel, or in the panel itself. A surface aluminised mirror avoids double reflection images and if positioned so that the face of the panel is effectively normal to the lens axis, the need for significant depth of field is eliminated (Fig. 12.6). The lateral reversal of a mirror image is usually unimportant.

The camera, mirror (if used) and instruments should be rigidly mounted in relation to the panel to avoid relative movement due to vibration. Anti-vibration mounting for the complete assembly is useful but individual anti-vibration mountings are best avoided.

12.3 *Special Instruments and Techniques*

12.3.1 CINETHEODOLITES. The cinetheodolite is an instrument for tracking and recording the trajectory of aircraft or missiles. The complete instrument consists of a cine camera (usually 35 mm) and two viewing telescopes on a single mount, which allows accurate control of both elevation and azimuth. A record of these angles is imaged on to the film together with the object being tracked. With a typical instrument separate operators controlling the two movements view and track the target through the telescopes while the camera records at about 5 fps. Analysis consists of reading the elevation and azimuth scales on each frame and applying a correction for the position of the object relative to a central fiducial marker. Two or preferably more such instruments with corresponding frame identification are used from widely separated positions so that the precise object position at any time can be calculated trigonometrically (Chapter 14). Synchronisation of the instruments is necessary and may need to include a timing correction to compensate for delays due to very long cable lengths.

Cinetheodolites came into use during the second world war and have been developed particularly by Askania and Contraves in Europe and by Mitchell and Akeley in America.

Modern versions (such as the Contraves Digital EOTS Theodolite Model E, Plate 26) convert elevation and azimuth angles (and time) into a binary coded display consisting of an array of neon lamps which is imaged on to the film. The advantage of such a system lies in the speed of analysis which is possible with automatic readers. Complete semi-automatic reading (with manual alignment of crosswires on to target) takes about 1 second per frame and completely automatic reading (ignoring tracking errors) is nearly twice as fast on the same reader. Complete computer processing to calculate the trajectory from the records of a series of instruments is also possible.

363

12.3.2 TRACKING TELESCOPES. The principle of the cinetheodolite has been used in the development of tracking telescopes for observing long range missiles, rockets and artificial (or natural) satellites. A number of such tracking instruments have been developed for specific purposes[6-10] having some or all of the following properties compared with normal cinetheodolites:

(1) Increased tracking velocities (up to 90° per second).
(2) Automatic tracking (using infra-red sensitive systems).
(3) Greater optical magnification, often using reflecting telescope optics with Schmidt field flattening plate.
(4) Faster recording rates (up to 360 fps on 70 mm film).
(5) Digital data display with fast response.
(6) More accurate synchronisation between instruments.
(7) Larger, more stable mountings to take increased load.

These instruments often use multiple recording cameras operating at both high and low speeds.

12.3.3 FAIRCHILD FLIGHT ANALYSER.[11] This is basically a still camera designed for short-range tracking at high azimuth rates. The camera itself is fixed and has a wide angle lens covering the entire field through which the target is recorded. It must be aligned at 90° to the flight path. Manual tracking of the target with an associated telescope causes a sequence of exposures to be made on a single static plate through a special focal plane shutter which has a slit in an oscillating cylindrical element of a length corresponding to the height of the picture. Each exposure records a thin vertical strip image showing the target together with corresponding time data (readable to 1/200 sec). The complete picture shows about 50 images of the target positioned in

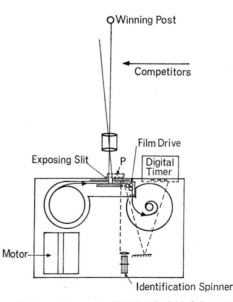

Fig. 12.7. General layout of race finish recording camera. Note that the field of view extends *past* the finishing line. The timer and identification drum are imaged onto the bottom of the film from below via a prism system (P).

364

relation to one another along the flight path, and is therefore easily analysed. The camera is used mostly for recording aircraft landing and take-off paths although it will operate on its side to deal with vertical trajectories.

12.3.4 RACE FINISH RECORDING. The principle of the race finish camera[12] as applied to athletics, horse or dog racing, is that of streak recording with the film velocity compensating for image movement. The plane of the finishing line is imaged on to the edge of a narrow vertical slit (about 1/100 in) so that the very narrow field of view extends forward of the line (Fig. 12.7). The film is driven horizontally at a speed which corresponds approximately to that of the image (i.e. speed of contestant × magnification) but accuracy is not vital to the record since the narrowness of the slit ensures sharpness of the image and some longitudinal distortion is unimportant. The camera records continuously the parts of contestants *on and slightly past the finishing line*, the horizontal distance on the record being only a measure of *time* which is usually recorded along the edge of the film. This accounts for the apparently strange attitudes and distortion of competitors which is sometimes seen on the record.

Thirty-five millimetre unperforated recording film is used and processed at high temperature. The negative is printed wet and usually a white line, formed by the shadow of a thin wire, is superimposed to assist in judging. The camera position is usually high so that masking of competitors by each other is reduced, but a second image from a strip of mirror on the opposite side of the track is also used to help judging when such masking occurs. In the latest cameras a rotating drum inside the camera carries identification of the event and, together with a digital electronic timer, is imaged onto the film immediately below the exposing slit.

References

General

1 HYZER, W. G., *Engineering and scientific high-speed photography*, Macmillan, New York (1962).

2 TAILEUR, M. C. (Ed), *Techniques of photo-recording from cathode-ray tubes*, Dumont Laboratories, Fairchild Camera & Instrument Corp, Clifton, N.J. (1964).

3 HOADLEY, H. W., *Manual of oscillography*, Focal Press, London (1967).

Specific

4 MANSBERG, H. P. and TASCHIOGLOU, K. P., *Oscilloscope trace recording with polaroid land photography*, Polaroid Corp, Cambridge, Mass (1959).

5 *Kodak Data Sheet IN-3*, Kodak Ltd., London.

6 MARQUIS, D. C., *Applied optics*, 5, (1966) [Several other papers also in this issue No. 4.]

7 REUYL, D. and CARRION, W., *JSMPTE*, 71, 505 (1962).

8 HEWITT, J., *Perspective*, 7, 301 (1965).

9 HENIZE, K. G., *Sky and telescope*, 16, 107 (1957).

10 NICOLA, J. F., *SPIE Journal*, 6, 97 (1968).

11 FAIRBANKS, K. J., *Photogramm Eng*, 22, 334 (1956).

12 ANON., *The British Racehorse*, Nov 1950.

13. STEREOSCOPIC PHOTOGRAPHY

13.1 *Definition of terms*

Some of the basic terms used in this chapter may be defined as follows:

Stereoscopy	Stereoscopy comprises all aspects of stereographic reconstruction. A stereoscope is a device for viewing stereographs in such a way that a 3-dimensional representation is created in the mind of the observer.
Stereophotography	The production of photographs for stereoscopic viewing.
Stereography	This refers, strictly speaking, to the preparation of stereo pairs by drawing; however, as in this book, the term is often used as a shortened form of stereophotography.
Stereogram	A pair of stereo pictures, correctly mounted for viewing in a stereoscope.
Orthostereoscopy	Stereographic techniques which give a geometrically correct 3-dimensional impression of a subject.
Hyperstereoscopy	Stereographic techniques which give an exaggerated impression of the subject depth.
Hypostereoscopy	The reduction of the camera lens separation for close-up work.
Binocular vision	Natural two-eyed vision and the associated mental processes which lead to a 3-dimensional interpretation.
Stereoscopic vision	The viewing of images in a stereoscope; the intention is normally to produce the same mental effect as in natural binocular vision.
Pseudoscopy	The interchange of a pair of stereograms so that each eye sees the 'wrong' record; the impression of depth tends to be inverted, concave surfaces looking convex.
Autostereoscopy	Stereographic methods that do not require the observer to wear glasses or to use any special viewing system.
Photogrammetry	The use of photography for precise measurement (see Chapter 14).
Stereophotogrammetry	The application of stereophotography under controlled conditions giving a third dimension to photogrammetry.
Monophotogrammetry	Under suitable conditions, accurate measurements can be made from a single camera record (see p. 387).

13.2 *Visual factors*

A single eye (monocular vision) presents only a flat two-dimensional picture to the brain, but with two spatially separated retinal images (binocular vision) there is automatic interpretation of the combined pictures as a single 3-dimensional image.

13.2.1 MONOCULAR VISION. When studying normal photographs, as in all monocular vision, there are several factors that we intuitively apply in assessing the depth of a subject.

367

(1) The perspective effect gives a strong impression of depth; this is observed in receding object planes and in the apparent reduction in size of distant objects. The camera viewpoint distance is the controlling factor in exaggerating or reducing this effect.

(2) The shape of the subject is usually shown by the modelling effect of the lighting.

(3) Subject resolution is naturally lower for distant objects and any indistinctness, or the presence of atmospheric haze may be interpreted as being due to increased distance.

(4) When viewing a scene, even with one eye, the necessity for refocusing on different parts of the scene gives an immediate sensation of depth. The effect can only be suggested in a still photograph by the use of differential focus to concentrate attention on one plane. This is not recommended in a stereograph because unsharpness tends to destroy the 3-dimensional illusion.

(5) We instinctively move our head from side to side when faced with a difficult decision as to the existence of different subject planes. Even in monocular vision, nearby objects then apparently move to a greater extent than distant objects. The effect cannot be achieved in normal stereographs but can be captured to a limited extent by cine techniques using a moving viewpoint.

The hologram (see Chapter 15) offers the greatest stereoscopic realism because it reproduces more of the natural features of the scene (points (4) and (5) above).

13.2.2 INTERPRETATION. Although we may become experienced in the evaluation of conventional photographs, stereography is often essential for removing ambiguity. For example, it can be very difficult to tell from a small isolated image if it was produced by a small object at close range or is due to a larger object at a greater distance.

In many cases our knowledge of the size of an object plays an important part in our estimation of its distance but there is a risk, particularly with unfamiliar objects, that optical illusions will arise. This is a subject worthy of a separate study,[5] but it is probably true to say that the more common illusions, which depend on confusion about spatial relationships, are less likely to arise if a stereographic record is made.

13.2.3 BINOCULAR VISION. Our total horizontal angular field of view is about 180°, with an overlapping binocular field of about 120° (horizontally) × 130° (vertically).

The term stereopsis refers to the property of human vision arising from the fact that each eye has a different viewpoint and therefore sees a slightly different aspect of the subject.

Apart from this eye separation (which is normally about 65 mm (2½ in.)), two factors contribute to our binocular assessment of distance:

(1) *Convergence:* When viewing objects at a distance, the optical axes of the eyes are parallel. When attention is fixed on a near object the eyeballs pivot and the axes converge. The angle subtended at the subject by the eye base is termed the angle of convergence or parallactic angle.

(2) *Accommodation:* We normally make our eyes accommodate or focus upon objects in front of us; there is a limiting near point of distinct vision which, for the normal eye, is about 10 in. Accommodation is also relevant to one-eyed (monoscopic) depth assessment.

These two adjustments of the eye are normally interlinked and are almost subconscious; we rely largely on these co-ordinated movements for our judgments of different subject planes.

13.2.3.1 *Calculation of the perceptible subject-plane separation.* If two objects subtend the same parallactic angle at the same degree of accommodation, they are judged as being in the same subject plane. Fig. 13.1 shows that for object A, which is closer to the observer, the angle ϕ is increased and there is a difference (α) between the parallactic angles for objects A and B. When α exceeds about 20 seconds of arc,* most people judge A to be nearer than B.

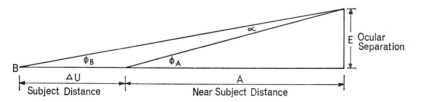

Fig. 13.1. The discrimination of subject depth. (The difference of parallactic angle for different subject planes.) ϕ_A—parallactic angle for subject A. ϕ_B—parallactic angle for subject B. $\alpha = \phi_B - \phi_A$. (Difference of parallactic angle between A and B.)

The ability to discriminate different planes may be termed the stereoscopic resolving power or the stereoscopic acuity; it is affected by the illumination level and the subject contrast. The minimum value for different individuals ranges from about 30 sec/arc to about 10 sec/arc, although some trained observers are able to translate a difference of less than 5 sec/arc into a sensation of subject depth.

Table 13.1 shows that, whatever the individual's value of α, distant subject planes must be widely separated if a stereo representation is required.

TABLE 13.1

VARIATION OF STEREO EFFECT WITH SUBJECT DISTANCE

Distance to nearer subject plane (A)	*Minimum detectable subject separation* (ΔU)
1 foot	0·006 ins.
10 feet	0·60 ins.
100 feet	60 ins. 5 feet
1000 feet	500 feet
10,000 feet	50,000 feet (10 miles)

These values have been calculated from the approximate formula:

$$\Delta U = \frac{\alpha A^2}{E} \qquad \text{Eq. 13.1}$$

where: E is the eye separation of 65 mm (2½ in.), here expressed as 0·2 feet.

A is the distance from the observer to the nearer object plane.

α is the stereoscopic resolution of the observer, here expressed in radians.

ΔU is the minimum separation (in feet) of the two subject planes necessary to give a stereoscopic effect.

*A second of arc is equal to 1/3600 of a degree (0·000277°); it is approximately equal to 5 microradians (5μrad)—see footnote to p. 140.

369

For example, at a range of 50 ft and assuming a value of 0·0001 radians for α:

$$\Delta U = \frac{0\cdot 0001 \times (50)^2}{0\cdot 2} = \frac{1}{2000} \times 2500 = 1\cdot 25 \text{ ft}$$

The factor 1/2000 is constant for the values of E and α assumed here.

All the figures quoted in this chapter refer to visual perception by the naked eye. The use of binoculars and tele-stereoscopes gives increased discrimination of depth (ΔU), because of increased lens separation and increased magnification.

13.2.3.2 *Calculation of the farthest point of binocular vision.* When observing an object at a great distance the ocular axes are parallel and the effort of accommodation is zero. If the object approaches, it will eventually be in a plane that can just be stereoscopically discriminated from infinity. The distance of this plane can be calculated once the stereoscopic resolution (α) and the eye separation (E) of the observer are known.

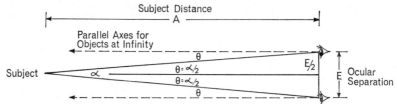

Fig. 13.2. The farthest point of binocular vision (where the angle of ocular convergence at the subject is equal to the limiting stereoscopic resolution of the individual α)

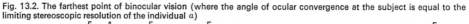

$$\tan \theta\ (\tan \alpha/2) = \frac{E}{2} \times \frac{1}{A} \qquad A = \frac{E}{2 \tan \theta} = \frac{E}{2 (\tan \alpha/2)} \qquad \text{As an approximation, where } \alpha \text{ is very small } A \approx \frac{E}{\tan \alpha}$$

Fig. 13.2 shows an object at a distance A which requires an ocular convergence just equal to α; this maximum stereoscopic subject distance is given by:

$$A \approx \frac{E}{\tan \alpha} \qquad\qquad \text{Eq. 13.2}$$

If α is assumed to be 20 sec/arc and E is 0·2 feet the limiting value is:

$$A = \frac{0\cdot 2}{\tan 20 \text{ sec.}} = \frac{0\cdot 2}{0\cdot 0001} = 2000 \text{ feet}$$

This implies that for an average observer an object at 2000 feet (610m), can just be distinguished from an infinitely distant background. More distant objects are in a 'neutral zone' in which no stereo effect is produced (unless the eye-base is artificially increased).

The same general limitation is imposed on stereo photographs; with the standard lens separation it is difficult to discriminate subject planes more than about $\frac{1}{4}$ mile (400 m) away.

13.2.4 STEREOSCOPIC VISION. There are several factors which tend to disturb the three-dimensional illusion in stereoscopic viewers, even when the geometrical conditions are correct:

(1) In many stereo viewers the natural inter-link between ocular convergence and accommodation is broken. The eyes may be converging on an image which is stereoscopically reconstructed several feet away, even though they are focused on the surface of the print which is only a few inches away. With some viewers

the eye is relaxed and is focused on infinity but nearby images still require convergence. In either case a variation in convergence is required to look at different planes in the image, but variation in accommodation is not required; this frequently causes discomfort to the observer.

(2) The camera angle of view is normally about 60°, but the eye's field is much greater. The stereoscopic image is thus always surrounded by a dark frame that tends to destroy the stereo effect near the edges of the picture.

(3) The photographic images lie in a fixed plane that may show surface texture and dust; this tends to call attention to the flat surface rather than to the 'solid' stereo image.

(4) Graininess and unsharpness are also disturbing.

There are generally small zones that can be seen only by one eye and which give no stereo effect (see p. 373). If widely separated cameras are used, these monoscopic zones may become so extensive that an overall stereo effect cannot be sustained.

The basis of stereoscopic depth perception and some of the psychological aspects have been discussed by Ogle.[6]

13.3 *Stereoscopic reconstruction*

An orthostereoscopic result is not always necessary or practicable, but an appreciation of the important factors is useful.

Fig. 13.3 shows the basis of stereo reconstruction for a simple scene consisting of three posts A, B and C. The distance to the nearest point (A) is U_s and the depth of the subject is D_s: the focal length of the camera lenses is F_c.

Stereoscopes normally have the viewing lens separation (S_v) equal to the camera lens separation (S_c). For the purpose of comparing the original subject and the reconstruction, Fig. 13.3b shows the processed images placed in front of the viewing lenses. By producing lines from the lenses through the film image points (A_l, A_r etc.) each stereoscopic image point can be plotted.

There are two vital factors if an orthostereoscopic result is required:

(1) The separation of camera lenses and viewing lenses must be identical:

$$(S_c = S_v)$$

(2) The focal lengths of the camera and viewing lenses must be identical:

$$(F_c = F_v)$$

Because these conditions are fulfilled in Fig. 13.3 the reconstructed image is geometrically correct, i.e.:

(1) The subject appears to be of the correct size.

(2) The subject appears to be at the correct distance ($U_v = U_s$).

(3) The subject shape appears to be correct because the viewed image depth (D_v) equals the real subject depth (D_s) and the apparent width (BC) is also correct.

Any mis-matching of the focal length between the camera F_c and the viewer F_v can be balanced by adjusting the print magnification M so that $M \times F_c = F_v$. For example, if F_v is 100 mm and F_c is 200 mm, the print magnification should be 0·5; the resulting print might be too small to fill the visual field, but the reconstruction would appear geometrically correct.

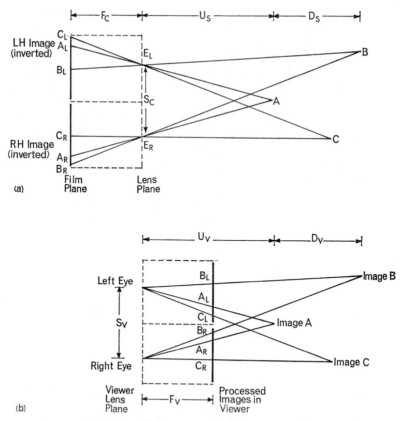

Fig. 13.3. Representation of stereographic recording and reconstruction. (a) Recording. (b) Orthostereoscopic reconstruction ($U_S=U_V$, $D_S=D_V$).

13.3.1 HYPERSTEREOSCOPY. The lens separation on stereo cameras is normally equal to the average human inter-ocular distance of 65 mm ($2\frac{1}{2}$ in.). The lens separation is termed the stereoscopic base and must be increased for distant subjects, or for other subjects where an enhanced stereo effect is required.

The necessary lens separation could be calculated from the visual formula (Eq. 13.1), although it must be remembered that a different value of stereoscopic resolution applies if the photographic resolving power is low. A simpler rule is adequate in all pictorial landscape work:

$$S_c = A/50 \qquad \text{Eq. 13.3a}$$

An alternative form makes some allowance for the subject depth D_s:

$$S_c = \frac{A}{50} \times \left(1 + \frac{A}{D_s}\right) \qquad \text{Eq. 13.3b}$$

Using Eq. 13.3a as a simple rule of thumb, a subject in which the nearest plane of interest (A) is at 1 mile (1·6 km) would require the two exposures to be made about

372

100 ft (30 m) apart. There is wide latitude in pictorial work and for closer subjects a factor of A/100 may give sufficient depth enhancement; subjects with little inherent relief call for a relatively greater lens separation and a value of A/20 may be appropriate.

When the stereo base is *increased* by a factor k, the apparent size and distance of the image are both *reduced* by a factor of k. The image appears closer (because greater ocular convergence is imposed on the person viewing), but it retains the apparent small size of a distant object; we therefore judge it to be a close-up view of a small object (see Fig. 13.4b).

This tendency to produce a model effect is a well-known feature of hyperstereographs. If a base of 25 in ($k=10$) is used for a subject 20 ft high located at 1000 ft the reconstruction appears to be a 2-ft object at a distance of 100 ft.

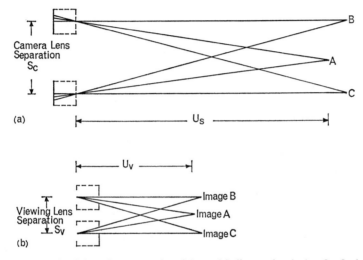

Fig. 13.4. Hyperstereography. Schematic representation of the model effect produced when $S_c > S_v$. In this case the camera separation is twice the normal value ($S_c = 2 \times S_v$) and the apparent distance of the subject (U_v) is half the true distance (U_s).

13.3.2 HYPOSTEREOSCOPY. It is possible to take close-up stereographs with the normal lens separation and to 'toe-in' the camera axes to centre the subject on both records (see Fig. 13.6). However, the difference between the two viewpoints may then be such that relatively large monoscopic zones are present in which no stereo effect can be seen. In addition, a close-up subject requires an unnatural degree of ocular convergence. At the normal minimum distance for distinct vision (10 in.) the angle of convergence is about 15°, but an object at 5 in. requires an angle of 28°; this would cause acute discomfort when viewing the stereo reconstruction at that apparent distance.

For the reasons given above, the normal stereo base (S_c) should be proportionately reduced when the subject distance (D) is less than 10 in. For example, if D=8 in., S_c should be reduced to $2\frac{1}{2}$ in. $\times 8/10 = 2$ in. The camera axes are still normally made to converge, but the reduced angle of convergence will be within comfortable limits for the observer of the stereogram.

13.4 *Camera techniques*

There are several ways of taking stereophotographs:
(1) The special stereo cameras.
(2) Normal camera with stereo attachment.
(3) Normal camera taking pairs of pictures successively.
(4) A pair of normal cameras taking pictures simultaneously.
13.4.1 STEREOGRAPHIC CAMERAS. The history of stereo camera development has been discussed by Dalzell and Linssen.[7] The once-popular plate cameras are now only available from second-hand sources, but Table 13.2 lists several stereo cameras that are currently available. Photogrammetric stereo cameras are discussed in Chapter 14.

TABLE 13.2
RECENT STEREOGRAPHIC CAMERAS*

	Film	Frame size	Lenses	
Duval Stereo	120 film	60 × 60mm	75mm f/4·5	Reflex focusing screen (f/2·8 viewing lens) Shutter 1/10–1/200s
Edixa Stereo 1a	35mm film	23 × 24mm	35mm f/3·5 Cassar	Shutter 1/25–1/200s
Iloca Stereo	35mm film	23 × 24mm	f/3·5 Cassar	Shutter 1/25–1/200s
Iloca Stereo Rapid	35mm film	23 × 24mm	f/2·8 Cassarit	Shutter 1–1/300s Coupled r'finder
Stereo Realist Model 1042	35mm film	23 × 24mm	35mm f/2·8	Shutter 1–1/200s Coupled r'finder
Wray Stereo Graphic	35mm film	25 × 24mm	35mm f/4 Wray	Shutter 1/50s
Viewmaster (G.A.F. Ltd.)	35mm film (double run)	12 × 13mm	20mm f/2·8 Trinar	Shutter 1/30–1/60s

*These details have largely been taken from the 1968 and 1969 lists of current cameras published by the *Amateur Photographer* and from information supplied by Duval Studios Ltd., 217 High Road, Chiswick, Middlesex.

Stereo attachments for standard cameras (see also p. 375)

Duval Stereax	Gives 65mm stereo base	For most miniature and roll-film cameras. Built-in view-finder.
Exakta Large Stereo attachment	Gives 65mm stereo base	Designed for subject distances ∞–2 metres.
Exakta Small Stereo attachment	Gives 12mm stereo base	Designed for subject distances 2m–15cm.

The basic stereo techniques can be adapted for television, using twin monitor viewing screens. Valyus[8] has described a number of autostereoscopic television systems.

13.4.2 STEREOGRAPHIC ATTACHMENTS. When it is not possible to obtain specialised stereo cameras, nor to use the twin-camera techniques mentioned below, a beam-splitting attachment can be fitted to a normal camera; this is the method normally used in stereocinematography.

13.4.2.1 *Two-mirror beam splitters.* Two surface-silvered mirrors are fitted in front of a standard camera (Fig. 13.5a). By setting the mirrors at an obtuse angle (about 170°) two viewpoints are effectively obtained and are recorded side-by-side.

374

The angle of view of each image tends to be limited and the margin between the images is rather ill-defined, but the cheapness and simplicity of the method may make it suitable for occasional use.

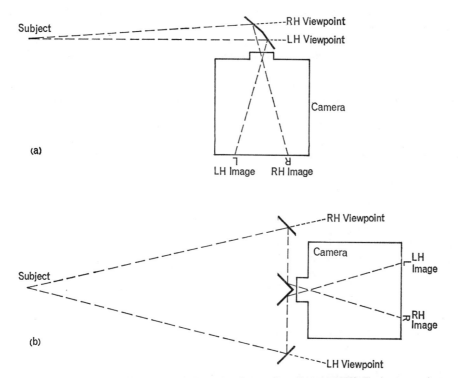

Fig. 13.5. Stereographic camera attachments. (a) Two-mirror beam splitter (Barnard, 1853). The images require transposition for stereo viewing. (b) Four-mirror beam splitter (Brown, 1894); prismatic beam splitters follow the same principle. The images can be viewed on the original film (e.g. cine reversal stock) without transposition.

13.4.2.2 *Four-mirror beam splitter.* Fig. 13.5b shows the principle of several stereo attachments (e.g. Stereax, Stereofocal, Bolex, Exakta, Pentax). These attachments are easily fitted to the camera and give twin vertical-format images correctly orientated within the normal format (e.g. two 16×24 mm frames in the standard 36×24 mm frame area).

The simpler mirror types cause noticeable absorption losses (about half a stop), but the more expensive prism types e.g. Zeiss Steritar give a minimal reduction in exposure and, in addition are less easily damaged or misaligned.

Results with wide-angle or large-diameter lenses are unsatisfactory, owing to vignetting or overlapping of the images. With the Duval Stereax, the recommended maximum aperture for 50 mm lenses is $f5·6$; for 75 mm lenses on 120 roll-film cameras, $f8$ is the suggested aperture.

13.4.2.3 *Interchangeable twin stereo lenses.* Plate cameras can be adapted to stereo work by replacing the lens panel by a mount containing a matched pair of lenses;

375

this principle was also applied in a stereo lens for the Contax 35 mm camera. The stereoscopic base is necessarily limited and this approach is therefore more suited to close-up work; a prismatic attachment can, however, be used to increase the effective viewpoint separation.

As in all twin-lens stereo cameras, the camera body must be divided by a 'septum', to prevent the two images from becoming superimposed.

13.4.3 THE USE OF NORMAL CAMERAS. Despite the continued availability of stereo cameras, most photographers' only experience in this field is with the relatively clumsy twin-camera methods.

13.4.3.1 *Twin cameras.* A pair of cameras can be mounted on to a support for holding in the hand or for mounting on a tripod. In many cases the camera size prevents the lens separation from being set at the standard 65 mm, but the slight hyperstereoscopic effect given by a small increase in base-line is not usually objectionable. For close-up work it is necessary to toe-in the cameras on the support bar. If this method is applied to cine cameras the drive mechanism should be synchronised frame-by-frame.

In long-range landscape work the cameras are often set some distance apart to achieve a hyperstereoscopic effect (see p. 372); in such cases both viewpoints should be at the same height. A signalling system is desirable so that two operators can synchronise their exposures.

When the stereo pair is produced on separate films the processing must be carefully matched. However, suggestions have been made for deliberately mis-matching the camera settings so as to give a superficial illusion of greater range. For example, one exposure can be slightly increased to favour shadow detail while the other is kept to a minimum to record highlight detail. In addition, the focus settings of the lenses may be different, so that sharp images are received over a greater total depth, even though both eyes are not receiving an equally sharp image of a given point.

The same principle of blending two dissimilar images is applied in the polychromatic anaglyph (see p. 378).

13.4.3.2 *Single-camera methods.* A change of viewpoint can be obtained for successive hand-held exposures by shifting the weight from one leg to the other. The lens separation will probably be about 4 inches, which will be satisfactory for most pictorial work.

When cameras are fitted on a tripod, it is easy to use a stereo slide (e.g. Linhof) to permit a rapid and repeatable shift between the two exposures.

A method commonly used with monorail cameras employs the camera shift movements (Fig. 13.6a). For the first exposure the camera cross-front and cross-back are set fully to the right; the second exposure is made with these movements shifted to the left. In close-up work this can be combined with a slight rotation of the camera to keep the subject centred on both negatives.

Instead of rotating the camera in this way, it may be preferable to give a reduced lens panel shift, in order to give a degree of toe-in; this has the advantage of keeping the film plane square with the subject for both exposures (Fig. 13.6b).

For close-up work it is possible to mount the camera on a swinging arm and to centre the subject above the axis of rotation (Fig. 13.6c). Bowler[9] has described a similar method covering the complete periphery of small objects at 10° intervals; this gives a set of 36 stereographs which can be viewed in pairs as required.

376

Another simple way of obtaining two viewpoints is shown in Fig. 13.6d. The camera is pivoted on the tripod, so that the subject is alternately in the left-hand and right-hand half of the field of view.

The camera-shift methods often use separate sheets of film, but it is possible to fit a mask covering half the film inside the slide holder; between the two exposures the slide is taken from the camera and the mask is moved (in a dark room). Alternatively, some studio cameras have been provided with a sliding or dividing back (e.g. Sinar) which allows the two exposures to be made in rapid succession with a standard film dark slide.

13.4.3.3 *Subject adjustment methods.* The preceding methods all involve adjustment of the camera. A similar effect can be achieved by moving the subject:

(1) Shifting the subject sideways.
(2) If the subject is set on a turntable, rotation of a few degrees gives the required change of viewpoint.

In cases where the subject is moved, shadows change their relative position and upset the stereoscopic illusion, so a plain background and diffuse lighting are often recommended. However, directional lighting can be important in a stereograph and it is preferable to fix the lights to the moving subject stage; any cast shadows within the subject will not then alter as the specimen is moved. (Fig. 13.6e).

Practical details of most of these methods, including constructional details, have been given by Symons.[10]

13.4.4 DEFECTS IN PERSPECTIVE. All methods in which the camera or subject is rotated suffer from a geometrical defect of perspective. With such adjustments the camera back is not parallel to rectangular planes running across the subject. They cannot therefore be reproduced as rectangles and the brain must try to interpret a pair of dissimilar trapezia as a rectangular surface. This is particularly unsatisfactory in close-up work, where there is a marked difference between the two viewpoints.

13.5 Stereoscopic viewing methods

The essential feature of any stereo viewer is that each eye should see only its own image. Even when this is assured, it is very important that the stereo pictures are correctly mounted and trimmed; details of the procedure are given in standard reference books[1, 2] and in the *Focal Encyclopedia*.

13.5.1 SIMPLE SYSTEMS. Some people can obtain stereo effect from a pair of stereo prints without any viewing aid. Some strain is involved, because the eyes are focused on the prints, while the ocular convergence is at a relatively small angle to suit the distance of the stereo reconstruction; an effort must also be made for each eye to concentrate only on its own image. Symons[11] has suggested a method for training the eye for this task, but inevitably the effect is of a central stereoscopic image with a monoscopic image on either side.

The effort of breaking the natural inter-link between ocular focus and convergence is slightly eased if the two images are isolated by a central septum, thus eliminating the unwanted side images.

13.5.2 MIRROR SYSTEMS. Wheatstone's viewer (1838) still finds application because the physical separation of the stereo pairs allows the viewing of large transparencies

or prints. The mirror causes lateral reversal and transparencies must be inserted in reverse; paper prints must be reversed in printing.

The Cazes viewer (1895) can readily accept large-format prints without the need for lateral reversal.

13.5.3 LENS VIEWERS. Most of the modern stereo viewers (e.g. Duval Stereolist) follow the principle of Brewster (1843) and Holmes (1861); the latter name is usually given to viewers with an open frame-work. Prismatic lenses are sometimes used: in addition to enlarging the stereo pairs, they deviate the image beam and improve viewing comfort.

The stereographs are placed at the principal focus of the viewing lenses. The emergent beam is then parallel and the eye accepts it as originating from an infinitely distant subject, allowing a relaxation of the eye's focus and improved viewing comfort.

13.5.4 ANAGLYPHS. An anaglyph is produced by printing the stereographs in the form of superimposed red and green images. The use of viewing spectacles, fitted with a red and a green filter, ensures that each eye sees only the appropriate stereo image.

The primary advantage of an anaglyph is that it can be printed photo-mechanically for large-scale distribution. It can also be printed as a transparency for projection to a large audience; no special projection screen is required and the method does not cause the viewing zone difficulties of some autostereoscopic processes.

There is no theoretical limit to the size of anaglyph prints, although there is a drawback in that a pair of viewing filters is required for every observer.

13.5.4.1 *Polychromatic anaglyphs.* The use of complementary colours to code the two stereo images makes natural colour reproduction impossible in normal anaglyphs. However, Dudley[12] has described a two-colour process which uses an adapted four-

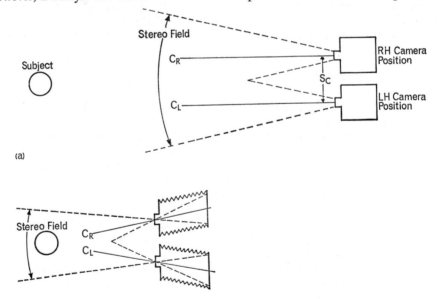

Fig. 13.6. Stereography with conventional cameras. (a) Basic method (lateral camera shift). (b) For close-up work the camera axes C_R and C_L are 'toed in' (here indicated by use of the lens panel shift movements).

378

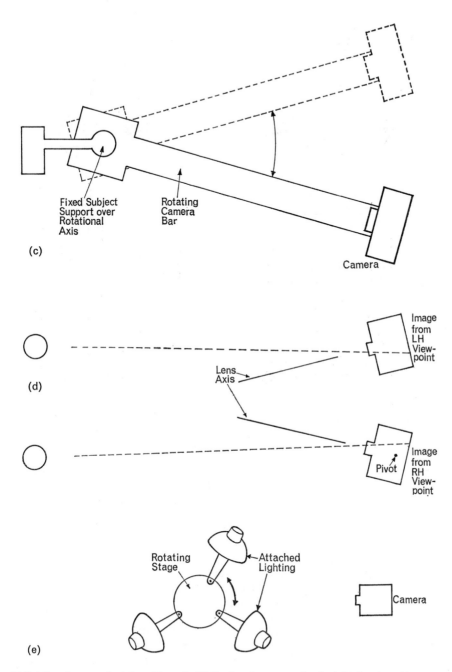

(c)

Fixed Subject Support over Rotational Axis

Rotating Camera Bar

Camera

(d)

Image from LH Viewpoint

Lens Axis

Pivot

Image from RH Viewpoint

Rotating Stage

Attached Lighting

Camera

(e)

(c) Rotation of camera about the subject axis. (d) Pivoting of camera on the tripod. (e) Rotating subject stage.

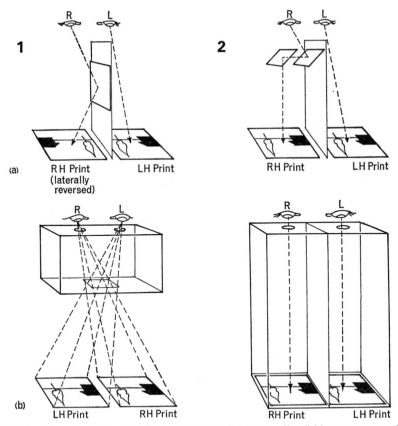

Fig. 13.7. Simple stereoscopic viewing systems. (a) Mirror systems allowing normal interlink between accommodation and convergence. Method 2 does not require a laterally reversed print and somewhat larger prints can be used. (b) Box viewers (without lenses). (1) Elliott stereoscope (1837); an unnatural degree of convergence is required. (2) Simple box viewer; requires reduced convergence.

mirror beam-splitter on the camera and conventional colour film. One aperture of the beam splitter is fitted with a blue-green filter and the other has a yellow filter. The two images are superimposed on the film and, after normal processing, are viewed with coloured filters similar to the camera filters.

One eye receives all the blue-green information from the subject and the other receives all the yellow and red information, but the mental process of binocular colour fusion gives an acceptable impression of the subject colours, while the use of two viewpoints ensures a stereoscopic representation.

13.5.5 POLARISED LIGHT SYSTEMS. Viewing methods using polarised light to code the stereo images can be applied to projected slides or films produced by any of the camera methods mentioned previously. The stereo system projects two beams on to the screen, one polarised vertically and the other horizontally by filters fitted to the projection lens. The audience wears Polaroid glasses which are orientated so that each eye receives only the correct image. Simple viewing boxes can be made on this principle, using polarisers behind the transparencies.

380

Many variations of this technique have been devised, but the projection systems all require a metallised projection screen, because a diffuse screen would depolarise the projected images. Unfortunately, metallised screens are always rather directional so that the viewing angle is restricted. However, the method permits the projection of colour films without any serious loss of quality and is often used, despite the absorption of light by the polarising filters.

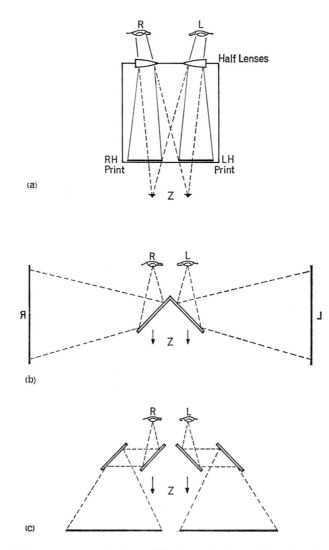

Fig. 13.8. The basis of common stereoscopic viewers (Z is the apparent zone of three dimensional reconstruction). (a) Brewster stereoscope (1844); the half lenses allow the eyes to converge naturally on the reconstruction. (b) Wheatstone stereoscope (1838); requires laterally reversed prints. (c) Cazes stereoscope (1895); normal matched prints are used.

381

In the Vectograph process (Land, 1940) the stereo image itself is formed in a polarising material. Valyus[13] has described the basis of preparing both reflection and transmission prints by this process.

Mention may also be made of Montagne's Spacial 3-D system,[14] which gives a partial illusion of depth by projecting a normal (non-stereo) transparency as two identical but slightly separated images.

13.5.6 AUTOSTEREOSCOPIC METHODS. Autostereoscopy implies a stereo system in which the audience is not required to wear any viewing device. The term 'free viewing' is used in this context, although there are often zones in the auditorium in which the stereo effect is inverted or disapppears. Details of many ingenious autostereoscopic projection systems have been given by Dudley,[15] and Valyus[16] has described much of the pioneer work by Ivanov and other Russian workers.

13.5.6.1 *Parallax stereograms.* Fig. 13.9 shows the principle of Ives' patent for printing a parallax stereogram (1902); Snook (1902) devised a similar method for stereoscopic X-ray fluoroscopy.

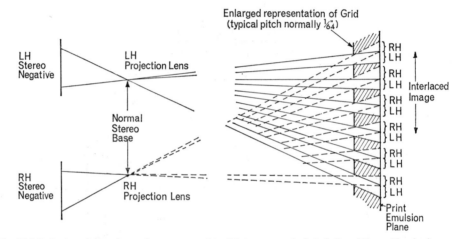

Fig. 13.9. Projection printing of a parallax stereogram (simplified representation). A similar grid is used for viewing; eyes placed at the same distance as the printing lenses will each see only the appropriate image.

A line grid or raster in front of the emulsion acts as a mask, enabling the left and right images to be separately recorded in a series of vertical lines. A positive transparency is then viewed through a similar grid on the projection screen, so that the eye can see only the appropriate image. A simple grid causes a considerable loss of light (about 80 per cent), so most modern systems use a grid of very fine cylindrical lenses.

13.5.6.2 *Parallax panoramagrams.* Kanolt (1915) developed a method using a standard single-lens camera with a grid mounted in front of the emulsion. During the exposure the camera was pivoted about the subject, giving a progressive change of viewpoint. At the same time the grid was moved laterally by one grid pitch (about 0·01 in.) so that elements of the changing viewpoint were recorded within each grid line. This method allows the observer's head to move sideways and see slightly different aspects of the picture while retaining a stereo effect. Valyus and Dudley have described later developments which avoid the need for grid movement (Bessiere, 1925)

382

and permit simultaneous exposure of the whole field on still or cine cameras (Kanolt, 1930). In some systems (e.g. Dudley's panoramic parallax stereogram) the field is recorded instantaneously by a number of separate cameras.

Holograms give a 3-dimensional representation with unique properties (see Chapter 15).

13.6 *Applications of stereophotography.*

Simple stereo techniques can be used to enhance the visualisation of any subject. Dubovik[17] has discussed applications in high-speed cinematography. Accurate measurement of the stereoscopic model, which requires rigorous photogrammetric control, may not be possible with the techniques mentioned here (see Chapter 14).

13.6.1 STEREOMICROGRAPHY. Stereomicrography is effective only when there is good depth of field, which implies low magnification. The technique is preferably used only with magnifications below about $50\times$.

13.6.1.1 *Conventional microscopes.* Most microscopes are fitted with binocular eye-pieces simply to improve viewing comfort and to enhance visual acuity; in such instruments both eyes view the same image and there is no real 3-dimensional effect.

Conventional microscopes can be used for stereo work if the subject stage is traversed between the exposures. As a rule of thumb, the separation should be reduced by S/M (where S is the normal eye separation of 65 mm). For example, at $M=20\times$ the subject shift should be $65/20=3\cdot25$ mm.

13.6.1.2 *Twin-objective microscopes.* Low-power binocular microscopes of the Greenough type consist of a pair of separate tubes mounted with convergent axes. The optical system is not always corrected for photographic work, but a camera can easily be fitted to each eyepiece in turn to record a stereo pair.

13.6.1.3 *Split-field objectives.* Many of the modern binocular magnifiers use a form of split-field objective (Fig. 13.10). Both Zeiss and Wild offer a number of stereo camera attachments for their stereomicroscopes.

Some older stereomicroscopes use a sliding stop behind the objective, which allows the left and right halves of the lens to be used successively as the stereo base. A similar effect can be obtained with a stop behind the substage condenser.

The same principle of 'dividing' the objective was adopted in some high-power binocular microscopes, using a prism to divert the left and right images simultaneously to separate eyepieces.

Further details of some of these methods have been given by Valyus[18] and by Symons;[19] instructions for the critical alignment of binocular microscopes have been given by Burrells.[20]

13.6.2 STEREORADIOGRAPHY. Normal radiographic methods can show internal features, but the location and true nature of defects can best be studied by stereo-radiography, either by fluorographic methods or directly on to film. General information on X-ray stereoscopy is given by Valyus[21] and by Judge.[22]

Stereoradiographs are normally viewed on Wheatstone or Cazes mirror stereoscopes because these allow the use of large films. Dudley[23] has also described a number of autostereographic methods using parallax stereograms and parallax panoramagrams.

The most common methods of depth localisation in radiography do not rely on stereo viewing, but use the 'tube shift' method, in which two exposures are made on

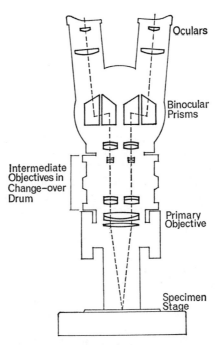

Fig. 13.10. Split field objective in Wild M4a Stereomicroscope. (By courtesy of Wild Heerbrugg Ltd.)

the same film from different tube positions. The technique (also termed tomography in medical work) is explained in the Kodak Data Book.[24, 25]

13.6.3 PUBLICATION OF STEREOGRAPHS. The presentation of stereographs in technical reports and external publications is inhibited because the readers cannot always be assumed to have access to stereoscopes.

The American Xograph process and the German Stereovit process have been used on a large scale for magazines and post-cards. These are autostereoscopic methods and are printed with an overlaid plastic lenticular grid, which is expensive and only suited for mass-circulation prestige productions. There is a strong sensation of depth, but the 3-dimensional effect is not likely to be precise enough for technical purposes.

The most practicable method for small-scale distribution or in text-books[4] is the anaglyph (see p. 378). It may lack certain aspects of realism, but a marked stereo effect can be achieved and there is the advantage that expendable viewing spectacles can be made for each copy of the publication without involving great expense. Hallert[26] has illustrated the use of anaglyphs in aerial photogrammetry.

An alternative approach is to supply stereo colour transparencies mounted in loose cards suitable for the popular stereo viewers (e.g. Viewmaster).

384

References

General

1 JUDGE, A. W., *Stereoscopic photography*, Chapman & Hall, London (1950). [This book gives a thorough account of the theory and application of stereography and, although it is now out of print, remains an excellent work for students.]

2 SYMONS, K. C. M., *Stereo photography*, Focal Press, London (1957). [A useful blend of theory and practice and a helpful introduction to the subject.]

3 DUDLEY, L. P., *Applied optics and optical engineering*, Ed R. Kingslake, Vol 2, Ch 2, Academic Press, New York (1965). [This chapter summarises some of Dudley's earlier book *Stereoptics* [23], and also gives an idea of current American practice.]

4 VALYUS, N. A., *Stereoscopy*, Focal Press, London (1966). [This work is largely concerned with the important Russian contribution to this field, but also gives a most thorough treatment of the whole subject and its modern applications. Anaglyph viewing spectacles are provided for the numerous illustrations.]

Specific

5 TOLANSKY, S., *Optical illusions*, Pergamon, Oxford (1964).

6 OGLE, K. N., *J Opt Soc Amer*, **57**, 1073–81 (1967).

7 DALZELL, J. M. and LINSSEN, E. F., *Practical stereoscopic photography*, The Technical Press, London (1953).

8 VALYUS, N. A., *op cit*, pp 242–260.

9 BOWLER, S. W., *B J Phot*, **110**, 502–3 (1963).

10 SYMONS, K. C. M., *op cit*, pp 56–69.

11 SYMONS, K. C. M., *ibid*, pp 186–88.

12 DUDLEY, L. P., *op cit*, pp 99–101.

13 VALYUS, N. A., *op cit*, pp 114–16, 192–5.

14 MANNHEIM, L. A., *Camera*, December 1963, p 54.

15 DUDLEY, L. P. *op cit*, pp 108–117.

16 VALYUS, N. A., *op cit*, Ch 3.

17 DUBOVIK, A. S., *Photographic recording of high-speed processes*, Eng trans, Ed G. H. Lunn, Ch 14, Pergamon, Oxford (1968).

18 VALYUS, N. A., *op cit*, pp 275–282.

19 SYMONS, K. C. M., *op cit*, pp 123–7.

20 BURRELLS, W., *Industrial microscopy in practice*, pp 377–94, Fountain Press, London (1961).

21 VALYUS, N. A., *op cit*, pp 285–289.

22 JUDGE, A. W., *op cit*.

23 DUDLEY, L. P., *Stereoptics*, Ch 6, Macdonald, London (1951).

24 *Kodak Data Sheet XR-3*, Kodak Ltd., London.

25 *Kodak Data Sheet MD-5*, Kodak Ltd., London.

26 HALLERT, B., *Photogrammetry*, pp 62–3, McGraw-Hill, New York (1960).

14. PHOTOGRAMMETRY

14.1 *Introduction*

Photogrammetry is the use of photography for dimensional analysis. Stereo-photogrammetric methods are normally used, but are not always necessary; a single picture (mono-photogrammetry) is adequate for some purposes.

Accurate measurement is sometimes required in the analysis of motion from standard cine-film records. This does not normally call for stereo techniques, but some of the problems of dimensional accuracy are similar to those of photogrammetry. The equipment used for this work is mentioned in Chapter 11.4.8 and the subject of film analysis and measurement has been discussed in some detail by Hyzer.[6]

14.2 *Photogrammetric principles*

14.2.1 SINGLE CAMERAS (MONO-PHOTOGRAMMETRY). A single camera can readily be used for the measurement of plane (two-dimensional) subjects. If the emulsion plane is set parallel to the subject and if the lens is free from distortion, the camera image is an accurate reproduction of the subject plane at a scale given by the classical lens formula $(m=v/u)$*. The photograph should include a scale or control grid in the subject plane, so that the magnification can be checked, preferably at a number of points in the field. The dimensional stability of the photographic materials must also be considered.

In situations such as aerial photography, parallelism between the subject and the camera cannot be guaranteed and subject rectangles may be recorded as trapezia; in such cases rectification is necessary at the printing stage. Alternatively, if the angle of camera obliquity is known, the true subject dimensions may be derived from measurements on the distorted negative image.

The inherent limitation of a single camera is that it indicates only the *direction* of subject points from the lens viewpoint. For example, in Fig. 14.1 the points A and B lie in the same direction and B is hidden by A. Furthermore, the relative distances of A and C could be deduced only from various intuitive considerations (see Chapter 13, p. 367).

Despite the limitations mentioned above and the inherent distortion of oblique photographs, it is possible to derive measurements to within a few per cent using almost any camera, provided that simple reference objects are included. Williams[5] has described many archaeological and architectural examples using a single square marked on the ground as the basis for constructing complete plan grids. In some cases the position of shadows at known times can give valuable information about the orientation of the photograph.

14.2.2 PAIRS OF CAMERAS (STEREOPHOTOGRAMMETRY). Only the simplest examples are given here in order to illustrate some of the principles involved; standard works on surveying and photogrammetry should be consulted for the approach to the vastly more complex situations of real life.[1,2,3,4,5]

*The special case of orthographic cameras, in which m is independent of u is discussed in Chapter 17.2.3.

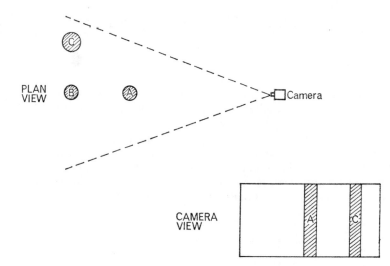

Fig. 14.1. The problem of recording a multiple-plane subject with a single camera. Only if the actual sizes of A and C are known can their distance be estimated from image measurement.

A single-camera record of objects in free space is virtually useless as a dimensional record. In the absence of other information there is no way of telling in which plane a point is situated and precise assessment of the subject's position or size is impossible.

Stereo techniques can be used to find the distance of remote objects, or to measure surface contours, or to estimate the volume of solid objects. It is often useful to study changes in these properties over a period of time by a sequence of stereo recordings.

Fig. 14.2 shows a case where a single photograph could give only limited information; for example, the height and width of the tower and the approximate size of any of the features could be estimated if some key preliminary measurements were made manually. However, although the Z and X co-ordinates of any point can be

Fig. 14.2. X, Y and Z axes in three-dimensional subjects. N.B. In aerial survey the Z-axis becomes the depth axis and the ground locations are given by X and Y co-ordinates.

388

measured on the negative, the exact size of subject features cannot be found unless scales are incorporated in the subject or unless the object distances are known.

A stereophotogrammetric pair of negatives would allow the distance to the tower to be measured in a stereo-plotter and the depth (Y axis) of any architectural feature could be found.

14.2.3 SIMPLE DEPTH MEASUREMENT. Fig. 14.3 shows a plan view of terrain in which an object A in the distant plane AB is photographed from two camera positions. The nodal points of the lenses are shown for the present purpose as single points at R and L. D and C are the principal focal points (the principal focal point is defined as the point where the lens optical axis intersects the principal focal plane).

In the diagram the following geometrical conditions are assumed:

(1) The optical axes DRG and CLH are parallel and are at the same height as the subject line AB (i.e. the cameras are parallel and level horizontally).

(2) The photographic plates are aligned with each other and are parallel to the stereoscopic base line RL and the subject line AB.

(3) The plates are at 90° to the optical axes.

(4) The lens-plate distances RD and LC are identical and in this case are equal to the focal length f. (For closer subjects a greater lens-plate distance (v) is measured and used in the calculation.)

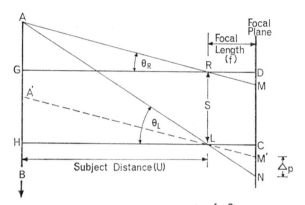

Fig. 14.3. The basis of the parallactic equation for depth measurement $\left(U=\dfrac{f \times S}{\varDelta P}\right)$ For point A the difference of parallax

$$\varDelta p = CN - DM$$
$$= CN - CM'$$

In practice, careful alignment and measurement is required before these conditions can be fulfilled. Where factors are not ideal (e.g. if the lens axes are non-parallel) it is necessary to measure the deviation or to use some other system of reference controls.

The object A produces an image point (M and N) on each plate. The distances of these image points from their respective principal points (DM and CN) are not identical because of the difference in the apparent angle (θ_R and θ_L) of object A from the two camera positions. The difference between the two distances on the negative is called the parallactic displacement or the difference of parallax \varDelta_p.

$$\varDelta_p = CN - DM \qquad (1)$$

389

It is these differences of parallactic angle which give a visual stereoscopic effect and it is the *measurement* of these differences which is the basis of stereophotogrammetry.

A line M^1A^1 is drawn parallel to MA, and M^1N shows the magnitude of Δ_p. The distance AA^1 is equal to RL (the stereoscopic base S).

$$CM^1=DM, \text{ therefore from (1), } CN-CM^1=\Delta_p. \tag{2}$$

AHL and NCL are similar triangles and:

$$\frac{AL}{LN}=\frac{HL}{LC}=\frac{u}{f}=\frac{\text{(subject distance)}}{\text{(focal length)}} \tag{3}$$

From the other similar triangles (AA^1L and LM^1N):

$$\frac{AL}{LN}=\frac{A^1L}{LM^1} \tag{4}$$

$$\text{and } \frac{A^1L}{LM^1}=\frac{AA^1}{M^1N}=\frac{RL}{M^1N}=\frac{\text{stereo-base (S)}}{\Delta_p} \tag{5}$$

Therefore from (3), (4) and (5):

$$\frac{HL}{LC}=\frac{RL}{M^1N} \text{ or } \frac{u}{f}=\frac{S}{\Delta_p}$$

This gives the parallactic equation:

$$u=\frac{f\times S}{\Delta_p} \qquad\qquad \text{Eq. 14.1}$$

which permits calculation of the subject distance from data that can be measured accurately by the photographer.

This example has covered the simple case of a single subject point (A) in free space, but in consequence, the depth variations (Δu) of a subject can be calculated.

The measurement of Δ_p could be carried out with dividers, but the stereo-comparator (Pulfrich, 1902) is used for greater speed and accuracy. Modern stereo plotters permit the direct drawing of subject contours (see p. 401).

14.2.4 HEIGHT DISPLACEMENT. An aerial camera, even if correctly aligned, does not record a true map because of the variations in the ground height:

(1) High ground is reproduced at a larger scale.
(2) The camera is vertically aligned with only one point on the ground (called the centre point, plumb-line point or nadir point) and objects over the rest of the field are viewed obliquely. Images of these off-axis points suffer from height displacement. As shown in Fig. 14.4, the displacement or shift of apparent position depends on the altitude of the object and its distance from the centre point.

When a stereo pair is taken, the outward image displacement of a given object is not the same on each record. The difference in relief displacement observed from two known viewpoints (aircraft positions) is used to find the height of objects on the ground or the ground altitude.

A simple geometric approach to the measurement of subject height is shown in Fig. 14.5.

Point B represents the top of an object BC of unknown height. Successive aerial photographs from A_1 and A_2 show the apparent position of point B to lie in the

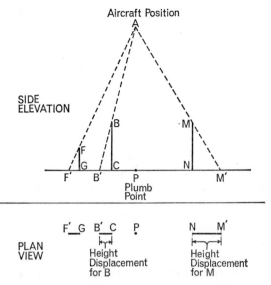

Fig. 14.4. Schematic representation of height displacement in aerial photographs. M′ is the apparent location of M on the ground when viewed from A.

direction of D and E respectively. The ground centre points of the photographs are at X and Y.

The distances A_1X, A_2Y (aircraft height) and A_1A_2 (exposure interval) are given by instruments, while the angles θ_1 and θ_2 (off-axis angles) and $\beta_1\beta_2$ (angular bearing) can be derived from the photographs. From these figures the point intersection C and the height BC can be calculated trigonometrically.

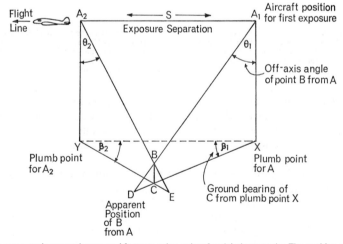

Fig. 14.5. Basic geometry in measuring ground features using pairs of aerial photographs. The position and height of the ground feature BC can be calculated from the known distance S, the known aircraft heights A_1X and A_2Y and the measured angles θ and β.

391

An extensive point-by-point analysis is extremely tedious and such methods have no place in modern cartography; this work is always handled by stereo plotting machines. A carefully planned programme of ground surveying is used in support of the aerial photogrammetry; the ground controls give accurate measurements of key distances and heights and may also clear up points of doubtful interpretation in the aerial photographs.

14.3 *Cameras*

14.3.1 BASIC CAMERA FEATURES FOR PHOTOGRAMMETRY. Any camera used for precise measurement must maintain its critical dimensions under practical conditions. Standard technical cameras can be adapted for this work, but the requirement for rigidity and precise alignment usually leads to the use of specially manufactured equipment. Photo-theodolites and aerial survey cameras fall into this category; these are, in essence, carefully engineered box cameras with auxiliary methods for checking the camera orientation.

Whatever camera is used for photogrammetry, two camera constants must be established; namely the principal distance of the camera and the principal point of the lens. Laboratory methods can usually measure these constants with an accuracy of about 10 μm (0·0004 in.).

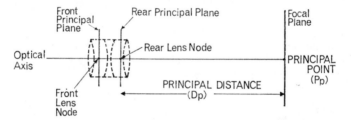

Fig. 14.6. Camera constants and related optical nomenclature. N.B. (a) In practice the principal 'planes' are in the form of spherical surfaces (also known as the equivalent refracting surfaces). The focal 'plane' may also be curved (curvature of field). (b) This diagram shows the normal photogrammetric meaning of 'principal point' (also known as the principal focal point). More generally, the term principal point refers to the intersection of a lens principal plane and the optical axis; it normally coincides with the nodal point.

The principal distance (D_p) is measured from the lens rear node to the required focal plane; survey cameras are usually focused on infinity and D_p is then equal to the focal length. In practice, the rear node is not accessible and the principal distance is calculated from image co-ordinates of collimated beams entering the lens at known angles.

The principal focal point (P_P) is defined as the point where the lens optical axis intersects the principal focal plane. The camera must expose reference marks on to every negative so that P_P can be found accurately on every record; with simple cameras, diagonal lines from the negative corners may be used for this purpose. Knowledge of the coordinates of the principal point is essential for depth measurement and, in any stereo-photogrammetric pair, the subject points corresponding to the two principal points must appear in both pictures.

392

Crone[7] has provided worked examples of camera calibration, including a simple 35 mm camera used for photogrammetry. The use of small cameras in preparing ground plans has been described in detail by Williams[5].

Most survey camera systems use auxiliary cameras or recorders to record information such as camera tilt angle and aircraft height. These 'outer orientation elements' permit exact calculation of the camera position and, together with the camera constants (the 'inner orientation elements') form the basis for all photogrammetric analysis.

Determination of the camera constants is an important part of calibrating the camera for photogrammetry. Other checks which are carried out include:

(1) Tests for film flatness.

(2) Measurement of the separation of focal plane reference marks.

(3) Measurement of lens distortion.

(4) Determination of calibrated focal length.

(5) Resolution tests.

14.3.2 LENSES FOR PHOTOGRAMMETRY. In addition to the stringent requirements for the camera lens, it is essential to have highly corrected lenses for printing the positives (usually diapositive glass plates) and for the stereo-plotting system.

A photogrammetric lens is expected to be free from curvilinear distortion, although this is rarely completely achieved. Other aberrations also affect the accuracy of measurement because they tend to spread the ideal image point into an irregular three-dimensional blob which affects the accuracy of measurement. Curtis[8] has discussed problems arising when accurate measurement is required at high magnification in photomicrography, where the optical system is not primarily designed for geometric fidelity.

Dimensional accuracy is of little use if the image lacks the necessary fine detail or has insufficient contrast; all the factors affecting information content (see Chapter 2) are important.

14.3.2.1 *Focal length.* Accurate knowledge of the lens focal length is a primary requirement; the catalogue value for the lens is often only correct to about 1 per cent (perhaps 0·5 per cent for process lenses) and individual measurement of the lens is required. In some cases the working conditions of temperature and pressure must be simulated at the time of measurement.

Even if the effects of chromatic aberration, spherical aberration etc. are ignored, lenses do not have a single value of focal length over the whole field. There are always small differences in each zone of the image, so that although an axial focal length can be quoted, a mean value may be more appropriate. The term 'calibrated focal length' refers to the value giving the preferred distribution of distortion over the whole field.

14.3.2.2 *Distortion.* In Fig.14.7, rays enter the front lens node (N') at certain angles to the optical axis (θ_1, θ_2 etc.) and emerge from the rear node (N) at corresponding angles (a_1, a_2). The rays in the diagram are assumed to come from infinity and, in the absence of aberrations and field curvature, would form point images exactly in the principal focal plane.

Ideally, these angles would exactly match ($\theta_1 = a_1$, $\theta_2 = a_2$ etc.) but the values of a usually vary slightly from the corresponding values of θ; furthermore, the variation is not constant over the field.

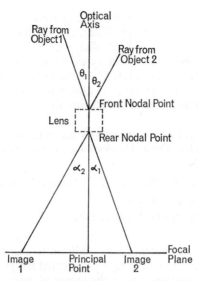

Fig. 14.7. Relationship between entry angle (θ) and exit angle (α). For a distortion free lens $\theta_1 = \alpha_1$ $\theta_2 = \alpha_2$ $\theta_n = \alpha_n$ over the whole field.

The emergent angle of ray Z in Fig. 14.8 is too large; the image point is formed too far from the optical axis and the images in this zone are of greater magnification than the nominal value. This is termed positive distortion, commonly known as pincushion distortion. The opposite situation also occurs and ray Y shows negative or barrel distortion.

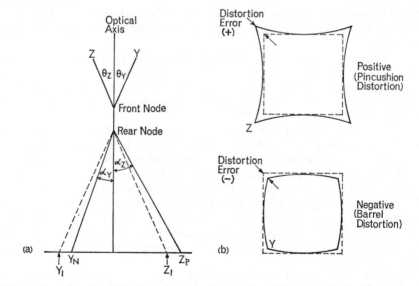

Fig. 14.8. Curvilinear distortion. (a) Positive and negative distortion. Y_1 and Z_1 show the ideal positions of image points Y and Z. Y_N and Z_P show the image positions in the presence of negative and positive distortion respectively. (b) Effect of distortion on a square image.

394

Distortion may be expressed in the following ways:

(1) Most laboratory methods rely on angular measurement of the difference between θ and α; a figure of angular deviation can then be quoted (e.g. '20 seconds of arc at the corner of the field').

(2) The angular measurement is more usually converted to a linear deviation ΔD (e.g. 'the maximum error is $+0.02$ mm').

(3) A percentage distortion figure may also be quoted. For example, an error of 0·2 mm over a 200 mm field is described as 0·1 per cent distortion. Quoted figures for enlarging and process lenses are normally in the range 0·01 to 0·2 per cent. Symmetrical lenses should give zero distortion at 1:1 magnification.

(4) Zonal variations in distortion are important and can be shown only by a curve such as Fig. 14.9.

With simple radial distortion (Fig. 14.8) diagonal lines through the lens axis are not altered in shape. However, errors in lens assembly or imperfections in the lens contour can lead to an asymmetrical effect known as tangential distortion.

In survey work it is usual to refer to a calibrated focal length (Fig. 14.9b) but the preceding points should make it clear that neither distortion nor focal length can be expressed exactly by a single figure.

Manufacturing variations make it essential to test every lens intended for photogrammetry, rather than to rely on batch figures. There may also be differences between distortion figures produced under laboratory and field conditions. The correction for distortion may be optimised for a stated magnification; separate tests are necessary if widely differing image scales are required.

TABLE 14.1

EXAMPLES OF AERIAL PHOTOGRAMMETRIC LENSES

			Field	Quoted Distortion	Negative size
Wild Aviotar	210mm	f/4	60°	$< \pm 10\mu m$	18×18cm ($7 \times 7''$)
Universal Aviogon*	152mm	f/5·6	90°	$< \pm 10\mu m$	23×23cm ($9 \times 9''$)
Super Infragon*	88mm	f/5·6	120°	$< \pm 50\mu m$	23×23cm ($9 \times 9''$)
Zeiss Topar*	305mm	f/5·6	56°	$\pm 3\mu m$	23×23cm ($9 \times 9''$)
Telikon*	610mm	f/6·3	30°	$\pm 50\mu m$	23×23cm ($9 \times 9''$)
Pleogon	115mm	f/5·6	96°	$\pm 4\mu m$	18×18cm ($7 \times 7''$)
Topogon	100mm	f/6·3	96°	$\pm 5\mu m$	18×18cm ($7 \times 7''$)
Wray Air Survey lens	150mm	f/5·6	90°		23×23cm ($9 \times 9''$)

*Lens corrected for infrared and visible spectrum.

A Zeiss Planar 100 mm f/3·5 is available for photogrammetric work with the Hasselblad 500C $2\frac{1}{4}'' \times 2\frac{1}{4}''$ camera.

14.3.3 PHOTOTHEODOLITES. A conventional theodolite consists of a telescope with an eyepiece graticule which can be aligned with any distant point. The bearing of the object point (both in elevation and azimuth) is given by angular scales which, on the best instruments, can be read to 1 second of arc (1/3600 degree or 5 microradians).*

*Some photogrammetric equipment has the angular readings expressed in the obsolescent centesimal method. In this system each quadrant of 90° is divided into 100 grades and these are further divided into 100 centesimal minutes which are again divided into 100 centesimal seconds. For example, 1 radian (57°.29578) equals 63ᵍ66ᶜ20ᶜᶜ (see also p. 140).

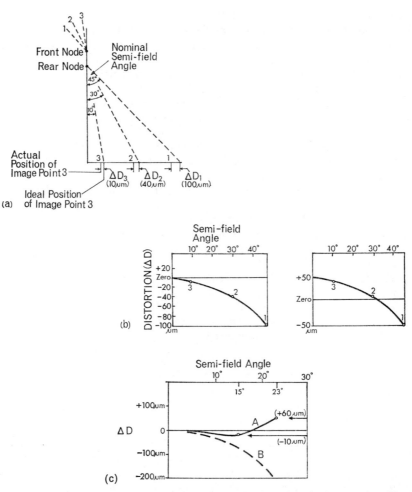

Fig. 14.9. Basis of distortion curves. (a) Simplified ray diagram showing progressive increase of negative distortion across the field. (b) Distortion curves (simple negative distortion). (1) Distortion ranges from zero to −100 um. (2) By selection of a suitable 'calibrated' value for the focal length, the distortion can be re-distributed to cover the range +50 um to −50 um. (c) Interpretation of distortion curves. In this example the maximum distortion over a standard 35 mm cine frame (semi-field angle 15°) is −10 um. Over the larger 24 × 36 mm frame (semi-field 23°) the maximum distortion is +60 um. Curve A shows the distortion at the designed magnification. Curve B shows that distortion may be more serious under other conditions of use.

The design of phototheodolites is based on a rigid fixed-focus camera with a low-distortion lens. The apparatus is fitted with a means of levelling in all planes and some form of fiducial marker or cross-line is fitted into the focal plane to show the position of the principal point on every negative. A reference grid may also be incorporated to show the angular bearing of recorded objects.

In stereophotogrammetry a conventional theodolite is used to establish the alignment and separation of the two phototheodolite positions. The bearing of key points in the subject can also be found by the visual instrument and noted for checking

Fig. 14.10. Calibrated distortion curve for Wray 6" f/5.6 Survey lens (with ⅜" register glass). (By courtesy of Rank Precision Industries.)

against the figures derived from the photographs. In some cases (e.g. the Wild P30 phototheodolite) the theodolite is mounted on top of the camera body.

The accuracy of phototheodolites is probably lower than with the best visual instruments, but a single photograph gives a complete record of many reference points and the time spent in the field is thus reduced; this can be important, for example, when recording the scene of an accident or any moving subject.

14.3.4 CINETHEODOLITES. The determination of missile trajectories requires the recording of subject elevation and azimuth at regular intervals during flight; this task calls for the use of cinetheodolites (see Chapter 12).

TABLE 14.2

SINGLE CAMERAS FOR TERRESTRIAL PHOTOGRAMMETRY

Wild P30 *Phototheodolite*	*Zeiss TMK* *Terrestrial camera**
100 × 150mm plates 165mm f/12 lens Shutter 1–1/500 sec	90 × 120mm plates 60mm wide angle Topogon f/11 Shutter 1–1/400 sec.
Fitted with theodolite reading to 1 sec/arc.	*Similar to a single SMK camera (see Table 14.3).

In both cases the equipment can be set to pre-determined angles of tilt.

The object must at all times be recorded by at least two, but preferably three, cine-theodolites and several instruments may be required to cover a long flight path.

The standard of angular measurement with a cinetheodolite system may correspond to a positional error of about 1 part in 20,000 (approximately 1 foot in 4 miles). In certain conditions, the atmospheric refraction between object and camera can cause significant errors.

14.3.5 SHORT-BASE STEREO PHOTOGRAMMETRIC CAMERA. If separate cameras are used for stereophotogrammetry, the separation and relative orientation of the two cameras must be known accurately. The stereo base is selected in relation to the subject distance and the angle of view of the camera.

For widely separated cameras, standard surveying methods must be used to establish the relative camera positions. However, for the great majority of work a stereo base of a few feet is sufficient and a short-base stereo camera can be used: this gives

397

the advantage of rigid mounting on a common metal base, with a known lens separation and accurately aligned cameras. The optical axes of the cameras are usually parallel, but some types permit a measured degree of convergence for close-up subjects. The camera back is normally kept vertical but many of these cameras also indicate any degree of tilt that is imparted to the camera.

Table 14.3 lists some of the short-base stereo cameras in current use for mapping and other applications; full details of the equipment and the range of accessories are available from the manufacturers.*

TABLE 14.3

SHORT BASE STEREOPHOTOGRAMMETRIC CAMERAS

	Negative format	Base length	Lens	Focusing range	Shutter speeds
Zeiss					
SMK 40	9 × 12cm	40cm	60mm f/11	2·5m–10m	1–1/400 sec
SMK 120	9 × 12cm	120cm	60mm f/11	5m–Inf.	1–1/400 sec
Zeiss Jena					
SMK 5·5/0808	9 × 12cm	40cm or 120cm	56mm f/5·6	1·5m–25m	1–1/500 sec
Galileo-Santoni					
Mark IV	23 × 23cm	30–70cm	150mm f/16		1/25 sec
'A' Standard	13 × 18cm	2m or 3m	150mm f/6·3	5·25m–Inf.	1–1/500 sec
'A' Multi-range	13 × 18cm	2m or 56cm	150mm f/6·3	1·5m–Inf.*	1–1/500 sec
'A' Special	13 × 18cm	56cm	150mm f/6·3	1·5m	1–1/500 sec
Mark II	6 × 9cm**	20cm–2m	75mm f/8	0·6m–Inf.	1–1/200 sec
Verostat	9 × 12cm	120cm	100mm f/6·3	2m–Inf.	1–1/500 sec
Wild					
C12	6·5 × 9cm	120cm	90mm f/12		1–1/250 sec

*By addition of supplementary lenses.
**Roll film.

The distance from the lens node to the emulsion plane is one of the camera constants and is an essential factor in any stereometric calculation. Any extra camera extension introduced for focusing close-up objects must be known accurately; short-base cameras are usually focused in pre-determined steps and the exact value of the extension is automatically recorded on the negative.

14.3.6 AERIAL CAMERAS. Air-to-ground photography falls into two categories—photo-reconnaissance and cartography—and the different circumstances of use lead to considerable differences in camera design.

14.3.6.1 *Photo-reconnaissance*. The use of this term implies that identification of the subject is more important than accurate measurement. Military photo-reconnaissance ranges from the original use of hand-held cameras in light aircraft to sophisticated installations in fast high- or low-flying aircraft. Some of the latter cameras use image-motion compensation (IMC), shifting the film during the exposure in synchronism with the moving image of the ground. Aircraft vibration and other movements necessitate the use of high-speed shutters.

398

In industry and civil engineering, light aircraft or helicopters are often used for illustrative photography. For work of this sort, the chief requirements are a high shutter speed (preferably 1/500 sec) and a compact design that permits rapid but steady operation in a confined space. Most roll-film single-lens reflex cameras are suitable for this work but special cameras such as the Linhof Aero Technika and the Koni Omega are also available.

14.3.6.2 *Cartography*. Where mapping or other accurate measurement is intended, greater precision is generally required than for photo-reconnaissance cameras. Vertically-mounted cameras are used and exposure at known flight intervals gives a succession of stereo pairs along the flight line. Focal-plane shutters give image distortion with moving subjects and between-lens shutters are always used for air surveys; special rotating disc shutters (e.g. the Zeiss Aerotop) can give exposure times down to 1/1000 sec.

Comprehensive details of aircraft cameras and their applications are given in the references [9], [10], [11]. Many examples of the civilian uses of aerial photography have also been published. [12], [13]

14.3.6.3 *The influence of aircraft environment*. Aerial survey cameras must maintain their alignment under all circumstances. One problem is that the reduced temperature and pressure on external cameras at high altitude can cause measurable changes in the camera length. The air density in and around an exposed high-altitude lens is less than at ground level; this causes a relative increase in the refractive index of the lens glasses and very slightly reduces the focal length. Fortunately, for aerodynamic reasons, aerial cameras are usually enclosed within the fuselage or a camera pod and they are also heated to ensure reliable electrical and mechanical operation.

Because of these difficulties, auto-focus systems have been used in some reconnaissance cameras, but the technique is not applied to air survey cameras.

The development of a typical modern air survey camera (the Williamson Eagle 10) has been described by Odle.[14] Cartographic aerial cameras are also made by Fairchild (USA), Galileo (Italy), Wild (Switzerland) and Zeiss (Germany).

14.3.6.4 *Aircraft movement and attitude*. Apart from piloting variations, small changes in aircraft heading, height and attitude arise from gusts and air turbulence. It is essential in photogrammetry to know the height of the aircraft at the instant of each exposure and to know the angle of rotation of the aircraft in three planes:

(1) Roll (rotation about the flight-line axis).
(2) Pitch (rotation about the wing axis—nose-up or nose-down).
(3) Yaw (rotation about a vertical axis—change in aircraft heading).

Readings from altimeters, level indicators and compasses are sometimes automatically exposed on to the margin of each film frame: alternatively, separate instrumentation recording cameras may be used in synchronism with the survey camera.

Horizon-recording cameras (e.g. the Wild HC1) may be used to show the angle of pitch and roll at the moment of the survey exposure. An alternative method of recording the orientation of the air camera is offered by the Galileo-Santoni Solar Periscope, which consists of a camera set on a common framework with the primary survey camera. With this system the sun's direction and a chronometer reading are recorded every time a survey frame is exposed.

14.3.6.5 *Film flatness*. For cartographic work the film should be within about 10 μm of the correct focal plane over the whole negative; any deviation affects the image sharpness and can also cause measurable image distortion.

Many cameras use pneumatic or vacuum systems to hold the film flat, but some designs (notably British cameras) use a mechanical pressure-pad to hold the film against an optically flat glass, through which the image is transmitted. This 'register glass' usually bears a fine grid or reseau, which is recorded on each negative and is used in the subsequent measurement. The grid image can also show any dimensional changes caused by processing.

A new technique devised at Britain's Royal Aircraft Establishment causes the film to be flattened on to the register glass by a travelling roller; auxiliary vacuum slots are set round the edges of the film to prevent ingress of air under the film.[15]

14.3.6.6 *Air survey lenses.* Most air survey lenses are designed to cover a fairly wide angle, for both operational and economic reasons. The aim is to make the survey with the smallest possible number of exposures and from the lowest possible height. The accuracy of contour plotting is improved at lower altitudes and difficulties with haze and low cloud are reduced.

Infrared films are used increasingly for aerial work (see Chapter 7, p. 252). In survey applications the IR image must be the same size as its visible counterpart and many survey lenses are therefore corrected for the visible and near IR regions.

14.3.7 SPECIAL CAMERAS

14.3.7.1 *Fish-eye lenses.* Although fish-eye pictures follow the distorted pattern shown in Fig. 14.11, their wide angle of view makes them useful for some survey work. The azimuth bearing of any object in the field can be measured with a protractor set at the centre point of the photograph; it is only necessary to take theodolite reference bearings of a few key features from the camera position. The measurement of subject distances requires a pair of such photographs to give crossbearings. The

Fig. 14.11. Survey measurements from fish-eye photographs. (a) Plan of subject. (b) Fish-eye view. The length R of each image gives a measure of the angle of elevation (e.g. top of a lamp post).

400

angle of elevation of any subject point from the camera position is related to the radial distance from the corresponding image point to the centre point (see Fig. 14.11).

Longmore has described his Full Field plate camera for the analysis of lighting in building research.[16] By use of a grid superimposed over the photographic prints, the solid angle subtended at the camera by windows and other light sources could be estimated to the nearest 0·001 steradian (a solid angle of about $3\frac{1}{2}$ minutes of arc). The use of the 10 mm Fish-eye Nikkor has been reported for similar work.[17]

14.3.7.2 *Panoramic cameras.* In ground survey work it is often useful to record the relative positions of key features round the horizon. For this purpose a series of conventional photographs can be mounted together, or a panoramic camera can be used. The Oude Delft Hoca-35 is designed to cover the complete horizontal field of 360°, with a vertical field of 14°.

Most panoramic cameras operate on the principle of rotating about the rear lens node (such as those cameras used for the photography of large groups of people).[18] (see 17.2.2) Many panoramic aerial cameras adopt a similar approach and give a strip record covering 180° from horizon to horizon underneath the aircraft. Even these highly distorted photographs, in which every subject point is at a different magnification, can give a basis for mapping if sufficient ground control points are known.

14.4 *Stereometric plotting*

There are two basic approaches to stereo plotting:
(1) Measurement of spatial co-ordinates allows a position to be described in three numbers; this is the digital or analytical approach.
(2) The direct or graphical approach produces a plan, usually showing the height variations as contour lines.

14.4.1 ANALYTICAL PLOTTING. The simplest stereo measuring techniques rely on the use of a parallax bar carrying two glass plates which can be moved along the bar by a micrometer adjustment; each plate bears a reference mark. A stereo viewer (usually of the Cazes mirror type) is used to create a stereoscopic model for the observer and the parallax bar reference marks are adjusted to coincide with two corresponding image points. The marks then fuse stereoscopically and appear to lie as a single 'floating mark' on the surface of the stereo model.

To achieve fusion of the marks at a different altitude on the stereo model, the parallax bar separation must be altered. The difference in micrometer setting enables the relative height of the feature to be calculated; the absolute height above sea level is found by reference to separate ground control data.

Stereo comparators (Pulfrich, 1902) offer a more sophisticated version of the parallax bar principle and in the most advanced forms are capable of measuring the image to 1μm, with automatic tape recording of the readings.

There is now a trend towards computer processing of the space co-ordinates; correction of systematic distortions can be made automatically by the computer before high-speed graphical plotting.

14.4.2 GRAPHICAL PLOTTING. The direct approach to plotting in a stereo-autograph uses the principle of the floating mark to draw the contours of the stereo model on a plotting table. The separation of the reference marks is correct only for one subject

Fig. 14.12. Carl Zeiss C-8 Stereoplanigraph Universal stereo plotter.

height and, if the mark can be moved over the model surface while remaining in apparent contact, contour lines are drawn. Some equipment enables correction to be made for factors such as camera tilt, lens distortion and the effects of atmospheric refraction. In other cases, cross-sections of the terrain can also be drawn.

Descriptions of the basic types of equipment in this field have been given by Crone[1] and Thompson[4].

14.5 *Sensitised materials*

Emulsion properties such as film speed, contrast and granularity set limits to the information capacity of photogrammetric records. These aspects are discussed in Chapter 2 and the only point to be considered here is the dimensional stability of the photographic image, which is largely governed by the base material and the processing and storage conditions (see also p. 445).

14.5.1 STABILITY OF SUPPORT MATERIALS. Many factors affect the dimensional stability of film base and it is impossible to quote fixed figures for the probable dimensional changes; some typical values are given in Table 14.4.

The factors that affect stability fall under two main headings:

(1) *Processing conditions:* Temperature gradients during processing; mechanical stress in processing machines; non-uniform drying. Different types of film base require different drying conditions for optimum stability; the manufacturer's recommendation should be sought.

(2) *Storage conditions:* Humidity; temperature; ageing (irreversible shrinkage due to loss of base solvents).

Some of the processing factors cause permanent size variations. Other changes are reversible and can occur throughout the life of the material.[19, 20] Further references are quoted in Chapter 16 in relation to engineering applications of photography.

All materials change size as the temperature varies and the stability of photographic materials is also closely related to their ability to absorb water. Processed films show a rather lower temperature coefficient of expansion than unprocessed films and the uncoated base shows a still lower value; in some cases the amount of silver present in the image can slightly affect the stability.

TABLE 14.4

DIMENSIONAL CHANGES OF PHOTOGRAPHIC MATERIALS

	Humidity coefficient (% expansion per % R.H.)	Temperature coefficient (% expansion per °C)	Processing size change %	Typical Ageing shrinkage %
Standard film base				
Cellulose acetate	0·007	0·0063	W −0·10 L− 0·09	W 0·44 L 0·33
Cellulose tri-acetate	W 0·0077 L 0·0055	W 0·0063 L 0·0045	−0·05	W 0·30 L 0·20
Polyester base				
Polyethylene terephthalate				
0·007″ Uncoated base	0·0008	0·0018	Range −0·005 to +0·005	
0·007″ Unprocessed film	0·0017	0·0018	—	
0·007″ Processed negative*	0·0015	0·0018	Range −0·01 to +0·03	0·03
0·004″ Processed negative*	0·0026	0·0018	Range −0·02 to +0·04	0,03
Paper base				
Single weight bromide	0·03		W −0·6 L −0·4	
Lacquered bromide	W 0·014 L 0·006		W −0·3 L −0·25	
Aluminium foil base		0·0077		
Glass	Nil	0·0008	Nil	Nil

*The humidity coefficient for a positive image (which usually contains less silver) is intermediate between that for a negative and the uncoated base.

Dimensional stability is a most complex property of photographic materials and the figures in Table 14.4 are included solely to give a general idea of the order of change involved; these values may easily be exceeded under poor conditions. In any application where precise measurements are required, the control of temperature and humidity

is necessary and a closely standardised procedure must be followed at all stages of handling the film.

Wherever practicable, glass plates are used for photogrammetry to avoid most of the dimensional problems. The Wild RC7a Automatic Plate camera offers this facility for aerial work; 80 plates can be stored in interchangeable magazines and can be exposed at intervals down to 4·8 seconds.

14.5.2 HANDLING OF PAPER BASE MATERIALS. Accurately-scaled bromide prints are required for many purposes and the following points may be of interest outside the context of photogrammetry.

Bromide paper is coated in roll form and normally shows greater shrinkage across the width of the roll during the manufacturing process. When the paper is wetted again during development there is a tendency for preferential expansion across the original roll width. Fortunately, if the washed print is allowed to lie flat and dry naturally, the expansion disappears and the final image size is fairly close to that of the exposed image. Gentle warming does not affect the result adversely, but with forced hot-air drying the final paper width is often less than the original size. On the other hand, prints glazed on a drum tend to maintain their wet size because of adhesion to the drum; they therefore may be larger (by as much as 2–3 per cent) than when they were exposed.

Uniform drying is essential to avoid print cockling or other variations in final size; prints should be wiped and laid face down to dry naturally.

When making up a photographic mosaic for copying, the size changes in the prints can be minimised by soaking the paper in water before exposure and by using the washed prints to lay out the mosaic while they are still wet; the copying process then takes place before any drying changes can occur. This approach shows some benefits even if the prints are allowed to dry after processing and are then re-soaked, laid out and copied while wet.

Most of the problems are caused by water absorbed in the paper base and the shortest possible processing times should be used in order to minimise water absorption. Special 'water-resistant' lacquered papers are available which give improved stability, but the best paper material for photogrammetric prints has aluminium foil laminated within the base.

'Developer-incorporated' papers (Ilfoprint, Ektamatic etc.) are scarcely wetted during processing and should retain their exposed size fairly well (to about 0·1–0·2 per cent in either dimension). There is still the possibility of changes during subsequent storage due to humidity variations.

Many of the difficulties can be minimised by correct storage conditions and by laying all the print exposures in the same direction relative to the original roll. When removing the paper from its packing, it should be allowed to come into equilibrium with the surroundings before exposure takes place.

14.5.3 EMULSION MOVEMENT. Whatever base material is used, photogrammetric records always consist of a silver image in a gelatin support. During emulsion manufacture the gelatin is hardened, but it is never a really stable material. Photographic processing and drying cause swelling and shrinkage of the emulsion which leads to microscopical changes in image position. Uneven drying can cause quite large shifts (up to 20 μm) in the vicinity of large water droplets and slow drying after a bath of wetting agent is therefore always recommended, even for glass plates.

404

Reaction products of development tend to cause local hardening of high-density areas; the gelatin layer is then subject to local variations in swelling and rate of drying, so that small image areas may change in size and position (Ross effect). Altman and Ball[21] have discussed the dimensional stability of plates and have emphasised the need for careful handling and controlled processing.

Emulsion movement also has detrimental effects in holographic interferometry (see Chapter 15, p. 433) where a reconstruction is compared directly with the original subject. Butters *et al*[22] have described a method of reducing emulsion movement by releasing strains in the gelatin before exposure.

The question of image movement may be considered in conjunction with the Kostinsky effect and other adjacency effects which influence the apparent position and size of small images.[23]

14.6 *Photogrammetric applications*

It is customary to make a distinction between topographical (mapping) and non-topographical photogrammetry. Although the former is the most widely-used single application, the emphasis of this chapter is on some of the broader scientific and industrial aspects.[24, 25]

Current developments in photogrammetry are discussed regularly in the specialist journals listed at the end of the chapter.

14.6.1 AERIAL SURVEY. Aerial photography is expensive and is particularly subject to weather delays, but for surveys of large remote areas the speed of operation is of tremendous advantage, despite the necessity for accurate ground controls to support the aerial work. Ground surveys are still used where very high accuracy is required over small areas, or where there is extensive tree coverage of ground features, but the wealth of detail in air photographs surpasses what can reasonably be recorded with ground survey instruments.

A simple or uncontrolled mosaic is made by laying together a set of aerial photographic prints. The scale varies over the mosaic because of camera tilt and variations in ground level (particularly with low-altitude surveys); it cannot be regarded as a true map, but is useful for many purposes that do not require exact measurement.

A controlled mosaic or photo map is made up from a set of prints which are rectified for tilt effects and are corrected for variations in scale.

A planimetric map is geometrically correct and shows the size and position of ground features without showing variations in height; the simplest example is a street map.

A topographic map shows contour lines as well as surface details. The contours are nowadays plotted automatically, all scale variations being eliminated either in the photographs or in the plotting machine.

Three-dimensional solid models of terrain and other objects can be cut directly from contour maps.[26]

The current uses of maps need hardly be listed here, but the following examples show ways in which aerial photogrammetry is used.[9, 10, 12, 13] The special features of hydrographic surveys have been covered by Kudritsky *et al*.[27]

Detailed maps of proposed road routes and civil engineering projects can best be produced by aerial survey. Where cutting or levelling is required the volume of earth to be moved can be calculated from stereo photographs; this obviously helps the planning of machinery requirements. Aerial survey may be particularly useful in charting seasonal changes in swamps or rivers or in studying the rate of coastal erosion.

There are many applications where an aerial survey costs only a fraction of an equivalent ground survey. Stereophotogrammetry has been used, for example, to measure the average height of trees; in inaccessible forest areas the volume of timber stocks in a given area can be estimated and a tree-type inventory can be drawn up. In agricultural work it has been possible to estimate the size of a fruit harvest by the size of the heaps of picked fruit.

In the event of widespread plant disease or attack by insects, aerial mapping may be the only method of progressive assessment. In such cases high cartographic accuracy is not usually required.

The scale of aerial surveys may range from about 1:100 000 to 1:1000, allowing the ground contours to be plotted with an accuracy of 1 or 2 feet. Cheffins has described low level (250 feet) surveys from a helicopter giving results accurate to \pm 1 inch.[28]

Colour photography (including IR false colour) has been used in survey work from low and high altitudes[10]; in general, colour may offer more rapid and accurate interpretation than B&W panchromatic records. A number of aerial colour films are made by Eastman Kodak and GAF (Anscochrome).

14.6.2 GEODESY. Geodesy is the study of the earth as a whole and its general shape rather than its local contours. Limited geodetic surveys have been made by aircraft, but a number of orbiting satellites now offer continuous survey information.

The precise plotting of the location of isolated islands has always been difficult, but a system of 'flare triangulation' offers improved accuracy. A rocket-borne flare is photographed from accurately surveyed control stations and the flare position is determined by normal photo theodolite methods. The flare is simultaneously photographed from the 'unknown' site and the image bearings from that point are used to calculate the ground position.

The geodetic satellite ANNA carries a xenon flash beacon and has served as a reference object for surveys of this type; a positional accuracy of a few feet has been achieved over distances of several hundred miles.[29]

14.6.3 PHOTOGRAMMETRY FROM SATELLITES. Orbiting satellites offer facilities for geodetic and other surveys on a global scale. Apart from military surveillance satellites, the best-known system is perhaps the TIROS series of weather satellites which record cloud patterns and gross surface details, such as ice cover. TIROS uses three television cameras with lenses giving a maximum surface resolution of 3 km, 2 km and 300 m respectively.

The requirement for accurate maps of the moon in the middle 1960's led to the development of a number of lunar satellites (e.g. Zond, Lunar Orbiter). These gave television survey photographs with a surface resolution of a few feet, at a time when the limit of resolution from earth-based cameras was about $\frac{1}{2}$ mile.

14.6.4 ASTRONOMY. Astrometry is the science of measuring star positions and charting the movement of heavenly bodies. Photogrammetric principles are used to find the space co-ordinates and these are expressed in digital form in star catalogues.

406

Determination of the orbital positions of artificial satellites is of great importance in space research. Fixed cameras are normally used, in which the orbiting satellite passes across the camera field and leaves a continuous trace. The Zeiss BMK Ballistic camera is made specifically for this purpose.

Hewitt[30] has described a $f1$ Schmidt lens camera for recording the position of satellites; in this design the exposure is interrupted by a rotating shutter which gives a time-base to the recorded trace with an accuracy of ± 0.5 msec. This is a single-camera system (as distinct from stereophotogrammetry) but an accurate directional reference is given by a supplementary pre-exposure to the star background. By this method the satellite direction can be fixed to within 1 sec/arc (about 5 μrad).

14.6.5 BUBBLE CHAMBERS. The bubble chamber (and the earlier cloud chamber) are used in the study of nuclear particles. Charged particles (mesons, neutrinos etc.) passing through the chamber cause tracks of droplets or bubbles. The trajectory of a track and any changes in direction after particle collisions are of vital interest to the physicist; very precise photogrammetry is required to determine the spatial co-ordinates of each event.

Bubble chamber recording is further described in Chapter 17.

14.6.6 MEDICINE. The development of tumours and other medical conditions has been recorded by stereo methods and the shape of the eye has also been studied photogrammetrically.[31] The method has been used to measure changes in facial appearance; according to Beard,[32] the facial volume can be estimated to 1·4 per cent.

14.6.7 INDUSTRY. Surface mapping of models by photogrammetry can be used to make accurately dimensioned drawings for production purposes. The contours of the model may be plotted graphically or the point co-ordinates may be recorded on tape; with numerically-controlled equipment the photogrammetric digital information can be used for automatic machining. Delius has described the use of this process in the car industry.[33]

In the field of engineering inspection, stereo methods can be used for checking completed installations. For example, the form of radar dishes has been recorded under severe wind loads which preclude direct visual measurement. In the metrology laboratory, stereo resolution may be good enough to measure variations in surface finish, although interferometric methods are normally used for polished surfaces (see Chapter 15).

Farrand[34] has applied stereophotography in the production of working drawings from planning models of chemical plant. He has also described a simple overlay photo-comparator for drawing-office use;[35] with this system the draughtsman has access to 3-dimensional information about a complete chemical plant without leaving the design office.

Photogrammetry has been used for the estimation of stock-piles or for assessing progress in excavation work. A contour map allows the measurement of the volume of mineral heaps that are too large for normal manual stock-taking.

Industrial inspection often calls for measurement of the position of internal defects and stereo techniques may be applied to radiography (see Chapter 9).

14.6.8 ARCHITECTURE. Ground-based photogrammetry is used for the survey of ancient monuments and large engineering projects such as dams and bridges. A case of archaeological interest was the recording of the statues at Abu Simbel;

photogrammetric contour maps of these structures offered the only basis for accurate reconstruction after they were moved to another site.

Another well-known reconstruction,[36] based on 'family' photographs taken many years previously, was undertaken at Castle Howard, which was destroyed by fire in 1940. The original cameras were available for post-calibration and the pictures were successfully used to make scaled plans for re-building. Williams has given several worked examples in the analysis of old photographs.[5]

During the last war the National Buildings Record was set up to make provision for the reconstruction of any buildings of national importance that might be destroyed. Instructions were issued through the Royal Photographic Society[37, 38] to enable the advanced amateur to produce usable photogrammetric records with conventional cameras; with suitable precautions a dimensional accuracy of ± 1 per cent was regarded as achievable.

Photogrammetry is also used for the study of structural flexing due to wind, traffic or other influences. Sequences of stereo photographs can show small random movements over a large structure far more readily than instrumental methods.

14.6.9 RADAR. The original application of radar as an aircraft location detector has been extended to provide CRT radar 'map' displays (plan position indicators—PPIs) for air traffic control and meteorological observation.

Airborne radargrammetry has an important role as an adjunct to normal aerial mapping because ground surveying can be undertaken from an aircraft under adverse weather conditions or in areas continually covered by cloud. Levine[39] has thoroughly described the basis of radar systems and has discussed the cartographic performance of both PPI and side-looking airborne radars, including factors affecting the photography of the CRT display.

De Loor[40] has illustrated the use of wavelengths in the 8 mm–50 mm band in the study of ground features; amongst other effects the 'radar signature' of vegetation was shown to vary according to the season.

The use of ultrasonics for finding the location of internal defects is mentioned in Chapter 15, p. 436.

References

General

1 CRONE, D. R., *Elementary photogrammetry*, Edward Arnold, London (1963).
2 MOFFITT, F. H., *Photogrammetry*, 2nd Ed, International Textbook Co., Scranton, Penn (1968).
3 THOMPSON, M. M. (Ed), *Manual of photogrammetry*, 3rd Ed, American Society of Photogrammetry, Washington DC (1966).
4 VALYUS, N. A., *Stereoscopy*, Ch 7, Focal Press, London (1966).
5 WILLIAMS, J. C. C., *Simple Photogrammetry*, Academic Press, London (1969).

Specific

6 HYZER, W. G., *Engineering and scientific high-speed photography*, Ch 10, Macmillan, New York (1962).
7 CRONE, D. R., *op cit*, p 28.

8 CURTIS, A. S. G., *Photography for the scientist*, Ed C. E. Engel, Ch 10, Academic Press, London (1968).
9 AVERY, T. E., *Interpretation of aerial photographs*, Burgess, Minneapolis, 2nd Ed (1968).
10 SMITH, J. T (Ed), *Manual of Color Aerial Photography*, American Society of Photogrammetry (1968).
11 MAGILL, A. A., *Applied optics and optical engineering*, Ed R. Kingslake, Vol IV, pp 143–63, Academic Press, New York (1967).
12 ST. JOSEPH, J. K. S. (Ed), *The uses of air photography*, John Baker, London (1966).
13 HAMMOND, R., *Air survey in economic development*, Muller, London (1967).
14 ODLE, J. E., *Photogramm Rec*, 5, 37–49 (1965).
15 CLARK, J. M. T., *Photogramm Rec*, 6, 168–187 (1968).
16 LONGMORE, J., *Phot J*, 104, 133–141 (1964).
17 ANON, *B J Phot*, 115, 1100–2 (1968).

18 THOMSON, C. L., *Phot J*, **106**, 214–18 (1966).
19 *Kodak Data Sheet RF-10*, Kodak Ltd., London.
20 MEERKAMPER, B. and COHEN, A. B., *J Phot Sci*, **12**, 156–167 (1964).
21 ALTMAN, J. H. and BALL, R. C., *Phot Sci Eng*, **5**, 278–82 (1961).
22 BUTTERS, J. N., DENBY, D. and LEENDERTZ, J. A., *J Sci Instrum*, **2**, 116–17 (1969).
23 PERRIN, F. H., *The theory of the photographic process*, Ed C. E. K. Mees and T. H. James, 3rd Ed, pp 521–3, Macmillan, New York (1966).
24 ATKINSON, K. B. and NEWTON, I., *Photography for the scientist*, Ed C. E. Engel, Ch 6, Academic Press, London (1968).
25 ATKINSON, K. B., *Perspective world report: 1966–69*, Ed L. A. Mannheim, pp 239–47, Focal Press, London (1968).
26 PACKMAN, P. J., *Civil Eng.*, October (1967).
27 KUDRITSKY, D. M., POPOV, I. V. and ROMANOVA, E. A., *Hydrographic interpretation of aerial photographs*, Israel Programme for Scientific Translation, Jerusalem (1966).
28 CHEFFINS, O. W., *Photogramm Rec*, **6**, 379–81 (1969).
29 SWENSON, J. P. B., *Phot Sci Eng*, **7**, 317–22 (1963).
30 HEWITT, *Phot Sci Eng*, **9**, 10–19 (1965).
31 ATKINSON, K. B. and NEWTON, I., *op cit*, pp 276–7.
32 BEARD, L. H., *Perspective world report: 1966–69*, Ed L. A. Mannheim, pp 249–53, Focal Press, London (1968).
33 DELIUS, P., *B J Phot*, **112**, 504–10 (1965).
34 FARRAND, R., *Photogramm Rec*, **5**, 100–112 (1965).
35 FARRAND, R., *B J Phot*, **114**, 482–85 (1967).
36 THOMPSON, E. H., *Photogramm Rec*, **4**, 94–119 (1962).
37 SPENCER, D. A., *Phot J*, **81**, 477–480 (1941).
38 WALDRUM, P. J., *Phot J*, **81**, 480–485 (1941).
39 LEVINE, D., *Radargrammetry*, McGraw-Hill, New York (1960).
40 DE LOOR, G. P., *Photogrammetria*, **24**, 2, 43–58 (1969).

Technical journals

Photogrammetria, published bi-monthly by Elsevier, Amsterdam for the International Society for Photogrammetry.
Photogrammetric Engineering, published monthly by the American Society of Photogrammetry.
The Photogrammetric Record, published half-yearly by The Photogrammetric Society, London.

15. PHOTOGRAPHIC VISUALISATION

15.1 *Introduction*

'If you can see a subject, you can photograph it' is a commonly accepted statement, although there may well be difficulties in achieving accurate or unambiguous reproduction. However, one of the advantages of photography is that it is not limited to recording visible effects and this chapter describes a number of optical and photographic methods that enhance visualisation. Other techniques that present fresh aspects of a subject such as high-speed and time-lapse photography, microscopy, IR and UV photography are covered elsewhere in this book.

There are still some phenomena that defy any form of visualisation (e.g. smell), but most properties of a subject can be shown and recorded, either by standard optical techniques (e.g. gas flow in a schlieren system, chemical composition in a spectrograph) or by indirect photography of instruments (e.g. sound recording, position indications on a radar screen).

The eye can distinguish colour more readily than monochrome tones and it is often helpful to transform some aspect of a subject into a 'false colour' visual display to assist interpretation (see p. 434).

15.2 *Simple flow visualisation*

Most designs for major engineering projects, ranging from aircraft to hydro-electric schemes, are now tested in model form. In many cases the effects of wind or water flow affect safety or efficiency and photography must be used to record the behaviour of the structure and its environment under simulated operational conditions.

Wind tunnel and water test tanks provide an essential stepping-stone between the designer's initial calculations and the completed project. However, even with carefully designed experiments, a number of factors may prevent a simple scaling-up of the test results; flow studies are often continued on full-scale prototypes.

In all motion studies the exposure frequency and the exposure duration must be carefully chosen in relation to the flow velocity. For example, in spray photography a short exposure gives good spatial resolution and may allow individual droplets to be studied; alternatively, a longer exposure shows each droplet as an elongated track, which indicates the flow line and may allow the velocity to be estimated from the length of the track.

The application of flow visualisation techniques and their interpretation has been described in a number of Papers on fluid mechanics and aerodynamics.[1, 2, 3, 4]

15.2.1 AERODYNAMICS

15.2.1.1 *Tufts and flags.* One of the simplest ways of showing the pattern of airflow across a surface is to attach tufts of cotton. The direction of flow is thus shown at a number of fixed points and the subject can be filmed at any required interval. Tufts give rather limited information, but require no special visualisation apparatus and need no attention during the test; they can easily be used on a full-scale structure.

411

15.2.1.2 *Smoke tracers*. Smoke streams react quickly to small and rapid fluctuations in an airstream and thin filaments of smoke can be introduced in wind tunnels or on full-scale structures.

White smoke is normally preferred, set against a black background; in some cases a 'slit' of light is used to confine the record to a single plane of the test chamber. Care is needed to ensure that the smoke is evenly illuminated.

15.2.1.3 *Solid tracers*. It may be difficult to sustain a smoke trace over large areas or at high velocities and, in some cases, solid tracers such as wood chips, aluminium flakes or chalk dust have been used. The size and density of the tracer particles must be considered in relation to the gas velocity, because gravity and centrifugal effects tend to draw the tracer out of the air stream.

15.2.1.4 *Surface coatings*. Coatings of oil and pigment are sometimes used on wind tunnel models to study the behaviour of the surface flow. The oil tends to flow along the lines of the air stream and leave a record of the surface air flow after the test. The specular reflections on a polished model may be avoided by using fluorescent oil as the surface coating. The flow pattern then shows clearly under UV irradiation but the ultraviolet metallic reflections are absorbed by a filter on the camera (see Chapter 8).

Wind tunnel models may also be given a coating of china clay suspension. A liquid overcoating is then applied which evaporates more quickly in regions of turbulent flow; the white china clay is revealed and the model can be photographed when required.

15.2.2 HYDROLOGY. Fluid flow and various hydrodynamic effects are studied in natural waterways and when designing ships, underwater equipment and chemical plant. In some cases *water* flow models are used to study the effects of *air* flow on models of aircraft or buildings.

15.2.2.1 *Surface tracers*. The photography of a water surface requires no special equipment, although the recording of wave patterns over a large area calls for careful positioning of the lighting; ripples and small wave crests are normally shown by controlled specular reflection.

Plate 29 shows the 'starry sky' technique, in which the undulating motion of the water surface is recorded by the time exposure of specular reflections from small lights suspended above the water.

Coloured dye, fluorescent solutions, milk, white powder, confetti, or powdered aluminium can be used to trace surface currents in model work, but to avoid chemical contamination in natural waterways, wooden floats or polystyrene spheres are normally used and recovered if necessary. Off-shore sea currents have been plotted, using a floating light and stereo photography from known positions on the shore.

15.2.2.2 *Sub-surface flow*. Solid tracers, dye streamers, immiscible liquids or bi-refringent liquids have been used in water-flow models[2] and in propeller boundary-layer studies;[5] the density must be well matched to that of the water, otherwise one liquid tends to sink. In some cases a stream of bubbles is generated to act as a buoyant flow tracer; these can be introduced from an air line or can be produced as hydrogen bubbles by hydrolysis of the water from a current-carrying wire.[6]

Some of the most important hydrodynamic work involves high-speed photography of turbulence and cavitation. Dark-field or simple side lighting is normally used to show the bubbles and entrained air, but if necessary the shadowgraph, schlieren or interferometric methods may be applied (see p. 412). These more sensitive techniques

can show small density gradients caused by temperature variations or by the mixing of fluids of different refractive index.

15.2.2.3 *Droplets and sprays.* In the photography of mists and spray patterns, flow tracers are not needed, because the droplets can be observed directly once a suitable lighting technique has been established. The best subject contrast is usually achieved either by a condenser optical system or by dark-field illumination.

It is sometimes necessary to use frontal or simple side-lighting which, although it produces a bright specular highlight in each droplet, does not usually show the full size of the individual bubbles. An opaque white fluid may be preferable, such as milk, or a fluorescent solution under UV irradiation.

The lighting technique can have a profound effect on the appearance of spray sheets and the information that can be obtained from the photograph. Fraser and Dombrowski[7] have shown the differences between diffuse and specular illumination, both with reflected and transmitted illumination.

15.2.3 WORK FLOW AND MOTION ANALYSIS. Since Muybridge's studies of human and animal movement (1879) sequences of still photographs have been widely used for the analysis of motion.

Time-lapse cinematography (see Chapter 10) assists the visualisation of the pattern of slow-moving events. It has been used, for example, to study traffic flow at complex road intersections.[8] Analysis of this type of record can show the interrelation of events separated both in space and time; if necessary, separate cameras can be pulsed together to cover different viewpoints.

Gilbreth (1912) originated the use of the chronocyclegraph in work study to record manual movements.[9] The usual method is to fix small battery-powered lamps to the hands; by working with a black background in a semi-darkened room, a time exposure during one cycle of the operation gives a trace of the sequence of events. Additional information can be obtained by the use of different coloured lamps on each hand and by stereo recording (see Chapter 13). If the trace is interrupted at regular time intervals by using a pulsed lamp, the speed of the movements can be deduced from the recorded light-spot separation. There may be ambiguity about the direction of some movements, but this can be indicated by modulating each light pulse to give a low intensity tail to the moving light spot.

It is difficult to fit lamps on to small mechanisms but it may be possible to use reflectors or fluorescent indicator spots.

Similar methods can be used to study mechanical movements.[10] It is sometimes easier to use continuously-running indicator lamps and to interrupt the exposure by a revolving shutter in front of the camera lens. The pulse frequency is then governed by the shutter revolution rate and the length of the pulse is controlled by the shutter sector angle and the subject velocity.

A similar technique is shown in Plate 31, using floating candles as indicator lights for tidal and current studies in scale hydrological models. In some cases the shutter opening has two unequal sectors, giving a long-and-short double pulse, which provides directional information.

15.2.3.1 *Oscillatory movements.* Some reciprocating movements cannot be studied by simple chronocyclegraphs because the indicator light would follow a single up-and-down path. In such cases a streak camera with continuously-moving film could

be used (as described for CRT recording in Chapter 11); the results would then take the form of a graph, with the motion amplitude traced out against time.

A similar effect can be obtained by rotating a still camera about the lens rear node during the event, which gives the equivalent of a moving-film camera with a fixed lens (see Plate 35).

Stroboscopic techniques in the study of cyclic events and vibration analysis have been mentioned in Chapter 11.

15.3 *Special optical systems*

The velocity of light through a medium is altered if changes in temperature or pressure affect the density of the medium. These effects occur, for example, whenever temperature gradients arise, or when different fluids are mixed, or at a shock-wave front.

There are three ways of visualising these changes in the subject medium:
(1) Light passing through a zone of different density is refracted from its original path (see Fig. 15.1): this is the principle of the shadowgraph.
(2) The refracted rays can be visualised by use of a knife-edge stop or similar device: this is the principle of schlieren systems (see Fig. 15.2).
(3) Light passing through a zone of different density changes in velocity; it can be made to interact with a similar undisturbed beam and show an interference pattern (see Fig. 15.5).

Each method has its own field of application[3] and Holder and North, in their classic monograph on schlieren methods,[11] have illustrated all these techniques (see Plate 36).

15.3.1 SHADOWGRAPHS

15.3.1.1 *Direct shadowgraphs*. Fig. 15.1a shows the simplest direct method of recording shadowgraphs, in which a small source produces a shadow of an object on the emulsion. As in radiography (see Fig. 9.5) the source size (S), the source distance (D) and the object-emulsion distance (E) all affect the sharpness of the shadow.

The tendency for image spread is minimised if the beam is collimated, this makes more efficient use of the light flux, although it limits the size of field that can be studied.

Under favourable conditions, direct shadowgraphs can show fine detail in silhouette and offer a simple way of recording sound shock-waves in acoustical studies. Good definition calls for a small source (an air spark is often used) and a small film distance (E), which is not always practicable.

The definition of the shadow may also be affected by diffraction at the subject. These factors may also be considered in high resolution contact printing, as for microcircuits.[12]

15.3.1.2 *Camera-recorded shadowgraphs*. Direct recording of shadowgraphs requires a darkened room and a sheet of film as large as the subject field and it is usually more convenient to use a camera to record the silhouette (Fig. 15.1b).

An evenly lit background is easily produced with translucent Perspex, but the scattered illumination tends to reduce image contrast, which may affect the resolution of fine details: a condenser system makes more efficient use of the illumination but

414

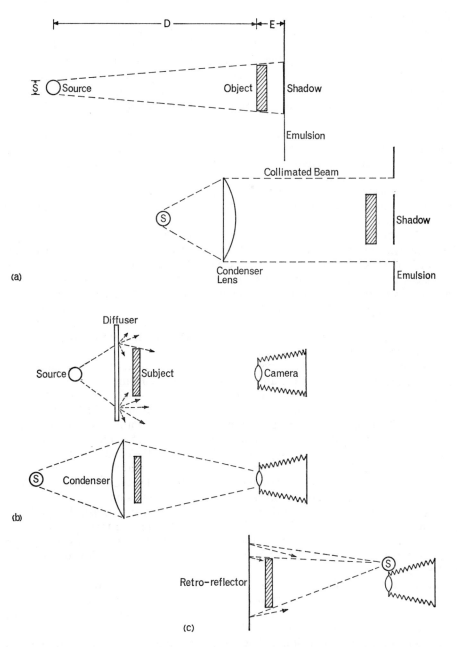

Fig. 15.1. Shadowgraph systems. (a) Direct shadowgraphs (b). Camera-recorded shadowgraphs. (c) Reflected-light shadowgraph.

requires much more care in alignment. However, it should not be assumed that these camera systems always give a resolution equal to that of the direct shadowgraph.[11]

Fig. 15.1c shows a method using Scotchlite* as a reflective bright-field background. The material is designed as a retro-reflector and directs most of the incident light back towards the source; if the source is close to the camera a useful proportion of the light enters the lens (the same principle is adopted in modern road signs). Any disturbance in the light path absorbs, scatters or refracts light away from the lens and is shown as a dark silhouette. With control of the ambient lighting entering the camera the method is efficient enough for the study of detonation shock-waves in full daylight.[13]

Barkofsky[14] has used this last approach to record six successive images of a missile trajectory on the same film, using a repetitive flash at rates up to 2000 per second. The fact that several superimposed images can be distinguished illustrates the high image contrast obtainable.

15.3.2 SCHLIEREN SYSTEMS. The schlieren methods were originally used to show variations in refractive index within glass; the word derives from the German *schliere* meaning streaks.

Fig. 15.2 shows Toepler's method (1864) and a few variations of the technique. The basic principle is that light rays are refracted as they pass through a density gradient in the test medium and are thus deviated either above or into a knife-edge stop placed at the focus of a condenser system. The brightness of each point in the image field is thereby modulated according to the density gradient at the corresponding point in the working section and a monochrome pattern is seen in the camera. For example, undisturbed areas appear grey, but areas of increasing gas pressure appear light and areas of decreasing pressure appear dark. Inversion of the knife-edge reverses the tones of the image pattern.

This simple system shows only rays displaced perpendicularly to the slit and knife-edge; these are aligned to suit the anticipated shock wave-front.

A graduated grey filter may be used in place of the knife-edge; the amount of light transmitted to any image point then depends on the position at which it strikes the filter which, in turn, depends on the refraction of the ray within the test medium.

A colour schlieren system may be set up as shown in Fig. 15.3. Light passes through the working section as a parallel beam and is brought by the condenser C_2 to a focus at the colour-banded filter. The image of the slit S is aligned with the central green filter band and is transmitted as green light to the camera lens (L). The camera lens is adjusted to focus an image of the working plane on the emulsion.

Light passing through the working section is deviated from its parallel path if it encounters a density gradient. The ray in Fig. 15.3c has passed through a region of higher density and will pass through the blue band of the filter. Areas of high gas density will therefore be seen as blue in the camera field; conversely, low-density areas will be shown as red.

This false-colour display gives a more immediate visual appreciation of the subject variations than a monochrome record and may be preferred because the black silhouette of the subject is clearly differentiated from the coloured field. Hyzer[15] has described other colour schlieren methods, using prism dispersion or lens chromatic aberration to separate the colours. The simple banded filter is the most common

*Scotchlite is the proprietary name for a number of products marketed by 3M Co. Ltd.

416

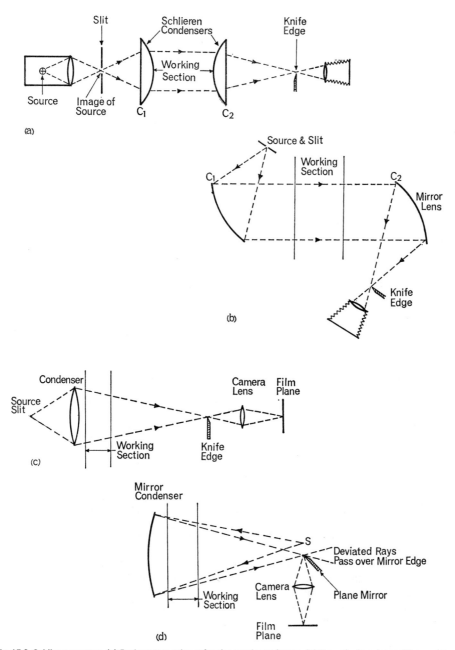

Fig. 15.2. Schlieren systems. (a) Basic system using refractive condenser lenses. (b) Normal mirror-lens schlieren system. The mirror offset angles have been exaggerated for clarity. In general, this angle is not allowed to exceed about 5°. (c) and (d) Some alternative schlieren systems using single condensers. In (d) the edge of the mirror acts as the schlieren knife edge.

417

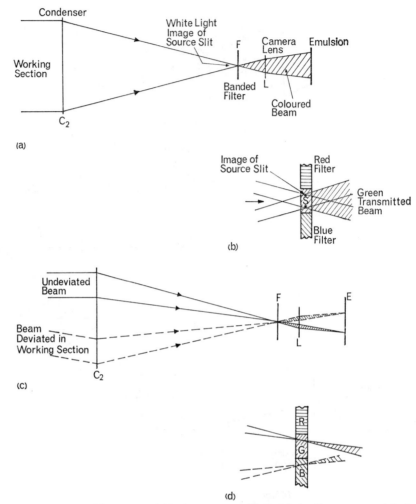

Fig. 15.3. Principle of a colour schlieren system. (a) Basic arrangement. (b) An undeviated beam passes entirely through the central filter band. (c) and (d) Deviated rays pass through the red or blue filter bands.

method, but Cords[16] has described a highly sensitive system using multiple colour zones in the slit planes.

The sensitivity of a schlieren system refers to the smallest disturbance that can be distinguished on the photograph. In a colour schlieren system it is governed by the relative width of the slit image and the central band. If the filter band is too wide, a large deviation is required before a ray passes into the red or blue band. The factors affecting the sensitivity of a single-mirror schlieren system have been discussed by Murray.[17]

The working range of the system is the air density range within which variations are shown. Holder and North[18] have discussed the relationship between this property and schlieren sensitivity and the photographic factors affecting negative contrast.

418

The width of the schlieren field is limited by the diameter of the condenser lenses. Mirror lenses are generally used because they are more easily obtainable in large sizes and also are free from chromatic aberration. Schlieren lenses must be of high quality, because any irregularity will be shown in the camera field.

15.3.3 INTERFEROMETRY

15.3.3.1 *Interference.* If two light rays are coherent (see p. 110) and are in the same plane of polarisation, they interfere when they are superimposed. The interference can be partial or complete and destructive or constructive, depending on the relative phase of the two beams at the point of combination. If the amplitude of the two beams is not equal, the destructive interference cannot be complete.

It is usual to distinguish between two classes of interference:

(1) Division of amplitude, where a beam is split by partial reflection and the components are later combined. This is the basis of most interferometers.
(2) Division of wavefront, where different parts of the original wavefront from a source are caused to interfere; this was used in Young's original interference experiment (1802).

The two examples mentioned below are typical of many ways in which interferometry is applied to measurement, further instances are discussed on pp. 192–4.

15.3.3.2 *Mach-Zehnder interferometer.* In aerodynamics an interferometer can give quantitative values of air density, from which pressure and gas velocity can be calculated. The Mach-Zehnder double-beam design is normally used (see Fig. 15.4).

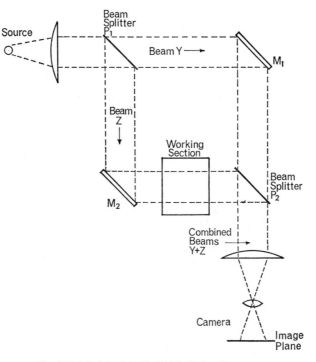

Fig. 15.4. Principle of the Mach-Zehnder interferometer.

419

A collimated beam from the source is divided by a partial reflector P_1 into two beams. Beam Y passes via mirror M_1 through a second partial reflector P_2 to the lens L, which brings the beam to a focus in the film plane. Beam Z passes through the working section via mirror M_2 and off the front surface of P_2; here the two beams combine. If the working section is at rest the two beams follow exactly equivalent paths and interfere constructively to give a uniformly bright field.

Any ray in beam Z may become retarded or advanced by passing through a region of higher or lower density in the working section. If this phase shift is equal to $\frac{1}{2}\lambda$, $1\frac{1}{2}\lambda$ etc. destructive interference takes place and shows as a dark point in the corresponding region of the image plane.

Hyzer[19] has given details of a wind tunnel equipped for simultaneous interferometry and schlieren recording and has illustrated how inherent irregularities in the interferometer paths can be subtracted photographically from the test record to give a true record of the air-flow density pattern.

15.3.3.3 *Surface topography.* Fig. 15.5 shows a transparent specimen laid in contact with a glass reference surface, which is finished to a high degree of flatness.

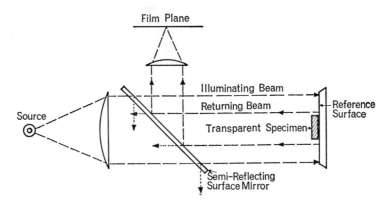

Fig. 15.5. Interferometer for surface topography.

A beam of parallel monochromatic light passes through the specimen and is partially reflected at the specimen exit face and at the flat reference surface.

The two beams combine as they travel back towards the source and interfere constructively or destructively depending on their relative phase difference. The returning parallel beam can be viewed or photographed by using a partially reflecting mirror and a lens.

Fig. 15.6 is an enlarged representation of the reflection interface, showing that the two reflected rays acquire phase differences according to the separation (SF) of the two reflecting surfaces. Ray R_f travels a distance $2 \times SF$ (there and back) before it combines with R_s; it also changes phase by 180° on reflection at the surface F (this phase-change always takes place when a ray in a low-density medium is reflected at the surface of a high-density medium).

420

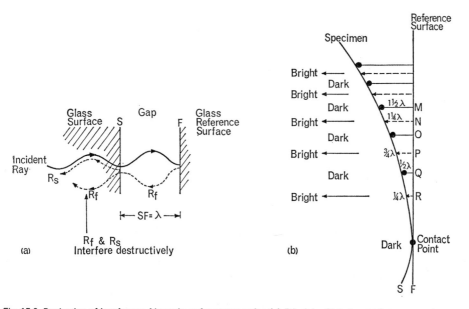

Fig. 15.6. Production of interference fringes in surface topography. (a) Principle of interference between specimen and reference surface. Ray R_s does not change phase on reflection (glass-air interface). Ray R_f changes phase by 180° on reflection (air-glass interface). (b) Formation of fringes at specimen height contours (variation of SF).

If the monochromatic wavelength is 546 nm (Hg e line) and the distance SF is 273 nm the ray R_s travels a total distance ($S \times SF = 546$ nm) equal to one wavelength. This, together with the reflection phase-change, means that R_s and R_f are 180° out of phase and interfere destructively; the point therefore appears dark to the observer.

Wherever SF is equal to a multiple of half-wavelengths ($\frac{1}{2}\lambda$, 1λ, $1\frac{1}{2}\lambda$ etc.), the phase difference $(2 \times SF) + 180°$ is equivalent to an odd number of half wavelengths ($1\frac{1}{2}\lambda$, $2\frac{1}{2}\lambda$, $3\frac{1}{2}\lambda$ etc.) and destructive interference occurs; this applies to points Q, O and M in Fig. 15.6b.

Points such as R, P and N, where SF is $\frac{1}{4}\lambda$, $\frac{3}{4}\lambda$ and $1\frac{1}{4}\lambda$ give a phase difference of λ, 2λ, 3λ respectively; the waves therefore reinforce each other and constructive interference takes place. Intermediate points show partial interference and appear to be of intermediate brightness.

Every black band on the interferogram corresponds to an increment of $\lambda/2$ in surface height; if $\lambda = 500$ nm the effect is of a topographic map with a contour separation of 250 nm. The distance between the fringes can be interpolated and height variations as small as $\lambda/100$ may be estimated. The accurate measurement of fringe separation can be assisted by equidensitometry (see p. 426).

If white light is used the interference pattern shows a series of coloured spectra (see fig. 5.26); the best-known example is Newton's rings. However, a monochromatic system (using a sodium or filtered mercury lamp) is normally used for quantitative work; the laser has a much greater coherence length and is now used for many interferometric purposes (see p. 110).

Baird and Hanes[20] have described many of the interferometers in current use

including the Twyman-Green interferometer used for studying optical surfaces, and the Fabry-Perot interferometer used for high resolution spectrography. A multiple-beam method giving sharper fringes for surface microtopography is described in Chapter 5.

Simpler methods may be preferable for certain subjects. An illuminated grid or array of slits can be projected across the surface (e.g. a patient's body) so that any relief causes a deformation in the regular projected pattern. With a suitable arrangement, each slit of light can represent a height contour and the gross surface shape is thereby graphically shown with relatively modest equipment.

15.3.4 MOIRÉ FRINGES.[21] If two regularly spaced grids are superimposed, relative movement between the grids produces a moving fringe pattern (see Fig. 15.7). The number of fringes passing a fixed point gives a measure of the lateral displacement of the grids and the direction of the fringe movement is a sensitive measure of the relative angular orientation of the grids. The fringes can be counted photo-electrically or can readily be photographed.

Moiré methods have been used to measure surface strain in engineering specimens, using a grid photo-etched into the surface.[22] A reference grid is placed over the specimen or in the focal plane of a lens system and a fringe pattern is observed when the specimen grid is displaced by stress. Variations of the technique permit measurement of displacement over the range from about 1μm to several metres.

Cooke[23] has described the application of this method to studying the vibration caused by explosions. Using a high-speed camera, lateral displacements of 0·005 in. (125 μm) and angular rotations of 1 milliradian (0·057°) were observed from a safe distance of 30 ft. (9 m).

15.4 *Polarised light techniques*

The properties of polarised light are treated theoretically in the standard works on optics. The main photographic uses are as follows:

(1) Elimination of reflections.

(2) Separation of images in stereo viewing systems (see Chapter 13).

(3) Kerr cell and Faraday shutters in high-speed photography (see Chapter 11).

(4) Polarised light microscopy (see Chapter 5).

(5) Photostress analysis (see below).

A broad coverage of these subjects and many other applications has been given by Shurcliff and Ballard.[24]

15.4.1 PHOTOELASTIC STRESS ANALYSIS[25]

15.4.1.1 *Birefringence.* A birefringent (or anisotropic) material divides an incident plane-polarised beam into two component beams which are polarised at right angles to each other (Fig. 15.9) (see also p. 186). The refractive index of the material is different in each plane (hence the term birefringent or doubly-refracting) and the two beams travel through the material at different speeds. The slower beam is retarded in relation to the other and, if the beams are re-combined, interference will take place according to the imparted phase difference.

Some materials are naturally birefringent (e.g. calcite) but others only exhibit this

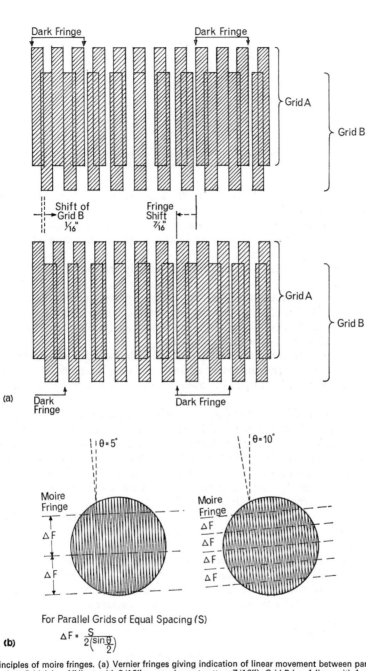

For Parallel Grids of Equal Spacing (S)

$$\Delta F = \frac{S}{2\left(\sin\frac{\theta}{2}\right)}$$

(b)

Fig. 15.7. Principles of moire fringes. (a) Vernier fringes giving indication of linear movement between parallel grids of dissimilar spacing. Grid A has ¼″ lines with 3/16″ spaces (repeat pattern 7/16″). Grid B has ¼ lines with ¼ space (repeat pattern ½″). A small movement of one grid gives a relatively large fringe shift. In (2) the Grid B has been moved 1/16″ and this has given a fringe shift of 7/16″. (b) Determination of angle between grid patterns. A small change of angle θ causes a relatively large change of fringe separation ΔF.

423

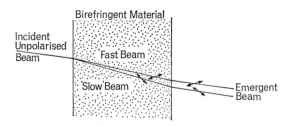

Fig. 15.8. The action of a bi-refringent material. The emergent beam consists of two components, these are polarised at 90° to each other and have a phase difference imparted by their different velocity through the bi-refringent material.

effect temporarily when subjected to stress or strain.* These strain-birefringent materials show two basic effects when stressed:

(1) The two beams are plane-polarised in the two principal axes of strain (in the simple case of simple uniaxial strain these are the direction of the strain and the plane at right angles to it).

(2) The relative retardation of the beams is directly proportional to the strain of the material.

The internal stress distribution of birefringent transparent materials can be studied in a polariscope (Fig. 15.9). If models of engineering components are made in these materials (e.g. expoxy resins) the stress patterns can be photographed under static loads or under simulated operating conditions.

15.4.1.2 *The polariscope.* The principle of the polariscope is shown in Fig. 15.9; it consists of a source S and a condenser system C_1 and C_2, giving a parallel beam through the specimen. The polarisers P_1 and P_2 are crossed to prevent any light passing directly through the system.

On entering a birefringent specimen, the plane polarised beam from P_1 is divided into two plane polarised beams A and B, whose planes of polarisation are aligned with the principal strain axes and are thus inclined with respect to the transmission planes of P_1 and P_2. If the planes of polarisation of P_1 and P_2 are taken to be vertical and horizontal respectively only the horizontal components (A_h and B_h)** of A and B will pass through the analyser P_2. These components fulfil the conditions for interference because they are coherent (originating from the same source) and are in the same plane of polarisation. The beams A_h and B_h retain the phase difference imparted in the birefringent specimen and interference therefore takes place according to their relative retardation.

15.4.1.3 *Interpretation.* If an unloaded specimen is placed in the polariscope, no effect is seen until a load is applied. Birefringence is then produced in the strained areas and some of the light from these zones can pass through the analyser. If the retardation is such that components A_h and B_h interfere constructively, an area of maximum brightness is seen in the camera focal plane (Fig. 15.10). As the strain on the model is increased, the relative retardation within the specimen is increased until

*The stress is the load carried by a unit area of the specimen; it is expressed in lb./in.²
The strain is the deformation suffered over a unit length as a result of an imposed load; it is normally measured in micro-inches per inch (μ in/in).

**A plane polarised beam can always be considered to have components in the vertical and horizontal planes. In Fig. 15.9b the analyser is set to transmit only the horizontal components A_h and B_h.

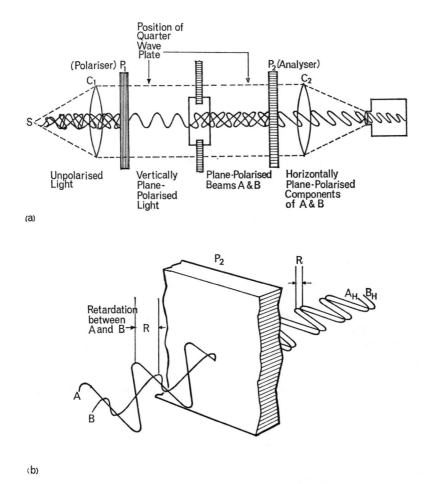

Position of Quarter Wave Plate

(Polariser) P₁

C_1

P_2 (Analyser)

C_2

S

Unpolarised Light

Vertically Plane-Polarised Light

Plane-Polarised Beams A & B

Horizontally Plane-Polarised Components of A & B

(a)

P_2

R

A_H B_H

Retardation between A and B

R

R

A

B

(b)

Fig. 15.9. The polariscope in photo-elastic stress analysis.

the rays interfere destructively and the area appears dark (Fig. 15.10); this is termed a first order line. Greater strain further increases the phase difference and the interference then becomes constructive and a bright band is again produced; further strain causes a second and higher order dark lines to appear.

These fringes are called isochromatic lines; they represent constant increments of strain and may be regarded as strain contours. The fringes show the differences in strain and may be counted to assess the strain at any point in the specimen. With a white light source the isochromatics are coloured spectra (see Fig. 5.26), but for quantitative work the black lines given by monochromatic sources are preferred because the fringes are more clearly defined.

The polariscope image also shows dark bands known as isoclinic lines (Fig. 15.10b). These lines are formed in areas where the direction of one of the principal strains coincides with the polarisation plane of the incident light from P_1. In these areas the

425

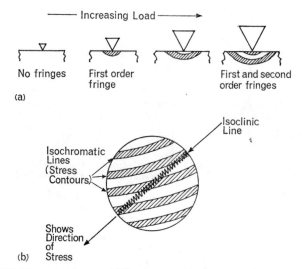

Fig. 15.10. Photo-stress patterns. (a) Development of isochromatic lines. (b) Isoclinic line.

beam passes through the specimen without birefringent division and is absorbed by the crossed analyser P_2.

The isochromatic lines thus show the magnitude of the stress and the isoclinic lines show the direction of the stress. It is easier to study the isochromatic lines if the isoclinics are removed. Quarter-wave retardation plates inserted on either side of the specimen change the plane-polarised light into circularly-polarised light, which removes the isoclinic effect.

Much of this work is carried out on transparent plastic models but a birefringent surface coating can be applied and a reflected-light technique used to study the surface strain in components of almost any material.[26] The method can be used with high-speed photography in engineering or ballistic impact studies to record dynamic strain patterns of short duration.

The theory and applications of photoelastic stress analysis have been thoroughly treated by Frocht.[27]

15.5 Tone derivation processes

Interpretation or measurement of an image is sometimes aided by simplification of the density pattern, using the tone-control processes familiar in pictorial photography. With proper control, additional information can often be extracted from photographic records.

Lau and Krug[28] have given a bibliography of the use of these methods in interferometry, photometry and other fields: the two main processes are equidensitometry and tone-separation.

15.5.1 EQUIDENSITOMETRY. There are various ways in which a continuous-tone image can be converted into a single iso-density line delineating a contour of equal density.

426

This is particularly useful when measuring the separation of interference fringes and similar patterns.

Fig. 15.11 shows in diagrammatic form the density gradient of a line on a negative (curve 1). A positive of fairly high contrast is made by contact (curve 2) and is then superimposed on the negative. The composite densities (curve 1+2) are shown as curve 3, which has a fairly well-defined minimum at point P. (The location of point P within the original negative scale depends on the exposure given to the positive.) The composite (curve 3) is printed at high contrast to give curve 4. Further stages of manipulation may be used to give still clearer higher order equidensities.

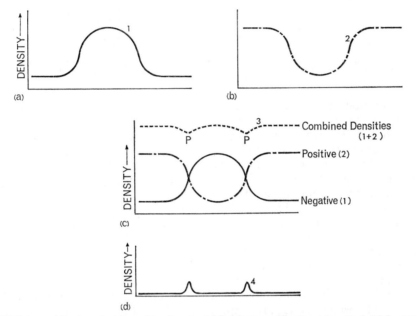

Fig. 15.11. Lau and Krug's method for equidensitometry. (a) Density trace of line image (negative). (b) Contact positive image. (c) Curve for overlaid negative and positive. (d) High contrast print from overlaid images.

Every point on the original negative having the density of point P appears on the same equidensity line. Applied to an interferogram, the method gives a line on each side of each fringe.

Lau and Krug also describe the application of the Sabattier effect to give a similar edge effect, the advantage being that separate negative and positive images do not have to be superimposed.

The same authors describe a method for converting any simple one-dimensional density gradient into a plotted curve, making use of the crossed-wedge system illustrated by Lobel and Dubois[29] for producing emulsion characteristic curves directly by photographic means. The negative to be converted (it may be a spectrograph plate) is overlaid with a continuous wedge. As shown in Fig. 15.12, this produces a profile of the original density pattern which can be contact-printed on high contrast material. Any diffuseness of the density profile can be converted into a crisp line by one of the equidensity methods.

427

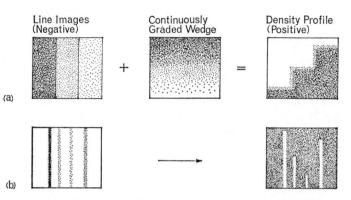

Fig. 15.12. Conversion of one-dimensional density variation into a density profile. (a) Principle applied to block areas. (b) Application to a line spectrum negative. A negative with lines of varying density is converted to a positive with profiles of different height.

Another method for producing equidensity outlines of photomicrographs with chemical-transfer copying materials has been described by Jones.[30]

The interest in iso-density contours has led to the development of automatic plotting equipment (e.g. the Joyce-Lobel Iso-densitracer and the Tech Ops Image Quantiser) and the use of television presentation to isolate equidensities.

Agfacontour film is a 'special order' product, which is designed to give an equidensity outline image from any continuous-tone original.

15.5.2 TONE SEPARATION. Fig. 15.13 shows diagrammatically the technique of posterisation in which a continuous-tone image is converted into stepped densities. In the simplest case a negative can be converted into two tones by high contrast printing. The print shows in white or black all those areas in a scene that were respectively above or below a certain luminance level.

The normal tone-separation techniques produce a three-, four- or five-step representation.[31] The method is basically to make a number of lith copy negatives of a normal bromide print; the negative exposure is adjusted in each case so that each negative records all tones above a different luminance level. The negatives are then printed successively in register on normal bromide paper, adjusting the exposure for each so that the required shade of grey is produced in each step.

Callender[32] has illustrated the application of tone separation to the representation of illumination patterns in streets and work-rooms. By use of reference surfaces of known luminance he was able to make quantitative assessment of the lighting level at any point in the picture. This offers advantages over conventional point-by-point photometric measurement of the area and gives immediate visualisation of subject luminance patterns.

15.5.3 IMAGE COMPARISON. The detailed comparison of a pair of photographs may be achieved by superimposing on one of the negatives a positive transparency of the other. If the two images are exactly complementary an overall monotone is produced but any discrepancy is apparent as an area of different density. Missing image components can be isolated and copied if necessary. Overlaid silver images may be too dense for easy viewing and it is possible to convert the images to coloured transparencies.

428

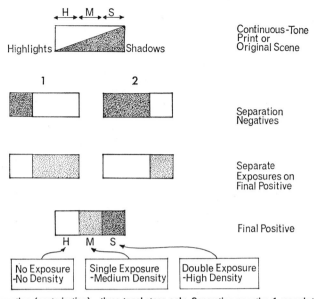

Fig. 15.13. Tone separation (posterisation)—three tonal steps only. Separation negative 1 records the highlights only; negative 2 records highlights and mid-tones. Printing from negative 1 gives medium density in mid-tones and shadows; a second exposure to negative 2 gives a high density in the shadows only.

The technique of *image subtraction*, using a pair of radiographs has notably been applied to show blood vessels in cerebral angiography.[64]

In large scale use, it may be preferable to use a flicker comparator (such as the Comparascope,* which is widely used to check complex electronic assemblies). The technique may be used, for example, to check production line radiographs against a master or to illustrate the degree of subject movement between successive cine frames.

Ford has discussed a number of these techniques and their applications.[33]

15.6 *Holograms*[34]

The hologram offers a reconstruction of the external appearance of an object with unique three-dimensional properties; movement of the head allows the observer to see round foreground objects and the eyes can focus selectively on different planes of the image. No lens is required, either for recording or reconstructing the hologram.

Holograms can be produced only under certain conditions and, although some recent methods are free from some of the restrictions of the original system, it is still normally necessary to use a monochromatic source with good coherence both for recording and reconstruction. Gabor's early experiments (1949) used a filtered mercury lamp with a fine slit, but his idea only became really practicable with the advent of the laser (see Chapter 3).

15.6.1 RECORDING HOLOGRAMS. Fig. 15.14 shows the most common arrangement for producing holograms; the development of methods in this field has been illustrated by Eaglesfield.[35]

*Vision Engineering, Send, Woking, Surrey.

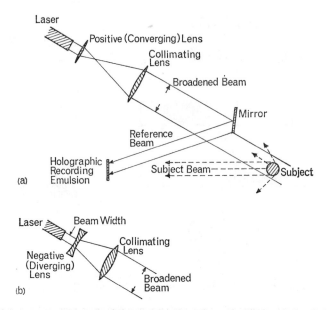

(a)

(b)

Fig. 15.14.(a) Arrangement for recording holograms. (b) Alternative method for broadening the laser beam with a negative lens.

An expanded laser beam is used to illuminate the subject and also to produce a reference beam. Some reflected light waves from the subject reach the photographic plate and form a signal beam which interferes with the reference beam to form the holographic record in the recording emulsion.

The reference beam has a simple plane or spherical wavefront and each point on the subject produces a reflected spherical wavelet. The complete subject wavefront is highly complex, but Fig. 15.15 illustrates the principles of interference between a plane wave and spherical wavelets from a single subject point. Only a cross-section is shown, the complete hologram for this single point would be a concentric series of circular fringes. The fringe spacing decreases regularly across the plate with the increasing angle of incidence of the signal wave. This is a vital point, which determines the apparent position in space of the subject point when the wavefront is reconstructed by diffraction from the recorded fringes.

A similar process occurs when a complex signal beam is imposed on the reference beam. Constructive interference takes place wherever the intensity peaks of the signal and reference waves coincide; destructive interference takes place wherever the two wavefronts are out of phase and the resulting interference pattern is recorded over the entire photographic plate.

The contrast of the interference fringes is governed by the relative amplitude of the reference and signal waves at each point on the plate: the spacing of the fringes is governed by the phase relationship between the two wavefronts. The developed image contains all the amplitude and phase information in the signal beam; this is the major advantage over a normal photograph, which contains only amplitude (luminance) information.

430

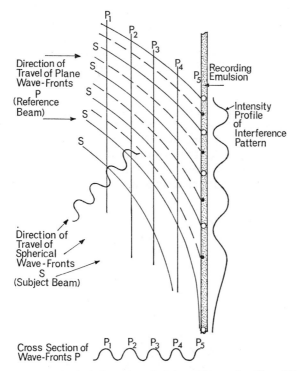

Fig. 15.15. Interference of plane and spherical wavefronts in holographic recording. The solid lines represent 'peaks' of the travelling wavefronts. The broken lines represent 'troughs' of the spherical wavefronts. The emulsion coincides with the plane wavefront P5 and records the intensity pattern in this plane.

The most common holographic system is shown in Fig. 15.14; every point on the plate receives light from the entire subject* and a photomicrograph of the plate shows a complex and highly irregular fringe pattern which represents the sum of the interference patterns of all subject points. No recognisable image is formed; the characteristic whorls seen on hologram plates are caused by dust in the light beams and bear no relation to the holographic image.

The fine hologram fringes require a high-resolution emulsion (usually of the Lippmann type) with enhanced red sensitivity to suit the lasers in common use. Kodak 649F, Ilford He-Ne/1 and Agfa-Gevaert 8E70 are among the materials used for this work; the Agfa-Gevaert range includes plates and films sensitised specifically for either helium-neon or ruby lasers.[36]

Other materials offer much more rapid processing than the silver halide system and may also give higher resolution. Xerographic thermoplastics,[37] photopolymers; and bichromated gelatine have been used; photochromic materials have been applied to recording holograms using infrared radiation of $10·6\mu m$ from a CO_2 laser.[38]

It is essential that there is no serious displacement of the signal beam during the exposure (<100 nm) and this imposes practical difficulties when applying the technique outside the laboratory.

*This does not apply to **all** holographic arrangements.

Image shifts within the emulsion (see p. 404) or emulsion shrinkage can affect the results in certain applications. For example in 'thick' holograms the reference beam is directed at the back of the holographic plate and the interference fringes are formed in layers throughout the thickness of the emulsion. These holograms may be viewed in white light and offer possibilities for three-colour holography; if processing shrinkage alters the layer separation the reconstructed wavelength is somewhat shorter than that of the recording laser.

15.6.2 HOLOGRAPHIC RECONSTRUCTION. The developed silver image on the holographic plate acts rather like a complex diffraction grating or, because it produces a focused image, like a Fresnel zone plate (see Chapter 8). Most of the light is transmitted directly (as a zero order beam) without deviation, but a useful proportion is diffracted into two first order beams (Fig. 15.16); very weak higher order beams are also produced at greater angles of deviation.

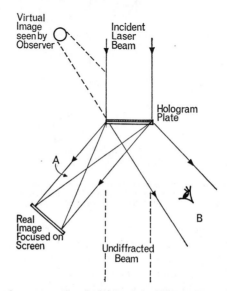

Fig. 15.16. Basic arrangement for reconstruction of a hologram. A—Diffracted beam of convergent wavefronts. B—Diffracted beam of divergent wavefronts.

The holographic plate contains all the information present in the signal wave-front and imposes the same wavefront on the reconstructing laser beam. One first order beam has the same divergent wavefront as the original signal wavefront, and can be seen as a virtual image. The other first order diffracted beam has a convergent wavefront and forms a real image without any further lenses; this image can be recorded directly on an emulsion placed in the correct plane.

Every part of the holographic plate has received a signal wave from every part of the subject and each piece of the plate contains sufficient information to reconstruct an image of the whole subject. However, the resolution is then limited by the fact that only a small part of the signal wavefront is represented.

The reconstruction is seen as a stereoscopic monochrome image viewed as though through a window frame; within these limitations, it is completely realistic in terms of

subject size and depth. There is complete freedom to move the head and to adopt any required viewpoint. The larger holograms (several inches square) can be viewed by several people.

Greater efficiency may be given in holographic reconstruction by bleaching out the photographic silver. Diffraction still takes place at the associated gelatine relief image, but by removal of the absorbing silver the image brightness may be increased by 5–10×. Such plates are called phase holograms as distinct from the conventional amplitude holograms.

15.6.3 CHARACTERISTICS OF HOLOGRAMS. Some of the special features of holograms are listed below. An explanation of these effects and their possible applications and a fuller theoretical background is given in the references.[34, 39]

(1) The reconstructed virtual and real images are positive in tone. If a contact transparency is made from the holographic plate any reconstruction from the second-generation plate is still a positive image. It is the fringe spacing and contrast which are important, rather than whether a particular area is opaque or transparent.

(2) It is possible to record several images on a single holographic plate without interaction between the different interference patterns. Images from differently-coloured lasers can also be recorded simultaneously and three-colour holograms have been displayed.[40, 41]

(3) Gabor's first interest was aroused by the possibility (still only theoretical because of the lack of suitable coherent sources and other physical problems) of recording electron beams, X-rays and other radiation beyond the range of optical methods. From diffraction theory it can be shown that if the reconstructing wavelength is n times greater than the recording wavelength, the holographic reconstruction will be larger than the subject by a factor of n. Thus, a X-ray hologram using a source of 0·1 nm wavelength (12·35 keV) would appear magnified by 5000× when viewed by light of 500 nm. It is far from certain whether this idea will ever become a reality: the possibilities have been discussed by Rogers and Palmer.[42]

15.6.4 APPLICATIONS OF HOLOGRAPHY. The interest in holograms may be judged from the large amount of published work. In view of the rapid development of new techniques the only way to keep abreast of progress is to study the specialist journals and the bibliographies that are periodically published.[43, 44]

Methods for recording multi-colour holograms and techniques using incoherent light[45] will further widen the field of application; this latter development may permit the holography of self-luminous events. Many of the early difficulties are being overcome and it seems unwise to predict that the current restrictions are fundamentally insuperable. It is certain that greater understanding of holographic principles will lead to their use on a much wider scale than the laboratory experiments of the past.[46]

(1) Holographic interferometry[47] is probably the most valuable industrial application so far developed; it can be applied to unpolished specimens and a far wider range of subjects than conventional interferometry (see p. 419). The basis of the method is to superimpose an object with its holographic reconstruction; any surface deformation or vibration gives rise to an interference pattern from which relative movements of as little as 1 μm can be measured. It is possible to compare two different objects or to record the same object at different moments in time.

If necessary the two holograms (or more) can be recorded on the same plate (multiplex hologram)

(2) In droplet studies and bubble-chamber recording holography using pulsed lasers offers a complete three-dimensional reconstruction that can be studied at leisure without any restrictions due to depth of field.

(3) Holographic microscopy[38] offers the possibility of recording an image of a transient event and subsequently applying many of the standard techniques of microscopy (dark-field illumination, phase contrast) to the reconstruction.

(4) Microwave and acoustic holograms (sono-holograms) offer a method of visualising these invisible phenomena (see p. 436).

15.7 *False-colour methods*

It should not be assumed that a colour record will *always* be more correctly interpreted[49] but colour photographs often give more complete information about a subject than monochrome pictures; the inferior spatial resolution and various practical difficulties are frequently outweighed by the improved recognition of subject features. In some work each colour may be regarded as a separate information channel and this advantage has led to the use of false-colour display systems, where the colours serve only to label different aspects of the subject.

15.7.1 OPTICAL SYSTEMS. Some optical techniques produce a false-colour display for visual assessment; colour photography of the image is usually relatively easy:

(1) A colour schlieren system uses colours to identify zones of increasing or decreasing density in the test medium.

(2) In a polarised-light microscope (see Chapter 5) interference colours are formed by birefringent specimens; this serves to differentiate the constituents of crystalline and other materials.

(3) In photo-elastic stress analysis with a white-light source, the interference colours show stress contours.

(4) Interferometric methods using white light for surface topography produce coloured fringes (Newton's rings) representing height contours.

15.7.2 COLOUR-CODING OF LIGHT SOURCES. As when drawing graphs and charts, colours may be used to enhance the visual separation of superimposed photographic images:

(1) In a multi-flash colour channel system (see Chapter 11) filtered lamps are used to identify the time sequence of the overlaid images.[50]

(2) Several systems for colour thermography use filtered lamps to indicate separate temperature bands in the subject (see Chapter 7).

(3) Some oscillograph cameras record several traces simultaneously; these may be recorded in different colours to assist interpretation (Chapter 12).

(4) The same principle is applied in the stereoscopic anaglyph, in which colours are used to code the left and right images (see Chapter 13).

15.7.3 FALSE-COLOUR SENSITISED EMULSIONS. Certain integral tripack films are falsely sensitised in the sense that the reproduced colours are not complementary to the spectral sensitivity of the tripack layers.

434

(1) The EGG Extended Range film is a tripack in which all the layers have the same spectral sensitivity, but have widely different speeds. The purpose is to cover a very wide tonal scale (see p. 77).

(2) Ektachrome Infrared film is sensitised to give a record of green, red and infrared wavebands (see p. 240).

15.7.4 COLOUR CONVERSION PRINTING. The principle of false-colour reproduction can be applied to many tasks by printing monochrome negatives on to colour material.

Thus, Land's UV Colour Translation Microscope (see Chapter 5) was used to make a monochrome negative at each of three UV wavelengths; these were then used as separation negatives in conventional colour printing.

Any short sequence of photographs, cine frames or radiographs can be superimposed in different colours. This maintains the correct spatial relationship between the different images and for some types of motion analysis is preferable to studying separate prints. It would be possible, for example, to combine a radiograph and a photograph or to superimpose normal panchromatic and infrared monochrome records by printing them in register in different colours.

Similar methods have been used by Yakowitz and Heinrich to produce colour-composite photographs of the CRT display from an electron microprobe analyser[39] (see p. 209). This method of presentation produced more information than conventional microscopy of far higher spatial resolution.

'Posterisation' techniques (see p. 428) can also be used in colour to enhance visualisation. The tone separation lith negatives can be exposed successively with different filters on to colour printing paper. Lau and Krug have shown a radiograph converted in this way to give the density scale posterised in three colours.[28] The same authors have described other methods of transforming monochrome images to a coloured form by modified reversal processing. The MRC* have demonstrated the use of a colour TV system to convert a monochrome transparency into a 7-step colour display to assist quantitative analysis.

15.7.5 COLOUR RADIOGRAPHY. There is some interest in producing radiographs in coloured form, partly because the eye is more sensitive to slight colour differences than to luminance variations and partly because of the increased exposure scale.

Ryan[52] has listed several ways in which colour radiographs can be made, including the colour-conversion of existing radiographs and the use of special colour films designed for radiography. Some of the latter materials have been patented but have not yet appeared on the market; the various proposals include the use of X-ray filters between the emulsion layers (to give each layer a different effective speed) and the use of differently coloured phosphors within a multilayer coating.

The most common method for making colour radiographs is to use a standard colour material such as Ektacolor Print film. It is exposed to X-rays by normal radiographic methods and is given standard colour processing. However, during the colour development the film is given a controlled flash of yellow light (usually to a Wratten OO safelight). The X-ray exposure generally produces a red-orange monochrome image, but the yellow 'flash' gives a blue image in areas corresponding to dense parts of the subject.

Beyer and Staroba[53] list references to this subject and describe the effects of intensifying screens and coloured pre-flashing with Ektachrome film.

*Medical Research Council, Cyclotron Unit, Hammersmith Hospital, London W12.

435

Despite the rather poor radiographic sensitivity (at best only about $\frac{1}{4}$ or $\frac{1}{2}$ the normal figure) and the need for longer exposure and longer processing than are normal in radiography, the technique may be of interest because the useful exposure scale is greatly increased. Although the contrast is low, a single colour radiograph can record the full range of a complex assembly that would require several conventional radiographs, each taken at a different exposure setting. Coloured viewing filters can be used to emphasise different parts of the subject range.

15.8 *Microwaves*

The microwave band is part of the electromagnetic spectrum (see Table 3.1), with wavelengths in the region of 1 mm. It exhibits all the optical properties of light (refraction, interference etc.) but produces no direct photographic effect. Furthermore, there is no equivalent to an image tube or television camera for visualising these wavelengths and the study of microwave field patterns has involved lengthy plotting with electrical instruments. There is considerable interest in the simultaneous display of a complete microwave field and several methods have been proposed.

Microwaves cause heating in objects absorbing the radiation and it is therefore possible to use IR thermographic methods (see Chapter 7) to visualise microwave patterns.

Iizuka[54] has described a method using Polaroid colour film chilled to $0°–5°C$ and fogged by light. Processing is started in the usual manner; the low temperature of the film inhibits development but it is placed (intact in its envelope) in the microwave field, which induces warmth in some areas and produces an image in the fogged film.

A more refined and sensitive method using liquid crystals (see p. 250) has been described by Augustine;[55] it has the feature of instantaneous visual display, with colour denoting the areas of greatest microwave intensity.

Experiments in microwave holography dating from 1950 and further references in the field of radar and radio-frequency holography have been discussed by Kock.[56]

Recording of conventional radar CRT displays is mentioned in Chapter 12.1.8.

15.9 *Sound and ultrasound**

Sound waves cause local pressure variations in the air and strong shock-waves can be visualised by a spark shadowgraph (Dvorak, 1880) or by a number of physical methods.[57]

Apart from recording sonic shock waves (by schlieren or shadowgraph methods) the main interest lies in using sound waves for image formation; this arises from the fact that sound can be propagated through solids and turbid liquids that would completely absorb or scatter light waves. The established echo-sounding techniques, such as sonar mapping of the sea-bed and ultrasonic inspection of defects inside metal

*Sound and ultrasound differ only in frequency; any frequency above 20,000Hz is normally described as ultrasonic, although the applications mentioned here use frequencies in the 0·5–20 MHz range.

Many of the familiar optical effects (refraction, reflection, interference etc.) are exhibited by sound waves. The image resolution of sound lenses is limited by the wavelength (as with light waves—see Eq. 2.6) and for this reason a high frequency (short wavelength) is preferred. However, even at 10 MHz the wavelength is about $30\mu m$, which gives a resolution that is poor by optical standards ($\lambda \approx 0·5\mu m$).

specimens, make use of this property and enable the distance and direction of invisible objects to be found. Modern developments have further extended the use of sound waves to give a complete visual representation of the sound field, despite the fact that photographic materials are not sensitive to sound waves.

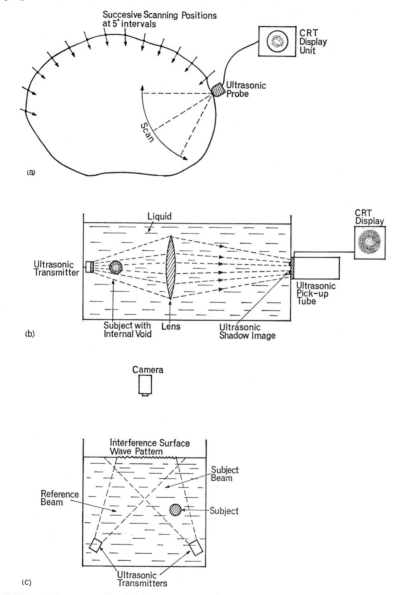

Fig. 15.17. Ultrasonic image recording. (a) Compound sector scanning with the Diasonograph. (By courtesy of Nuclear Enterprises Ltd.) The ultrasonic probe scans the subject from several positions and a cross-sectional representation of the internal structure is built up on a CRT screen. (b) Projection system with ultrasonic image convertor tube. (c) Surface wave method of sonoholography.

437

The Diasonograph uses a scanned ultrasonic beam to build up by echo reflection a profile of internal structure point-by-point on a CRT screen. This equipment is used in obstetrics and other applications where the more conventional X-ray methods are too dangerous to the patient. Redman has described a method for converting a series of these cross-section records into a three-dimensional holographic display.[58]

Fig. 15.17b shows the principle of a number of ultrasound cameras in which a Perspex lens in a liquid medium forms an ultrasonic image on an immersed detector. McGonnagle[59] has described early work in which the image was rendered visible by: (a) its effect on particles suspended in the liquid, (b) the ultrasonic extinction of luminescence and (c) the fact that ultrasonic activity causes a slight increase in the development rate of a fogged plate suspended in a developer.

However, following the work of Sokolov (1939), most modern applications use an ultrasonic image converter television tube (e.g. Twentieth Century Electronics UC9 camera tube), which gives the advantage of an instantaneous 'real time' display. These tubes have a piezo-electric crystal as the detector element and the ultrasonic image produces an electrical signal which is scanned and displayed on a television video monitor.

15.9.1 ACOUSTICAL HOLOGRAMS (SONOHOLOGRAMS).[60, 61, 62] The quality of acoustic lenses leaves much to be desired and there is considerable interest in acoustical holography, for which no lenses are required.

The principles are similar to those of optical holography, although there is little prospect of achieving similar image quality. Interference takes place between a reference signal and a sound wave that has been modulated by the subject.

In a simple mechanical system the field is scanned by a microphone and the sum of the two signals modulates the intensity of a glow lamp or a light spot on a CRT screen. The light is photographed throughout the microphone scan and, by a linked scanning system, builds up a record of the sonic interference pattern.

The system is rather slow and another approach may be used to give an instantaneous holographic record. In the surface relief method shown in Fig. 15.17c the subject and reference sound beams interfere to form a surface ripple pattern on the water, which is photographed by a dark-field or schlieren method.

The processed sonohologram plate is viewed in the same way as a normal hologram and shows in visual form the objects in the sound field. Because of the disparity between the wavelengths of the recorded sound and the wavelength of the reconstructing light waves, the holographic display is greatly reduced in size (by a factor of 3000 for sound of 1 MHz frequency in water) and must be viewed in a microscope. Korpel[63] has discussed ways of overcoming this problem and has considered the possibilities of ultrasonic holography becoming a practical method.[64]

438

References

1 BRADSHAW, P., *Experimental fluid mechanics*, Ch 6, Pergamon, Oxford (1964).
2 CLAYTON, B. R. and MASSEY, B. S., *J Sci Instrum*, **44**, 11 (1967).
3 NORTH, R. J., Paper 13, Conference proceeding *Photography in Engineering*, Institute of Mechanical Engineers (1970).
4 MALTBY, R. L., *Flow visualisation in wind tunnels using indicators*, Agardograph No 70, April (1962).
5 BERRY, L. W., *J Phot Sci*, **10**, 104–9 (1962).
6 DAVIS, W. and FOX, R. W., *J Bas Eng*, **89**, 771–81 (1967).
7 FRASER, R. P. and DOMBROWSKI, N., *J Phot Sci*, **10**, 155–69 (1962).
8 CONSTANTINE, T., YOUNG, A. P. and LARCOMBE, M. H. E., *Phot J*, **106**, 311 (1966).
9 *Kodak Data Sheet IN-7*, Kodak Ltd., London.
10 POLAK, P, Paper 6, *op cit* (Ref 3).
11 HOLDER, D. W. and NORTH, R. J., *Schlieren methods*, HMSO, London (1963).
12 GEIKAS, G. I. and ABLES, B. D., pp 47–54, *Kodak Photoresist Seminar Vol II*, Eastman Kodak (1968).
13 HYZER, W. G., *Engineering and scientific high-speed photography*, pp 427–9, Macmillan, New York (1962).
14 BARKOFSKY, E. C., *JSMPTE*, **58**, 480–6 (1952).
15 HYZER, W. G., *op cit*, pp 434–5.
16 CORDS, P. H., *JSPIE*, **6**, 85–88 (1968).
17 MURRAY, W. L., *J Phot Sci*, **15**, 191–6 (1967).
18 HOLDER, D. W. and NORTH, R. J., *op cit*, pp 61–80.
19 HYZER, W. G., *op cit*, pp 436–9.
20 BAIRD, K. M. and HANES, G. R., *Applied optics and optical engineering*, Ed R. Kingslake, Vol 4, Ch 9, Academic Press, New York.
21 GUILD, J, *Diffraction gratings as measuring scale*, OUP, London (1960).
22 MEEK, R. M. G., Paper 12, *op cit* (Ref 3).
23 COOKE, D., *6th International Congress on High-speed Photography: The Hague, 1962*, Ed J. G. A. Le Graaf and P. Tegelaar, pp 387–91, Willink, Haarlem (1962).
24 SHURCLIFF, W. A. and BALLARD, S. S., *Polarized light*, Momentum Book No. 7, Van Nostrand, Princeton, N.J. (1964).
25 *Kodak Data Sheet SC-1*, Kodak Ltd., London.
26 WINDOW, A. L., *J Phot Sci*, 11, 186–93 (1963).
27 FROCHT, M. M., *Photoelasticity*, Wiley, New York (1948).
28 LAU, E. and KRUG, W., *Equidensitometry*, Focal Press, London (1968).
29 LOBEL, L. and DUBOIS, M., *Sensitometry*, 2nd Ed, pp 63–6, Focal Press, London (1967).
30 JONES, E. J., *J Phot Sci*, **16**, 79–81 (1968).
31 JACOBSON, C. I. and MANNHEIM, L. A., *Enlarging*, 20th Edn, pp 492–6, Focal Press, London (1969).
32 CALLENDER, R. M., *B J Phot*, **108**, 636–40 (1961).
33 FORD, B. J., *Phot J*, **108**, 102–5 (1968).
34 SMITH, H. M., *Principles of Holography*, New York (1969).
35 EAGLESFIELD, C. C., *Laser light: fundamentals and optical communications*, Macmillan, London (1967).
36 NASSENSTEIN, H., DEDDEN, H., METZ, H. J., RIECK, H. E., SCHULTZE, D., *Phot Sci Eng*, 13, 144–9 (1969).
37 URBACH, J. C. and MEIER, R. W., *Appl Opt*, 8, 2269–81 (1969).
38 IZAWA, T. and KAMIYAMA, M., *Appl Phys Lett*, **15**, 201–3 (1969).
39 DE VELIS, J. B., and REYNOLDS, G. O., *Theory and applications of holography*, Addison-Wesly, Reading, Massachusetts (1967).
40 COLLIER, R. J. and PENNINGTON, K. S., *Appl Opt*, **6**, 1091–96 (1967).
41 SMITH, H. M., *op cit*, Ch 7.
42 ROGERS, G. L. and PALMER, J., *J Microsc*, **89**, 125–35 (1969).
43 LATTA, J. N., JSMPTE, 77, 540–580 (1968).
44 KALLARD, T. (Ed), Holography: State of the art review 1970, Optosonic Press, New York (1970).
45 BRYNGDAHL, O. and LOHMANN, A., *J Opt Soc Amer*, **58**, 625–8 (1968).
46 LEITH, N., *Perspective world report, 1966–69*, Ed L. A. Mannheim, pp 297–304, Focal Press, London (1968).
47 BUTTERS, J. N. and DENBY, D., Paper 7, *op cit* (Ref 3).
48 VAN LIGTEN, R. F., *Optics Tech.*, **1**, 71–7 (1969).
49 MACLEOD, S. and ALEXANDER, G., *Phot Sci Eng*, **13**, 246–51 (1969).
50 KENT, J. C., *Appl Opt*, 8, 1023–6 (1969).
51 *Photo Methods for Industry*, 12, 5, 51–4 (1969).
52 RYAN, M. C., *Mat Eval*, 26, 8, 159–162 (1968).
53 BEYER, N. S. and STAROBA, J. S., *ibid*, pp 167–72.
54 IIZUKA, K., *Electronics*, **41**, 8, 130–1 (1968).
55 AUGUSTINE, C. F., *Electronics*, 41, 3, 118–120 (1968).
56 KOCK, W. E., *Microwaves*, 11, 46–54 (1968).
57 JENNY, H., *Sci J*, 4, 6, 46–52 (1968).
58 REDMAN, J. D., *Ultrasonics*, 7, 26–9 (1969).
59 MCGONNAGLE, W., *Non-destructive testing*, 2nd Ed, pp 232–5, Gordon & Breach, New York.
60 METHERELL, A. G., EL-SUM, H. M. A., and LARMORE, L., *Acoustical holography Vol I*, Symposium, Plenum Press, New York (1969).
61 METHERELL, A. F., *Sci J*, 4, 11, 57–62 (1968).
62 HALSTEAD, J., *Ultrasonics*, Vol 6, 79–87 (1968).
63 KORPEL, A., *IEE Spectrum*, 5, 10, 45–52 (1968).
64 ALDRIDGE E. E., Ch. 3 in *Research Techniques in Non-destructive Testing*, Academic Press, London (1970).

Technical journals

There are many journals and learned societies concerned with the topics covered in this chapter; the following are suitable for occasional reading in order to keep abreast of current developments in methods and equipment.

Flow visualisation

Journal of Fluid Mechanics, published semi-monthly by Cambridge University Press.

Photoelastic stress analysis

The Journal of Strain Analysis, published quarterly by the Institute of Mechanical Engineers.
Experimental Mechanics, published monthly by the Society for Experimental Stress Analysis, Easton, Pa, USA.

Holography

Optics Technology published quarterly by Iliffe Science and Technology Publications Ltd.
Laser Review, published by Milton Publishing Co., 31 Percy Street, London, W.1.

Non-destructive testing

Non-destructive testing, published by Iliffe Science and Technology Publications Ltd.

439

16. APPLICATIONS OF PHOTOGRAPHY IN ENGINEERING

16.1 *Introduction*

Many of the photographic methods mentioned in this book are commonly used in engineering and allied fields: specific examples include metallography (Chapter 5), radiographic inspection (Chapter 9), high-speed photography (Chapter 11), photogrammetry (Chapter 14), fluid flow studies and photoelastic stress analysis (Chapter 15). Photographic grids and graticules are also widely used for measurement systems in engineering and metrology.[1]

In addition to these photographic applications and the reprographic systems mentioned on p. 452, photo-sensitive materials can be used as a manufacturing tool. Photo-engineering methods may be summarised under the following categories:

(1) *Photo-etching:* Metals, ceramics and glass can be etched to produce graticules or for decorative purposes.

(2) *Photo-milling*[2,3] Chemical milling is the controlled etching of metal in depth for weight reduction, for complex shaping or for finishing to very close tolerances. In photo-milling the extent of the etched areas is controlled by a photo-sensitive resist.

(3) *Photo-fabrication:* Small components in thin metal can be made by etching right through the material as an alternative to stamping or other metal-cutting processes. In a similar way, printed circuit boards (printed wiring) are made by etching through a copper layer bonded on to a support of glass fibre or resin bonded paper (RBP). Various thicknesses and grades of laminated board are available, including polyester film for flexible circuit strips.

(4) *Micro-miniaturisation:* The manufacture of micro-electronic components relies on photo-fabrication methods. Because of the much smaller size of the components and the different materials used, more refined techniques are employed and this type of work must be considered separately from the normal printed wiring board.

The categories listed above are different applications of the same principle, in which photo-resists are used to control further chemical processing; the term photo-fabrication is sometimes used collectively to describe all these methods. The resist can also be used to control the areas of deposition by plating or other processes; this is sometimes termed *photo-electroforming*.

(5) *Photo-stencils.* As an alternative to stencilling or mechanical engraving of name-plates and instrument panels, photo-sensitive processes are available for producing images on plastic or metal surfaces.

(6) *Photo-lofting:* If raw material (metal, wood, plastics) is coated with a photo-sensitive material, an image exposed and processed *in situ* can serve as a guide for cutting or drilling.

The smaller components made by photo-resist methods are sometimes divided into macro and micro categories; the latter is arbitrarily defined as any work in which printed dimensions of less than 0·002 in. (50 μm)* are required. Some macro work,

*In the American usage common in this field, a thousandth of an inch (0·001 in) is a mil.

although of relatively large dimensions, must be made to very close tolerances and thus calls for the more strict control necessary for micro components.

In most applications mentioned, the final product is the result of collaboration between the design draughtsman, the photographer and the electronic or mechanical engineer. Other processes, such as precision drilling, solder coating, electro-plating, multi-layer fabrication vacuum deposition and component assembly may be involved in the production line[4], but the present outline is confined to the factors affecting the photographic and photo-mechanical stages. The emphasis here is on the applications most likely to arise as a small-scale requirement in a photographic section: printed circuit manufacture and the photo-fabrication of small components.

16.2 *Photo-sensitive resists*

The resists originally used in half-tone printing processes were based on bichromated colloids, such as fish glue or albumen.[5] These materials are still in use, but photo-sensitive synthetic polymers are now available to meet a wide range of specific requirements (see Table 16.1).

TABLE 16.1
PHOTOSENSITIVE RESISTS

Kodak Printed Circuit Resist	KPC	Printed circuits
Kodak Photosensitive Lacquer	KPL	Printed circuits. Photo etching
Kodak Photo Resist	KPR	Photo electroforming
Kodak Photo Resist Type 2	KPR 2	Electro-plating resist etc.
Kodak Photo Resist Type 3	KPR 3	General purpose and electroplating resist
Kodak Thin Film Resist	KTFR	Micro-electronics
Kodak Metal Etch Resist	KMER	Photo-milling and deep etching
Kodak Ortho Resist	KOR	General purpose resist with high sensitivity
Kodak Photo Resist Type 4	KPR4	Printed circuits (especially for roller-coating)
Kodak Autopositive Resist	KAR	Printed circuits and chemical milling (positive working resist)
Shipley	AZ–340	Printed circuits and chemical milling (positive working resist)
Shipley	AZ–1350	Micro-circuitry (positive working resist)

The resist is normally soluble in its original state, but is polymerised and hardened by exposure to UV radiation (see Fig. 16.0). In the hardened state it will withstand chemical etchants and, after the unexposed soluble resist has been removed, the hardened resist is used as a 'stencil' through which the metal surface can be etched or plated by electro-deposition.

Most resists are negative working and are rendered insoluble by exposure as described above. Positive working resists are initially insoluble, but exposure renders the coating soluble and thus allows etching in areas corresponding to the clear parts of the negative.

16.2.1 PROPERTIES OF PHOTO-RESISTS. A photo-resist is chosen for a particular job after consideration of the following properties:

16.2.1.1 *Speed*. Most resists are relatively slow and contact printing is usually the only practicable method for exposing large areas. A projection system can be used in

442

micro-miniature work because the reduction in image size gives a corresponding increase in image illumination and the objectives used have a reasonably large numerical aperture.

16.2.1.2 *Spectral sensitivity.* Most resists are sensitive only to blue and ultraviolet radiation, as shown in Fig. 16.1. The Kodak Orthochromatic resist (KOR) is sensitive up to about 550 nm and is 20 to 40 times faster to tungsten light than a normal resist such as KPR. It can, therefore, more readily be used in projection printing, which is preferable for uneven surfaces.

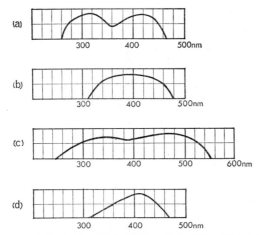

Fig. 16.1. Spectral sensitivity of Kodak photo-resists. (a) Kodak Photo Resist (KPR). (b) Kodak Thin Film Resist (KTFR). (c) Kodak Ortho Resist (KOR). (d) Kodak Autopositive Resist (Type 3) (KAR 3).

16.2.1.3 *Solid content.* There are three main constituents in a polymer resist:
(1) The polymer resin or carrier (equivalent to the photographic gelatin layer).
(2) The sensitiser (originally potassium bichromate, now usually an organic azide).
(3) The solvent (xylene, ethyl glycol acetate etc.).

The resin is rendered insoluble by reaction products from the exposed sensitiser and the percentage of resin or solid content of the resist is the major factor governing its ability to withstand the etchant.

Resists for normal printed circuit work have a solid content of about 6 to 10 per cent, but for deep etching or for work with highly active etchants, a resist with a solid content of 25–30 per cent is used. A high solid content is also necessary for micro-circuit work, where only a thin film of resist can be used.

16.2.1.4 *Resolution.* The resolving power of photo-resists is higher than that of any silver halide system, including the Lippmann maximum resolution emulsions. The limiting factors in the resolution of micro circuits are the thickness of the resist coating, the optical performance of the reduction lens system and the etching characteristics of the metal which is to be fabricated. In thin-film circuits line widths down to perhaps 20 μm are involved, while in semi-conductor integrated circuits widths of the order of 5 μm or less may be required; this latter work comes into the category of high resolution microphotography (Chapter 6).

16.3 *Photo-fabrication*

Photo-mechanical methods permit the manufacture of small components and shapes of extreme complexity that could not be made economically by any mechanical process. The operation can be carried out in most metals and the only major limitation is the thickness that can be accurately etched without undercutting; copper can be etched up to 0·007 in. (175 μm) without undue edge distortion; steel and molybdenum can be etched up to about 0·003 in. (75 μm). In chemical milling for weight reduction, much greater thicknesses can be removed because edge gradient is often less important.

Some of the advantages of photo-fabrication are:

(1) Complex shapes can be made more easily and more cheaply[6] than if a die had to be made (micro-sieves, springs, evaporation masks[7]).

(2) The metal edges are free from burrs.

(3) The magnetic properties of the specimen are not affected.

(4) The finished component is free from the distortions and stresses that are often produced in thin-walled components by normal engineering methods.

(5) The original tool (the photographic negative) does not suffer from wear and can be used to make large quantities of identical components.

(6) There is no need for marking-out or scribing.

Stevens has quoted many sources of reference on fabrication, including the use of photo-sensitive glass and photopolymers.[8]

TABLE 16.2

TYPICAL TOLERANCES ACHIEVED IN PHOTOFABRICATION

| | Metal thickness | | | | |
	·0005″	·001–·003″	·005–·007″	·01–·02″	over ·02″
Copper	± ·0002″	± ·0005″	± ·001″	± ·002″	In general,
Aluminium alloys	± ·0005″	± ·0008″	± ·0015″	± ·003″	tolerances of $\frac{1}{4}$ to $\frac{1}{2}$
Carbon steel and					the metal thickness
Tool steel etc.	± ·0004″	± ·0005″	± ·001″	± ·005″	can be achieved

Values quoted from Kodak Photoresist Review No. 14 (1968).

16.4 *Printed circuits* [4, 28]

The following sections explain in sequence the main steps in printed circuit manufacture; most of these points also apply to photo-fabrication, photo-milling and other techniques.

16.4.1 DRAWING THE ART-WORK. The original drawing is usually prepared on dimensionally-stable (polyester) translucent film. Adhesive drafting tape and pre-cut symbols are normally used to give a clean edge and to ensure a consistent line width. For the highest accuracy, cut-and-strip film or scribing plates are cut on a plotting table (co-ordinatograph). In the most advanced installations a computer-controlled scribing machine creates the art-work from the basic design parameters fed into the computer by the engineer.

Ink drawings on paper can be used for low-tolerance work, but the use of translucent originals with a transilluminated camera copy board gives much better contrast and avoids specular reflections from the adhesive tape.

Factors affecting the preparation of microphotographic originals are mentioned in Chapter 6.1.3.

The original drawing is usually many times larger than the final component; this greatly assists the draughtsman and reduces the effect of small dimensional errors on the drawing (although it does not help to correct errors of shape or angle). For example, if the permitted tolerance in the finished component is \pm 100 μm and the master drawing cannot be guaranteed to be of greater accuracy than \pm 500 μm (1/50 inch), a drawing scale of at least 5\times must be used.

16.4.2 PHOTOGRAPHY. The camera reduction for most printed circuit work is in the range 1:2 to 1:10, giving sizes from less than 1 sq. in. to perhaps 18\times24 in. or more; these negatives are normally made in one stage of photographic reduction. The work can be carried out with any process camera with a good quality lens, but for the best results with the minimum of trial and error a fixed-reduction camera may be used. For this stage of the process, accurate scaling and freedom from distortion are more important than very high resolution.

The main problem with standard cameras is to achieve the required image scale, bearing in mind that the tolerances even for the relatively simple boards are frequently in the order of ±0.01 in. (250 μm) over an image length of several inches.

A traversing microscope is fitted to some cameras to check the size of the aerial image, but a more common arrangement is to mark the camera bed with reference points for the standard reduction ratios in use. A methodical approach to camera adjustment is assisted if micrometer gauges are fitted to the camera to allow the lens and film planes to be moved by known increments. Once a trial negative has been measured, the small camera adjustments necessary to give the required scale can be calculated[9].

For all such work a travelling microscope is an essential aid for checking the negatives and the final component; it will probably be necessary to be able to measure dimensions of several inches to an accuracy of 0.001 in. (25 μm).

Total reductions in the range 1:100 to 1:1000 are used for micro-miniature work. This is usually achieved in two stages; the first negative is often made at 1:10 scale as outlined above and is further reduced at the final printing stage in a microphotographic camera, using high-resolution techniques (see Chapter 6).

16.4.2.1 *Dimensional stability*. Lith negatives are used for most work and can give a resolution up to 200 l/mm; Lippmann emulsions are used for the final high-resolution stage in micro-circuit work. Stable-base materials (polyester film or glass) must be used throughout the process and precautions must be taken to maintain dimensional stability throughout the drawing and photographic stages.

This is a very complex operation; the film base thickness, the area of developed silver in the image, the relative humidity, the temperature and the processing and drying conditions can all affect the result (see Chapter 14.5). Some of these factors may temporarily cancel each other out, but the total probable size change can be estimated for given working and storage conditions.[10]

Kodak suggest that some environmental control is necessary if a variability of less than 0.003 in. over a 10 in. dimension (0.03 per cent) is required; for closer tolerances than 0.001 in. strict control is essential.

16.4.3 METAL PREPARATION. Absolute cleanliness of the metal is vital if reliable adhesion of the resist coating is to be achieved. The metal should be de-greased in a

445

solvent such as carbon tetrachloride, preferably using a vapour degreaser. A chemical cleaner is then used, followed by a water rinse; abrasive cleaning with pumice is an alternative. The exact treatment varies with different metals and specific advice should be sought for each application. In some cases a conversion coating dip is used to assist adhesion of the resist to the specimen.

All traces of moisture must be removed and the water blown clear with oil-free compressed air. The specimen may also be warmed for a short period to ensure complete drying and to drive absorbed gases from the metal.

16.4.4 COATING. A thin and even coating of resist is then applied to the metal surface; both sides of the sheet are normally coated. There are several methods of coating printed circuit boards and most of these are also suitable for small photo-fabricated components. A thick coating gives greater chemical resistance and allows deep etching, but gives lower resolution.

16.4.4.1 *Dip-coating.* The metal sheet or copper laminate is suspended from a mechanical arm and dipped into a tank of resist. The tendency to produce a wedge-shaped coating is reduced by control of the withdrawal rate and the resist viscosity.

16.4.4.2 *Flow coating.* The coating may be poured on to the horizontal specimen, which is tipped from corner to corner until the surface is covered. This is suitable for occasional work, but tends to give an uneven layer; a coating whirler gives more consistent results and is always used for thin-film circuits.

16.4.4.3 *Spray coating.* Spray coating is a little difficult to set up, because factors such as air pressure, resist viscosity and spray nozzle velocity must be considered. However, great uniformity can be achieved and atomiser spraying is used for some microcircuit work.

16.4.4.4 *Roller coating.* A good method of coating large quantities of boards is by a roller applicator. These machines are relatively expensive, but allow control of coating thickness and have advantages when resist is not required in pre-drilled holes in the board (as in some plated-through-hole boards).

Whatever the coating method, it is important to keep the resist clean and to use regular filtration.

16.4.5 PRE-BAKE. After coating, the resist is allowed to dry naturally for a few minutes and may then be pre-baked for 10–15 minutes to remove residual solvents; this is particularly necessary where thick coatings are used for subsequent deep etching, but is not normally required for the thin coatings used in micro circuit work. Specific advice is given by the resist manufacturer.

16.4.6 EXPOSURE. The coated metal is usually exposed through the prepared negative in a vacuum contact-printing frame, using carbon arcs or high-pressure mercury lamps. It is not possible to give a close guide to the exposure duration but a time of 1–2 minutes at a lamp distance of 3 ft is typical. Stepped exposure tests are easily carried out and are assessed from the quality of the finally etched image.[11]

16.4.6.1 *Double-sided exposure.* Printed circuit boards are often double-sided and carry different circuit patterns on each side. Photo-fabricated components may be etched from both sides simultaneously to improve the etch factor and must therefore bear a matching photo-resist image on each side.

In these cases a pair of lith negatives is prepared and brought into register under a microscope, using a spacer between the films equivalent to the specimen thickness; either tape or pin-bar registration may be used.[12]

446

For double-sided etching of photo-fabricated components a pair of mirror-image negatives are required; the second negative can be produced by contact printing the first on to Kodalith Duplicating Film.

16.4.7 DEVELOPMENT. After exposure, the soluble (unexposed) areas of photo-resist are washed away in a suitable 'developer'; dish or spray-tank development may be used. The specimen is finally rinsed with water.

In many cases a dye developer is used to make the resist image visible, so that it can be inspected for pin-holes or fine cracks which may be spotted out with lacquer. Dyeing is undesirable for micro-miniature work or where maximum etch resistance is needed.

16.4.8 POST-BAKE. The exposed image is insoluble in the developer but it is still relatively soft physically. To increase its etch resistance it is often baked at an elevated temperature, normally in the range 100–200°C, according to the type of resist.

16.4.9 ETCHING. Ideally, the etchant should only remove metal in areas defined by the resist pattern. In practice, once the etching has started to penetrate the metal, a lateral etching (undercut) also takes place. The ratio between etched depth (D) and undercut (U) is known as the etch factor (D/U),* which depends on the material, the type of etchant and its method of application. As shown in Fig. 16.2, etching from both sides of a sheet of metal doubles the etch factor. In many cases the amount of undercut is known from previous tests and the line thickness can be correspondingly increased on the drawing.

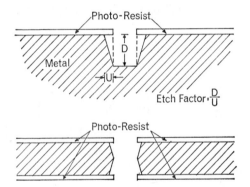

Fig. 16.2. Under-cut and etching factor in photo-fabrication. When etching right through a specimen, a reduced under-cut is given by double-sided exposure and etching.

The etchant used depends on the specimen (e.g. ferric chloride for copper, sodium hydroxide for aluminium, hydrofluoric acid for glass) and, to a lesser extent, on the resist in use.

The etching process may be carried out with manual agitation in a dish or tank, but this is slow and tends to give uneven results, with low etch factors. Bubble-etching tanks with gas-burst agitation give an improved performance.

*In photomechanical printing processes, the etch factor has traditionally been improved by brushing resinous powder (Dragon's Blood) on to the partly etched work-piece, so that it adheres to the walls of the etched lines and inhibits further lateral etching. Modern processes of powderless etching achieve a superior result by use of additives in the etchant and some proprietary etchants claim built-in shoulder protection using inhibitors based on this principle.

The more efficient etching machines use forced spray application, which greatly reduces the time required and gives good etch factors; in many machines both sides of printed circuit boards can be etched simultaneously if required. For large-scale production a conveyor-belt etching machine is preferable.

For photo-milling applications, where the depth of etching must be controlled, tests are made to establish the etching rate at a certain temperature under standardised agitation or spray-etch conditions. For example a steel specimen may be found to etch at the rate of 0·001 in. (25 μm) per minute in ferric chloride at 32°C.

Electrolytic etching is sometimes used in preference to chemical methods for materials such as tungsten.

16.4.10 STRIPPING. After etching, the specimen is washed with water and the hardened resist (which still covers the remaining metal surface) must be removed. If no post-baking has been used, gentle rubbing with resist solvent may remove the coating, but with a baked resist, commercial stripping fluids or machine buffing may be necessary; firing off at 400–500°C may be used with the more robust metal specimens.

16.4.11 INSPECTION. The process is now complete and the specimen must be inspected for flaws in the circuit and for smoothness of the etched sides. It is measured against the original specification and is then passed for plating or solder-coating and any drilling or machining operations that may be necessary.

16.4.12 SCREEN-PRINTED CIRCUITS. An alternative method of making the resist pattern is provided by adaptation of the silk screen printing process.

A positive photographic image is used to expose a photo-sensitive material; this is processed to give a cut-out stencil of the circuit pattern on a nylon (or steel) mesh

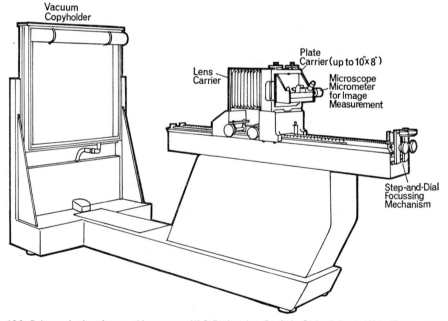

Fig. 16.3. Dekacon I microphotographic camera—HLC Engineering Co. Ltd., Oreland, Penn. USA. (By courtesy of W. Watson & Sons, Ltd.)

screen. Etch-resistant ink is then printed on to the prepared metal by application with a squeegee through the screen and stencil; the resist is then baked on to the board and the circuit is etched as in the photo-mechanical method described previously.

Despite the effect of the screen (100–300 mesh threads per inch), line thicknesses down to 0·01 in. (0·25 mm) or less can be obtained, with sufficiently good edge-definition for most printed circuits; the method is extensively used for mass-production (and for thick-film micro-circuits, see below). Once the stencil has been prepared, circuits can be made more cheaply and quickly (over a thousand impressions an hour on automatic machines) than by the photo-resist method. Some circuit manufacturers find the screen process competitive even for prototype quantities of 5–10 circuits.

16.4.13 XEROGRAPHIC METHOD. The Xerox 1385 camera, which is used mainly for producing offset litho plates (Duplimats) by an electrostatic process, has also been used for making prototype printed wiring boards. A pigment image is formed at the required scale on a photo-conductive surface as in the standard process, but is transferred to a copper laminate material. The baked pigment is etch-resistant and the board is then etched and treated in the normal way.

The edge-definition and line quality are adequate for many purposes and, by eliminating the need for a negative, the method offers the possibility of making experimental circuits in a few minutes without darkroom facilities.

16.5 Integrated circuits

Photo-resist techniques are universally employed in the production of integrated micro-circuits. The term 'integrated' implies that circuit elements such as resistors and capacitors are formed as an integral part of the conductive circuit pattern.

There are three basic types of integrated circuit: the thin film circuit, the thick film circuit and the much smaller semi-conductor integrated circuit (SIC) which is also known as a 'chip'; hybrid circuits are made from a combination of these different types of micro-circuit.

The relative merits of these devices and their potentialities are described in current works on micro-electronics,[13, 14] but the following brief points indicate the differences in the photographic stages of manufacture; further details have been given by Stevens[15] and by Eastman Kodak Ltd.[11, 16]

16.5.1 THIN FILM CIRCUITS. These circuits are typically 1×1 in. and are formed in layers of metal such as gold and nichrome (a nickel-chrome resistive alloy) which have been deposited on a glass ceramic substrate.

Standard resists and etchants are used, although the thinness of the metal (less than $1 \mu m$) requires a refined technique. The resist is exposed by printing through a photographic negative, which is often a single-staged reduction of 1:10 or 1:30 scale. Line widths are in the range down to about $20 \mu m$, so this work does not call for extreme resolution techniques.

In a typical circuit, the gold layer is first etched to form the gold conductor pattern and the circuit is then re-coated with resist and exposed to a second negative, which produces the pattern for etching the nichrome layer to leave the resistive elements of the circuit.

Active components such as transistors or SIC chips may subsequently be bonded or soldered on to the circuit; connector leads are attached to the circuit and the entire assembly is sealed into a 'flat pack' for incorporation into a printed wiring board.

The more recently introduced thick film circuits[17] are of similar size but have circuit layers about 0·001 in. (25 μm) thick. These layers are produced by precision screen-printing of resistive, conductive or dielectric inks, usually on to an alumina ceramic substrate. The screen stencil is formed in a photo-insolubilised film, which is exposed in contact with a photographic negative (see 16.4.12).

16.5.2 SEMI-CONDUCTOR INTEGRATED CIRCUITS. The monolithic semi-conductor circuit is normally formed on a wafer of silicon about $1 \times 1 \times 0·2$ mm thick; the active circuit lazer is about 1 μm thick. Photo-fabricated metal foil masks or a succession of photo-resist masks are used to control the deposition of conductive, resistive or insulating layers by vacuum evaporation or sputtering. The semi-conductor is also doped in selected areas by the diffusion of impurities (e.g. boron or phosphorus) through a mask.[18]

Whatever method is used, the accuracy of registration between the set of photographic images requires the closest control of environmental conditions throughout the process. It has been shown, for example, that a master negative on 0·004 in. polyester base can expand by more than 0·0015 in. (38 μm) over a 2 in. dimension during the change from winter to summer conditions; a 0·007 in. polyester film would show only about a quarter of this variation.[10]

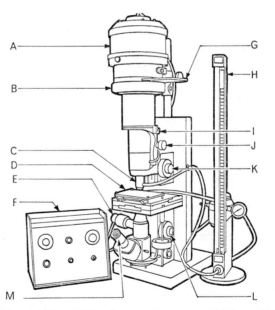

Fig. 16.4. Watson Mark III Step and Repeat Photomask system. (By courtesy of W. Watson & Sons, Ltd.) Key: A Lamp house. B Master negative holder. C Objective with pneumatic shroud. D Vacuum stage (image plane). E Illuminator for viewing microscope. F Exposure control unit. G Shutter and filter holder. H Pneumatic focusing indicator. I Plate rotation. J Tube length adjustment. K Camera focusing. L Viewing focusing. M Viewing microscope eyepiece.

The photographic negative has a limited life and a metal image is often photo-fabricated for mass-production printing. Kodak Photosensitive Metal-clad glass plates have a thin chromium film (<0.10 μm) coated with photoresist and give a scratch-resistant printing master of high quality.

Both KMER and KTFR show a loss of speed in the presence of oxygen, particularly in thin films. Exposure of sub-micron coatings are sometimes made in a partial vacuum or in an atmosphere of nitrogen.

These circuits are very rarely made singly, the economics of manufacture being such that it is preferable to make the circuits in a multiple array of say 10×10 over a 1-inch square. When the photo-resist method of masking is used, the multiple images are exposed on to the coated wafer by reduction printing (at 1/10 or 1/20 scale) from the master negative in a step and repeat microphotographic camera. The Watson Mk III Step-and-Repeat semi-automatic camera is shown in Fig. 16.4; other automatic camera systems (such as the Mann Photorepeater) are available for higher output. The position of each image should be located with a precision of about 0.25 μm and this standard must be maintained for each successive circuit layer (frequently 6 or more) over the entire array. Alternative methods of producing an array of images in this work are mentioned in Chapter 6.

After the completion of fabrication the individual circuits or chips are separated and encapsulated.

The strictest attention to cleanliness is essential for micro-circuit manufacture and a clean room installation is necessary at all stages of the process.

16.6 *Photo-lofting*

The manual marking-out of material before the machining of templates and other components is a lengthy and expensive process, requiring constant reference to the original drawings. In photo-lofting a permanent image of the drawing is produced on the raw material and gives all the information necessary for machining, without the need for quoting any dimensions on the drawing;[19] errors in marking-out are avoided and reproducibility is assured between a number of components.

In the original process, silver-halide liquid emulsions or transfer sensitising paper were used. This may still be preferable if projection printing is required on to large components, but for most purposes contact printing is used with the slower diazo-based materials.

Tupholme has described variations of this process and has illustrated several war-time applications.[20] Photo-lofting has been used in the production of most British aircraft in recent years as well as in the motor industry; it has also been used in box-making for transferring marking-out patterns to ply-wood, prior to cutting and folding of cartons.

Materials and equipment for photo-lofting are currently available from Lee-Smith Photomechanics. Their Loftline Photolacquer is a diazo-sensitised coating which is sprayed or brushed on to the specimen. Exposure is made by contact printing through the original drawing or tracing; the developer solution is then applied with a sponge and an indelible positive line image appears in a few seconds; no fixing or washing is required. The entire process can take place in a normal workshop provided that it is

451

shielded from direct sunlight. Vacuum printing frames up to 5×8 ft are available and larger sizes up to 8 ft wide and of almost any length can be constructed on a modular basis. The larger units use a travelling tubular light source to give even illumination of the coated material; the rate of traverse is about 8 ft a minute.

16.7 *Three-dimensional photo-polymer models*

Terrain contour models up to 20 mm in height have been prepared in photo-polymers which are insolubilised by light.[21] A thick layer of polymer is coated on to a transparent support and is exposed through the base to a projected image. The thinner areas of the negative correspond to the high-altitude parts of the terrain and thus expose the polymer in greater depth. Development consists of washing off the unexposed polymer, leaving the model surface, which varies in height according to the relative exposure.

The polymer model is then used to make rubber moulds for casting quantities of models in plastic or plaster.

16.8 *Drawing-office applications*

The principal requirement for photo-sensitive materials in the drawing office is for the reproduction of drawings, mainly by diazo printing, reflex printing, or using electrostatic or microfilm methods.[22] Some technical aspects of microfilming have been mentioned in Chapter 6; the economic and practical aspects of other processes are discussed in works on document copying.[23, 24]

Apart from these reprographic systems, photography may assist the draughtsman in other ways, for example:

(1) The repetitive drawing of symbols, particularly in printed circuit design, can largely be avoided by use of photographic symbols; Ozalid supply a diazo-type film (Ozakling) with a self-adhesive backing, which is well suited as a short-run substitute for pressure-sensitive transfer symbols.

(2) Screened photographs of buildings, chemical plant and engineering assemblies can be combined with line work to give a combined photo-drawing, which can be reproduced cheaply on diazo paper for workshop use.[25, 26]

By placing reference scales within the scene, 'perspective grids' may be drawn on the prints. In this way the area and location of key points on walls and floors can be estimated to a few per cent without rigorous photogrammetric techniques[27] (see also p. 387).

(3) The use of a stereo-photogrammetric library for draughtsmen working on revisions of complex chemical plant has been mentioned in Chapter 14.

452

References

1 STEVENS, G. W. W., *Microphotography*, 2nd Ed, Ch 10, Chapman & Hall, London (1968).
2 *Chemical milling with Kodak photoresists*, Eastman Kodak Publication P-131 (1968).
3 DOLBY, R. F., *Indust. Comm. Phot.*, 9, 8, 81–4 (1969)·
4 COOMBS, C. F., *Printed Circuits Handbook*, McGraw Hill, New York (1967).
5 HEPHER, M., *Phot J Sci*, 12, 180–90 (1964).
6 HEMENWAY, D., *Photo Methods for Industry*, 12, 4, 50–62 (1969). [Includes a useful bibliography on photoresist applications.]
7 GERMAN, D. E. B. and STEWART, J. C. J., *J Phot Sci*, 15, 137–44 (1967).
8 STEVENS, G. W. W., *op cit*, pp 323–7.
9 WILSON, E. T., *J Phot Sci*, 12, 328–30 (1964).
10 *Artwork for photofabrication*, Kodak Compass No. 2, Eastman Kodak Ltd. (1963).
11 *An introduction to photofabrication using Kodak photosensitive resists*, Eastman Kodak Publication P-79.
12 *Artwork for photofabrication*, p 13, Kodak Compass No. 2, Eastman Kodak Ltd. (1963).
13 HOLLAND, L. (Ed) *Thin film microelectronics*, Chapman & Hall, London (1965).
14 COOMBE, R. A. (Ed) *The electrical properties and applications of thin films*, Pitman, London (1967).
15 STEVENS, G. W. W., *op cit*, Ch 11.
16 *Kodak seminars on microminiaturisation:* No. 1 (1965) Pamphlet P-77; No. 2 (1966) Pamphlet P-89; No. 3 (1967) and No. 4 (1968) 2 vols Pamphlet No. 192.
17 *Joint conference on thick-film technology; London, April 1968*, IERE Conference Proceedings No. 11.
18 SHEPHERD, A. A., *Thin film microelectronics*, Ed L. Holland, Ch 3, Chapman & Hall, London, 1965.
19 *Prod Technol*, 1, 252–8 (1963).
20 TUPHOLME, C. H. S., *Photography in engineering*, pp 22–32 and Plates 13–30, Faber & Faber, London (1945).
21 CLAUS, C. J., KROHN, I. T. and SWANTON, P. C., *Phot Sci Eng*, 5, 211–15 (1961).
22 *Kodak Data Sheet IN-5*, Kodak Ltd., London.
23 VERRY, H. R., *Document copying and reproduction processes*, Fountain Press, London (1960).
24 HAWKEN, W. R., *Copying Methods Manual*, American Library Association, Chicago (1966).
25 FARRAND, R., *Photo methods for industry*, 12, 6, 60–71, 76 (1969).
26 *Photo drawing*, The Focal Encyclopedia of Photography. Rev. edn. (1969).
27 FARRAND, R., Paper 2. *Photography in Engineering*, Conferences London, 1969. Inst. Mechanical Engineers, London (1970).

Technical journals

Solid state technology, published monthly by the Cowan Publishing Corp, Washington.
Microelectronics, published monthly by Shaw Publishing Co., London.
Plan and Print, published monthly by the International Association of Blue Print and Allied Industries Inc., Chicago.

453

17. SPECIAL PURPOSE CAMERAS

17.1 'Convenience' Designs

Special purpose cameras may be desirable for reasons of convenience or necessity. 'Convenience' purposes include:
(1) To increase the speed of the photographic operation.
(2) To produce consistent results regularly, even with different operators.
(3) To simplify photography, enabling operation by non-photographic personnel.
Such special purpose cameras are particularly useful when repeated photography of similar subjects under similar conditions is needed over a period of time and are usually required for close-up or macro photography.

17.1.1 BASIC CAMERA SYSTEM. Important factors in deciding the optics and sensitive material of the camera system are:
(1) Size and nature of subject.
(2) Manner of use (fixed or hand held) and by whom (photographer or non-photographer).
(3) Limitations (if any) on overall size.
(4) Purposes for which records are required.
(5) Number of pictures to be taken at any one time.
(6) Acceptable delay in access to the results.
Focal length, aperture and correction of the lens; size, form (e.g. sheet or roll film) and type (conventional or Polaroid) of material should be considered. Approximate dimensions for any image scale can be assessed by normal lens conjugate calculations (Chapter 4.1.2). Simplicity of both design and operation is a virtue and is made easier by precise specification of the requirement and, where possible, the avoidance of dual-purpose operation. Fixed focus designs are ideal for use by non-photographers, with reflex systems the best alternative.

Depth of field is small with close-up subjects but a simple spacer device, to locate the camera relative to the subject, is effective even at high magnifications (10 or more). Where different magnifications are necessary, separate spacer units, each complete with an appropriate supplementary lens are often practical. These eliminate the need for a focusing movement, so reducing production cost and simplifying operation. Another way of locating the camera for low magnifications (up to about 2) is by use of a fixed focus light beam range finder consisting of two light beams coming from opposite extremities of the camera and meeting in the plane of camera focus[1] (Fig. 17.1). To focus, the camera is moved towards the subject until the two beams are seen to fall on the same spot. Exposure by flash effectively swamps the rangefinder light. For some applications the camera may need to be located on a special stand which also accepts the subject in a fixed position. In this case the whole apparatus must be considered as one unit (Fig. 17.2).

Built-in fixed camera movements may be useful. Rise, fall or cross movements can help to eliminate distortion of plane subjects and sometimes make illumination simpler (by avoiding specular reflections). Swing movements give a suitable plane of focus with oblique viewing (Chapter 4).

455

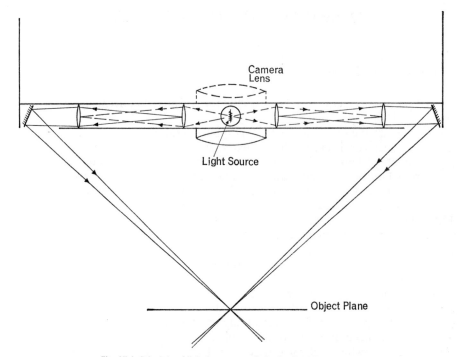

Fig. 17.1. Principle of light beam rangefinder for fixed focus camera.

Mirrors can be valuable either to allow different views of the subject (e.g. front and back) or to bend the optical path, making the complete apparatus more convenient in size and shape (Fig. 17.3).

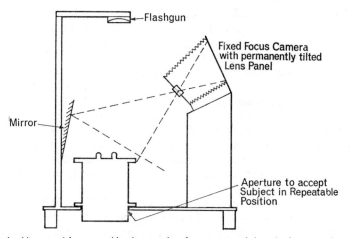

Fig. 17.2. Camera and subject stand for repeatable photography of process vessel deposits for comparison purposes (see Plate 33).

456

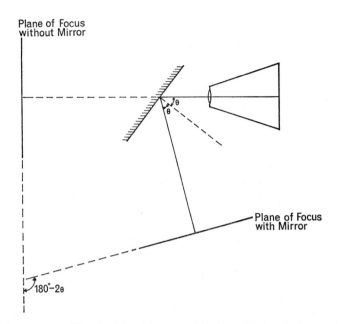

Fig. 17.3. Use of mirror. The plane of focus is displaced through an angle $180° - 2\theta$ where θ is the angle between camera axis and normal to mirror.

The use of components available commercially in standard form should be considered, e.g. 5×4 in. international back, 35 mm reflex body or shutter units. Such components when suitable are usually cheaper than the workshop costs involved in special production. A study of the appropriate British (or American) standards is often necessary to avoid difficulties due to incompatibility with standard sensitive materials or other equipment.

Illumination provided as an integral part of the camera is effective in ensuring consistent quality. Small self-contained electronic flash units are particularly suitable and the short duration allows hand held operation even with magnified images. Miniature low voltage lamps powered by a capacitor discharge are another possibility with more limited output. This system is used in the Envoy fingerprint camera described on page 459.

17.1.2 CRITICAL DIMENSIONS. When the general form of the camera is decided, attention should be given to the fixing of the critical dimensions. These will usually be the object and image conjugates, the mechanical distances associated with these and possibly other dimensions concerned with the position of the camera body relative to the subject (e.g. lateral positioning).

Most lenses differ, however slightly, from their nominal focal length and the position of the principal planes is not usually known. They can be measured and calculations made accordingly, but it is generally more practical to build the proposed optical system into a standard camera, or set it up on an optical bench, and measure the critical dimensions accurately. A cardboard or plywood mock-up can provide a valuable check.

It is prudent to allow some final adjustment of focus (and image size, if critical) in the design. This could be effected by using screw threaded mounting(s) which can be locked and preferably sealed after setting. Alternatively, components can be made initially oversize, the final machining of locating surfaces taking place after trials. To ensure that too much material is not removed, accurate calculations of focus *differences* between actual design conditions can be made using formulae in the form:

$$v_2 - v_1 = (m_2 - m_1)F \qquad\qquad \text{Eq. 17.1}$$

$$u_2 - u_1 = \left(\frac{1}{m_2} - \frac{1}{m_1}\right)F \qquad\qquad \text{Eq. 17.2}$$

where u_1 and u_2 are actual and intended object distances.

v_1 and v_2 are actual and intended image distances.

m_1 and m_2 are actual and intended magnification with sharp focus.

F is the focal length of lens in use.

These do not rely on actual measurement of u or v and so avoid any uncertainty due to the unknown position of the principal planes. Many lenses supplied in focusing mounts can have the movement (or iris diaphragm) locked in any position by judicious insertion of a grub-screw to avoid wrong settings being inadvertently used. Careful examination or consultation with the manufacturer is recommended to ensure that no damage is caused to the lens.

The position and particularly the angles of mirrors used in the design are likely to be critical because they affect the alignment of the optical path as well as its length. Mirrors used close to the camera lens are generally most critical because they exert an 'optical lever' effect. They are best mounted on accurately machined angle blocks or provided with a fine adjustment.

Once the critical dimensions and those associated with commercial components have been determined the remainder of the design is a matter of convenience. Sharp corners and protrusions should be avoided and if the camera is to be used hand-held some form of handgrip and convenient shutter release are desirable. 'Everset' type shutters, which require no separate cocking action, are useful because they simplify the operation.

17.1.3 CONSTRUCTIONAL MATERIALS. The suitability of materials depends largely on the purpose, size, strength requirements of the design, acceptable weight and the workshop facilities available. Sheet metals (e.g. 16 swg brass) are generally suitable for enclosed (box) structures giving adequate strength and light weight but, for components requiring strength and rigidity from the material rather than the construction, duralumin is suitable and easily worked. Wood can be used for larger structures. Sindanyo, a solid form of asbestos material, is useful for parts exposed to heat, e.g. fixings to a furnace.

Surface coated mirrors should be used to avoid double reflections. Aluminised surfaces are very delicate and somewhat impractical for exposed use but can be obtained with a protective coating of silicon monoxide[2] which permits normal cleaning. Semi-reflecting mirrors are sometimes used for illumination purposes or superimposition of images. For such purposes titanium dioxide coatings are more efficient and resistant to damage.

17.1.4 EXAMPLES OF SPECIFIC CAMERA DESIGN. The *skin camera* due to C. E. Engel[3] is a macro camera which can give fixed magnifications of 1, 2, 3, 4 or 5 with built in

electronic flash. A spacer device is used to ensure sharp focus, but to overcome the resilience of the skin a fibre ring with a microscope cover slip is mounted on two sensitive feelers which ensure that the pressure is suitable and even. The circuit is arranged so that the flash fires automatically when and only when the required conditions are satisfied.

A *fingerprint camera* made by Envoy (Photographic Instruments) Ltd. and available commercially, is a fixed focus camera producing a 1:1 image on $2\frac{1}{2} \times 3\frac{1}{2}$ in. cut film. Four 3·5 volt 0·3 amp lamps situated at the front corners of the camera are powered by the discharge of a capacitor which is fed by two 30 volt deaf aid batteries. The discharge is synchronised to the shutter operating at 1/25 second, and gives adequate exposure on medium speed film. The lens is offset in the camera body to allow the recorded area to extend into right angled corners when necessary. A removable target mask is provided which outlines the field of view.

For some applications the use of a *pinhole camera* may be quite attractive (see also p. 269). The advantages of such a system include the large depth of field, wide angle of view, and absence of spectral absorption, although resolution and image luminance are limited.

The optimum pinhole diameter is given by*

$$D = \sqrt{1\cdot8}\,\sqrt{2v\lambda} \text{ or }$$

$$D = \sqrt{3\cdot6v\lambda} \qquad\qquad \text{Eq. 17.3}$$

where v=pinhole-image distance λ=wavelength of light used, both expressed in the same units.

e.g. If v=100 mm, λ=500 nm (i.e. 5×10^{-4} mm), then:

$$D = \sqrt{3\cdot6 \times 100 \times 5 \times 10^{-4}} \text{ mm}$$

$$D = \sqrt{18 \times 10^{-2}} \qquad\qquad = 4\cdot24 \times 10^{-1} = 0\cdot424 \text{ mm}$$

A special pinhole camera designed for recording the interior walls of cylinder bores in diesel engines has been described by Lorant.[5]

17.2 *Specific Purpose Cameras*

Instruments such as flight analysis or race finish cameras and other cameras described in this book were developed because specific requirements could not be satisfied with conventional cameras. The following are some other examples.

17.2.1 PERIPHERY CAMERA. A requirement which is virtually impossible to satisfy with normal equipment is the recording, in a single 'rolled out' photograph, of a complete cylindrical surface. Various simple but limited methods have been suggested for achieving such a record.[6, 7] A versatile design by Shell Research Ltd. is the basis of the commercially available R.E. Periphery Camera.[8, 9]

The principle of this system (Fig. 17.4) depends on the object being rotated about its vertical axis while the film, in a stationary camera, is driven past a vertical slit at a velocity (v_f) equal to that of the image:

*Other values are also suggested, both higher and lower.[4]

$$v_t = 2\pi rmR \qquad\qquad\qquad\qquad \text{Eq. 17.4}$$

where r is the radius of the object.

 m is the magnification.

 R is the rotational speed of the object.

e.g. if r=3 cm, m=$\frac{1}{2}$ and R=1 rev/min.

$$v_t = 2\pi \times \frac{3}{2} = 3\pi = 9{\cdot}42 \text{ cm/min.}$$

Fig. 17.4. Periphery camera. The exposing slit and centre of rotation should be on the lens axis. The ratio of film and object velocities depends on the magnification.

Only if the traversing velocity of the film corresponds to the rotation of the object is an undistorted picture obtained. Details of hollows or protrusions on the cylindrical surface may be unsharp, because their image velocity does not match that of the film drive, but this can be largely overcome by use of a very narrow slit which restricts the exposure time of any point. However, the horizontal scale of the image of these areas is always distorted, owing to the difference in circumferential velocity, so that hollows are stretched and bulges compressed. The distortion factor is $\frac{r}{r^1}$ where r is the normal radius and r' is the radius at any particular point.

The turntable and film are driven at fixed speeds by synchronous motors and the magnification is adjusted to satisfy the equation $v_t = 2\pi rmR$.

Lighting an object for peripheral photography by this system is simplified by the fact that only a narrow strip is recorded at any one time and its position is fixed. Illumination can therefore be critically arranged on this strip to give the exact effect required, which is then reproduced uniformly over the entire surface.

The camera can also be used for recording the 360° of an *interior* cylindrical surface, by angling it downwards to view the further inner surface (with some distortion unless sufficient drop front can be used) or by using fixed 45° mirrors to view the surface at right angles.

Applications of the periphery camera include use in engineering (e.g. piston and bearing surfaces, gears etc.), forensic science (fingerprints on pencils), archaeology (details of pottery) and many other fields. (Plates 35 and 36.)

17.2.2 PANORAMIC CAMERA. A panoramic camera is used to obtain a very wide angle of view in one plane (usually horizontal for ground level photographs). Modern high quality wide angle lenses have reduced the need but such cameras are still required for some applications. Compared to a conventional camera with wide angle lens the panoramic camera:

460

(1) Gives a wide angle in one plane only.

(2) Can give better resolution by using highly corrected lenses covering only a small field.

(3) Does not give the inevitable wide angle distortion of spherical or cylindrical objects, because the image forming rays are nearly normal to the film surface.

(4) Gives a panoramic distortion, making curved surfaces with centre of curvature at the camera appear straight and flat surfaces normal to the camera scanning plane appear convex.

(5) Always has a time separation between the recording of different angles.

(6) Can cover a 360° angle relatively easily (with some designs).

The simplest and most effective panoramic principle involves rotating the camera about an axis perpendicular to the lens axis and passing through the lens near nodal point. This produces an image which is stationary in space and can be received on a stationary cylinder of film through a slit which rotates with the lens (Fig. 17.5a). Alternatively, with the film chamber as part of the rotating assembly, the film can be driven 'backwards' past the slit at a speed equal to the circumferential speed (Fig. 17.5b). This latter method can cover 360° simply whereas mirrors must otherwise be used to avoid the obstruction of the film cylinder for angles greater than about 160°. To ensure uniform exposure and freedom from local distortions, the rotation and film drive must be smooth and accurately synchronised. The effective exposure time at any image point is $\frac{\text{width of slit}}{\text{film velocity}}$. A very narrow slit increases the chance of high frequency fluctuations in the drive speed causing striations due to exposure variations.

The use of moving film can be extended by modification of the drive speed to systems with rotation about other axes, in which the image is not stationary. As in the periphery camera such a drive speed can be correct only for one particular magnification; linear distortion and possibly unsharpness resulting at other image scales. The correct film drive speed (v_f) to match the image movement is given by the formula:

$$v_f = 2\pi R\,[d - (d-v)\,(1+m)] \qquad \text{Eq. 17.5}$$

where R is the rotational speed of the camera

d is the distance of the axis of rotation *in front of* the image point (negative if axis of rotation is behind film plane).

v is the image distance from the lens rear node.

m is the magnification.

Note that when d=v (i.e. the lens rear node is on the axis of rotation):

$$v_f = 2\pi Rd \ (\text{or } 2\pi Rv) \qquad \text{Eq. 17.6(a)}$$

and is independent of m.

Also, when m is small, as with distant objects:

$$v_f = 2\pi Rv \qquad \text{Eq. 17.6(b)}$$

and is independent of the position of the axis of rotation. Provided the film velocity is correct and it passes the slit in a plane, the width of the slit is not particularly critical, several millimetres being usually quite practical. The limitations of slit width are discussed by Magill.[10]

The periphery camera used to record interior surfaces (p. 460) is effectively a panoramic camera with its axis of rotation at the centre of the subject. In this case the

461

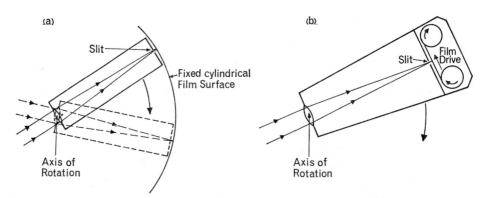

Fig. 17.5. Panoramic camera with rotation about lens rear nodal point (a) with fixed cylindrical film surface (b) with reverse film drive.

mechanics are different (the subject rotating with the camera stationary) but the optical principle is the same.

Thirty-five millimetre cameras using a lens rotating about its rear nodal point are available (Japanese Widelux and Russian Horizon) which cover a very wide field of view (140° or 120°). These expose on to a stationary film in a curved track by means of a focal plane shutter in the form of slotted cylinder. The scan time is less than one second to expose a format 24×60 mm or slightly less.

Cameras using rotating mirrors or prisms to obtain the field sweep have been designed,[11] and in particular models with a double-dove prism are used for aerial reconnaissance purposes. Taking measurements from the records of such cameras raises various problems.[12]

17.2.3 ORTHOGRAPHIC CAMERA USING TELECENTRIC OPTICS. With normal photographic optics, the magnification as well as the sharpness depends on the object distance and the image distance. It is possible, however, using a *telecentric* optical system, to make the image size independent of one or both of these distances, producing an orthographic image. A simple system is shown in Fig. 17.6, using a telecentric stop at the principal focus of the lens so that the central image-forming ray from any point on the object is initially parallel to the axis. This means that the object distance is not

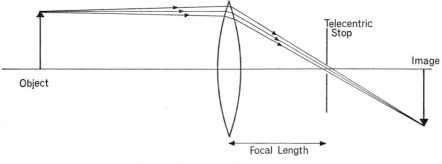

Fig. 17.6. Simple lens with telecentric stop.

462

critical in deciding the magnification, the effect of perspective being eliminated. The image sharpness, of course, is still limited by the depth of field. The same system reversed (i.e. stop in front of lens) is telecentric with respect to the image plane only. The object (or image) field of any telecentric system is limited to the physical diameter of the front (or rear) lens element.

Such a system is useful in applications where magnification needs to be repeated *precisely* and exact location cannot be guaranteed or where the size or position of two objects not quite in the same plane is to be accurately compared. It can give, for example, a parallax-free image of a pointer in front of a scale. Telecentric optics with collimated illumination are used frequently in profilometers but their application to photographic recording is not yet widespread. A unit magnification system with a 2-in. diameter field of view is described by Luxmoore[13] for the measurement of strains by moiré fringe technique. This is telecentric on both sides (Fig. 17.7) making both object and image plane insensitive and, being symmetrical about the stop, it gives very little curvilinear distortion. Field curvature is unfortunately rather large and only small apertures are useful.

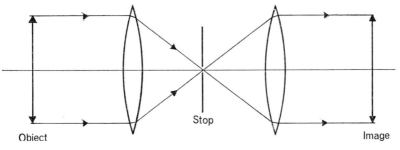

Fig. 17.7. Double telecentric lens, telecentric with respect to both object and image planes.

17.2.4 BUBBLE CHAMBER CAMERA. The bubble chamber[14] is a sophisticated device for making visible the tracks of nuclear particles. It consists of a chamber whose volume may be several cubic feet, containing a low temperature liquid (e.g. helium, hydrogen, propane etc.) .When pressure on the liquid is reduced, bubbles form in the wake of the tracks of charged particles. These bubbles are usually recorded by three or more cameras simultaneously, so that the precise path of the particles can be determined by photogrammetric analysis.

Positional accuracy of the image on the film is generally required to be about 1 μm and is achieved with vacuum holddown systems to ensure film flatness. This factor is particularly critical with conventional wide angle lenses and has led to the development of lenses telecentric with respect to the image plane (see above) with very wide acceptance angles (up to 140°).

Conventional recording cameras (e.g. Flight Research, Model 207) may be used in modified form but special cameras are usually built for use with individual chambers. The intense magnetic field associated with the chamber may prevent the camera motors from operating. Special cameras are driven by motors mounted comparatively remotely from the magnetic field, but even then shielding is necessary. Large film capacities are used (usually 300 metres) to restrict loss of valuable operating time during film reloading.

Because the location of the camera lenses is basic to the accurate analysis of the records, the lenses are permanently mounted with their axes parallel on a single lens plate and the whole assembly mounted rigidly with respect to the chamber. The remainder of each camera, essentially the film supply and transport system, is then located separately behind each individual lens offset from its axis so that the whole chamber image is recorded (Fig. 17.8).

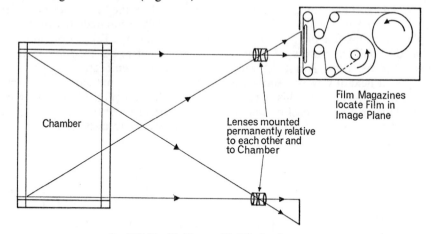

Chamber

Lenses mounted permanently relative to each other and to Chamber

Film Magazines locate Film in Image Plane

Fig. 17.8. Simplified layout of bubble chamber cameras.

Small lens apertures are necessary (typically $f22$–$f32$) to obtain sufficient depth of field, even though maximum resolution is not then obtained.

Chromatic spread of white light passing from the chamber liquid through a thick glass window and to the camera lens can produce quite serious colour fringing and filters are commonly used to restrict the bandwidth to about 50 nm. The optical surfaces of condensers and windows have anti-reflection coatings to improve contrast.

The front (camera) window must be of the very highest quality optical glass, and extremely accurately worked to avoid introducing local distortions. In large chambers

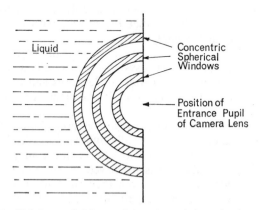

Liquid

Concentric Spherical Windows

Position of Entrance Pupil of Camera Lens

Fig. 17.9. Concentric fish-eye windows for use in large chambers.

this becomes increasingly difficult and expensive and, together with the aberrations resulting from large field angles, makes an alternative arrangement attractive. Latest designs propose the use of smaller fish-eye windows at the centre of which the entrance pupil of the lens can be situated (Fig. 17.9).

A short-duration flash source (typically 100–200 μsec) is used for illumination. To identify corresponding views of the same event a secondary data recording exposure is made via separate optics and this may use a simple shutter.

The most common illumination is a sensitive dark field system. This and other methods, including the use of Scotchlite for bright field illumination, have been described by Welford.[15]

Results of testing of various films for bubble chamber use have also been described by Welford[16] who concludes that Ilford Track Recording film (similar to Pan F but non-colour sensitised) and an equivalent Kodak experimental film are most satisfactory.

References

Special Purpose Cameras

1 CAUDELL, P. M., *Med Biol Illus*, **11**, 168 (1961).
2 HASS, G., *Applied optics and optical engineering*, Ed R. Kingslake, Vol III, p 321, Academic Press, New York (1965).
3 ENGEL, C. E., *J Phot Sci*, **4**, 40 (1956).
4 FJELD, J. M., *JSMPTE*, **74**, 320 (1965).
5 LORANT, M., *B J Phot.*, **111**, 140 (1964).
6 WISE, L., *B J Phot*, **113**, 384 (1966).
7 LUCK, H. R., *J Phot Sci Am*, **12**, 61 (1946).
8 DELIUS, P., *B J Phot*, **108**, 598 (1961).
9 ANON—RESEARCH ENGINEERS LTD., *Periphotography with the R.E. Periphery Camera*, Research Engineers Ltd., London.

10 MAGILL, A. A., *Applied optics and optical engineering*, Ed R. Kingslake, Vol IV, p 154, Academic Press, New York (1967).
11 ANON—ITEK LABORATORIES, *Photogramm Eng*, **27**, 747 (1961).
12 ANON—ITEK LABORATORIES, *Photogramm Eng*, **28**, 99 (1962).
13 LUXMOORE, A. R., *A portable camera for accurate strain measurement*, University of Wales (1968).
14 SHUTT, R. P., Ed *Bubble and Spark Chambers*, Vol 1, Academic Press, New York (1967).
15 WELFORD, W. T., *Bubble and Spark Chambers*, Ed R. P. Shutt, Vol I, Ch V, Academic Press, New York (1967).
16 WELFORD, W. T., *J Phot Sci*, **10**, 243 (1962).

18. PHOTOGRAPHY OF INACCESSIBLE OBJECTS

Subjects may be inaccessible to the photographer in different ways and for different reasons. They may be large and separated from the photographer only by distance, as in astronomy, inaccessible because of their hazardous nature, e.g. radioactive materials, or they may be physically inaccessible due to their configuration, e.g. the inside of small bore tubes, cavities etc.

18.1 *Telephotography*

There are two approaches:
(1) Telephotography by using extra long focal length lenses of either normal or telephoto construction.
(2) The use of a camera with a telescope, involving both primary and secondary magnification.

18.1.1 LONG-FOCUS LENSES. Using very long focal length lenses is the simplest method of achieving larger than normal image sizes. There is no point in increasing the final image size above that needed to see the finest detail resolved by the lens.

Theoretically the smallest detail of a distant subject which can be resolved is given by the formula:

$$s = \lambda f/m \qquad\qquad \text{Eq. 18.1}$$

where s is the separation of two resolved points on the subject
λ is the wavelength used.
f is the *f*-number of the lens.
m is the image magnification

Very long focal length lenses (over 1000 mm) for 35 mm cameras usually have maximum apertures of about $f8$, giving in Eq. 18.1: if $\lambda = 500$ nm and $m = 1/100$:

$$s = 0 \cdot 0005 \times 8 \times 100 = 0 \cdot 4 \text{ mm}$$

However, owing to the difficulty of producing long focus lenses of high correction and the effect of emulsion resolution, the practical value may be 4 or 5 times greater (typically 2 mm in this example). To make this detail just visible on a print it should be enlarged to be $0 \cdot 1$ mm (see Fig. 5.7), which requires an enlargement factor of $0 \cdot 1/0 \cdot 02 = 5$ from the negative.

In practice, there is unlikely to be significant advantage in using a lens of focal length of more than about 40 times the normal for a given negative size (2000 mm in the case of a 35 mm still camera). Even with telephoto construction such a lens is inevitably bulky.

Mirror lenses may be used, and have the advantage of comparative freedom from chromatic aberrations, as well as being lighter and less bulky than refracting lenses of similar focal length and aperture (Fig. 18.1).

The use of ultra-long focal length lenses requires extreme care to ensure absence of vibration. It is generally better to provide a mount for the lens and regard the camera as an attachment. Atmospheric haze can also be a problem in long range photography. A clear blue sky is not necessarily an advantage, although generally the best weather

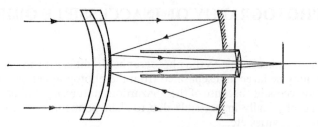

Fig. 18.1. Mirror lens with weak doublet correcting lenses.

conditions, short of those producing heat haze, are needed. The use of filters, absorbing the shorter wavelengths, reduces the effect of haze and infra-red photography can be advantageous (see Chapter 7.3.1).

18.1.2 PHOTOGRAPHY VIA TELESCOPES. The camera in this type of work usually has no optics of its own and can be regarded as a recording system attached to the telescope itself.

(a)

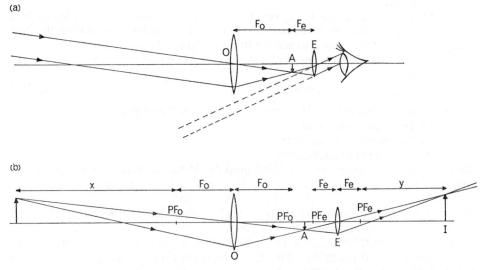

(b)

Fig. 18.2. Simple astronomical refracting telescope. (a) Visual observation of object at infinity. (b) Image of close object focused in film plane. PF_o and PF_e are principal focal points of objective and eyepiece respectively.

High power refracting telescopes are of two main types, astronomical and terrestrial. The latter contain an erecting lens or prism which for photographic purposes is unnecessary. An astronomical refracting telescope has a positive objective of long focal length and a positive, short focal length eyepiece. The objective O forms a real image at A (Fig. 18.2a), and in viewing, the eyepiece E observes the virtual image of A at infinity. The magnifying power is then equal to $\dfrac{F_o}{F_e}$. As in the case of the microscope (Fig. 5.4) adjustment of the eyepiece causes a real image I to be formed in the film plane of the camera. In this case the camera magnification (M) given by

468

$$M=\frac{F_o}{F_e}\times\frac{y}{x}$$ Eq. 18.2

where x is the object distance from the front principal focal plane of the objective and y is the image distance from the rear principal focal plane of the eyepiece (Fig. 18.2b). Practical calibration is necessary where accurate magnification is required.

The resolution, and hence the useful magnification, of any telescope objective is governed by its diameter.

If F is the objective focal length
 u is the object distance
 d is the objective diameter
then, substituting $m=F/u$ and $f=F/d$ in Eq. 18.1 we get $S=\lambda u/d$.

The most powerful astronomical telescopes are of the reflecting type, using a large concave mirror as the objective. In a Newtonian telescope the mirror is parabolic allowing a large aperture with freedom from spherical aberration. This is efficient from the light gathering point of view and gives high axial resolution but performance suffers severely from coma, the useful field being less than $\frac{1}{2}°$[1]. The largest reflecting telescope, the 200 in. diameter instrument at Mount Palomar, is of this type and has an aperture of $f3\cdot3$.

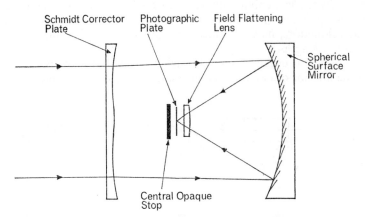

Fig. 18.3. Simple Schmidt camera. A plane (or convex) mirror may be used to reflect image back through a central aperture in the principal mirror, as in Fig. 18.1.

The Schmidt telescope (sometimes called the Schmidt camera*) considerably reduces the effect of coma by using a spherical mirror with a specially shaped corrector plate. This flattens the image field and allows very large apertures (e.g. $f1$) to be used.[2] The largest Schmidt telescope is the 48 in. diameter, also at Mount Palomar.

The majority of stars are too faint to be seen by the naked eye, and exposure times, increased by the effect of reciprocity failure, can run into many hours. Complex tracking mechanisms (equatorial mountings) are used to enable the telescope to follow the apparent motion of stars caused by the rotation of the earth.

*Such instruments usually use a single stage magnification only, so that the term 'telescope', as described above, does not strictly apply.

18.2 *Endoscopic Photography*

Endoscopes and periscopes are essentially similar instruments, comprising a tube containing an optical system to enable an observer to view from one end of the tube, an area or object at the far end of the tube. Usually such instruments have a mirror or prism at the object end to permit other than axial viewing, and in endoscopes some form of lighting is incorporated. Borescopes, introscopes, cystoscopes, and other instruments are basically similar in optical design, being named according to their intended application. In their earliest crude forms, such instruments consisted merely of a hollow tube with a mirror at the object end, but most modern instruments incorporate some form of optics. Any endoscope system incorporating internal optics is limited in aperture (and therefore resolution) by its diameter, so that for any particular application an instrument should be used with as large a diameter as possible.

18.2.1 OPTICAL PRINCIPLES. In a typical endoscope (Fig. 18.4a) the objective O focuses an image of the object at I_1. This is then re-imaged at I_2 by the first pair of collimating lenses C_1 and C_2. The distance from I_1 to the focal point of C_1 is equal to the focal length of C_1, and therefore rays from a central (on axis) point of the object are parallel between C_1 and C_2. The spacing between each lens of a collimating pair is equal to two focal lengths and the system is repeated for collimators C_3 and C_4. The image formed by the last collimating lens (C_4 in this case) is observed or re-imaged on to a photographic film via the eyepiece E. Any number of sections, each comprising one pair of collimators, may be added, so that one basic instrument may be used with a variety of lengths.

Curvature of field is usually present in such a system but in many applications, e.g. looking at the interior of narrow tube bores, this is no disadvantage.

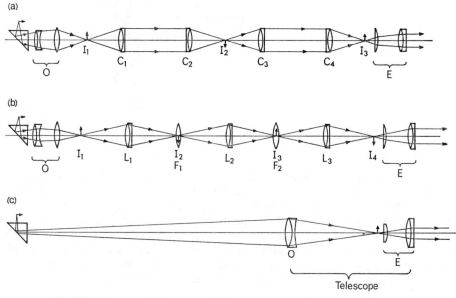

Fig. 18.4. Endoscope optical systems. (a) Using collimating lenses. (b) Using field lenses. (c) Using telescope principle.

470

An alternative system (Fig. 18.4b) uses field lenses (F_1, F_2 etc.) between successive image forming lenses to re-converge the beam so as to fill the image forming lenses L_2, L_3 etc. The image and field lenses are of equal focal length, two focal lengths apart. This system can give a comparatively wide field of view but any dirt or blemishes on the field lenses tend to be focused on to the film. For this reason they are sometimes displaced from their ideal optical position. The system has the further disadvantage of being less easily broken down into separate units.

A disadvantage of both systems, especially for photography, is that the relatively large number of air/glass surfaces produces significant flare, even with coated lenses. A third method keeps all the optics at one end of the tube viewing a mirror at the other end by means of a simple telescope (Fig. 18.4c). This system is relatively inexpensive, but is not capable of working at such long distances as the other systems.

Most instruments are provided with a range of viewing heads or probes (Fig. 18.5), using mirrors or prisms for viewing at different angles.

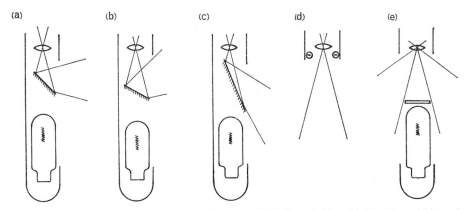

Fig. 18.5. Endoscope viewing heads; (a) right-angle (b) retrograde (c) forward oblique (d) direct forward (e) annular forward oblique (360° panorama). Prisms may be used in place of mirrors.

18.2.2 FOCUSING METHODS. Many endoscopes are designed primarily as visual instruments and the photographic recording of the image is often disappointing in relation to the visual image. In particular the sharpness of the image is reduced by the effects of field curvature, small aperture and, possibly, limited depth of field.

The effective aperture of an endoscope is typically of the order of $f100$. Although reasonably short exposures ($\frac{1}{2}$ sec or less) may be adequate with fast films, any movement or vibration of the subject can cause difficulty. Also, although visual focusing of the aerial image through the eyepiece may be easy, focusing of the camera image is much less easy owing to its poor illumination.

The following focusing method is useful when illumination is poor, or when the instrument has insufficient eyepiece movement to allow focusing of the image direct on to the film (as is the case with some visual instruments). A good visual focus is obtained with the eye 'resting' at infinity (keeping the second eye open aids this operation) and the camera, complete with its own lens focused at infinity, is located close to the eyepiece. With this method, the camera lens must be located close to the exit pupil of the eyepiece to avoid vignetting. Also the image size is dependent on the

471

focal length and may be rather small with a standard camera lens. In practice a 75–90 mm telephoto lens on a 35 mm camera is often suitable in both respects.

18.2.3 LIGHTING METHODS. *Distal* lighting in endoscopes usually employs a small low voltage tungsten lamp located at the tip of the objective head, i.e. beyond the viewing prism. This enables the maximum optical use to be made of the instrument diameter, but prevents straight ahead (axial) viewing. This lighting system is adequate for visual use, but may be less so for photography.

Electronic flash illumination is a possibility, but the location and efficient insulation of leads carrying several kV is a problem where the instrument diameter must be small. For larger instruments mounting of a complete flash unit at the object end may well be practical.

Systems using an external telescope optical system can have advantages from the point of view of illumination. One such instrument, the Vision Inspectascope* uses tungsten illumination reflected from an annular 45° mirror, the telescope viewing through the central hole in the mirror. This simple system has great flexibility in that one optical and illumination unit can serve for a range of tube and probe diameters.

Lighting may also be provided from the eyepiece end of an instrument via light guides (*proximal* lighting). Total internal reflection is possible at a specular interface between any two transparent substances, e.g. glass/air. Light incident at the interface is totally reflected from the higher index side when the angle of incidence exceeds a certain critical value, θ_C, such that $\sin\theta_C = n_1/n_2$, where n_2 is the higher refractive index and n_1 the lower (Fig. 18.6). The principle of total internal reflection may be used to pipe light along the length of a transparent rod usually made of quartz, glass or plastic.

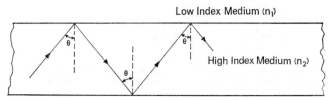

Fig. 18.6. Light guide principle. Total internal reflection occurs when $\sin\theta > \dfrac{n_1}{n_2}$

However, surface contamination, defects or external optical contact with material of similar refractive index attenuate the reflected ray by scattering, absorption or 'escape' of some of the light.

Although such loss is only a few per cent per reflection, the number of reflections in even a short light guide, is such that optical insulation is necessary. This is achieved by coating the surface with a material of lower refractive index.

The use of light guides permits more intense light sources to be used externally, and enables a higher level of illumination to be provided than with distal illumination, with the advantage of less heat on the subject. The single rod light guide usually has a much smaller diameter than the bulb used for distal illumination. This permits unobstructed forward view, but limits the diameter of the viewing optical system relative to the overall diameter of the instrument.

*Vision Engineering Ltd., Woking, Surrey.

472

18.2.4 USES OF FIBRE OPTICS. Fibre optic bundles,[3, 4, 5] consisting of many very narrow, cylindrical light guides optically separated but physically bonded together, may also be used. These inevitably have a lower overall light transmission than a single rod light guide but may be made flexible.

One design of instrument using a fibre optic light guide has the fibrils arrayed around the optical system, thus giving unobstructed forward view, combined with high optical efficiency in terms of the instrument diameter.

Both the direction and shape of the illuminating beam can be varied within a fibre optic light guide system (Fig. 18.7).

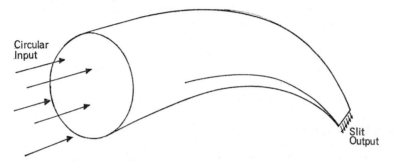

Fig. 18.7. An example of the shape and direction control possible using a suitable light guide.

Fibre optics can also be used for image transmission. If the individual fibres are identically aligned at each end of the fibre bundle, a *coherent* fibre bundle results. Such a bundle can be arranged to form an optical relay system for endoscopes and similar instruments. The number of information points transmitted by such a system is equal to the number of aligned and intact fibres, so the smaller the fibre diameter, and hence the greater number per unit area, the greater is the resolution. The smallest practical fibre diameter is about 2 μm. The numerical aperture (NA) of a fibre bundle (Fig. 18.8) refers to the angular aperture of each fibre and is given by:

$$NA = n \sin i \qquad \text{Eq. 18.3}$$

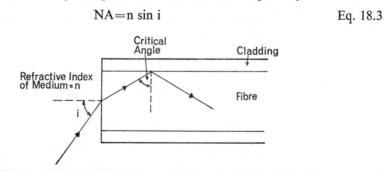

Fig. 18.8. Numerical aperture (NA) of a fibre or bundle equals n sin i. (n=1·0 for air).

Fibrescopes using more than 10^6 elements with lengths in excess of 12 ft have been produced. This type of instrument has many applications where rigid endoscopes are unusable, especially in medicine[6] and in the examination of curved piping etc. Either distal or light guide illumination may be used.

473

All radioactive materials are in some degree hazardous to man. Special facilities are needed to handle them, and in the design of such facilities the safety of personnel is the paramount consideration.

18.3.1 SAFETY PRECAUTIONS. The two hazards which form the prime obstacles to photography of radioactive materials are those of radiation and contamination.

Where contamination is the danger and radiation level is low, effective containment of the radioactive material (dusts, gases or liquids) in a Perspex glove box is usually possible. Materials or equipment which emit highly penetrating radiation (γ rays, X-rays or neutrons) are handled in cells with walls of high density material, such as lead or concrete, of thickness up to several feet, depending on the level of radiation. Viewing in such cells is possible through windows of either lead glass or zinc bromide solution in a glass tank and handling of materials in the cell is by means of remote tongs or manipulators.

18.3.2 PHOTOGRAPHY IN GLOVE BOXES. Photography of many samples through the glove box window may be practical, special optical glass sections being inserted if necessary. Equipment for macrophotography and photomicrography can be installed in such boxes with the objectives inside, giving the necessary short working distance, and film plane outside to allow convenient operation (film changing etc.).[7] The optical path passes through a sealed optically flat window.

18.3.3 PHOTOGRAPHY IN LEAD CELLS. When sources of penetrating radiation are to be handled in lead cells, which typically have walls about 6 in. thick, shielded viewing is often provided with a lead-glass window about twice as thick. Monochrome photography via the window is often feasible, using filters to minimise the effect of chromatic dispersion of oblique rays. Colour photography is unsatisfactory because of this dispersion and the selective absorption of the window.

Equipment for macrophotography and photomicrography has to be built-in, in a similar fashion to that described for glove boxes, except that mirrors are necessary to bend the light path so that its exit from the cell is usually above head height. This prevents dangerous shine of radiation out of the cell, because the mirrors transmit the radiation rather than reflect it. With the activity levels requiring lead cells, darkening of glass due to radiation becomes a problem, although cerium stabilised glasses which darken much less rapidly, can be used.

18.3.4 PHOTOGRAPHY IN CONCRETE CELLS. Large cells with concrete walls up to 6 ft thick impose greater restrictions because of the increased distance of the operator from the subject. Sodium lighting is used in the cells to eliminate chromatic effects from the window and with large subjects photography through the zinc bromide window may be the only possible method. Ports with removable plugs about 6 in. in diameter are usually provided in the concrete wall to allow small objects to be introduced into the cell, and also permit viewing by endoscopes and periscopes. The radioactive item is positioned outside the line of the port to prevent direct shine of radiation. Periscopic or endoscopic photography may be performed in the usual manner, with the added advantage that auxiliary lighting may be used.

Telephotography via a mirror or mirrors usually gives resolution superior to that of endoscopes and is often used.[8] Standard photographic lighting techniques can be

474

used, electronic flash being particularly suitable because tube life is long and there is no heating problem, as might be the case with tungsten illumination.

For large photographic programmes the design of special in-cell photographic facilities is worthwhile. Attention is given to such features as:

(1) Means of accurately and easily locating the subject, with respect to the camera.
(2) Reproducible illumination.
(3) Maximum information output. Multiple mirror systems may be useful to obtain more than one view of the subject with each exposure.
(4) Easy replacement of components, using master/slave manipulators.
(5) Easy remote adjustment of optical components.
(6) Reasonable compactness, so that the photographic facility can remain in the cell without interfering with other work.

Examples of actual systems designed on these principles are shown in Figs. 18.9 and 18.10. The system for recording the entire circumference of graphite rods (Fig. 18.9) consists of a light box (a) containing two flash tubes, and fluorescent tubes for setting-up purposes, an arcuate reflector (b) which provides even illumination of the rod by a bounced flash technique, and a front surface mirror (c) to reflect the image through the port to an external telephoto camera. This mirror allows the subject to

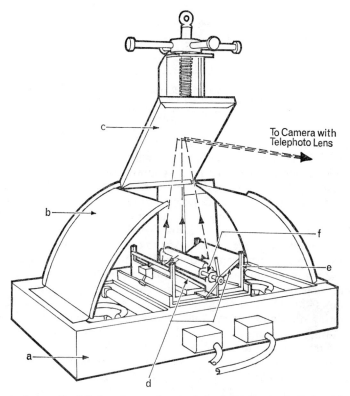

To Camera with
Telephoto Lens

Fig. 18.9. Apparatus for recording full circumference of reactor fuel rods. (a) Housing for flash and fluorescent tubes. (b) Reflector. (c) Surface mirror. (d) Mirrors providing view of entire circumference. (e) Sliding jig. (f) Specimen support.

475

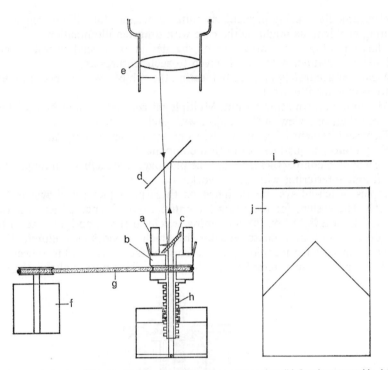

Fig. 18.10. Method of photographing ring interiors. (a) Radioactive specimen ring. (b) Specimen turntable. (c) Surface coated mirror mounted on long peg. (d) Semi-mirror. (e) Microscope lamp. (f) Slow speed motor to drive turntable for cine recording. (g) Belt drive. (h) Helical thread for height adjustment. (i) Light path to telephoto camera, viewing through part in cell wall. (j) Additional lead shielding.

remain out of alignment with the port, enabling the light beam to be reflected to the camera without leakage of radiation. The pair of lower mirrors (d) are provided to give full 360° coverage. A sliding jig (e) contains the lower mirrors and specimen locating support (f). An example of the type of result is shown in Plate 38.

Another system (Fig. 18.10) was developed to record the interior of graphite rings of about 1 inch diameter. The ring (a) is mounted on a turntable (b). A 45° front surface mirror (c) is located inside the ring which is rotatable without moving the mirror. A beam splitter (d) reflects the image to the telephoto camera. Illumination is provided by the microscope lamp (e) and reflected off the mirror (c). The mirror is mounted on a peg to permit easy replacement, and both the beam splitter and lamp unit are replaceable by remote handling manipulators. Cinematography of the rotating specimen allows the whole circumference to be studied and, due to the gradually changing lighting effect and viewing angle, shows the surface irregularities much more clearly than still photography. A conical mirror could be used at (c) to show the entire circumference at one time, but with less vertical height.

For the inspection and photography of the interiors of nuclear reactors, periscopes and endoscopes are almost invariably used.[9] Standard commercial instruments, usually of large diameter, can be used as discussed in 18.2, provided a right angle viewing facility is available to avoid radiation reaching the operator and camera.

476

Radiation darkening of the optics is a real problem, radiation levels sometimes being so high that even stabilised glass becomes darkened.

Front surface mirrors, preferably hard coated, should be used in preference to prisms where possible, because they are not susceptible to radiation darkening. The number of optical components should be kept to the absolute minimum: each additional element increases flare and reduces light transmission.

Remotely operated conventional film cameras are useless for operation without protection in highly radioactive environments because all films are fogged by high levels of radiation. Television cameras however are very valuable (see 18.5).

18.4 *Remotely Controlled Cameras*

Applications for remotely controlled cameras include photography from unmanned satellites and missiles, underwater photography at depths greater than those attainable by divers, bore hole photography, the close range photography of explosions, etc. Much of this work can be classed as instrumentation (Chapter 12).

Certain fundamental attributes are required of all remotely controlled cameras:
(1) Absolute reliability; in this respect the simpler the camera can be and still fulfil its purpose, the better.
(2) Adequate film capacity.
(3) Rugged, robust design.
Also systems may be required for relaying information regarding the correct functioning of the camera and for data recording, e.g. to show time, orientation or other relevant information on the record.

A special camera produced by the Olympus Optical Co, Tokyo may be swallowed and is used to give 5×3 mm colour transparencies of the stomach interior.[10]

18.4.1 UNDERWATER PHOTOGRAPHY. Remotely controlled photography at great ocean depths requires primarily a suitable waterproof camera housing capable of withstanding the pressure prevailing at the depth at which the camera is to be used.

Generally, very high power light sources are essential, as ambient lighting is virtually non-existent and the turbidity of the water greatly reduces the effective performance of artificial lighting. High power electronic flash sources are probably most suitable, although continuous sources may be preferable in some circumstances. The light unit should be positioned as far away from the optical axis as possible to minimise flare.[11, 12, 13]

Camera triggering may be automatic or by remote control from the surface. An automatic device due to Ewing[14] depended on a contact striking the sea bottom and firing an electronic flash. More advanced systems rely on sonar to determine camera depth and position giving an accuracy of heights above the sea bed of a few feet at depths of over 15,000 ft.

Owing to the refractive index of water, there is a reduction in the field of view of any camera of about one-quarter when used underwater, making wide angle lenses preferable. Distances appear less (both to the eye and camera) and allowance must be made if a focusing scale is used. Distances measured optically e.g. by rangefinder or reflex methods will be automatically compensated.

A method for using cameras mounted internally or externally under a ship's hull in the study of cavitation has been described by Fisher.[15]

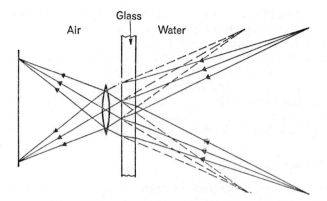

Fig. 18.11. Reduction in angle of view and apparent distance underwater. The broken lines show the equivalent ray paths in air.

18.5 *Closed Circuit Television*

Closed circuit television[16] has many applications in the photography of inaccessible objects. The television camera may function as an electronic image transfer system, providing an accessible image on a monitor screen which is filmed or photographed. Alternatively, the television camera can act as a viewfinder for remotely controlled conventional cameras in the applications discussed above, enabling an operator to decide when photography is required.

When used as a prime source of information, a television system has lower resolution, and therefore lower information carrying capacity than most still photographic records being very roughly equivalent to 16 mm cine film.

However, television has great advantages in hazardous environments. The camera does not require periodic reloading with film and need only be handled or removed in the event of a component failure. The information is available instantly, and if a permanent record is required, it may be recorded on video tape, or photographed in either cine or still. The television camera may be used in highly radioactive environments where a photographic emulsion would be fogged by radiation.

Other advantages are the ability to display the image to any number of monitors simultaneously and the ability to transmit an image in circumstances where optical image transfer would be impossible.

18.5.1 RECORDING THE TELEVISION IMAGE. The most obvious method of recording a television image is on video tape, in which the signal is retained in magnetic form. This has the advantage of simple and immediate playback, but is less convenient than film for distribution of multiple copies. Cinematography of the television screen is discussed in Chapter 10.

Still photography of a slowly moving event is simple; if the exposure is arranged to be equivalent to about 10 field scans or more ($> \frac{1}{5}$ sec), synchronisation is unnecessary. If an exposure of about 1/25 sec is essential, synchronisation so as to record precisely one scan is necessary if unevenness is to be consistently avoided. One automatic system is available in which the television picture is blacked out on operating the shutter

478

release. Once the shutter is open, the picture is automatically restored for an exact number of scans, then blacked out again. The shutter then closes and the receiver continues functioning in the normal way.

References

1 FELLGETT, P. B., *J Sci Instrum* (*J Phys E*), Series 2, Vol 1, 1968.

2 HEWITT, J., *Phot Sc and Eng*, **9**, 10 (1965).

3 KINGSLAKE, R., *Applied optics and optical engineering*, Vol 4, pp 1–29, Academic Press, London (1967).

4 DROUGARD, R. and POTTER, R. J., *Advanced optical techniques*, Ed A. C. S. Van Heel, Ch 11, North-Holland, Amsterdam (1967).

5 KAPANY, N. S., *Fibre Optics*, Academic Press, New York (1967).

6 HIRSCHOWITZ, B. I., *JSMPTE*, **73**, 625 (1964).

7 WITTAM, E. M. and HAINES, H. R., *A.E.R.E. Memorandum M-1604*, U.K.A.E.A. Research Group.

8 STEWART, J. C. J., *J Phot Sci*, **11**, 279 (1963).

9 MONK, G. S. and McCORKLE, W. H., *Optical instrumentation*, McGraw-Hill, New York (1954).

10 PAGE, A., *New Scientist*, **29**, 783 (1966).

11 SCHENK, H. and KENDALL, H., *Underwater Photography*, Cornell Maritime Press, Cambridge, Maryland (1954).

12 SELVIDIO, J. F., *JSMPTE*, **74**, 324 (1965).

13 EDGERTON and HOADLEY, *JSMPTE*, **64**, 345.

14 EWING, *J Opt Soc Amer*, **36**, 307 (1946).

15 FISHER, *Nature*, **169**, 1074 (1952).

16 SHACKEL, B. and WATSON, G. R., *Photography for the Scientist*, Ed C. Engel, Ch 14, Academic Press, London (1968).

Periodical

Underwater Science and Technology, Iliffe Science and Technology Publications Ltd. (Quarterly).

APPENDIX A

WAVELENGTH UNITS

With the increasing use of SI units (Système International d'Unités)* it is preferable to standardise on the micrometre (μm) and the nanometre (nm) as the units of wavelength, at least within the IR, visible and UV wavebands. However, in spectroscopy and other fields, different units are still in common use and the following terminology may be useful in the interpretation of some technical literature.

The micrometre (μm), formerly called the micron (μ)$=10^{-6}$m$=10^{-3}$ mm.

The nanometre (nm), formerly called the milli-micron (mμ) and previously the milli-micro-metre (mμm or $\mu\mu$)$=10^{-9}$ m$=10^{-3}$ μm.

The Angstrom unit (Å or AU)$=10^{-10}$ m$=10^{-1}$ nm.

The X-unit is used by crystallographers to express X-ray wavelengths XU$=10^{-13}$ m$=10^{-4}$ nm.**

The wave-number ($\bar{\nu}$) is often quoted in infrared and microwave spectroscopy; it is the number of wavelengths in 1 centimetre and is therefore given by $1/\lambda$ where λ is expressed in centimetres. For example, radiation with a wavelength of 10 μm (1/1000 cm) has a wavenumber ($\bar{\nu}$) of 1000; this may also be expressed as reciprocal centimetres e.g. 1000 cm^{-1}.

*There are several British Standards publications on metrication, including the following:
BS 3763:1964 International System (SI) units
PD 5686 The use of SI Units (January, 1969).
**In SI nomenclature the prefix femto denotes the sub-mutiple 10^{-15}. The X-unit could therefore be expressed as 100 femtometres (10^2 fm).

APPENDIX B

STANDARDS INSTITUTION PUBLICATIONS

Many of the British Standards in the photographic field are concerned with such topics as the dimensions of materials and components or the purity of chemicals; the following have been selected for their relevance in the context of this book.* These booklets can generally be recommended for reading by students because of their concise coverage of the theoretical background and their methodical approach to test procedures.

233: 1953	Glossary of terms used in illumination and photometry.
1019: 1963	Photographic lenses. Definitions, methods and accuracy of marking (Appendices on measuring focal length and measuring effective aperture and aperture ratio).
1153: 1955	Recommendations for the storage of microfilm.
1380	Methods for determining the speed of sensitised photographic materials.
Part 1: 1962	Negative monochrome material for use in daylight.
Part 2: 1963	Reversal colour film for still and cine photography.
1383: 1966	Photoelectric exposure meters.
1384: 1947	Measurement of photographic transmission densities.
1437: 1948	Methods of determining filter factors of photographic negative materials.
1592: 1958	Camera shutters (Recommended test methods are mentioned in an Appendix).
1613: 1961	Method of determining the resolving power of lenses for cameras.
2597: 1955	Glossary of terms used in radiology.
2833: 1957	Classification of expendable photographic flashbulbs.
3115: 1959	Recommendations for density and contrast range of monochrome films, slides and photographic opaques for television.
3205: 1960	Photographic electronic flash equipment (includes discussion of the relationship between performance data and exposure calculations).
3216: 1960	Dimensions of stereo still pictures on 35 mm film.
3824: 1964	Colour transmission of photographic lenses.
3890: 1965	General recommendations for the testing, calibration and processing of radiation-monitoring film.
3971: 1966	Image quality indicators for radiography and recommendations for their use.
4095: 1966	Method for determination of photographic flash guide numbers.
1000 (77): 1968	Universal decimal classification UDC 77 Photography. This booklet briefly explains the use of the UDC system commonly used in libraries and gives full details of the classification for all aspects of photography. References are also given to the UDC for related subjects.

*A complete list of British Standards and Recommended Practices is published annually in the BSI Yearbook.

American Standards are published by the United States of America Standards Institute (USASI)*; the following is a selection from over 300 in the field of photography.

PH2.2–1966	Sensitometry of photographic papers.
PH2.3–1956	Method for determining the actinity or the relative photographic effectiveness of illuminants.
PH2.4–1965	Method for determining exposure guide numbers for photographic lamps.
PH2.5–1960	Method for determining speed of photographic negative materials (monochrome, continuous-tone).
PH2.7–1966	Photographic exposure guide.
PH2.8–1964	Sensitometry of industrial X-ray films for energies up to 3 million electron volts.
PH2.9–1964	Sensitometry of medical X-ray films.
PH2.10–1965	Evaluating films for monitoring X-rays and Gamma rays.
PH2.15–1964	Automatic exposure controls for cameras.
PH2.17–1958	Diffuse reflection density.
PH2.19–1959	Diffuse transmission density.
PH2.20–1960	Sensitometric exposure of artificial-light-type color films.
PH2.21–1961	Determining speed of reversal color films for still photography.
PH2.22–1961	Determining the safety time of photographic darkroom illumination.
PH2.25–1965	Photographic printing density (carbon step tablet method).
PH2.27–1965	Determining the speed of color negative films for still photography.
PH4.1–1962	Manual processing of black-and-white photographic films and plates.
PH4.5–1961	Temperature and temperature tolerances for photographic processing baths.
PH4.14–1964	Evaluation of developers with respect to graininess of black-and-white films and plates.
PH4.29–1962	Manual processing of black-and-white photographic paper.

*10 East 40th St., New York NY 10016. Formerly known as the American National Standards Institute (ANSI) and the American Standards Association (ASA). The BSI are agents for these standards in the UK.

484

APPENDIX C

PHOTOGRAPHIC CONTENT OF SCIENTIFIC JOURNALS

The familiar range of British and American technical photographic journals can usefully be supplemented by reference to current scientific papers. Fortunately, the task of regularly reading through the whole of the current literature can be eased by subscribing to the photographic abstracting services:

(1) Abstracts of Photographic Science and Engineering (APSE), published monthly by the SPSE (about 6,000 abstracts a year).

(2) Photographic Abstracts, published bi-monthly by the RPS (about 3,000 abstracts a year).

(3) Physics Abstracts (Science Abstracts Series A), published fortnightly by the Institute of Electrical Engineers (about 100 abstracts p.a. are given under subject code 08.50—Photography).

There is inevitably a delay before articles are mentioned in the abstract journals and the following table may help the reader to select for occasional reading the most productive 'non-photographic' journals in the fields covered by this book. Hanson*

FREQUENCY OF PHOTOGRAPHIC ARTICLES IN SCIENTIFIC JOURNALS 1967–69

Chapter	Appl. Opt.	J.Opt. Soc.Amer.	J. Sci. Instrum.	Rev.Sci. Instrum.	Sci. Amer.	Sci.J.
1. Sensitometry	4	2	2			
2. Information capacity	15	20	1		5	1
3. Light sources	6		1	5	5	2
4. Macrophotography						
5. Photomicrography	1	1	5	1		
6. Microphotography				1		1
7. Infrared	8	2	1	3	1	2
8. Ultraviolet	6	3	2	2	2	1
9. Radiography	3		5	6	2	
10. Cinematography			1			
11. H.S. photography	1		3	6		
12. Instrumentation			1			
13. Stereo photography	3					
14. Photogrammetry				1		
15. Visualisation (inc. holography)	29	20	15	5	3	3
16. Engineering			1	1		1
17. Special cameras			1	1	1	
18. Inaccessible objects			1			
Total	76	48	39	33	19	11

Appl. Opt.	Applied Optics
J.Opt.Soc.Amer.	Journal of the Optical Society of America
J.Sci.Instrum.	Journal of Scientific Instruments (published as the Journal of Physics E)
Rev.Sci.Instrum.	Review of Scientific Instruments
Sci.Amer.	Scientific American
Sci.J.	Science Journal

*Hanson, P. P. 'Journals most cited by photographic scientists and engineers.' SPSE News, Vol. 11, No. 2 pp. 16–17 (1968).

has analysed a more comprehensive range of sources over a three-year period and has ranked 98 journals, including foreign language journals and the standard photographic publications; both these categories are excluded from the present survey.

The table shows the number of articles in each journal that were judged to fall within the scope of this book; the more abstruse theoretical papers, work on photographic chemistry, lists of patents and letters to the editor are not included. In each case, 24 issues of the journal were scanned over the period 1967–69.

Each individual will want to choose the sources best suited to his own field of work. It is suggested that the student should look through a few issues of the periodicals given here, in order to assess their potential usefulness. Further specialist journals are listed with the references to individual chapters.

There are a number of libraries in the United Kingdom that specialise in photographic literature; in some cases photocopy services and postal loans are offered.*

*Gauntlett, M.D. *J. Phot. Sci.* **17** p. 170–3 (1969).

INDEX

487

489

493

497

507

510